The Art of Ancient Egypt

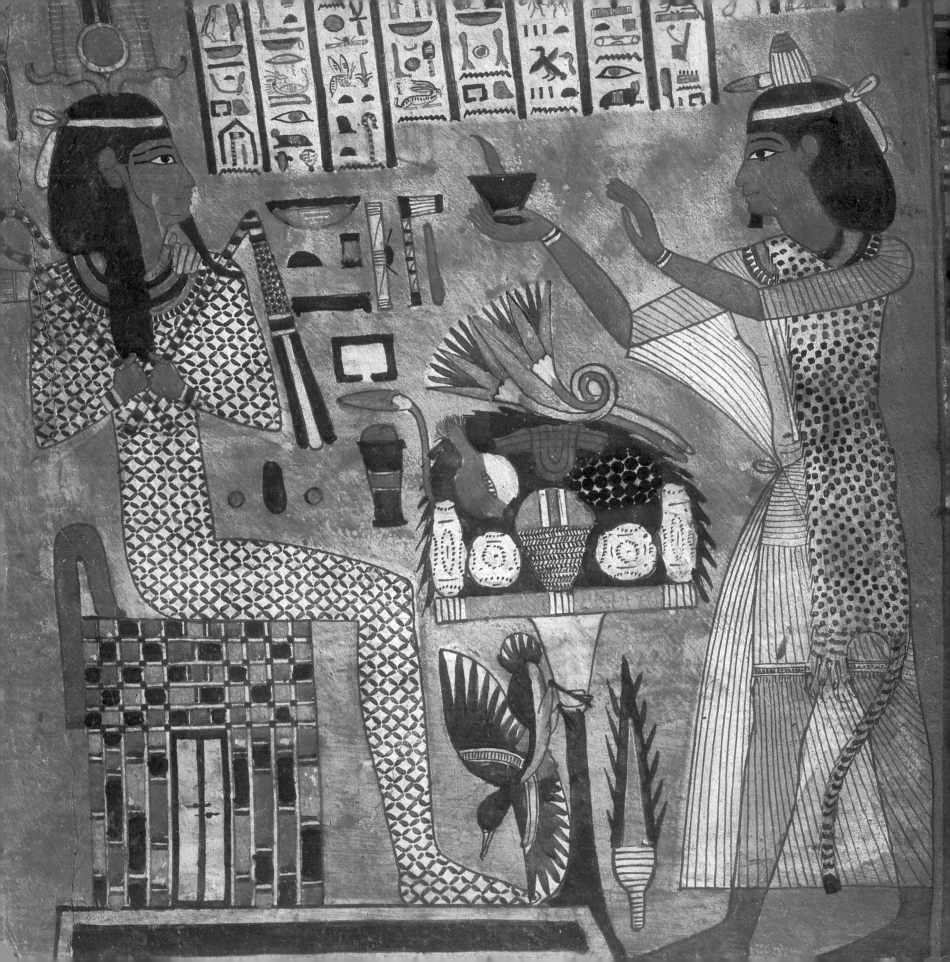

Gay Robins

The Art of Ancient Egypt

HARVARD UNIVERSITY PRESS

CAMBRIDGE, MASSACHUSETTS

Half-title page: Detail from the interior of the outer coffin of the
steward and chief of physicians Seni (see fig. 89).

Front cover and frontispiece: Amenemopet, priest of Amun, makes an offering to the
god Osiris. Painting on Amenemopet's wooden coffin from Thebes,
late Twenty-first or early Twenty-second Dynasty, *c.* 950–900 BC.
London, British Museum.

Back cover: Colossal quartrite head of Amenhotep III (see fig. 135)

© 1997 The Trustees of the British Museum

First Harvard University Press paperback edition, 2000

Library of Congress Cataloging-in-Publication Data

Robins, Gay.
 The art of ancient Egypt / Gay Robins.
 p. cm.
 Includes bibliographical references and index.
 ISBN 0-674-04660-9 (cloth)
 ISBN 0-674-00376-4 (pbk.)
 1. Art, Egyptian. 2. Art, Ancient–Egypt. I. Title.
N5350.R63 1997
709'.32–dc21 97-19458

Printed in Slovenia

Designed and typeset by Andrew Shoolbred

Contents

103195

Acknowledgements

I owe thanks to all those who have helped and encouraged me in researching and writing this book. The project was supported in part by the University Research Committee of Emory University and by a sabbatical leave that gave me the time to write my initial draft of the manuscript. I am extremely grateful to John Baines and Richard Parkinson for taking the time to read the manuscript and making many valuable suggestions. I would also like to thank Vivian Davies for all his encouragement while I was working on the book; Jim Romano for allowing me to read his paper 'Sixth Dynasty Royal Sculpture' before publication; Andrea McDowell for her helpful advice on texts concerning artistic practice from Deir el-Medina; Lorelei Corcoran for answering my query about bound prisoners on the footcases of Ptolemaic mummies; Carol Andrews, Stephen Quirke, Richard Parkinson and John Taylor for useful discussions and help in selecting illustrations; Tony Brandon, John Hayman and Jim Putnam for showing me objects in storage at the British Museum; and my editor Teresa Francis for her patience and help during the long period of incubation. As always, my husband Charles Shute made the whole project possible by taking care of the daily chores of life as well as reading and rereading the manuscript innumerable times and providing many discerning comments and helpful suggestions for its improvement.

Foreword

The purpose of this book is to provide an accessible and up-to-date introduction to ancient Egyptian art for a wide audience, both general and scholarly. If such a book is to encompass the whole span of ancient Egyptian civilisation, it must necessarily make many choices about what to include and what to leave out, lest it become a multivolume work. An obvious strategy is to treat only briefly aspects of Egyptian art that are addressed elsewhere and to concentrate on those that are not so readily accessible. I have therefore focused rather little on stylistic analysis and development, topics which have been treated by others.[1] Instead, one of my major aims is to explore why art was so important to the ancient Egyptians and why they invested such a large amount of their resources in its production. In examining this question I consider the original contexts for which different artistic genres were designed, and study how they functioned within and in relation to the social structure of ancient Egypt and its religious system. I discuss how the fact that only men held bureaucratic office affected matters of patronage and the way men and women were represented together. I also briefly incorporate the results of my research on the artist's squared grid system and on the far from constant proportions of the human figure.

Any treatment of the great monuments of ancient Egypt – temples, tombs, statuary – has such an overwhelming amount of material to draw upon that other art forms are often mentioned only briefly or even left out of consideration altogether owing to constraints of space. I decided, therefore, to include genres, such as coffins and funerary and votive stelae, that are not widely covered in existing books on Egyptian art. By contrast, the attention I have given to statuary takes into account the fact that its privileged treatment in many books will enable readers who so wish to obtain further information elsewhere.[2] Performance and other ephemeral arts are not considered in any detail, in the main because of lack of evidence.

I have, however, sought to give the final millennium of ancient Egyptian art a proper treatment in relation to the first two millennia. This span of a thousand years that ends with the conquest of Egypt by Rome in 30BC is often treated cursorily in a belief that it was an uncreative, stagnant and decaying period. I hope to demonstrate that such a view is unwarranted. I have chosen to end the book with the Ptolemies, even though traditional temple decoration and funerary arts continued to be produced after the Roman conquest, because it was at this point that Egypt ceased to have a resident king and was administered merely as part of the Roman empire.

The book is arranged chronologically. Each chapter is organised around two focal points, first the monuments and art forms associated with the king, and then those relating to the ruling elite group, because the king and the elite were the patrons who determined the nature of artistic production. I hope that this stratagem will help readers to follow the different themes that are found in art during the three thousand years of ancient Egypt's history, and the ways in which they developed and changed in different periods.

1 E.g. Aldred 1980; Smith 1981 (new edition pending).
2 Aldred 1980; Smith 1981. See also e.g. Evers 1929; Bothmer 1960; Habachi 1985; Russmann 1989; Fay 1996.

Chronology

After J. Baines and J. Málek, *Atlas of Ancient Egypt*, Oxford, 1980, 36–7.
All dates are BC. Those before 664 are approximate.

5000–2920	**Predynastic Period**
5000–4000	Badarian
4000–3600	Naqada I
3600–3100	Naqada II
3100–2920	Naqada III
	Scorpion; Narmer
2920–2649	**Early Dynastic Period**
2920–2770	First Dynasty
	Aha; Djer; Wadj; Den; Anedjib;
	Semerkhet; Qaa
2770–2649	Second Dynasty
	Hetepsekhemwy; Raneb; Ninetjer;
	Peribsen; Khasekhem(wy)
2649–2134	**Old Kingdom**
2649–2575	Third Dynasty
	Five kings including
2630–2611	Netjerykhet (Djoser)
2575–2465	Fourth Dynasty
2575–2551	Sneferu
2551–2528	Khufu
2528–2520	Radjedef
2520–2494	Khafra
2490–2472	Menkaura
2472–2467	Shepseskaf
2465–2323	Fifth Dynasty
2465–2458	Userkaf
2458–2446	Sahura
2446–2426	Neferirkara
2426–2419	Shepseskara

2419–2416	Raneferef
2416–2392	Neuserra
2396–2388	Menkauhor
2388–2356	Djedkara
2356–2323	Wenis
2323–2150	Sixth Dynasty
2323–2291	Teti
2289–2255	Pepy I
2255–2246	Merenra
2246–2152	Pepy II
2150–2134	Seventh-Eighth Dynasties
	Numerous ephemeral kings
2134–2040	**First Intermediate Period**
2134–2040	Ninth-Tenth Dynasties (ruling from Herakleopolis)
2134–2040	Eleventh Dynasty (ruling from Thebes)
2134–2118	Sehertawy Inyotef I
2118–2069	Wahankh Inyotef II
2069–2061	Nakhtnebtepnefer Inyotef III
2061–2010	Nebhepetra Montuhotep
2040–1640	**Middle Kingdom**
2040–1991	Eleventh Dynasty (ruling all Egypt)
2061–2010	Nebhepetra Montuhotep
2010–1998	Sankhkara Montuhotep
1998–1991	Nebtawyra Montuhotep
1991–1783	Twelfth Dynasty
1991–1962	Amenemhat I
1971–1926	Senwosret I

Understanding ancient Egyptian art

1 The east wall of the tomb chapel of Khnumhotep at Beni Hasan (no.3), looking into the shrine that once contained a rock-cut statue of the deceased in a niche on the rear wall. To the left of the doorway Khnumhotep is shown in the marshes, hunting birds with a throw-stick from a papyrus skiff. This composition is balanced by a similar one on the other side of the door showing Khnumhotep in a papyrus skiff spearing fish. Between the two scenes, over the doorway, Khnumhotep and his sons trap birds in a clap net. The whole wall is laid out in a symmetrical fashion with vertical and horizontal lines predominating, and the scenes are all related by their setting in the marshes. The door frame at the entrance to the shrine has been painted to imitate the costly and prestigious stone pink granite. It was once hung with double wooden doors that closed off the shrine when not in use. The chapel formed the setting for the performance of the funerary cult for the dead owner. The ritual would have centred on the statue in the shrine where the *ka* of the deceased could manifest itself in order to benefit from the presentation of offerings. Twelfth Dynasty.

This is a book about ancient Egyptian art, yet, as far as we know, the ancient Egyptians had no word that corresponded exactly to our abstract use of the word 'art'. They had words for individual types of monuments that we today regard as examples of Egyptian art – 'statue', 'stela', 'tomb' – but there is no reason to believe that these words necessarily included an aesthetic dimension in their meaning. Did the Egyptians then have no idea of art as we think of it today? Certainly they had no notion of gathering pieces of 'art' together in a gallery or museum for the sole purpose of viewing it, although later generations were not averse to visiting earlier monuments and leaving their comments in the form of graffiti. However, this does not mean that Egyptians were not aware of and did not aim for an aesthetic content in their monuments. It is rather that these monuments and other representational items were first and foremost functional.[1] To represent was, in a way, to create, and Egyptian representation in both two and three dimensions was bent on creating images that would function as a meaningful part of the cults of the gods and the dead. Statues provided places where deities could manifest themselves. Images of the dead ensured their survival in the next world and formed a point of contact between the realms of the living and the dead where the dead could receive the offerings brought by the living (fig. 1). Representations of temple cult ensured its enactment for all time, and depictions of offerings presented to the dead meant that these items would be available in the next world. Images of protective deities found in houses, on furniture and made into amulets created a powerful shield against the malign forces of the universe.

When we visit museums today or look through the illustrations of books on Egyptian art, the pieces that are presented to us are pieces that in general appeal to modern aesthetic tastes. Yet these represent only a selection of surviving Egyptian material. Visit any museum's reserve collections or examine the finds from many an excavation in Egypt, and you will discover another world completely. Here are objects that are plainly recognisable as statues, stelae, coffins, amulets, and yet one would hesitate to call them works of art. They may demonstrate poor workmanship, unbalanced composition, awkward proportions, clumsy execution. Nevertheless these pieces had the same functions as the more aesthetically appealing items. The difference between those objects that we prize as high-quality art and those we relegate to storage frequently derives from the status of their owners. The prized objects prove on examination to have been made almost invariably for kings and their high-ranking officials; the lesser pieces were usually commissioned by people lower in the social hierarchy. Since the king and his top officials commanded the most resources in ancient Egypt, it follows that they had access to the best artists, that is, the artists who had the skills to produce in the best possible way what their patrons desired. That the monuments produced by these artists also appeal to us today suggests that our aesthetic tastes and those of the ancient Egyptians were similar. However, people of lesser rank who could not get access to first-class artists had to accept work from second-rate talents. Although the resulting objects frequently lacked the artistic quality of the more accomplished works, they must still have functioned to the benefit of the owner or there would have been no point in having them made.

Today it is the aesthetic quality of Egyptian art that many people admire. Statues, stelae, fragments of wall decoration that appeal to modern tastes are displayed as iso-

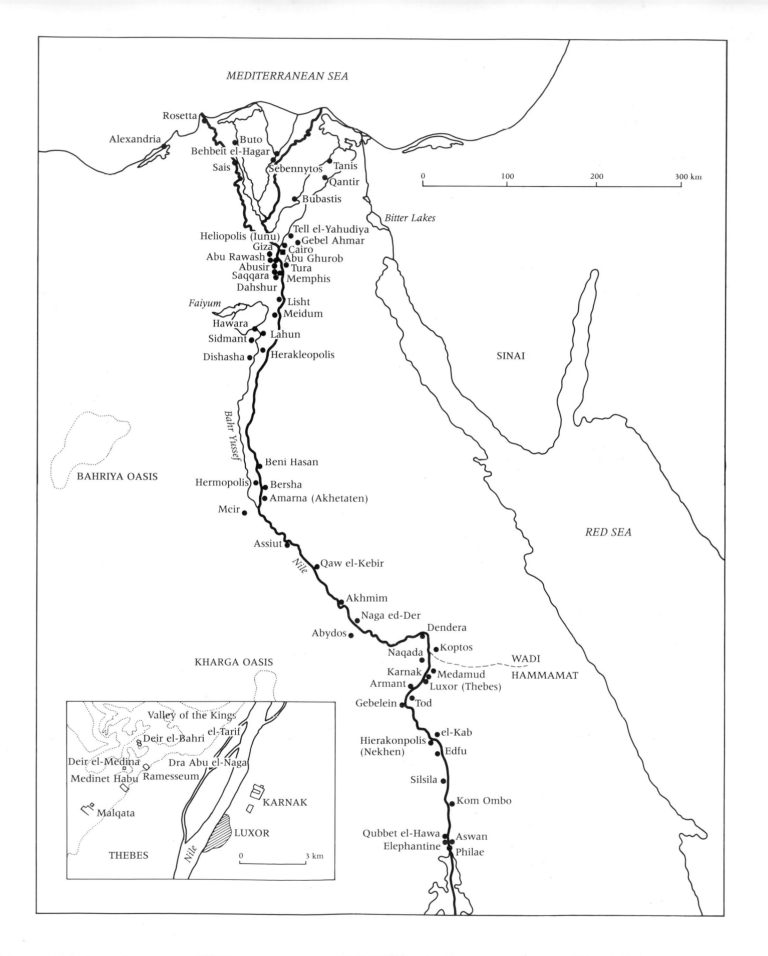

MEDITERRANEAN SEA

Rosetta
Alexandria
Buto
Behbeit el-Hagar
Sais
Sebennytos
Tanis
Qantir
Bubastis
Bitter Lakes

Tell el-Yahudiya
Heliopolis (Iunu)
Gebel Ahmar
Giza
Cairo
Abu Rawash
Abu Ghurob
Abusir
Tura
Saqqara
Memphis
Dahshur
Faiyum
Lisht
Meidum
Hawara
Sidmant
Lahun
Dishasha
Herakleopolis

Bahr Yussef

BAHRIYA OASIS

Beni Hasan
Hermopolis
Bersha
Amarna (Akhetaten)
Meir

Assiut
Qaw el-Kebir
Nile

Akhmim
Naga ed-Der
Abydos
Dendera
Koptos
Naqada
WADI
HAMMAMAT
Karnak
Medamud
Armant
Luxor (Thebes)
Gebelein
Tod

el-Kab
Hierakonpolis
(Nekhen)
Edfu

Silsila
Kom Ombo

Qubbet el-Hawa
Aswan
Elephantine
Philae

SINAI

RED SEA

KHARGA OASIS

Valley of the Kings
el-Tarif
Deir el-Bahri
Deir el-Medina
Dra Abu el-Naga
Medinet Habu
Ramesseum
Malqata
KARNAK
LUXOR
THEBES
Nile
0 3 km

0 100 200 300 km

11

770–750	Kashta
750–712	Piye

712–332	**Late Period**
712–657	Twenty-fifth Dynasty (Nubia and all Egypt)
712–698	Shabaka
698–690	Shebitku
690–664	Taharqa
664–657	Tantamani

664–525	Twenty-sixth Dynasty
664–610	Psamtik I
610–595	Necho II
595–589	Psamtik II
589–570	Apries
570–526	Amasis
526–525	Psamtik III

525–404	Twenty-seventh Dynasty (Persian)

404–399	Twenty-eighth Dynasty
	Amyrtaios

399–380	Twenty-ninth Dynasty
399–393	Nepherites I
393	Psammuthis

393–380	Hakoris
380	Nepherites II

380–343	Thirtieth Dynasty
380–362	Nectanebo I
365–360	Teos
360–343	Nectanebo II

343–332	Thirty-first Dynasty (Persian)

332bc–ad395	**Graeco-Roman Period**
332–304	Macedonian Dynasty
332–323	Alexander the Great
323–316	Philip Arrhidaeus
316–304	Alexander IV

304–30	Ptolemaic Dynasty
	Fifteen kings and several ruling
	queens including
304–284	Ptolemy I Soter I
246–221	Ptolemy III Euergetes I
205–180	Ptolemy V Epiphanes
170–163, 145–116	Ptolemy VIII Euergetes II
51–47	Ptolemy XIII
51–30	Cleopatra VII

30 bc–ad 395	**Roman emperors**

1929–1892	Amenemhat II
1897–1878	Senwosret II
1878–1841	Senwosret III
1844–1797	Amenemhat III
1799–1787	Amenemhat IV
1787–1783	Sobeknefru

1783–post 1640	Thirteenth Dynasty
	About seventy kings including
	Wepwawetemsaf
	Fourteenth Dynasty
	A group of minor kings who were
	probably all contemporary with the
	Thirteenth or Fifteenth Dynasty

1640–1532	**Second Intermediate Period**
	Fifteenth Dynasty (Hyksos)
	Sixteenth Dynasty (minor Hyksos rulers)
1640–1550	Seventeenth Dynasty
	Numerous Theban kings including
	Sekhemrawadjkhau Sebekemsaf
1555–1550	Wadjkheperra Kamose

1550–1070	**New Kingdom**
1550–1307	Eighteenth Dynasty
1550–1525	Ahmose
1525–1504	Amenhotep I
1504–1492	Thutmose I
1492–1479	Thutmose II
1479–1425	Thutmose III
1473–1458	Hatshepsut
1427–1401	Amenhotep II
1401–1391	Thutmose IV
1391–1353	Amenhotep III
1353–1335	Amenhotep IV/Akhenaten
1335–1333	Smenkhkara/Neferneferuaten
1333–1323	Tutankhamun
1323–1319	Ay
1319–1307	Horemheb
1307–1196	Nineteenth Dynasty
1307–1306	Ramses I
1306–1290	Sety I

1290–1224	Ramses II
1224–1214	Merenptah
1214–1204	Sety II
	Amenmesse (usurper during reign of Sety II)
1204–1198	Siptah
1198–1196	Tawosret
1196–1070	Twentieth Dynasty
1196–1194	Sethnakhte
1194–1163	Ramses III
1163–1100	Ramses IV–Ramses X
1100–1070	Ramses XI

1070–712	**Third Intermediate Period**
1070–945	Twenty-first Dynasty
1070–1044	Smendes
1044–1040	Amenemnisu
1040–992	Psusennes I
993–984	Amenemope
984–978	Osorkon I (Osorkon the Elder)
978–959	Siamun
959–945	Psusennes II
945–712	Twenty-second Dynasty
945–924	Shoshenq I
924–909	Osorkon II (Osorkon I)
	Shoshenq II (co-regent only)
909–883	Takelot I
883–855	Osorkon III (Osorkon II)
860–835	Takelot II
835–783	Shoshenq III
783–773	Pami
773–735	Shoshenq V
735–712	Osorkon V (Osorkon IV)
828–712	Twenty-third Dynasty
	Various contemporary lines of kings including
828–803	Pedubaste I
777–749	Osorkon IV (Osorkon III)
754–734	Takelot III
	Iuput II
724–712	Twenty-fourth Dynasty (Sais)
770–712	Twenty-fifth Dynasty (Nubia and Theban area)

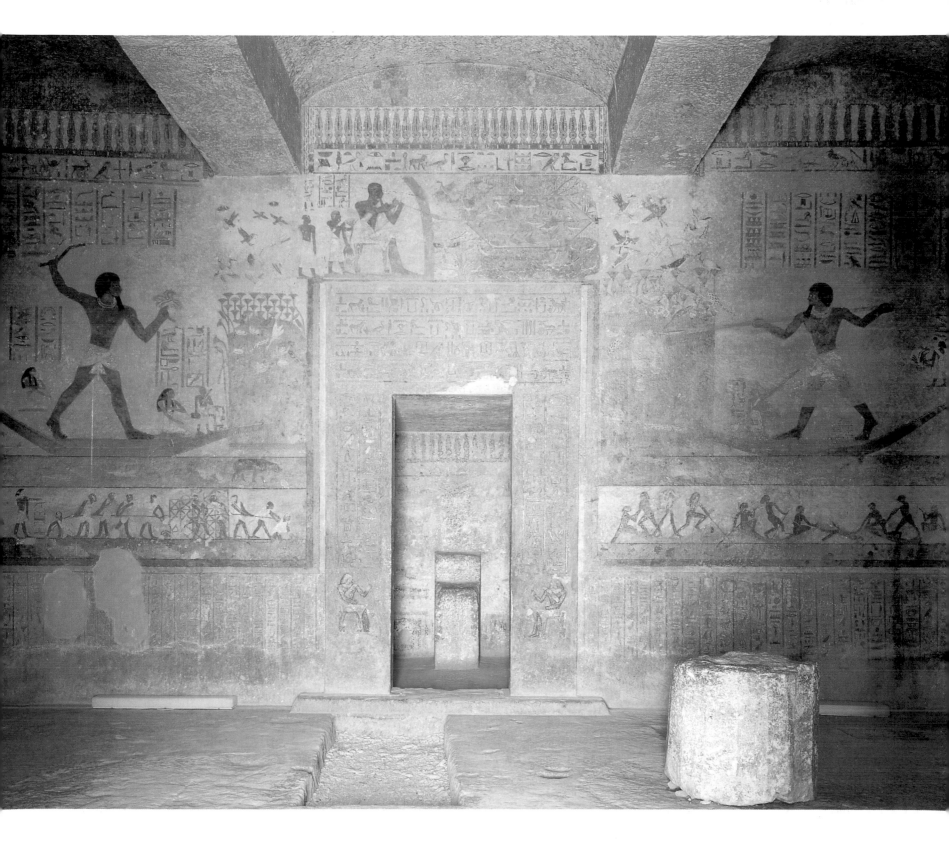

lated objects for the viewer's delectation. Many have no provenance, all are out of context. The relationship between an architectural form, its two-dimensional decoration and the statues created to occupy the resulting space is lost and can seldom be restored. However, by studying the remains of ancient temples, tombs and settlements that still survive in Egypt and by reading the written records left by the ancient Egyptians, we can begin to understand something of the Egyptians' world view and how this shaped their attitude towards the 'art' that they created.

The Egyptian world view

The way the Egyptians perceived the world was greatly influenced by their geographical environment. Ancient Egypt was situated in the north-east corner of the African continent in an area that would have been total desert were it not for the river Nile that ran and still runs north from central Africa for thousands of miles before splitting into the several channels of the Delta that empty into the Mediterranean Sea. In Egypt the Nile forms a thin thread of life-giving water in an otherwise waterless region, for there is far too little rainfall in the area to support life. The

miracle of the river was its annual inundation that flooded the land to either side of the river channel, watering the soil and spreading fertile black silt in which farmers could plant their crops. However, the area of land brought under cultivation extended only as far as the flood waters reached. Beyond that was desert, and the edge of the cultivation formed a clear line, with the fertile fields on one side and sterile sand on the other.

This phenomenon was reflected in one pair of names that the Egyptians gave to the region they inhabited: *Kemet*, 'the black land', and *Desheret*, 'the red land'. Together the pair formed a contrasting duality that represented more than just the opposition of fertile and sterile land, but also a cosmic struggle between the forces of order and the forces of chaos.

At the time of creation the ordered world was brought into being. Before that, nothing had been ordered, and there had been only the primaeval waters called Nun. Out of these waters a mound had arisen, just as muddy mounds emerged out of the flood waters of the Nile each year as the inundation retreated, and it was on this mound that the creator god, who came into being of himself, appeared.² How the creator god generated the universe was

2 Part of the *Book of the Dead* of the king's scribe Ani, showing Ani, followed by the smaller figure of his wife Tutu, adoring Osiris, the ruler of the underworld, and his sister-consort Isis, who are enclosed within a shrine. Osiris is shown wrapped and shrouded in white linen like a mummy, but his green skin symbolises his regeneration, when he was brought back to life by Isis after he had been murdered by the god Seth. Although the papyrus belongs to Ani, he is accompanied by his wife in some, but not all, of the vignettes. The two groups of figures frame fifteen columns of hieroglyphs containing an address and a hymn to Osiris. These have to be imagined as being recited by Ani as part of his adoration of the deity. Thebes. Paint on papyrus, H. 38 cm. Nineteenth Dynasty. London, British Museum.

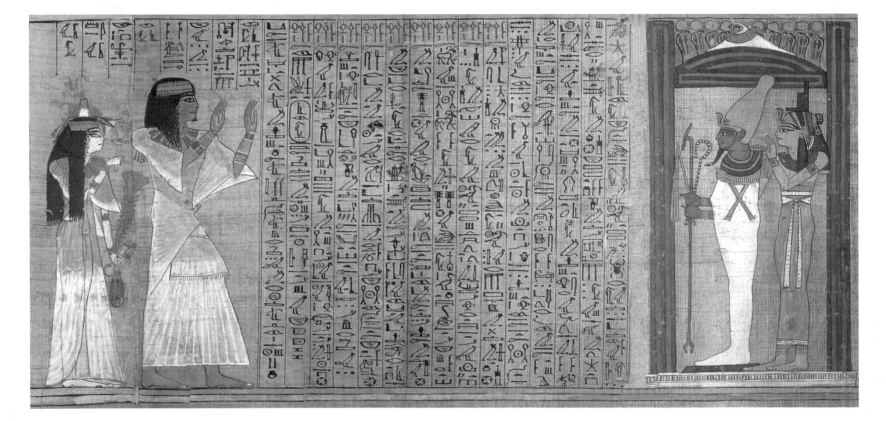

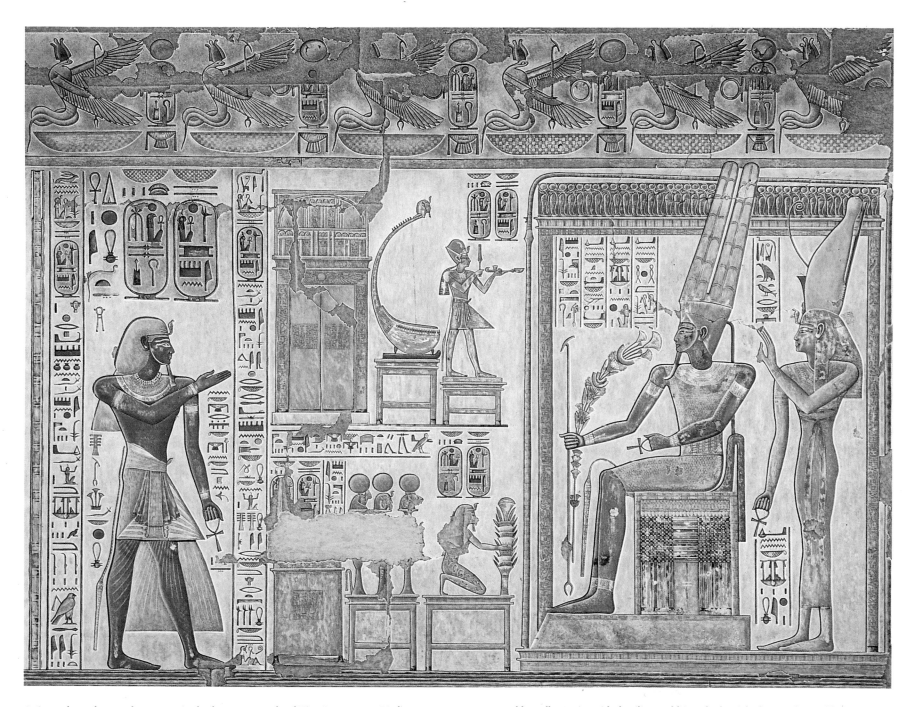

3 Scene from the temple treasury in the funerary temple of King Ramses III at Medinet Habu. The most valuable ritual items of the temple, made of gold, silver and other precious materials, were kept in the treasury, and the decoration of the walls reflects this fact. Here, in a scene captioned 'presenting chests of silver and gold to his father Amun-Ra, king of the gods', Ramses III is shown offering various items of ritual furniture to the god, who is seated in a shrine with his consort Mut standing behind him. The objects presented are statues of the king, a harp and three tall vases with elaborate stoppers, all placed on stands for storage. Behind them are a large shrine with double doors and a smaller chest. Gold is represented by yellow paint with detailing and hieroglyphs picked out in fine red lines. Other dominant colours are turquoise, dark blue and red, the colours of the (semi-)precious stones most frequently used by the Egyptians. White is sparingly employed, so that, where one would expect white on Mut's crown and the king's headdress and kilt, yellow is used instead. This overall colour scheme adds to the feeling of richness and wealth engendered by the subject matter. From the post-Amarna period on, Amun-Ra was often represented with dark blue skin, perhaps a reference to the colour of the sky or to the precious stone lapis lazuli. Twentieth Dynasty.

4 Glazed tiles from the palace of King Ramses III at Tell el-Yahudiya in the Delta showing (from left) a bound Libyan, Syrian and Nubian. The figures are easily recognisable as foreigners by their non-Egyptian hairstyles and costume, which also serve to distinguish the different ethnic groups represented. The representation of foreign prisoners in subjection to the Egyptian king symbolised the king's role in establishing and maintaining the correct order of the universe by triumphing over the forces of chaos. H. of Libyan 8.9 cm. Twentieth Dynasty. London, British Museum.

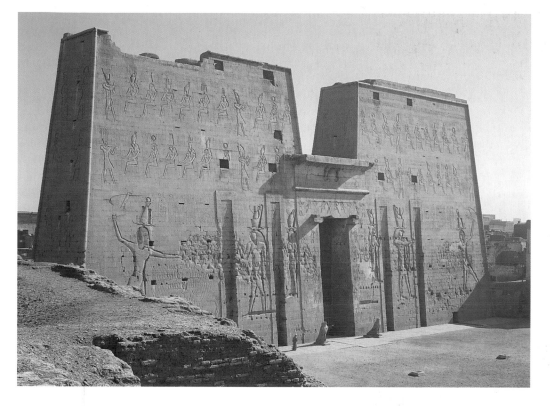

5 The pylon fronting the temple of Horus at Edfu. The towers on either side of the entrance are decorated with large figures of King Ptolemy XIII smiting enemies before the deities Horus and Hathor. In addition to symbolising the triumph of order over chaos, the images have an apotropaic function, protecting the pure environment of the temple interior from the polluting influences of the outside world. The four grooves in the face of the pylon and the holes above once held four flagpoles whose tips were hung with coloured pennants and covered in metal to catch the sun's rays. Internal staircases give access to the top of the pylon. Sandstone. Ptolemaic period.

world and to prevent it from slipping back into chaos: this is reflected over and over again on the monuments. The king was the mediator between the divine and the human worlds. In temple decoration he was always the one shown performing the rituals for the gods, although in practice the task was delegated to priests. By maintaining the cults of the gods through the various temple rituals centred on the cult statues, the king persuaded the gods constantly to re-enact creation and maintain world order. In building and decorating temples, or in commissioning furnishings and items to be used in cult, the king engaged in acts of creation that strengthened order and banished chaos (fig. 3).

Just as the ordered, cultivated area of Egypt was opposed to the chaotic regions of the desert, so Egypt itself stood in contrast to the foreign lands that lay outside its borders. In Egypt the world was ordered in the correct way and people behaved in a proper manner. Outside Egypt everything was at odds with these norms. Other countries had no Nile to bring water and had instead to make do with rain. Mesopotamia did, indeed, have the river Euphrates running through it, but it flowed the wrong way. Customs in foreign countries differed from those in Egypt, and people wore different clothes, worshipped unfamiliar deities and spoke incomprehensible languages (fig. 4). They did not behave in accordance with the norms established at the time of creation. Therefore foreign lands and their inhabitants were regarded as representatives of the forces of chaos, and the king could strike a blow for the maintenance of order by trouncing Egypt's foreign enemies in battle. A major icon of kingship showed the victorious king about to smite cowering enemy captives, in an image that symbolised the triumph of order over chaos (fig. 5).

This fundamental pairing of order and chaos illustrates the Egyptians' tendency to see their world in terms of dualities. Another name for Egypt was the Two Lands, referring to the Valley (Upper Egypt) and the Delta (Lower Egypt). One of the king's most important titles was *nesut bity*, usually translated as King of Upper and Lower Egypt, but increasingly rendered as 'Dual King'. It was once believed that this division of Egypt into two parts was based on historical fact, that before the country was first united into a single state there had been two kingdoms, one in the south and one in the north. Today it is thought more likely that the duality of Egyptian kingship was conceptually rather than historically based. It was a concept that affected the decoration of temples and royal monuments throughout pharaonic history. Whatever their origins, the king's white crown came to be associated with Upper Egypt in the south and his red crown with Lower Egypt in the north. Paired

conceptualised in a variety of ways. According to one version he masturbated and brought forth the first divine couple, Shu and Tefnut, thus separating the male and female principles of the universe.[3] Shu and Tefnut, in their turn, gave birth to the deities Geb (earth) and Nut (sky), who subsequently bore the deities Osiris, Isis, Nephthys and Seth.

In many ways Osiris represented the ordered world. He came to be regarded as having ruled Egypt as a beneficent king who brought the benefits of civilisation to his country. Seth, by contrast, represented the antithesis of order. His very birth from his mother Nut had been irregular, and he caused the death of Osiris, so as to claim the kingship of Egypt for himself.[4] However, Osiris' sister-consort Isis brought Osiris back to life through her powerful magic and conceived a son, Horus, who was to avenge his father's death and, as his father's heir, would challenge Seth for the kingship.[5] Seth was displaced and Horus became king of Egypt, while the resurrected Osiris became ruler of the underworld (fig. 2). Thus order was re-established in the universe and chaos brought under control.

Every king of Egypt was identified with Horus during his lifetime and then with Osiris after his death. One of the main functions of the king was to maintain the order of the

6 Large fragment of a limestone relief showing King Neuserra seated on a throne raised on a dais that is decorated with two kneeling fecundity figures tying the plants of Upper and Lower Egypt around the hieroglyph for 'union'. This is an elaborate version of the *sema tawy* motif, signifying the union of the Two Lands in the person of the king. A jackal-headed deity, probably either Anubis or Wepwawet, stands in front of Neuserra holding an *ankh*, the hieroglyph for 'life', to the king's nose with his forward hand, and with his other hand he places three more *ankh*-signs into the king's outstretched hand. Neuserra grasps three further *ankh*-signs in his rear fist. Since 'life' was an attribute of deities, given by them to the king, the presentation of one or more *ankh*-signs is a common theme in royal iconography and serves to demonstrate divine acceptance of the king. The goddess Wadjit stands behind Neuserra with her arm around his shoulders in a gesture of protection and acknowledgment of his kingship. The eyes of the figures were originally inlaid.

While the main register represents the sacred sphere in which the king and deities interact, the much smaller register below with two facing rows of bowing figures depicts the human world of which the king is also a part. The small scale of the figures and their location in the lower register symbolise the subordinate position of humanity in relation to deities and the king within the cosmic hierarchy. From the pyramid temple of King Neuserra. H. 240 cm. Fifth Dynasty. Berlin, Ägyptisches Museum.

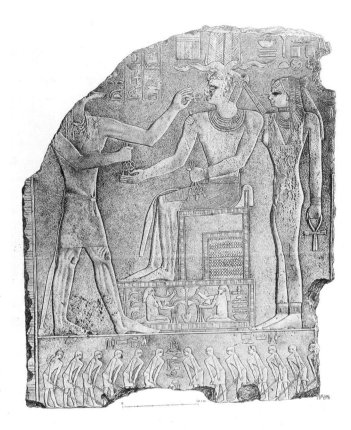

figures of the king, for instance on either side of a doorway, would be placed so that the southern figure wore the white crown and the northern figure the red. Each of the two areas also had its own goddess and heraldic plant: the vulture goddess, Nekhbet, and the 'lily' for Upper Egypt, and the cobra goddess, Wadjit, and the papyrus plant for Lower Egypt (fig. 243). Their appearance on monuments was also carefully positioned according to the overall orientation of the structure. The two heraldic plants as a pair stood for the entire country, and a very common motif found in royal contexts, especially on the sides of the king's throne, showed the plants with their stems knotted around a large version of the hieroglyph meaning 'union', the whole symbol reading *sema tawy*, 'the union of the Two Lands'. Thus it was in the single person of the king that the duality of Egypt was bound into one (fig. 6).

The king not only united Upper and Lower Egypt but he was also the link between the human and divine worlds. Although the king was himself a human being, the office of kingship was divine; the human body of the king was the vessel in which divine kingship manifested itself in the form of the royal *ka* or life force that was passed on from one king to the next. The king was thus in some ways similar to, though not identical with, the gods, and one of his titles, *netjer nefer*, meant 'Perfect God'. In the hierarchical ranking of beings, this title placed him in a junior relationship to the major gods, who bore the title *netjer aa*, 'Great God'. Indeed the king was clearly not the same as one of these gods, since he could be deified after his death, or even during his lifetime when the living king could be depicted performing ritual actions before his own deified form.[6]

If the king was junior in relation to other gods, he was the most important figure in the world of the living. He stood at the head of the government, ruling Egypt through a male scribal bureaucracy. Literacy was the basic qualification for a government position, and it has been reckoned that only a very small percentage of the population was literate.[7] Thus these officials, together with their families, formed a small, elite group that was itself hierarchically organised. At the top were the high national officials, like the vizier who was second only to the king, who themselves had a series of officials under them. Lower than the national officials were high-ranking administrators in important provincial regions and their staffs, and lower still were local scribes. Beneath the scribal elite were artists of various kinds and other semi- or non-literate professionals who produced goods and provided services for the elite. Finally, the mass of the population worked on the land as independent farmers, tenant farmers or landless labourers in order to produce the surplus necessary to supply the non-food-producing classes.

It is the smallest part of the population, the king and the elite scribal class, about whom we know most. They were the ones who commissioned the monuments and wrote the texts that form much of the source material that we use today in order to study ancient Egypt. The vast bulk of the population had neither the resources to commission monuments nor the knowledge to write texts. What we know of these people comes from what the elite class chose to record about them, which is tantalisingly little. When depicted, they were shown only in their service to the elite group with no independent lives of their own. Whether the non-elite had their own tradition of folk art is not known, since we have little knowledge archaeologically of the villages and houses they lived in, where we might expect to find evidence of any such tradition. Thus, the works of art that form the subject of this book were produced for the elite and express their world view.

7 Black basalt statue of Wahibra found near Lake Mareotis in the western Delta. This kneeling statue shows the official presenting a small shrine containing an image of the god Osiris. Like all formal statues, the figure of Wahibra exhibits frontality, facing forward with no marked turning or twisting of the head or body. The statue would have been set up in a temple to enable Wahibra to take part in the ritual performed there for eternity. His piety is commemorated through his act of offering a shrine containing Osiris's image. This image, carved in high relief, likewise demonstrates frontality, since the god needs to look out of the shrine at the ritual being performed before him. The whole statue has been worked into smooth, rounded forms that contrast with the hardness of the stone. The full, oval face with its heavy lower lip exhibits the bland, idealising expression typical of the Twenty-sixth Dynasty. H. 180.3 cm. Twenty-sixth Dynasty. London, British Museum.

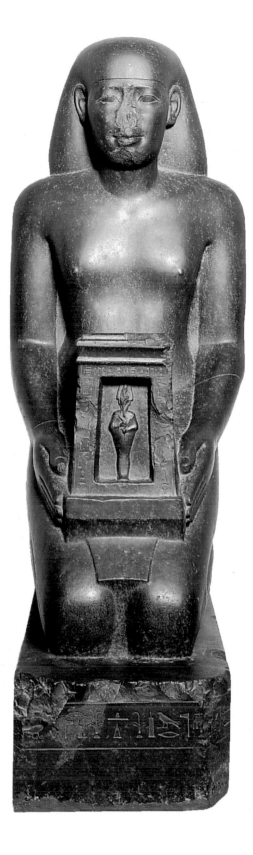

Principles of Egyptian art

In order to understand Egyptian art it is vital to know as much as possible of the elite Egyptians' view of the world, and the functions and contexts of the art produced for them. Without this knowledge we can appreciate only the formal content of Egyptian art, and we will fail to understand why it was produced, or the concepts that shaped it and caused it to adopt its distinctive forms. In fact a lack of understanding concerning the purposes of Egyptian art has often led it to be compared unfavourably with the art of other cultures: why did the Egyptians not develop sculpture in which the body turned and twisted through space, like classical Greek statuary; why do artists seem to get left and right 'muddled'; why did they not discover the rules of geometric perspective as European artists did in the Renaissance? The answer to such questions is that these supposed shortcomings had nothing to do with a lack of skill or imagination on the part of Egyptian artists, and everything to do with the purposes for which they were producing their art.

The majority of three-dimensional representations, whether standing, seated or kneeling, exhibit what is called frontality: they face straight ahead, neither twisting nor turning (fig. 7). When such statues are viewed in isolation, out of their original context and without knowledge of their function, it is easy to criticise them for their rigid attitudes that remained unchanged for three thousand years. Frontality is, however, directly related to the functions of Egyptian statuary and the contexts in which statues were set up. Statues were created not for their decorative effect but to play a primary role in the cults of the gods, the king and the dead. They were designed as places where these beings could manifest themselves in order to be the recipients of ritual actions. Thus it made sense to show the statue looking ahead at what was happening in front of it, so that the living performer of the ritual could interact with the divine or deceased recipient. Very often such statues were enclosed in rectangular shrines or wall niches whose only opening was at the front, making it natural for the statue to display frontality (fig. 7). Other statues were designed to be placed within an architectural setting, for instance, in front of the monumental entrance gateways to temples known as 'pylons', or in pillared courts, where they would be placed against or between pillars: their frontality worked perfectly within the architectural context (figs 8, 213).

Statues were normally made of stone, wood or metal. Stone statues were worked from single rectangular blocks

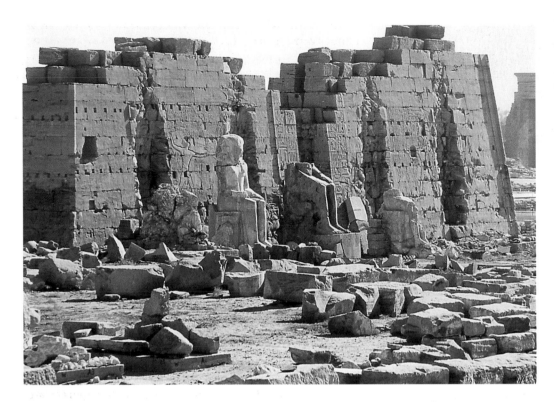

8 View from the top of the temple of Khons looking towards the eighth pylon of the temple of Amun-Ra at Karnak. The pylon was erected by the female king Hatshepsut to the south of the main temple, at right angles to its east–west axis, in order to create a processional way leading to the temple of the goddess Mut and to Luxor. The frontality of the colossal statues placed before the pylon suits the architectural setting. Eighteenth Dynasty.

bread, brewing beer, producing pots, making music. They have no role in cult and are not meant to perpetuate the existence of a particular person. They were made exclusively for the benefit of the deceased member of the elite in whose tomb they were put, just like any other item of funerary equipment. Unlike formal statues that are limited to static poses of standing, sitting and kneeling, these figures are engaged in a variety of activities and shown in appropriate poses, bending and squatting as they carry out their tasks (figs 72–3). In fact it is the action and not the figure itself that is important. Those made of stone often lack the solidity of formal statues, because the stone has been cut away everywhere, leaving limbs separate from the body and each other.

When artists work in three dimensions they can, if they so desire, achieve a realistic correspondence between the three-dimensional world and their three-dimensional sculptures. The matter is quite different, however, for artists who wish to reproduce the three-dimensional world on a two-dimensional surface. In a number of cultures artists have found means by which to obtain the illusion of the third dimension, depth, in their work, but in others the two-dimensionality of the drawing surface has been accepted and even exploited. The ancient Egyptians belonged to the latter group, which historically is more

of material, and retained the compactness of the original shape. The stone between the arms and the body, and between the legs in standing figures or the legs and the seat in seated ones, was not normally cut away. From a practical aspect this protected the figures against breakage, and psychologically gives the images a sense of strength and power, usually enhanced by a supporting back pillar (fig. 9). By contrast, wooden statues were carved from several pieces of wood that were pegged together to form the finished work, and metal statues were either made by wrapping sheet metal round a wooden core or cast by the lost wax process.[8] The arms could be held away from the body and carry separate items in their hands; there is no back pillar. The effect is altogether lighter and freer than that achieved in stone, but, because both perform the same function, formal wooden and metal statues still display frontality (fig. 10).

Apart from statues representing deities, kings and named members of the elite that can be called formal, there is another group of three-dimensional representations that depicts generic figures, frequently servants, from the non-elite population. The function of these is quite different. Many are made to be put in the tombs of the elite in order to serve the tomb owners in the afterlife. These statues depict a wide range of actions: grinding grain, baking

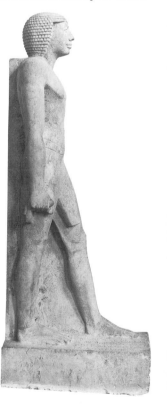

9 Standing statue of the official Tjayasetimu, viewed from the right side and showing the rectilinear back pillar that runs behind the statue from the level of the shoulders to the statue base. Although its form may vary, sometimes providing a useful dating criterion, the back pillar is found on Egyptian stone statuary of all dates from the Old Kingdom to the Graeco-Roman period. It is often inscribed with texts and sometimes also two-dimensional images. Limestone, H. 126 cm. Twenty-fifth to Twenty-sixth Dynasty. London, British Museum.

10 Wooden statue of the official Tjeti from the provincial site of Akhmim, displaying the style of the later Sixth Dynasty with large eyes, narrow shoulders and waist, raised small of the back and little musculature. The statue was originally painted and traces still survive, including black paint on the wig and nipples, the latter being inlaid in wood. The eyes are inlaid with black obsidian and white limestone and outlined with a band of copper. The modern staff replaces a lost original, while the right hand, which is pierced, probably once carried a sceptre. Tjeti is identified by his titles and name inscribed on the statue base. Nude statues of elite males occur only in the Fifth and Sixth Dynasties and perhaps refer to rebirth into the afterlife. In other contexts and periods male nudity seems to indicate a lack of status. H. 75.5 cm. Sixth Dynasty. London, British Museum.

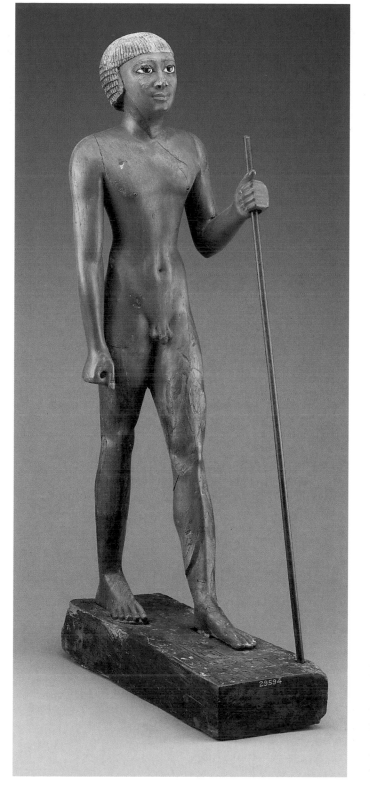

widespread. When creating representations on a two-dimensional surface, they did not aim to incorporate the appearance of depth.[9] Rather they arranged two-dimensional images of the objects they wished to represent over the flat drawing surface. These objects were rendered from their most characteristic and easily recognised aspect, usually in profile, full view, plan or elevation. These were then grouped together to form a scene. Because these different views can occur together in the same picture plane, the result is not rendered as from a single viewpoint, but rather is a composite assemblage encoding information that can be interpreted by the educated viewer.

The rendering of the human figure forms a composite built up from its individual parts (fig. 11). Thus the head is usually shown in profile with a full-view eyebrow and eye set into it. The shoulders of formal figures are most frequently depicted full view but the waist, buttocks and limbs are in profile. The nipple on male figures and the breast on female ones are drawn in profile on the front line of the body. However, items that lie on the chest, such as collars, necklaces, pectorals and clothing are shown full view on the expanse of the torso framed by the front and back lines of the body. The navel, shown full view, is placed inside the front line of the body at the appropriate level. Up until the later Eighteenth Dynasty the two feet are rendered identically from the inside, showing the big toe and the arch. After that time, the near foot was increasingly rendered from the outside with all the toes showing.[10]

The order that the Egyptians strove to maintain in the world around them was also fundamental to their art. Images were not placed haphazardly on the drawing surface, unless there was a deliberate evocation of chaos, but were ordered by a system of registers (fig. 13). The lower border of a register acted as the ground line for the figures within that register. The positional relationship of one image to another could be cued for the viewer by overlapping and placement within the register. When items overlap, what is behind is further from the viewer than what is in front. When items are stacked above one another in a register, those higher up are behind those lower down. The hierarchical ordering of society was reflected in art by the manipulation of scale. The larger a figure the more important its status (figs 11, 13). The king's figure, for instance, is usually the same, or nearly the same, size as the figures of the deities he interacts with (fig. 12), but larger than the figures of his subjects.

Ancient Egyptian representations, whether two- or three-dimensional, were usually combined with texts written in hieroglyphs.[11] Short texts acted as captions, identify-

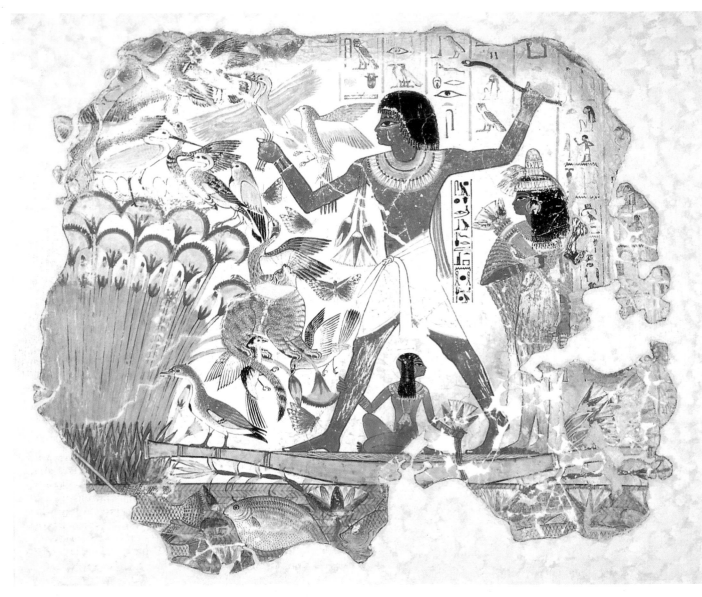

12 *right* Scene showing King Thutmose III offering bread to the god Amun-Ra, on a block from the dismantled boat sanctuary of Hatshepsut at Karnak. When Hatshepsut assumed the titles of king, she ruled as co-regent with the young Thutmose III, and his figure often appears on her monuments, as here. The scene is typical of interior temple decoration where the king is shown interacting with deities. Although the status of the king is junior to that of the gods, the figures of the king and deities are usually represented on a similar, or almost similar, scale. The two figures of Thutmose and Amun-Ra face one another in a balanced composition, except that the king has no tall headdress to match the two double feathers worn by the god. Instead the space above his head is occupied by his cartouche. Without the cartouche the composition would become unbalanced, demonstrating that inscriptions were an integral part of compositions and not added as an afterthought. Quartzite. Eighteenth Dynasty.

11 Scene showing the official Nebamun hunting birds in the marshes, accompanied by his wife and child. Originally this scene was balanced by a similar one showing Nebamun spearing fish, and part of the spear can still be seen at the left-hand corner of the fragment, cutting across the bottom of the papyrus clump to impale a tilapia fish. Nebamun, as the most important person, is the largest figure and occupies the centre of the scene. His wife, drawn on a smaller scale, is placed behind him in the space beneath his upraised arm. The still smaller child occupies the area between Nebamun's spread legs that would otherwise be left empty. The large almond-shaped eyes set at a slight slant, the full lips and fleshy lower part of the face are typical of the reign of Amenhotep III.

Fowling scenes like this one go back to the Old Kingdom and were repeated in countless tomb chapels with endless variation. The genius of Nebamun's artist or artists lies in the fresh conception and rendering of the elements that are essential to this type of scene. As a whole the scene is drawn conceptually according to the principles of Egyptian two-dimensional art, and it is not intended to be naturalistic. No cat could balance on two bent papyrus stems, holding a bird in its mouth, one in its front paws and another in its back paws, all at the same time; nevertheless, this detail is remarkably effective compositionally. Although the elements of the scene are put together in a non-realistic manner, individually the wild birds, the goose on the prow of the boat, the cat and the butterflies have all been carefully observed and drawn with their natural colourings and markings, so that the species of each animal can be recognised. The painter of the scene was, in addition, a master of texture, richly evoking the downy softness of the goose's neck and breast feathers or the short, soft fur of the cat, in contrast to the harder, unyielding scales of the fish. Theban tomb chapel of Nebamun. Painted plaster, H. 81 cm. Eighteenth Dynasty. London, British Museum.

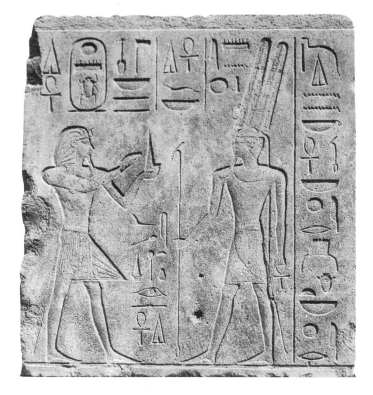

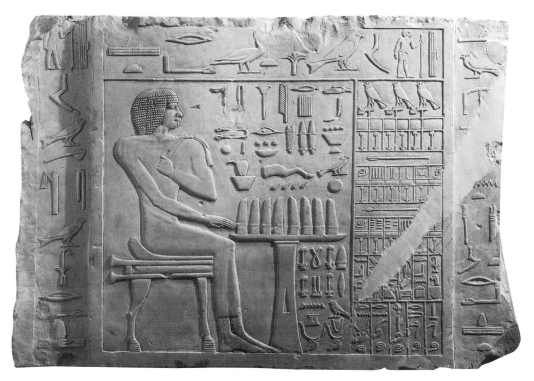

14 *above* Limestone false door panel of Rahotep, the king's son and high priest of Ra at Heliopolis, from his tomb chapel at Meidum. It shows Rahotep seated on the left facing right before a table of offerings, and, beyond, a formally laid-out offering list. A line of inscription runs across the top of the scene, giving Rahotep's titles and name. The hieroglyphs all face right, in the same direction as the figure they identify. Above the table of offerings, which bears loaves of bread, are hieroglyphs naming individual items presented to Rahotep: incense, green eye paint, wine and figs. These are turned left to face towards the deceased, to indicate that they are being offered to him. The close connection between text and representation is demonstrated by the way in which the offerings are represented by the hieroglyphic writings of their names, rather than by their visual images. Further, the large image of Rahotep takes the place of the seated man hieroglyph that would normally conclude the writing of a male name. The precise carving of the individual hieroglyphs, Rahotep's figure and the other elements in the scene is complemented by the clear compositional design. The line of hieroglyphs at the top and the offering list on the right form a frame around the main image of the deceased and the table of offerings, presenting and highlighting them as a coherent group, and this scheme overrides the underlying horizontal division of the scene into approximate thirds, occupied by the figure, the table and the offering list. The predominance of horizontal and vertical lines is broken only by the curve of Rahotep's head and the oblique lines of his arms and thighs, which thus draw the eye and highlight Rahotep's figure as the most important element in the composition. The high-quality relief, which must have come from a royal workshop, would once have been painted but the colour is now lost. H. 79 cm. Fourth Dynasty. London, British Museum.

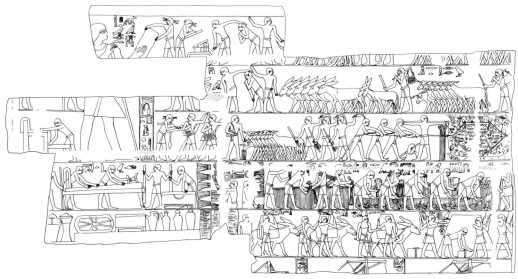

13 Drawing of part of the east wall of the tomb chapel of Werirenptah, a priest in the sun temple of Neferirkara, showing scenes of agriculture and bird trapping laid out in a series of registers. Depth is indicated by the overlapping of figures, but there is no attempt to render the illusion of the third dimension on the two-dimensional drawing surface, so that in each register the feet of all the figures, human and animals, stand on the register line. Figures are shown from the side (in elevation), but the clap net in its marshy pond is shown from above (in plan), although the birds and plants within it are drawn in profile. Thus two distinct views are combined on the same picture plane. The largest, and therefore most important, figure on the wall is that of the tomb owner himself, which occupies the height of three registers. Saqqara. H. 145 cm. Fifth Dynasty. London, British Museum.

ing the figures depicted and the actions taking place. Longer texts included requests for offerings for the dead (the offering formula), hymns to deities and words spoken by deities to the king. The texts within any given scene formed an integral part of the whole composition, with blocks of hieroglyphs often set against representational elements, so that, without the hieroglyphs, the composition would not be balanced (fig. 12).

In addition, hieroglyphs themselves are small pictures drawn according to the principles underlying Egyptian two-dimensional art. Despite this, many do not write the object they depict but are phonetic, standing for different consonantal sounds in the Egyptian language. Others, however, are logographic, standing literally or metaphorically for an object or idea. Furthermore, hieroglyphs can act as determinatives, that is, they are placed at the ends of individual words to show the categories to which these words belong; these have no phonetic value. Thus, for example, verbs of movement are followed by a pair of legs, names of men by the image of a man and those of women by the image of a woman.[12] So closely are art and hieroglyphs connected that, when a figure is identified by its name in hieroglyphs, the expected determinative is mostly omitted, so that the representation itself acts as the determinative.[13]

The primary orientation in two-dimensional art for hieroglyphs and figures was facing to the viewer's right.[14] However, both could be reversed to face left as the occasion demanded. Further, hieroglyphs could be written in horizontal lines or vertical columns, and this allowed for great versatility and subtlety in the combination of hieroglyphs with representations. Normally hieroglyphs face the same way as the figure to which they refer. Reversals of hieroglyphs were not usually done at random, but were intentionally designed to carry meaning (fig. 14).[15]

15 Coffin of the official Hetepnebi, made of tamarisk wood. The unevenly shaped and irregularly sized pieces of timber have been expertly fitted together to form the coffin. This type of rectangular coffin with smooth sides and a flat lid was introduced in the Sixth Dynasty. A line of inscription containing versions of the offering formula and identifying the deceased runs round the upper part of the sides. The coffin was oriented so that the body was placed inside with the head to the north, allowing the deceased, lying on his left side, to look out through the pair of eyes towards the east. From Asyut. L. 186.5 cm. Sixth Dynasty. London, British Museum.

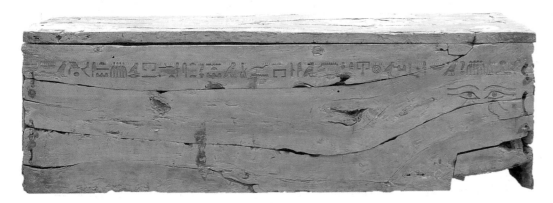

Materials, techniques and artists

Egyptian artists worked with a great variety of materials. One of the most readily available was limestone, since the Nile valley in Egypt was bordered for much of its length by limestone cliffs. Other fairly soft stones available were calcite, a crystalline form of calcium carbonate, sandstone, schist and greywacke. In addition there were harder stones, including quartzite (a crystalline form of sandstone), diorite, granodiorite, granite and basalt. Stone was the major building material for free-standing and rock-cut temples and tombs. It was also used to make statues, stelae, offering tables, libation bowls, vessels and other ritual equipment.

Soft stones were usually covered with a thin layer of plaster and painted. Although paint was sometimes applied to harder stones, it would seem that much of the stone was left visible, and that the colour of the stone was often chosen for its symbolism.[16] Black stones like granodiorite referred to the life-giving black silt brought by the Nile inundation. Thus they symbolised new life, resurrection and the resurrected god of the dead, Osiris, who is often shown with black skin. A range of colours – red, brown, yellow, gold – was associated with the sun, so that stones of these colours, such as red and brown quartzite and red granite, carried a solar symbolism. Green stones referred to fresh, growing vegetation, new life, resurrection and Osiris, who can also appear with green skin.

We have already seen that statues could be made of wood as well as stone, and there was a long tradition of wood-working in ancient Egypt. The timber provided by native Egyptian trees such as tamarisk, acacia and sycomore fig tends to be irregular, small and knotted, compared with the straight blocks and planks of coniferous wood imported from Syria. Nevertheless, Egyptian woodworkers were skilled at piecing these uneven lengths of wood together to form furniture, chests, coffins and statues (fig. 15). As on soft-stone statues, the surface of these objects was often plastered and painted, but sometimes paint was applied directly on to good-quality wood (fig. 113).

Tomb scenes from the Old Kingdom onwards occasionally depict the working of metal. The Egyptians used copper from early times, arsenic bronze (copper and arsenic) from the late Old Kingdom and bronze (copper and tin) from the later Middle Kingdom. Gold and silver were highly valued as precious metals. Metals were used to make statues, temple fittings and cult implements (fig. 3), jewellery and funerary equipment. Cult statues of deities were made of gold and silver inlaid with precious materials. Not surprisingly, few survive today, as they were repeatedly melted

down for their metal.[17] It was not only the value of these materials that made them suitable for employment in divine images, but also the symbolism associated with them. Gold was considered the flesh of the gods, especially the sun god. Silver was the material of which the bones of the gods were made. It was also associated with the moon, and lunar disks on statues might be made of silver.

The Egyptians manufactured a material often called Egyptian faience or glazed composition.[18] It is made from a quartz core covered on the surface with a glaze. The material could be modelled and moulded, and, because it was not costly, it was ideal for the mass-production of small items, such as statuettes, amulets, rings and ear studs (fig. 16). The colour of the glaze depended on the additions to the basic mixture, and faience was often made to imitate and substitute for real stones. One of the commonest colours was a blue-green related to turquoise and linked with the goddess Hathor, who was called 'Lady of Turquoise'. The word for faience was *tjehenet*, from the root *tjehen*, 'to dazzle/gleam', which was associated with the sun, giving a solar symbolism to the material.

Limestone and other soft stones were carved with copper chisels and stone tools. Hard stones were worked by hammering and grinding them with tools made of even harder stone together with sand, which is basically quartz, acting as an abrasive. Drills with copper bits were employed with an abrasive to hollow out stone vessels, and

to apply details and inscriptions to hard stone monuments. The finished object was polished with a smooth rubbing stone. Wood was shaped with chisels and adzes and the surface smoothed down with rubbing stones (fig. 17).

Scenes on stone surfaces were often cut into relief before painting. There were two main types of relief: raised relief and sunk relief. In both, chisels were used to cut round the outlines of figures. Then, in raised relief, the stone of the background was cut away, so that the figures were left standing out from the surface (fig. 14). In sunk relief it was the figures that were cut back within their outlines, leaving the surface of the background at a higher level (fig. 18). Finally, in both types of relief, the figures were modelled to a greater or lesser extent within their outlines. Traditionally, sunk relief was used on outside walls and raised relief on interior ones, since bright sunlight has the effect of flattening raised relief and enhancing sunk relief.

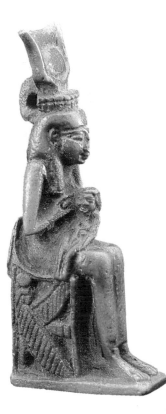

16 Blue-green faience amulet in the form of a goddess with a child god on her lap, to whom she offers her right breast. The unnamed goddess wears a sun disk between two cow's horns that rise out of a circlet of *uraei*. Although originally associated with the goddess Hathor, this headdress is frequently worn by Isis, and the group should probably be understood as Isis with the infant Horus. A figure of a winged goddess decorates either side of the throne, adding a protective element to the group. A loop for hanging the amulet is placed at the back of the headdress, and such an image would have been worn by women and children to promote their well-being and protect them from misfortune and disease. H. 8.5 cm. Third Intermediate Period. London, British Museum.

17 Part of a scene showing a sculptors' workshop in the tomb chapel of the high official Ti at Saqqara. On the left two men work on a nude standing statue, one using a chisel and the other an adze. Above the second man is written *nedjer*, 'smoothing'. In the middle two men are labelled as 'polishing' a second standing statue, even though there are no rubbing stones visible in their hands. To the right two more men are pounding away at a seated stone statue with hammers consisting of a stone tied to two sticks to form a handle. The man on the far right is using a drill to hollow out a spouted stone vessel. Fifth Dynasty.

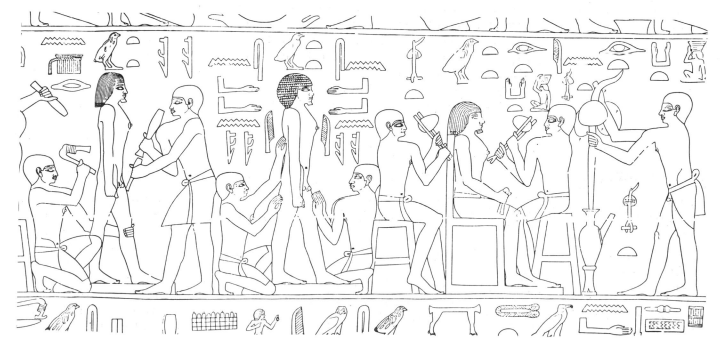

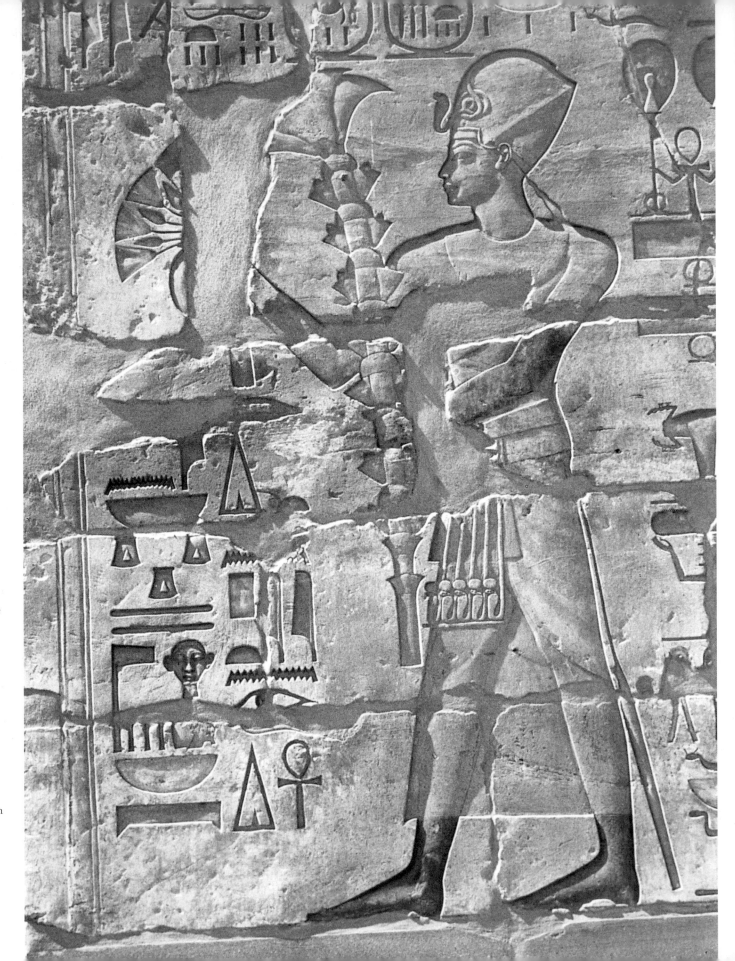

18 Sunk relief showing King Thutmose IV offering two formal bouquets. In sunk relief the figure and other elements in the scene are cut into the stone below the level of the background. Within the outline the relief may be carved on several levels and the surface of the stone modelled, as can be seen here in Thutmose's figure. Sunk relief was originally developed for use on outside walls, since the sharp shadows caused by sunlight enhance the image, whereas the contours of raised relief tend to be flattened when exposed to bright light. Some of the colour still remains in this scene, showing that it was once brightly painted. Karnak. Eighteenth Dynasty.

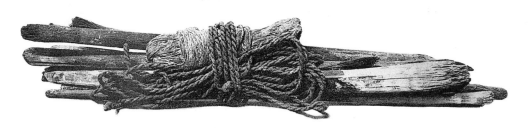

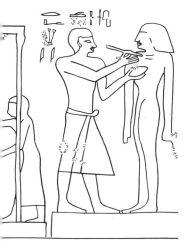

19 Bundle of brushes wrapped round with string stained with red paint, found in the tomb of Montuherkhopeshef at Thebes (no.20). The thick brushes are made of fibrous wood. One end has been beaten to make the fibres separate and form coarse bristles that are still full of paint. The red-stained string would have been used to mark out squared grids and other compositional lines on the tomb chapel walls. Eighteenth Dynasty.

20 Drawing of a scene showing a man, captioned as the draughtsman/painter Rahay, painting a female statue. Rahay holds a thin brush in one hand and a container for his paint in the other. From the tomb chapel of Meresankh III at Giza. Fourth Dynasty.

Before stone was painted, the surface had to be smoothed, and any holes in the stone or joins between blocks filled in with plaster. In painted, as opposed to relief-cut, Theban tombs, the rock-cut walls were covered with a layer of mud that was then plastered before painting. Similarly in mudbrick buildings, such as houses and palaces, surfaces were prepared for decoration with a layer of plaster. Scenes were laid out by first marking off the area to be decorated and then drawing in the initial sketches in red, to which corrections were often subsequently made in black, probably by the master draughtsman in charge of the project (fig. 198). Squared grids, introduced at the beginning of the Middle Kingdom, were often drawn out on the surface before the scene was sketched in. Their function was to help artists to obtain acceptable proportions for their figures and often also to lay out the composition as a whole. The lines of the grid were either drawn against a straight edge (fig. 161) or more usually made with a string that was dipped in red paint, stretched taut across the surface and snapped against it (fig. 19). The sketches were drawn with brushes, similar to those used by scribes, made from fine reeds that were trimmed at one end to an angle and chewed or split to fray the fibres.

Paint was laid on in flat washes, pigment by pigment, so that painters mixed as much of one colour as they needed, painted in all the appropriate areas, and then moved on to another colour. For this purpose they used thicker brushes made from fibrous woods, such as palm ribs, or from bundles of twigs tied together that were beaten at one end to separate the fibres and make a coarse brush (fig. 19). The final stage of painting was to outline figures and add interior details with a fine brush (fig. 20). Many details in relief work and on statues were often only added in paint and not cut into the stone.

In addition to wood and stone, linen, too, could be plastered and painted to make decorated funerary and votive cloths. Alternating layers of linen and plaster could be built up to form cartonnage, from which painted funerary masks, coffins and mummy trappings were manufactured (fig. 302). Papyrus, made from the papyrus reed, was the ancient Egyptian equivalent of paper.[19] Its main use was as

a writing surface for a wide range of administrative, economic, literary and ritual documents. In addition it was used in the production of funerary texts, such as versions of the *Book of the Dead*, which also included illustrations drawn and painted with the fine scribal brush. Other papyri of a non-funerary nature contain painted or sketched images with little or no text (fig. 232).

The pigments used consisted mainly of minerals that occur naturally in Egypt and the surrounding deserts.[20] White was generally made from calcium carbonate (whiting) or calcium sulphate (gypsum). A third mineral, huntite, which was already used in the Middle Kingdom and became common in the New Kingdom, is more intensely white, and it was sometimes employed to paint white areas, such as clothing, so that they would stand out against a white background of calcium carbonate. Black was produced from one of several forms of carbon, most commonly soot or charcoal.

A range of colours from light yellow to dark brown can be obtained from ochre (iron oxide) depending on the level of hydration, and it was widely used to yield reds and yellows. From the New Kingdom realgar was also used for red, but it is unstable in light, and has often degraded over time to yellow. Orpiment was used from the Middle Kingdom onwards to obtain a bright yellow that was frequently used to represent gold, but it fades in light to a dull off-white, so that its effect is often lost today. By contrast a pale yellow was obtained from jarosite. Different yellow pigments might be used side by side, showing that artists could choose between them as appropriate and that they were not mere substitutes for one another.

Blue was sometimes obtained from azurite (copper carbonate), which over time becomes green as it changes to malachite, another form of copper carbonate. More commonly Egyptian blue was used, an artificial compound made from heating quartz, ground malachite and calcium carbonate together. Different shades of blue could be obtained according to the way in which the resulting compound was ground for use, since the finer the grain the paler the blue. If the proportions of malachite and calcium carbonate were varied, green was produced instead of blue. However, green pigment most frequently consisted of naturally occurring malachite.

Pigments were prepared by grinding on a hardstone mortar, and they were applied by mixing them with a medium, often plant gum or animal glue, to attach them to the surface. Colours were frequently used singly, but they could also be painted over one another in layers to obtain different colour effects. Different pigments could also be

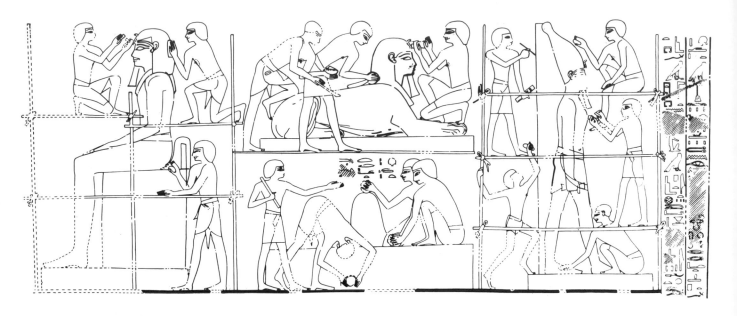

21 Drawing of a scene showing the production of three colossal granite statues of the king in the tomb chapel of the vizier Rekhmira at Thebes. Several men work on each statue, polishing them with rubbing stones and painting them with fine brushes. The height of the standing and seated colossi necessitates the use of scaffolding. Eighteenth Dynasty.

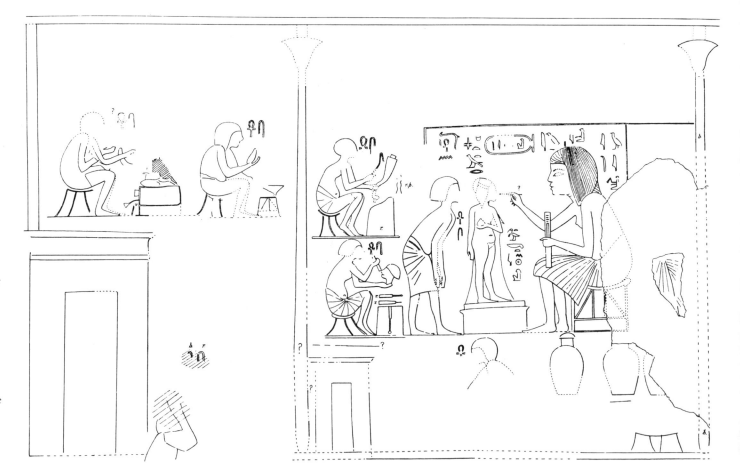

22 Drawing of a scene depicting a sculptors' workshop in the tomb of Huya, steward of Queen Tiy, at Amarna. The largest figure depicts Iuti, the overseer of sculptors of Queen Tiy, who paints a statue of the king's daughter Beketaten, watched by a deferential assistant. A second sculptor carves a chair leg with an adze, perhaps for a seated statue, while a third works on a head, presumably for a composite statue in which the various parts were made of different stones and pieced together. Eighteenth Dynasty.

mixed together before application, for instance black and white to obtain grey, or red and white to make pink.

We sometimes get glimpses relating to the working lives of artists in documents from Deir el-Medina, the village that housed the workmen who excavated and decorated the royal tombs in the Valley of the Kings. We learn that the state issued the workmen with metal chisels for their work on the royal tombs and that a record was kept of the weight of these tools. When the tools were returned they were weighed to make sure that the workmen had not pilfered any of the metal.[21] The state also provided these artists with the pigments and other supplies needed for their work on the tomb, and a letter survives from the workman Inherkhau, who lived in the reign of Ramses II, in which he writes to the vizier: 'we have been working [in] the places (the royal tombs) which my lord said must be decorated in proper order, but there are [no more] pigments at our disposal (?). May my lord [let] me carry out his good purposes and [have] a message sent that Pharaoh, life, prosperity, health, may be informed. And have a dispatch sent to the majordomo of Ne, to the high priest of Amon and the second prophet (of Amon), to the mayor of Ne, and to the administrators who are managing in the treasury of Pharaoh, life, prosperity, health, in order to supply us with whatever we require. List for my lord's information: yellow ochre, gum, orpiment, realgar, red ochre, blue frit, green frit, fresh tallow for lighting and old clothes for wicks.'[22] The lighting supplies were essential, since the artists were working underground.

The workforce at Deir el-Medina was divided into two groups that worked on each side of the tomb. A letter from the draughtsman Hori to his father, the scribe of the necropolis Hori, written in the mid Twentieth Dynasty, asks for him to be sent someone to 'assist me with the drawing – I'm alone, for my brother is ill. The men of the right side have carved in relief one chamber more than the left.'[23] Hori was a draughtsman for the left side of the tomb and, being on his own, could not work as fast as the draughtsmen on the right side, so that the relief cutters on the left side, whose job it was to cut Hori's sketched scenes into relief, were being held up.

The evidence from Deir el-Medina together with scenes in private tomb chapels of the Old, Middle and New Kingdoms that depict sculptors' workshops (figs 21–2)[24] and other types of production show that artists worked in teams. Therefore, when we think about artists in ancient Egypt, we have to rid ourselves of the Western notion of the lonely genius toiling in a garret to create unappreciated masterpieces (which is itself a recent fiction).[25] In ancient Egyptian society as a whole, conformity not individualism was encouraged, and there was hardly a place for an artist with a personal vision that broke the accepted norms. This does not mean, however, that artists could not experiment and innovate within these limits.

We shall see that many of the fundamentals of Egyptian art were established at the very beginning of Egyptian history and changed little thereafter. In addition, much of the subject matter portrayed remained unchanging over long periods of time. This has given rise to the mistaken notion that Egyptian art remained virtually the same for three thousand years. In fact, despite the limited repertory of subject matter, Egyptian artists valued variation and avoided producing exact copies of the same forms. Nevertheless, the content of Egyptian art was tied to its function, which was dependent on the Egyptian world view. Only if the latter had changed fundamentally would there have been a need to alter radically what artists depicted.

Notes
1 Baines 1994; Simpson 1982.
2 Allen 1988.
3 Faulkner 1969, 198, Utterance 527.
4 Te Velde 1977.
5 Griffiths 1960.
6 For kingship, see Baines 1995a.
7 Baines and Eyre 1983, 65–77.
8 Scheel 1989.
9 Schäfer 1986; Robins 1986.
10 Russmann 1980.
11 Fischer 1986.
12 Davies 1987.
13 Fischer 1973.
14 Fischer 1977a, 6–8.
15 Fischer 1977a.
16 Kozloff and Bryan 1992, 133, 142, cat. nos 5–6. For colour symbolism see Brunner-Traut 1977, 122–5; Wilkinson 1994a, 106–10.
17 For possible cult statues see Reeves and Taylor 1992, 172; Quirke and Spencer 1992, fig. 55.
18 Nicholson 1993.
19 Parkinson and Quirke 1995.
20 Lucas 1962; Le Fur 1994; Davies forthcoming.
21 Massart 1957, 181–2.
22 Wente 1990, no. 49.
23 Wente 1990, no. 158.
24 Eaton-Krauss 1984.
25 Drenkhahn 1995.

Origins

THE EARLY DYNASTIC PERIOD

Human beings have inhabited the region of the Nile valley in the area that is now modern-day Egypt for a long time. At some point around 5000 BC they began to grow crops and keep domesticated animals, and to live in small permanent settlements. Over time these settlements began to increase in size, with some outstripping others until they formed centres that controlled the surrounding areas some way up and down the river.[1] In the late Predynastic Period in Upper Egypt there were political centres at Hierakonpolis, Naqada, and probably This (near Abydos). The cemeteries serving these towns show that social stratification was well developed. For instance, at Hierakonpolis a number of tombs stand out by reason of their wealth in funerary equipment and the quality of their construction;

one of them even had decorated walls, and was almost certainly built for a late Predynastic ruler of the region (fig. 23).[2]

Although these cities and their subject regions were separate political entities, they all shared a common culture, today called Naqada II/III after the archaeological site at Naqada where it was first encountered. Because there are no written texts from this period, the evidence for the culture comes from its material remains recovered through archaeological excavation, licit and illicit, and from the art forms that some of these items display. Naqada II/III is distinguished from earlier cultures of Upper Egypt by its greatly increased social stratification and the growing sophistication of its products. Continuity is shown, however, by the manufacture of stone maceheads attached to handles and used as weapons, and of stone palettes used to grind green and black pigments to make eye paint, since both had also been produced in the preceding periods. One immediately recognisable product is a type of decorated pottery that is painted in red line on a buff background. The subject matter includes boats, plants, animals and human beings disposed over the surface of the vessel (fig. 24). A similar style was used to decorate the painted tomb at Hierakonpolis (fig. 23).

In the north of Egypt, including the Delta, the different geographical conditions make excavation more difficult, but some sites have been discovered that show that for most of the Predynastic Period the north was culturally distinct from the south.[3] So far, however, what is known about the northern cultures does not exhibit the richness of the south. Rather, the cultures of the south gradually spread to the north, so that by the end of the Naqada II period there was a single culture over the whole country.[4]

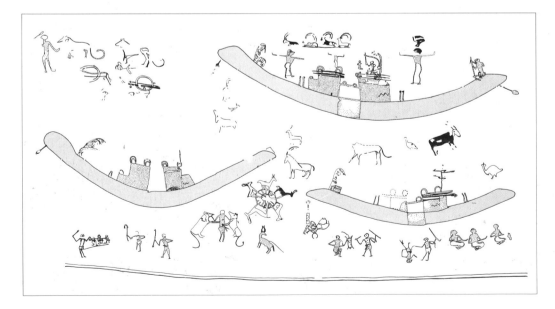

24 Pottery vessel decorated with boats, birds, plants, and male and female human figures. From El-Amra. H. 29.2 cm. Naqada II. London, British Museum.

23 *opposite* Drawing of the painted wall decoration from tomb 100 at Hierakonpolis showing boats, animals and human figures. In contrast to later two-dimensional art, registers and register lines are not used, although a few groups, such as the horned animals at the top or the bound prisoners at the bottom left, have their own baselines. The human figures lack any great detail, having round heads with beak noses, a dot for the eye, and stick limbs. At the lower left corner a figure stands with a weapon in his raised rear arm while he grasps the first of a row of three bound prisoners with his forward arm. This may be an early example showing the ruler about to smite his enemies, a motif that appears on the First Dynasty Narmer palette (fig.25) and still occurs in the Roman period. H. 110 cm. Naqada II–III.

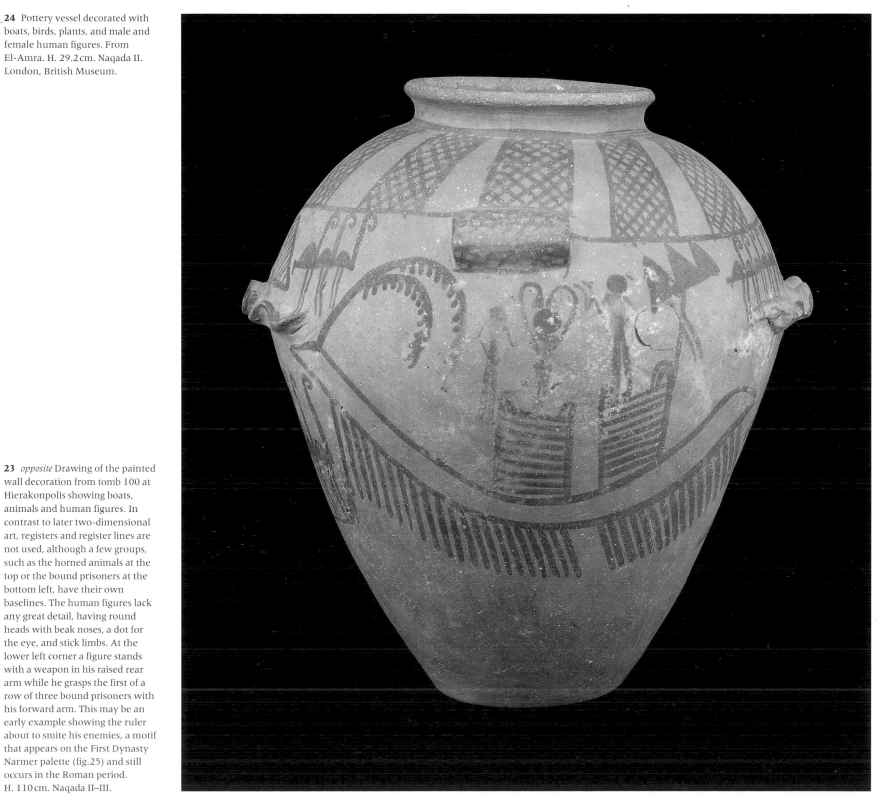

25 Schist palette of King Narmer, decorated on both sides, found in the temple of Hierakonpolis. H. 63.5 cm. Naqada III. Cairo, Egyptian Museum.

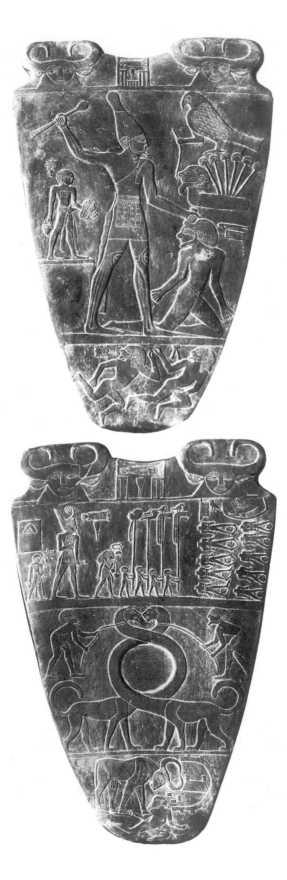

The king

During the Naqada III phase it seems that the south of Egypt coalesced into a single entity that then began to expand northwards in a political process that followed the spread of southern material culture.[5] The process probably took place over a couple of centuries, until finally north and south were incorporated into one state. According to tradition the city of Memphis, located where the Nile valley and the apex of the Delta join – an area that was already important – was founded by the first king of the First Dynasty.[6] Nevertheless, the great southern centres remained prominent. The kings of the First Dynasty were said to come from This[7] and their tombs were built near that city in a cemetery at the desert site of Abydos that had long been used as a necropolis.[8] Finds from Hierakonpolis show that the kings of the First and Second Dynasties dedicated votive offerings at the temples there.[9] Sadly these offerings were not discovered in their original locations: at a later period objects presented at the temple during the late Predynastic and Early Dynastic Periods were reburied in a number of deposits within the early temple precincts.

The most famous of these pieces is the Narmer palette (fig. 25). It is a descendant of the palettes made for grinding eye paint, but this palette was never meant for such use, being designed as a ritual object. The palette, made of schist, is 63 cm in height and carved on both sides in low raised relief. It shows a king, identified by the name 'Narmer' written in hieroglyphs, celebrating a victory over a northern enemy. Thus the subject matter relates to the expansion of the south into the northern region of Egypt, although it does not record the specific conquest of the north by the south, since this was not a single event and the process was already complete by the reign of Narmer.

If we compare the palette with the typical two-dimensional art of the pottery of Naqada II and the painted tomb at Hierakonpolis (figs 23–4) we can see immediately that it is quite different in composition and in the rendering of the human figure. Many of the conventions of Egyptian two-dimensional art employed here were to remain standard for the next three thousand years. The 'stick' figures with undefined blob heads found in Naqada art are replaced by composite human figures built up from the most characteristic view of each part. The composition is organised so that the important figures are placed on baselines producing a division into registers. Scale is used to encode importance, so on both sides of the palette the figure of the king is the largest in his register. Hieroglyphs identifying some of the participants are included.

26 Upper part of the limestone funerary stela of King Wadj from his tomb at Abydos. The stela is one of a pair that would have been set up on the east side of his tomb to mark the place where offerings were to be made. W. 65 cm (H. of whole stela 143 cm). First Dynasty. Paris, Louvre.

The central figure is the king, and here we see numerous elements of royal iconography that were to become standard in dynastic times. The name of the king is written at the top of the palette on both sides, enclosed in a square that is patterned in its lower half. The name itself is written with two hieroglyphs, a catfish and a chisel. The surround is recognisable as a form of the *serekh* used by kings to contain their Horus names. The king's Horus name is the oldest of the five names – Horus name, Two Ladies name, Golden Horus name, throne name and birth name – that came to form the full titulary of the king.[10] It is usually written in the upper part of a rectangle, the lower part containing a patterned area representing the type of niched façade used in mudbrick monumental architecture. The whole is usually surmounted by a falcon representing the sky god Horus – hence the term 'Horus name'. This distinctive surround for the Horus name is known as a *serekh*. It represents the king's palace shown in a combination of plan and elevation. The rectangular enclosure is the plan and the patterned area the elevation of the façade. The writing of the king's name within the *serekh* symbolises the king in his palace, the centre of royal administration and power, and the whole group was thus a potent symbol of kingship. The presence of the Horus falcon showed that the living king was a manifestation of the god (fig. 26). However, the falcon is not depicted above Narmer's *serekh* on his palette, probably because each is placed at the top of the palette which symbolises the region of the sky, domain of Horus, so that the presence of the Horus falcon is implied.[11] The equation of the top of the palette with the sky is reinforced by the two full-view faces with cow's ears and horns, for the sky goddess could be envisaged as a cow.

The king wears the white crown on one side of the palette and the red crown on the other. These were later associated with Upper and Lower Egypt respectively, as symbols of the duality of Egyptian kingship. There is no evidence, however, that the association had already been made in Narmer's reign, although, if it had been, it would neatly encapsulate a claim to control both north and south.

On one side of the palette the large dominating figure of the king stands with one arm upraised, holding a mace, while with the other hand he grasps the hair of a kneeling prisoner. The image is one of the victorious king triumphant over his defeated enemy. From this time on it was a standard icon of kingship, appearing in both monumental and small-scale contexts, that survived into Roman times. On the palette the prisoner is identified by two hieroglyphs that perhaps read *wash*, but from which we can gain little information today. However, it is possible to read in general terms the emblematic group above the prisoner's figure. It shows a falcon perched on one leg, its talons grasping a clump of papyrus that grows out of a strip of land terminating in a head. The other leg, ending in a human hand, grasps a rope attached to the nose. The papyrus reed, which grew abundantly in the swamps and marshes of the Delta, became the heraldic plant of the north. The head growing out of the land from which the papyrus springs must symbolise the population of the Delta region. The falcon represents the god Horus, of whom the king was the living manifestation. Thus the group shows the falcon god dominating the inhabitants of the land where the papyrus grows, the subjugation made explicit by the rope attached to the head and held by the falcon.

Behind the king stands a much smaller male figure on its own baseline, carrying the king's sandals. The person represented is identified by two hieroglyphs, but they cannot be read. The same person appears again behind the king on the other side of the palette. Small as he is by comparison with the king, his inclusion here indicates that he must have been of high rank. Below the main scene on this side of the palette are two fallen enemies. They are shown naked, a device used in the art of many cultures to humiliate opponents: clothes indicate status, so to be stripped of them is to be deprived of status. In Egypt the depiction of nude enemies occurs only in the Early Dynastic Period. By being positioned below the register containing the king, these enemies are visually placed beneath his feet. Further, if the king inhabits the ordered world, then they lie outside it.

The composition on the other side of the palette is differently designed. It is divided into three registers, with the middle one somewhat taller than the other two. The figure of the king does not immediately dominate, but his size clearly shows him to be the most important figure in the upper register, where he views two rows of enemy bodies that have been decapitated and their heads placed between their legs. He is again accompanied by his sandal-bearer, and also by another figure wearing long hair and an animal skin, identified by two hieroglyphs as *tjet*. Four even smaller figures carry sacred standards topped with different emblems.

The theme of conquest is repeated in the lowest register, where the king, now in the form of a bull, attacks a walled and fortified town, only part of whose perimeter is shown, and tramples on the naked body of one of its inhabitants. The identification of the king with a bull was to remain a constant theme, and can be seen much later in the Horus names of New Kingdom kings, most of which begin 'strong bull'.

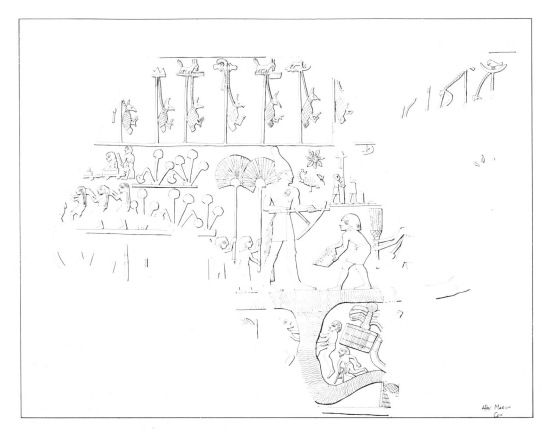

27 Drawing of a fragmentary limestone macehead of King 'Scorpion', decorated in raised relief showing the king holding a hoe and performing a ritual associated with agriculture and water. Above, dead lapwings or *rekhyt*-birds hang by the neck from standards. Later these birds represented the Egyptian population. Their meaning here is unclear, but, if the lapwings represent people of Lower Egypt, the image may reflect conflicts between the rulers of Upper Egypt and the population of the Delta in the struggle to unite Egypt. From Hierakonpolis. H. 32.5 cm. Naqada III. Oxford, Ashmolean Museum.

The central register shows a symmetrical group of two opposing animals with long necks twisted round one another, each controlled by a rope around its neck that is held by a male figure. Similar pairs of animals appear on contemporary Mesopotamian and Iranian cylinder seals,[12] and may have influenced the Egyptian composition. The symmetry and balance of the composition and the subjugation of mythical animals that perhaps represent the forces of chaos probably symbolise the order of the cosmos that it is the king's duty to maintain. The vivid motifs of the conquest of enemies on the rest of the palette demonstrate the means by which he achieves this order.

The palette is worked in low raised relief, often with details carefully incised into the stone. The king's figure is shown with stylised limb musculature. The proportions display a short neck, narrow shoulders and high small of the back, small buttocks and long legs. Other royal figures of the period display similar proportions (fig. 27).

Although the Narmer palette seems very different from earlier Predynastic representations, we have to remember that many of the elements found on it were not new. A depiction of the red crown, from Upper not Lower Egypt,

occurs much earlier on a fragment of a Naqada I pot.[13] The motif of smiting enemies occurs in the painted tomb at Hierakonpolis (fig. 23), the *serekh* was used by earlier rulers of Upper Egypt and hieroglyphs were employed in the late Naqada period.[14] What is new on the Narmer palette and other royal objects of the same period is the way all the elements come together. These items display a deliberately created art form designed to underpin the ideology of kingship.[15] It is no coincidence that this new style developed as the Nile valley and Delta were unified into a hierarchically structured state under a single ruler. Any political entity needs a *raison d'être* or it will not survive. In a system where a small elite controls the majority, the elite group has to produce an ideology to legitimise its power, both for its own benefit and also to persuade the rest of the population to accept its rule. The construction of an ideology of kingship, expressed in images and words, at the beginning of the Early Dynastic Period was a deliberate act by the ruling elite. Naturally it drew on elements already associated with the power of the ruler in earlier periods, but it put them together into something new. This royal ideology was to underpin the existence and authority of the Egyptian state for the next three thousand years. Even in periods of disunity, the ideal of a unified state ruled by one king remained.

The decorated palettes of the late Predynastic and Early Dynastic Periods represented the last development of these objects from utilitarian items, first known from the Badarian period, into votive objects presented to the gods. A similar pattern of development occurred with maceheads. Originally maceheads were attached to handles and used as weapons; Narmer holds just such a mace in the smiting scene on his palette. However, during the late Predynastic Period maceheads were produced that were decorated with scenes in raised relief and presented in temples to the gods. These objects functioned no longer as weapons but as votive offerings. One such macehead found at Hierakonpolis shows the figure of a king holding a hoe and performing some kind of rite associated with water and agriculture (fig. 27).[16] In front of the king are placed two hieroglyphs – a rosette and an emblem in the form of a scorpion – just as the catfish and chisel are placed in front of one of the figures of Narmer on his palette. It has been assumed, therefore, that these signs write the king's name. Since neither became a standard hieroglyph and we do not know how they would have been read, Egyptologists usually call this king 'Scorpion'. It is thought that Scorpion was one of the rulers at the very end of the Naqada III period. The figure has much in common with those of Narmer on his palette.

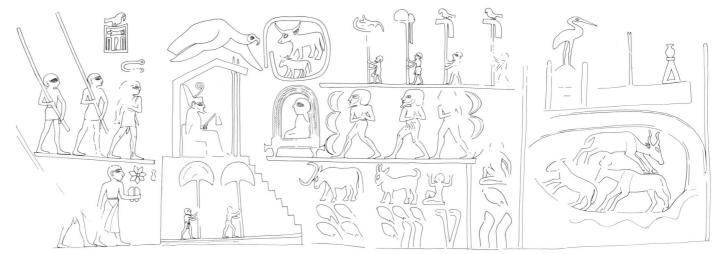

28 Drawing of a fragmentary limestone macehead of King Narmer showing the king wearing the red crown and seated in a raised kiosk reached by steps. Three bearded naked figures with bound hands run between the symbolic boundary stones that mark the king's territory. From Hierakonpolis. H. 19.8 cm. Naqada III. Oxford, Ashmolean Museum.

29 Ebony label of King Den showing the king wearing the double crown and holding the flail, and running between the stone markers that symbolise the boundaries of his territory. The king is shown a second time, again wearing the double crown and holding the flail, seated on a throne in a pavilion raised on a platform reached by steps. Den is identified by his Horus name, to the left of which is placed the name of the high official Hemaka, whose tomb has been discovered at Saqqara. From the tomb of Den at Abydos. H. 5.5 cm. First Dynasty. London, British Museum.

Scorpion wears the white crown, and has a short neck, narrow shoulders, a high small of the back, small buttocks and long legs. He is followed by two attendants holding roughly semi-circular fans. The stone is worked in raised relief with much detail incised on the surface.

A second macehead from Hierakonpolis depicts a king seated in a kiosk on a platform reached by steps (fig. 28).[17] Some of the elements are familiar from the Narmer palette, while others are different. The king wears the red crown and is followed in the same register by the *tjet* official and in the register below by his sandal-bearer. Like King Scorpion, he is accompanied by two fan-bearers. There are also four standard-bearers identical to the ones on the Narmer palette. The king is identified by the name of Narmer written in a *serekh* on which the Horus falcon perches. Above

the king a vulture hovers, as though protecting him. This motif foreshadows myriad later scenes where a vulture hovers directly above the king's figure. There the bird is a manifestation of Nekhbet, the vulture goddess of Upper Egypt, who had her cult centre at el-Kab just across the river from Hierakonpolis, and the image probably represents Nekhbet here also. Facing the king is a round-topped carrying chair containing an unidentified figure. Behind it, in the same register, three bearded, naked figures, reminiscent of the figure that Narmer smites on his palette, and shown with their hands bound together, run between two sets of three crescent-shaped markers. These markers, well known from contemporary and later depictions and from actual examples found in the Third Dynasty step pyramid complex of Djoser, symbolise the area ruled by the king. In depictions the king is shown running between the stones as he symbolically encircles his territory to lay claim to it (fig. 29). Here, the bound enemies are placed between the markers to show their subjugation and incorporation into the king's territory. The macehead commemorates the king as victor over his enemies, but in a different way from the palette.

From early Predynastic times the Upper Egyptians had buried their dead in shallow pits in the desert together with grave goods including food and drink. These provisions suggest that the Egyptians already believed in an afterlife where the dead needed nourishment and other supplies, just like the living. During the Naqada II period an increasing disparity in the size of burials, the use of a brick lining in some graves and wide variations in the wealth of grave goods demonstrates that society was becoming stratified. By

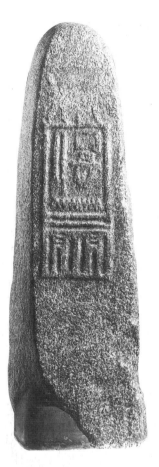

30 Granite funerary stela of King Peribsen with the king's name enclosed in a *serekh* surmounted by the Seth animal, now erased, instead of the Horus falcon. From the tomb of Peribsen at Abydos. H. 113.5 cm. Second Dynasty. London, British Museum.

31 The two forms of King Khasekhemwy's name: (a) written in a *serekh* surmounted by a Horus falcon and Seth animal facing in the same direction; (b) written in a *serekh* with the additional epithet 'the two lords/gods are at peace in him', surmounted by the Horus falcon and Seth animal facing each other, and each wearing the double crown. Second Dynasty.

the late Predynastic Period some tombs were certainly the burial places of local rulers, like the painted tomb at Hierakonpolis (fig. 23). At Abydos an area known as cemetery U, which was already in use during the Naqada I and II periods, also contains increasingly elaborate brick tombs from the end of the Predynastic Period.[17] The latest tombs extend towards the south from the central part of the cemetery. Although they are plundered, enough survives to show that some contained extremely rich grave goods, including pottery, stone vessels and ivory objects. There were even inscriptions, albeit very simple in form, on ivory tags intended to identify the items to which they were attached, and versions of the *serekh*, although early examples did not contain a king's name.[18] In one of the most elaborate tombs (known as U-j), the excavators recovered a sceptre made of ivory resembling the *heqa* sceptre or crook that became a standard item of kingly regalia in later periods.[20]

A little to the south of these tombs, in what can be regarded as an extension of cemetery U, were built other tombs that can be identified as belonging to the first kings of the First Dynasty.[21] Although some of the Second Dynasty kings seem to have been buried at Saqqara in the north,[22] the last two kings of that dynasty were also buried at Abydos.[23] Over time the Early Dynastic royal tombs became larger and more elaborate. Two stone stelae carved in relief with the king's Horus name were erected on the east side of the tombs to identify both the owner and the place where offerings were to be made.[24] A particularly well-preserved example of a stela belongs to King Wadj (fig. 26). Made of limestone, it is approximately 143 cm tall to allow for it to be set in the ground. At the top the visible portion displayed the name of the king, written with a hieroglyph of a snake, enclosed in a *serekh* on top of which perches the Horus falcon. The details of the elaborate niched façade of the royal palace are clearly shown.

In addition to the actual tomb, Early Dynastic royal burials at Abydos included a second element: a large enclosure containing buildings, situated nearer the edge of the desert just behind the Early Dynastic town of Abydos.[25] The best-preserved example is that of the last king of the Second Dynasty, Khasekhemwy, which is surrounded by a massive inner and outer mudbrick wall with a niched façade on the outside.[26] These enclosures are a prime example of royal display. In this they were presumably complemented by the palaces of the living king, but today only the arrangements made for the dead king survive. These demonstrate the king's central position in society that sanctioned the expenditure of resources and effort to produce such elaborate funerary complexes.

The *serekh* containing the king's name was used on a variety of objects and made a fundamental statement of royal ideology, that the king in his palace embodied on earth the essence of the god Horus. Any change in royal ideology would have meant changing this image, and we find exactly this happening in the reign of Peribsen, the penultimate king of the Second Dynasty. Although he enclosed his name in a *serekh*, instead of the Horus falcon, the whole was surmounted by the animal of the god Seth, as can be seen on the stelae that once marked his tomb (fig. 30).[27] The king thus made a visual statement that he was the earthly embodiment of Seth.

Seth was an ambivalent figure to the Egyptians. In the Old Kingdom Pyramid Texts (funerary texts carved inside royal pyramids from the end of the Fifth Dynasty) he is identified as the murderer of the god Osiris, and for most of Egyptian history he was associated with the forces that challenged the rule of order: the sterile desert, the unpredictable storm, the foreigner who failed to conform with the correct way of doing things. After murdering Osiris, Seth claimed the throne of Egypt, only to be challenged and ultimately replaced by Horus. How much of these later beliefs is applicable to the Early Dynastic Period is unclear. The situation at this time may have its origins in the late Predynastic kingdoms of Upper Egypt.[28] Throughout its history Hierakonpolis was the centre of the cult of Horus of Nekhen (= Hierakonpolis), a form of Horus mentioned in

a

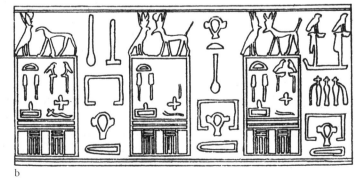

b

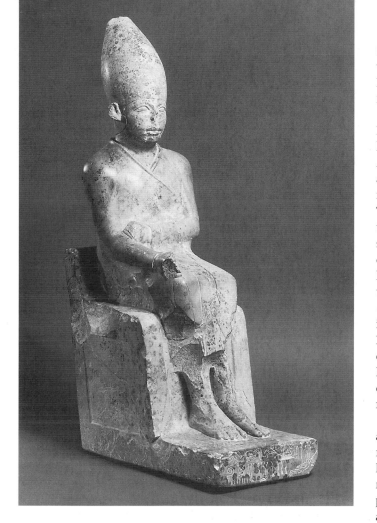

32 Limestone statue of king Khasekhem, restored from fragments, wearing the white crown and the wrap-around robe associated with the *sed*-festival. Hierakonpolis. H. 62 cm. Second Dynasty. Oxford, Ashmolean Museum.

33 Ivory statuette of a king wearing the white crown and the wrap-around robe associated with the *sed*-festival. From Abydos. H. 8.8 cm. Probably First Dynasty. London, British Museum.

Seth'.[29] The title must refer to the consort's relationship with the king. However, Peribsen's decision to replace the Horus falcon on the *serekh* with the animal of Seth was a radical departure from tradition.

Peribsen's successor, the last king of the Second Dynasty, used three variations of his name.[30] He seems to have come to the throne as Khasekhem, 'The One who Arises in respect of the Power', and this name was placed in a *serekh* surmounted by a falcon.[31] But he later used the name Khasekhemwy, 'The One who Arises in respect of the Two Powers', which he wrote in a *serekh* surmounted by the Horus falcon and the Seth animal both facing in the same direction (fig. 31a). Finally the same king added an epithet to the name Khasekhemwy meaning 'the two lords/gods are at peace in him'; the *serekh* is surmounted by the Horus falcon and Seth animal facing each other (fig. 31b). These variations undoubtedly expressed ideological meaning, even if the details of this are lost for us today. It would seem that Khasekhemwy was attempting to reconcile the position of the two deities within the ideology of kingship. Nevertheless, after his reign until the end of pharaonic history, only the Horus falcon surmounted the *serekh*.

Peribsen's stelae also demonstrate another common phenomenon relating to representation throughout Egyptian history: subsequent erasure aimed at negating an image of something disapproved of. The erasure of the Seth animals on these stelae suggests, therefore, that, whatever reasons lay behind Peribsen's substitution of animal for falcon, they failed to win acceptance.

Khasekhem's name appears on objects found at Hierakonpolis,[32] amongst which the most important are two fragmentary statues of the king, one of limestone and one of schist, approximately 62 cm high, that are among the earliest surviving examples of royal stone statuary (fig. 32).[33] Three-dimensional male and female figures had been produced in a variety of materials in the Predynastic Period, and a tiny ivory figure of a king wearing the white crown and probably dating to the First Dynasty was found at Abydos (fig. 33).[34] The original context of the Khasekhem statues is unknown, as they were found in later deposits.

the Pyramid Texts. It seems likely that the cult of Horus already existed here in the late Predynastic and Early Dynastic Periods. The ancient site of Naqada is known to have later been an important cult centre of Seth. The size, structure and burial equipment of some late Predynastic tombs there suggest that they belonged to a line of rulers.

Thus, in the late Predynastic Period the neighbouring kingdoms of Hierakonpolis and Naqada were probably centres for the cults of Horus and Seth respectively. As the smaller kingdoms of Upper Egypt coalesced into a larger unit that eventually expanded to include Lower Egypt as well, the identification of the king as an embodiment of Horus became part of the royal ideology. While the king's name sometimes appears in a *serekh* without an image of a deity above, no deity other than Horus is so far known to occur on the *serekh* until the reign of Peribsen. There is evidence, however, that the king was in some way also identified with Seth, because one title of the king's consort, known from the First Dynasty onward, was 'she who raises

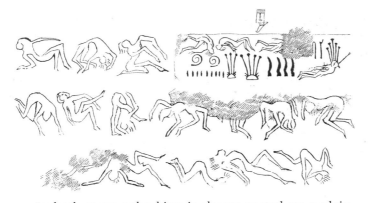

In both statues the king is shown seated on a plain throne with a low back, placed on a base. He wears the white crown and a wrap-around calf-length robe that later became associated with the *sed*-festival, a ceremony in which rituals were enacted for the renewal of the king. The same robe is worn by the First Dynasty ivory figure from Abydos (fig. 33) and by Narmer on his macehead (fig. 28). Khasekhem's left arm is held horizontally across the front of his body underneath the robe. The other arm lies along the top of the thigh, with the clenched fist emerging from the robe. The pieces have a strictly frontal pose and are typical of later stone statuary in their solidity. The space beneath the seat between the throne's legs is merely marked by being very shallowly cut back. The statues are identified by the king's Horus name, Khasekhem, which is cut roughly in the stone in front of the king's feet. The name is oriented as it might be viewed by the seated king above, that is, upside down with respect to anyone approaching the statue. Around the sides of the base are naked figures, falling in all directions, that represent defeated enemies. At the front a bound prisoner with a clump of papyrus on his head is shown being struck by a mace (fig. 34). Behind the prisoner are the numerals 47,209. The whole is possibly to be understood as a claim to have killed or taken prisoner 47,209 people of the Delta. Although the statues may commemorate an actual event or series of events, they are also icons of kingship. The king as establisher of order sits above, and thereby dominates, his enemies, the representatives of chaos. Thus the image presents the successful accomplishment of one of the main duties of the king, and carries a message comparable with that of the Narmer palette.

Elite burials

While the late Predynastic Period saw the gradual unification of Egypt into a single state and the establishment of royal ideology and iconography to support the authority of the king, it also saw the establishment of an elite group who served the king and implemented his rule. Our knowledge of the members of this group comes mainly from their tombs, located at various cemeteries, including Saqqara, which served the city of Memphis. A line of these tombs, moving in date from north to south, runs along the edge of the north-eastern desert plateau at Saqqara.[35] One must imagine that the majority of the population continued to be buried in shallow pit-graves in their local desert cemeteries as they had been in Predynastic times. The complex and rich burial customs for the king and his elite set them apart from the rest of the population and displayed their special status to all who saw their monuments.

The need to provide a dwelling place for the bodies of the dead, together with a supply of food, drink and other items to sustain life after death, lay behind the increasingly elaborate burials of those who had the resources to build and equip their tombs. Like the royal tombs, Early Dynastic elite tombs consisted of an excavated substructure topped by a mudbrick superstructure. The burial chamber was in the substructure, surrounded by rooms in which most of the funerary equipment was placed. The superstructure, built of mud brick, formed a large rectangle roughly 40–60 m long and 15–25 m wide that was divided inside into another set of storerooms. The exterior of the superstructure took the form of a niched 'palace façade' that was plastered and painted to resemble the brightly coloured reed matwork that decorated contemporaneous palaces and houses. A low enclosure wall surrounded the entire edifice.

By the Second Dynasty changes had occurred in the superstructure of elite burials. Instead of containing a series of storerooms, it was often composed of a solid core of mud brick or of rubble cased in mud brick. The white-painted mudbrick walls were no longer niched except for two niches on the east side, one at the northern end and a larger one at the southern end, to mark entrances through which the deceased could pass and the places for making offerings. The major site was the southern one and this was sometimes expanded into an offering room, either going back into the superstructure or extending outside it. At the rear of the niche was placed the so-called niche-stone, a square or rectangular flat stone block on which was carved an image of the deceased seated on the left side (from the viewer's viewpoint), facing towards the right before a variety of offerings represented by loaves on a table and a hieroglyphic list (fig. 35).[36] The figure of the deceased is identified by titles and name. Because of the creative powers of both representation and writing, the objects

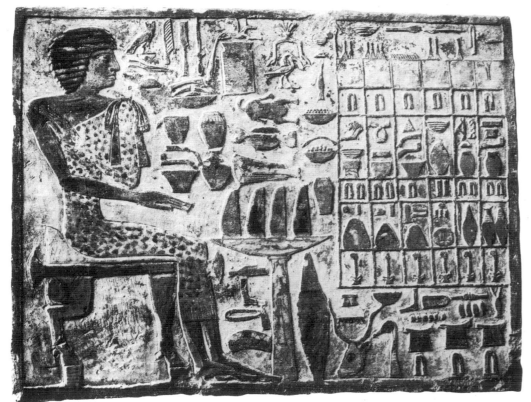

high-quality stone vessels. The Early Dynastic Period was a time when the conventions of two- and three-dimensional art were established, together with a specific royal iconography to express the ideology of kingship that underpinned the new state. The elite group who served the king developed elaborate burial customs and funerary monuments that displayed their special status in this world and ensured their survival in the next. Much of what we think of as typical of ancient Egyptian art has its roots in the formative period of the first two dynasties.

Notes

1 Kemp 1989, 31–46.
2 Quibell and Green 1902; Case and Payne 1962.
3 Kemp 1989, 43–4.
4 Kemp 1989, 44.
5 Kemp 1989, 44.
6 Herodotus II, 99.
7 Waddell 1940, 5, 27–9, 31, 33, 35.
8 Petrie 1900b; 1901; Kemp 1966; 1967; Kaiser 1981; Kaiser and Dreyer 1982; Dreyer 1993; Dreyer et al. 1993, 56–62.
9 Quibell 1900; Quibell and Green 1902.
10 Quirke 1990b.
11 Baines 1989a, 475.
12 Frankfort 1939, pls 4d, f, h, 5h; Smith 1992, 236–8, fig. 12.
13 Payne 1993, cat. no. 774.
14 Dreyer 1993, pl. 7.
15 Baines 1989a, 472. For kingship in the Early Dynastic Period see Baines 1995b.
16 Quibell 1900, pl. 26c.
17 Quibell 1900, pl. 26b; Quibell and Green 1902, 32.
18 Dreyer et al. 1993, 23–56; Dreyer 1993, 12; Baines 1995b, 107–9.
19 Dreyer 1993, pl. 7.
20 Dreyer 1993, 11.
21 See n. 8.
22 Arnold and Hornung 1980, 498.
23 Petrie 1901, 11–14.
24 Thomas 1995, 117 no. 32.
25 Ayrton, Currelly and Weigall 1904, 1–5, pls 6–8; Kaiser 1969; O'Connor 1989b; 1995b.
26 Kemp 1989, 53–4, pl. 2; O'Connor 1991b, fig. 3.
27 Petrie 1901, pl. 31; Spencer 1980, cat. no. 15, pls 8–9.
28 Kemp 1989, 35–41.
29 Troy 1986, 189, B3/2.
30 Baines 1995a, 17.
31 E.g. Quibell 1900, pls 36–8.
32 Quibell 1900, pl. 36; Quibell and Green 1902, pl. 58. The name Khasekhemwy with epithet also appears, Quibell 1900, pl. 2.
33 Quibell 1900, pls 39–41; Quibell and Green 1902, 27–8, 30.
34 Petrie 1903, pl. 2 no. 3, 13; Spencer 1980, cat. no. 483, pl. 55.
35 Emery 1938; 1949; 1954; 1958; Porter and Moss 1981, 436–47.
36 Kaplony 1963, pls 138–40, 147.

35 Niche stone showing a man seated on the left, facing right before a table with loaves of bread, above which are hieroglyphic representations of offerings, including cuts of meat, a bird and bowls of fruit. On the right side is a formally laid-out offering list. The man wears a garment made of leopard skin that wraps round the body and fastens on the shoulder with long ties, so that it covers the forward shoulder and arm. This type of garment is worn by men and women into the Fourth Dynasty before disappearing from the monuments (see fig. 14). From Saqqara. Painted limestone. Second Dynasty.

depicted will exist in the afterlife and ensure that the needs of the dead person will be supplied for eternity. Thus the niche-stone introduces the standard offering scene for the deceased that can be found until the end of pharaonic civilisation.

Conclusion

The first two dynasties developed out of Egypt's Predynastic cultures and achieved their new character through the establishment of a united state under a single ruler. Their Predynastic roots are clear in the development of the utilitarian palettes and maceheads of the Predynastic Period into royal votive objects; the evolution of royal and elite tombs from Predynastic ones; the continued use of Predynastic cemeteries; and the on-going production of

The first flowering

THE OLD KINGDOM (I)

The king and royal monuments

Third Dynasty

Following the first two dynasties the Third Dynasty formed a further period of transition, when large decorated palettes and maceheads ceased to be produced; stone vessels of the earlier dynasties were still prized but production of new examples diminished; and the king's funerary complex developed differently from the tombs of the elite, and was built entirely of stone, instead of mud brick with some stone elements.

Of the four or more Third Dynasty kings the best known is Djoser, whose funerary complex, built of limestone, is famous today as the Step Pyramid at Saqqara (fig. 37).[1] Just as the First and Second Dynasties took elements from the late Predynastic Period and used them as part of their new coherent statement of kingship, so many of the individual elements in Djoser's novel funerary complex originated in the royal funerary complexes of the Early Dynastic Period but were combined differently.[2]

The Step Pyramid stood at the centre of a large, rectangular enclosure surrounded by a stone wall 20 royal cubits (10.5 m) high, built in the form of a modified palace façade pattern (fig. 38). There were fourteen entrances, but thirteen were non-functional and only one, at the southern end of the east wall, allowed the living access to the complex. The shape of the enclosure, with its one functional entrance on the east side, recalls the Early Dynastic funerary enclosures at Abydos.[3] Within the enclosure the superstructure of Djoser's tomb was originally begun as a square structure resembling those found within the royal enclosures at Abydos,[4] but it was subsequently enlarged and three progressively smaller squares added one on top of

another to give four steps. Finally it was enlarged yet again and another two steps added, giving a height of about 60 m.

A roofed and colonnaded corridor leading from the entrance opened into a large rectangular court lying to the south of the pyramid. At each end on a north–south axis stood a pair of crescent-shaped stones, north of which, in front of the Step Pyramid itself, was a stone platform approached by steps. A very similar configuration of these elements occurs in Early Dynastic scenes, for instance, on the Narmer macehead and on an ebony label of King Den (figs 28–9). Kemp suggests that Early Dynastic palaces contained a large open area with a raised platform and a set of the crescent-shaped stones that symbolised the limits of the king's territory.[5] This area would have functioned as a setting for the formal appearance of the king on state occasions such as the presentation of booty or tribute and also for the royal ritual in which the king claimed his territory by running round the territorial stones. This great arena and its paraphernalia was incorporated into the Step Pyramid enclosure, so that the ruler could continue to perform the rituals of kingship perpetually.

Three out of six limestone relief panels set up in the substructure of the funerary complex show Djoser running between territorial markers represented emblematically.[6] On one the king is shown performing the ritual before 'the great white one', a baboon deity who is also known from Early Dynastic material (fig. 39). The image of the king is surrounded by symbols of his office. He is preceded by a sacred standard bearing the image of a jackal god that is carried by an animated *was*-hieroglyph with a pair of arms. The *was*-hieroglyph depicts a type of sceptre frequently held by deities. It is usually translated 'dominion' and

36 The three pyramids of Giza belonging (right to left) to Kings Khufu, Khafra and Menkaura. The high-quality white limestone casing blocks brought from the quarries at Tura across the river have all been stripped away except at the very top of Khafra's pyramid. The remaining blocks, of lesser-quality stone, were quarried locally.

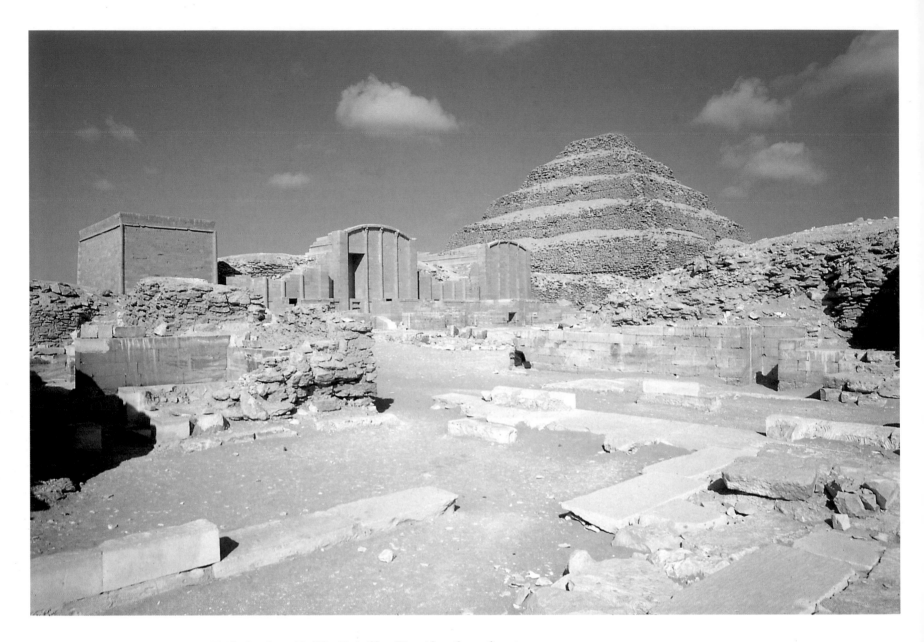

37 The Step Pyramid of King Netjerikhet (Djoser) from the south-east.
The Step Pyramid and the surrounding complex constituted the first
architectural project to be built entirely of stone. The pyramid itself
underwent several changes of plan until it consisted of six steps and reached
a height of about 60 m. The complex was probably modelled on the royal
palace, but the majority of the buildings within it were solid and non-
functional for the living. Nevertheless, they provided an arena where the
dead king could continue to perform the rituals of kingship throughout
eternity. Saqqara. Third Dynasty.

encompasses a concept of power and authority that was also closely associated with kingship. Above the king hovers a divine bird, either the falcon of Horus or the vulture of Nekhbet, holding in its claws the *shen*-hieroglyph signifying eternity. The far wing is outstretched horizontally above the king, while the near one points downwards behind him, forming a potent image of protection. Two more hieroglyphs with arms stand behind the king, one above the other, holding fans. The lower hieroglyph is another *was*-sceptre. The upper one is the well-known *ankh*-sign, the hieroglyph for 'life'. Like the *was*-sceptre, it is carried by deities and closely associated with divine kingship, for 'life' was a gift from deities to the king. Below the hieroglyphs are two symbols that write the word *medenbu*, 'limits', and, like the semi-circular marker stones, represent the extent of the king's rule.[7] The boundary markers them-

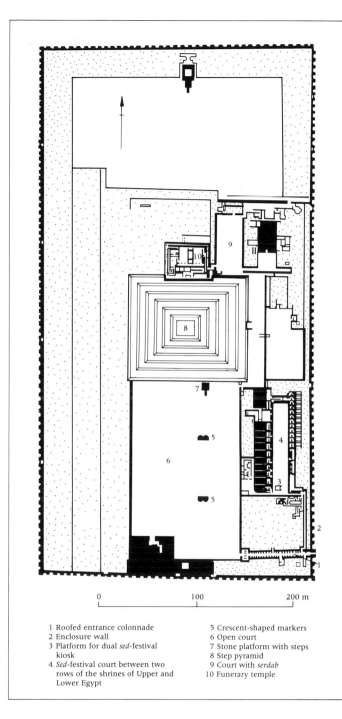

0 100 200 m

1 Roofed entrance colonnade
2 Enclosure wall
3 Platform for dual *sed*-festival kiosk
4 *Sed*-festival court between two rows of the shrines of Upper and Lower Egypt
5 Crescent-shaped markers
6 Open court
7 Stone platform with steps
8 Step pyramid
9 Court with *serdab*
10 Funerary temple

38 Plan of the Step Pyramid complex of King Netjerikhet (Djoser). Third Dynasty.

39 Drawing of a limestone relief from beneath the Step Pyramid, showing King Netjerikhet (Djoser) running between territorial markers represented emblematically. From Saqqara. H. 87 cm. Third Dynasty.

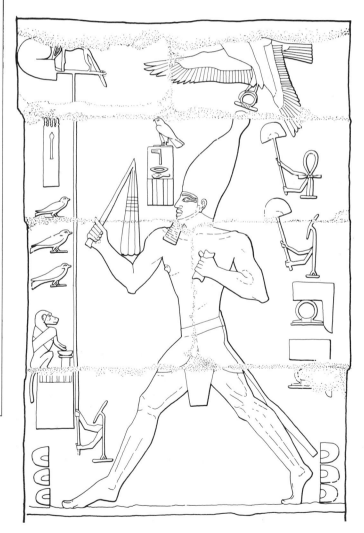

selves, between which the king runs, are placed three in front and three behind his feet. His stride easily encompasses the distance between them, visually expressing his royal authority over his territory.

The king is identified by his Horus name, Netjerikhet, written within the *serekh* surmounted by the Horus falcon. Although the king is referred to in later texts as Djoser, this name does not appear on contemporary monuments, where he is called by his Horus name. He wears the white crown and bull's tail, and carries the flail, an item of royal insignia already associated with the king in the First Dynasty (figs 28–9). Like Narmer (fig. 25) he wears a beard, but Djoser's beard is longer, broader and cut square at the end, with horizontal lines running across it. This form of beard was especially associated with the king. The royal figure resembles that of Narmer in its short neck, small buttocks and representation of musculature, but in little else. In addition to the subtler modelling of the relief, the shoulders are broader, the small of the back lower, and the legs shorter. These changes affect the relative sizes of the upper and lower parts of the body, and the small torso placed atop long legs that characterises Early Dynastic royal figures gives way to proportions that are nearer those found in living male figures.[8]

A second ritual of kingship well-known from later periods is the *sed*-festival, already mentioned on First Dynasty objects.[9] Later the *sed*-festival was normally held after the king had ruled for thirty years, in order to renew his kingship, and this was probably its original significance also.[10] During the *sed*-festival the king wore a wrap-around robe (figs 32–3), rather than the usual kilt. He is shown seated on two thrones set back-to-back and raised on a dais, once as king of Upper Egypt and once as king of Lower Egypt. In reality the thrones were probably placed side by side and the king performed the rituals twice, for each part of the dual state, in front of a series of shrines where the images of the provincial deities of Upper and Lower Egypt were gathered. The architecture of the Step Pyramid complex provides a separate setting for the performance of the *sed*-festival to the east of the great courtyard.[11] Here two rows of shrines run either side of an oblong court with a stone platform at its southern end. This platform, which once had a building on it, was reached by two sets of steps, one at either end of its east side. Just as the king was able eternally to celebrate the rituals of kingship associated with the territorial markers in the great open courtyard, so here he could eternally celebrate the ritual of the *sed*-festival.

Because the Step Pyramid complex was designed to serve the dead king, it had to provide a place for his body and a location where his cult could be performed. The burial chamber was cut into the rock beneath the pyramid. Against the north side of the pyramid, facing the imperishable stars in the northern sky amongst which the king hoped to pass eternity, was built the funerary temple where the daily rituals and offerings for the dead king could be performed. To the east of this building was a small enclosed chamber (*serdab*) that housed a life-size, seated statue of the king (fig. 40).[12] This image faced towards the north wall of the *serdab*, in which two holes were cut in order to link the worlds of the dead and the living.

The statue was made of limestone, plastered and painted, with the eyes originally inlaid. Netjerikhet wears a heavy, striated tripartite wig, of a type worn by deities, thus assimilating the dead king to the divine world. The wig is partly covered by a striped headcloth, an early form of the king's *nemes*-headdress which from the Fourth Dynasty on is shown as completely covering the hair (fig. 45). The king wears a long beard, broken at its end, and a thin moustache. His body is wrapped in a long robe under which the right arm is held horizontally across the chest. The left forearm rests on the thigh, with the extended hand placed palm down. The pose of the arms recalls Khasekhem's statues, only there the left arm crosses the body, and the right one with the hand clenched rests on the thigh (fig. 32). The seat is also very close in form to Khasekhem's seat, in that the stone is shallowly cut back to indicate the space between the legs. The image is identified as Netjerikhet by an inscription on its base.

The statue was not made to be seen and admired by human eyes, since it was walled into the *serdab*, but it had a very practical function. It provided a place where the king's *ka* could manifest itself in order to observe and benefit from the ritual that would be carried out in front of the *serdab*. Here the funerary priests would burn incense, make offerings and recite texts for the benefit of the deceased king. The *ka* could inhabit the statue and look out through the holes in the *serdab* wall, breathe the scented smoke of the burning incense and draw out the nourishing essence from the offerings.

Fragments of statues found in the Step Pyramid complex show that this was by no means the only statue of the king set up there and that some statues of royal women may also have been included.[13] Only the base remains of one life-size statue of the king, but it is of interest for two reasons. The king's feet are placed on a series of nine archery bows cut in relief on the surface of the base.[14] The enemies of Egypt were traditionally called 'the nine bows', and were often symbolised by a depiction of nine actual

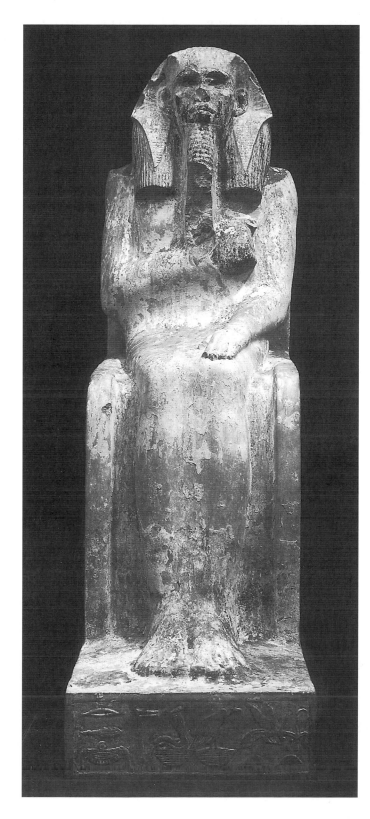

40 Seated statue of King Netjerikhet (Djoser) from the *serdab* on the north side of the Step Pyramid at Saqqara. Painted limestone, H. 142 cm. Third Dynasty. Cairo, Egyptian Museum.

bows. By showing the king treading on nine bows, the statue represents him as triumphant over his enemies and the forces of chaos, stressing the cosmic aspect of the king's role as establisher of order. This same motif is found frequently on kings' statues during most of pharaonic history.

The second point of interest lies in the inscription on the front of the statue base, which contains not only the king's Horus name but also the titles and name of the high official Imhotep.[15] This extremely rare inclusion of an official's name on a royal statue suggests that Imhotep had an uncommonly elevated status and may indicate that he was responsible for the construction of the Step Pyramid.

Fourth Dynasty

In the Fourth Dynasty there was a complete change in the layout of the king's funerary complex.[16] The superstructure of the tomb was built in the form of a true pyramid with smooth sides instead of steps (fig. 36). It no longer sat in the middle of a large enclosure, oriented north-south, where the rituals of the king as territorial ruler could be performed throughout eternity. Instead the complex was set out as a series of elements in a linear sequence on an east-west axis (fig. 41). At the western end, on the desert plateau, stood the pyramid itself that marked the burial. In the middle of the east side of the pyramid was the funerary temple where the cult for the king's *ka* was carried out. From here a causeway ran down to the valley temple at the edge of the cultivation.

This radically altered design can have come about only to express changing ideas concerning kingship, and all the evidence points to already existing concepts of the divine power of the sun and the relationship between the king and the sun god being given increased emphasis. The true pyramid shape was a symbol of the sun, relating to the sacred *benben*-stone that stood in Heliopolis, the centre of the sun cult.[17] The funerary temple was moved from the north side of the pyramid, where it related to the eternal life promised by the imperishable northern stars, to the east side, oriented towards the rising sun that promised eternal life through its endless cycle of setting and rising. For the first time kings began to call themselves 'son of Ra (the sun god)'.[18] The king's funerary monuments no longer catered for the king's eternal re-enactment of the territorial rituals of kingship. Instead the king became an earthly manifestation of the sun god, expressed in the form of the king's filial relationship to Ra, and at death he joined the sun god on his eternal cycle of renewal. This did not preclude the king's still being regarded as a manifestation of Horus, an identification that was to remain fundamental to

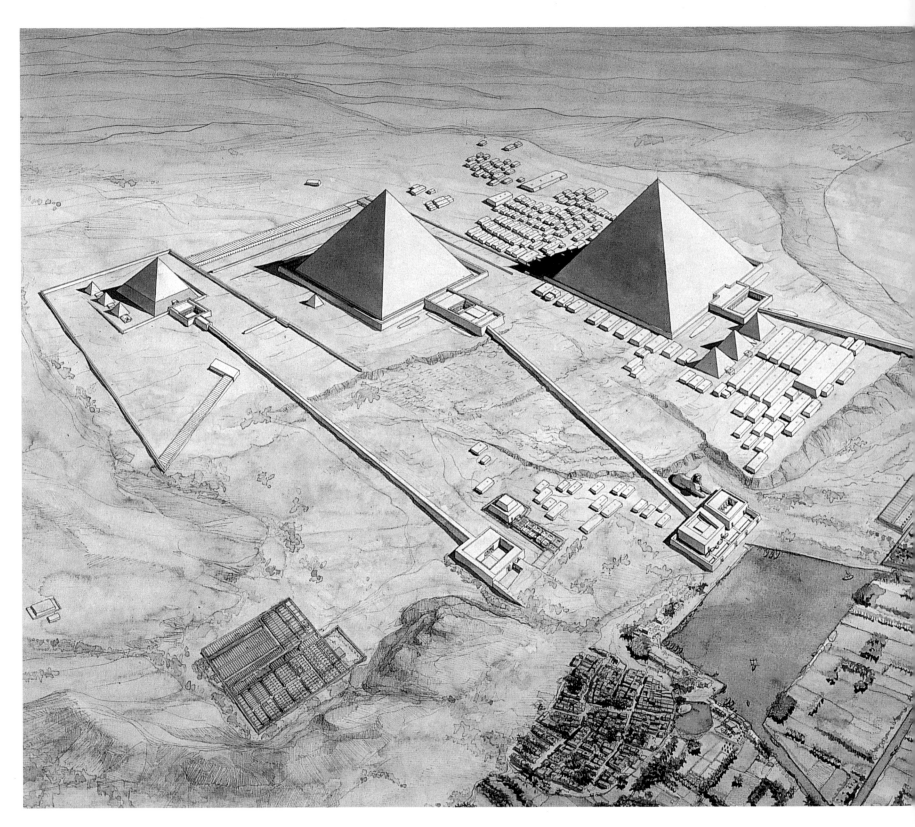

concepts of kingship until the end of the pharaonic period.

The new, linear complex appears in the reign of Sneferu, the first king of the Fourth Dynasty. The pyramid at Meidum, thought by later generations to have belonged to Sneferu according to graffiti left in the Eighteenth Dynasty, was originally built with steps that were later filled in to form a true pyramid.[19] The pyramid was surrounded by a pavement of mud plaster and a stone enclosure wall. Unlike the Step Pyramid complex, the only building within the enclosure wall was a small funerary temple placed against the middle of the east face of the pyramid. The temple contained a limestone offering table, where the daily offering ritual would have been performed; it was flanked on either side by a round-topped limestone stela. These should have named the king to whom the pyramid belonged, but they were never carved. The causeway led from a point in the enclosure wall virtually next to the funerary temple down to the valley temple some 215 m away on the edge of the cultivation, which has not been excavated because the site is now waterlogged.

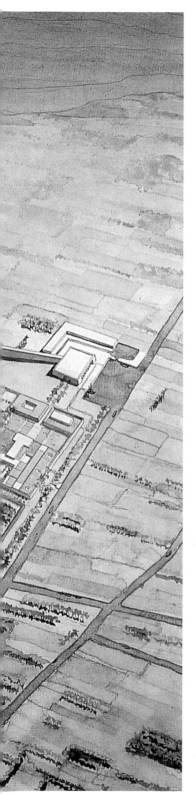

41 *left* Reconstruction drawing of the Giza plateau with, from right to left, the pyramid complexes of Kings Khufu, Khafra and Menkaura together with the *mastaba* tombs of officials and members of the royal family. Each pyramid complex consists of the pyramid with its funerary temple on the east side situated in the desert and a long, straight causeway leading to the valley temple on the edge of the cultivation. Fourth Dynasty.

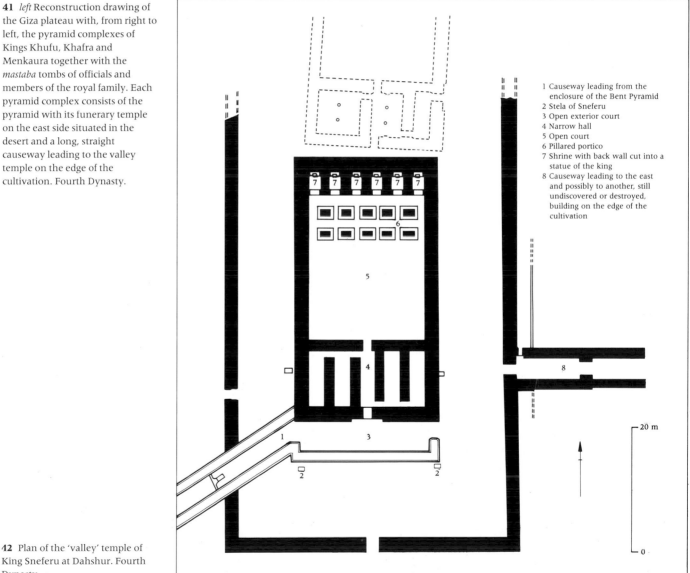

1 Causeway leading from the enclosure of the Bent Pyramid
2 Stela of Sneferu
3 Open exterior court
4 Narrow hall
5 Open court
6 Pillared portico
7 Shrine with back wall cut into a statue of the king
8 Causeway leading to the east and possibly to another, still undiscovered or destroyed, building on the edge of the cultivation

42 Plan of the 'valley' temple of King Sneferu at Dahshur. Fourth Dynasty.

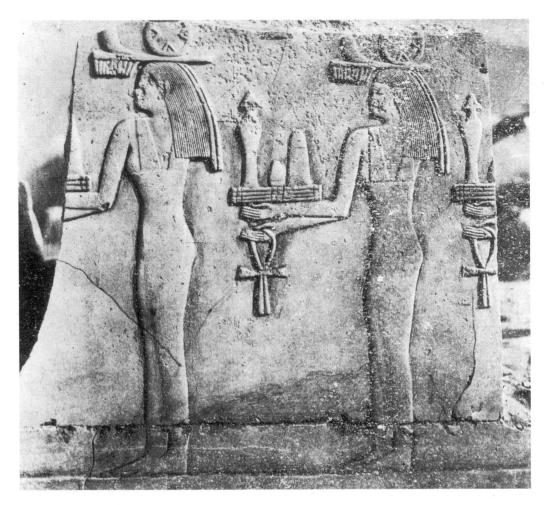

43 Part of the procession of Lower Egyptian estates in raised relief on the east wall of the entrance hall of the 'valley' temple of King Sneferu at Dahshur. On one outstretched arm the female personifications carry a reed mat, in the centre of which is placed a loaf of bread, the combination forming the hieroglyph meaning 'offerings'. On one side is a spouted vessel for pouring libations and on the other is a tall conical object that might be a second loaf of bread or perhaps a cone of incense. From the hand of the second arm depends a large *ankh*-sign. Limestone. Fourth Dynasty.

The Bent Pyramid at Dahshur, so-called because the angle of the faces changes part way up, belonged without doubt to Sneferu.[20] The small funerary temple on the east side of the pyramid contained an offering table with an extremely tall stela, approximately 9 m high, on either side. The stelae, which were found in fragments, had been decorated with the titles and names of Sneferu. Unlike later true pyramid complexes, the causeway entrance to the Bent Pyramid lay at the eastern end of the north, not the east, side of the enclosure, and the causeway led to a monumental temple that lay in a depression in the desert rather than on the edge of the cultivation. The resources put into this temple were considerable, especially when compared with the rather small funerary temple. It was rectangular in plan and built of local stone faced by the very fine limestone obtained across the river in the quarries at Tura (fig. 42). Outside the front wall of the court that lay before the temple entrance, two more stelae of

Sneferu were erected. An entrance led from the horizontal court into a narrow hall flanked on either side by two rooms. Beyond this hall lay an open court with a pillared portico at the far end consisting of two parallel rows of five rectangular columns. Finally, at the back of the building were six shrines, their openings corresponding to the spaces either side of and between the columns. Originally parts of the temple were decorated with painted high raised relief. Although the decoration was smashed into small fragments in later times, over 1,400 pieces were found during the excavation of the temple, from which the programme of decoration can be recovered.

Along the walls of the narrow entrance hall, the thicknesses of the door into the open court and the side walls of the portico was carved a procession of female offering-bearers representing the estates whose produce supported the funerary cult of the king (fig. 43).[21] They were divided into groups according to the district or *nome* in which the estates were situated, with Upper Egyptian estates on the west and Lower Egyptian ones on the east. These scenes stress once more the importance of supplying the dead with food and other offerings. This is the first example where the estates set aside to supply the king's cult were depicted, and it shows the grandiose scale of the cult. The function of the scenes was probably twofold. First, it provided a record of the estates contributing to the cult, displaying the huge resources that the king could draw on. Second, the figures provided a means of supplying the king's *ka* should the offering cult cease. Through the creative properties inherent in representation, the provisions from the royal estates would continue to be brought for eternity. The estates were shown as female figures because the key word in all their names was *hut*. Since this is of feminine grammatical gender, it was natural to show personifications of the estates as female.[22]

The shrines at the back of the temple were closed by double-leaved wooden doors. The walls on either side of the niches were decorated each with a standing relief figure of the king facing towards the niche. The back of the niche itself was carved into a statue of the king. The statues housed the *ka* of the dead king and were the recipients of offerings. The relief figures of the king were placed under the hieroglyphic sign for sky decorated with stars and protected by flying vultures representing the goddess Nekhbet or by falcons representing Horus. The figures were identified by the king's Horus name and cartouche. The baseline on which the king stands is drawn in the form of the hieroglyphic sign for 'land'/'earth'. The scenes represent the king's central position in the cosmos between the sky

44 Fragment of raised relief showing King Sneferu embraced by a lion-headed goddess so that their noses touch. The skin of the goddess is the pale colour of female figures, contrasting with the darker skin of the male king. The hand on the king's forward shoulder has similarly dark skin and belongs to the figure of a male deity that once stood behind the king. From the 'valley' temple of King Sneferu at Dahshur. Limestone. Fourth Dynasty.

above and the earth below. Elsewhere the king is embraced by various deities who thus show their acceptance of him (fig. 44). The decoration of the temple forms a carefully conceived programme relating to the offering cult of the dead king and his position in the cosmos. Later in his reign Sneferu built a second pyramid at Dahshur, often now known as the Northern Pyramid.

Sneferu's successor was Khufu, who built the so-called Great Pyramid at Giza, the largest pyramid to be built in Egypt (fig. 41).[23] As in other pyramids, the entrance was in the north face, and the funerary temple was situated on the east. An entrance on the temple's east side led into a court paved with black basalt, around the four sides of which ran a portico with pillars of granite. There is evidence that the limestone walls were decorated with relief scenes, but little survives today. The decoration was worked in a lower relief than in the Sneferu temple, and a very fine low relief was a hallmark of the royal workshops during most of the Fourth and early Fifth Dynasties. Some of the fragments come from processions of estates, and others are from scenes relating to the *sed*-festival.[24] Khufu's valley temple lies under a modern settlement and has not been excavated.

The next king, Radjedef, built his pyramid at Abu Rawash, but little is left of it.[25] His successor, Khafra,

returned to Giza for his burial site and built the so-called Second Pyramid there.[26] We know more about this pyramid complex, which includes the Sphinx, than we do about Khufu's. Just as Khufu had made use of different types and colours of stone in his funerary temple, so this tradition was continued in Khafra's buildings. The pyramid itself was cased in dazzling white limestone, except for the lowest course, which was of red granite. Both the funerary and valley temples combined the use of red granite for some walls and pillars with floors of white calcite. The funerary temple was more elaborate than earlier buildings. It was the first to include all the elements of entrance hall, open court, five statue niches, offering chamber and storage rooms. These elements became standard in funerary temples of the Fifth and Sixth Dynasties, although their arrangement varied from temple to temple. Twelve seated statues of Khafra, about 3.65 m high, once stood in front of the red granite pillars of the court, projecting forward from recesses. The limestone walls of the court were probably decorated with reliefs, since a depiction of a bound Asiatic prisoner was found.

By contrast, the valley temple contained no relief decoration, although the entrance doorways were each surrounded by a band of hieroglyphs giving the titles and names of the king. The main part of this temple was in the shape of an inverted T with six square granite pillars forming a horizontal line down the centre of the cross-bar and two parallel lines of five pillars in the stem. The main decoration consisted of twenty-three seated statues of the king. None was found *in situ*, but their original locations and number are shown by the marks of their emplacements in the floor. One almost intact statue and six others that were less well preserved were found in 1860, buried, for some unknown reason, in a pit in the floor of the temple.[27] These surviving pieces are of extremely high quality, and illustrate a fundamental characteristic of Egyptian art, the dislike of absolute repetition, for none of them exactly resembles another. The statues divide into two groups: those that sit on a high-backed seat with figures of lions forming the sides, and those where the king sits on a simple block seat with no back. The king wears the *nemes*-headdress, and looks straight forward, with both forearms on his thighs; the right hand is clenched into a fist and the left hand lies palm down. The statues are inscribed with versions of the titles and names of Khafra arranged differently on each one.

The best-preserved statue is 168 cm high and made from diorite-gneiss quarried west of Toshka, in the Nubian desert beyond the borders of Egypt (fig. 45). The fact that

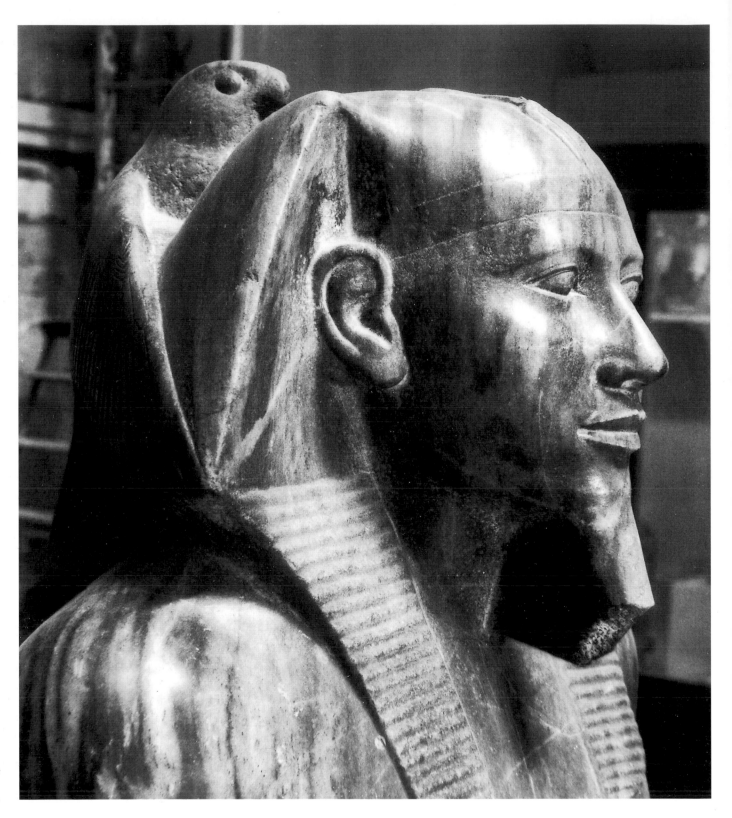

45 Head of a seated statue of King Khafra from his valley temple at Giza. Diorite-gneiss. Fourth Dynasty. Cairo, Egyptian Museum.

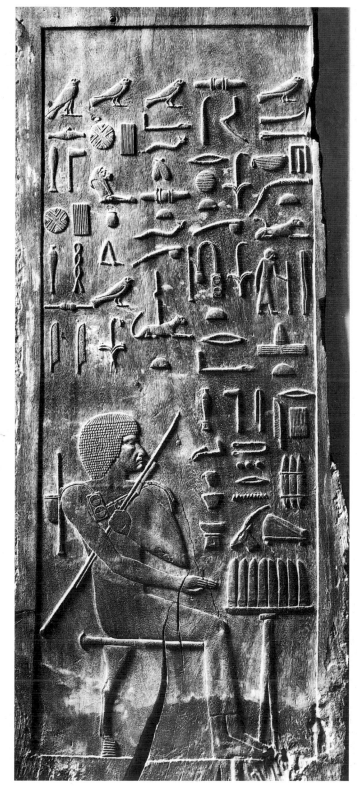

46 Wooden panel carved in raised relief showing the high official Hesira seated facing right. In his forward hand he carries a staff held diagonally across his chest and over his rear shoulder are slung the palette, water pot and pen holder that made up the scribal kit of an official at this time. The same combination was adopted as the standard hieroglyph for 'scribe' and can be seen in the inscription above Hesira that identifies him by his titles and name. From the tomb of Hesira at Saqqara. H. 114 cm. Third Dynasty. Cairo, Egyptian Museum.

the king could command a supply of this stone displayed his far-ranging authority. The hard stone was cut with great skill, as can be seen in the modelling of the face, and the statue was finished with a high polish that enhances the graining of the stone. The effect of the dark stone (if not painted) against the red granite and white calcite of its architectural setting would have been impressive, while the rectilinear, frontal properties of the statue would have harmonised with the square pillars and rectilinear form of the temple.

On top of the tall back of the seat the Horus falcon perches with its wings spread in a protective gesture around the king's head, so that the back of the head and the front of the falcon's body seem to merge. This image is a concrete expression of the notions that the king is both under the protection of Horus and also the manifestation of the god on earth.[28] On both sides of the seat between the chair legs, the *sema tawy* motif is carved. The large *sema*-hieroglyph is flanked by the plants of Upper and Lower Egypt. Their stems are knotted around the hieroglyph in order to symbolise the union of the two parts of Egypt in the person of Khafra.

Non-royal tombs

In the Third Dynasty the high elite continued to build tombs at Saqqara with rectangular superstructures, built either of solid mud brick or of rubble with a mudbrick casing, although there was an increasing use of stone elements. Such superstructures are often today called *mastabas*, from the Arabic word for 'bench'. Many *mastabas* continued to be plain on the outside with two offering niches on the east side, one at the north end and the other at the more important south end. However, the offering niches were often cut back into the superstructure to form an approximately cruciform room, part of which could be lined with stone and decorated.[29]

In some Third Dynasty tombs the use of the palace façade motif was revived, but usually only on the most important east side with the offering niches. The niched façade was then protected by a plain wall that extended from the superstructure at either end and ran in front of and parallel to the façade. A typical corridor chapel of this type can be found in the tomb of Hesira, dated by a clay sealing to the reign of Djoser.[30] When it was excavated the protected panelled façade still preserved the painted patterns that imitated reed matting. At the back of each of eleven niches was originally placed a carved wooden panel, six of which survive in part (fig. 46). Each shows a

right-facing figure of Hesira; in five of them he stands and in one he sits before a table bearing half loaves of bread.[31] On the opposite side of the corridor, on the inside of the protective wall, were painted items of funerary equipment, beds, chairs, stools and boxes with their contents. On the west wall of the outer corridor were remains of painted scenes that included a crocodile and men with cattle, perhaps remnants of early so-called everyday life scenes that became more common during the Fourth Dynasty.

Like the niche stones of the Second Dynasty, the function of the wooden panels of Hesira was to perpetuate the existence of the deceased in the next world and to provide the necessary offerings needed to achieve this. The image of the deceased standing with the far leg advanced, holding a long staff in his forward hand and a sceptre in the rear one, was to become standard in funerary art. The staff and sceptre were symbols of the authority and status of an official, and a similar image was also being developed around this time in statuary.[32]

In the brick-built corridor chapel of Khabausokar two of the niches opened into separate cruciform chapels, lined with decorated limestone panels.[33] The more important southern chapel belonged to Khabausokar and the subsidiary northern chapel to his wife, Neferhotephathor. In both chapels the back panels showed the owner seated on the left facing right before a table of offerings, the whole above a list of offerings. The side panels show figures of the owner standing facing outwards towards those who came into the chapels to perform the offering rituals. Above the figures, columns of hieroglyphs identify them by name and titles in order to perpetuate their memories in this world and their existence in the next (fig. 47).

Like the seated figure of Khabausokar on the back panel, the hieroglyphs that identify him also face right, but the hieroglyphs and images representing offerings are reversed, facing left in order to indicate that they are being presented to him. The separate offering list beneath reverts to the primary, right-facing orientation. Because the figures of Khabausokar on the side panels are both oriented to face towards the performer of the ritual, only one figure, that on the right panel, can face to the right. On the left panel the figure with its accompanying hieroglyphs has to be reversed. The elements on both panels balance each other, but the compositions are not mirror images. On the left-facing figure the forward hand is shown from the back not the front, the rear hand is shown from the front not the back, and the sceptre passes behind not in front of the body.

The reason for these differences can be deduced from three-dimensional images, where the staff is always held in the left hand and the sceptre in the right. A viewer looking at a person facing right holding the staff and sceptre in the left and right hands respectively would see the hand holding the staff from the front and the one holding the sceptre from behind. When a viewer looks at a person holding the same items but facing left, the left hand holding the staff is seen from the back and the right hand holding the sceptre from the front. Moreover, since the sceptre is held on the right side of the body, the body will intervene between the viewer and the sceptre. Other ways of representing left-facing figures were also developed, giving artists a choice as to how to depict them.[34]

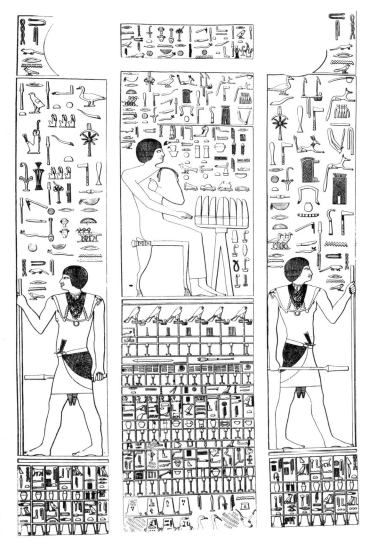

47 Drawing of the limestone relief-cut panels from the offering niche of the tomb chapel of the high official Khabausokar at Saqqara. H. 195 cm. Third Dynasty. Cairo, Egyptian Museum.

All the figures and hieroglyphs are cut in high, raised relief that is subtly modelled with an emphasis on musculature. Both standing figures are wider across the shoulders and waist than the figures of Hesira (fig. 46), but their proportions are not exactly the same. The figure on the left panel is fatter with a more pronounced stomach, thicker waist and fuller buttocks. The figures form a pair showing two different stages in Khabausokar's life. On the right Khabausokar is shown at the physical peak of early adulthood. On the left his figure is more mature, showing the extra flesh accumulated by a successful official who eats well and gets little exercise as he sits in his office directing his staff.

At the south end of Khabausokar's chapel a small room built into the superstructure communicated with the corridor only by a slit in the wall.[35] This room had the same function as the *serdab* of Djoser. It was meant to house a statue of the deceased where his or her *ka* could dwell. The *ka* in the statue could look out through the slit to watch the performance of rituals. No statues survive of Khabausokar or his wife, but other Third Dynasty statues, representing both men and women, seated and standing, still exist today.[36] A seated statue of the ship-builder Ankhwa is made of red granite and is 64 cm high (fig. 48).[37] Ankhwa sits on a rectilinear block seat. Contrasting with the straight lines of the seat, the inner, curvilinear, bent wood supporting frame is shown in relief on both sides and the back of the block. This characteristic feature of early seated statues disappears subsequently, perhaps because the curve of the bent wood was felt to be incompatible with the rectilinear forms that dominate formal statues.

In the Fourth Dynasty a number of tomb chapels were decorated with so-called everyday life scenes, a type of scene that had probably already appeared in the Third Dynasty tomb of Hesira. These were never meant to be accurate records of everyday life, but were created for the benefit of the tomb owner in the afterlife. Some of the earliest examples of such scenes appear at Meidum in the chapels of the neighbouring tombs belonging to Rahotep and his wife Nefert,[38] and to Nefermaat and his wife Itet,[39] dating to the reign of Sneferu. The superstructures were built in the traditional mud brick, and the chapels were lined with stone blocks. The technique of decoration varied in the two tombs. In that of Nefermaat and Itet some of the scenes were painted while others were incised and filled with coloured paste, whereas in the chapels of Rahotep and Nefert, the scenes were cut in raised relief and painted. The technique of using a fill of paste did not become accepted.

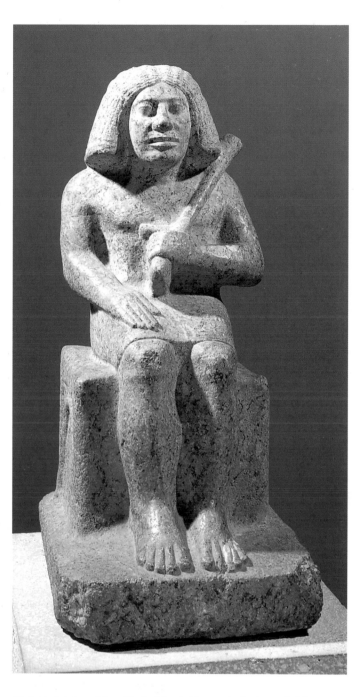

48 Seated statue of the ship-builder Ankhwa, who is shown holding an adze in his left hand as a reference to his office. The piece would have been placed in the *serdab* of Ankhwa's tomb chapel. Red granite, H. 64 cm. Third Dynasty. London, British Museum.

49 Reconstruction drawing of a scene in the tomb chapel of Itet showing four men in the marshes engaged in trapping birds in a clap net. A sub-register shows six geese standing and grazing among the marsh plants. Another register below depicts the beginning of the agricultural year, sowing seed and ploughing with oxen. The whole was watched by a large figure of Nefermaat, even though the tomb chapel belongs to Itet. It is possible that a figure of Itet drawn on a smaller scale stood behind her husband, as elsewhere in the chapel, but no fragments confirming this have been found. North wall of the first corridor of the tomb chapel of Itet at Meidum. Fourth Dynasty.

50 Fragment from a scene showing four men trapping birds in the marshes with a clap net (see fig. 49). The skill of the painter is shown in the detailed rendering of the plumage of the bird, which conveys texture as well as colour. From the tomb chapel of Itet at Meidum. Painted limestone, L. 59 cm. Fourth Dynasty. London, British Museum.

In both tombs there were two chapels in the east wall: one in the primary southern location belonging to the man and one in the secondary northern location belonging to the woman. The west wall of each chapel was fashioned in the form of a complex door, usually called a false door, through which the deceased could pass to receive the offerings brought by the living. The idea of a door linking this world and the next can already be seen in the architectural settings of the panels of Djoser, Hesira and Khabausokar. The traditional image of the deceased seated before a table of offerings was carved on a panel above the central doorway. In the chapel of Rahotep, who was a king's son and high priest of Heliopolis, the deceased is shown seated on the left side of the scene facing right (fig. 14). In the middle is a table carrying half-loaves of bread and, above and below it, the names of more offerings written out in hieroglyphs that face to the left towards Rahotep. The right side of the scene is occupied by a formally arranged offering list, similar to the offering lists that had been placed beneath the scenes in the chapels of Khabausokar and his wife. In the chapel of Rahotep this area was occupied by the central element of the false door.

The false door and depictions of funerary items occupied the rear of the chapel. The rest of the wall space was covered with scenes of 'everyday life' depicting hunting in the desert, bringing desert animals, netting birds and fish, bringing and butchering oxen, ploughing and boat building. All these subjects relate to supplying the needs of the deceased in the afterlife. Scenes like these subsequently became part of the repertory of tomb decoration.

Similar scenes of everyday life appeared in the neighbouring *mastaba* of Nefermaat and Itet. Several painted fragments survive from a scene in the corridor of Itet's tomb that once showed four men trapping birds in the marshes with a clap net (fig. 49). The net was left open with bait inside. When enough birds had been lured into it the hunters pulled it shut with a rope, trapping the birds inside. The first man in the scene is not pulling the rope, but already holds a bird in each hand (fig. 50). The artist skilfully represented the different colours and textures of the plumage, and may have been provided by the king from a royal workshop. The ability to command first-rate artists displayed the tomb owner's wealth and status, while the scene's function, as earlier, was to ensure that the deceased had a perpetual supply of table fowl in the afterlife. The scene was situated above another one that showed men ploughing and sowing seed, activities that marked the beginning of the agricultural year that culminated in the grain harvest. Thus Itet and her husband were also assured of a continuous supply of bread and beer.

For some reason, the chapels in both *mastabas* were blocked off in ancient times and new offering places for the cult were provided.[40] The chapel of Rahotep was turned into a kind of *serdab* in which a pair of statues representing Rahotep and Nefert were walled up, until they were found by the French Egyptologist Auguste Mariette when he excavated the tomb in the early 1870s.[41] Because they were protected, they have retained most of their paint. It is possible that the statue of Nefert was originally meant to have been placed in the southern chapel.

The statues, of plastered and painted limestone, are just over 120 cm high (fig. 51). Both figures sit facing forward on rectilinear seats with high backs and projecting foot rests. Rahotep wears only a short white kilt and a single-strand necklace carrying a heart amulet. His black hair is cut short, his eyes outlined in black paint, and his upper lip adorned with a trimmed moustache. His skin is a reddish-brown, the standard colour for men. The seat is painted white, so that the predominantly brown figure of Rahotep stands out against it. Either side of Rahotep's head are three columns of black hieroglyphs, stark against the white ground of the seat. The inscriptions identify Rahotep by his most important titles and his name. The posture of Rahotep's arms, the right held across the chest and the left resting on the thigh, resembles that of the statue of Djoser (fig. 40). The horizontally held arm went out of fashion in the course of the Fourth Dynasty.

In contrast to Rahotep's figure, that of Nefert is almost totally wrapped in a white outer garment, while her exposed skin is of a much lighter colour, so that her body seems to merge with the white seat rather than stand out from it. The straps of her dress are visible where they emerge from her outer robe and from under her wide, multicoloured collar. She wears a full, shoulder-length, black wig, from under which her own hair appears on her forehead. On her head she wears a fillet decorated with brightly coloured, stylised floral motifs. The statue is identified by two identical columns of black hieroglyphs, one either side of her head. Unlike Rahotep, who was a government official and held a number of titles, Nefert has only one, 'king's dependant' (or perhaps 'acquaintance'). This title is not one of administrative office, but rather links the holder to the king, perhaps as a part of his household. Given the exalted position of the king, such an association suggests a high status on the part of the title holder, as we would expect of the wife of a king's son and high government official.

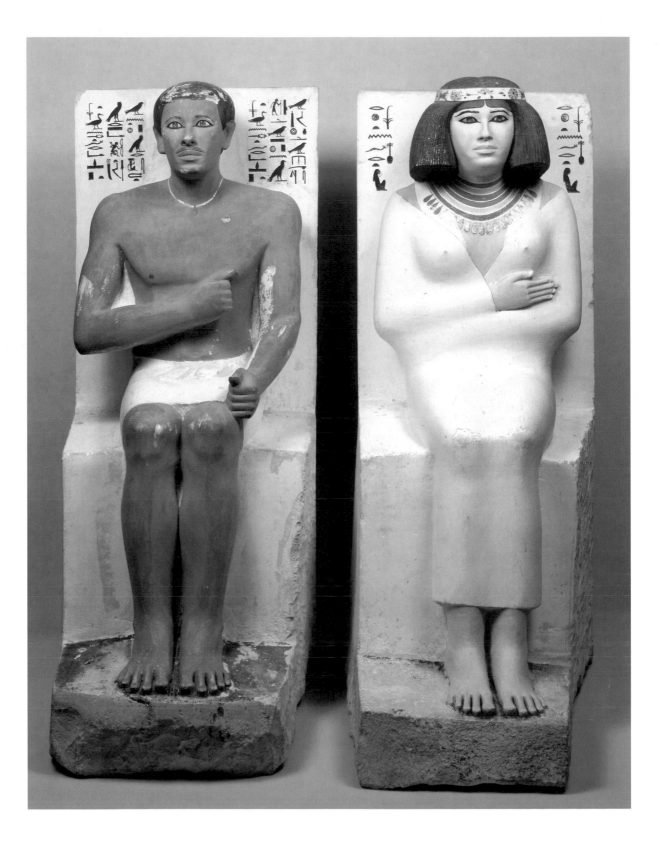

51 Painted limestone statues of Rahotep and Nefert from the tomb chapel of Rahotep at Meidum. H. 121 cm and 122 cm. Fourth Dynasty. Cairo, Egyptian Museum.

Conclusion

The Third Dynasty forms a link between the formative period of the first two dynasties and the classic pyramid age of the Old Kingdom initiated in the Fourth Dynasty. Elements from Early Dynastic royal burials were reworked into a new configuration, the Step Pyramid, which was then transmuted into the true solar pyramid at the beginning of the Fourth Dynasty. At the same time the form of royal and elite tombs diverges sharply, as the latter continue to be built in the older *mastaba* form, following their own line of development with the evolution of the decorated tomb chapel and scenes of everyday life in addition to images of the deceased receiving offerings. Nevertheless, the monuments of the elite pale beside the colossal size and undertaking of the royal pyramid complexes that proclaim the unique position of the king within the cosmos. It is probable that the gap between the power of the king and the elite was never greater than in the Fourth Dynasty.

Notes

1 Firth and Quibell 1935; Lauer 1936; 1939; 1962; Edwards 1993, 34–58; Friedman 1995.
2 Kaiser 1969; O'Connor 1989b; 1991b; 1995b.
3 O'Connor 1989b, 84.
4 O'Connor 1995b, 7.
5 Kemp 1989, 59.
6 Firth and Quibell 1935, pls 15–17, 40–2; Friedman 1995, fig. 2b.
7 Spencer 1978, 54.
8 Robins 1994a, 228.
9 Hornung and Staehelin 1974, 16–18.
10 Hornung and Staehelin 1974; Martin 1984.
11 Kemp 1989, 58 fig. 19, 71 pl. 4.
12 Firth and Quibell 1935, 9, 51–2, pls 24, 27–8; Lauer 1936, pls 21.2, 23.1.
13 Firth and Quibell 1935, pls 58–9, 63.2, pp.129–30, pl. 95.
14 Firth and Quibell 1935, pl. 58; Malek 1986, 88–9.
15 Wildung 1977, 5–9, pl. 1.
16 Kemp 1989, 62–3; Roth 1993; Hawass 1995.
17 Kemp 1989, 85–8, fig. 30.
18 Quirke 1990b, 25.
19 Edwards 1993, 71–8.
20 Fakhry 1959, 1961a, b; Edwards 1993, 78–89.
21 Jacquet-Gordon 1962.
22 Jacquet-Gordon 1962, 26–8.
23 Edwards 1993, 98–121.
24 Goedicke 1971, 11–23; Hassan 1960, 20–4, 34–5, pls 5–7.
25 Porter and Moss 1974, 1–3.
26 Edwards 1993, 124–37.
27 Borchardt 1911, nos 9–10, 12–15, 17.
28 See also Baines 1990b, 19.
29 Reisner 1936, 263–70.
30 Quibell 1913; Reisner 1936, 270–3.
31 Wood 1978.
32 Smith 1946, 17, pl. 4c.
33 Mariette 1889, 71–9; Murray 1905, 2–4, pls 1–2; Terrace and Fischer 1970, 37–40; Reisner 1936, 203, 267–9.
34 Schäfer 1986; Robins 1986, 15–16.
35 Reisner 1936, 269, fig. 158.
36 Smith 1946, 15–19, pls 3–4; Spencer 1980, no. 2.
37 Spencer 1980, no. 1.
38 Mariette 1872, pls 16D, E, F, 18–20; Mariette 1889, 478–84, 487; Petrie 1892, 11 29, 37 8, pls 1, 5, 7, 9 15; Harpur 1986.
39 Mariette 1872, pls 16A, B, C, 17; Petrie 1892, 11–29, 39–40, pls 16–28.
40 Reisner 1936, 222–3.
41 See n. 39.

A golden age

THE OLD KINGDOM (II)

The king

The pyramid complex

In many ways the Fifth and Sixth Dynasties continued the traditions of the Fourth, but this does not mean that there were no changes. In the king's pyramid complex the basic elements and linear form with an east–west orientation remained the same. Nevertheless, the pyramids themselves never again achieved the colossal sizes of the pyramids of Khufu and Khafra, and indeed that of Menkaura, the third pyramid at Giza, had been less than half their height. In the Sixth Dynasty, however, all four kings' pyramids were standardised with a height of 100 cubits (52.5 m) and a base of 150 cubits (78.75 m), dimensions already used in the pyramid of Djedkara Isesi, penultimate king of the Fifth Dynasty. The standardisation of the four Sixth Dynasty kings' pyramids is unusual, since architects and artists normally avoided exact copies, as the variety of royal pyramid proportions during the Old and Middle Kingdoms shows.

The elements that made up the pyramid temple, though not their exact layout, now became standard. Like all pyramid temples, the function of those of the Fifth and Sixth Dynasties was to house the dead king's cult. Each temple is divided by a central transverse corridor into two parts: the long hall and open court; and the statue chapels, intervening rooms and offering chamber (figs 53–4). A statue of the king was placed in the middle of the open court with an altar for the presentation of offerings in the north-west corner. Such altars were decorated with processions of Upper and Lower Egyptian *nomes* and royal estates and the *sema tawy* symbol of dual kingship.[1]

In the inner part of the temple stood statues showing different forms of the king, for instance as king of Upper or Lower Egypt, one in each of five chapels.[2] These were linked by two intervening rooms to the offering chamber, where the focal point was the false door on the west wall that allowed the king to come through from his pyramid in order to receive offerings.

The decoration, which is best preserved, although still fragmentary, in the complexes of Sahura,[3] Wenis[4] and Pepy II,[5] divides into several major themes, each realisable through a variety of scene types that could be expanded or contracted depending on available space: inscriptions with the king's titles and names; the king as establisher of order; legitimation and renewal of kingship, including the king's interaction with deities; and provisioning the deceased king. Most of the subject matter had antecedents in earlier royal monuments, and it is probable that a body of iconography suitable for decorating the royal pyramid complex was established during the Fourth Dynasty.[6] Each complex would then have drawn from this body for its decoration, but each monument was designed anew, combining basic architectural and decorative units in different ways.

Throughout the complex, inscriptions proclaimed the king's titles and names in order to display his ownership and perpetuate his name for eternity. The king's role as establisher of order could be expressed in a number of different ways. One group of scene types shows him triumphant over his enemies, either in the ancient motif of smiting them, or as a sphinx (lion with human head) or griffin (lion with falcon head) trampling them under foot. In the causeway of Sahura bound foreigners are led by deities to the king (fig. 55), and in his funerary temple two large scenes show the king's victory over Libyans and Asiatics. Statues of bound foreigners repeat the theme in three

52 Fragment of raised limestone relief showing a goddess suckling King Wenis. The goddess embraces the smaller figure of the king with her forward arm and offers her breast with her rear hand so that the king can take the nipple between his lips. From the pyramid temple of Wenis at Saqqara. Fifth Dynasty. Cairo, Egyptian Museum.

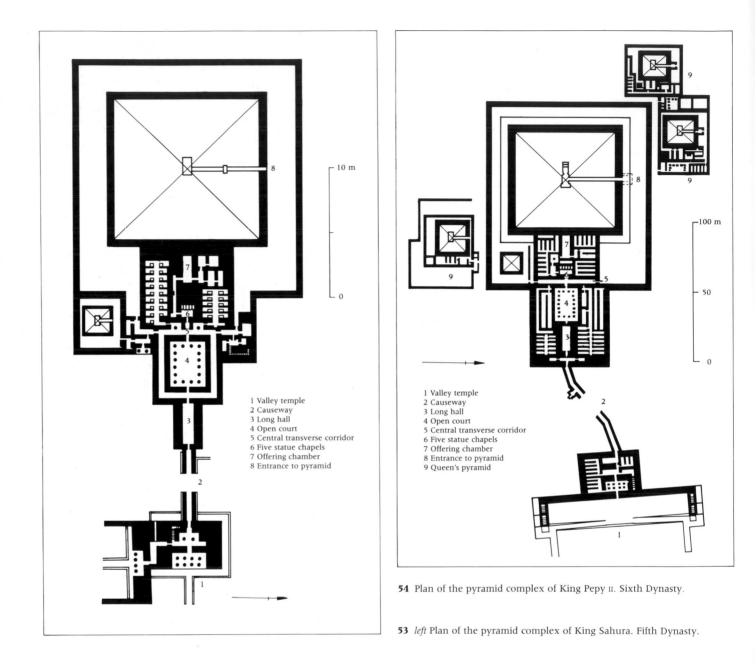

1 Valley temple
2 Causeway
3 Long hall
4 Open court
5 Central transverse corridor
6 Five statue chapels
7 Offering chamber
8 Entrance to pyramid

1 Valley temple
2 Causeway
3 Long hall
4 Open court
5 Central transverse corridor
6 Five statue chapels
7 Offering chamber
8 Entrance to pyramid
9 Queen's pyramid

54 Plan of the pyramid complex of King Pepy II. Sixth Dynasty.

53 *left* Plan of the pyramid complex of King Sahura. Fifth Dynasty.

dimensions.[7] A second group of scenes depict the king dominating the chaotic forces of nature that lay outside the cultivated land of Egypt. The commonest scene seems to feature the king fishing and fowling in the marshes, but he is also represented spearing hippopotamuses, and shooting animals in the desert.

The legitimation and renewal of kingship could be expressed by scenes showing the king in the presence of or interacting with deities, who thereby demonstrate their support of him as king. The motif depicting a goddess suckling the king survives in several examples from the Fifth and Sixth Dynasties (fig. 52).[8] The meaning is clear: the divine essence of the goddess is transferred to the king through her milk. Elsewhere the king sits between deities on a throne decorated with the *sema tawy* motif, marking him as the legitimate dual king who has joined the two parts of Egypt (fig. 6). Another way of expressing the same theme was through depictions of the *sed*-festival.[9] Other

55 Part of a block from the funerary temple of King Sahura at Abusir showing various deities leading foreign captives to the king. The deities are drawn on a larger scale than the foreigners and stand in a separate register above their prisoners. In their rear hands they hold ropes that cross into the lower register and attach to the captive figures. Above the deities the top of the register is bounded by a starry sky hieroglyph, but no such border is found above the prisoners and, in fact, the two registers are not separate units. Rather, they must be read together, as the ropes running from one to the other suggest, with the captives visually placed beneath the feet of the gods to show their subject status. The latter is further emphasised by the way in which most of the prisoners have their arms contorted and tied into a variety of uncomfortable positions. Although the paint has been lost from this piece, it is still possible to appreciate the extremely high quality of the relief carving. The figures of the gods exhibit the broad shoulders and low small of the back characteristic of male figures in this period. Limestone. Fifth Dynasty. Berlin, Ägyptisches Museum.

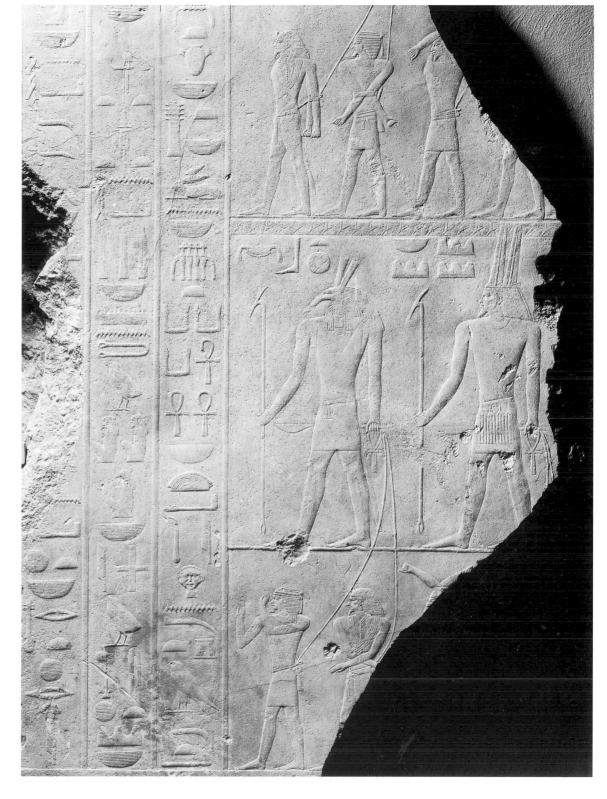

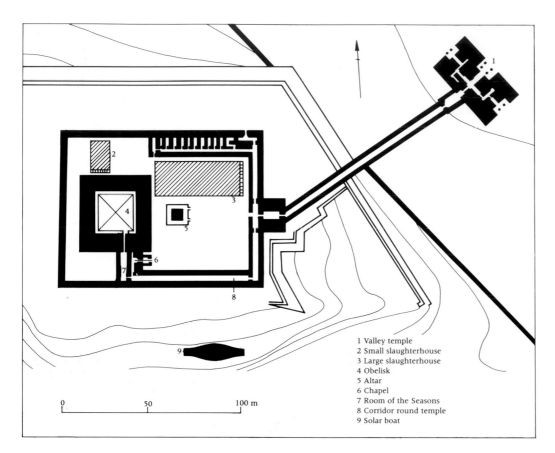

1 Valley temple
2 Small slaughterhouse
3 Large slaughterhouse
4 Obelisk
5 Altar
6 Chapel
7 Room of the Seasons
8 Corridor round temple
9 Solar boat

56 Plan of the sun temple of King Neuserra at Abu Ghurob.

scenes represent official and ritual appearances of the king, shown as a large figure in the midst of standard-bearers, priests, officials and the royal sons.[10] A block found in the area of Sahura's causeway in the mid-1990s preserves part of a scene that once depicted the arrival of the king's pyramidion, the capstone that crowned the pyramid,[11] thus commemorating a specific, contemporary event.

Scenes relating to provisioning the dead king include processions of *nome* deities and personified estates. Processions of fecundity figures, including personifications of the Nile inundation, represent the fertility and bounty of the land which they bring to the king in the form of symbolic offerings.[12] Other scenes show cattle being brought and butchered; piles of offerings; and the king seated in front of a table of offerings.[13] Offering lists record in hieroglyphs all the offerings necessary for the deceased king.

Solar temples

In addition to their pyramid complexes, six kings of the Fifth Dynasty, from Userkaf to Menkauhor excluding Shepseskara, are each known from texts to have built a temple dedicated to the sun god Ra.[14] Only two of these temples, those of Userkaf and Neuserra, have been located and excavated.[15] They were built on the west bank of the Nile at the edge of the desert plateau just north of Abusir. The others were probably situated in the same general area. The location of these temples on the west bank of the Nile, where the various necropoleis of the Old Kingdom lay, suggests that they had a funerary significance. Moreover, there seem to have been close connections between a king's pyramid complex and his sun temple. Some of the scene types found in the sun temple are drawn from the repertory of scenes for pyramid complexes, and administrative documents show that provisions were sent from the sun temple of Neferirkara to his pyramid temple.[16] There is also an architectural similarity in that the sun temple, situated like the pyramid and its funerary temple on the desert plateau, was reached by a long causeway entered through a valley temple placed at the edge of the cultivation.

The main cult place of Ra was at Heliopolis on the east bank of the Nile, but little has survived of its temples, upon which solar temples built elsewhere were probably modelled. Evidence from other temples and periods makes it clear that the sun god was worshipped in the open air rather than in an interior sanctuary. Neuserra's sun temple consisted of a rectangular walled enclosure, 100 by 76 m, entered on the east side (figs 56–7). At the west end a large limestone podium with inclined sides stood on a granite base and supported a colossal masonry obelisk that represented the sacred *benben*-stone of Heliopolis. To the east of the obelisk, in the centre of the open court, was an altar where offerings were presented. It was constructed from five large calcite slabs, those on the four sides having the shape of the *hetep*-hieroglyph meaning 'to offer'. On the north side of the court was an area for butchering sacrificial animals, and a series of storerooms. Textual evidence records that in the sun temple of Userkaf two oxen and two geese were offered on the altar every day.[17]

A covered corridor ran along the east and south sides of the court, turning in towards the obelisk at its west end. Parallel with this last short section of corridor and lying to its east was a chapel entered from the court. These covered areas were decorated with relief scenes, now either destroyed or in fragments. The corridor on the east and south sides depicted the renewal of the king at the *sed*-festival.[18] *Sed*-festival scenes also appeared in the chapel together with depictions of the rituals of temple foundation.[19] The short corridor between the south side and the obelisk contained scenes relating to the seasons, and thus did not come, as far as we can tell, from traditional royal

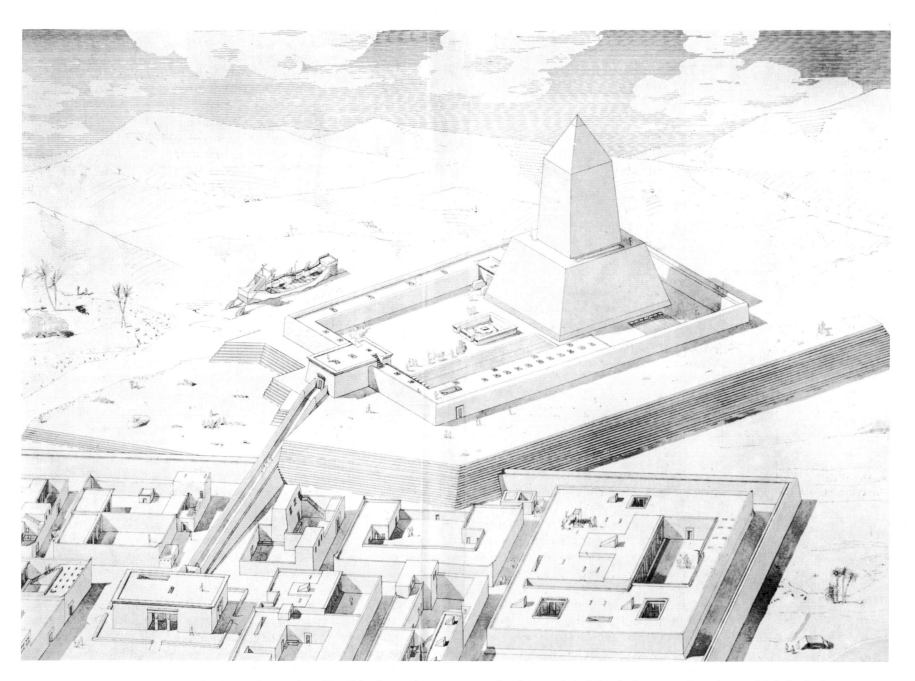

57 Reconstruction drawing of the sun temple of King Neuserra at Abu Ghurob.

funerary decoration. Possibly they relate to scenes in the temple of Ra at Heliopolis. From the surviving fragments we can deduce that the reliefs depicted two of the three seasons of the Egyptian year: *akhet* (inundation) and *shemu* (harvest).[20] Personifications of the seasons were accompanied by scenes showing seasonal activities such as netting fish, trapping birds, making papyrus boats, and various stages of the agricultural cycle (fig. 58). These activities are placed in their natural setting, which includes water, growing plants and animals that are often mating or giving birth. If the king was the central figure in the rest of the decoration, here he yields to the bounty of nature. The meaning of the scenes seems clear. They celebrate the sun's benevolence in creating and sustaining the world, and so are wholly appropriate to a temple dedicated to the cult of the sun god.

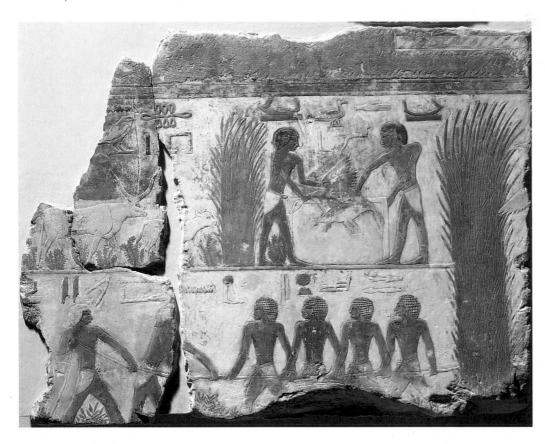

58 Fragment of relief from the sun temple of King Neuserra at Abu Ghurob showing two registers of activities in the marshes. In the lower register is preserved part of a scene showing the trapping of birds in a clap net. The clap net itself is missing but six men can be seen holding the rope that will pull the net shut. In the register above, two men are depicted putting birds that have already been caught into a cage. To the left a cow and her calf can be seen, part of a larger scene of animal husbandry that is now lost. The top of the block preserves the bottom of a water scene. The marsh setting of the scenes is made explicit by the tall stands of reeds and other vegetation. Much of the colour survives, with blue for the water, green for the plants, black for hair and reddish brown for the skin of the labourers. Painted limestone, H. 51 cm. Fifth Dynasty. Berlin, Ägyptisches Museum.

In the Pyramid Texts the dead king was identified with various deities including Osiris. Horus, manifest in the living king, was associated with Osiris as his son by his sister-consort Isis. Although no coherent version of the Osiris myth survives from the Old Kingdom, many of the recitations refer obliquely to the killing of Osiris by his brother Seth, the search for his body by his mourning sisters, Isis and Nephthys, his resurrection through the magic of Isis and the subsequent conception of Horus, who grew up to avenge his father's murder.[24] These events became fundamental to Egyptian funerary beliefs, and later the mourning Isis and Nephthys were widely represented in funerary art.

Statues of the king[25]

Statues of the king played a significant role not only in his pyramid complex but also in *ka*-chapels, which were shrines dedicated to the king set up in local temple precincts.[26] Divine statues were also important, as is shown by the fact that the manufacture and ritual dedication of the statues of various deities were used to name individual years in the annals recorded on the Palermo Stone and related fragments.[27] These annals also list the making of a copper statue of King Khasekhemwy.[28] Since copper corrodes easily, the survival rate for objects made from this material is low. However, a life-size standing copper statue of Pepy I was found, together with a second copper image about a third of the size, buried in one of the deposits in the ancient temple of Hierakonpolis (fig. 59).[29]

The two statues are not solid metal but were made of copper sheets shaped and nailed to a wooden core. By the time the statues were buried, the wood had been removed, since the smaller statue was discovered inside the larger. The copper sheet that had once covered the statue base and carried the titles and name of Pepy I had been crumpled up and put on the statue's chest. The second statue, which is unnamed, may have stood on the same base as the large one, and may represent Pepy's son and successor, Merenra, or perhaps the *ka* of Pepy himself, but there are still many unanswered questions concerning this piece.[30] The statue of Pepy I shows the king standing in the traditional manner on the nine bows, and the inscription mentions 'the first occasion of the *sed*-festival', which may have been the reason for the dedication of the statues in the temple.

In contrast to this life-size metal statue of Pepy is a small seated calcite statue of the king (fig. 60).[31] Its provenance is unknown but it may have come from a *ka*-chapel of the king, and it too has an inscription mentioning 'the first occasion of the *sed*-festival'. The statue shows Pepy sitting,

Pyramid Texts and Osiris

The last two kings of the Fifth Dynasty, Djedkara and Wenis, did not erect sun temples. The reason is unknown,[21] but it could have been economic, since building and endowing a pyramid complex and a sun temple every reign but one in a period of about eighty years may well have strained royal resources. Wenis incorporated scenes depicting the seasons in the causeway of his pyramid complex,[22] perhaps to compensate for not building a sun temple, and it is possible that Djedkara did the same in his very damaged complex.

It was during the reign of Wenis that decoration was first introduced inside the pyramid itself, the interior limestone walls being covered with what we now call 'Pyramid Texts'.[23] These texts subsequently appear in the pyramids of all Sixth Dynasty kings and in those of the three queens of Pepy II. The texts consist of a collection of ritual recitations designed to ensure the king's safe passage into the afterlife. Most of them are older than the Fifth Dynasty and some had probably long played a part in royal burial ritual and funerary cult. Carving them inside the pyramid made their power available to the deceased for all eternity.

59 Two copper standing statues with inlaid eyes found dismantled in a secondary deposit in the temple of Hierakonpolis. An inscription from the base identifies the larger figure as King Pepy I. The smaller one, which possibly stood on the same base, is unidentified. H. of larger figure as reconstructed 177 cm. Sixth Dynasty. Cairo, Egyptian Museum.

60 *far right* Seated statuette of King Pepy I wearing the white crown and wrap-around *sed*-festival robe. Unlike the majority of stone statues, the stone is cut away between the legs of the figure and the front of the seat. Over time, breakages have occurred at weak points in the statue, such as the neck, the top of the white crown and the legs of the falcon perched on the back of the throne. Repairs have been made, some of which are ancient, showing that the statue was valued enough in antiquity to merit repair. Calcite, H. 26.5 cm. Sixth Dynasty. New York, Brooklyn Museum of Art.

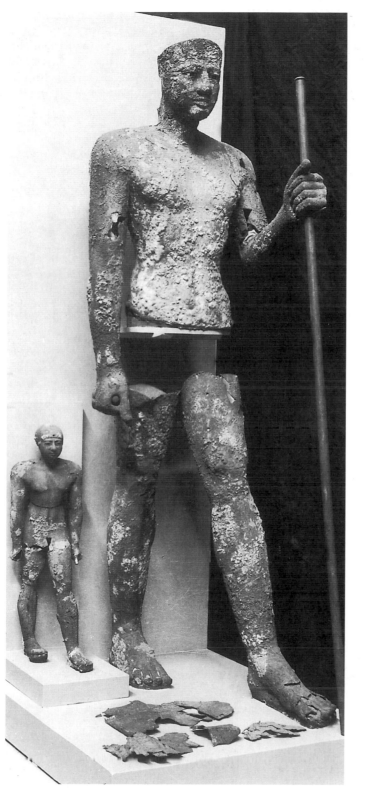

facing forward, on a seat with a tall back. In profile it is exactly the shape of the hieroglyph representing a throne that writes the name of Isis. The king wears the white crown of Upper Egypt and the *sed*-festival robe, and carries the royal crook in his left hand and a flail in his right. His arms are crossed at the wrist, and the crook and flail are held obliquely so that they cross on his chest. Behind the king, perched upon the back of the seat, is an image of a falcon facing to the king's left, oriented at ninety degrees to the king's figure. The reason is clear when the statue is viewed from behind (fig. 61). The flat surface of the rectangular throne back is carved into a *serekh* containing the king's Horus name, Meritawy. Here the three-dimensional falcon perches to produce the *serekh* surmounted by the Horus falcon, signifying that Horus, in his manifestation as Meritawy, is in the palace. Since the statue would have been placed in a shrine, the back would have been invisible to the priests performing the cult rituals. This would not have lessened the potency of the image.

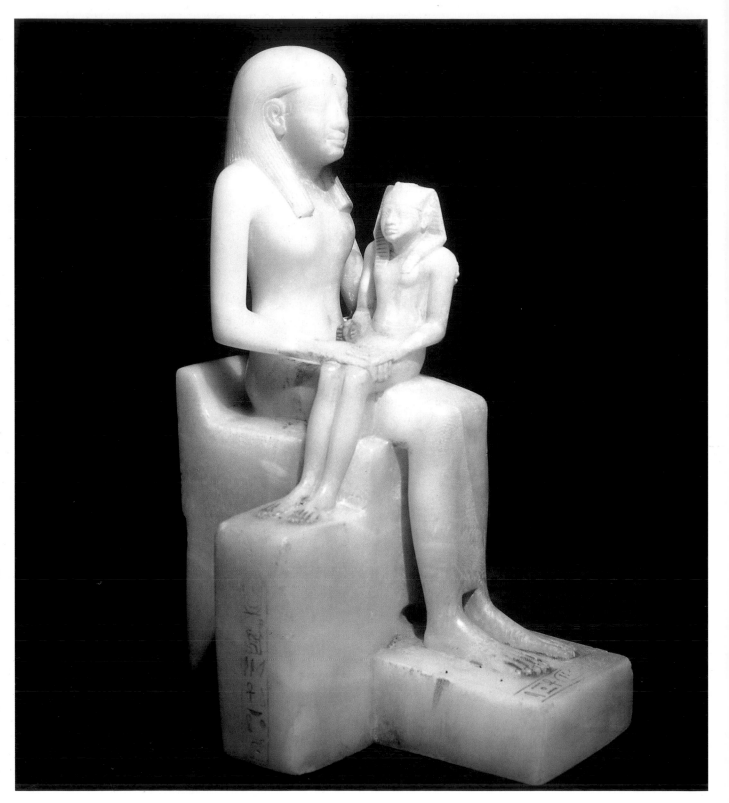

61 Drawing of the back of King Pepy I's throne (fig. 60) carved into the form of his Horus name enclosed in a *serekh* surmounted by the Horus falcon. Sixth Dynasty. New York, Brooklyn Museum of Art.

62 Seated statue of Queen Ankhnesmerira with her son King Pepy II seated on her lap. Like the calcite statue of King Pepy I (fig. 60), the stone is cut away between the legs of Ankhnesmerira and the front of her seat, and also between her arms and body, giving a sense of lightness to the sculpture. Provenance unknown. H. 39.2 cm. Sixth Dynasty. New York, Brooklyn Museum of Art.

By chance another small calcite statue of a Sixth Dynasty king survives (fig. 62).[32] It shows Queen Ankhnesmerira, the mother of Pepy II, holding the king on her lap. The queen is seated on a block throne with a low back. As a symbol of her position as queen she wears a vulture headdress: the cap is formed by the bird's body, and the wings extend down the sides of her wig. The tail and legs of the bird are carved on the back of the wig. The head of the vulture, or possibly the royal cobra, was inset on the forehead in a different material, but was subsequently lost. Only the hole for its attachment remains.

The vulture headdress was originally the attribute of the vulture goddess, Nekhbet, when she was shown in human, not bird, form. The headdress was transferred to the human form of her partner, the cobra goddess Wadjit, except that a rearing cobra (*uraeus*) was substituted for the vulture head. The headdress is first firmly attested for queens in the Fifth Dynasty,[33] and was surely meant to associate them with the goddesses Nekhbet and Wadjit. It suggests that just as the king had a divine aspect, so did the queen. The vulture headdress became one of the most important items of queenly insignia, and continued to be worn into the Ptolemaic period. Its use also spread to goddesses in general, strengthening the item's divine reference.

The figure of Pepy II is shown on a much smaller scale than that of his mother, wearing a kilt and the royal insignia of the *nemes*-headdress with a *uraeus*. Like Ankhnesmerira, the king's figure exhibits frontality, as is appropriate for a formal statue, and it is set at right angles to the figure of his mother. The body of the king is supported by his mother, who places her left arm behind his back, while her right hand grasps his knees. The stone below the king's feet is left as a rectangular supporting block attached to the right side of the throne. An identifying inscription runs down the front of this block, with another in front of the feet of the queen.

Since the king is normally represented as the largest figure in a group, the small scale of Pepy in comparison with his mother must be significant. Pepy II is thought to have come to the throne as a child, and it seems that the statue may refer to this circumstance. It is possible that Ankhnesmerira ruled as regent during Pepy's childhood and that the image refers to this time of regency. The composition recurs in later periods with other subjects in order to represent filial relationships. These include the king seated on the lap of a goddess, showing her as his divine mother. The best-known examples, however, are the images, mostly dating to the first millennium BC, that depict Isis holding her son Horus on her lap.

Non-royal tombs

Decoration of the tomb chapel

During the Fifth and Sixth Dynasties most of the upper elite continued to be buried in *mastabas*,[34] or less often in rock-cut tombs,[35] situated at Saqqara, Giza and Abusir near the pyramid of the king they had served as an official or to whose funerary cult they had been attached. Some officials, increasing in number during the Sixth Dynasty, were buried in provincial cemeteries.[36] As was traditional, the burial chamber lay at the bottom of a shaft cut into the ground, over which the tomb chapel was built to house the funerary cult. The focal point of the chapel was, as always, the offering room with one or more false doors (fig. 63), but large tombs belonging to high-ranking owners might contain many rooms that occupied the whole of the interior of the once-solid *mastaba*.[37] These rooms were decorated with a variety of different scenes normally executed in painted raised relief. Any decoration on exterior walls that stood in the bright sunlight was cut in sunk relief.

The central figure in the decoration was the tomb owner, usually male. We have already seen that size encodes importance in Egytian art, so the largest figure in any scene will normally be the tomb owner. Other family members – wives, parents, offspring – might be included, frequently drawn on a smaller scale than the owner. Wives were normally buried in their husbands' tombs and their funerary cult carried out in the tomb chapel. Some chapels housed the funerary cult of other family members also.

Despite the great expansion of the tomb chapel and its decoration, the basic function of the wall scenes differed little from the niche stelae of the Second Dynasty. The hieroglyphic inscriptions recorded the deceased's titles and names, thereby establishing identity, status and existence in the afterlife. Longer texts often comprised a more or less stereotypic 'biography' of the deceased.[38] The false door linking the worlds of the dead and the living marked the place for presenting offerings. The false door panel displayed the traditional image of the deceased before a table of offerings that ensured provisions for eternity (fig. 63). This image was so potent that it was often repeated elsewhere in the chapel. In addition processions of offering-bearers and personified estates bringing supplies into the chapel continued the theme of provisioning the tomb.

This theme was taken even further in the so-called scenes of everyday life that had appeared in the Fourth Dynasty. In the large Fifth and Sixth Dynasty chapels they expanded to decorate the greatly increased wall surfaces. The principal function of these scenes was to show the pro-

63 Drawing of the west wall of the tomb chapel of Werirenptah, a priest in the sun temple of Neferirkara, from Saqqara, showing the southern false door for Werirenptah and the northern one for his wife, Khentkaues. Only Werirenptah's figure appears on his false door stela and jambs, whereas both husband and wife appear on the northern false door, with Khentkaues yielding the dominant compositional placement on the stela to her husband. The figures on the jambs are oriented to face towards the 'door' through which the *ka* passes. The decoration on the rest of the wall is oriented towards the main, southern false door, so that the figures of the couple to its left face right, and those to the right face left. Below, on the left, are registers of offerings, offering-bearers facing right to approach the false door, and butchers slaughtering cattle whose heads are placed to the right, all of which are concerned with provisioning the deceased. On the right, between the two false doors, the three registers of piled offerings are replaced by three registers showing family members kneeling before tables of food, entertained by musicians and dancers. The bottom two registers show offering-bearers and butchers as on the other side, but with reverse orientation. Across the top of the whole wall, binding the four vertical sections together, run three lines of horizontal text containing an offering formula for the benefit of Werirenptah. It terminates on the left with a seated figure of Werirenptah himself, the height of all three lines, that acts as the hieroglyphic determinative to his name that ends the last line. H. 244 cm. Fifth Dynasty. London, British Museum.

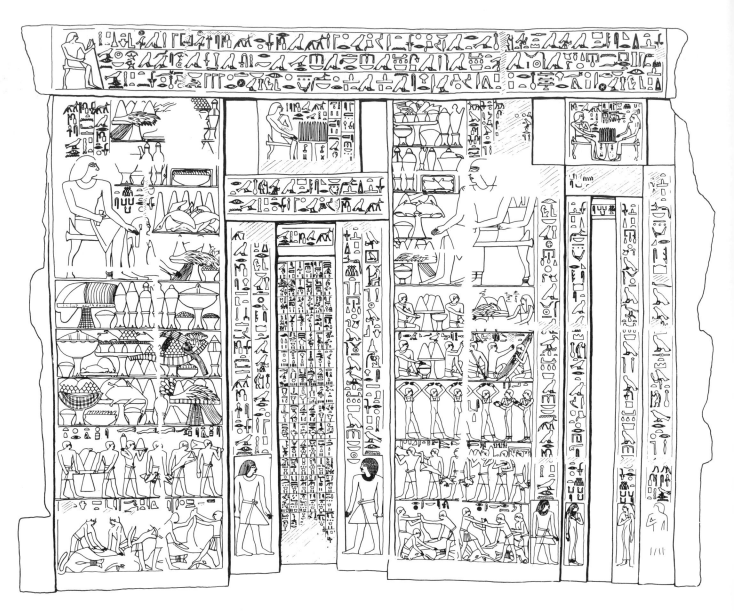

duction of supplies needed by the deceased for all eternity. Extensive depictions of the agricultural year, beginning with ploughing and sowing and ending with the harvest ensured the plentiful provision of grain (fig. 13), and scenes of baking and brewing turned the grain into bread and beer, staples of the Egyptian diet. Other food and drink were provided by scenes of wine making, animal husbandry (fig. 64), netting birds and fish in the marshes, and preparing and cooking food. However, it was not only food that was needed by the deceased. Depictions of the flax harvest provided linen for clothes and other uses, and scenes showing metal-workers, carpenters, boat builders, jewellers, leather-workers and sculptors made their products available in the next world. The tomb owner does not take part in these activities any more than he would in real life. However, to maintain his centrality in the decoration and to make plain that the end results are for his benefit, the scenes are normally laid out in three or four registers at one end of which a large static figure of the tomb owner is placed facing towards the activities as though overseeing them (fig. 13), and captions to such scenes tell us that the tomb owner is 'viewing' them.

64 Detail from scenes of animal husbandry in the tomb chapel of the high official Ti at Saqqara, expertly carved in high-quality low raised relief. Above, a virtually nude male peasant under the supervision of a man in a kilt helps a cow give birth, while to the left a man bends over to hobble a calf. Below, three men in a papyrus boat oversee a herd of cattle crossing a stretch of water in which a crocodile lurks. The gesture of the extended forefinger was intended to ward off any dangers, such as the crocodile, that threatened the herd. The horns of the cattle overlap to form an abstract, two-dimensional pattern against the flat surface, an effect often used by Old Kingdom artists. Unlike the static representations of the elite, the low-status figures of the peasants are shown in a variety of poses suited to the activities in which they engage. Fifth Dynasty.

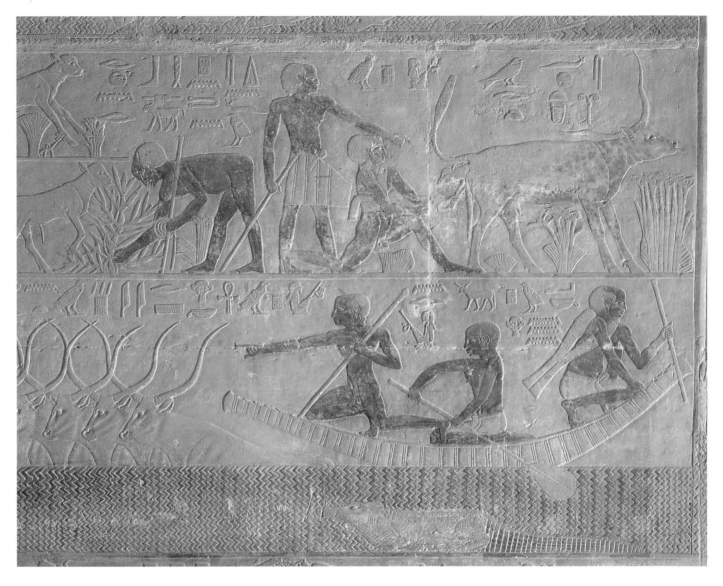

There are other scenes in which the owner takes an active part: fishing and fowling in the marshes and hunting in the desert. These were all activities that elite Egyptians enjoyed in life and that they probably wished to continue in the afterlife. They also provided supplies of fish, birds and game. But it is possible that there was another layer of meaning to them. These scene types also appear in the context of the royal pyramid complex where they relate to the king's role in overcoming chaos represented by the animals of the marshes and deserts, since their habitat lacks the order of the cultivated land where people actually lived. In the context of the tomb chapel where the deceased needs to overcome death and pass into the next life, the forces of chaos can be equated with death. So these scenes show the tomb owner triumphant over death and their depiction would thus help him in his passage to the afterlife.

Other scenes of a different type also relate to this transition. They depict the correct funerary rites that help to ensure the survival of the deceased after death. These include the dragging of the coffin and statues of the deceased to the tomb, and funerary priests performing the appropriate rituals.

Coffins

The coffin, along with all the funerary equipment, was placed in the burial chamber. This room was undecorated

throughout much of the Old Kingdom, but during the Sixth Dynasty decoration spread into it (fig. 65). The subjects depicted most commonly related to the provisioning of the deceased: offerings, offering lists, offering-bringers, butchers, granaries, and items such as linen, jewellery, vessels, furniture, tools, weapons, games and a variety of ritual objects.[39] Exceptionally scenes of 'everyday life' might be transferred into the burial chamber.[40]

Wooden coffins had been in use since at least the Early Dynastic Period. In addition to their practical function of protecting the body from physical harm, they acted as a house for the deceased where the *ka* could dwell for eternity. Some early coffins dating to the Second or Third Dynasties were made in a form that emphasised their function as a house. The chest was rectangular and the lid vaulted. One or more sides included niches in imitation of the palace façade found on early mudbrick buildings.[41] Rectangular coffins derived from this type remained in use into the Sixth Dynasty, but early in that dynasty a second

type of coffin was introduced.[42] It was also rectangular but with smooth sides and a flat lid. A line of inscription ran down the centre of the lid and around the upper part of the sides. The body was placed on its left side and oriented so that the head was to the north and the face to the east. On the exterior of the coffin in front of the face was painted a pair of stylised *wedjat*-eyes, and on the inside a false door linking the world of the dead to this world and allowing the deceased to look out from one world to the other, in the direction of the rising sun (fig. 15).

Tomb statues

An elite tomb of the Fifth and Sixth Dynasties would not have been complete without one or more statues representing the deceased and often other members of his family as well. In rock-cut tomb chapels they were carved from the walls of the chapel and stood in full view of those who entered to perform the funerary cult. In free-standing *mastabas*, however, during the Fifth Dynasty and the first

65 East wall of the decorated burial chamber of the official Mehi at Saqqara, showing four registers of heaped offerings of food and drink, an elaborately decorated false door and an extensive formal offering list. Along the length of the wall at the top runs a single line of hieroglyphs containing an offering formula for the benefit of Mehi. The composition of the offerings breaks down into sixteen groups, four in each of the four registers. Both horizontally and vertically the groups alternate between piles of food with an underlying horizontal structure and rows of five jars with a strongly marked verticality. Since similarly formed groups abut only at their corners, a strong diagonal element is introduced into the composition. Painted limestone. End of Sixth Dynasty.

66 Statue of Nenkheftka from the *serdab* of his tomb chapel at Dishasha. Nenkheftka stands with both arms held at his sides and his left leg striding forwards in the typical pose of a male stone standing statue. His only garment is a knee-length white kilt that leaves the rest of the body exposed. His skin is painted reddish brown, the conventional colour for male figures, against which the black hair of his short, curled wig stands out clearly. The figure is well-built with broad shoulders and chest, and muscled limbs. Painted limestone, H. 134 cm. Fifth Dynasty. London, British Museum.

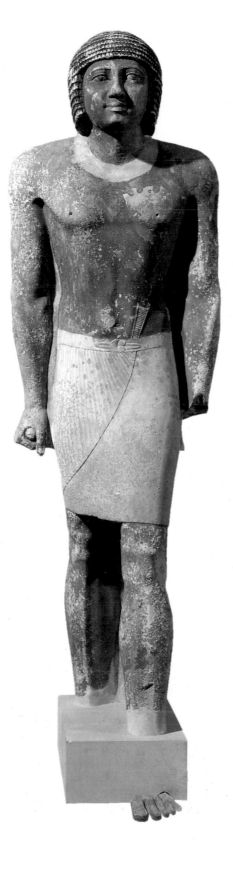

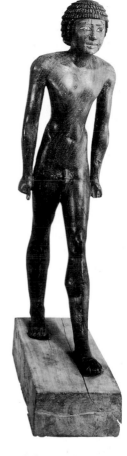

67 Standing wooden statue of the official Merirahashetef, found in the fill of the burial shaft of his tomb at Sidmant with two other standing male statues, a standing female statue and three wooden models showing the preparation of beer, roasting a bird on a spit, and grinding grain and baking (fig. 73). Although the statues are uninscribed, the context almost certainly identifies the male ones as the tomb owner himself. These latter all exhibit the proportions typical of the later Sixth Dynasty, with slender shoulders and chest, a high narrow waist and little emphasis on musculature (compare fig. 66). It is unusual for figures of elite males to be shown nude, except during the later Fifth and Sixth Dynasties, when a number of such statues occur. Since nudity was associated with children, these images may have been intended to refer to the rebirth of the owner in the next life. H. 51 cm. Sixth Dynasty. London, British Museum.

part of the Sixth, they continued to be placed in the *serdab*, shut off from the tomb chapel except for a small connecting slit.[43] The *serdab* was often behind the false door and the statues were placed so that they faced towards the false door beyond which the offering ritual was performed. Later in the Sixth Dynasty, as tomb chapels diminished in size and became less common, the *serdab* was gradually abandoned and the statues were transferred to the burial shaft,[44] or to the burial chamber.[45] Thus most statues were made not to be seen and admired by the living but to provide a body that the *ka* of the deceased could occupy in order to watch the ritual carried out in the chapel. Individuals could include more than one statue of themselves, and some had large numbers.

Although large, even life-sized, non-royal statues are known,[46] most are small, many being less than 50 cm in height. They are usually made of limestone or wood which was then plastered and brightly painted, but hard stone was also used. In rock-cut tombs engaged statues were often cut in the walls of the tomb chapel itself.[47] The most common poses were standing (figs 66–7) or seated for both men and

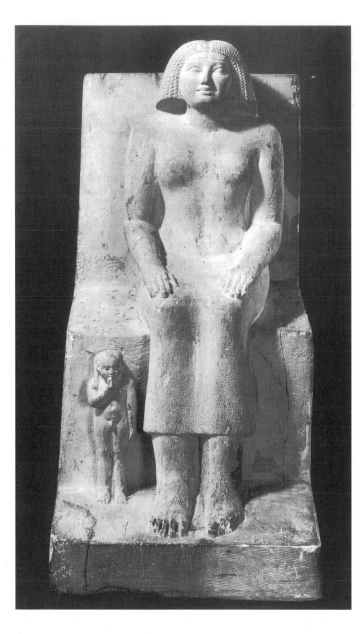

68 Limestone seated statue of Khent, wife of the official Nisutnefer, with a small standing figure of her son Rudju. Khent sits on a high-backed seat, facing straight ahead, with both her hands palm down on her thighs, in contrast to the male pose where one hand is usually clenched on the thigh (fig. 70). She wears the traditional sheath dress, and her natural hair can be seen on her forehead coming out from below her wig. Rudju is represented by the traditional image of a child, nude, with a child's plaited sidelock falling to the right side of the shaven head and with the right forefinger held to the mouth. The tomb chapel of Nisutnefer at Giza had two *serdabs*, one behind the southern false door and one behind the northern one. In the first was a statue of Nisutnefer and in the second, behind the false door traditionally associated with the wife, was the statue of Khent. H. 53 cm. Fifth Dynasty. Vienna, Kunsthistorisches Museum.

women (fig. 68) and, for men, seated cross-legged on the ground in the guise of a scribe. The scribe statue displayed an official's ability to read and write, which underlay his appointment to government office. Since women could not serve in the bureaucracy, this type of statue was irrelevant to them.

In addition to single figures, statues could depict groups, most commonly husband and wife with or without children. The two figures of the couple are often represented on the same scale, standing or seated (fig. 69). Sometimes the man is shown seated and the woman standing (fig. 70). Since their heads are on the same level the woman is in fact depicted on a smaller scale than her husband. Further, sitting was a more prestigious pose than standing in ancient Egypt, so that in these groups the man is shown to be the more important figure. Other groups show the wife on a much smaller scale, kneeling at the feet of her husband or standing by his lower leg, no higher than his knee. There are no statues where the wife is the large figure and her husband is shown in miniature.

Small figures of children are often included on statues of their parents (figs 68, 70–1). To indicate their status as children, they are shown on a smaller scale than adult figures, nude, either with all their hair close cropped or with one lock of plaited hair on the right side of the head (the 'sidelock of youth'). They often hold the right forefinger to the mouth, a gesture deriving from the childish habit of sucking a finger.[48]

Some statue groups, usually referred to as pseudo-groups, show more than one image of the same person, most often male, but occasionally female. Sometimes, other family members are also included.[49]

Orientation of figures on tomb chapel walls

During the Fifth and Sixth Dynasties there were many variations in the size and plan of the tomb chapel, although there were certain basic rules that governed the layout of the decoration. The main false door belonging to the chapel owner was placed at the south end of the west wall of the offering chamber. It faced, therefore, in the same direction as the original niche in the east exterior face of the *mastaba*. A secondary false door was often placed at the north end of the west wall, deriving from the subsidiary Early Dynastic niche at the north end of the exterior east *mastaba* face. It was often given to the wife of the tomb owner. Other family members might also be buried in the tomb and be given their own false doors in the chapel.

The orientation of figures on the false door was very carefully planned (fig. 63). The false door panel set above

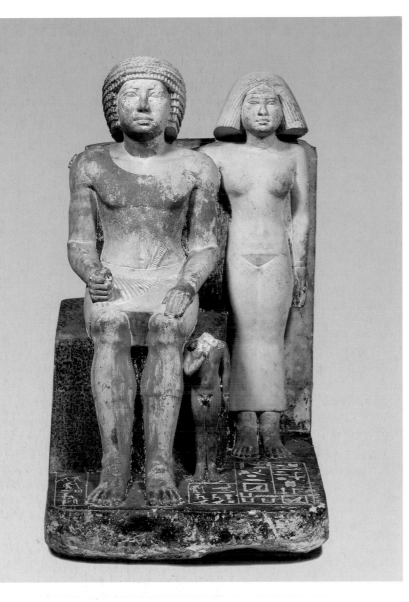

69 Painted limestone pair statue of the official Katep and his wife Hetepheres. The couple are depicted on the same scale and seated side by side. In typical Old Kingdom fashion Hetepheres places her arm around her husband, but he does not reciprocate. The two figures show clearly the differences in male and female skin colour and proportions. Katep has reddish-brown skin, broad shoulders and low waist, whereas Hetepheres has light yellowish skin, narrower shoulders and a higher waist. Probably from Giza. H. 47.5 cm. Fifth to Sixth Dynasty. London, British Museum.

70 Painted limestone statue of the official Shepsi with his wife Nikauhathor, a priestess of Neith, and their son Shepsipudjednedjes. Shepsi sits on a block seat painted to resemble red granite, a more prestigious material than limestone. His wife stands beside him with her arm round his shoulders. Although their heads are on approximately the same level, the difference in pose means that Shepsi's figure is on a larger scale than his wife's. In addition, sitting was superior to standing, leaving no doubt that Shepsi occupies the primary place in the composition. The small figure of the son is shown in the typical image of a child (see fig. 68). From the tomb chapel of Shepsi at Saqqara. H. 66 cm. Fifth Dynasty. Cairo, Egyptian Museum.

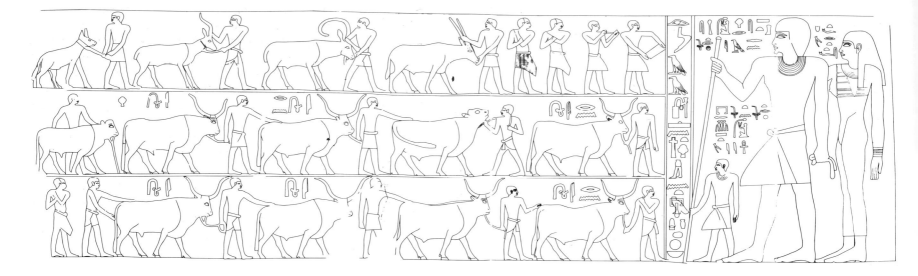

71 Drawing of a scene showing the official Iasen, his wife Merytites and his son Meryankh viewing the presentation of desert animals and cattle, arranged in three registers. The couple face to the left because the scene occurs on the east wall of Iasen's tomb chapel, and their figures are oriented towards the entrance, which lies on the chapel's north side. Although Iasen and his wife are drawn at the same scale, Iasen's extra height being only what might occur in life, Iasen is given precedence over his wife by being placed nearer the action. The figure of Meryankh is dwarfed by both his parents, and fills the space between Iasen's staff and legs, a common compositional placement for children. His small size signifies his filial relationship to the main figures, but the fact that he has reached adulthood and himself holds government office is indicated by his adult dress and list of titles. Giza. Fifth to Sixth Dynasty.

the lintel preserved the traditional scene of the deceased, male or female, seated on the left side facing right before a table of offerings. On the jambs of the door figures face inwards, so that on the left jamb figures are right-facing, and on the right jamb left-facing. When husband and wife share a false door the husband is almost always given the more prestigious orientation to the right on the panel, while the wife is placed on the opposite side of the table of offerings, at the right edge of the scene facing left.[50] This gender distinction, which privileges the husband, presumably reflected social perceptions that the man, by holding a high government office, had a public status women could not match, for it was through his office that he obtained the right and resources to build a tomb chapel. The male tomb owner is always identified by his official titles, while the wife's name and titles (if she has any) are usually introduced by the phrase 'his wife'.

Elsewhere in the tomb, away from the false door, other rules of orientation come into play. Figures of the deceased face out of the tomb, looking from the realm of the dead towards that of the living, whereas figures of the living, such as offering-bearers, face into the tomb, parallel to the orientation of the participants during the performance of the funerary cult. In addition, since figures in 'everyday life' scenes usually face the figure of the deceased, they too look into the tomb.

On some walls the figures of the deceased will be right-facing but on the opposite walls they must be reversed in order to face towards the tomb entrance. When the tomb owner's wife accompanies him she stands by his side, but, in order to prevent one figure obscuring the other, the two

figures are moved apart along the baseline of the register, so that the man is placed in front of his wife in order to give a clear view of both (fig. 71). The forward position in this grouping is the more important, partly because it is closer to the centre of the scene and the activity depicted there.

In view of the religious function of the tomb it is perhaps surprising to find no images of either deities or the king in the decoration of tomb chapels. In fact places where divine and royal images could appear were restricted in the Old Kingdom, and the non-royal context of a tomb chapel was inappropriate for their display. It was not until the end of the Middle Kingdom that deities first appeared on private monuments, and images of the king are not commonly found before the Eighteenth Dynasty.

Servant statuettes

In addition to statues of the tomb owner and his family, other statues showing servants engaged in different tasks were also sometimes placed in the *serdab* or later in the burial shaft or chamber (figs 72–3). This custom seems to have begun in the late Fourth Dynasty and become common in the Fifth and Sixth Dynasties. The majority of Fifth Dynasty servant statues are made of limestone, but in the Sixth Dynasty they were more often made of wood.[51] Both materials were plastered and brightly painted. The earlier statues usually represented only one servant but the later ones could depict groups of figures. The types of activities represented can all be paralleled in scenes on tomb chapel walls: various stages of bread and beer making, butchering, cooking birds, men and women bringing offerings. Indeed the function of the statues was exactly the

72 Painted limestone statue of a male brewer straining beer mash through a sieve. The statue catches the effort of the action as the brewer stoops over his work, his knees bent, pushing with his arms. In contrast to formal stone statues, the limbs are totally freed from the stone. The figure is not intended to represent a specific person, but rather the activity being performed. This statue was one of a group placed in the *mastaba* of an official called Djasha, who served in the royal funerary cult. Other activities represented include grinding grain, baking, butchering and cooking, and the group as a whole ensured the deceased a supply of food in the afterlife. Giza. H. 36 cm. Fifth Dynasty. Hildesheim, Pelizaeus-Museum.

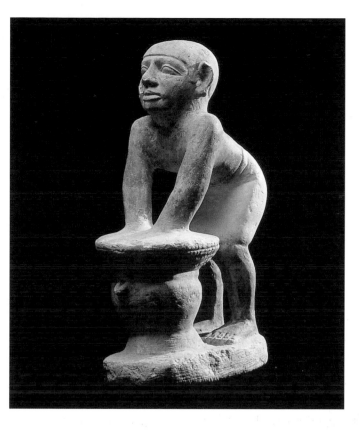

same as that of the tomb scenes, to provide supplies for the deceased in the next world.

There are a number of differences of treatment between these statues and the formal statues of the deceased. The latter occur mainly in two poses, seated and standing, and exhibit strong frontality. They are usually inscribed with the titles and names of the owner in order to give the image its identity. Servant statues occur in a wide range of poses suitable to whatever activity they are engaged in. Thus they kneel to grind grain, squat to bake bread or bend over to strain beer. The effort of their task is often apparent in the treatment of the body. Unlike most formal stone statues, stone servant statues are usually cut away between the body and their legs or their arms. Everything about the statues is designed to emphasise the activity shown; the servant is simply a generic figure and has no individual identity.

The human figure

One of the conventions of ancient Egyptian art was that formal figures of the elite should be shown in the ideal form desired for the next world without any signs of disease, deformity or old age. There was no need for artists to strive after exact likeness since identity was established by the inscription or, less often, context, rather than by the fea-

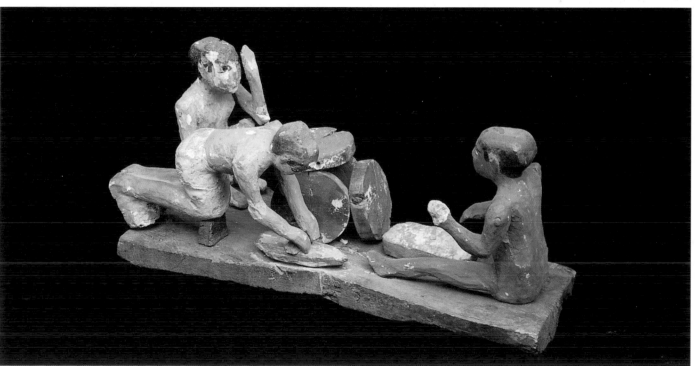

73 Painted wooden model with three figures grinding grain and baking. From the tomb of the official Merirahashetef at Sidmant. H. 16.5 cm. Sixth Dynasty. London, British Museum.

74 Drawings of figures on the east and west jambs of the door leading into the offering chamber of the *mastaba* of the official Idu at Giza. The figures are on the thicknesses of the jambs and look out of the offering chamber. On the east Idu is shown as a youthful adult wearing a leopard skin over a knee-length kilt. On the west he is shown in a mature image with a pendulous breast and a spreading waistline. The longer, mid-calf-length kilt and the cap of close-cut hair are typical of this older image. Sixth Dynasty.

tures. This does not mean that artists never achieved a likeness, but that it was not necessary to the functioning of the image.[52]

Two idealised images continued to exist for male figures, one youthful and one more mature (fig. 74), as we have already seen with the figures of Khabausokar (fig. 47). The most commonly depicted male costume was a white kilt that wrapped around the waist, leaving the upper part of the body bare. In the youthful image the kilt was normally knee length, whereas in mature figures it usually fell to mid-calf.[53] Elite men were rarely shown completely nude, in contrast to the common nudity of non-elite men, and nudity in adults may have indicated a lack of status. An exception is one type of standing statue found in the late Fifth and Sixth Dynasties that shows the tomb owner without clothes (figs 10, 67). Nudity cannot signify lack of status in this context. Perhaps these statues deliberately refer to the nude image of a child in order to symbolise the rebirth of the deceased into the next world.[54] However, these figures are not shown as children, since they are clearly circumcised whereas young boys are not.

In contrast to male figures, female figures are shown only as youthful and slender (fig. 75). They have no image corresponding to the mature male, since they could not hold government office. In addition a mature image might suggest that they were too old for child bearing, one of their most important functions in society. Indeed the female image is designed to display to the full the figure's sexuality and consequent potential fertility. Although elite female figures are not depicted nude, their costume is manipulated in both two and three dimensions in order to display the shape of the body underneath. Almost all women wear a dress that falls from below the breasts to just above the ankles, with straps over the shoulders that in three-dimensional renderings cover the breasts. By contrast, in two dimensions the breast is shown in profile on the front line of the body, while the strap runs over the expanse of the chest, leaving the breast uncovered. This image derives solely from artistic conventions, and it is unlikely that the breasts of elite women were normally uncovered in life. The dress itself, in both two and three dimensions, is depicted as clinging so tightly that the outline of the body, including the stomach, buttocks, thighs and pubic area, is absolutely clear. Such a dress must be an artistic fiction, probably intended to stress female fertility, since it could not exist in reality. Its close fit would make it impossible to move, let alone sit, kneel or walk, but in all these poses the dress is depicted as if it were a second skin.

In complete contrast to formal figures are the figures of the non-elite depicted in both two and three dimensions. Unlike the limited poses and movement of the elite, the generic figures of the non-elite show a tremendous range of variation in their postures as they perform the activities that are the reason for their depiction (figs 13, 64, 72). They bend and turn their bodies, often in violent movement. Sometimes they have a less than perfect body that would be unacceptable for a formal figure. Non-elite males working in the fields and marshes are often shown virtually nude with their genitals displayed, in contrast to the high-status kilted figure of the deceased who watches their work.

During the Fifth Dynasty artists developed a system of guide lines to aid in the drawing of the human figure (fig. 76).[55] The system included a vertical axial line that passed through the ear and divided the torso in half, and up to

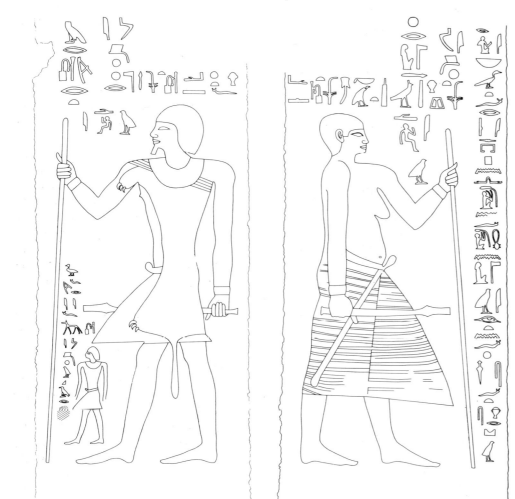

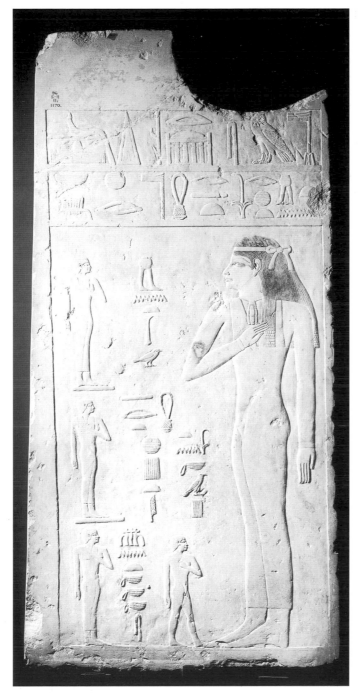

75 Painted limestone relief of Inet from the tomb chapel of her husband, the official Iry, showing the ideal female image, youthful and slender. The sheath dress is drawn so that it follows and reveals the contours of the body. H. 105 cm. Fifth Dynasty (?). London, British Museum.

seven horizontal lines at the levels of the top of the knees, the lower border of the buttocks, the elbow of the hanging arm, the armpits, the junction of the neck and shoulders, the hairline and the top of the head. Not all lines were present on all figures, and the hairline, where hair and forehead meet, was more commonly marked than the top of the head. The knee and elbow lines divided the figure between the soles of the feet and the hairline into thirds. The same distance was divided into halves by the line running through the lower border of the buttocks. The distance between the elbow line and the hairline was divided unevenly into two by the line marking the junction of the neck and shoulders, the distance between the elbow line and the junction of the neck and shoulders being twice that between the junction of the neck and shoulders and the hairline. During the Sixth Dynasty an eighth line was introduced halfway between the soles of the feet and the kneeline.

The guide lines formed part of the initial draft of a scene and were not meant to be seen in the completed version. Nevertheless, examples can still be found in unfinished scenes in private tombs.[56] One of their functions was to help line up rows of figures, so that the different parts of the body lay at the same levels, a manifestation of the Egyptian need for order. The use of guide lines did not prevent change occurring in the proportions of the human figure over time. During the Fifth and early Sixth Dynasties the proportions of male figures were fairly standard, with the width across the shoulders approximately a third of the hairline height of the figure, and the level of the small of the back lower than the elbow line. These proportions gave the figure wide shoulders and a long upper torso. By contrast female figures of the same period are shown with narrower shoulders and waist and with a higher small of the back, reflecting a distinction between male and female figures found in nature (fig. 75). The contrast between male and female is heightened by the musculature that is represented on male but not female limbs.

During the Sixth Dynasty the proportions of male figures change until in the second half of the dynasty a new type prevails.[57] The shoulders become narrower so that they are less than a third of the hairline height in width and the small of the back rises to roughly the level of the elbow line. The body is also narrower at this level than in earlier figures. As a result the upper torso becomes smaller in relation to the figure as a whole, more closely resembling the proportions of earlier female figures. This similarity is enhanced by the fact that late Sixth Dynasty male figures rarely display musculature. At the same time the proportions

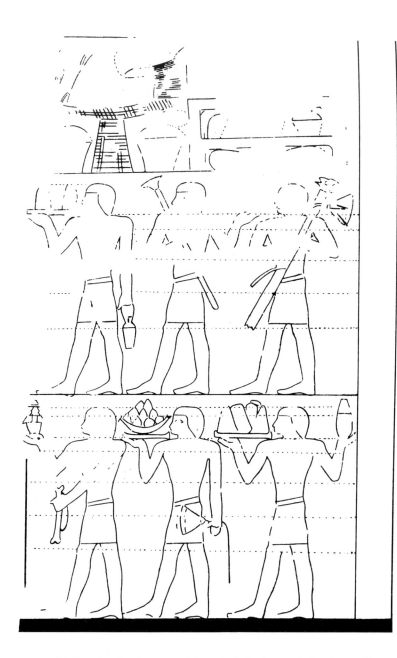

76 Drawing showing two registers of offering-bearers laid out on guide lines. The lines mark the levels of the knees, the lower borders of the buttocks, the elbows, the armpits, the junction of the neck and shoulders, the hairlines and the tops of the heads. Guide lines like these helped artists to proportion figures and to line them up evenly. From the tomb chapel of Akhethotep at Saqqara.

of the face change, with the eyes enlarging to occupy a greater area of the face than before. The changes in proportions occur in both two- and three-dimensional art (fig. 10). The spread of decorated chapels into the provinces carried with it this late Sixth Dynasty style.

Conclusion

Despite the diminished size of the king's pyramid, the architecture and decoration of royal monuments continued to be of the highest quality. At the same time, the tomb chapels of the upper elite expanded until they often consisted of a whole series of decorated rooms containing numerous scenes of 'everyday' life, offering-bringers, and the tomb owner seated before a table of offerings. Nevertheless, towards the end of the Sixth Dynasty changes occurred that have been linked to increasing economic problems that affected the central government and the power of the king. Pepy II was the last Old Kingdom king to build on a large scale, while in the later Sixth Dynasty the tomb chapels of the elite became smaller or disappeared altogether. Further, during the Sixth Dynasty increasing numbers of officials now chose to build their tombs in the provinces they governed rather than near the capital. In the next chapter we shall examine the consequences both of this spread of elite burials into the provinces and of the collapse of centralised royal authority.

Notes

1 Baines 1985a.
2 Posener-Kriéger 1976, 501–2, 544–5.
3 Porter and Moss 74, 326–35; Borchardt 1910; 1913.
4 Porter and Moss 1981, 417–22; Labrousse, Lauer and Leclant 1977.
5 Porter and Moss 1981, 425–31; Jéquier 1936; 1938; 1940.
6 Hawass 1995, 230–2.
7 E.g. Hayes 1953, fig. 67; Jéquier 1940, 27–9, pls 47–8; Lauer and Leclant 1969.
8 Borchardt 1913, pl. 18; 1907, figs 21, 23; Malek 1986, 102; Jéquier 1938, pls 30–3.
9 E.g. Borchardt 1913, pls 45, 47.
10 E.g. Borchardt 1913, pl. 32; 1907, fig. 50; Jéquier 1940, pls 19–28.
11 Hawass and Verner 1996, 181.
12 Baines 1985a.
13 Borchardt 1913, pls 57–63; 1907, figs 55–9; Jéquier 1938, pls 61–96.
14 Stadelmann 1984.
15 Porter and Moss 1974, 314–25; von Bissing 1923; Ricke et al. 1965; 1969.
16 Edwards 1993, 156.

77 Detail from a scene in the tomb chapel of the high official Ti at Saqqara (fig. 64), showing a cow giving birth to a calf.

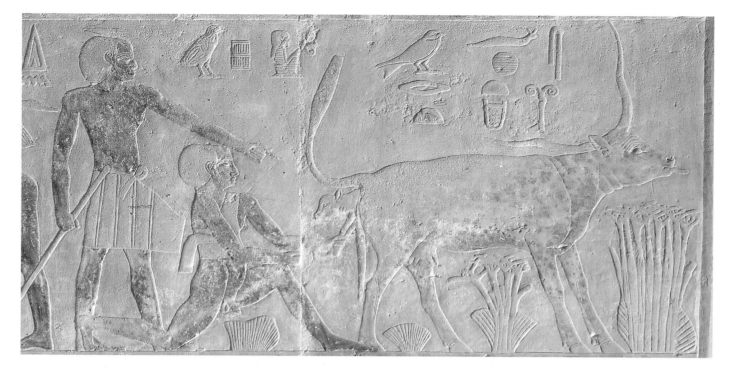

17 Edwards 1993, 157.
18 Porter and Moss 1974, 317–18.
19 Kaiser 1971.
20 Porter and Moss 1974, 319–24; Wenig 1966; Edel and Wenig 1974.
21 But see Helck 1991.
22 Porter and Moss 1981, 419.
23 Altenmüller 1984; D'Auria *et al.* 1988, 38–9.
24 Griffiths 1960; Griffiths 1980.
25 For Sixth Dynasty royal sculpture see Romano forthcoming.
26 Fischer 1958, 331; Kaplony 1980.
27 Helck 1982.
28 Sethe 1914, 233; Malek 1986, 55.
29 Quibell 1900, pls 44–5; Quibell and Green 1902, 27–8 no.68, 46–7, pls 50–6.
30 But see Romano forthcoming.
31 Gorelick *et al.* 1991–2; Baines 1990, 20.
32 Fazzini *et al.* 1989, no.15.
33 Troy 1986, 117.
34 E.g. Steindorff 1913; Épron and Daumas 1939; Wild 1953, 1966; Duell 1938; Moussa and Altenmüller 1977; James 1953; Verner 1977.
35 E.g. de Rachewiltz 1960; Simpson 1976, 21–9; Porter and Moss 1974, 208–14.
36 E.g. Petrie 1898; Kanawati and McFarlane 1993; Petrie and Brunton

1924; Fischer 1968; Saleh 1977; Blackman 1924, 1953a; Davies 1901b; 1902a, b; el-Khouli and Kanawati 1989, 1990; Kanawati 1993.
37 E.g. James 1953; Duell 1938.
38 Lichtheim 1988, 5–20.
39 E.g. Duell 1938, pls 199–208; James 1953, pls 34–40.
40 Junker 1940, pls 3–15.
41 Taylor 1989, 15.
42 Lapp 1983, 430–1; Taylor 1989, 15.
43 Brovarski 1984; D'Auria *et al.* 1988, 88–90.
44 Petrie and Brunton 1924, 2.
45 Smith 1946, 90–2, 94.
46 E.g. Saleh and Sourouzian 1987, nos 45–6.
47 E.g. de Rachewiltz 1960.
48 E.g. Saleh and Sourouzian 1987, no. 39.
49 Eaton-Krauss 1995.
50 Fischer 1989, 2.
51 Breasted 1948; Tooley 1995.
52 Spanel 1988, 1–37, especially p.13.
53 E.g. James 1953, pl. 7; Saleh and Sourouzian 1987, nos 45–6.
54 Behrens 1982, 292; Goelet 1993, 21–2.
55 Lepsius 1884; Robins 1994a, 64–9.
56 Robins 1994a, 64 n. 2.
57 Russmann 1995b.

Diversity in disunity

THE FIRST INTERMEDIATE PERIOD

The provinces

So far in our exploration of Old Kingdom art we have focused on the royal and elite funerary monuments in the area around the capital city of Memphis. There are good reasons for this, for Memphis was where the wealth of the king and his officials was concentrated during the Fourth and Fifth Dynasties. High provincial officials retained close connections with the capital and built their tombs in the cemeteries there. Provincial cemeteries rarely included high-status burials accompanied by decorated tomb chapels. During the Fifth Dynasty the provincial administration of Upper Egypt began to be decentralised and, as already mentioned, some provincial governors began to be buried in the district (or *nome*) they governed.[1] From the Sixth Dynasty, cemeteries containing the tombs of local governors and their staffs are found throughout Egypt from Aswan in the south to the Delta in the north. Officials who possessed the means, mostly the nomarchs themselves, had decorated tomb chapels cut into the local cliffs over the shafts leading to their burial chambers.[2] Lesser officials would be buried near the nomarch they served, but for the most part they could not afford decorated chapels.

It was one thing for provincial officials to decide to build their tombs in local cemeteries, but another to find artists to do the work. Since most decorated tombs up to this time had been built at the capital, there was no provincial tradition of tomb decoration, and probably little suitable artistic experience to draw upon. Provincial officials, however, were in close contact with the capital, and naturally they looked there to find artists to carry out their projects. Presumably the best artists in the royal workshops could not leave the capital, so it is doubtful if the artists who went to work at provincial centres were of the top rank, although many were plainly competent. They would have been trained in the full repertory of tomb decoration and the techniques of stone-working and painting, and eventually they brought with them the style of the later Sixth Dynasty, with its large eyes and slender, unmuscled male figures.

The central government virtually collapsed during the generation after the reign of Pepy II. No one cause was responsible for this. Rather, a number of economic and political factors came together during the Sixth Dynasty that in combination led to the disintegration of the state.[3] The decline in the economic power of the central government can be seen in the fact that Pepy II's pyramid complex was the last monumental building project undertaken by a king for over a century. In addition, from the middle of the Sixth Dynasty most private tombs in the Memphite cemeteries became smaller and were undecorated except for the burial chamber. To cap it all Pepy II had a very long reign, and at his death problems arose over the succession, perhaps because he had outlived most of his sons. One son ruled for just over a year, and the dynasty probably ended with the short reign of a female king. A series of ephemeral rulers followed who are traditionally assigned to the Seventh and Eighth Dynasties, at which time Egypt was divided into local regions, each controlled by its governor.

The provincial rulers of Upper Egypt fought each other in order to enlarge their territories and influence. Each local governor worked to underpin and legitimise his *de facto* authority by displaying his ability to build monuments, not least a decorated tomb for himself. But now the provinces were cut off from the artistic centre at Memphis,

78 Fragment of painted limestone relief showing parts of the standing figures of King Nebhepetra Montuhotep and Kemsit. Kemsit is depicted on a smaller scale than the king, whom she embraces with her forward arm. Her other hand is held by the king. The deep-cut sunk relief is roundly modelled within the outlines. Both faces have the large eyes that descend from the later Sixth Dynasty style. The noses have marked wings and the lips are prominent and thick. Despite the width of the king's shoulders, his figure exhibits little musculature. The details of jewellery and clothing are elaborately carved into the stone. From the tomb chapel of Kemsit in the funerary temple of King Nebhepetra Montuhotep at Deir el-Bahri, Thebes. H. 68 cm. First Intermediate Period. London, British Museum.

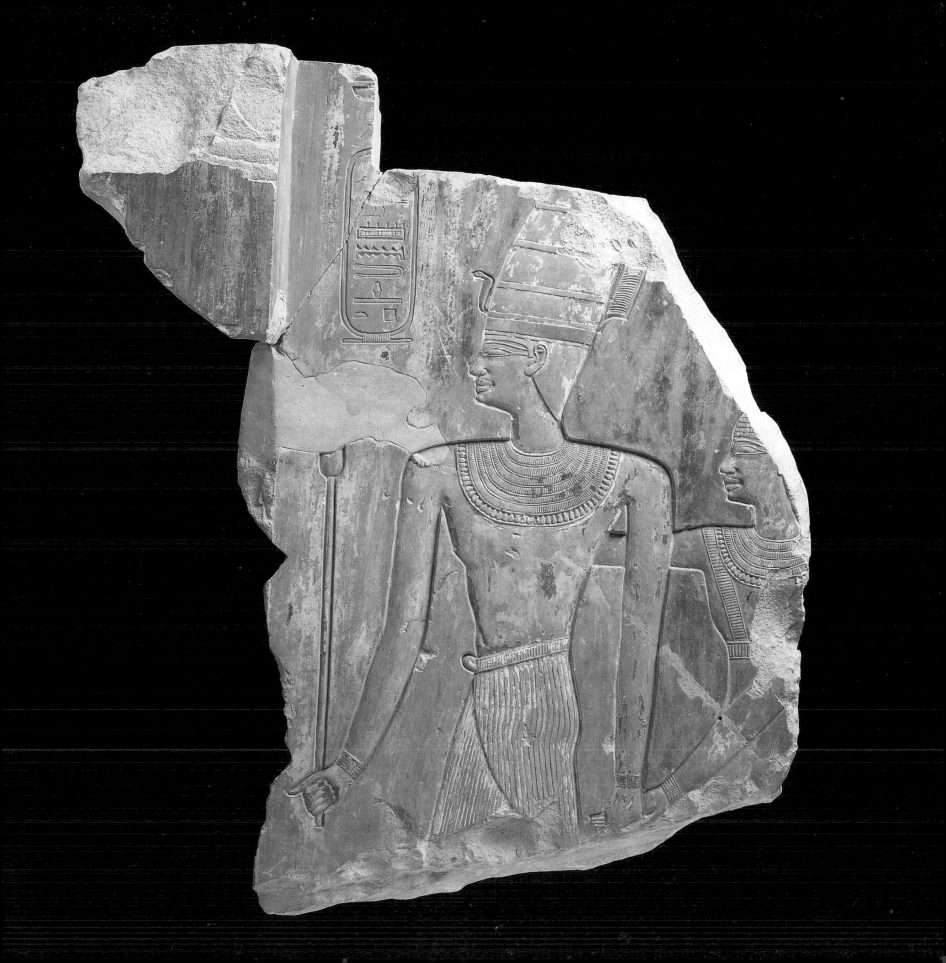

79 Stela of Inhurnakht and his wife Hu, showing the couple standing facing right before offerings. Five horizontal lines of text run across the top of the stela, and the scene is framed by a coloured border typical of stelae from Naga ed-Der. Also typical are the arrangement of the offerings to fill the tall, narrow strip between the framing border and the man's staff, and the very small figures of the offering-bearer and the servant who holds out a drink to Inhurnakht. Probably Naga ed-Der. Limestone, H. approx. 77 cm. First Intermediate Period. London, British Museum.

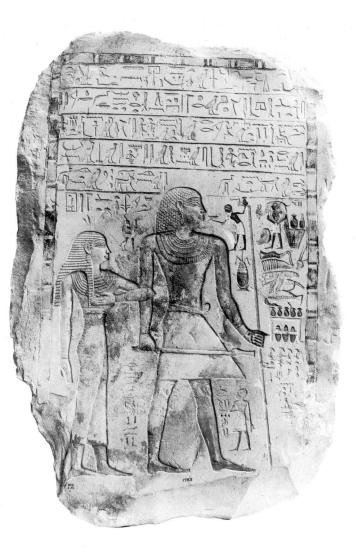

and skilled artists trained at the capital were in short supply. Provincial rulers, therefore, had to rely on whatever local artists were available.

The various regions of Egypt gradually coalesced around two centres, Herakleopolis in the north and Thebes in the south. The rulers in each area claimed the titles of king, those at Herakleopolis traditionally composing the Ninth and Tenth Dynasties, and those in the south the pre-unification Theban Eleventh Dynasty. We know little about the Herakleopolitan kings, for they are rarely mentioned on the monuments of their subordinates. Their capital at Herakleopolis lay about 100 km upstream from Memphis, and several important *nomes* ruled by powerful nomarchs, including those of Akhmim and Asyut, lay in their territory.

The Ninth Dynasty may have been recognised in the south until challenged by the kings of the Eleventh Dynasty. These rulers had originally been the nomarchs of the Theban area, but Inyotef, son of the nomarch Montuhotep, took the titles of king with the Horus name Sehertawy, 'he who causes the Two Lands to be content', which makes clear his claim to rule all Egypt. He was followed by two more kings named Inyotef, who fought to extend their control over the whole of Upper Egypt, subordinating the nomarchs of the region to their rule. Their successor was another Montuhotep, whose throne name was Nebhepetra. Nebhepetra Montuhotep had a long reign of over fifty years, during which, some time before year 40, he finally defeated the Herakleopolitans and reunited the country.

Thebes had not been an important city in the Old Kingdom. It was situated in the fourth Upper Egyptian *nome*, the capital of which lay at Armant. Armant was one of the most important cult centres of the falcon god Montu, whose name appears in the name Montuhotep. Both this god and Amun-Ra, the local god at Thebes, became important as a result of the triumph of the Eleventh Dynasty. Amun-Ra eventually eclipsed Montu and became one of the most powerful national deities of all Egypt.

During the hundred years or so of division when the south was severed from the artistic traditions of the north, local officials continued to build and decorate tombs, albeit often modest ones, using local artists. Distinct styles developed at various Upper Egyptian centres, but all related to a more general style that tended to exhibit the lack of musculature, high small of the back and large eye derived from the later Sixth Dynasty style. In relief work raised relief became very high and sunk relief very deep, often with layering of different levels of relief and with modelling of the surface within outlines. Intricate surface details and patterns were often included in the carving.

A version of this style can be seen clearly in the stelae set up at Naga ed-Der, a cemetery of the eighth Upper Egyptian *nome*.[4] The tombs possessed only small, undecorated rock-cut chapels in which a rectangular stone stela marked the offering place. These stelae, which were brightly painted, are remarkably similar in their decoration and style. Horizontal lines of text run across the top containing an offering formula for the benefit of the deceased, who was thus named and his or her identity perpetuated in the next world. Below the text was depicted an image of the deceased or a deceased couple, in most cases facing right, standing before offerings. Male figures hold a staff in their forward hand and stride with the far leg forward.

Female figures stand more passively with their feet almost together. Both figures are derived from Old Kingdom tomb images such as those commonly appearing on the jambs of false doors, but they break the ancient tradition of showing the deceased seated before offerings.

The quality of workmanship on these stelae varies greatly. Some examples exhibit bad draughtsmanship and crude execution, while others reach a high standard. Some stelae preserve guide lines lightly incised into the stone, showing that the guide line system had been adopted and preserved in Upper Egypt. A good example of one of the better-quality stelae is that of Inhurnakht and his wife (fig. 79). Although the stela lacks provenance there can be little doubt that it comes from Naga ed-Der. The piece is cut in deep sunk relief with overlapping levels. For instance, the front tress of the woman's wig is cut at a higher level than her collar, while her hand, at a higher level than either wig or collar, overlaps both items. The details of the couple's wigs, collars and bracelets are meticulously incised into the stone. All the figures have large eyes that fill the upper part of the face, and the male figures lack any indication of musculature.

The ancient town of Dendera in the sixth Upper Egyptian *nome*, some 56 km north of Thebes, was a major cult centre of the goddess Hathor.[5] *Ka*-chapels of Sixth Dynasty kings were built in the precincts of the temple, and Pepy I called himself 'son of Hathor, mistress of Dendera'. This important site continued to flourish in the First Intermediate Period, eventually coming under the control of Thebes. The high officials of the region built tombs with relief-cut decoration showing the deceased and his family, and the bringing of offerings to supply the needs of the dead in the afterlife.[6] A block from the tomb of Mereriqer, a high-ranking official in the cult of Hathor, shows a bull being led by one man and driven by a second, who, as the rope in his hand shows, was leading another animal (fig. 80).[7] Originally the block formed part of a scene showing the bulls and maybe other livestock being presented to the tomb owner, a frequent motif in Old Kingdom tombs. The style has features in common with the Naga ed-Der stelae. The raised relief is very high and modelled, with the details of the men's hair and collars and the bull's tail incised into the stone. The men have slender, unmuscled figures and enormous eyes that fill the upper part of the face.

The pre-unification Theban style

When the Theban nomarchs claimed the kingship of Egypt, even though they could enforce their rule only in a limited area in the south at first, they needed to behave like kings, and this meant building and decorating monuments. Supporting such projects was one way of displaying and main-

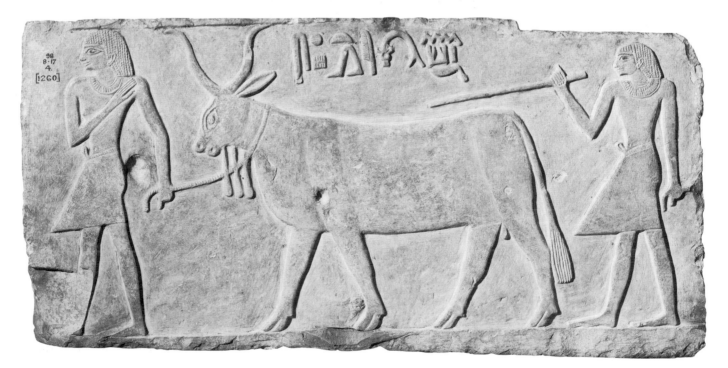

80 Limestone relief showing a man leading an ox which is driven from behind by a second man. From the tomb of the official Mereriqer at Dendera. H. 34.3 cm. First Intermediate Period. London, British Museum.

81 *right* Seated limestone statue of the steward Mery from Thebes. The features of the face are typical of the pre-unification Theban style, especially the full lips and the flat eyebrows above large eyes which dip to a marked inner canthus and have a long cosmetic line that widens at its outer end. H. 57 cm. First Intermediate Period. London, British Museum.

82 Limestone stela of the official Maaty, showing the deceased seated on the left before a table of offerings. The scene is cut in deep sunk relief and worked in the pre-unification Theban relief style. Thebes. H. 36.2 cm. First Intermediate Period. New York, Metropolitan Museum of Art.

taining power, but in addition, the act of creating a monument fulfilled the kingly duty to impose order on the world and overcome chaos. To achieve their aims the Theban rulers needed to establish royal workshops and attract the best artists available to their service. As a result a highly competent and distinctive version of the Upper Egyptian style of art developed in the Theban area, both on royal monuments and on those of high-ranking officials who had access to the royal workshops.

The pre-unification Theban relief style represents the final stage of the Upper Egyptian style, with high raised relief, deep sunk relief and incised details (figs 78, 82–8).[8] Figures tend to have narrow shoulders and a high small of the back. The limbs are rounded, and in male figures musculature is hardly ever shown. The eye is large and is outlined by an encircling band of relief representing eye paint (figs 86, 88). The band meets at the outer corner of the eye to form a cosmetic line that runs back to the ear, widening at its outer end. The inner canthus of the eye is plainly depicted and usually dips sharply downwards. The eyebrow is virtually flat where it runs above the eye, rather than imitating the curve of the upper eyelid. The nose is broad with a heavy wing marked off by a deep incision. The lips are thick and protruding, and come together at the outer corners of the mouth in a vertical line rather than in a point. The ear is large and often set obliquely. The same strong facial features and rounded modelling of the limbs with little musculature can be seen in statues also (fig. 81).[9]

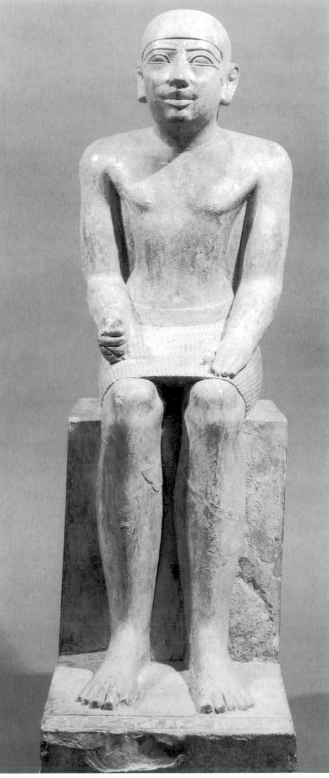

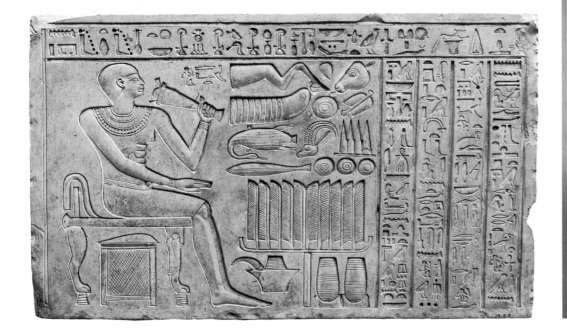

83 Limestone stela of King Wahankh Inyotef II from his funerary complex at Thebes. Six horizontal lines running the width of the stela and eight vertical columns below them on the right contain hymns to the god Ra-Atum (the setting sun) and to the goddess Hathor. The ninth column identifies the figure of Wahankh Inyotef to the left. The king holds out two jars of different types in the gesture of offering, and the caption reads 'presenting milk and beer to Ra and Hathor, and reciting what the two of them [i.e. Ra-Atum and Hathor] love'. What the king is reciting can only be the hymns that are inscribed on the stela, so the monument records not only the act of offering but also the words that go with it. The stela demonstrates the close interconnection between text and representation, for neither alone records the complete ritual. The king's figure is worked in very high raised relief with intricate detail carved into the stone to show the texture of the curled wig, the beaded collar and the woven kilt. The large eye with its long cosmetic line and almost flat eyebrow above, the pronounced wing to the nose and prominent lips are all elements of the pre-unification Theban style. H. 43 cm. First Intermediate Period. New York, Metropolitan Museum of Art.

84 *far right* Limestone relief of a female offering-bearer from the tomb of the high official Tjetji at Thebes. The woman carries on her head a basket of supplies which she steadies with her forward hand. Her rear hand hangs at the side of her body, grasping a bird by its wings. The figure is worked in the pre-unification Theban style, in deep sunk relief with the details of the woman's hair, jewellery and the plumage of the bird incised into the stone. First Intermediate Period. London, British Museum.

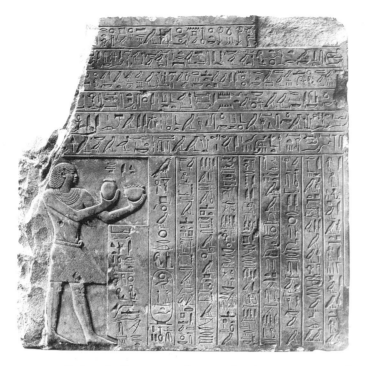

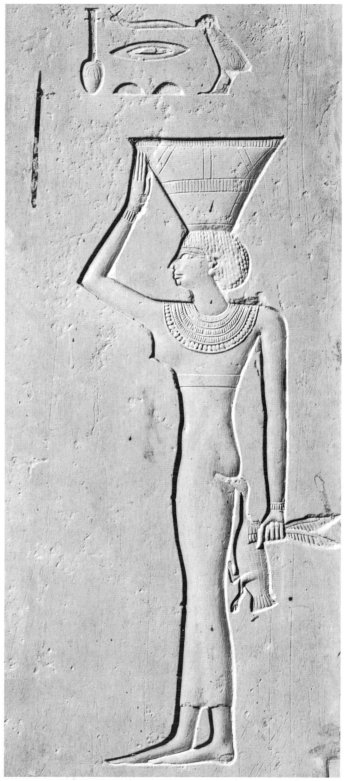

In relief male figures are frequently given pronounced angular breasts, often with rolls of fat below that derive from the Old Kingdom mature male image (figs 82, 85). The female breast can also be angular or pointed in shape (fig. 84), in contrast to the curved profile seen at other periods. Alternatively it can appear as a long, gentle curve, often with no discernible nipple (figs 78, 86). When the hand is outstretched the fingers are drawn straight (figs 84–5), in contrast to the slight curve given them at other periods. In seated figures the lower legs are placed at an angle to the seat, sometimes showing only one leg, not two overlapping (figs 82, 87).

Piles of offerings have a readily recognisable configuration that contrasts with the overlapping, luxuriant designs of the Fifth and Sixth Dynasties (figs 63, 65). Items seldom overlap, and often do not even touch each other, and are arranged in straight rows forming a square or rectangular outline (fig. 82). The loaves of bread on the offering table, which are shown in the shape of reed leaves, perhaps referring punningly to the field of rushes in the afterlife, turn outwards, a form that can be traced back to the end of the Sixth Dynasty (figs 82, 85).

The pre-unification Theban relief style can be seen in the reigns of Wahankh Inyotef II and Nakhtnebtepnefer Inyotef III. The first three kings of the Theban Eleventh Dynasty built their tombs on the west bank at Thebes on the gravel plain of el-Tarif, cut back into the rock of the

85 Limestone relief of the high official Tjetji from his tomb at Thebes. The fourteen horizontal lines of text at the top contain an account of Tjetji's life, spent mostly in the service of King Wahankh Inyotef II, although he survived into the next reign. The five vertical columns on the right contain an elaborate version of the offering formula. The depiction of Tjetji shows him standing facing right followed by two smaller male figures whose captions suggest they are members of his official staff: 'his sealer Magegi' and 'his follower Tjeru'. The account of Tjetji's life shows that by the time the stela was made he was moving towards the end of a highly successful career. His image appropriately depicts him as a mature official with a pronounced breast, rolls of fat on his torso and a calf-length kilt. By contrast his subordinates, Magegi and Tjeru, are shown as youthful, wearing the short kilt of the more active. H. 152 cm. First Intermediate Period. London, British Museum.

escarpment that bordered the western edge of the plain.[10] These burial complexes, oriented east–west, had enormous forecourts with a rock-cut pillared portico at the west end that gave access to the funerary chapel and burial shaft of the king. The complex of Inyotef II had a small, brick-built offering chapel at the east end of his long courtyard, in which he set up a stela with images of himself and four of his hunting dogs.[11] Other stelae were also set up in his complex. One, which includes hymns to Ra-Atum and Hathor, shows the king holding out a bowl of beer and a jar of milk as offerings to the gods (fig. 83).[12]

Around the courtyard of the royal complex were tombs for the important officials of the king, decorated with relief-cut images. It is probably from one of these that the reliefs of the high official Tjetji come.[13] The main one shows a mature figure of Tjetji standing before a pile of offerings, followed by two smaller standing male figures, one above the other in sub-registers (fig. 85). The inscriptions contain an idealised biography of Tjetji that includes the information that he served Kings Inyotef II and III as treasurer, and also an offering formula to ensure that the official will be properly supplied in the afterlife.[14] The depiction of offerings on the relief reinforces the formula visually (fig. 84).

More modest in size is the small stela of Maaty, which, nevertheless, is of high-quality workmanship (fig. 82). It depicts the standard scene of the deceased seated before a table of offerings. It is cut in crisp, deep sunk relief with the details of the collar, the box under the chair, the plucked bird and the reed leaves carefully worked into the stone. The limbs are rounded and lack musculature. The torso displays a pronounced, angular breast with rolls of fat underneath, as in the image of a mature official. The text records a version of the offering formula for the benefit of Maaty in the next life.

In order to assert control of their territory it is likely that these Theban kings also built monuments elsewhere, but little evidence has survived. However, the names of both Wahankh Inyotef and Nakhtnebtepnefer Inyotef were found in the sanctuary of Heqaib on Elephantine island.[15] Heqaib was a Sixth Dynasty official who was buried in a rock-cut tomb in the cemetery situated on the west bank of the Nile at Qubbet el-Hawa opposite Elephantine. He was subsequently deified and during the Twelfth and Thirteenth Dynasties he was honoured in a sanctuary founded by the local governor, Sarenput I, during the reign of Senwosret I. During the excavation of this Middle Kingdom sanctuary two statues naming Wahankh Inyotef were found as well as a re-used block originally inscribed for Nakhtnebtepnefer Inyotef, recording how he had restored an even older building that had been erected in honour of the deified Heqaib.

Nebhepetra Montuhotep

By the time of the reign of Nebhepetra Montuhotep there was, therefore, already a well-developed Theban artistic tradition capable of supplying his needs. At Thebes the king started on his funerary complex on the west bank together with nearby tomb chapels and burial chambers for some of his wives. Outside Thebes he built at Dendera to the north and Gebelein to the south,[16] both sites sacred to the goddess Hathor. Like Pepy I he often used the epithet 'son of Hathor, mistress of Dendera'.

Nebhepetra Montuhotep chose to build his mortuary complex not at el-Tarif with the tombs of his predecessors but at the site known today as Deir el-Bahri, a rocky desert bay in the Theban cliffs about 3 km to the west. This area probably had an ancient association with Hathor, and the king may have chosen it because of his own connection with the goddess. Although work on the complex began before the reunification of the country, it continued on afterwards. During this long period of construction the monument underwent several changes of plan, and most of what survives today belongs to the later stages. We do not know, therefore, what form the mortuary complex was originally intended to take. All that survives from the early stages consists of the tombs of the king's wives and a large burial chamber at the end of a long rock-cut tunnel that was entered in what became the forecourt of the later complex.[17] This tomb, now known as the Bab el-Hasan, was never used for the king's burial, but it was later sealed with a seated statue of the king inside.[18] The tombs of the king's wives were used, and their free-standing chapels were subsequently incorporated into the structure of the king's later mortuary temple.

There were six chapels in all, belonging to five women called Kawit, Aashit, Kemsit, Sadeh and Henhenet, and a young girl called Mayet.[19] The decoration, which survives only in fragments, showed the owner of the chapel alone (fig. 86) or with the king (fig. 78), together with scenes of offering. It was worked in very deep sunk relief on the exterior and very high raised relief on the interior. Much of the paint is preserved, but it is clumsily applied; for instance, the reddish-yellow of the king's skin sometimes also covers his bracelets, which should be in a different colour to represent the metal or stones of which they are made (fig. 78). Although the painters may simply have

been less careful than the sculptors, it is probable that what we see today is not the original paint but the result of later renovation in the early Nineteenth Dynasty, undertaken while artists were working at the site to repair damage done to monuments during the Amarna period.

At Dendera, Nebhepetra Montuhotep erected a *ka*-chapel to house a statue of himself.[20] The chapel would have been built of mud brick, and only the relief-cut limestone slabs that lined the inside walls survive today. The chapel would have been associated with the main temple of Hathor and the statue would have received daily offerings through the redistribution of offerings from the

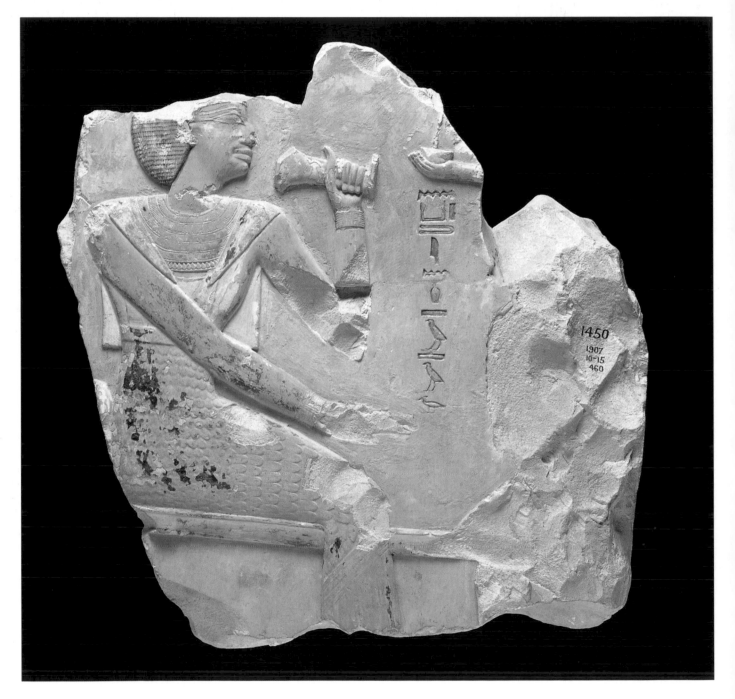

86 Fragment of painted limestone relief showing a seated figure of Kemsit from her tomb chapel in the funerary temple of her husband, King Nebhepetra Montuhotep, at Deir el-Bahri, Thebes. Kemsit is seated, holding a jar of perfumed ointment to her nose. Her figure is cut in very high relief with multiple levels where different elements lie on top of one another. The details of her hair, jewellery and feathered dress are all incised into the stone. Originally a smaller figure of a servant stood in front of her, pouring a drink into a cup. Only the hand holding the cup and part of the stream of liquid survive on this fragment. H. 37.5 cm. First Intermediate Period. London, British Museum.

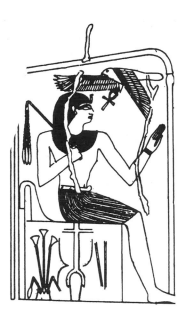

87 *above* Seated figure of King Nebhepetra Montuhotep enclosed in a shrine depicted in his *ka*-chapel from Dendera. An image of the Horus falcon hovers protectively over the king, holding an *ankh* sign towards him. The king's legs are placed together and set obliquely to the edge of the throne as on the stela of Maaty (fig. 82). The side of the throne is decorated with a large *sema tawy* emblem. Limestone. First Intermediate Period. H. 82 cm. Cairo, Egyptian Museum.

88 Detail of the head from a smiting figure of King Nebhepetra Montuhotep in his *ka*-chapel from Dendera, showing the fine quality of the decoration in the chapel. The very high raised relief and the intricate details cut into the stone are typical of the pre-unification Theban relief style. Limestone. First Intermediate Period. Cairo, Egyptian Museum.

temple cult. The statue has long since disappeared, but its equivalent in relief is depicted in the lower register at the far end of the right wall, showing a seated figure of the king enclosed in a shrine (fig. 87).

Because the chapel was located at Dendera the decoration features Hathor as one of the main figures appearing with the king. It works on a number of levels, but one of the major themes is the divine nature of kingship in general and more specifically the divine birth of Nebhepetra Montuhotep, born and suckled by Hathor.[21] The figures of the king represent two generations, the king who fathers his successor, and the successor himself. Both kings are labelled as Nebhepetra Montuhotep, expressing a fundamental tenet concerning renewal within the Egyptian cosmos. The sun god, as he sets every evening, impregnates the sky goddess, his consort, and is born of her every morning. Thus there is a perpetual cycle in which the sun god engenders himself through the agency of the sky goddess, who can be identified as Hathor and who is both mother and consort. This concept is transferred from the

god to the king, so that the king engenders his heir and is subsequently reborn as the new king. The self-engendering sun god is often depicted in ithyphallic form, as is the figure of the king as father in the scene where Hathor suckles the young, reborn king.[22] Thus the scenes depict the divine, self-engendered birth of the king that is part of the mythology of kingship. Further, by identifying the king with Nebhepetra Montuhotep, they legitimise his rule as king, for he is displayed as the self-engendered offspring of the goddess Hathor on whom the kingship has been divinely conferred.

On the representation of the king's statue, and presumably on the statue itself, the side of the throne is decorated with the *sema tawy* motif (fig. 87). An elaborate version of the same motif is placed in the register beneath a figure of the smiting king that occupies the rear wall.[23] In this chapel the traditional group that signifies the dual kingship of Egypt takes on additional meaning, since Montuhotep changed his Horus name to Sematawy, 'He who unites the Two Lands' after he reunited the country.

The distinctive pre-unification Theban style in which the Dendera chapel and so many other monuments of Nebhepetra Montuhotep were worked did not get a chance to continue to evolve naturally. Instead it was deliberately replaced, at the command of the king, by a new style based on Old Kingdom Memphite reliefs, as we shall see in the next chapter.

Notes
1 Fischer 1977b, 408–13.
2 See ch. 4, n. 36.
3 Malck 1986, 117–20.
4 Dunham 1937.
5 Fischer 1968.
6 Petrie 1900a, 13–22, pls 8–15; Fischer 1968, 113–76; Bourriau 1988, no.1.
7 Petrie 1900a, pl. 8. See Fischer 1968, fig. 27.
8 Bourriau 1988, nos 2–4; Robins 1990a, 39–45; for a discussion of painting as well as relief styles see Jaroš-Deckert 1984.
9 E.g. Saleh and Sourouzian 1987, no.70.
10 Arnold 1976, 19–22, 25–38, 50–9.
11 Arnold 1976, 52–6, pls 43–4, 53.
12 Arnold 1976, 56–7. Translation of texts in Lichtheim 1973, 94–6.
13 Blackman 1931.
14 Lichtheim 1973, 90–3.
15 Habachi 1985, 110–12 nos 98–100, pls 189–92.
16 Habachi 1963, 19–28, 37–40; Robins 1990b, 68–75.
17 Arnold 1979, 40–1, 45.
18 Arnold 1979, 41; Saleh and Sourouzian 1987, no. 67.
19 Porter and Moss 1960, 385–6; Porter and Moss 1972, 386–90; Naville 1907, 47–51, 53–6, pls 17–19A, B, 20–3; Naville 1910, 6–9, pls 11–20.
20 Habachi 1963, 19–28; O'Connor 1992.
21 O'Connor 1992.
22 Habachi 1963, fig. 8.
23 Habachi 1963, fig. 6.

Return to the heights

THE MIDDLE KINGDOM (I)

Eleventh Dynasty

The process of reunification by Nebhepetra Montuhotep probably took place gradually over a number of years. Following his final victory over the Tenth Dynasty, by his regnal year 40 at the latest Egypt was again united under a strong central government. This meant that after a hiatus of about a century the south once more had access to the north, including Old Kingdom monuments in the Memphite necropoleis. Artistic evidence suggests that the king deliberately ordered a style influenced by Fifth and early Sixth Dynasty Memphite models to be adopted in the decoration of his monuments, and that the elite followed his lead, for the pre-unification Theban relief style all but disappears at this time.[1]

The reasons for this change were no doubt ideological. By abandoning a style that had developed during the chaos of division and returning to models that derived from a period of strong centralised rule over a united Egypt, the king signalled a corresponding return to the political ideals of the Old Kingdom, and a renewal of the centralised state. Thus monuments that date to after the reunification can usually be distinguished by their style of decoration. Raised and sunk relief become very low or very shallow respectively, and the surface within outlines tends to be flat with little incised detail (fig. 90). In the human figure the exaggerated eye in many cases becomes smaller, as does the ear, and the outstretched hand regains a slight curve to the fingers. Male figures exhibit musculature, broad shoulders and a low small of the back. Piles of offerings touch and interlock, and the reed-leaf loaves on offering tables turn inwards.[2]

Despite the reunification of Egypt and the adoption of a relief style based on northern models, Montuhotep did not return his residence or burial complex to the area of Memphis, nor did he model his mortuary complex on the architecture of the Old Kingdom pyramid complex. Instead he maintained his residence at Thebes, and continued to work on the funerary complex that he had already begun on the west bank at Deir el-Bahri (fig. 91). During the long period of its construction the complex underwent several changes of plan.[3] We have seen that the tombs of the wives of Montuhotep belonged to an early stage of the design, when their entrances were intended to stand in the open air. The king's first burial chamber, the Bab el-Hasan, belonged to this same phase, but later a new burial chamber was constructed further to the west. At this time, the greater part of the temple was built on top of a large raised platform. The front part of the complex consisted of a solid central core about 22 m square. It was faced in limestone and may have reached 10 m or more in height. Once thought to have formed the base for a pyramid, this structure is now believed to have had a flat top and perhaps to have represented the primordial mound on which creation took place. It may also have had links to similar features in early solar temples or even in the Early Dynastic funerary enclosures at Abydos. It was surrounded on all sides by an ambulatory with octagonal sandstone pillars enclosed by a thick limestone wall. It was into this wall that the six tomb chapels of the royal women were incorporated. To the west of the ambulatory, cut back into the cliffs, was the rear part of the temple. An open court with pillared porticoes on the east, north and south sides contained the entrance to the king's later burial chamber. An underground corridor that ran 150 m into the cliff ended in a chamber lined with granite that contained a calcite shrine.[4] It was robbed long

89 Detail from the interior of the outer coffin of the steward and chief of physicians Seni, showing the skill with which the coffin is painted. The hieroglyphs at the top are part of an offering formula on behalf of Seni. Painted in great detail in a variety of colours, they are miniature works of art in themselves. From Bersha. Painted cedar wood. Twelfth Dynasty. London, British Museum. (See also fig. 112.)

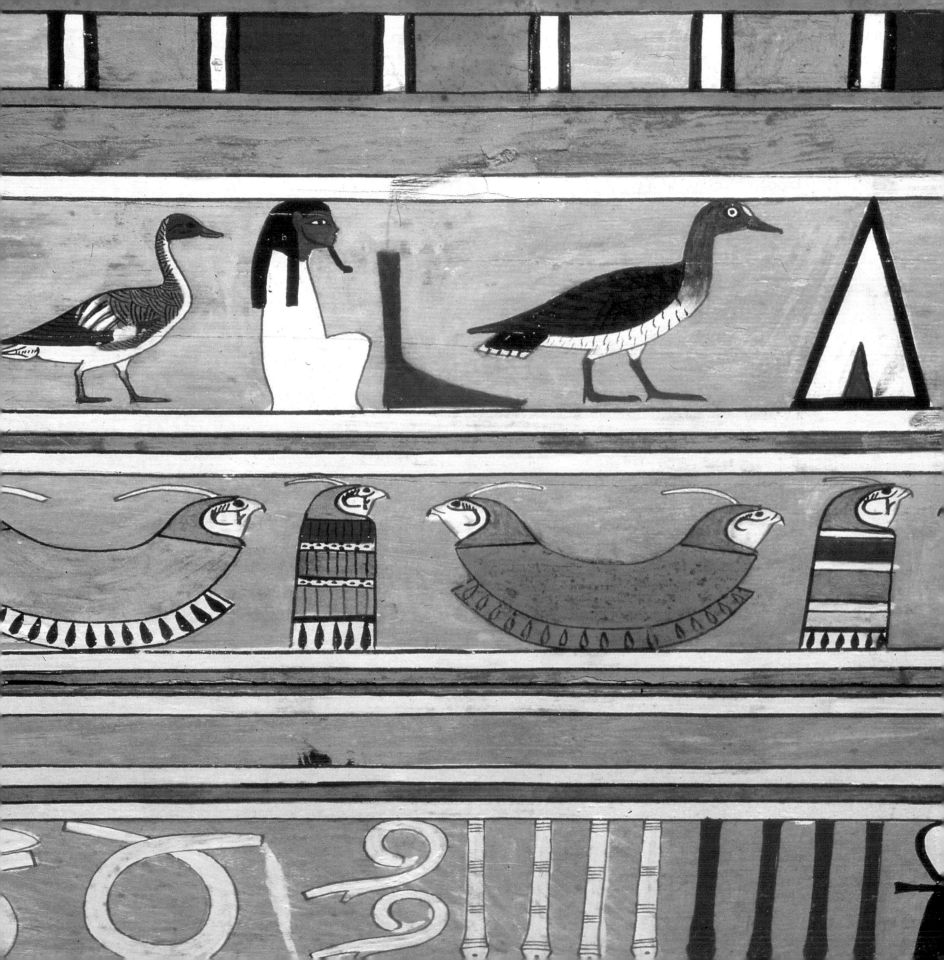

90 Limestone stela of the official Inyotef born to Tjefi, showing Inyotef and his wife seated before a table heaped high with offerings. The raised relief is very low and flat with little modelling and few details cut into the stone. Inyotef's rear leg is placed vertically with some indication of musculature. The offerings touch, interlock and overlap, and the reed leaves on the table turn inwards. A comparison with the stela of Maaty (fig. 82) shows the difference in style before and after the reunification of Egypt by King Nebhepetra Montuhotep. From Thebes. H. 78 cm. Eleventh Dynasty. New York, Metropolitan Museum of Art.

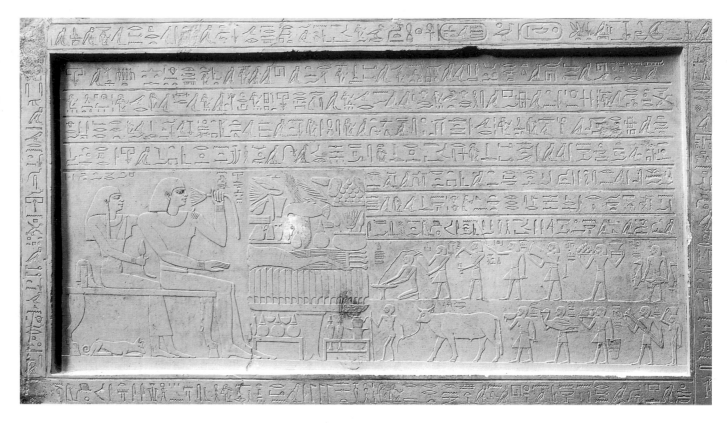

before modern excavators entered it. Above ground to the west of the open court was a hypostyle (columned) hall with ten rows of eight columns. A niche for the king's statue was cut in the middle of the west wall.

In the final building stages, upper colonnades were added in front of the east, north and south walls around the ambulatory (fig. 92).[5] A lower colonnade was erected in front of the east side of the platform on which the temple was built, to either side of the ramp that led up on to the platform from the large forecourt below. A three-corridor, unroofed causeway led up to the walled forecourt from a building at the edge of the cultivation, now lost.[6] The inner sides of the inner stone walls were probably lined with standing sandstone statues of the king, while others were erected in the forecourt along the processional way (fig. 93).[7] They wore the knee-length, wrap-around *sed*-festival cloak and held the crook and flail crossed on the chest. All the statues on the south side probably wore the white crown of Upper Egypt (fig. 94) and on the north the red crown of Lower Egypt (fig. 93). At the rear of the temple, at the west end of the hypostyle hall, four columns from each of the two central rows were enclosed with limestone

blocks to make a sanctuary directly in front of the statue niche.[8]

The temple was decorated throughout with painted relief scenes. Today these survive only in fragments that can be reconstructed in part. Both the style and subject matter were modelled in large part on the pyramid complexes of the Fifth and Sixth Dynasties. In the front half of the temple were scenes showing the king as the victor over chaos, defeating foreign enemies in battle (fig. 95), hunting wild animals in the desert, harpooning hippopotamuses, and fishing and fowling in the marshes; others depicted ritual processions of boats, official and cult scenes and, on the pillars of the upper colonnade, the king being embraced by various deities.[9]

At the rear of the temple the sanctuary was decorated with scenes relating to the cults of the king and Amun-Ra and showing the ritual role of the king in relation to the gods, offering to them and being embraced by them (fig. 96).[10] On the east end of the exterior north wall the king appears seated on a throne with the *sema tawy* motif, between Horus and the goddess Wadjit of Lower Egypt and Seth and Nekhbet of Upper Egypt, the two gods handing

91 Reconstruction plan of the latest phase of the funerary temple of King Nebhepetra Montuhotep at Deir el-Bahri, Thebes. Eleventh Dynasty.

1 Forecourt
2 Ramp
3 Lower colonnades
4 Upper colonnades
5 Ambulatory
6 Solid central core
7 Tombs (originally free-standing) of six royal women
8 Open court
9 Hypostyle hall
10 Sanctuary
11 Limestone altar
12 Statue room

92 Reconstruction drawing of the latest phase of the funerary temple of King Nebhepetra Montuhotep at Deir el-Bahri, Thebes. Eleventh Dynasty.

93 *far right* Painted sandstone standing statue of King Nebhepetra Montuhotep from his funerary complex at Deir el-Bahri, Thebes. The king wears the red crown of Lower Egypt, a divine beard and the wrap-around *sed*-festival robe. His arms are crossed on his chest, and his hands, which are pierced, once held a separately made crook and flail. There is no back pillar, and the body is modelled behind. H. 203 cm. Eleventh Dynasty. New York, Metropolitan Museum of Art.

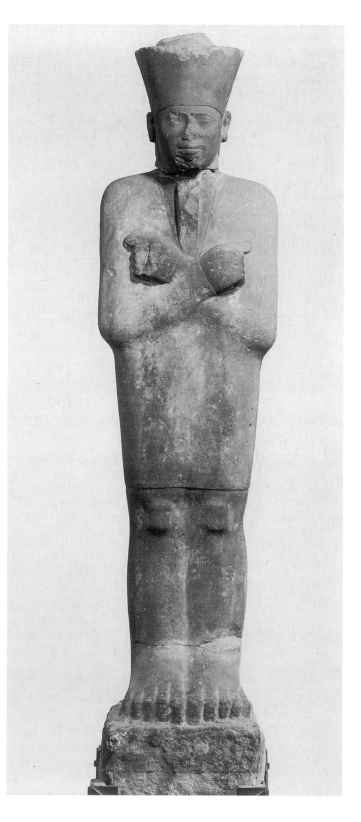

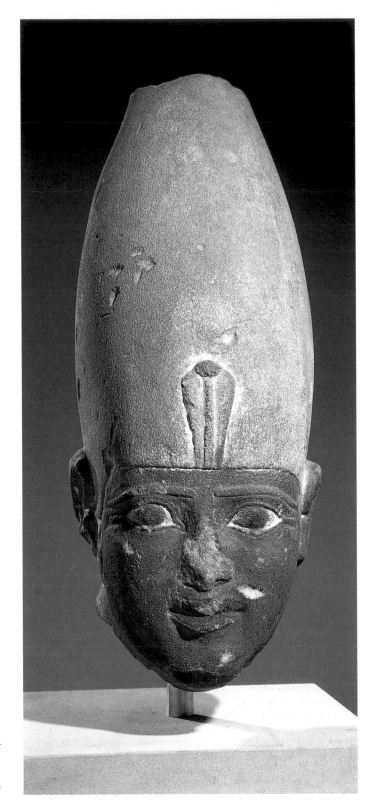

94 Painted sandstone head from a statue of King Nebhepetra Montuhotep from his funerary complex at Deir el-Bahri, Thebes. The king wears the white crown of Upper Egypt, in contrast to fig. 93, where he wears the red crown. The different crowns relate to the locations of the statues within the complex. H. 38 cm. Eleventh Dynasty. London, British Museum.

the king the symbol for millions of years.[11] At the back of the sanctuary the statue room was narrow, dark and difficult to enter, and may have been left inaccessible. In it stood a more than life-size limestone statue of the king.[12] The sanctuary itself was occupied almost entirely by a large limestone altar with steps leading up to it.[13] Two carved granite offering tables probably also came from here and were part of the cult furniture.[14]

Although the final complex was far grander than the tombs of Montuhotep's predecessors at el-Tarif, it was related to the same Theban tradition, with a large forecourt and no pyramid. Even the idea of pillared porticoes may have derived from the rock-cut pillared façades of the earlier tombs. These tombs were largely undecorated except for stelae set up in connection with them. After obtaining access to the Old Kingdom pyramid complexes Montuhotep used their decorative programmes as a model for the subject matter of the reliefs on the front part of his temple.

The stylistic change seen in relief is not apparent in statuary.[15] The statues that were set up in the mortuary complex belong to the final stage of the building but maintain many of the strong facial characteristics of the pre-unification style (fig. 94). The large eyes have emphasised inner canthi that turn down, and cosmetic lines that flare at the outer end. The eyebrows, modelled in relief, run straight above the eye. The nose is broad with pronounced wings, the lips are thick and the ears large.

Nebhepetra Montuhotep built widely in Upper Egypt after the reunification.[16] Unfortunately, none of his buildings has survived until modern times, and all that remains of them are blocks, often fragmentary, that were re-used in the foundations, pavements or fill of later structures. However, these surviving fragments show that the post-unification relief style was used on royal monuments (fig. 97). No material of Montuhotep has been found north of Abydos, possibly showing a lack of interest in the northern part of the country, although the absence may be due to chances of survival.

A barely begun funerary complex that lies to the south of the complex of Nebhepetra Montuhotep was once thought to have belonged to his immediate successor, Sankhkara Montuhotep. However, it has been shown that it was in fact the work of Amenemhat I, the first king of the Twelfth Dynasty, begun before he moved the royal residence and funerary complex to the north.[17] Thus we do not know where Sankhkara Montuhotep and his successor, Nebtawyra Montuhotep, sited their complexes. Although there are no temple buildings still standing from this period, blocks of Sankhkara Montuhotep re-used in later buildings

95 Fragment of painted relief from a battle scene showing fallen Asiatics, from the mortuary temple of King Nebhepetra Montuhotep at Deir el-Bahri, Thebes. The pale skin of the northerners contrasts with the normal reddish-brown skin colour of Egyptian males. H. 54 cm. Eleventh Dynasty. London, British Museum.

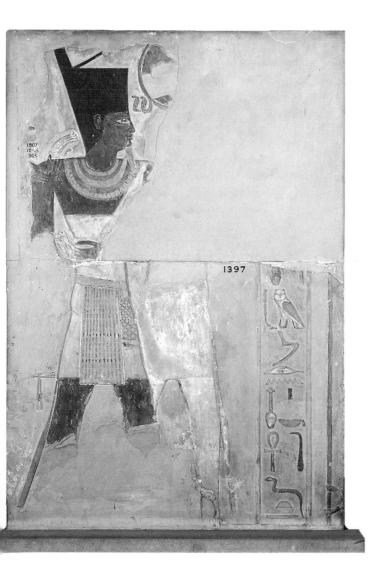

96 Relief fragment showing the god Montu embracing King Nebhepetra Montuhotep, who wears the red crown. Originally a second deity, probably the goddess Hathor, stood behind the king, and her forward hand can still be seen on the fragment. Nevertheless, there appears to be one hand too many. The lowest hand belongs to Montu, leaving two for the goddess, one of which must have been cut in error, perhaps in the Nineteenth Dynasty when this temple was restored. The low, flat relief with little incised detail contrasts with the pre-unification style from earlier in Montuhotep's reign, seen in figs 78 and 86 which come from the first building phase of the temple. From the sanctuary of the funerary temple of King Nebhepetra Montuhotep, Deir el-Bahri, Thebes. Painted limestone, H. 77 cm. Eleventh Dynasty. London, British Museum.

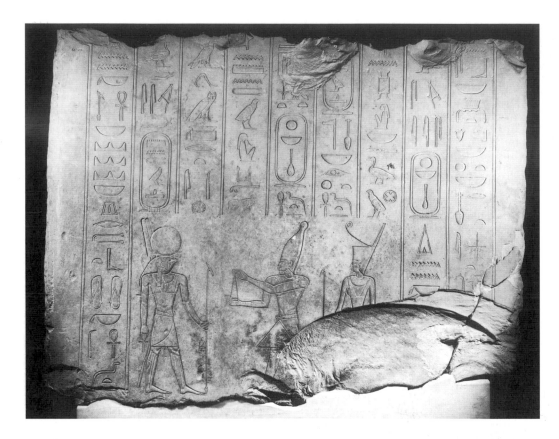

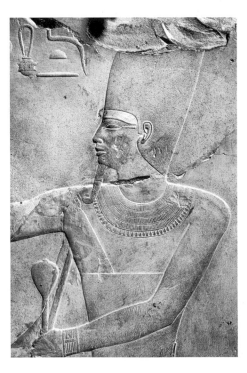

97 Limestone relief scene showing King Nebhepetra Montuhotep, with the goddess Neith standing behind him, offering a loaf of bread to the god Montu. Montu is shown with a falcon head crowned by a sun disk and two feathers. In his forward hand he carries a *was*-sceptre and in his rear one an *ankh*. Neith, who also carries a *was*-sceptre, wears the red crown of Lower Egypt, since her main cult place was at Sais, a city in the western Delta. The scene is very finely worked. The musculature of the legs is plainly modelled, unlike the smooth, rounded limbs from earlier in the reign. There is little detail cut into the stone, so that, for instance, the surfaces of the collars, bracelets and kilts are left smooth. The relief would have been painted, and these details were probably added in paint. From the temple of Montu at Tod. H. 140 cm. Eleventh Dynasty. Cairo, Egyptian Museum.

98 Detail of a limestone block showing King Sankhkara Montuhotep wearing the white crown. The high-quality relief continues the post-unification style of King Nebhepetra Montuhotep, but there is a greater amount of detail cut into the stone, for instance on the king's beard, collar, mace handle and bracelet. H. 35 cm. From Tod. Eleventh Dynasty. Paris, Louvre.

are known from a number of Upper Egyptian sites.[18] They exhibit reliefs of very high quality, and also show a change from the flat, plain relief of the later years of the reign of Nebhepetra to one where there was more modelling and incised detail (fig. 98).

The change from the Eleventh to the Twelfth Dynasty

Nebtawyra Montuhotep was the last king of the Eleventh Dynasty. His vizier was a man called Amenemhat, and it was probably this official who became the first king of the Twelfth Dynasty. Like the kings of the Eleventh Dynasty he was of southern origin,[19] and probably began his reign ruling from Thebes.[20] The means by which he became king are unclear. He may have been Nebtawyra's appointed successor or he may have seized the throne. Whatever happened, it is Nebtawyra who was omitted from the later king lists, while Amenemhat I was included as a legitimate ruler. Nevertheless, Amenemhat probably had to fight to overcome opposition to his succession. After setting up his government at Thebes he began a funerary complex on the west bank. Like the Eleventh Dynasty rulers, he may at first have tended to ignore Lower Egypt, but resistance to his rule may have come from Lower Egyptian leaders. Once he had subdued the Delta and its border regions, Amenemhat probably realised he could not rule Egypt successfully from the south, and he transferred the royal residence to the north. At some point in his reign he changed the first three names of his fivefold titulary, and this alteration may have marked the transference of the residence from the south. Initially he may have moved to the Old Kingdom capital at Memphis, and even have begun to prepare a funerary complex at Saqqara. Eventually, however, he built a new royal residence named with the royal epithet Itj-tawy, 'he who takes possession of the Two Lands'. Although the site has not been located, its necropolis, where Amenemhat built his final funerary complex, was at Lisht, a little north of Meidum.

The king

The pyramid complex

The kings of the Twelfth Dynasty were buried in pyramid complexes modelled on those of the Fifth and Sixth Dynasties, although the older models were never copied exactly.[21] New methods of pyramid construction were

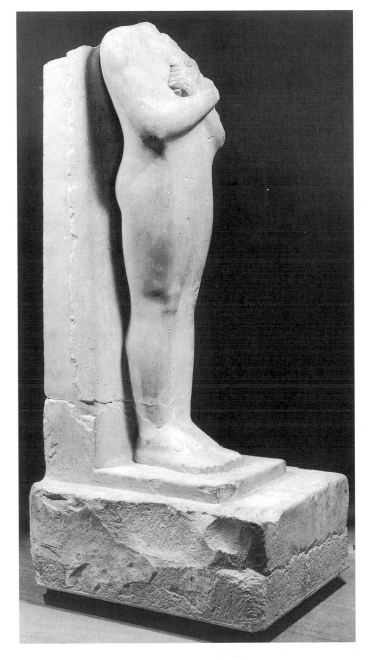

99 Part of a limestone mummiform statue of King Senwosret I from his pyramid complex at Lisht. The statue is one of a series that lined the causeway leading from the valley temple to the funerary temple. It is now missing its head, but would probably have worn the red crown, since it was found in a niche on the north side of the causeway. Traces of colour on the various statues when found showed that the skin was painted reddish brown, the linen wrapping the body was white, the eyes were white with black pupils, the eyebrows were blue and the beard black. Much of this colour has since disappeared. Original H. approx. 239 cm. Twelfth Dynasty. New York, Metropolitan Museum of Art.

introduced that in the end proved less effective than the old, and the pyramids of the Twelfth Dynasty have not survived well.[22] In contrast to the standardisation of the Sixth Dynasty, a variety of heights, base lengths and angles of inclination were used. However, the elements of the whole complex, with valley temple, causeway, mortuary temple and pyramid, all follow the Old Kingdom tradition.

The pyramid complex of Senwosret I, like that of his father, was built at Lisht. It is badly preserved, but careful excavation has brought to light much information about it, although the valley temple is as yet unexcavated.[23] The causeway has been traced and can be shown to have had two building stages.[24] Originally it was designed to be 10 royal cubits wide (1 royal cubit = 52.5 cm) and to be uncovered. In the second stage, interior facing blocks were added to reduce the width to 5 cubits so that it could be roofed in the tradition of Fifth and Sixth Dynasty causeways. The original plan may have been based on the unroofed causeway of Nebhepetra Montuhotep at Thebes. The new interior wall was almost certainly decorated, and fragments found in the vicinity come from scenes showing the king victorious over Nubians and Libyans, hunting in the desert and fishing and fowling, and also processions of estates and *nomes* of Upper and Lower Egypt. It is possible, however, that some of these blocks came originally from the mortuary temple.

The stone walls of the causeway were flanked on either side by white, plastered mudbrick walls set at a distance of about 12 cubits, contributing three corridors to the causeway. This arrangement was not found in the Old Kingdom but was first seen in Nebhepetra's complex. It was adopted in all Twelfth Dynasty causeways. In addition to relief decoration, the causeway contained a series of statues of the king. Niches were cut into the later interior wall every 10 cubits, and in each niche was placed a life-size mummiform limestone statue of Senwosret (fig. 99).[25] Like the three-corridor causeway, the statues depart from Old Kingdom tradition and may have been influenced by those that lined Nebhepetra's unroofed causeway. Unlike those statues, the figures of Senwosret lean against massive back pillars. These pillars and the statue bases were painted pink to imitate granite.

The mortuary temple is in a very bad state of preservation. Nevertheless about six hundred fragments of decoration have been found, and the plan of the building can be reconstructed from pavements and foundations, and through a comparison with Old Kingdom mortuary temples (fig. 100).[26] The rectangular pillared court had six pillars on the short sides and eight on the long ones. The walls, pave-

ment, pillars and architraves were all of limestone in contrast to Old Kingdom models where the pillars and architraves were of granite. Old Kingdom tradition was followed in the placement of an altar in the north-west corner of the court. The transition between the outer and inner parts of the temple was marked by the traditional transverse corridor. Both this element and the inner part of the temple are poorly preserved, although the plan of the five statue chapels linked by two rooms to the offering chamber can be traced. Fragments of wall relief from the offering chamber depict processions of offering-bearers worked in high raised relief (fig. 101).

101 Fragments of raised relief from a scene showing offering-bearers bringing supplies for the king's cult. From the offering chamber in the funerary temple of King Senwosret I at Lisht. Painted limestone, H. 139 cm. Twelfth Dynasty. New York, Metropolitan Museum of Art.

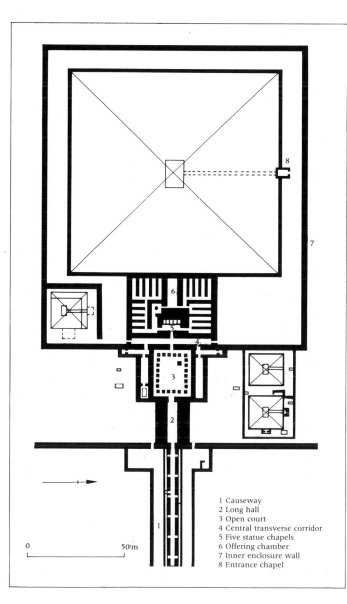

100 Plan of the funerary temple of King Senwosret I at Lisht. Twelfth Dynasty.

1 Causeway
2 Long hall
3 Open court
4 Central transverse corridor
5 Five statue chapels
6 Offering chamber
7 Inner enclosure wall
8 Entrance chapel

0 50 m

The inner enclosure wall that ran around the pyramid and inner part of the mortuary temple was unlike any other extant enclosure wall. It was made of limestone and decorated with one hundred regularly spaced panels on both inside and outside.[27] The panels, which can be calculated to have been 10.5 cubits or just over 5.5 m in height, were carved with outsize renderings of the king's Horus name (fig. 102). At the top, carved in great detail in very high, rounded relief, stood the Horus falcon wearing the double crown. Below was cut the rectangular enclosure of the *serekh* with a version of the palace façade in the lower part. The upper part contained the king's Horus name together with either his throne name Kheperkara or his given name Senwosret, the latter two alternating on the panels. Beneath the Horus name was carved a life-size fecundity figure that represented the prosperity of Egypt. In the middle of the west wall two panels were placed closer together, with the fecundity figures on them standing back to back. From there they proceeded in two great proces-

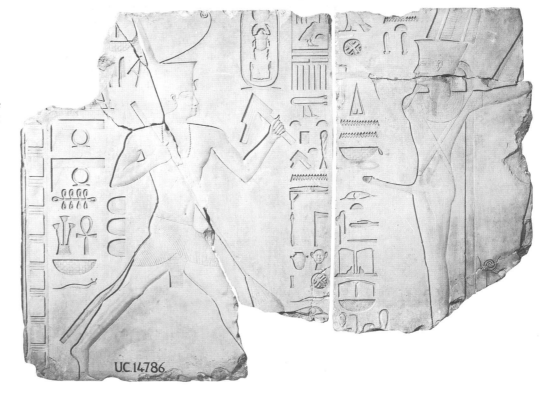

102 *left* Reconstruction drawing of one of the limestone panels from the inner enclosure wall of the pyramid complex of King Senwosret I at Lisht, showing the Horus falcon at the top above the king's Horus and given names, an elaborate palace façade and, at the bottom, a fecundity figure bearing symbolic offerings. The falcons on all the panels are worked in very high, layered relief with the details of their plumage carved in the stone. Reconstructed H. about 551 cm. Twelfth Dynasty.

103 Sunk relief showing King Senwosret I running before the god Min. Re-used in the Ptolemaic temple of Min at Koptos. Limestone, 111 cm. Twelfth Dynasty. London, University College.

sions around the walls, moving towards the east side as though they were going into the temple.

The inner enclosure wall had no precursor, although it combined totally traditional elements. The alternation of the slightly raised panels with the surface of the wall imitates in a simplified form the ancient niched palace façade of early enclosure walls. The panels, each with a *serekh*, recall and multiply the paired stelae displaying the king's Horus name that marked the offering place in earlier royal tombs. Processions of fecundity figures had long been associated with the royal funerary cult in the wall decoration and in the decoration of the altar in the open court. Now the notion was transferred to the enclosure wall. The result was a new way of displaying and perpetuating the king's name and authority, and of ensuring that Egypt's abundance would supply his needs in the afterlife. For those privileged to see the wall the effect must have been dazzling. Yet it remained unique, and no other Middle Kingdom king had an enclosure wall incorporating similar panels.

Local temples

Kings of the Twelfth Dynasty built throughout Egypt. However, local temples were still constructed mainly of mud brick with stone elements, so that little now survives, owing to the practice of replacing earlier temples. Our knowledge of temple decoration, therefore, derives from relief-cut blocks discovered re-used in later buildings. The most common themes depicted show the interaction between the king and the gods: the king as performer of cult for deities, and deities as bestowers of gifts on the king and the legitimators of the king's rule.

The town of Koptos, at the entrance to the Wadi Hammamat leading into the eastern desert and eventually to the Red Sea was the cult centre of the ithyphallic god Min. Today the buildings on the site are mostly Ptolemaic in date, but colossal statues of Min found here dating to the late Predynastic Period show that there was a long history of temple building. Although no complete structures survive from the Middle Kingdom, blocks from buildings of both Amenemhat I and Senwosret I were found re-used in later temples.[28]

A scene, preserved on two blocks, shows Senwosret running between territorial markers before Min (fig. 103).[29] The speech of the god refers to a performance of the *sed*-festival, and the scene may relate to the *sed*-festival celebrated by Senwosret in his year 31. Although it is not complete,

104 Drawing of the limestone chapel of King Senwosret I reconstructed in the Open Air Museum at Karnak. Twelfth Dynasty.

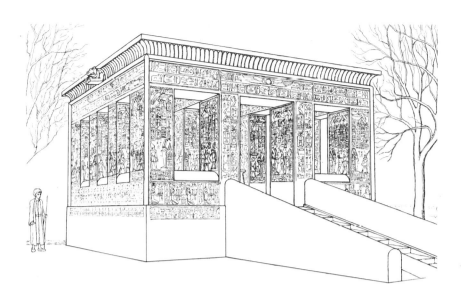

105 Relief from the chapel of King Senwosret I (fig. 104) showing the god Atum giving life to the king and leading him to an ithyphallic image of the god Amun-Ra. The relief is very high and subtly modelled, as can be seen here around the navels and in the musculature of the legs. Internal details on the hieroglyphs, the king's red crown, jewellery and clothing are cut into the stone. Karnak. Limestone. Twelfth Dynasty.

106 *far right* Limestone relief block of King Senwosret I from Karnak, showing the god Amun-Ra leading the king, whose figure is lost, and offering him life. To the right is a niche once meant to contain a statue. The relief is high, as in the chapel of King Senwosret I (fig. 105), but the surface is less modelled and few details are incised into the stone. Twelfth Dynasty.

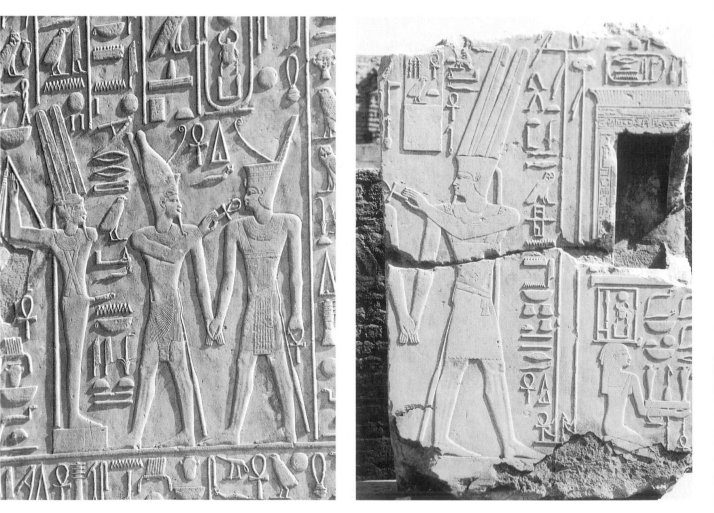

enough remains to demonstrate the high quality achieved by artists at this time. The piece is worked in very deep sunk relief, with the interior details of hieroglyphs, the feathers and collar of Min, and the king's kilt cut into the stone. The figures are modelled within their outlines. The muscles of the king's rear arm, where the hand grasps a long oar, are shown bulging in tension. Similarly, the muscles of the rear leg indicate the physical effort of running. Despite this energetic action, the figure is held suspended within a balanced composition.

We have already discussed the rise to prominence of the god Amun-Ra during the Eleventh Dynasty. The centre of his cult at Thebes lay on the east bank of the Nile at the site known today as Karnak. As at Koptos, we know very little about the Middle Kingdom buildings there because they were all replaced in the Eighteenth Dynasty.[30] However, Middle Kingdom blocks survive because they were re-used

in later buildings. Most of them remain isolated and out of context, but work is being done to reconstruct the Middle Kingdom complex on paper. In addition, most of the blocks survive from a small way-station chapel of Senwosret I, allowing it to be physically reconstructed and displayed in the Open Air Museum at Karnak.[31]

The chapel was built on a platform and reached by two stepped ramps placed on opposite sides of the square building (fig. 104). Twelve pillars linked by low balustrades formed the four exterior sides of the chapel. These surrounded four free-standing pillars in the interior, making four rows of four pillars in each direction. At the centre is a stand on which the sacred boat of Amun could be rested during processions. The pillars are decorated with reliefs consisting of long columns of text at the top, relating to a scene below in which the king ritually interacts with Amun-Ra and other deities, under which two horizontal lines contain references to the 'first occasion of the sed-festival'.[32]

The style of very high relief is similar to that at Lisht and equivalent to the deep sunk relief at Koptos, suggesting that one style, presumably emanating from the royal workshops, was in use on royal projects throughout the country. In the chapel the raised relief is subtly modelled, with body contours and musculature indicated (fig. 105). In addition the interior details of hieroglyphs, the god's feathers, some crowns, jewellery and costume are cut into the stone. Other blocks from the main temple complex at Karnak show the same style of high relief and high-quality artistry, but use less modelling, with little if any interior detail cut into the stone (fig. 106). This indicates that within the overall royal style differences could occur, perhaps marking the output of different workshops.

Fragments of statues of the king have been found also at Karnak, and we must assume that they formed an integral part of the architecture (fig. 107). Some of these were in the shape of mummiform statues, a type we have already met in the king's funerary complex. These statues identified the king with the resurrected god Osiris and guaranteed his survival into the next life.

Private funerary art

High-ranking elite officials continued to be buried in tombs with a chapel above the burial shaft. Members of the central government built free-standing *mastabas* in the cemeteries near the pyramid of the king they had served.[33] Provincial governors were buried, as earlier, in decorated rock-cut tombs in their local cemeteries at sites such as Beni Hasan (fig. 1),[34] Bersha (fig. 108),[35] Meir,[36] Asyut,[37] Qaw el-

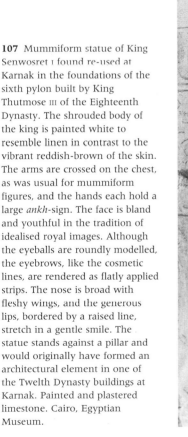

107 Mummiform statue of King Senwosret I found re-used at Karnak in the foundations of the sixth pylon built by King Thutmose III of the Eighteenth Dynasty. The shrouded body of the king is painted white to resemble linen in contrast to the vibrant reddish-brown of the skin. The arms are crossed on the chest, as was usual for mummiform figures, and the hands each hold a large *ankh*-sign. The face is bland and youthful in the tradition of idealised royal images. Although the eyeballs are roundly modelled, the eyebrows, like the cosmetic lines, are rendered as flatly applied strips. The nose is broad with fleshy wings, and the generous lips, bordered by a raised line, stretch in a gentle smile. The statue stands against a pillar and would originally have formed an architectural element in one of the Twelfth Dynasty buildings at Karnak. Painted and plastered limestone. Cairo, Egyptian Museum.

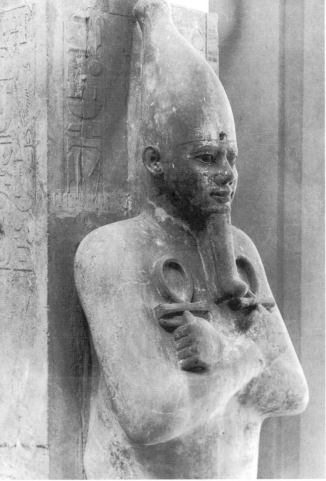

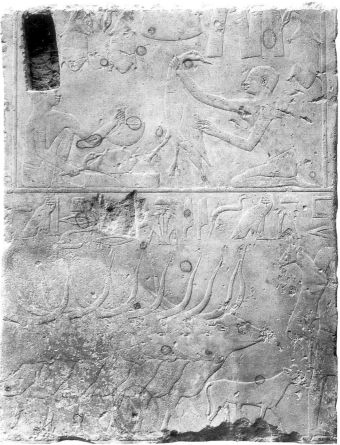

108 Painted limestone relief from an agricultural scene in the tomb chapel of the nomarch Djhutynakht at Bersha. The man on the left is sowing seed which he carries in the bag slung over his shoulder. He is walking forward to the left but has his head turned back to look behind him, where a second man breaks the soil with a hoe. The latter is followed by a partially preserved pair of oxen that once pulled a plough. These activities marked the beginning of the agricultural year after the retreat of the inundation. Other fragments from the same wall depict the grain harvest at the conclusion of the agricultural year. The man with the hoe is shown with receding hair that leaves a bald patch at the front of his head. It was not uncommon for signs of balding to be depicted on non-elite figures, but they are avoided on the idealised figures of the elite. H. 51 cm. Twelfth Dynasty. London, British Museum.

109 *above right* Block with two registers showing the preparation and cooking of birds, and cattle being driven. The subject matter of both scenes draws on the traditions of Old Kingdom tomb decoration. From a tomb chapel at Lisht. Limestone. Twelfth Dynasty. New York, Metropolitan Museum of Art.

Kebir[38] and Aswan.[39] The repertory of decoration comprised themes similar to those of the Old Kingdom, since the function of the tomb chapel remained the same: to provide a place for the performance of the funerary rituals, to aid the successful transference of the deceased to the afterlife and to ensure for him an unfailing supply of provisions (fig. 109). However, in the Middle Kingdom, statues were placed in the tomb chapel itself, often in niches or shrines at the back that formed the focal point for the cult (fig. 1).

Funerary stelae expand on the traditional image of the deceased seated in front of a table of offerings. In addition to the deceased and his wife (these stelae are mostly owned by men), other family members, deceased or living, are frequently shown (fig. 110). The text usually includes the offering formula and sometimes a more or less formulaic 'biographical' text.[40] There is no one standard type of funerary stela. They may be rectangular or round-topped. The number of registers and figures depicted vary, as do the disposition and amount of text, and also the quality of workmanship.

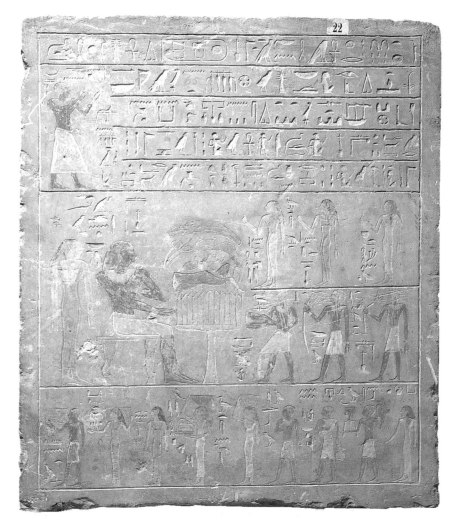

110 Painted limestone stela of the chamberlain Minnefer, dated to regnal year 29 of King Amenemhat II. The rectangular stela is divided into three unequal areas. At the top are five horizontal lines of text and a small image of Minnefer. The first line contains the date of the stela, and the next four an offering formula. To the left of these lines Minnefer stands with his arms raised in adoration, while the text reads 'kissing the ground for Wepwawet and for Khentamentiu' (gods of the necropolis). Small hieroglyphic images of the deities determine their names, but there are no larger images of the gods adored by Minnefer, in accordance with the rule that deities should not be depicted on private monuments, a rule that was not relaxed until later in the Twelfth Dynasty (fig. 130). Below, Minnefer is shown seated before a table of offerings. Behind him, in the less prestigious standing pose, is his mother, Inu. To the right of the table the space is divided into two sub-registers containing, at the top, figures of three women including Minnefer's wife and, below, three men including his father and the father of his mother. The latter is also called Minnefer and the owner of the stela was probably named after him, since it was a common custom to name children after grandparents. At the bottom a final register shows a row of nine figures facing to the left bringing offerings to Minnefer and his mother. The composition is constructed so that it is dominated by the seated figure of Minnefer, which is not only drawn on the largest scale but also set apart by its pose. Although his mother is placed in a pose and position that are subordinate to her son's, her figure is larger than the other standing figures, and together Minnefer and Inu form the focal point of the composition. H. 63.5 cm. Twelfth Dynasty. London, British Museum.

111 Rectangular limestone stela of the sculptor Userwer with five horizontal lines containing an offering formula and prayer to the living: 'O living ones who are on the earth who pass by this tomb, as your deities love and favour you, may you say: "A thousand of bread and beer, a thousand of cattle and birds, a thousand of alabaster [i.e. vessels] and clothes, a thousand of offerings and provisions that go forth before Osiris".' In the upper of two registers below, Userwer sits on the left with his wife Satdepetnetjer before a table of offerings, in front of which stands a woman called 'his wife Satameni'. Polygamy was not unknown in ancient Egypt, but it is also possible that Satdepetnetjer predeceased her husband, who then married Satameni. On the right side of the same register, balancing the figures of Userwer and Satdepetnetjer, are seated Userwer's parents, who are offered a leg of beef by a son, Sneferuweser. In the lower register, eight figures representing family members face right towards the figures of Userwer's parents rather than towards Userwer himself. The stela is unfinished and grid lines can still be seen where the stone has not been cut away or polished. In the lower register the last two figures and the heads of the two women in front of them have not yet been cut into relief and the original sketches can still be seen. It is tempting to speculate that Userwer was making this stela for himself but did not complete it before he died. H. 55 cm. Twelfth Dynasty. London, British Museum.

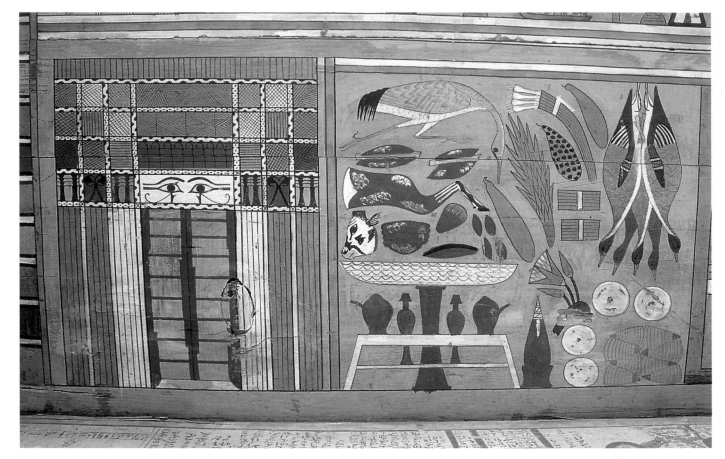

112 Detail of the interior of the outer coffin of the steward and chief of physicians Seni, showing the false door, towards which the deceased faced lying on his left side, and a pile of offerings for the next world. From Bersha. Painted cedar wood. Twelfth Dynasty. London, British Museum.

The owner of the stela, as the most important person represented, is usually placed on the left side of the scene facing right (fig. 110). If there is more than one register he is usually placed in the highest, since higher registers take precedence over lower ones. If the deceased's wife is shown, she takes a secondary position 'behind' her husband and thus further away from the centre of the scene and the action. Sometimes she will stand while he is seated, standing being a subordinate pose in relation to sitting. Living family members are usually shown offering, and face left towards the deceased, just as they would face the statue of the deceased in the tomb chapel. Compositions become more complex when deceased relatives are included. They may be depicted in the same register as the owner of the stela, but in the less prestigious left-facing position on the right (fig. 111). In other instances they are shown in a lower register. Because there are so many variations possible in the composition of funerary stelae, few monuments are alike, despite the fact that the subject matter is so limited and all perform the same function.

Painted wooden tomb models showing groups of servants engaged in a variety of activities continued to be placed in the tomb, either hidden in niches cut in the floor and paved over or placed with the coffin in the burial chamber. At this period additional themes were added to the repertory of model granaries, boats, offering-bringers and food production that had been in vogue since the Old Kingdom.[41] Now models show workshops for wood-working, metal-working, pottery-making and weaving. The models of the First Intermediate Period had seldom been of high artistic quality, and those of the late Eleventh and early Twelfth Dynasties also varied in craftsmanship. The twenty-four models from the tomb of the chancellor Meketra at Thebes, now dated to the early Twelfth Dynasty, are among the finest preserved (fig. 113).[42]

The coffins of the First Intermediate Period and Twelfth Dynasty were a development of the inscribed, rectangular, flat-lidded type introduced in the Sixth Dynasty, to which further decoration was added on the exterior or interior. The finest examples were made of imported coniferous

113 One of a pair of model offering-bearers from the tomb of the chancellor Meketra at Thebes. Models of female offering-bearers were common in tombs of the First Intermediate Period and early Twelfth Dynasty and were the descendants of the female personifications of estates found in Old Kingdom pyramid complexes and private tomb chapels. This figure from the tomb of Meketra is of particularly high quality, with its subtle modelling of the body and skilled application of paint. Made of coniferous wood, the head, body, legs and right foot are carved in one piece with tenons below the feet to attach the figure to the base. The arms and front part of the left foot are made separately and joined by pegs. The whole figure is completely painted, with blue hair (now turned dark green), black eyes and eyebrows, yellow skin, and patterns in red, green, yellow and blue for the jewellery and dress. The wig was plastered before painting; the rest of the figure was painted directly on to the wood. In her right hand the figure carries a duck held by its wings, and on her head she balances a basket of food offerings containing various cuts of beef and different types of loaves and vegetables. The pair to this statue (in the Egyptian Museum, Cairo) carries four jars of drink in her basket, so that between them the two models ensured that Meketra was provided with both food and drink in the afterlife. H. 112 cm. Twelfth Dynasty. New York, Metropolitan Museum of Art.

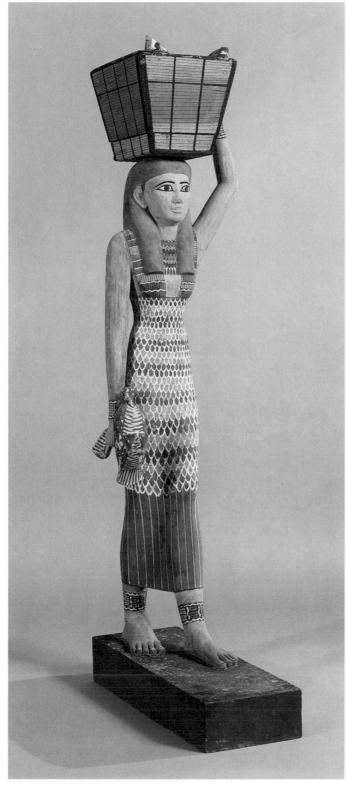

wood, involving a large outlay for the material. More modest ones were made of local timber, with the patchwork of irregular pieces hidden by a layer of painted plaster. Sometimes these latter were painted to resemble the graining of the more prestigious coniferous wood.[43]

Coffins decorated on the inside continued to place a false door at the north end of the east side next to the face of the occupant (fig. 112).[44] Beside this would often be depicted a pile of offerings, and also an offering list. On the opposite side and often on the ends of the coffin would be painted a frieze of objects including articles of clothing and jewellery, mirrors, furniture, games, tools, weapons, ritual items and different kinds of vessels. In addition at the head end there were usually depictions of the seven oils used in the ritual of opening the mouth, granaries to provide a perpetual supply of food, and headrests used by the Egyptians to support the head in sleep and in death. At the foot end sandals were represented. On the sides one or more bands of hieroglyphs carrying versions of the offering formula ran above the rest of the decoration.

The decoration was painted in bright colours and in many cases reaches a very high quality. The hieroglyphs are often works of art in themselves, combining different colours and exhibiting careful detailing, as, for instance, in the plumage of the birds (fig. 89). The function of the decoration was to ensure that the deceased had everything that he or she could possibly need in the afterlife. Further texts written on the inner sides of coffins are now known as Coffin Texts. They were descended from the Old Kingdom Pyramid Texts, but also included new material, such as guides to the hereafter, often with a map, that would help the deceased make the transition into the next world safely.[45]

Memorial chapels at Abydos

By the Middle Kingdom Abydos was the major cult centre for Osiris, the resurrected god who presided over the underworld.[46] The rituals at his temple included the annual festival that re-enacted his death and triumphant resurrection. Every year the statue of Osiris was taken from the temple to his mythical tomb and then, having overcome his enemies, the resurrected god was returned with great rejoicing to the temple.[47] It became the custom for the elite to build memorial chapels near the enclosure of the Osiris temple along what was probably the processional way used in the festival.[48] After the Middle Kingdom these buildings were abandoned and later built over.

Excavators in the nineteenth century found and removed from these chapels a large number of stelae that

are now in museum collections around the world.[49] Originally they would have been placed in niches within the chapels or cut into the walls of the courtyard that fronted the chapels.[50] They are very similar in design to funerary stelae, showing the deceased, often with his wife and other family members, seated before a table of offerings. The main inscription usually consists of the offering formula in favour of the deceased and sometimes includes a 'biographical' text.[51] In some instances statues were included in the chapels (fig. 114). Since it is clear that these buildings were not associated with burials, what then was their function? By erecting a chapel in the vicinity of the temple of Osiris and the processional way, the owner associated himself and his family with the rituals carried out there for the god and especially with the triumph of the resurrected god during his annual festival. In addition, a share of the offerings presented in the temple would be handed on after the deities there had done with them. Although the owners of the chapels were in fact buried elsewhere, they would continue to derive benefit from their chapels after death. The close association with Osiris would aid them and all those commemorated in their chapels to make the passage through death to the next world, and the constant provisions of offerings would keep them supplied in the afterlife.

The human figure and the development of the squared grid system

With the introduction of the Memphite style after reunification, proportions of figures returned to those of the Fifth and early Sixth Dynasties, and these proportions continued in use during the first half of the Twelfth Dynasty.[52] Male figures display broad shoulders, a low small of the back and thick, muscled limbs. Female figures are slenderer, with a

114 Limestone stela and block statue of Sahathor, a high official in the reign of King Amenemhat II. Under the cavetto cornice at the top of the rectangular stela, four lines of text contain an offering formula on behalf of Sahathor. Below, a scene carved in very low raised relief shows Sahathor seated on the left facing a heaped table of offerings, on the other side of which sits a smaller female figure identified by two short lines above as Merytaset, probably Sahathor's wife. She sniffs an open lotus flower, a symbol of rebirth, referring to the myth of the young sun god's birth from a lotus. A niche has been cut in the centre of the stela, below the scene, to contain the block statue of Sahathor. Although the shape of the elbows and arms has been modelled to show through the garment, only Sahathor's head, hands and feet emerge into view. The two pieces come from Abydos, where they would have been placed in a memorial chapel. H. of stela 112 cm. H. of statue 43 cm. Twelfth Dynasty. London, British Museum.

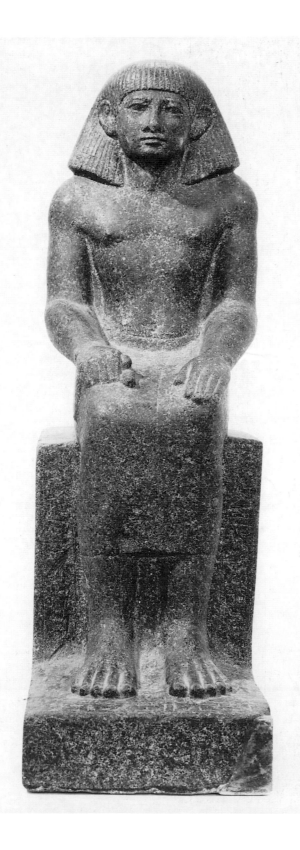

115 Black granite seated statue of the official Amenemhat, showing the broad shoulders and developed musculature typical of male figures in the first part of the Twelfth Dynasty. It can be contrasted with statues from later in the Twelfth and Thirteenth Dynasties where the body is thinner, lacks musculature and is often largely concealed by enveloping garments (figs 128–9). H. 50.8 cm. Twelfth Dynasty. London, British Museum.

higher small of the back and no musculature. These proportions occur in both two and three dimensions. The black granite seated statue of the high official Amenemhat is a fine example of male proportions at this period (fig. 115). The modelling of his bare torso plainly shows the muscles of his broad shoulders, chest and upper arms.

The Old Kingdom guide line system remained in use during the First Intermediate Period at Thebes and elsewhere, whereas unfinished scenes from the Twelfth Dynasty indicate that sketches were now laid out on a squared grid (fig. 111).[53] Standing figures always comprise eighteen squares between the soles of their feet and their hairline (fig. 116). A comparison with the older guide line system shows that this was incorporated in the new grid system. The knee line at a third of the hairline height became horizontal 6 on the grid. The line that marked the lower border of the buttocks and divided the hairline height in two became grid horizontal 9. The elbow line that lay at two-thirds of the hairline height became grid horizontal 12. The line that marked the junction of the neck and shoulders lay at two-thirds the distance between the elbow and hairline lines and became horizontal 16 on the grid. The calf line that divided the lower leg in half became grid horizontal 3. A vertical line of the grid ran through the ear and divided the upper torso in two. This corresponded to the axial vertical of the older system. Only the guide lines designating the top of the head and the armpits did not fit into the grid square system, so that these levels were no longer indicated.[54]

The squared grid system's greater number of lines allowed other parts of the body to be marked (fig. 116). Horizontal 17 lay between the nose and the upper lip, 14 ran through the nipple and 11 through the small of the back in a man, often corresponding with the back of the belt. When hanging beside the body, the length of the forearm between the elbow and outstretched finger tips was often five squares. In male figures the width of the body across the shoulders measured along horizontal 15 was six squares and at the level of the small of the back about two and a quarter to two and a half squares. Female figures are approximately five squares wide across the shoulders and less than two across the small of the back, which lies on horizontal 12. The distance between the armpits is commonly four squares in male figures and three squares in female ones.

Seated figures occupied fourteen squares between the soles of the feet and the hairline because the thigh and knee are no longer included in the stature (fig. 117).[55] The fourteen squares are made up by nine squares between the

116 Detail of the stela of the sculptor Userwer (fig. 111) showing the artist's sketches that were not cut into relief. The male standing figures consist of eighteen squares between the soles of the feet and the hairline, with the knees on horizontal 6, the lower border of the buttocks on 9, and the junction of neck and shoulders on 16; the width across the shoulders is six squares. The two figures are not exact replicas of one another, since the small of the back on one lies on horizontal 11, while on the other it is placed above the horizontal. The female figures are also drawn on a grid of eighteen squares between soles and hairline, but they are narrower across the shoulders and waist, with a higher small of the back. In both male and female figures the length of the forearm from the elbow bone to the fingertips is five squares. Twelfth Dynasty. London, British Museum.

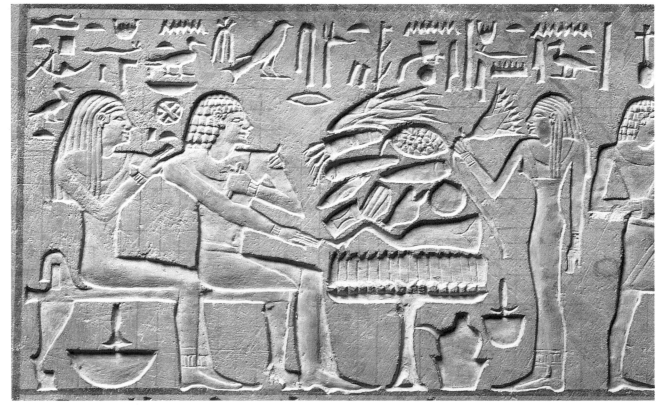

117 Detail of the stela of the sculptor Userwer (fig. 111) showing the seated figures of Userwer and his wife, which comprise fourteen grid squares between the soles of the feet and the hairline. The top of the seat is on horizontal 5, the top of the knees on 6 and the junction of the neck and shoulders on 12. Twelfth Dynasty. London, British Museum.

hairline and the lower border of the buttocks, on which the figure sits, and five squares from the top of the seat to the baseline. The lower leg to the top of the knee comprises six squares as in standing figures, but the topmost square does not contribute to the height of the figure as it rises above the top of the seat.

Grids, which were usually laid out in red paint, were often uneven, and it is clear that artists were not aiming at mathematical accuracy. The lines were merely an aid to drawing acceptably proportioned human figures, and artists did not have to follow them slavishly. Small variations within the proportions of figures occur even on the same monument. Two adjacent standing male figures on the stela of Userwer have slightly different levels for the small of the back. In the second figure the small of the back, corresponding to the top of the belt, plainly lies on horizontal 11, but in the first figure it is placed above it (fig. 116).

During the late Eleventh Dynasty and early Twelfth Dynasty a new type of statue was introduced, commonly known as the block statue, because its pose reduces the form of the body to a 'block' (fig. 114).[56] The subject is shown seated on the ground with his knees drawn up to his chest, and his arms resting on his knees. The body is totally wrapped in a tight-fitting garment, from which only the head, hands and sometimes the feet emerge. The surface of the garment provided a convenient space for inscriptions. Once introduced, the block statue remained a common type into the Ptolemaic period, but from its inception it was used almost exclusively to portray male subjects.

Conclusion

An outstanding feature of the art produced in the post-unification Eleventh Dynasty is the reversion, for ideological reasons, to traditional Memphite models. Although the resulting style was of high quality, one cannot help feel somewhat sad that the striking pre-unification Theban style was so abruptly jettisoned. The uniformity of style found throughout the country during the earlier Twelfth Dynasty can be seen as a result of the centralised control exerted through the royal workshops of the political capital, now once again in the north. During this time the quality of artistic production for the king and the upper elite reached a high point that, although equalled at other periods, was never surpassed.

Notes

1 Bourriau 1988, 10, 17–19 nos 5–7; Robins 1990a, 43.
2 Fischer 1959; Robins 1990a, 43, fig. 6.8.
3 Arnold 1974a, 65–6; Arnold 1979, 41–2, 45 (Phase C).
4 Arnold 1974a, 44–51.
5 Arnold 1974a, 66–7; 1979, 42–5 (Phase D).
6 Arnold 1979, 43; 1988, 20–1.
7 Arnold 1979, 46–8.
8 Arnold 1974a, 36 fig. 23.
9 Porter and Moss 1972, 383–6; Bourriau 1988, 18 no. 7.
10 Arnold 1974b.
11 Arnold 1974b, pl. 10.
12 Edwards 1965, 18 pl. 9; Arnold 1974a, 43–4.
13 Arnold 1974a, 42–3.
14 Arnold 1974a, 43–4.
15 Bourriau 1988, no. 8.
16 Habachi 1963; Bisson de la Roque 1937, 62–79; Freed 1984, 30–55, 95–7, 106–10, 124–9, 134–47.
17 Arnold, Dor. 1991.
18 Bisson de la Roque 1937, 79–97; Mond and Myers 1940, pls 94–7; von Beckerath 1982; Freed 1984, 90–1, 117–22, 129–34, 148–50.
19 Lichtheim 1973, 143 with n.15.
20 Arnold, Dor. 1991, 17–20.
21 Arnold 1988, 56–7.
22 Edwards 1993, 211, 212–14, 222; Watson 1987, 51–3; Baines and Malek, 1980, 139.
23 Arnold 1988, 18.
24 Arnold 1988, 18–20.
25 Arnold 1988, 21–2, pls 6–7.
26 Arnold 1988, 41–57.
27 Arnold 1988, 58–63.
28 Petrie 1896, 11, pls 9–10.
29 Petrie 1896, pl. 9 lower; Bourriau 1988, 22–4 no. 11.
30 Lauffray 1979, 46–7; Barguet 1980, 341–2.
31 Lacau and Chevrier 1956; 1969.
32 Strauss–Seeber 1994.
33 Bourriau 1991, 7.
34 Newberry 1893a, b; de Morgan 1903, 77–86; Shedid 1994b.
35 Newberry 1893c; 1894.
36 Blackman 1914; 1915a, b; 1953b.
37 Porter and Moss 1934, 259–64.
38 Steckeweh 1936.
39 Müller 1940.
40 Lichtheim 1988.
41 Tooley 1995, 17.
42 Winlock 1955.
43 E.g. Robins 1990b, 81–3 no.34.
44 Lapp 1983, 431; Lapp 1993; Taylor 1989, 18–21; Willems 1988.
45 Piankoff and Jacquet-Gordon 1974, pls 1–9; Parkinson 1991, 134–6.
46 Kemp 1975, 31.
47 See Lichtheim 1973, 123–5.
48 O'Connor 1985.
49 Simpson 1974.
50 O'Connor 1985, 171.
51 Lichtheim 1988.
52 Robins 1994a, 249.
53 Robins 1994a, 70.
54 Robins 1994a, 73–6.
55 Robins 1994a, 76, 79.
56 Bourriau 1988, 32; Schulz 1992.

Change and collapse

THE MIDDLE KINGDOM (II)

The reign of Senwosret III saw an extension of Egypt's borders through a series of military campaigns and the culmination of changes by which the administration of the country was restructured through greater centralisation. The policy of centralisation led to an end to the building of new decorated tombs in the necropoleis where the great provincial officials and their dependants had formerly been buried.[1] The undisputed centres of the country were the Residence at Itj-tawy, the city built by Amenemhat I near Lisht, and Thebes, the centre of Upper Egyptian administration and the dynastic home of the Twelfth Dynasty. In the eastern Delta there was probably a growing centre around the site that later became the Hyksos capital, Avaris. Abydos remained a major religious centre as the foremost cult place of Osiris.

The last kings of the dynasty, Amenemhat III, Amenemhat IV and Sobeknefru, built on Senwosret III's achievements. Egypt enjoyed a period of great prosperity, seen in the increasing quality of the materials used for royal and private monuments.[2] By the late Twelfth and Thirteenth Dynasties this wealth was spreading down the social scale as more people of the lower elite were able to commission small-scale monuments, such as statues and stelae. Many of these objects are of poor artistic quality, and this may have been due to strain put on existing workshops by increased demands, and the appearance of new workshops with less skilful and less rigorously trained artists. Only the king and upper elite would have had access to the best artists.

The Twelfth Dynasty was followed by a series of over seventy kings in about 150 years, who are grouped together as the Thirteenth Dynasty. Despite the rapid turnover of rulers, the government administration continued as before with no apparent loss of stability.[3] Nor was there any sudden break between the art and culture of the two dynasties. However, as time passed, the area controlled by the Thirteenth Dynasty gradually decreased as its rule was challenged in the Delta by foreigners who had settled there. During the Twelfth Dynasty immigrants from Syria–Palestine had gradually moved into the eastern Delta, bringing with them their distinctive 'Canaanite' culture that allows them to be recognised archaeologically.[4] Eventually a group among them gained political control of the whole Delta as far south as the region of Itj-tawy. The king was forced to abandon the north and move his residence to Thebes.

The foreigners, ruling from Avaris, produced a line of rulers of their own who took the titles of Egyptian kings and came to be identified as the Fifteenth Dynasty. They ruled their territory through local leaders who were later grouped together as the Sixteenth Dynasty. The intrusive foreigners came to be labelled as the Hyksos, a word derived from the Egyptian phrase *heqa khasut*, 'ruler of foreign lands'.

As the territory of the Thirteenth Dynasty contracted, the king controlled decreasing resources, and this may have affected the quality of work produced by the royal workshops, adding to the decrease in artistic standards already seen in private monuments. One of the last kings of the dynasty, Wepwawetemsaf, is known only from a stela he dedicated at Abydos (fig. 119).[5] Its small size and crude workmanship suggests that this king was unable to command much in the way of resources or artists.

The political situation seems to have stabilised later, with the Hyksos ruling the north and a line of local rulers constituting the Seventeenth Dynasty ruling the south from their centre at Thebes. There is some evidence that the two sides reached an accommodation and were not

118 Detail of eye panel from the inner wooden coffin belonging to a priest called Amenhotep (fig. 127). The painted eyes allowed the deceased to look out from the coffin towards the rising sun and the land of the living. Twelfth to Thirteenth Dynasty. London, British Museum.

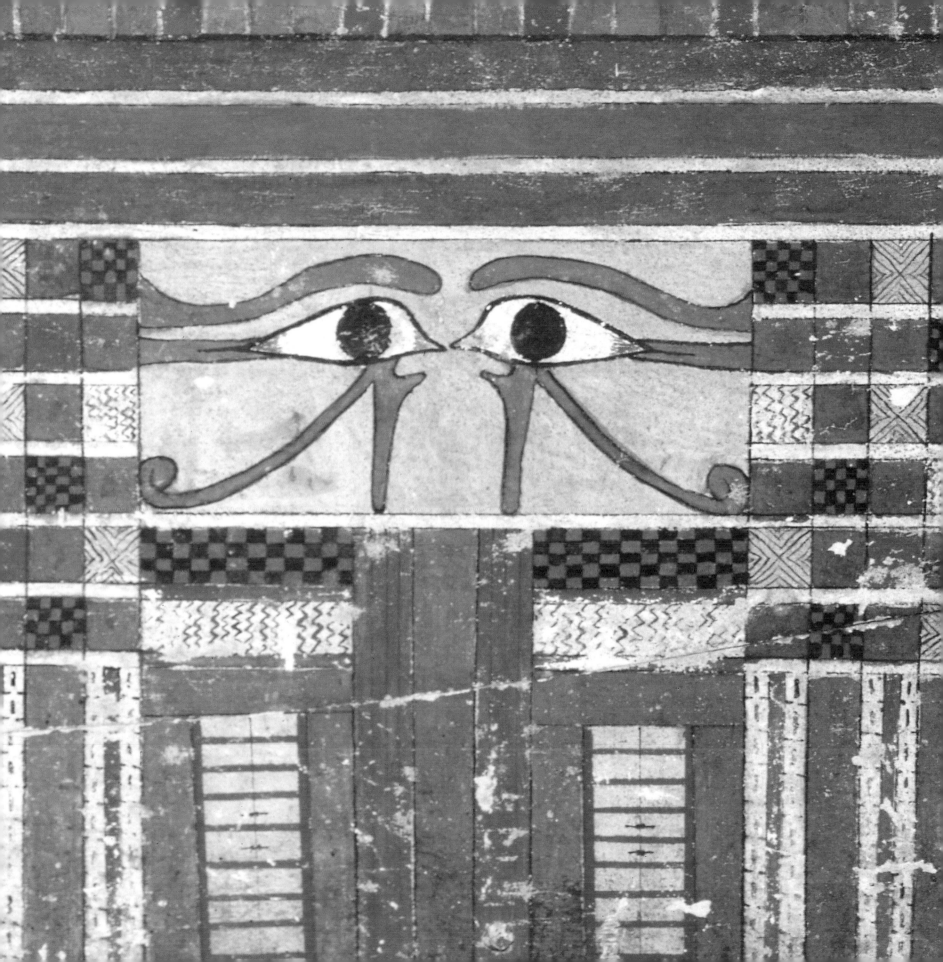

119 Limestone stela of King Wepwawetemsaf from Abydos. The king is unknown apart from this stela, and he was probably one of the last kings of the Thirteenth Dynasty. The small size of the monument and its crude execution suggest that he lacked any great resources. Across the arch of the stela is cut a winged sun disk with two *uraei* hanging from it. Below, four columns of hieroglyphs name the king, with his throne name on the left and his given name on the right. The main area shows the king on the left standing facing towards a jackal-headed deity, holding a *was*-sceptre and *ankh*, who is identified by the column of inscription between the figures which reads: 'Adoring Wepwawet-Ra, Lord of Abydos.' This reverses the normal orientation where the god would be placed as the right-facing figure, and may relate to where the stela was set up. The two figures are incised, rather than cut into relief, with virtually no modelling. Their proportions exhibit narrow shoulders and waists and a high small of the back similar to proportions found on non-royal figures of this period (see figs 131–2). H. 27.4 cm. End of Thirteenth Dynasty. London, British Museum.

involved in constant hostilities. Certainly the Seventeenth Dynasty rulers were able to erect monuments at Thebes and other southern cities. However, the last king of the dynasty, Kamose, had ambitions to reconquer the north and refused to accept the *status quo*. Although Kamose died before he could finish what he had begun, the Hyksos were eventually driven out of Egypt by his successor, Ahmose.[6] Ahmose was subsequently regarded as the founder of a new era and new dynasty, the Eighteenth.

The king

Senwosret III and Amenemhat III built widely all round the country, in addition to their funerary complexes at Dahshur and Hawara.[7] Large numbers of statues or statue fragments are known for these kings, many of them life-size or colossal.[8] They employ a variety of hard stones – granite, quartzite, basalt and diorite – as well as limestone. Most of them would have been made to stand in temples, where they served not only to present the king to the gods and as ritual focal points but also as embodiments and

reminders of the king's power, strengthening the ties between the king and the local communities where the temples were located. They could also be used to associate the king with prestigious predecessors. Statues erected by Senwosret III in the funerary complex of Nebhepetra linked him with the great Theban king who had reunited Egypt, a fitting connection for a ruler who was in his own way engaged in rebuilding Egypt (fig. 120).[9]

These statues functioned in a similar manner to those of preceding kings. However, instead of the bland, idealised, youthful images of earlier Twelfth Dynasty rulers (fig. 107), the faces of Senwosret III and Amenemhat III display individuality and are immediately recognisable. Senwosret's statues all depict a severe-looking face, but examples vary in the degree of ageing they show.[10] The eyes are deep-set and protruding beneath pronounced brows. Heavy, curving lids cover the upper part of the eyeballs, with pouches modelled under the eyes. The ears are large and low-set, and stick out from the head. Lines run down from the wings of the nose to the downturned corners of the protruding mouth. Below, a strong chin juts forward.

Although the face of Senwosret appears to age, his body does not (fig. 120). It remains idealised as in earlier statues, displaying broad shoulders and musculature that gives an

impression of youth and vigour. In addition, iconography and poses remain traditional. This suggests that, rather than there being any fundamental change in the meaning of the statues, the new facial image was regarded as a suitable, if different, way of displaying the authority and divine role of the king. Without explanatory texts it is difficult for us today to understand how an ancient Egyptian would have read this image. The subjectivity of modern attempts is shown by the range of suggested interpretations – from a ruler worn down by care for his people to a ruthless dictator. Although Senwosret's image appears to be a startling departure from what went before, there is at least one surviving statue of his predecessor, Senwosret II, that portrays the king with 'non-idealising' features,[11] suggesting that Senwosret III was building on an existing trend.

The early portrayals of Amenemhat III were influenced by those of his father, but later a distinct image developed that became fixed for the rest of the king's reign and did not age (fig. 121).[12] As with his father, the ears are low-set, large and protruding, lines run from the wings of the nose to the corners of the mouth, the lips are pushed forward and the chin is strong. However, the eyes are more shallowly set than in Senwosret's images, the brows are only lightly modelled, the eyeballs are almost flat and the lips do not turn down. The two kings can, then, be told apart.

Representations of the king were not confined to monumental works. For example, the designs of pectorals worn by royal women could incorporate the motifs of the king smiting or trampling his enemies. Several caches of jewellery have been found in connection with otherwise plundered burials of royal women in the pyramid complexes of Amenemhat II and Senwosret III.[13] One cache belonged to Mereret, who lived during the reigns of Senwosret III and Amenemhat III and owned two pectorals depicting the king. One with the name of Senwosret III shows him as a falcon-headed sphinx trampling enemies, an image that was common in Old Kingdom funerary complexes (fig. 122). The second with the name of Amenemhat III shows the king smiting foreigners.[14]

The frame of the pectoral naming Senwosret III imitates a shrine with a cavetto cornice supported by slender pillars with lotus capitals. The composition divides into two balanced parts around a central axis. Across the top a vulture hovers with outspread wings. Its vertical body lies on the scene's dividing axis, while the horizontal span of the wings spreads over the two halves, binding them together. Immediately below the vulture's body is a cartouche with the throne name of Senwosret III. On either side two sphinxes face towards the cartouche, which they support with their

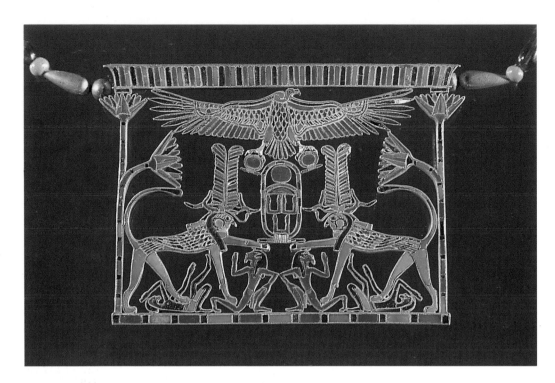

122 Pectoral of the royal woman Mereret from her burial in the pyramid complex of Senwosret III at Dahshur. Gold, carnelian, lapis lazuli and turquoise, H. 6.1 cm. Later Twelfth Dynasty. Cairo, Egyptian Museum.

ifestations of chaos, these disasters could be warded off by images of the king triumphantly enforcing order over the chaotic elements of the universe. Such pectorals would have been confined to royal wearers.

Non-royal monuments and associated objects

In addition to the disappearance of large, decorated tombs from provincial cemeteries, there were changes in the types of objects placed in tombs.[15] Wooden tomb models declined drastically in number and variety and were replaced by small, faience models of food items. Further, a number of items that are known from settlements sites to have been used by the living – magic wands[16] and rods, models of protective animals and fertility figurines – were now also placed with the dead. The wands and the rods carry images of various deities, mythical and real animals, and hieroglyphs that help the sun god fight and overcome his enemies (figs 123–4). Their purpose was to summon these protective powers to guard newborn children and infants from the malevolent spirits and dead that sought to harm them. Since death was equated with rebirth into the afterlife, the newly dead were as vulnerable as the newly born, and methods devised to safeguard the newborn in this world also worked to protect the newly dead during their dangerous transition into the next world. Single figures of protective animals featured on the wands and rods, including lions, baboons and crocodiles, are also found in settlements and burials. The images of lions and crocodiles show how the Egyptians hoped to harness the aggressive power of these terrifying animals and use it for their own protection. In much the same way the king, since early times, had worn the image of the rearing cobra (*uraeus*) on his forehead: the deadly powers of the creature were controlled by the king and turned against his enemies.

Fertility figurines represent nude female figures with their pubic region carefully marked (fig. 125).[17] Commonly made of limestone or faience, they often wear elaborately arranged hairstyles, some even having hair in a different material inserted through holes in the head. In more detailed examples the figure wears jewellery and has tattooing or body painting on the thighs. Sometimes a child is carried. The figures are generic images that related to the general notion of fertility, encompassing sexuality, conception and the successful bearing and rearing of children, that ensured the continuity of the family and society as a whole. However, like the magic wands and rods, fertility figurines were also potent icons for the dead, helping and protecting them as they were reborn into the next world.

far forepaws. Underneath on each side a kneeling enemy looks back toward the sphinx with a hand raised in supplication. The sphinx's other paw tramples on the leg of its victim. A second enemy writhes on his back under the hind leg of each sphinx. The balanced nature of the composition into which the chaotic poses of the foreigners are subsumed signifies the ordered world triumphant over the forces of chaos.

The pectoral is worked in cloisonné with a framework of gold, and cells inlaid with pieces of carnelian, turquoise and lapis lazuli. Highly valued and widely used in jewellery making, these stones had to be obtained from outside Egypt. Expeditions were sent to Sinai for turquoise – a large number are recorded for the reign of Amenemhat III in particular – and to the eastern desert for carnelian, while lapis lazuli arrived in Egypt along international trade routes from the region of present-day Afghanistan. Thus the circumstances of the stones' procurement added to their prestige.

Whenever Mereret wore this pectoral she would have displayed a potent image of royal power to all those privileged to see it, which reinforced the authority of the king and the proper cosmic order. In addition the image would have functioned on a more personal level to protect its wearer against malign influences. Since the Egyptians believed that misfortune and disease were caused by the malevolent dead and hostile spirits, which were clear man-

123 Apotropaic wand with images of various deities and real and mythical animals, intended to safeguard the living and the newly dead against malevolent spirits. The aggressive nature of the lions and snakes is harnessed to protect the owner of the wand. The composite image of Ipi is made up of the head of a hippopotamus and the limbs and paws of a lion, with a stylised crocodile tail as her mane. She carries a *sa*-hieroglyph meaning 'protection' and a knife to fight off harmful entities. The frog represents Heqat, the goddess of childbirth, and the scarab beetle the newborn sun. Hippopotamus ivory. L. 36.5 cm. Twelfth to Thirteenth Dynasty. London, British Museum.

124 Apotropaic rod decorated with images of protective animals. The rod consists of three hollow segments, the longest of which is in the middle, each made in the form of a reed mat. The two end segments are carved on both sides with the protective *wedjat*-eye and a lamp watched over by a squatting baboon. The middle section is divided in two. On one side is a crocodile and a stalking cat, and on the other a crocodile and a lion and crouching cat. Separate figures of individual animals are attached by pins to the top of the rod. At either end two lions face outwards, a well-known symbol for the two mounds of the horizon between which the sun rises each day. Between them are attached two crocodiles, two frogs and a turtle that together with various felines acted as the sun's helpers and protectors. The object symbolised the triumph of the sun over the dangers that lurk in the underworld every night. The rod protected the highly vulnerable state of the newly deceased and guaranteed rebirth. Possibly from a tomb near Heliopolis. Glazed steatite, L. 28 cm. Late Twelfth to Thirteenth Dynasty. New York, Metropolitan Museum of Art.

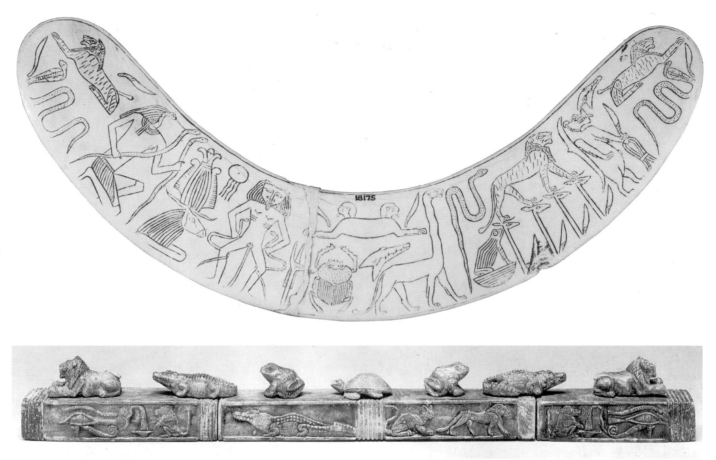

In the later Twelfth Dynasty coffins with interior decoration became rare, while decoration on the outside became more elaborate (fig. 127).[18] The top of the coffin was now often painted with a design taken from the cavetto cornice, an architectural element that often surmounted chapels, shrines, gateways and doors. On the sides it was now common to depict a false door below the eye panel, and as time went on the other spaces between the inscriptions were also painted with elaborate versions of false doors. Sometimes a pile of offerings would be substituted for one of the false doors,[19] and a figure of Isis might appear on the foot of the coffin and one of Nephthys on the head end.[20] Since Isis and Nephthys mourned the dead Osiris before bringing him back to life, the presence of these goddesses identified the deceased with Osiris, thus guaranteeing his resurrection in the next world. This was an important development, because it was only at this period that figures of deities began to be depicted on non-royal objects.

In the mid Twelfth Dynasty a new type of coffin was introduced alongside the older rectangular type. Made of wood or cartonnage (layers of linen and plaster), these coffins imitated the form of a body wrapped in white linen with a large beaded collar placed on the chest and a funerary mask on the face.[21] They were the first coffins to be made in human or anthropoid form, a shape that would remain in use from this time on. At Thebes during the Seventeenth Dynasty the anthropoid coffin developed a new type of decoration in the form of a pair of wings wrapping the body from the shoulders to the feet (fig. 126).[22] Such coffins are usually called *rishi*-coffins from the Arabic for 'feather'. The wings may represent the wings of Isis wrapped protectively around the deceased. An image of the vulture goddess Nekhbet often spreads its wings across the chest region in a further gesture of protection.

During the late Twelfth and Thirteenth Dynasties the numbers of private statues (figs 128–9) and stelae (fig. 130) grew, although the size and quality of workmanship of the great majority declined.[23] It became increasingly common to dedicate such monuments in temples and shrines, a new phenomenon, as well as in tombs and memorial chapels.

125 Fertility figurine of blue Egyptian faience with details added in black. The figurine emphasises the belly, the hips, around which a girdle of cowrie shells is worn, and the pubic area. The legs are not broken but intentionally end at the knees. This is a common characteristic of such Middle Kingdom figurines, perhaps meant to limit the figure's power of movement or possibly because the lower legs were regarded as inessential to the figure's function. Such figurines were potent images for the living and the dead, encompassing the notion of fertility and family continuity in this life, and the protection of the dead as they were reborn into the next life. From Thebes. H. 8.5 cm. Twelfth to Thirteenth Dynasty. London, British Museum.

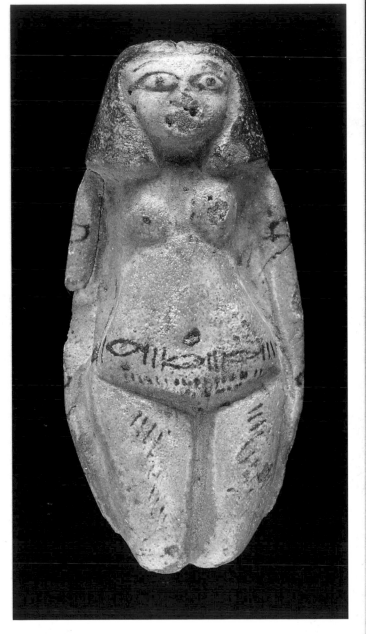

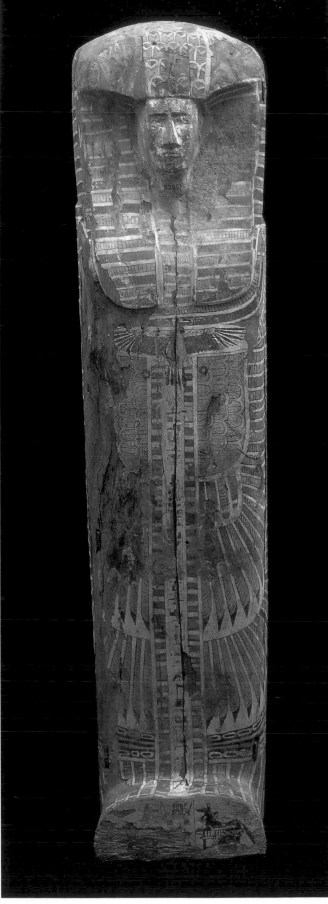

126 *Rishi*-coffin of painted sycomore fig, decorated with a pair of brightly painted wings that wrap the body from shoulders to feet. Across the chest the goddess Nekhbet is shown in her vulture form with her wings outspread in protection, while an inscription containing the offering formula runs down the centre of the lid. Two images of the god Anubis in jackal form lying on a shrine face each other on the foot of the lid. Probably Thebes. H. 191 cm. Seventeenth Dynasty. London, British Museum.

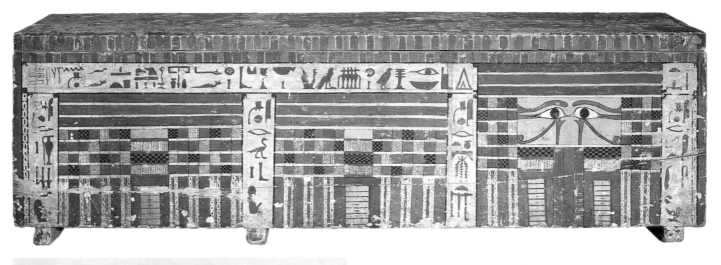

127 Exterior view of the inner wooden coffin belonging to a priest called Amenhotep. The traditional *wedjat*-eye panel at the north end of the east side is incorporated into an elaborately painted false door. Brightly patterned false doors also fill the other panels between the vertical columns of inscriptions, spaces that were previously left blank. At the top the edge of the coffin and its lid are painted with a coloured pattern resembling the decoration commonly found on a cavetto cornice, giving an architectural dimension to the coffin. Painted wood, L. 200 cm. Twelfth to Thirteenth Dynasty. London, British Museum.

128 Quartzite standing statue of the official Senebtyfy showing the voluminous garment commonly worn by elite men in the late Twelfth and Thirteenth Dynasties. H. 51.5 cm. Thirteenth Dynasty. London, British Museum.

129 *far right* Quartzite seated statue of Ankhrekhu, showing the official wrapped in a garment that envelops him from his shoulders to his ankles. Although the shape of the arms is visible under the cloak, only the hands emerge. This type of garment came into fashion for male statues in the later Twelfth and Thirteenth Dynasties. It was revived from time to time in the Eighteenth and Twenty-fifth Dynasties by artists who drew inspiration from later Middle Kingdom models (see fig. 168). The face of Ankhrekhu belongs to the non-idealising type used to represent the mature official at this period and ultimately derived from the royal images of Kings Senwosret III and Amenemhat III. Heavy upper eyelids curve over deep-set, protruding eyes; fleshy cheeks sag to form a line running obliquely down from each side of the nose; thin lips form an unsmiling mouth; and large ears are pushed forward by the wig. H. 71 cm. London, British Museum.

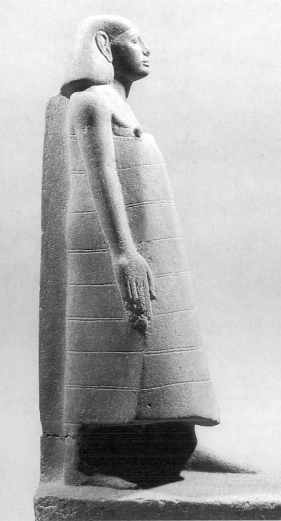

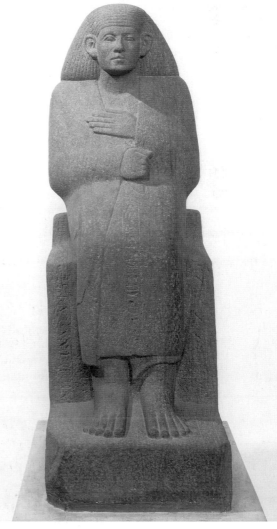

130 Round-topped limestone stela of the official Senbi, from Abydos. In the central register Senbi is shown seated with three male figures standing facing him. Below, ten figures kneel in two registers, separated from each other by a vertical column of inscription, so that the individual figures are enclosed in their own rectangular space, a common compositional arrangement on stelae of the late Twelfth and Thirteenth Dynasties. At the top of the stela, under the pair of *wedjat*-eyes, are five columns of text containing two offering formulae invoking Ptah, the god of Memphis, and Amun-Ra of Thebes. In addition the two deities are depicted on either side of the inscription, Ptah to the left and Amun-Ra to the right. The representation of divine figures on non-royal monuments is an innovation that does not occur before the late Twelfth Dynasty. H. 90 cm. Late Twelfth to Thirteenth Dynasty. London, British Museum.

They were placed in the outer areas of the temple, rather than in the more sacred inner parts. Nevertheless their function was to associate their owners with the deity, so that they would participate in the rituals performed in the temple and share in the offerings made.

Statues representing single figures continued to be common, but in addition statue groups showing three, four or five figures became increasingly popular.[24] Stelae, as before, display great variety in composition, but several changes distinguish them from earlier examples. There is a tendency to include many more figures representing family members or other associates of the owner (fig. 130), while texts no longer feature 'biographies' but record the basic offering formula and often list the names of people to be commemorated; hymns to Osiris or Min may also be included.[25] For the first time images of deities being adored by the owner appear on non-royal stelae (fig. 130), paralleling the appearance of Isis and Nephthys on coffins during this period.[26] The majority of stelae come from Abydos and show the ithyphallic god Min, here identified with the triumphant Horus, son of Osiris, who avenged his father, but other deities appear also.

The human figure

Changes in the proportions of the human figure occur in the later Twelfth Dynasty and remain effective throughout the Thirteenth to Seventeenth Dynasties.[27] In their most extreme form male figures have small heads in proportion to the rest of the body, narrow shoulders and waists, a high small of the back, slender limbs and no visible musculature (fig. 131). Although these various features do not always occur together, the presence of even some produces figures that are very different from the broad-shouldered, long-backed, muscled figures of the early part of the Twelfth Dynasty. Female figures display even narrower shoulders and waists, slenderer limbs and a higher small of the back in order to maintain the natural distinction between male and female proportions (fig. 132).

Although women continue to wear the traditional close-fitting sheath dress, men frequently wear a long garment that ties round the body a good way above the natural waist, sometimes as high as under the arms. This heightens the impression of a small upper part of the body already created by the high small of the back. In two dimensions the long garment can be transparent, revealing a short kilt underneath that runs from near the natural waist to above the knee (fig. 132). When worn by statues the long, opaque garment billows out in front, so that in profile the figure looks to be of enormous girth, increasing the bulk of most of the body in comparison to the small area of the upper torso left uncovered (fig. 128). Statues of men can also wear an enveloping robe that wraps around the body, leaving only the hands, ankles and feet free (fig. 129), contrasting strongly with statues earlier in the dynasty that wore only a knee-length kilt (fig. 115).

In late Twelfth and Thirteenth Dynasty private statuary, the modelling of the face is often an amalgam of the images of Senwosret III and Amenemhat III.[28] The eyes tend to protrude under heavy lids. The thin lips may turn down like Senwosret's or be straight like Amenemhat's. Oblique lines run down from the wings of the nose, the chin is firm and

131 Detail from a stela of the official Nebipusenwosret showing the deceased standing facing right. The figure is worked in high-quality raised relief and displays proportions typical of the later Twelfth Dynasty, with slightly narrow shoulders and a high small of the back. This reduces the size of the upper torso in relation to the rest of the body, an effect that is heightened by the fashionably high level at which the waistband of the long kilt is tied. Probably from Abydos. Limestone. Late Twelfth Dynasty, reign of Amenemhat III. London, British Museum.

132 Detail from the limestone obelisk stela of the official Sebekhotep, son of Sebeknakht, with the cartouches of King Sekhemrashedtawy Sebekemsaf II of the Seventeenth Dynasty. The figure of Sebekhotep shows the typical proportions found in the late Twelfth to Seventeenth Dynasties, with small head, narrow shoulders and high small of the back. The long over-skirt, tied some way above the top of the knee-length kilt, and here treated as transparent, is typical of male dress of the period. The rather awkward cutting of the relief is characteristic of many private stelae of this time. Seventeenth Dynasty. London, British Museum.

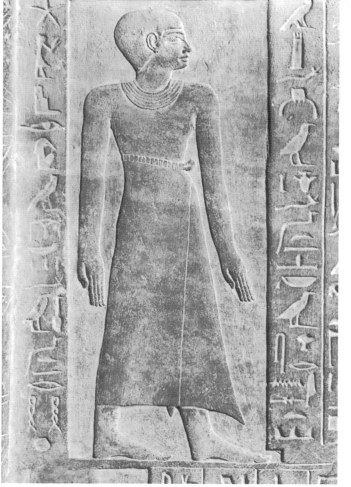

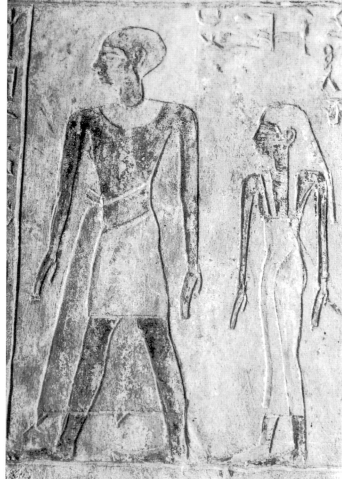

the ears are large, low-set and everted (fig. 129). The resulting faces are by no means copies of one another, but they all have an underlying resemblance arising from their common inspiration.[29]

The figure of the Thirteenth Dynasty king Wepwawetemsaf from Abydos exhibits many of the changes found in private figures (fig. 119). However, good-quality royal figures tend to be rendered more conservatively than private figures. The Seventeenth Dynasty king Sekhemrawadjkhau Sebekemsaf decorated a gateway in the temple of Medamud near Thebes, originally erected by Senwosret III, with scenes showing the king offering and smiting enemies before the god Montu (fig. 134).[30] The scenes are worked in crisply cut, high raised relief, with interior details on the figures and the hieroglyphs meticulously incised into the stone. Within their outlines both figures and hieroglyphs are flat and unmodelled, except for the highly

stylised musculature displayed on the legs. The figures have broad shoulders, waists and limbs, and long torsos in relation to the whole body.

A statue of the same king, probably set up in the temple of Karnak, exhibits somewhat different proportions (fig. 133).[31] Although the right side of the throne, ankles, feet and pedestal are restored, it can be calculated that the red granite figure was originally about 1.8 m high, somewhat over life size. The shoulders are proportionally rather narrow, and the waist is high and pinched. This combination gives the impression of a small upper torso in relation to a long lower part of the body.

The high quality of this statue shows that the royal workshops at Thebes contained good artists at this date. The figure was once embellished by inlaid eyes, with overlays attached to the eyebrows and cosmetic lines. Unusually, the back of the throne is decorated with two figures of the god-

133 Red granite seated statue of King Sekhemrawadjkhau Sebekemsaf I, probably from Karnak. H. originally about 180 cm. Seventeenth Dynasty. London, British Museum.

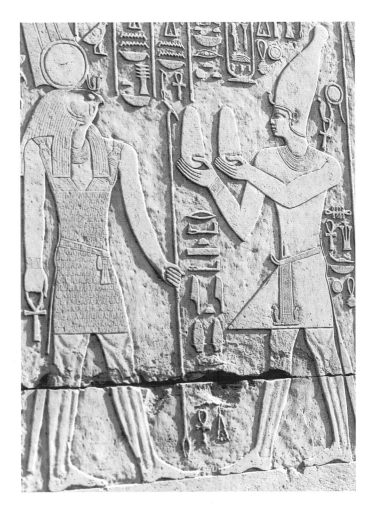

134 Scene from a gateway in the temple of Medamud decorated by King Sekhemrawadjkhau Sebekemsaf I, showing the king offering two cakes to the god Montu. Limestone. Seventeenth Dynasty.

dess Ipi standing back to back. Ipi, a composite animal figure usually shown pregnant, is one of the deities that appears on the magic wands in order to provide protection to newborns and their mothers. Here her figure, abnormally appearing in a monumental temple context, is used to protect the king. An inscription between the two figures that reads 'all protection and life are behind him' reproduces a standard formula used in royal temple relief of all periods.

Conclusion

The proliferation of monuments, as people lower down the social scale gained the resources to commission statues and stelae, led to a tremendous variation in quality. Workshops staffed by artists outside the royal network must have sprung up to supply the increased demand. During the Thirteenth Dynasty, as the king gradually found his territory and resources reduced by the encroachment of the Hyksos, even the quality of the royal workshops was affected. Nevertheless, it is clear that the kings of the Seventeenth Dynasty, even though they controlled only Upper Egypt, were able to command the resources and artists to produce high-quality work. Thus, while many monuments of the Second Intermediate Period exhibit poor composition and execution, the period cannot be dismissed as one that produced no works of artistic merit.

Notes
1 Franke 1991.
2 Bourriau 1991, 8.
3 Quirke 1990a.
4 Bietak 1979; 1996.
5 Bourriau 1988, 72–3.
6 Vandersleyen 1971.
7 Simpson 1984; von Beckerath 1975; Arnold 1982, 1266–7; Edwards 1993, 213–27.
8 F. Polz 1995.
9 Naville 1907, **37**, **57**, pl. 19; 1910, 20, pl. 2; 1913, 10–12, pls 1, 21.
10 Desroches Noblecourt 1981, nos 213–15; Bourriau 1988, 37–9, 41–4 nos 28–30.
11 Seipel 1992, 158 no. 43.
12 Bourriau 1988, 39, 44–6 nos 31–2.
13 De Morgan 1895, 60–72, pls 16–24; 1903, 50–68, pls 5–13; Brunton 1920; Winlock 1934.
14 Saleh and Sourouzian 1987, no.110.
15 Bourriau 1991, 11.
16 Altenmüller 1986.
17 Bourriau 1988, 122–7, esp. nos 118–20.
18 Lapp 1983; 1993; Willems 1988, 161–4 (Type VI); Taylor 1989, 23, fig. 14.
19 Curto *et al.* 1990, nos 156–7.
20 E.g. Bourriau 1988, 90–1 no.71; Taylor 1989, fig. 15.
21 Bourriau 1988, 91–2 no.72; Taylor 1989, 24–5 fig. 16.
22 Sourouzian 1984; Taylor 1989, 28.
23 Bourriau 1988, 53–4.
24 E.g. Vandier 1958, pls 84–5.
25 Bourriau 1991, 15.
26 Malaise 1984.
27 Robins 1994a, 249–54.
28 Bourriau 1988, 55.
29 It has recently been argued that these non-royal images developed first and that the images of Senwosret III and Amenemhat III were derived from them: Bianchi 1995, 2550; 1996, 64, 82.
30 Bisson de la Roque 1930, 94–104, pls 6.2–7, 10–11, 13–14.
31 Davies 1981.

A new momentum

THE NEW KINGDOM (I)

The first king of the Eighteenth Dynasty, Ahmose, belonged to the Theban Seventeenth Dynasty royal family. Towards the end of his reign he triumphantly concluded Kamose's struggle against the foreign Hyksos in the north and once more reunited Egypt.[1] This led him to be regarded as the founder of a new era. The role played by Thebes in the reunification reconfirmed the importance of the city and its god Amun-Ra. Although Eighteenth Dynasty kings spent most of their time at Memphis and other northern sites, Thebes remained the place of royal burial, guaranteeing it a high degree of royal attention.

Owing to chances of survival, we know far more about Thebes than we do about the great royal centre at Memphis, home of the national god Ptah, or the cult centre of the sun god at Heliopolis, cities that were together at least as important and rich as Thebes. Further, most of what we know about Thebes relates to stone-built temples and rock-cut tombs. The mudbrick houses of the city have long since vanished, their few remaining traces lying under present-day occupation. So we have an abundance of information about the gods and the dead, but less about the living, although the remains of a number of palaces are known.

After the expulsion of the Hyksos the kings of the Eighteenth Dynasty went on to acquire an empire, expanding their territory both south and north. Eventually their southern border lay far upstream in Nubia between the fourth and fifth Nile cataracts, and their northern border was situated in Syria. Control of the gold mines of Nubia gave the king great wealth, which made him a major player in the diplomatic network of the ancient Near East, especially during the late Eighteenth and Nineteenth Dynasties. The aggressive policies of Thutmose I, Thutmose III and Amenhotep II that won Egypt its empire in Syria were replaced in the reign of Thutmose IV by a peace treaty with the Mitanni, Egypt's most powerful opponents in the region. The rewards of peace were reaped by Amenhotep III, whose reign was one of the wealthiest and most luxurious in the history of Egypt.[2]

The king

The royal funerary complex

The tombs of Ahmose and his son, Amenhotep I, have not been located. They may have been situated in the Seventeenth Dynasty royal cemetery, which still awaits discovery.[3] Subsequent kings cut their tombs in the cliffs of the Valley of the Kings, a *wadi* (dried-up river valley) behind the rock escarpment on the west bank of the Nile.[4] Long passageways, linked by intermittent stairs, led to a burial chamber and side rooms where the funerary equipment was stored. The burial chamber was decorated with a funerary text (fig. 136), not known from earlier, called the *Book of the Hidden Chamber* (later subsumed under the term *Amduat* along with other similar texts), and with images of the king with the funerary deities Osiris, Anubis and Hathor, goddess of the west, who hold out the sign of life (*ankh*) to the king, as a guarantee of renewed life in the next world (fig. 137).

In the tombs of Thutmose III and Amenhotep II texts are written in red or black paint in cursive hieroglyphs, and images appear as black stick figures, all on a cream background in imitation of an unrolled papyrus (fig. 136).[5] Their purpose is to describe the journey of the sun god through the twelve hours of the night from the western horizon to the eastern. The Egyptians imagined the underworld as a dangerous place that frequently worked in ways contrary to

135 Colossal quartzite head wearing the red crown of Lower Egypt, from one of a series of statues of King Amenhotep III erected on the north side of the sun court in his funerary temple at Thebes. The statues were placed between the columns and stood with their feet together in the passive stance of mummiform deities like Osiris, although the king was shown wearing a kilt rather than wrapped as a mummy. H. 131 cm. Eighteenth Dynasty. London, British Museum.

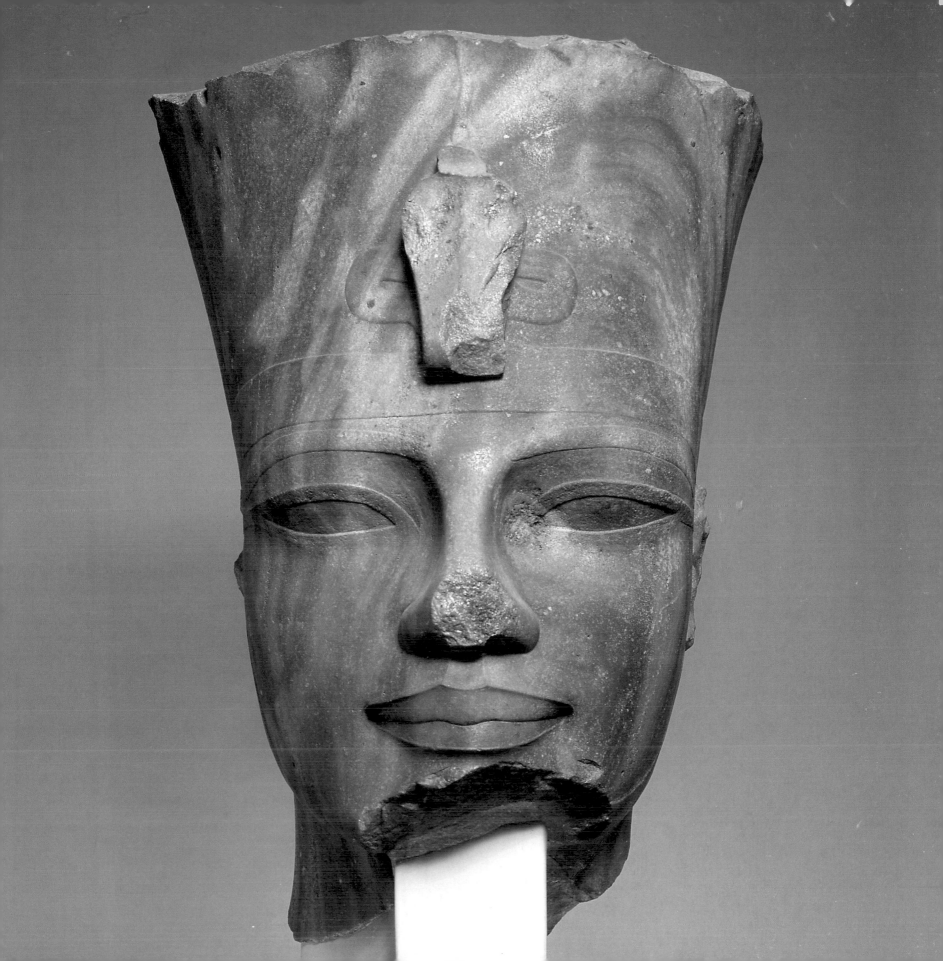

136 Part of the decoration of the burial chamber of King Amenhotep II, showing the seventh hour of the sun god's journey through the underworld. In the top register the god Osiris, protected by a snake, watches the decapitation of his enemies by a god with cat's ears. Below, the solar boat moves towards the deadly Apophis snake that tries each night to prevent the sun from completing his journey to the eastern horizon. Here the snake's threat has already been overcome, for his body is pierced along its length by a series of knives. In the bottom register the god Horus, seated on a throne, addresses the hours 'who protect Ra and fight for him in the underworld'. Valley of the Kings, tomb no.35. Paint on plaster. Eighteenth Dynasty.

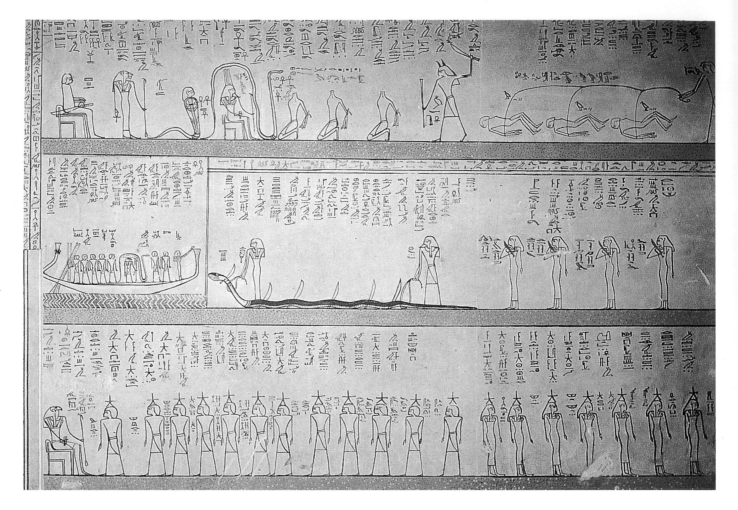

the known universe[6] – people may have to walk on their heads, and directions are confused – so that the way through it was far from straight. Every night the great serpent, Apophis, representing the chaos of non-being existing outside creation, tries to destroy the world by stopping the sun on his journey to the eastern horizon.

Despite these dangers, the underworld has another side, an endless capacity for renewal.[7] The reversals that characterise the region include the peculiarity that time runs backwards. As the sun god crosses the sky during the day he ages, but during the night, as he travels through the underworld, he is rejuvenated, so that when he rises again in the east he appears as a child. This model of cyclical renewal is what the king hoped to draw on by merging with the sun god on his journey. The royal tomb, therefore, was conceived as a microcosm representing the underworld, through which the sun passed from sunset to triumphant birth at sunrise.

In the Eighteenth Dynasty the place where the funerary cult of the dead king was carried out no longer lay adjacent to the place where he was buried, but was situated nearer the river on the edge of the cultivation. Further, it housed cults of Amun-Ra and other deities, and in many ways functioned like a state temple. The best-preserved was built by the female king Hatshepsut in the great bay in the cliffs at Deir el-Bahri, next to the funerary complex of Nebhepetra Montuhotep (fig. 138).[8] The raised platform and the use of pillared colonnades in the Eleventh Dynasty temple may have provided one source of inspiration for the architecture of Hatshepsut's complex. Contemporary tomb chapels cut in the Theban cliffs also had pillared façades, so that Hatshepsut's temple can also be seen as a grander version of this type of Theban funerary architecture.

A valley temple, now lost, was linked to the funerary temple by an open causeway.[9] The temple stood on three different levels. The first two levels consisted of large open

137 Decorated wall in the tomb of Thutmose IV in the Valley of the Kings (no. 43) showing the king being given life by the deities Hathor, Osiris and Anubis. Paint on plaster. Eighteenth Dynasty.

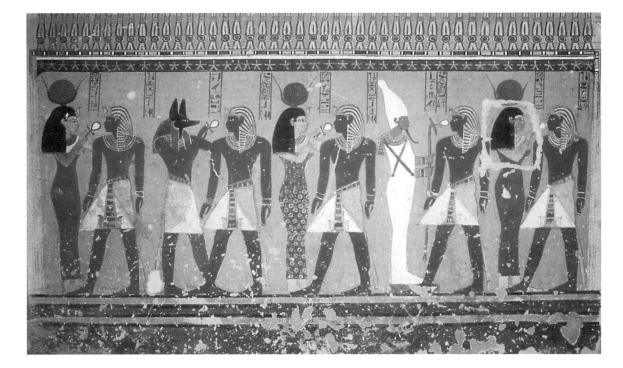

138 View of the funerary temple of King Hatshepsut at Deir el-Bahri, Thebes, built to the north of the Eleventh Dynasty temple of King Nebhepetra Montuhotep. Dedicated to the god Amun-Ra, it housed the funerary cults of Hatshepsut herself, her father King Thutmose I and probably also those of her father's mother, Senisonb, and her own mother, Ahmose. In addition it served as the end point of the great Festival of the Wadi, when the divine boat of Amun was processed to the west bank to visit the royal funerary temples, finally reaching the bay or *wadi* at Deir el-Bahri that gave the festival its name. Late in his reign, around year 43, King Thutmose III began to build his own temple at Deir el-Bahri between the two existing ones. This project coincided with the king's campaign to erase Hatshepsut's name and image from her monuments. The function of the new temple was to replace Hatshepsut's temple as the final stopping place for the boat of Amun, perhaps because the presence of the divine boat in the funerary temple of a king confirmed that king's legitimate place among the royal ancestors. Eighteenth Dynasty.

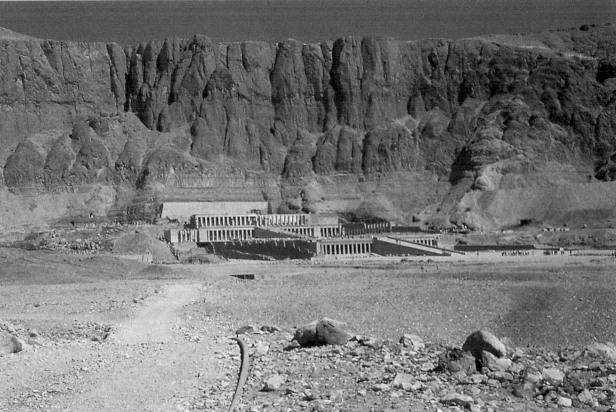

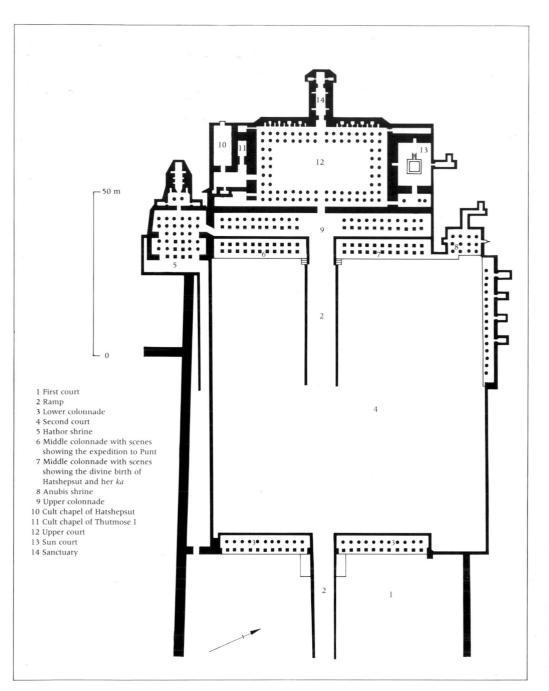

50 m

0

1 First court
2 Ramp
3 Lower colonnade
4 Second court
5 Hathor shrine
6 Middle colonnade with scenes
 showing the expedition to Punt
7 Middle colonnade with scenes
 showing the divine birth of
 Hatshepsut and her *ka*
8 Anubis shrine
9 Upper colonnade
10 Cult chapel of Hatshepsut
11 Cult chapel of Thutmose I
12 Upper court
13 Sun court
14 Sanctuary

139 Plan of the funerary temple of King Hatshepsut at Deir el-Bahri, Thebes. Eighteenth Dynasty.

the other up the cliff face (fig. 138). The vertical lines formed by their pillars echo the vertical striations of the cliffs rising behind the temple.

The temple was decorated throughout with painted relief (figs 140–1). Some of the subject matter is familiar from earlier funerary complexes. For instance, on the north side of the lower colonnade, scenes once showed the king fishing and fowling, and as a trampling sphinx. Fragments of texts relating to a foreign campaign of Hatshepsut suggest there were once battle scenes here, as on the lower colonnade of Montuhotep. Other scenes are peculiar to Hatshepsut, like those on the south side of the lower colonnade that show the transport of obelisks by river and their subsequent presentation to Amun by the king.[10]

The south side of the middle colonnade records an expedition sent by Hatshepsut to the land of Punt to fetch items such as cattle, giraffes, panthers, leopard skins and above all incense trees and incense for use in temple ritual.[11] Punt, known from as early as the Old Kingdom, was both semi-mythical and an actual place, probably located at this time somewhere in modern Eritrea or southern coastal Sudan. Although the scenes surely record an actual event, they also represent the theme of Egyptian domination over foreigners, cast here as the exploitation of foreigners and their resources. The reliefs depict the inhabitants of Punt submitting to the demands of the Egyptians, and the ruler of Punt is made to greet the visiting Egyptians with his arms raised in the gesture of adoration normally used by Egyptians before deities. His enormously fat wife, the exact opposite of the Egyptian notion of female beauty, is also shown, perhaps to stress the otherness of these people. The products of the foreign land are brought to Egypt, presented to Amun-Ra and put to use in the service of the gods.

The opposite side of the colonnade is decorated with two series of scenes designed to legitimise the rule of Hatshepsut as king. Hatshepsut was the daughter of Thutmose I and the principal wife of Thutmose II. When the latter died leaving as his heir a young son by a secondary wife, Hatshepsut became regent for the boy. However, at some point between regnal years 2 and 7 of the young king, Hatshepsut herself took the full titulary of a king and became co-regent with Thutmose III. In order to justify this unusual step she claimed that her father, Thutmose I, had chosen her as his successor during his lifetime, introducing her to the court and to the deities of Upper and Lower Egypt as his heir and crowning her as king. These events are recounted in the upper register of the colonnade.[12] Below them is depicted the divine birth of Hatshepsut and her royal *ka*.[13] Amun-Ra visits the king's principal wife Ahmose in the guise of her

courts with central ramps leading to the level above (fig. 139). The third level comprised a colonnaded court, with a series of rooms on either side, and the main sanctuary, for the cult of Amun-Ra, was cut back into the cliff. The most noticeable features of the temple when viewed from the east are the three pillared colonnades that rise one above

140 Detail from the decoration of the funerary temple of King Hatshepsut at Deir el-Bahri, Thebes, showing the goddess Nekhbet as a vulture hovering with its wings outstretched. The bird form of Nekhbet ultimately derives from the griffon vulture but is normally rendered in a highly conventionalised way in Egyptian art. Although the white head and neck are found in nature, the bright red and blue plumage owe more to artistic licence than to reality. Eighteenth Dynasty.

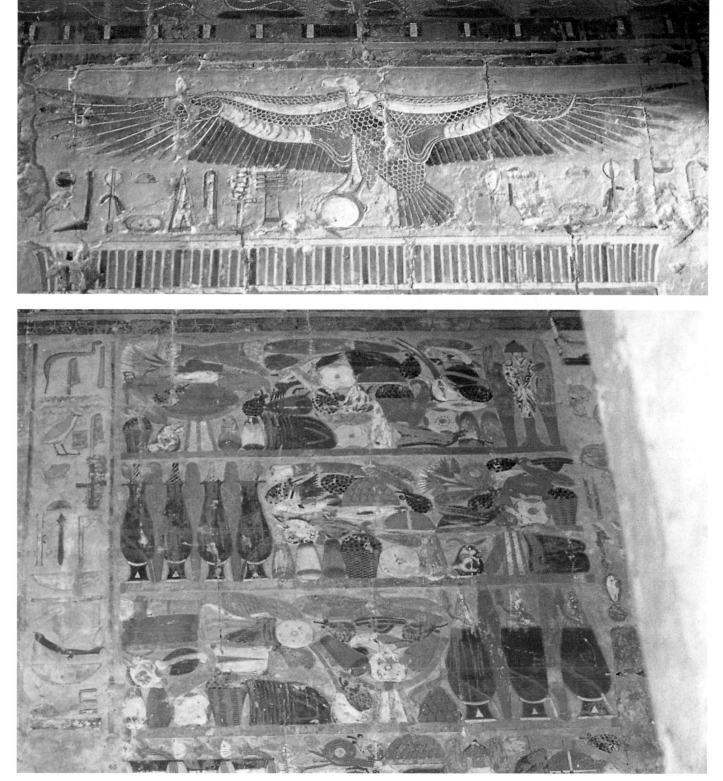

141 Detail from a scene showing the god Anubis seated before offerings in the funerary temple of King Hatshepsut at Deir el-Bahri, Thebes. The brightly painted offerings are heaped high in a series of registers that run almost the full height of the wall and provide a visual display of the abundant offerings of food and drink presented to the deities of the temple. Among the items seen here are jars of various types of drink, an assortment of loaves, cuts of beef and different sorts of fruit and vegetables. Eighteenth Dynasty.

142 Fragment from the head of a mummiform statue of King Hatshepsut. This head comes from one of a series of ten statues that stood in shallow niches cut in the rear wall of the upper court of Hatshepsut's funerary temple at Deir el-Bahri, Thebes. Painted limestone, H. approx. 38,5 cm. Eighteenth Dynasty. New York, Metropolitan Museum of Art.

143 Colossal kneeling statue of King Hatshepsut, restored from fragments. The statue is one of eight that were set up in the upper court of Hatshepsut's funerary temple to line the way to the entrance of the sanctuary. The king kneels and offers two *nu*-jars, often associated with the offering of wine. However, the gesture can also symbolise the general notion of offering, since an image of an outstretched arm holding a *nu*-jar is used as a hieroglyph to write words meaning 'to offer', and this must be the case here, for a text on the base of the statue refers to 'offering Maat [the correct order of the universe] to Amun'. From Deir el-Bahri, Thebes. Red granite, H. 259 cm. Eighteenth Dynasty. New York, Metroplitan Museum of Art.

figures of Hatshepsut seated in front of offerings.[15] Also in the upper court, a series of kneeling statues showed the king presenting two jars (fig. 143). Further mummiform statues flanked doorways in the sanctuary. Other statues showed the king standing, seated and in the form of a sphinx.

The majority of Hatshepsut's images show her as a male king in male dress and without female breasts. A few, however, show her in female dress (fig. 144).[16] It is possible that, when she first proclaimed herself king, artists tried to reconcile her biologically female sex with what was traditionally a male gender role. The result may have been felt to be unsatisfactory, since for most of her reign Hatshepsut was represented by the conventional image of a male king. By contrast her scribes frequently replaced the masculine grammatical gender of traditional royal texts with feminine forms.

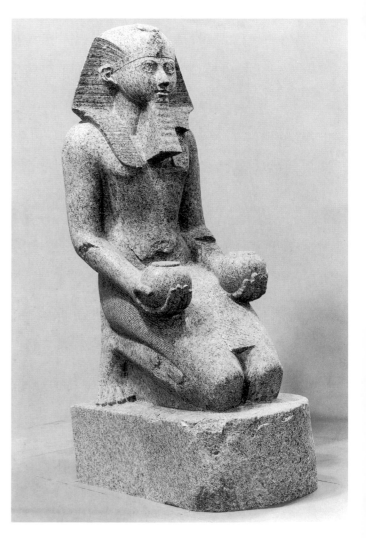

husband Thutmose I, and as a result Hatshepsut is conceived and born. According to this myth Hatshepsut was destined to rule Egypt from the time of her conception, an idea that applied to all kings, but Hatshepsut may have been the first to have her divine birth explicitly depicted in a series of reliefs. The accounts in both registers show that Hatshepsut claimed the throne through her father, and the importance of this relationship is further emphasised by the fact that the temple also housed a cult of Thutmose I.

In addition to the architecture and decoration, the temple was designed as a setting for a vast amount of statuary.[14] As well as architectural sculpture, niches throughout the building were meant to contain statues of the king or deities, and many statues and statue fragments have been recovered from the temple area. Colossal mummiform statues of the king stood in front of the pillars of the upper colonnade. Ten more mummiform statues stood in shallow niches cut in the western wall of the upper court (fig. 142). These alternated with deeper niches that probably held seated statues of the king, since the decorated walls show

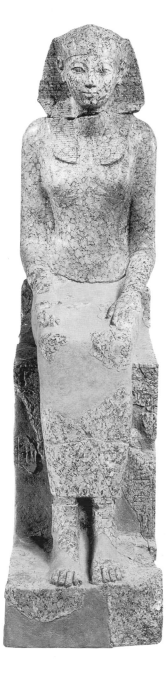

144 *left* Seated red granite statue of Hatshepsut as king wearing a dress, from her funerary temple at Deir el-Bahri, Thebes. The torso was discovered last century and is now in the Rijksmuseum van Oudheden, Leiden. The head and lower part of the statue were found in 1927–8 and are now in the Metropolitan Museum of Art, New York, where a cast of the Leiden piece has been inserted between the two original pieces. Although she is shown wearing female dress, Hatshepsut's status as king is indicated by the *nemes*-headdress and by her throne name Maatkara. Her kingly titles are given in feminine grammatical form: 'perfect goddess' and 'daughter of Ra'. H. 167 cm. Eighteenth Dynasty. New York, Metropolitan Museum of Art.

145 Detail of the decoration above a statue niche in King Hatshepsut's funerary temple at Deir el-Bahri, showing an example of the removal of Hatshepsut's names. Below the winged sun disk three lines give the Horus name, throne name and given name of King Thutmose III on the right. They were originally balanced by the Horus name, throne name and given name of Hatshepsut on the left, but these have been chiselled out. Eighteenth Dynasty.

After a successful reign Hatshepsut disappears from our sources, and Thutmose III became sole ruler. Hatshepsut's claim to the throne had not led to the removal of Thutmose as king. Throughout her reign he was present as co-regent, and his figure appears as part of the original decoration of her funerary temple and other monuments. However, late in his long fifty-four-year reign, he systematically obliterated Hatshepsut's memory by removing her names and figure from her monuments (fig. 145), or else replacing her name by his own or those of earlier kings.[17] The cult of Hatshepsut in her funerary temple was abolished, but the temple itself continued to be a cult centre of Amun-Ra, and also of Hathor, who had a chapel on the south side of the temple. During the annual Festival of the Wadi the sacred boat of Amun-Ra was processed across the river and visited the temple.[18] Thutmose III later built his own temple at Deir

146 The colossal quartzite statues of King Amenhotep III that sit at the entrance to his funerary temple at Thebes. Engaged figures of the king's principal wife, Tiy, stand by his right legs and the king's mother, Mutemwia, by his left. The sides of the thrones are decorated with the *sema tawy* motif, in which fecundity figures tie the plants of Upper and Lower Egypt around the *sema*-hieroglyph. Eighteenth Dynasty.

el-Bahri for Amun-Ra, with a chapel for Hathor between those of Montuhotep and Hatshepsut. Its main purpose was probably to take over the reception of the sacred boat of Amun-Ra at the Festival of the Wadi.[19]

The largest funerary complex at Thebes belonged to Amenhotep III, although little remains today.[20] The precinct was originally enclosed by a mudbrick wall with a towering entrance pylon in the east wall, in front of which sat the pair of colossal quartzite statues known today as the colossi of Memnon (fig. 146). Their function was to guard the entrance to the complex, to inspire awe at the king's might and to celebrate the achievements of the state. The size and location of the statues made them visible even to people

who were barred from entering the precinct within. Engaged figures of the king's mother Mutemwia and his principal wife Tiy stood by the king's lower legs. Together these women represented the combined mother/consort role of the sky goddess through which the sun god renewed himself, so that their presence symbolised the king's perpetual renewal through self-regeneration.

One element in the temple architecture was an open sun court surrounded on all sides by three rows of columns. Between the columns on the north and south sides stood a series of colossal mummiform statues over 8 m tall. Their arrangement demonstrates the importance of ritual orientation in temple architecture. The statues on the south side

wore the white crown of Upper Egypt and were made of red granite from the southern site of Aswan. Those on the north wore the red crown of Lower Egypt and were made of brown quartzite from the northern quarries of Gebel Ahmar (fig. 135).[21]

These statues demonstrate how royal statuary could be used to make religious statements about the king and his relationship to deities. Both stones used had solar connections, the red of granite being the colour of the rising and setting sun, while quartzite was associated with Heliopolis, cult centre of the solar deity and creator god, Atum. The statues, however, had the passive pose of Osiris. By the Eighteenth Dynasty the sun was thought to unite with Osiris in the underworld every night. The statues thus evoke the nightly merging of the sun with Osiris, but since the images are named as representing the king they also identify Amenhotep with both deities. The king as Osiris is promised resurrection and, as Atum, rejuvenation and rebirth.[22]

State temples

During the Eighteenth Dynasty state temples dedicated to the cults of the national gods became larger and more important than before.[23] As always, the king was responsible for their construction, and Eighteenth Dynasty kings built widely throughout the major centres of Upper and Lower Egypt and Nubia. Old and Middle Kingdom temples constructed of mud brick were replaced by great complexes of limestone or sandstone, entered through colossal pylons, gateways with tall towers on either side.

Access to temples was restricted and there were no congregations. The rituals were kept deliberately mysterious, being performed in rooms hidden deep in the interior of the building. The sacred precinct surrounding the temple was shut off from the outside world by a high enclosure wall. The outer walls of the temple itself acted to protect and delimit the sacred space of the interior. The temple was a microcosm, a model of the world at its very beginning, when the mound of creation rose out of the watery swamp of chaos.[24] The hypostyle hall in front of the sanctuary symbolised the swamp, with the columns representing stylised marsh plants. Between the hypostyle hall and the sanctuary the floor level rose, so that the sanctuary became the emerging mound of creation, and the deity manifest in the cult statue kept in the sanctuary shrine was the creator. The entrance to the temple was guarded by huge relief figures of the smiting king cut into the two wings of the pylon. These images kept at bay the impure and chaotic forces of the world outside, and proclaimed the might of the king and his role in maintaining cosmic order.

In fact the whole temple functioned on a cosmic level, its purpose being to encourage the gods to maintain the correct order of the universe established at the time of creation and to ensure the continued existence of the world. Thus the temple had to be made attractive to the deities so that they would be persuaded to take up residence in their statues. In temple decoration the main performer of the temple cult was the king, but the daily enactment of ritual was performed by priests, and during the Eighteenth Dynasty priests as a group became an important part of the government bureaucracy. Women at this time seem rarely to have performed temple ritual, with the exception of the 'god's wife of Amun' at Thebes.[25] This priestly office was held by royal women who took part in rituals enacted in the temple of Amun at Karnak. They represented the female principle of the universe that stimulated the creator god endlessly to re-enact creation.

The decoration inside the temple depicted the relationship between the king and the gods. In the inner rooms the temple deities are shown legitimising the king's rule in scenes where they embrace him, hand him items of royal insignia or offer him life, a divine attribute symbolised by the *ankh*-sign. Their speeches, recorded in hieroglyphs that form an integral part of these scenes, also confirm the king as an effective ruler. Complementary scenes represent the king carrying out the ritual for the deities.

In addition to the daily ritual, temples celebrated festivals when the cult statue of the deity was carried in its sacred boat out of the temple and processed amid crowds who had gathered to greet the deity. Since these processions began and ended in the temple, the architecture was designed to accommodate them, with routes running through pillared halls, open courts, pylons, and along defined processional ways lined with chapels containing stands where the boat could be rested for the performance of rites during its progress.

It is hard to imagine the splendour and mystery of these temples from the stone ruins that survive today. All the precious metal and wood fittings and the gleaming white plaster that covered the stone-work have vanished, as has most of the paint that once covered the walls and ceilings with brightly coloured decoration. In many temples light pours into the sacred inner rooms that were supposed to enclose the divine mystery of the deity in darkness. The temple was designed as a setting for the performance of ritual and today we miss this dynamic dimension, the processions and presentation of offerings amidst the smell of burning incense, the musical sounds of voices and instruments, and the recitation of the ritual words that ensured

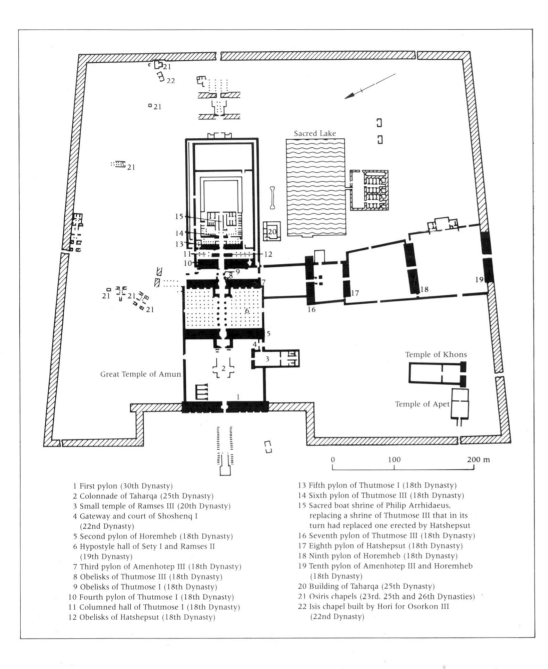

147 Plan of the temple of Amun and its precinct at Karnak.

1 First pylon (30th Dynasty)
2 Colonnade of Taharqa (25th Dynasty)
3 Small temple of Ramses III (20th Dynasty)
4 Gateway and court of Shoshenq I (22nd Dynasty)
5 Second pylon of Horemheb (18th Dynasty)
6 Hypostyle hall of Sety I and Ramses II (19th Dynasty)
7 Third pylon of Amenhotep III (18th Dynasty)
8 Obelisks of Thutmose III (18th Dynasty)
9 Obelisks of Thutmose I (18th Dynasty)
10 Fourth pylon of Thutmose I (18th Dynasty)
11 Columned hall of Thutmose I (18th Dynasty)
12 Obelisks of Hatshepsut (18th Dynasty)

13 Fifth pylon of Thutmose I (18th Dynasty)
14 Sixth pylon of Thutmose III (18th Dynasty)
15 Sacred boat shrine of Philip Arrhidaeus, replacing a shrine of Thutmose III that in its turn had replaced one erected by Hatshepsut
16 Seventh pylon of Thutmose III (18th Dynasty)
17 Eighth pylon of Hatshepsut (18th Dynasty)
18 Ninth pylon of Horemheb (18th Dynasty)
19 Tenth pylon of Amenhotep III and Horemheb (18th Dynasty)
20 Building of Taharqa (25th Dynasty)
21 Osiris chapels (23rd. 25th and 26th Dynasties)
22 Isis chapel built by Hori for Osorkon III (22nd Dynasty)

the beneficence of the deity and the continued existence of the created universe.

Owing to chances of survival, one of the best-known state temples of the New Kingdom is the temple of Amun-Ra at Karnak (fig. 147).[26] Eighteenth Dynasty kings invested large resources in this temple, and gradually the Middle Kingdom sections were replaced by new structures. Consequently the design of the temple was never static, and successive kings refashioned or replaced the creations of their predecessors and sometimes even their own earlier work.

Amenhotep I erected a double gate to form the entrance to the temple, and set up a number of calcite and limestone chapels, now known only from re-used blocks. His successor, Thutmose I, replaced Amenhotep's gate with the fourth pylon, behind which he built a columned hall with papyrus columns covered in gold leaf and a series of mummiform statues standing against the walls. On the other side of the hall he erected the fifth pylon that opened on to a court in front of the Middle Kingdom sanctuary. Before the fourth pylon, at the entrance to the whole complex, Thutmose set up two soaring red granite obelisks, with the tops of their tapering shafts cut into pyramidions and sheathed in precious metal, in order to reflect the rays of the sun. Thutmose II also embellished the temple entrance by building a limestone court in front of the fourth pylon.

Hatshepsut made further changes when she erected two obelisks in her father's columned hall (fig. 148) and built a shrine for the sacred boat of Amun-Ra in the court behind the fifth pylon, together with a series of surrounding rooms that pushed up against the façade of the Middle Kingdom temple. The first evidence of the annual *Opet*-festival, when the statues of Amun-Ra and his consort Mut were processed from Karnak, south to Luxor and back, comes from reliefs in the reign of Hatshepsut, and Hatshepsut built a pylon, now numbered eight, to the south of the temple at right angles to the main west–east axis, through which processions could travel to the temple of Mut and on to Luxor (fig. 8). Along the processional way were shrines where the divine boats could be set down while rituals were performed.

The shrine for the sacred boat in the main temple was built from blocks of red quartzite on a base of black granite.[27] It was replaced by another shrine late in the sole reign of Thutmose III, and many of its blocks were eventually used by Amenhotep III in his third pylon. These have now been recovered and put on display in the Open Air Museum at Karnak. As in her funerary temple, some of the decoration of Hatshepsut's boat shrine underpins the legitimacy of her reign. Texts again recount her appointment to the kingship by her father and her subsequent coronation. A series of scenes shows her being crowned by Amun-Ra and various goddesses, who also address appropriate speeches to the king (fig. 149). Other scenes depict the celebration of the *Opet*-festival, showing the sacred boat being carried in procession (fig. 150). Also shown are standard scenes of the type found decorating the inner parts of temples. The figure of Thutmose III appears in the decoration of

148 Head of King Hatshepsut cut in sunk relief from the pyramidion of the fallen obelisk of Hatshepsut in the temple of Amun-Ra at Karnak. This detail from Hatshepsut's obelisk not only shows the consummate skill with which artists worked in hard stone, but it is also a good example of the distinctive profile with its very prominent nose that is found on images of both Hatshepsut and Thutmose III. Granite. Eighteenth Dynasty.

149 *below left* Scene cut in sunk relief showing King Hatshepsut kneeling in a shrine before the god Amun-Ra, who crowns her with the *atef*-crown. The goddess Hathor stands before the shrine and reaches in to touch the crown. With her other hand she holds to the king's nose a *was*-sceptre with an *ankh* on the end. Amun-Ra says: 'My daughter, whom I love, I have established for you the *atef*-crown on your head so that you may appear in it for the Egyptian population and so that the Nine Bows may adore you.' Hathor says: 'You have received this beautiful crown from your father. ... May it place the fear of you in the hearts of the people.' Thus both by their visual gestures and by their words, the two deities acknowledge Hatshepsut as the legitimate king. From Hatshepsut's dismantled shrine for the sacred boat of Amun, Karnak. Quartzite. Eighteenth Dynasty.

150 Scene showing the procession of the sacred boat of Amun-Ra carried by priests during the *Opet*-festival, when the statue of the god was taken from Karnak to the temple of Luxor. From Hatshepsut's dismantled shrine for the sacred boat of Amun, Karnak. Quartzite. Eighteenth Dynasty.

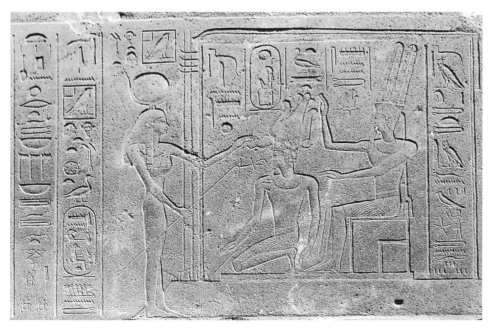

151 Reconstruction of the temple of Luxor from the south, looking north to the precincts of Mut, Amun-Ra and Montu at Karnak.

the shrine as the co-regent of Hatshepsut (fig. 12), and several times the two kings occur side by side, with Hatshepsut in the senior, forward position.

Late in the sole rule of Thutmose III, much of Hatshepsut's work at Karnak was undone, as in her funerary temple. Not only was her boat shrine replaced, but the lower parts of her obelisks were walled up and hidden by masonry, and everywhere her figure and name were erased, or her name was replaced by Thutmose's name or sometimes that of his father. In addition to his campaign to obliterate Hatshepsut's memory, Thutmose continued to alter and expand the temple. He divided the court between the fifth pylon and the boat shrine by another pylon, the sixth; increased the number of columns in Thutmose I's columned hall and added two obelisks at the main entrance of the temple in front of the fourth pylon. To the south of

the temple he built the seventh pylon, between the temple and Hatshepsut's eighth pylon, and erected a pair of obelisks on its south side. During his long reign of fifty-four years, Thutmose celebrated a number of sed-festivals, and many of his building projects were associated with these occasions.

Further expansion took place in the following reigns. Amenhotep II built a pillared court on the south side of the eighth pylon, and his son, Thutmose IV, further embellished the main entrance to the temple by decorating the door to the fourth pylon, erecting a porch in front of it, and adding decorated sandstone walls and a double peristyle with square pillars inside the earlier court of Thutmose II (fig. 18).[28] When he came to the throne Amenhotep III completed his father's court, but later in his reign he conceived plans for a completely new entrance to the temple. He dismantled the court and other buildings in the area and re-

152 Plan of the temple of Luxor. Eighteenth to Nineteenth Dynasty.

153 Glazed steatite statuette of King Amenhotep III kneeling holding an offering. The king is shown with a round, chubby face with large eyes that give a child-like appearance. He wears the double crown, the *shebyu* necklace consisting of two strands of gold rings, and gold armlets. The statuette was once glazed blue-green, a colour symbolising rejuvenation. It represents the king in the image he adopted in his year 30 after his first *sed*-festival to signify the renewal brought about by this ritual. Probably from the temple of Horus at Edfu.H. 13 cm. Eighteenth Dynasty. Boston, Museum of Fine Arts.

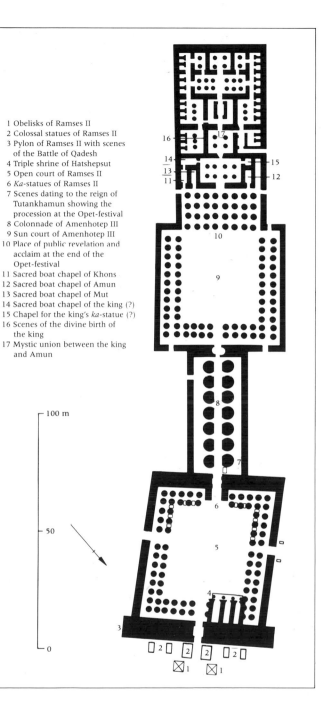

1 Obelisks of Ramses II
2 Colossal statues of Ramses II
3 Pylon of Ramses II with scenes of the Battle of Qadesh
4 Triple shrine of Hatshepsut
5 Open court of Ramses II
6 *Ka*-statues of Ramses II
7 Scenes dating to the reign of Tutankhamun showing the procession at the Opet-festival
8 Colonnade of Amenhotep III
9 Sun court of Amenhotep III
10 Place of public revelation and acclaim at the end of the Opet-festival
11 Sacred boat chapel of Khons
12 Sacred boat chapel of Amun
13 Sacred boat chapel of Mut
14 Sacred boat chapel of the king (?)
15 Chapel for the king's *ka*-statue (?)
16 Scenes of the divine birth of the king
17 Mystic union between the king and Amun

used the blocks to build a much larger pylon, the third, in front of the fourth.

During the long, prosperous reign of Amenhotep III even more stress than before was laid on solar aspects in the cults of national deities, a change that was expressed architecturally by the inclusion of large sun courts in many temple complexes.[29] Surrounded by one or more rows of columns, these lay open to the sun, so that its visible disk acted as its own cult image as it crossed the sky.

The purpose of the solar cult was to ensure the daily renewal of the sun's cycle on which the existence and well-being of the world depended. Amenhotep III, like all kings, was the son and living manifestation of the sun god on earth. In the last part of the reign the use of such epithets as 'dazzling sun disk of all lands' states his identification with the sun god explicitly.[30] This emphasis on the divine aspect of the king is manifest in the cult of a divinised form of the king established at the temple of Soleb in Upper Nubia,[31] and in the temple Amenhotep built at Luxor for the celebration of the cult of the royal *ka*.[32]

The site of Luxor, 5 km south of Karnak, was the location for the annual *Opet*-festival, in which the divine nature of the king was renewed each year. Here Amenhotep erected a monumental sandstone temple, which perhaps replaced an earlier building (fig. 151). It was oriented on a north–south axis and fronted by a sun court approached by a processional colonnade (fig. 152). During the *Opet*-festival, when the images of Amun-Ra, Mut, and Khons were taken in public procession from Karnak to Luxor, they were placed in shrines within the temple, while the king went into its rear portion.[33] Here one room depicts the divine birth of Amenhotep and his *ka* from the union of his mother with Amun-Ra, clearly paralleling the depictions of Hatshepsut's divine birth at Deir el-Bahri.[34] In the mysterious *Opet* ritual the human king merged with the royal *ka*, the entity that carried the divine aspect of kingship through the generations, and was reborn as Amun-Ra's divine son. The transformed king then reappeared in the front part of the temple and, after the triumphant completion of the rites, the cult images were returned to their boats and processed back to Karnak.

In year 30 Amenhotep celebrated the first of his three *sed*-festivals, which he depicted in his funerary temple at Thebes and in the temple of Soleb. After the performance of this ancient ritual of royal renewal the image of the king underwent a change. His face now appears as extremely youthful, even childlike, in its full, rather pudgy, roundness. In addition he is shown wearing *shebyu*-necklaces, which were made of gold rings, gold armlets on his upper

arms and large numbers of *uraei* wearing sun disks. Both gold and *uraei* are solar symbols, and link the rejuvenated king with the self-regenerating sun god (fig. 153).³⁵ Much of the construction of Amenhotep's funerary temple is now dated by scholars to around this time.

Palaces

Unlike temples, palaces were built of mud brick and have not survived well. The main palace on the east bank at Thebes probably stood near the temple of Karnak but is known only from texts.³⁶ On the west bank Amenhotep III built a large palace complex at Malqata, of which foundations and other fragmentary remains survive.³⁷ The complex included residential quarters and ceremonial areas that were probably used during the performance of the *sed*-festival. Fragments of painted plaster from ceilings, walls and floors show that the buildings were lavishly decorated.

Kings had a number of palaces throughout Egypt that served as royal residences, administrative centres and ceremonial settings for ritual appearances of the king.³⁸ We know from texts and from scenes in private tombs that the king gave formal audience to his officials, received foreign delegations and announced decisions to undertake royal projects in his palace. At Malqata and other New Kingdom palace sites we can learn something about the architectural setting of the audience hall.³⁹ A columned hall led into the throne room, at the far end of which stood a raised dais. The architecture clearly resembles that of a temple, with the columned hall, throne room and dais being equivalent to the hypostyle hall, the sanctuary and the shrine for the

cult statue. Like the temple, the palace is also a microcosm.⁴⁰ The rooms with columns in the form of marsh plants represent the primaeval swamp, out of which the elevated throne dais rises, symbolising the mound on which the creator god appeared. Thus the enthroned king is the equivalent of a divine cult statue in its shrine and identified with the creator. Nevertheless, the decoration is distinctive, with little relating specifically to deities in contrast to the inner rooms of a temple. Instead the floors were painted with pools full of lotuses, fish and ducks, around which a variety of plants grow. Among the plants animals leap and play, while birds fly overhead. The whole composition depicts the reanimation of nature by the life-giving rays of the sun god, when he rises from the underworld at the start of each day. The king appears on his throne like the sun in the heavens, the creator and sustainer of life in the world.

Throughout the palace the king was also depicted as the upholder of created order. Scenes showing the king triumphant over foreigners were carved on stone columns and door jambs,⁴¹ and may have been painted on the outer walls. Figures of bound prisoners decorated the floors and throne emplacements, so that the king regularly walked over them and sat above them, holding them in subjection (fig. 155).⁴²

Images of the enthroned king occur in private tombs in scenes where the tomb owner is shown being received in audience (fig. 155). The king, sometimes accompanied by his mother or principal wife, sits in an elaborate kiosk placed on a raised dais, which is reached by steps at the front.⁴³ Slender pillars in the form of plants support the upper part of the structure, which is decorated with friezes of *uraei* wearing sun disks, a motif often found on divine shrines. The king wears full royal regalia, and the text often refers to him as 'the exemplar of Ra', confirming him as a manifestation of the sun god.

In these scenes the throne dais is decorated with images of bound foreigners, often labelled with the names of the countries or districts they represent. On the arm of the king's seat the king sometimes appears as a sphinx trampling his enemies, often with the caption 'trampling all foreign lands' (fig. 155). That such thrones were not artistic constructs but existed in reality is shown by similarly decorated arm panels from a chair found in the tomb of Thutmose IV (fig. 154).⁴⁴ In the palace the enthroned king was undoubtedly regarded as a living manifestation of the sun god and, like deities in their temples, faced out of his abode towards humanity, and specifically towards those who were privileged to enter and approach the king.

154 One of two arms from a throne of Thutmose IV, showing the king as a human-headed sphinx trampling a group of southern enemies. The king is identified by his cartouche placed in front of his face, while above and behind him the Horus falcon hovers in protection. A personified *ankh* placed behind the sphinx holds a semi-circular fan which indicates a divine presence, showing that here the divine form of the king is manifest in the sphinx. The caption, placed within the curve of the sphinx's tail, describes the king's action as 'trampling all foreign lands'. The same caption is used on the second arm, where the king in sphinx form tramples northern enemies. The two arms of the throne together symbolise the king's dominion over the totality of the world outside Egypt. From the tomb of Thutmose IV. Cedar, H. 25 cm. Eighteenth Dynasty. New York, Metropolitan Museum of Art.

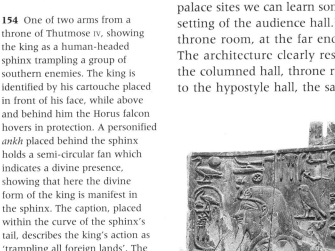

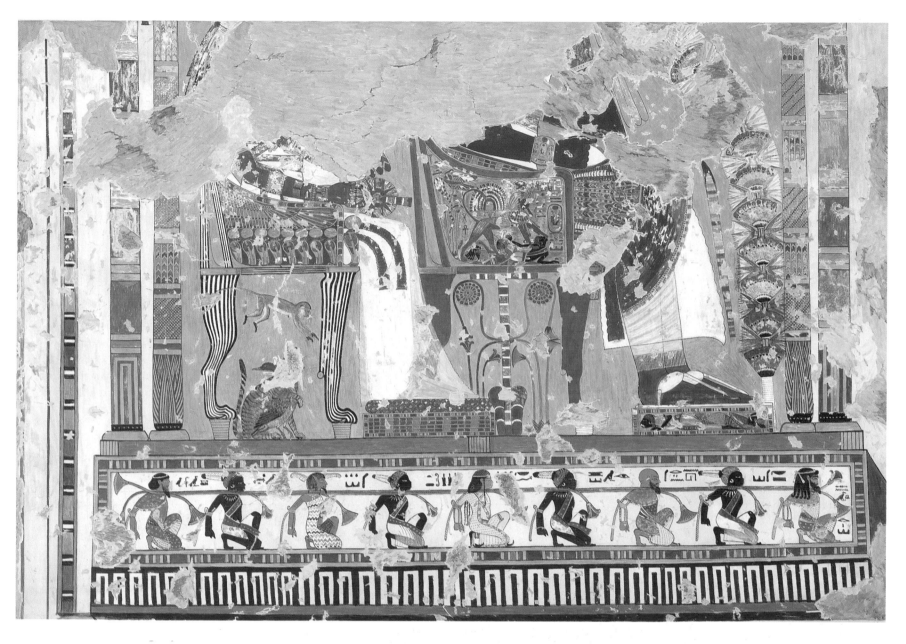

155 Facsimile painting of a scene in the tomb chapel of Anen, second priest of Amun, at Thebes (no.120), showing King Amenhotep III and his principal wife, Tiy, seated in a kiosk on a throne dais in the palace. The upper parts of the kiosk and figures are lost, but the lower portions of the inner and outer columns that supported the double canopy of the kiosk remain. They rest on the raised throne dais, which is decorated with a row of kneeling images of bound foreigners linked together by stems of the Upper Egyptian lily and Lower Egyptian papyrus. Northerners and southerners alternate; the former are given light skin and the latter black skin and all are dressed in brightly coloured, non-Egyptian costume to mark them as aliens. Within the kiosk Amenhotep sits on a throne that incorporates the *sema tawy* motif between its legs. On the arm of the throne the king is depicted as a sphinx trampling foreigners, protected by the goddess Wadjit in the form of a winged cobra. Even the king's footstool is decorated with images of prostrate foreigners, a visual rendering of the common royal phrase: 'all foreign lands are under your sandals'. The arm of the queen's chair is adorned with a row of *uraei* crowned with sun disks and, above, the multicoloured wing of a bird. If we imagine a similar wing on the other arm of the throne, then the queen would be sitting within the protective embrace of a winged deity. The background inside the kiosk is painted a warm yellow that represents gold. The pillars and furniture are painted predominantly red, dark blue, turquoise and more yellow, the colours of the materials used by the Egyptians in their jewellery. The effect of the whole colour scheme is to give an opulent and jewel-like quality to the scene. The predominance of 'gold' reflects the solar aspect of the king as the earthly manifestation of the sun god. Eighteenth Dynasty. New York, Metropolitan Museum of Art.

Non-royal tomb chapels

At the beginning of the Eighteenth Dynasty private burials at Thebes continued to be made in the Seventeenth Dynasty cemetery on the plain near the modern village of Dra Abu el-Naga.[45] Some tombs had mudbrick superstructures consisting of an open court with a small chapel containing a pedestal for offerings in front of a funerary stela. During the joint reign of Hatshepsut and Thutmose III it became the custom for high officials to construct rock-cut tomb chapels in the cliffs with burial shafts for themselves and family dependants excavated beneath the chapel. The chapel usually took a form resembling an inverted T, with a transverse room entered from an open court leading into a long, narrow room, at the end of which a niche was cut into the wall to house the statue or statues forming the focal point of the offering ritual (fig. 156). Some statues were sculpted from the rock and remained attached to the wall. Others were free-standing and are now found in museums throughout the world, wrenched from their context and often without any record of their provenance. Burials with tomb chapels are also found at other sites, including el-Kab some 80 km south of Thebes,[46] but the Theban necropolis is the best known and the largest.

The decoration of tomb chapels included many scene

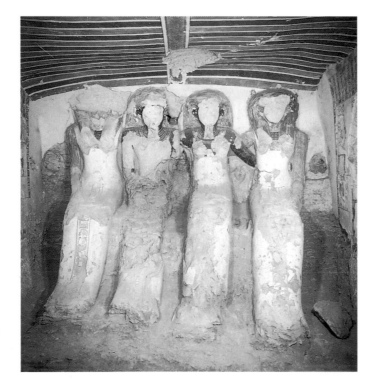

156 The rock-cut statues at the rear of the tomb chapel of the official Ineni, representing Ineni, his wife and Ineni's parents. The statues formed the focal point of the funerary cult performed in the chapel. Thebes (tomb no. 81). Painted limestone, H. of statues 240–4 cm. Eighteenth Dynasty.

types already found in Old and Middle Kingdom tombs: the deceased seated in front of offerings; offering-bringers; the funeral procession and burial rites; scenes of 'everyday life' (figs 157–8); the deceased hunting, and fishing and fowling (fig. 11). Their function – to help the deceased pass safely into the next life and to supply all his needs there – was unchanged. In addition, new scenes were introduced. For the first time in the context of private tombs the owner is depicted adoring various deities, most often Osiris and Anubis because of their funerary connections. The function of such scenes was to associate the deceased with deities who could help in the dangerous transition to the afterlife.

Once a year at Thebes, during the Festival of the Wadi, the living crossed from the east bank to the west to visit the tombs of their relatives and to eat a commemorative meal there. This meal is shown in the elaborate banquet scenes depicted in tomb chapels, which at the same time may also represent the meal eaten at the tomb during the actual funeral (fig. 159). These meals were times when the living and dead could commune, and the deceased are depicted as present. Much of the imagery relates to Hathor, who, in her role as the goddess of the west, helped the dead make the transition to the next world. Since music and dance were sacred to Hathor, these scenes frequently include images of musicians and dancers, often with nude female performers. The latter resemble female fertility figurines and may have had the same function, to stimulate the rebirth of the deceased. Hathor was also associated with ritual drunkenness, which could break down the barriers between the living and dead, and wine jars and servants pouring drink figure prominently in the scenes, some of which show explicit intoxication in the form of vomiting guests.[47]

For the first time images of the king become common in private tomb chapels of high officials, mostly in kiosk scenes showing the enthroned king giving audience. Sometimes the deceased may be shown presenting foreign delegations, and scenes of foreigners bringing tribute were popular at this time.[48] Most frequently they depict processions of Nubians and Syrians (fig. 160), who represent Egypt's southern and northern enemies, bearing the produce of their countries and making submission. In accordance with the Egyptian world view, all foreigners coming to Egypt, whether on diplomatic missions, for trade purposes or as subject peoples, were depicted in the same way, as coming to submit by presenting tribute. The scenes demonstrate the king's successful fulfilment of his duty to subdue foreign lands and overcome chaos. For the tomb owner they guarantee the continued order of the cosmos, including triumph over death and rebirth into the next world.

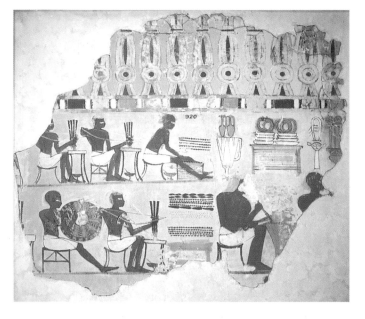

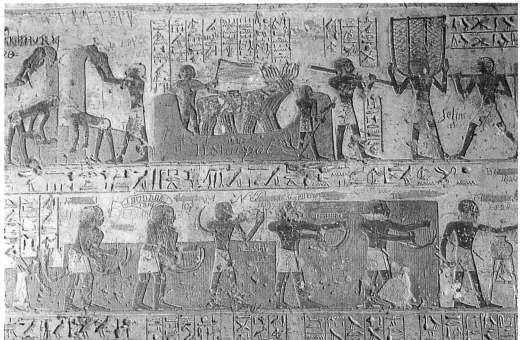

157 *above* Fragment of a workshop scene showing the manufacture of jewellery from beads, and of other precious objects from gold and silver. Three men use bow drills to pierce stone beads that are strung into necklaces or bracelets, or made up into multi-rowed broad collars. From the tomb chapel of the official Sebekhotep at Thebes (no.63). Painted plaster, H. 66 cm. Eighteenth Dynasty. London, British Museum.

158 Part of the harvest scene from the tomb chapel of the official Paheri at el-Kab. Below, male peasants cut the grain with sickles, followed by a woman who picks up the fallen ears. Above, the grain is taken in baskets to the threshing floor where it is trampled by oxen to separate the grain from the stalks. Finally it is winnowed by tossing it in the air, so that the heavy grains fall to the ground and the light chaff is blown away. Painted limestone. Eighteenth Dynasty.

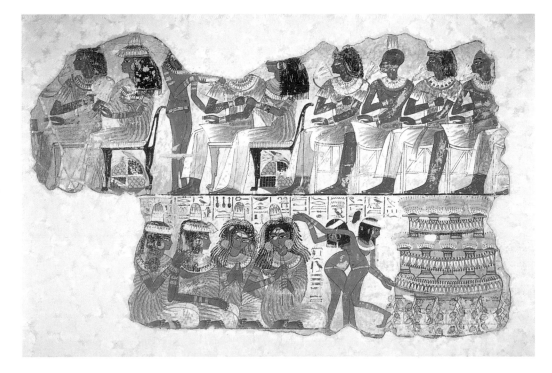

159 Part of the banquet scene from the tomb chapel of Nebamun at Thebes. In the upper register elite guests sit dressed in their most elaborate clothes. The large almond-shaped eye set at a slight angle and the full lower part of the face with the rather fleshy throat, suggesting a plentiful diet, are typical of the reign of King Amenhotep III. A nude serving girl, her body ornamented with armlets, bracelets and a hip girdle, offers a drink to a guest. In the register below, a stack of wine jars ensures a plentiful supply of drink. A woman plays a flute, accompanied by the clapping of three companions, and two nude adolescent girls engage in a sinuous dance. The deceased tomb owner would have been depicted facing his guests, for the meal in the tomb was a time when the living could contact the dead. The wine, music and dance all invoke the goddess Hathor who guarded the threshold between this world and the next and facilitated the passage from one to the other. Painted plaster, H. 61 cm. Eighteenth Dynasty. London, British Museum.

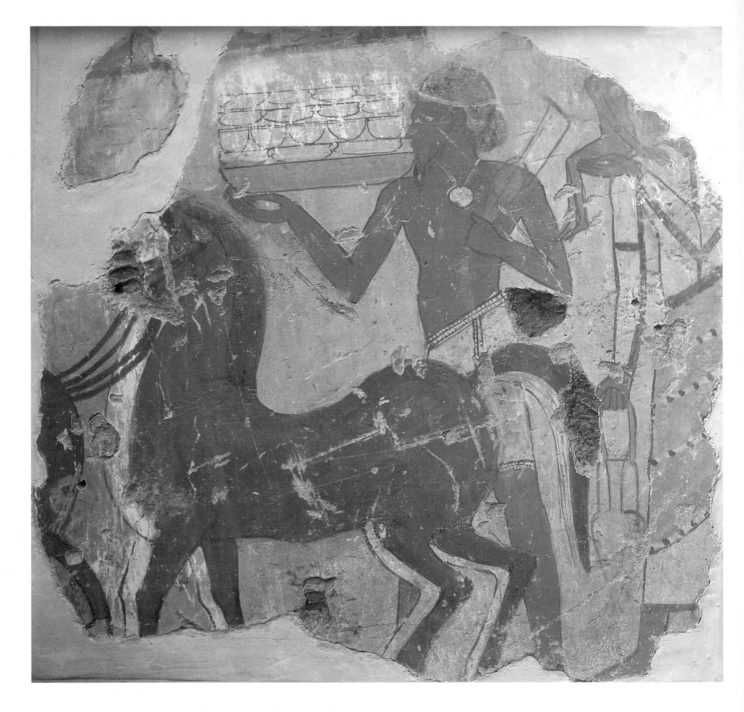

160 Fragment of a scene showing Syrians bringing 'tribute', including
horses. The hair bound with a white fillet, the blue kilt of the first man
and the long-sleeved garment with coloured borders worn by the second
man mark the figures out as non-Egyptians. The convex line of the belly,
seen on the first figure, occurs on other foreign figures in this tomb.
From the tomb chapel of the official Sebekhotep, Thebes (no.63).
Painted plaster, L. 60 cm. Eighteenth Dynasty. London, British Museum.

The decoration in the majority of rock-cut tombs is merely painted, rather than being carved into relief before painting, because the quality of the limestone rock was too poor to allow relief cutting. Instead the walls were covered with a layer of plastered mud. After the plaster was dry the decoration was sketched out in red and then painted. In the first part of the Eighteenth Dynasty the use of squared grids on which the sketches for scenes were laid out was widespread (fig. 161). Sometimes a grid with squares appropriate to the largest and therefore most important figure in the scene was drawn over the whole scene and smaller figures were added freehand.[49] In other cases grids were drawn with different sized squares appropriate to the different-sized figures.[50] This variation in artists' working practices may reflect different workshop traditions or the preferences of individual artists, but it shows that there was no absolute uniformity in working practices any more than there was in the style and content of scenes. Further, the development of flat painting in tomb chapels led to experimentation and stylistic effects that are different in kind from those in relief-cut chapels.

From about the reign of Amenhotep II a change occurred in the way grids were used. Now, instead of covering almost every wall of the chapel, they were only used for

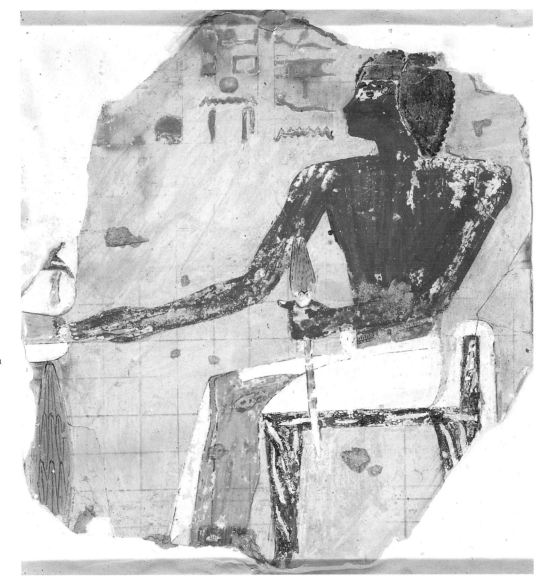

161 Fragment of painted plaster showing a seated male figure from a row of guests in a banquet scene. The background paint has fallen away in places to reveal the red grid lines on which the figure was drawn. Originally there would have been fourteen grid squares between the soles of the feet and the hairline, which helped the artist not only to produce acceptable proportions but also to line up the row of guests evenly. Provenance unknown, but probably a tomb chapel at Thebes. H. 26 cm. First part of Eighteenth Dynasty. London, British Museum.

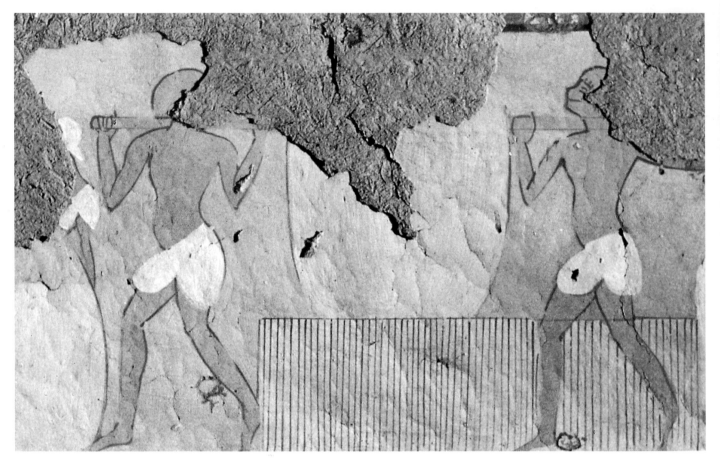

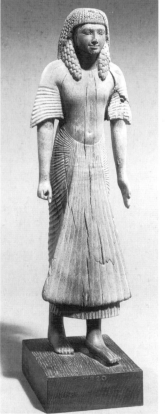

162 *above* Detail from an unfinished harvest scene in the tomb chapel of the official Pehsukher at Thebes (no.88) showing two peasants carrying a basket of grain slung on a pole. Although colour has begun to be laid on, the original sketches of the two figures can still be seen. These are rendered in fluid, dynamic lines that vividly convey the forward movement of the figures. Painted plaster. Eighteenth Dynasty.

163 Wooden statue of an official showing the elaborate, pleated garments that became fashionable in the later Eighteenth Dynasty. The large amounts of linen that went into these clothes provided a visible display of the wearer's wealth. H. 29.2 cm. Eighteenth Dynasty. London, British Museum.

major figures, mostly the tomb owner and his wife. Elsewhere minor figures, for instance, peasants, labourers, dancers, musicians and banquet guests, would be drawn with a few simple guide lines or completely freehand (fig. 162). At the same time the stiff figures of the early part of the dynasty give way to freer, more fluid renderings (compare figs 158 and 162, 159 and 161). In male figures musculature disappears and the small of the back is often raised, so that the upper torso is reduced in size in relation to the lower part of the body.[51] These changes in style and proportion are enhanced by an elaboration in depicted costume. The woman's body-hugging sheath dress is replaced by a loose wrap-around garment that falls in flowing lines (fig. 11). The kilts, bag tunics and sashes worn by men incorporate increasing amounts of material that wind about the body (fig. 163). This spirit of change also encouraged experimentation in the drawing of minor figures. Faces were very occasionally drawn full- or three-quarter-view (fig. 159) and the feet differentiated, so that the near foot was shown from the outside with all five toes visible.[52]

Stelae

Like tomb chapels, funerary stelae were normally owned by men and showed the deceased, often accompanied by his wife or mother, seated before a table of offerings, with a family member standing to perform the offering ritual. A version of the offering formula was usually written out in lines of horizontal text below the scene. During the Eighteenth Dynasty it became increasingly common to include, above the offering scene, a register showing the deceased adoring one or several funerary deities (fig. 164). The relative position of the two scenes was governed by rules of precedence. Since on stelae registers decrease in importance from top to bottom and, in the hierarchy of being, deities rank over humans, whether living or deceased, scenes with deities were placed above scenes that contained only humans.

The elite could also dedicate votive stelae in temples. Their function, like that of statues, was to associate the donor with the deity and the ritual performed in the temple in perpetuity. Such stelae depicted the donor adoring the deity (fig. 165). The more important figure of the god was usually given the dominant right-facing orientation, while

164 Funerary stela of the high priest of Onnuris, Amenhotep, divided into four horizontal fields. At the top in the arch of the stela is a winged sun disk from which hang two *uraei*, one wearing the white crown and the other the red crown. Between them is a single cartouche with the throne name of King Thutmose IV. Since all the hieroglyphs are symmetrical, they can be read from right to left or left to right. On each side of this central group another cartouche contains the king's given name. In both cases the ibis hieroglyph, which is not symmetrical, faces towards the central cartouche and the vertical axis of the stela. The space either side of the cartouches is filled with the title 'king of Upper and Lower Egypt' together with an image of the Anubis jackal on his shrine. Below, two deities sit back to back in a shrine, with Osiris facing to the right and the jackal-headed funerary god Wepwawet to the left. The top of the shrine is decorated with rearing *uraei* wearing sun disks. Either side of this decoration, over figures of Amenhotep, are a *shen*-sign above the water sign and a *wedjat*-eye. During the Eighteenth Dynasty, only divine and royal figures could be placed under the sun disk, and non-royal figures usually stood below a *wedjat*-eye, as here. Amenhotep stands with his arms raised in the gesture of adoration, and the caption describes him as 'giving praise' to the two deities. The next distinct field on the stela consists of six lines containing a long offering formula in favour of Amenhotep. Finally, at the bottom, a double scene shows Amenhotep and his mother seated on the left in front of a table of offerings while the offering ritual is performed by Amenhotep's son Qenna, and on the right, in a similar but reversed grouping, Amenhotep sits with his wife, Henut, the musician of Onnuris, while another son, Hat, carries out the ritual. The stela is laid out so that the two sides, without being mirror images, are symmetrical round the central vertical axis of the stela. Limestone, H. 85 cm. Eighteenth Dynasty. London, British Museum.

165 Sandstone votive stela dedicated to Isis by the viceroy of Nubia, Amenhotep. The goddess Isis sits on the left, facing right, before a table of offerings, beyond which once stood a figure of the viceroy, now erased. At the top of the stela, in the centre, is a sun disk from which one wing extends over the figure of Isis. This is balanced on the other side, above the figure of Amenhotep, by a large *wedjat*-eye. Two *uraei* hang from the sun disk, between which King Thutmose IV's throne name, Menkheperura, is written. The sun-disk hieroglyph that writes the 'ra' element of the name is omitted and replaced by the sun disk at the top of the stela. The four lines of text below the scene take the form of an offering formula, but instead of the usual funerary benefits they ask that Amenhotep 'be on earth in the favour of the king and make a good lifetime'. From Buhen in Nubia. H. 91.5 cm. Eighteenth Dynasty. Oxford, Ashmolean Museum.

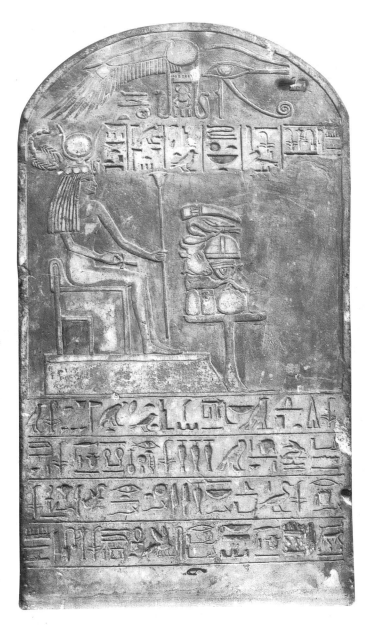

stretched over the divine side of the scene. The asymmetrical form of the sun disk was balanced by a single *wedjat*-eye above the non-royal side (fig. 165).[55]

Statues

Statues made to inhabit the statue niche in the tomb chapel could depict single figures of the tomb owner and family members whose cults were conducted in the chapel. The deceased could also be depicted with his wife or mother as a pair statue (fig. 166). In the majority of examples the man is placed on the right side of the woman, the symbolically dominant side of the group. As recipients of cult the statues all exhibit the normal frontality, which enables them to look out from their niche at the rituals being performed in front of them.

During this period a new type of statue was introduced. It showed the owner kneeling, holding in front of him a stela with a hymn to the sun carved on it (fig. 167).[56] These 'stelophorous' statues were set up in niches over the chapel entrance or in the small pyramidion that topped the chapel. The image faced east to greet the rising sun, whose reappearance every morning acted as a guarantee of rebirth for the deceased. Such statues show the increasing importance of the solar cult for private people as well as the king. For some reason this type of statue was not used to represent women.

In addition to commissioning funerary statues, elite officials frequently erected statues of themselves in the outer parts of state temples and shrines, in order to associate themselves for eternity with the deity of the temple and the rituals performed there (fig. 168). Texts on the statues often took the form of the offering formula developed for funerary contexts, but asked for different benefits. Some statues volunteered in their texts to act as intermediaries between suppliants and the deity in return for offerings made to them. One such statue set up in a shrine of the goddess Hathor at Deir el-Bahri was addressed specifically to women and offered to intercede with the goddess to obtain 'a good husband' for them.[57]

Coffins

In the early Eighteenth Dynasty burials were still made in *rishi*-coffins, but from at least the reign of Thutmose I a new type of anthropoid coffin had been introduced, and by the reign of Thutmose III the *rishi*-coffin with its feathered pattern had disappeared.[58] The new lid still took the form of a mummy wearing a tripartite wig and large, beaded falcon

the lower-status human figure faced left, towards the god. The distinction between divine and royal figures on the one hand and non-royal figures on the other was marked also by the devices used at the top of the scene. On stelae in general, scenes containing figures of deities, the king and members of the royal family were placed under the winged sun disk whose wings spread over the whole scene,[53] whereas those with non-royal figures were most often topped by paired *wedjat*-eyes.[54] On stelae where divine and human figures appeared together, figures of deities were frequently placed under a sun disk with a single wing

166 *below* Limestone pair statue of the official Khaemwaset and his wife Nebettawy. The couple sit side by side, with Khaemwaset in the dominant position to the right of Nebettawy. The texts invoke 'Montu-Ra residing in Armant' and it seems likely that the statue was originally erected at this site on the west bank of the Nile to the south of Thebes. H. 29 cm. Eighteenth Dynasty, reign of Amenhotep III. London, British Museum.

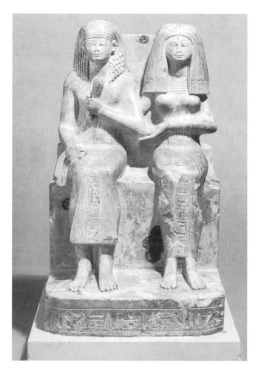

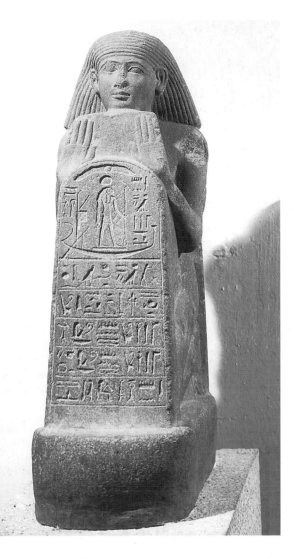

167 *left* Quartzite stelophorous statue of Amenwahsu, the high priest of Montu, who kneels with his hands raised palm forwards in the gesture of adoration. In front of him is a stela, at the top of which a scene shows a winged sun disk arching over the solar boat, which carries a ram-headed figure with a sun disk on its head and a *was*-sceptre in the forward hand. The figure is identified by a caption to the right as 'Amun-Ra-Horakhty, great god, lord of the sky' and to the left as 'lord of the sky, ruler of Thebes'. Below five lines of text read: 'Giving praise to Ra-Horakhty when he rises in the east of the sky by the high priest of Montu, lord of Thebes, the high priest of Montu, lord of Tod, Amenwahsu.' The provenance is unknown, but the references to Amun and Montu and to Thebes and Tod, cult centre of Montu (20 km south of Luxor), suggest that the statue came from the Theban area. H. 56 cm. Eighteenth Dynasty. London, British Museum.

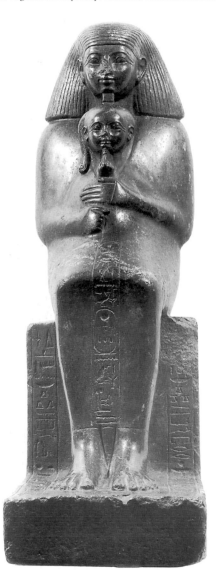

168 *right* Black granite seated statue of the high official Senenmut holding Neferura, the daughter of Hatshepsut and King Thutmose II. Senenmut was one of the most important officials during Hatshepsut's regency and subsequent joint reign with Thutmose III, and, even for a high official, he commissioned an unusually large quantity of statues of himself. A number of these include Neferura, whose steward and tutor he was. Here the princess is shown seated on his lap, wrapped in his enveloping garment except for her head and one hand. She is depicted as a child, with her forefinger held to her mouth and her head shaved apart from a plaited sidelock that falls on the right side of her head. The statue was given as a favour to Senenmut by Hatshepsut at a time when she was still using the title of god's wife, before she became king. Two offering formulae on the seat invoke the god Amun-Ra that he may give 'a thousand of all good and pure things' and 'everything which goes forth on his altar' for the benefit of Senenmut's *ka*. The provenance of the statue is uncertain, but it is likely that it was set up in the temple of Karnak. H. 72 cm. Eighteenth Dynasty. London, British Museum.

169 Coffin of Ahmose, son of the mistress of the house Nakht, showing the typical decorative scheme of early Eighteenth Dynasty coffins. The ground is white with four vertical bands on the case that continue on to the lid. The chest is covered by a large collar with falcon-head terminals and a vulture with extended wings. Two columns of inscription run down the centre of the lid containing offering formulae invoking the gods Osiris and Amun-Ra. In the space between the wig and first band is a panel containing a *wedjat*-eye that is matched by a similar one on the other side, the pair perhaps deriving from the eye panel on rectangular coffins. Between the first and second bands a recumbent jackal figure of the god Anubis occupies the space on the lid, while below Ahmose's wife Hapu and his daughter Ahmose are shown with their arms raised, mourning the dead man. Finally, in the next space, two sons, Djehuty and Mekyniwetef, are shown. Thebes. Plastered and painted wood, L. 228 cm. Early Eighteenth Dynasty. New York, Metropolitan Museum of Art.

170 Funerary mask of an elite woman, Satdjhuty. Probably from Thebes. Painted cartonnage with gold leaf, H. 52 cm. Early Eighteenth Dynasty. London, British Museum.

collar, but the decoration of the rest of the lid and case was taken over from the old rectangular coffins. Four vertical bands of inscription were evenly spaced along each side of the case, joining up with bands that ran across the lid. Another column of hieroglyphs ran down the front of the lid from below the collar to the feet. The spaces in between the texts were often filled with representations. In earlier examples these might consist of offering or funerary scenes, but images of Anubis, Thoth and the four sons of Horus became standard. A vulture spreads protective wings across the breast of the coffin. In the reign of Amenhotep III the bird was replaced by a winged image of the sky goddess Nut, to whom the text running down the lid referred. Earlier versions of this coffin type, in use up to the reign of Thutmose III, had a white ground, to represent the white linen of the mummy shroud, and polychrome decoration (fig. 169).[59] These were superseded by coffins with a black ground, the colour associated with resurrection, with decoration in gold leaf or yellow paint to represent gold, which both formed the flesh of the gods and as a colour had a close association with the sun god (fig. 171).[60] The wealthy might have up to three anthropoid coffins nested inside each other, together with an outer coffin in the shape of a shrine. Most burials, however, had only one coffin.

The Middle Kingdom tradition of placing a funerary mask over the head of the wrapped mummy continued. The mask of Satdjhuty dates to the early Eighteenth Dynasty (fig. 170).[61] Linen from Satdjhuty's tomb bears inscriptions naming Ahmose Nefertary, principal wife of King Ahmose, making it likely that Satdjhuty was in the service of the queen. The superb manufacture of the mask and its extensive gilding suggest a high status for its owner, and the piece may even have been the product of a royal workshop. The mask uses the same white ground as coffins of the period. Two columns of text at the front, now broken at the bottom, contain offering formulae invoking Osiris and Anubis. The gilding of the face, also found on other high-quality funerary masks, links the deceased to the perpetual cycle of the sun and, since gold never corrodes, carries a promise that the body of the deceased will not putrefy and decay.

Conclusion

The first part of the Eighteenth Dynasty was a time of new momentum. Although the art began by drawing on classic Middle Kingdom models, innovations abounded, as for instance in the location of royal burials in the Valley of the Kings with separate funerary temples; state temples built of

171 Coffin of an unnamed man, showing the typical decoration of later Eighteenth Dynasty coffins. The ground is black with predominantly yellow decoration, representing gold, with additional blue, red and white paint, especially on the collar. The panels between the columns of inscription are filled with images of the god Anubis, the *wedjat*-eye and the four sons of Horus. A vulture stretches out across the chest. The crossed arms are shown on this coffin, but they do not become a regular feature before the Nineteenth Dynasty. Thebes. Painted wood, L. 183 cm. Eighteenth Dynasty. London, British Museum.

stone instead of mud brick; the inauguration of the *Opet*-festival that led to the building of Amenhotep's magnificent temple at Luxor; scenes of the enthroned king giving audience in his palace; and representations of foreigners bringing 'tribute' to Egypt.

It was at this time that Egypt first acquired an empire, the fruits of which made the country wealthier than ever before. After the peace treaty of Thutmose IV with the Mitanni, the expansionist policies of earlier kings were replaced by an era of peace under Amenhotep III. With less opportunity to play the role of a military king, Amenhotep instead implemented a large-scale religious programme that systematically worked to solarise existing cults and stressed the divine aspect of kingship with the king as the earthly manifestation of the sun god. This emphasis on divine kingship and the solar cult, which included a new prominence given to the sun disk Aten as a deity, led to radical religious reforms in the following reign, as we shall see in the next chapter.

Notes

 1 Vandersleyen 1971.
 2 Kozloff and Bryan 1992.
 3 D. Polz 1995, 7.
 4 Hornung 1990a.
 5 Bucher 1932.
 6 Hornung 1990a, 73–6.
 7 Hornung 1990a, 87–94.
 8 Naville 1894; 1896; 1898; 1901; 1906; 1908; Werbrouck 1949.
 9 Van Siclen 1995.
10 Naville 1908, pls 153–4.
11 Naville 1898, pls 69–81.
12 Naville 1898, pls 56–64.
13 Naville 1896, pls 46–55; Brunner 1964.
14 Hayes 1959, 89–100. For Hatshepsut's statues in general see Tefnin 1979.
15 Porter and Moss 1972, 364 (niches B, D, F, H, K, M, O, Q).
16 Chevrier 1934, pl. 4; Hayes 1959, 100; Tefnin 1979, 31–6.
17 Nims 1966.
18 Graefe 1985; O'Connor 1995a, 282–3.
19 Dolinska 1994.
20 Haeny 1981; Kozloff and Bryan 1992, 90–3.
21 Kozloff and Bryan 1992, 157.
22 Kozloff and Bryan 1992, 157.
23 Baines 1995b, 307–14; Kozloff and Bryan 1992, 73.
24 Baines 1976; Hornung 1992, 115–29.
25 Gitton 1976; Robins 1993, 149–53.
26 Barguet 1962, 1980; Lauffray 1979; Aufrère, Golvin and Goyon 1991, 81–98.
27 Lacau and Chevrier 1977; 1979.
28 Bryan 1991, 167–71.
29 Kozloff and Bryan 1992, 74–6.
30 Johnson 1990, 38; Kozloff and Bryan 1992, 5, 134–5.
31 Kozloff and Bryan 1992, 106–10.
32 Bell 1985.
33 Kemp 1989, 206–8.
34 Brunner 1964.
35 Johnson 1990; Kozloff and Bryan 1992, 77, 103 fig. IV.23, nos 8, 20–1.
36 O'Connor 1995a, 270–9.
37 Tytus 1903; O'Connor 1980; Lacovara 1994; Waseda University 1993.
38 O'Connor 1989a; 1991a; 1995a.
39 Because of the sparsity of material, evidence from after the reign of Amenhotep III will also be considered here.
40 O'Connor 1995a, 290–2.
41 Thomas 1995, no. 87.
42 Daressy 1903; Kuhlmann 1977, pl. 5; Weatherhead 1992; Waseda University 1993, pls 1–2; Lacovara 1994, 16.
43 Radwan 1969, 3–40, 52–68; Säve-Söderbergh 1957, pls 30–1; Epigraphic Survey 1980, pls 24, 47.
44 Carter, Newberry and Maspero 1904, 20–2, pls 6–7.
45 D. Polz 1995.
46 Tylor and Griffith 1894.
47 E.g. Davies 1963, pl. 6.
48 Porter and Moss 1960, 464 no. 5.
49 E.g. Mackay 1917, pl. 17 nos 1–2, 5–6.
50 E.g. Säve-Söderbergh 1957, pl. 7; Robins 1994a, 24 pl. 1.1.
51 Robins 1994a, 254.
52 Russmann 1980.
53 E.g. Lacau 1909, pls 2, 5, 7, 9–10, 15, 20.
54 E.g. Robins 1995, nos 8, 11–12, 22, 45.
55 E.g. Lacau 1909, pls 35–7.
56 Stewart 1967.
57 Robins 1995, 104–5 no. 63.
58 Niwiński 1984, 434–8; Taylor 1989, 30–4.
59 E.g. Hayes 1959, 69 fig. 37, 71 fig. 38; Desroches-Noblecourt 1981, 189–93.
60 E.g. Kozloff and Bryan 1992, 312–15 no. 61, pls 34–5.
61 Taylor 1995.

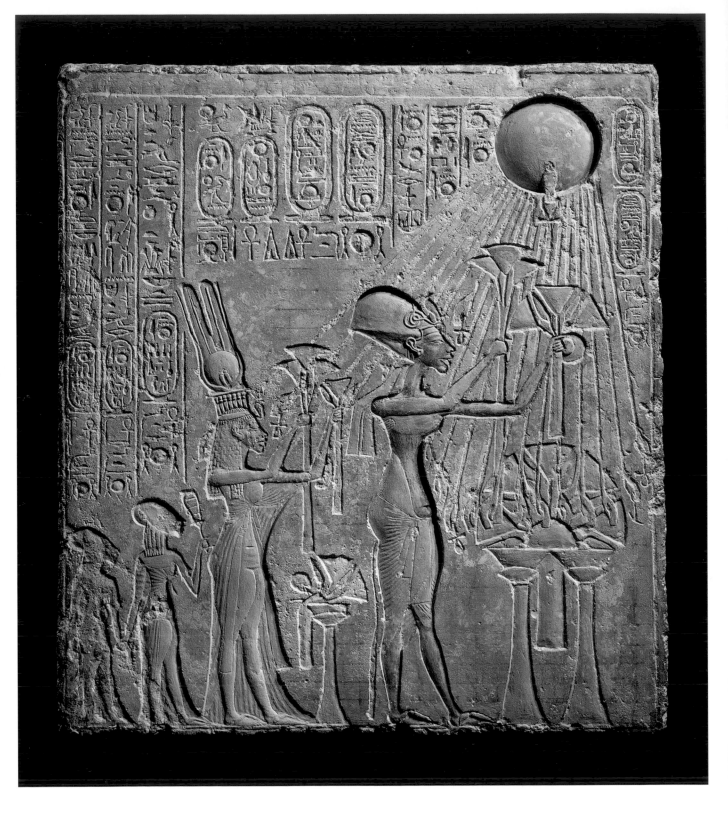

172 Rectangular painted limestone slab worked in sunk relief, showing King Akhenaten and his consort Nefertiti, accompanied by two daughters, offering flowers to the non-anthropomorphic image of the Aten, whose rays stream down on the royal couple and hold *ankh*-signs to the noses of the king and queen. The larger pair of cartouches at the top of the scene identify the Aten, and the smaller pair the king. The figures are in the earlier Amarna style, displaying long faces and necks, narrow shoulders, short upper torsos, prominent buttocks, large thighs and spindly limbs. The grid lines relating to the king's figure were never removed from the background stone. They show that the figure occupied twenty squares, not the traditional eighteen, between the soles of the feet and the hairline. The extra two squares were added to accommodate the changed proportions of the figure. From the royal tomb at Amarna. H. 53 cm. Eighteenth Dynasty, Amarna period. Cairo, Egyptian Museum.

The great heresy

THE NEW KINGDOM (II)

Amenhotep III was succeeded by his son, also called Amenhotep. The two kings may have ruled together for a time, but scholars disagree as to the length of this co-regency, estimates varying from less than two years to as many as eleven.[1] In this chapter I shall follow those who argue for a brief co-regency only, and assume that for most of his seventeen-year reign the son ruled independently of the father.

At the beginning of his reign Amenhotep continued his father's building projects and his emphasis on the sun god, giving prominence to the solar deity Ra-Horakhty, who was traditionally depicted in human form with a falcon head.[2] However, he introduced an expanded name for the sun god that may be translated 'Ra-Horakhty who rejoices on the horizon in his name of "light" which is the sun disk (Aten)'. When a short form of the name was needed, the deity was referred to as the Aten, the sun disk with whom Amenhotep III had already identified himself. The long name was soon divided and placed in two royal cartouches (fig. 172), emphasising the kingly dimension of the god. Next, a completely new divine image was introduced. The falcon-headed human image was abandoned and replaced by a non-anthropomorphic representation of the sun disk with rays ending in hands (fig. 172).

In accordance with Eighteenth Dynasty solar religion the Aten was both creator and sustainer of his creation; the divine and royal deity with his name in paired cartouches also celebrated sed-festivals. The king was the child and image of the Aten, his high priest and representative on earth, who also had his own high priest to minister to the cult of his divine aspect.[3] He and his principal wife, Nefertiti, represented the generative force of the male and female principles of the universe that had been separated out from the androgynous creator at the time of creation. Religious texts relating to the Aten are concerned with the life-giving aspects of the deity as he travelled across the daytime sky; the traditional journey through the underworld at night is ignored. It is unclear what form of afterlife the Aten theology offered, but the traditional funerary iconography relating to Osiris and the underworld mostly disappeared.[4]

At first Amenhotep attempted to establish the cult of the Aten in the historic centres of Egypt, including Thebes, where he built a vast temple complex for his god to the east of the main temple precinct.[5] However, Thebes was ultimately too closely linked with Amun-Ra, as other cities were with their deities, and the king decided to build a new city dedicated to the Aten. He selected an uninhabited desert site on the east bank of the Nile in Middle Egypt, situated in a great bay in the cliffs. He called the place Akhetaten, 'horizon of the Aten', perhaps in part because the shape of the eastern cliffs was such that, when the sun rose over them, the combination resembled the hieroglyph for 'horizon'.[6] Today the site is called Amarna. The move to Akhetaten began in year 5, when the king set up dated boundary stelae marking out the territory of his chosen site.[7] At around the same time he changed his name from Amenhotep, 'Amun is content', to Akhenaten, 'beneficial to the Aten'. The cult of the Aten left no place for other deities, who were mostly neglected, but, probably after year 9, the cult of Amun-Ra was actively attacked, and the name and image of the god removed from the monuments. Also around year 9 the long name of the Aten was changed to eliminate the reference to Horus in Horakhty, so that the name instead began 'Ra, ruler of the double horizon [akhty]'.

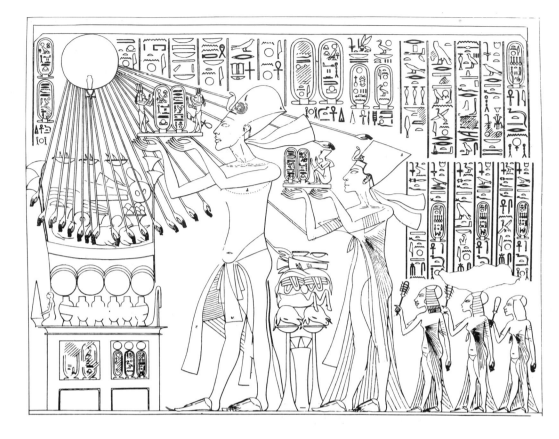

173 Drawing of a scene in the tomb chapel of the official Ipy at Amarna showing King Akhenaten and his consort Nefertiti, accompanied by three daughters, offering to the Aten. The figures are drawn in the later, less extreme, Amarna style with slightly wider shoulders and a lower small of the back than in the earlier style, so that the upper torso is longer in relation to the total body height. Eighteenth Dynasty, Amarna period.

The human figure

To most viewers the art of the Amarna period looks radically different from traditional Egyptian art. One of the more obvious changes lies in the proportions of the human figure, seen at their most extreme in that of the king (figs 172, 177). The head is large with drooping features and a long neck. The shoulders and waist are narrow, and the small of the back high, so that the upper torso is small. Below the waist the body swells out to form large buttocks and curvaceous thighs. The belly droops over the sagging waistband of the kilt. The arms and short lower legs are thin and lack any musculature. Later in the reign the form of the body becomes less extreme. The shoulders and waist tend to be slightly wider, and the small of the back is lowered, so the acute contrast between a tiny upper torso and the enlarged stomach, buttock and thigh region is somewhat mitigated (fig. 173).

There are no texts explaining these changes, but they must have been instigated or at least approved by the king. Because the new royal image coincided with the pre-eminence given to the Aten, the new image was probably designed to make a religious statement. Many of the proportions give a feminine appearance to the figure: the slenderness of the torso, the high small of the back, the prominent buttocks and the swelling thighs. Since the king was the manifestation of the Aten on earth and the Aten as creator was androgynous, the king may have intended that his image should incorporate both male and female elements. In addition the Aten brought abundance and prosperity to the land, concepts associated with Hapy, the Nile inundation, traditionally shown as a fat fecundity figure. Texts identify Akhenaten with Hapy, and his corpulence may be meant to display this aspect of the king. This supposition is strengthened by an extraordinary detail that occurs in the rendering of the king's thighs and genital region. Traditionally, figures of kings and elite males wear opaque kilts that reveal nothing of what is underneath. By contrast, most two-dimensional figures of Akhenaten show the forward line of the near thigh beneath his kilt, as it runs upwards to meet the stomach fold; no genitals are visible (fig. 174).[8] This recalls the way in which fecundity figures are depicted. Like Akhenaten, they too show no genitalia, perhaps in order to enhance the notion of their corpulence through the conceit that the folds of the fat stomach droop so low as to conceal the genitals.[9]

Although the king's figure is feminised it remains distinct from female figures.[10] The most obvious difference, apart from the clothes, lies in the genital region. Female dress is treated as transparent, so that the body is visible underneath, including the stomach, thighs and pubic triangle (figs 172–4). The configuration of this area of the body is totally different from the king's figure. The display of the female body was not new in Egyptian art, since the tight sheath dress outlined the shape of the body and drew attention to the pubic region. Its purpose was probably to produce an icon of female fertility. At Amarna it was particularly appropriate to Nefertiti's image, since she represented the cosmic female principle.

The new rendering of the royal figure influenced the representation of non-royal people, so that they too have narrow shoulders, slender limbs, short lower legs, drooping stomachs and pronounced buttocks. Their figures are, however, generalised imitations and not exact copies of the king's figure, and they are less extreme, lacking the king's drooping facial features (fig. 175).[11] Further, in two-dimensional art a deliberate distinction is made between the rendering of royal and non-royal feet. The near and far feet of royal figures during the Amarna period are differentiated, but non-royal figures are depicted with both feet shown from the inside.[12]

174 Limestone block showing parts of the figures of King Akhenaten and his consort Nefertiti. The two figures clearly show the difference in the treatment of the genital region of the royal couple. In Akhenaten's figure the front line of the rear thigh runs up to meet the stomach fold near the front line of the body. In Nefertiti's figure the line of the thigh curves back at the top to form one side of the pubic triangle. Although Akhenaten's garments are rendered as if transparent, no genitals are displayed. From Amarna. H. 24 cm. Eighteenth Dynasty, Amarna period. Oxford, Ashmolean Museum.

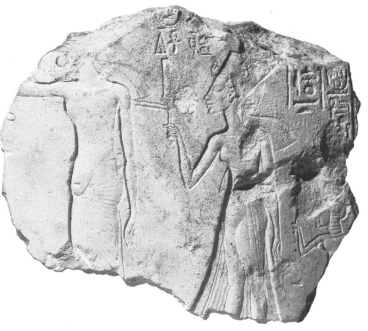

175 Drawing of a figure of the royal scribe Ahmose from his tomb chapel at Amarna. While the proportions are less extreme than those of the king's figure, they show similar changes, with narrow shoulders, a high small of the back, and pronounced buttocks and belly fold. Eighteenth Dynasty, Amarna period.

At the same time as the proportions of figures were changed, adjustments were made to the grid system.[13] Although few grid traces survive on Amarna monuments, enough remain to show that standing figures were drawn on a grid of twenty squares between the soles of the feet and the hairline (fig. 172). One of the extra squares was added between the junction of the neck and shoulders and the hairline to accommodate the long neck and face. The other was added to the torso to allow for the pendulous stomach. The top of the knee lay on horizontal six as it did in the eighteen-square grid, but in the older system the height of the lower leg was a third of the hairline height, whereas in the Amarna system it was less than a third; the lower legs of Amarna figures, therefore, appear short.

Despite the changes in proportions, the fundamentals of both two- and three-dimensional representation remained unchanged. In the former, the human figure was still a composite of its parts. Objects were portrayed in their most characteristic aspect. Scenes were organised into registers. The illusion of depth was not incorporated. In both cult and architectural statuary the formal frontal pose governed composition.

The king

The royal funerary complex

The king excavated his rock-cut tomb deep in a *wadi* that ran back into the eastern cliffs of Akhetaten, in a series of stairs and corridors that led downwards to the burial chamber.[14] Although the architecture was not dissimilar to previous royal tombs, the decoration, which survives only in fragmentary form, differed completely. The journey of the sun through the underworld and scenes of the king with funerary deities were inappropriate to the Aten religion. Instead, ritual offering scenes were substituted showing the king, queen and royal children worshipping the Aten. In addition, one scene in the burial chamber showed the king and queen, followed by royal daughters, offering to the Aten before a shrine containing the standing figure of a royal woman, perhaps Akhenaten's mother, Tiy. Behind the royal family were several registers of mourners. A second very fragmentary scene seems to show another scene of mourning and perhaps the funeral of the king.

Two subsidiary tombs led off the main royal tomb. One, consisting of a series of corridors and rooms, was unfinished and undecorated. It may have been intended for Nefertiti.[15] The other comprised a group of three rooms with decoration in the first and third.[16] The first contained two ritual scenes that showed the adoration of the rising and setting sun by the royal family, Egyptians and foreigners. As the

sun rises the birds and the animals of the desert wake and greet the deity. A separate scene of mourning seems to show the death of a royal woman in childbirth. The third room is concerned entirely with the death in childbirth of the king's daughter Meketaten, showing her being mourned by the royal family and court; this was surely the burial place of the princess (fig. 176).

The main tomb was almost certainly used for the burial of Akhenaten, but it was despoiled in antiquity and his body removed or destroyed.[17] His sarcophagus was smashed to pieces, but enough fragments remain to give an idea of the decoration. Instead of the traditional texts and representations of funerary deities, each side showed a large image of the Aten, with the disk centred at the top and the rays streaming down below, each holding an *ankh* with the promise of life for the king. At the corners, figures of Nefertiti stood with their arms outspread in the gesture of protection traditionally associated with goddesses.[18] The presence of the Aten in the decoration signified that the life-giving rays of the sun penetrated even into the tomb.

State temples

In the first years of his reign the king erected a large temple complex for the Aten at Karnak. Little now remains *in situ* because the buildings were later dismantled. The blocks, known as *talatat* after an Arabic term referring to their dimensions, were re-used in other building projects, from which many have now been recovered, so that it is possible to get some understanding of Akhenaten's decorative programme.[19] Further, excavations have recovered the foundations of part of a colonnaded court and a number of colossal statues of the king that once stood in front of the pillars (fig. 177).[20] The interior walls of the colonnade were decorated with painted relief scenes showing the king celebrating a *sed*-festival, an act that was unusual so early in a reign (fig. 178).[21] However, it was also celebrated by the Aten, another departure from tradition, since deities were the givers of *sed*-festivals to the king, not the recipients of them. Thus the ancient ceremony was adapted to the new concept of the Aten as divine king.

The buildings at Karnak introduce the ubiquitous ritual offering scene that appears in temples, palaces and non-royal tombs and on stelae throughout this reign. The king stands below the sun disk making offerings, and the rays of the sun stream down from the disk, touching the king and holding the *ankh*-sign to his nose (figs 172–3). When the queen is present she is often similarly favoured (fig. 172). This scene type takes the place of the traditional series of temple scenes in which the king offers to a deity, the deity embraces the king, and hands him the *ankh*-sign or items of

176 Drawing of a scene showing the royal family mourning the dead princess Meketaten. An image of Meketaten is placed on a raised platform approached by steps and covered by a canopy supported by papyrus columns twined around with convolvulus. The latter plant appears particularly with women in scenes relating to birth and rebirth (fig. 229). The elaborate floral bouquet in front of the image has a similarly positive connotation, since the word for such formal bouquets was *ankh*, homonymous with *ankh* ('life'). In front of the shrine, beneath the image of the Aten, stands King Akhenaten, followed by Nefertiti and three of his daughters, Meritaten, Ankhesenpaaten and Neferneferuaten the younger, all with one arm raised in front of the face in the mourning gesture. Behind, the register splits into two sub-registers containing groups of women in more varied attitudes of mourning. Below, in a separate register, are depicted tables piled with offerings and jars of drink on stands which may have been presented to the deceased as part of her funerary cult, perhaps to be shared later as a meal with the mourners. From room gamma, wall B in the royal tomb at Amarna. Eighteenth Dynasty, Amarna period.

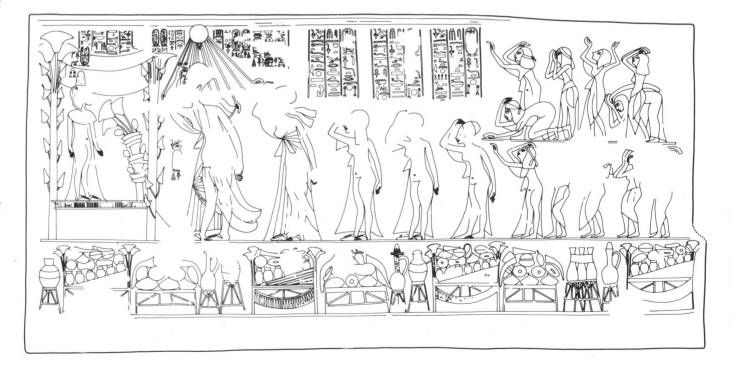

177 Colossal sandstone statue of King Amenhotep IV (later Akhenaten) from the Aten temple at Karnak. The statue originally stood in front of a pillar in a colonnade that ran round an open court. It exhibits the traditional frontal pose of Egyptian statuary, and the king wears and carries traditional royal insignia: the double crown, the *afnet*-headdress, the *heqa*-crook (now broken) and the *nekhakha*-flail. However, the proportions are those of the early part of Akhenaten's reign, with a long neck, narrow shoulders and full hips, and a belly that sags over the waistband of the kilt. The crescent-shaped navel is typical of Amarna art, replacing the round navel of other periods. The face displays very narrow, elongated eyes set slightly obliquely, a long nose, full, pouting lips and a large chin. H. 396 cm. Eighteenth Dynasty, Amarna period. Cairo, Egyptian Museum.

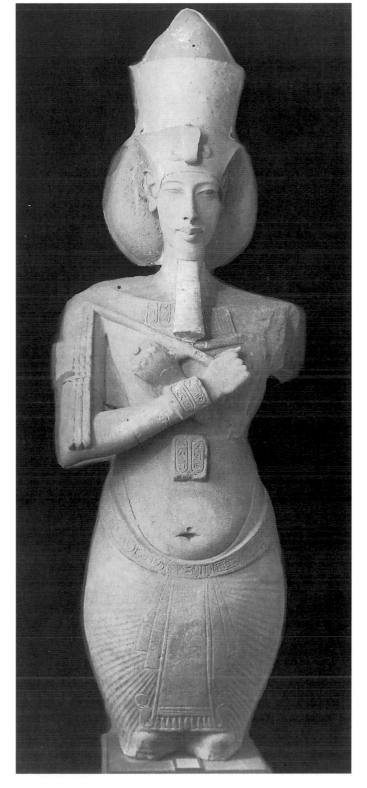

kingly insignia. In such scenes the king and the anthropomorphic deity stand face to face on an equal footing, but Akhenaten's new version shifts this balance. The sun disk is placed at the top of the scene with the figure of the king standing below, giving the Aten the primary position in the composition. Nevertheless, the human king dominates by virtue of being the largest figure, so that he rather than the divine icon seems to be the focal point. When the queen is also present she is almost always drawn on a smaller scale, and the royal children are smaller still. The members of the royal family are often positioned so that the descending heights of their heads form an oblique line that echoes the obliquity of the outer Aten rays (fig. 172).

Only the foundations of the temples at Amarna remain, but some details can be added from representations in non-royal tomb chapels. The great temple was an enormous enclosure 229 by 730 m, in which only two buildings seem to have been completed.[22] At the front of the enclosure was the 'House of Rejoicing', entered through a pylon into a pillared hall that led to a series of open courts, all filled with stone offering tables. The second building, at the rear of the enclosure, also consisted of open courts with offering tables. As in all solar temples, there were no enclosed sanctuaries for the divine cult statue. Instead altars for performing the offering rites stood under the open sky and the overhead sun acted as the cult image of the god. In one tomb scene a round-topped stone on a pedestal is depicted standing in the temple enclosure (fig. 179). This is the *benben*-stone, a sacred solar symbol of Heliopolis. Although there were no statues of the Aten,[23] evidence from tomb scenes and fragmentary remains shows that large numbers of statues of the king, and also the queen, were placed in the temple (fig. 179), and indeed statues of the royal family were ubiquitous throughout the city.

Instead of cult statues of the Aten, Akhenaten himself was the living manifestation of the deity, and the city was deliberately laid out to provide a setting for his display.[24] A broad road, 30 m wide, ran from the palace on the north edge of the city, where the royal family resided, south to another palace in the administrative section of the city, where the king dealt with the business of government. In non-royal tomb scenes the king is shown riding along this road in his chariot, escorted by running soldiers, with everyone along the way bowing low with their arms raised in adoration as he passes (fig. 180). One can imagine how in the morning Akhenaten would appear in his chariot, make his royal progress south to attend to his ritual and governmental duties, and then return along the same route in the evening, in a cycle as regular as that of the sun disk

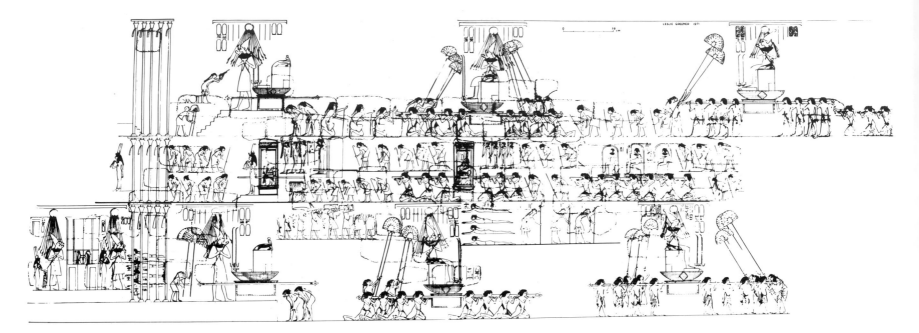

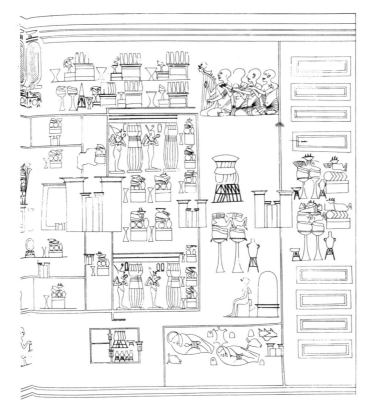

178 *above* Reconstruction drawing of scenes showing part of the *sed-*festival of Akhenaten, in which the queen and royal children also take part. From the Aten temple at Karnak. Eighteenth Dynasty, Amarna period.

179 Drawing of a detail of a scene showing statues of the king in an architectural setting in a pillared colonnade in a temple at Amarna. The statues are mummiform, carry the *heqa*-sceptre and *nekhakha-*flail, and wear either the red or the white crown. In front of this colonnaded court, but within the temple enclosure, a seated statue of the king is depicted, together with a round-topped stone on a pedestal that represents the *benben*-stone, a sacred solar symbol of Heliopolis. From the tomb chapel of the high priest of the Aten Merira I at Amarna. Eighteenth Dynasty, Amarna period.

travelling across the sky.[25] These royal processions provided an opportunity for the inhabitants of the city to adore and acclaim the living manifestation of the Aten, as they had previously adored and acclaimed the divine cult statues that were carried in procession.

The administrative palace was the setting for appointing and rewarding officials. Scenes in non-royal tombs do not show these occasions taking place in the throne room as earlier, but at a 'window of appearance' from which the king and his family lean down towards the official standing below (fig. 181). The remains of one of the rooms in the palace preserve a raised platform built against one wall.[26] Enough survives of the outside of this wall to show that it was painted with figures of bound foreigners. The window must have been set in the wall above, and would have looked out over the palace courtyard where the official and his entourage would have assembled for the ceremony. The tomb scenes show the window as an open shrine-like feature decorated with friezes of *uraei* and admitting the sun's rays that fall from the sun disk overhead on to figures of the king and queen. These three images represent the triad of creator and his first creations, the male and female principles of the universe.

This triad is also the focus of veneration on stelae that were set up in private garden and household shrines (fig. 182).[27] Figures of some of the royal children were usually included, perhaps to symbolise the interaction of the two principles and the continued existence of the created world.

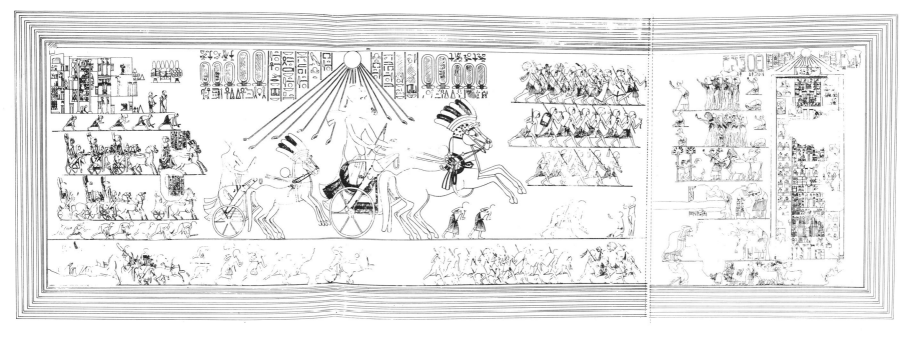

180 *above* Drawing of a scene in the Amarna tomb chapel of the high priest of the Aten Merira I, showing the king and queen driving south along the road that led from the residential palace in the north to the administrative and ritual part of the city. Here they are going towards the temple. The king and queen, who drives her own chariot, travel under the protection of the Aten rays. They are followed by four of their daughters in two chariots, together with their entourage. Military outrunners precede the royal couple, and crowds of people, bowing with their arms raised in adoration or kissing the ground in obeisance, greet the procession outside the temple. Eighteenth Dynasty, Amarna period.

181 Scene showing the king and queen at the window of appearance, rewarding the official Parennefer with gold necklaces. The structure is surmounted by a broken lintel that leaves it open to the sky to allow the sun's rays to enter. Below, the exterior is decorated with southern and northern prisoners bound by the plants of Egypt; these are also tied round the *sema*-sign to form an elaborate *sema tawy* motif. To the left of the window the artist shows the interior of the palace and the royal children, while to the right is depicted the open courtyard in front of the window. From the tomb chapel of Parennefer at Amarna. Eighteenth Dynasty, Amarna period.

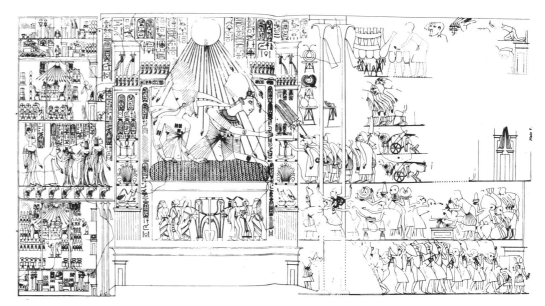

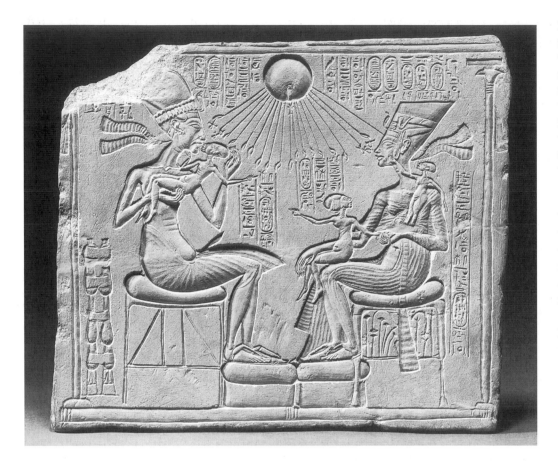

In addition to these stelae, the shrines could contain small statues of the king (fig. 183).[28] The walls of the shrine would be decorated with versions of the standard ritual scene showing the king and his family making offerings to the Aten.[29] The cult images found in these shrines show that Akhenaten and his family were objects of veneration for the elite, as is also indicated by texts that address prayers to the king and queen, suggesting that the royal couple acted as intermediaries between the rest of humanity and the Aten.

Non-royal tombs

The tombs of the elite officials of Akhetaten were cut into the eastern cliffs, north and south of the entrance to the royal *wadi*.[30] The chapels of the bigger tombs consisted of an outer room leading to an inner room with a large statue niche in the form of a shrine in the centre of the back wall (fig. 184). Smaller chapels had only one room and a statue niche. Most of the tombs are unfinished, with only the outer room decorated. Here the decoration shows a complete change from traditional chapels. Scenes of the deceased hunting, fishing and fowling, overseeing 'everyday life' activities or banqueting have mostly disappeared.[31] Instead the king and his family form the focus of the decoration. The scenes show the king offering to the Aten, riding in his chariot through the city, eating and drinking in the palace or rewarding the tomb owner from the window of appearance that has replaced the kiosk scene. Unlike earlier scenes that had little or no background, those in Amarna tomb chapels frequently have elaborate architectural settings depicting specific parts of the city, palaces and temples (figs 179–81).

At first sight, scenes relating to the burial and funerary ritual of the deceased appear to have vanished also, but it seems that these were confined to the statue shrine, left undecorated in most tombs. In the tomb of Huya, steward of the king's mother, the two side walls of the shrine show the rites performed over the coffin (fig. 185), groups of male and female mourners, and the bringing of food offerings and funerary items.[32] The shrine in the tomb of Panehsy, first servant of the Aten in the house of the Aten in Akhetaten, was decorated with

182 Limestone altar stela showing King Akhenaten and Queen Nefertiti with their three eldest daughters seated beneath the Aten in a pavilion. Stelae like this one were set up in garden or household shrines at Amarna, where the Aten and the royal couple were venerated as the creator and his first two creations, representing the male and female principles of the universe. The children may symbolise the continuous process of creation. The composition is carefully balanced between the two figures. Nevertheless, Akhenaten's figure is given the primary right-facing orientation and Nefertiti the secondary left-facing one. The stela is not just a pretty picture showing the private life of the royal family but a religious icon that encodes a statement of belief. Probably from Amarna. H. 32.5 cm. Eighteenth Dynasty, Amarna period. Berlin, Ägyptisches Museum.

183 Painted limestone statuette of King Akhenaten (feet and base restored) found in a private house at Amarna. The *uraeus*, browband, collar and the centrepiece lying on the kilt are all gilded. The figure almost certainly stood in the domestic shrine of the house where it was found as an object of veneration and mediator between the household and the Aten. H. 21.9 cm. Eighteenth Dynasty, Amarna period. New York, Brooklyn Museum of Art.

184 View of the rock-cut seated statue of the royal scribe Iny in the shrine at the rear of his tomb chapel at Amarna. The statue is raised on a platform with steps leading up to it. As in earlier tomb chapels, this was intended to be the focal point of the funerary cult. Limestone. Eighteenth Dynasty, Amarna period.

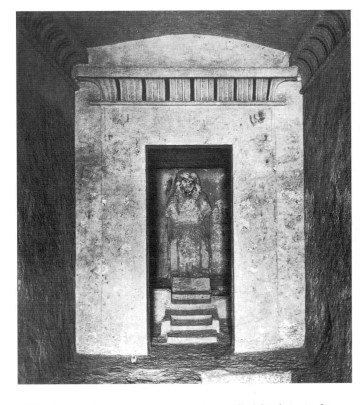

the traditional scene of the deceased and his wife seated before a table of offerings with a male figure performing the offering rites (fig. 186). Similar offering scenes appear on the walls of the shrine in the tomb of the royal scribe Iny.[33] The traditional nature of the scenes is not matched by the texts. Since traditional funerary formulae were not appropriate to the Aten religion, the inscriptions invoke the Aten and the king.[34]

Few non-royal stelae were found at Amarna.[35] This may be in part because the type of scene showing an individual adoring a deity could not be used, since only the king and his family could adore the Aten directly. However, statues of non-royal individuals are also extremely rare, in contrast to the countless sculptures of the king and his family that were erected in the temples, palaces and private houses of Amarna. The dominant position given to the king and his family in tomb chapels and the paucity of other non-royal monuments demonstrate the overwhelming emphasis placed on the depiction of the king and the relative marginalisation of images of the elite.

185 *below* Drawing of a scene on the eastern wall of the shrine in the Amarna tomb chapel of Huya, the steward of the king's principal wife, showing the rites before the coffin. The coffin of Huya stands upright before a large heap of offerings in front of which a man in a leopard skin performs the ritual. Four mourning women stand behind the coffin and three registers of mourning men are placed behind the officiant. The texts, as would be expected, omit any reference to Osiris and other traditional funerary deities. Eighteenth Dynasty, Amarna period.

186 *below* Drawing of a scene from the shrine in the Amarna tomb chapel belonging to Panehsy, the first servant of the Aten in the house of the Aten in Akhetaten, showing the owner and his wife seated before a table of offerings together with their children. On the other side of the table a standing male figure offers a formal bouquet to the couple. Behind this figure the scene ends with an enormous formal bouquet the height of the register. The word for such bouquets was *ankh*, a homonym for *ankh* ('life'), hence the fact that they are often featured in funerary ritual. The text invokes the Aten and asks for a 'good old age' for Panehsy. Eighteenth Dynasty, Amarna period.

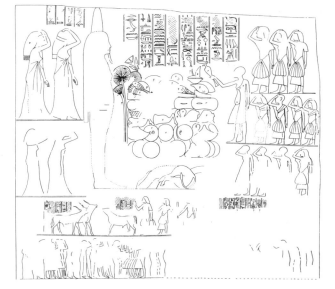

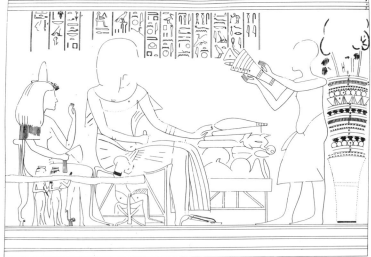

The aftermath of Amarna

The king

It is not known how Akhenaten's reign ended, but his ultimate successor was the famous Tutankhamun, who came to the throne as a young boy and reigned for ten years. His parentage is much debated.[36] A block originally from Amarna that names Tutankhaten (the king's original name) and gives him the title 'king's son of his body' shows that he was the offspring of a king. Since he could have been a son of Amenhotep III only if there had been a long co-regency, it is simplest to accept that he was the son of Akhenaten.

The first year or so of his reign was spent at Amarna, but it was not long before the royal residence was moved back to Memphis. At the same time the Aten theology ceased to be exclusive and traditional cults were restored. Unfinished building projects abandoned in Akhenaten's reign were resumed, new projects were instituted in state temples throughout Egypt and Nubia, and the divine images destroyed by Akhenaten were replaced with new statues. The extent of Tutankhamun's restoration programme is difficult to appreciate today, because his reliefs and statues were usurped by his successors, through the simple expedient of replacing his name with their own (fig. 187). It is clear, however, that the walls of Amenhotep III's colonnade at Luxor were decorated at this time with scenes of the Opet-festival.[37] Figures of the king and deities are drawn in accordance with traditional proportions, so that the height of the lower leg is once again a third of the hairline height (figs 187–8). However, in the scenes showing the procession of the sacred boats the Amarna influence is still strong.

Tutankhamun is famous today because of the discovery of his almost intact burial in 1922.[38] The tomb is small and consists of a stairway and corridor leading to four rooms. The plan is very different from those of earlier Eighteenth Dynasty royal tombs. It seems likely that, when Tutankhamun died unexpectedly young, his tomb was not ready and a more nearly finished non-royal tomb was used instead. The painted decoration in the burial chamber must have been applied between the time of his death and his burial. Although very abbreviated, the decoration on three of the walls is traditional. Instead of the whole journey of the sun through the underworld, the west wall has a version of the first hour of the night. On the south wall and part of the north the king is shown with various deities (figs 190–1). However, on the east wall a group of officials is depicted dragging the dead king in a sarcophagus as part of his burial procession, and on the adjacent east end of the

north wall Tutankhamun's successor, King Ay, is shown performing the 'opening of the mouth' ritual on the royal mummy in order to reanimate the body. These scenes remind one of the very fragmentary scene in the burial chamber of Akhenaten that may depict his funeral, but have no precedent in earlier tombs in the Valley of the Kings.

The figures of the king and deities still show some Amarna influence. It is curious, however, that those on the south wall exhibit lower legs with a length one-third of the hairline height (fig. 191), as in pre-Amarna proportions, whereas those on the north wall retain the short Amarna lower leg that is less than a third of the hairline height (fig. 190).[39] This can mean only that different artists worked on the north and south wall, the former still using modified Amarna proportions and the latter returning to traditional proportions.

The contents of the tomb showed the astonishing wealth and variety of royal funerary paraphernalia.[40] Some items, such as the funerary masks, coffins, shrines, canopic equipment and divine and royal statues, were made specifically for burial, their purpose being to protect the dead king and aid his triumphant transformation into the next life. Other objects, such as items of furniture, clothing, writing equipment, ceremonial sticks, fans and chariots, had been used by the king during life. Many of these are decorated with motifs that show him triumphant over foreigners. Bound prisoners adorn his footstools and sandals, placing them literally under the king's feet; the handles of his ceremonial sticks, where the king would grasp them in his fist; and the panels of his chariots, the vehicle of royal display and aggression. A small painted chest has four scenes of the king in his chariot on its long sides and lid (fig. 189).[41] The composition is the same in all of them. The king in his chariot dominates the central part of the scene as he charges against the forces of chaos, represented by Syrians and Nubians on the sides and by desert animals on the lid. The foreigners and animals form a chaotic mass without register lines. Behind the king, much smaller figures of Egyptian chariotry and infantry are arranged neatly in three registers. These scenes encapsulate the Egyptian world vision that contrasts the ordered world with the surrounding chaos of the desert and foreign lands, and puts the king at the centre of the struggle to maintain order in the face of chaos.

The succeeding reign of Ay was short, and was followed by the accession of Tutankhamun's top general, Horemheb. Horemheb completed the return to orthodoxy. He began the dismantling of the Aten temples and the restoration of

187 Relief showing King Tutankhamun burning incense and libating on the east side of the north wall in the colonnade of the temple of Luxor. The cartouches identifying the king's figure have been recut into the names of King Horemheb. Eighteenth Dynasty.

188 Relief showing the god Amun-Ra on the west side of the north wall in the colonnade of the temple of Luxor. The god's figure is rendered in a very traditional manner with little, if any, Amarna influence. The shoulders are broad and the lower leg is a third of the figure's height to the hairline, in contrast to the narrow shoulders and short lower legs of Amarna figures. Eighteenth Dynasty.

189 Plastered and painted wooden chest of King Tutankhamun from his tomb in the Valley of the Kings (no.62). The king in his chariot, followed by his loyal Egyptian troops, attacks a group of Nubians. The chaotic mass of foreigners graphically captures the role of non-Egyptians as symbols of chaos. The text complements the theme: 'Perfect god, likeness of Ra, who appears over foreign lands like the rising of Ra, who destroys this land of vile Kush, who shoots his arrows against the enemy.' The theme of Egyptian domination is repeated on the ends of the chest, where Tutankhamun is portrayed in the traditional image of a sphinx trampling Egypt's southern and northern enemies. H. 44 cm. Eighteenth Dynasty. Cairo, Egyptian Museum.

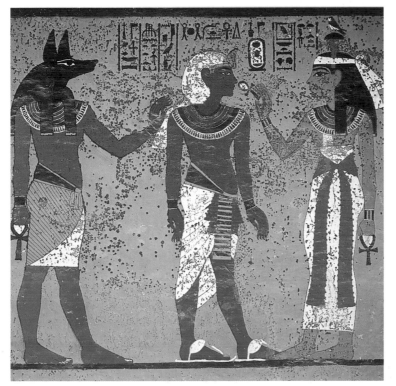

190 *above* North wall of the burial chamber in the tomb of King Tutankhamun in the Valley of the Kings (no.62). The scenes show, from right to left, Tutankhamun's successor, King Ay, wearing the ritual leopard skin, performing the opening of the mouth ritual on Tutankhamun's mummy; Tutankhamun before the goddess Nut; and Tutankhamun, followed by his *ka*, embracing a figure of the god Osiris, who welcomes him to the underworld. The scene with Ay has no parallel in a royal tomb, but perhaps was included in the decoration in support of Ay's claim to the throne, since each new king was responsible for the burial of his predecessor. If so, the human audience for such a message would be the artists who painted the tomb and the people who brought the funerary equipment into it, but it was probably also intended for a divine audience. The style of the figures still shows some Amarna characteristics, such as the pronounced belly with crescent-shaped navel, the large buttocks and short lower legs. Only the feet on King Ay's figure are differentiated between left and right. Painted plaster. Eighteenth Dynasty.

191 South wall of the burial chamber in the tomb of King Tutankhamun in the Valley of the Kings (no. 62). Hathor, as goddess of the west, holds out an *ankh*-sign to the king's nose, while the funerary god Anubis stands behind the king, his forward hand reaching out to touch the king's shoulder. The figures apparently exhibit a similar style to those on the north wall, with pronounced bellies, crescent-shaped navels and large buttocks (fig. 190), but their lower legs are longer in proportion to the total height of the figures, suggesting that the figures on the two walls were drawn by different artists. Both Hathor and Tutankhamun have undifferentiated feet, but the rear foot of Anubis is seen from the outside and shows all five toes. Painted plaster. Eighteenth Dynasty.

damage done during the reign of Akhenaten. He also usurped most of the monuments of his two predecessors. The reigns of Akhenaten and his immediate successors were expunged from the records, and Horemheb was given their regnal years in addition to his own. However, in his tomb in the Valley of the Kings a curious hold-over from the Amarna period remains. The subject matter is perfectly orthodox, depicting the king with various deities and the sun's journey through the underworld,[42] but the proportions of the figures retain the short Amarna lower leg (fig. 192).[43] Since the short lower leg is not found on other royal monuments of the reign, it would seem that the artists who decorated the royal tombs, by retaining this one Amarna characteristic, departed from the mainstream of artistic practice.

Non-royal tombs at Saqqara

For most of the Eighteenth Dynasty the best evidence for non-royal tombs comes from Thebes, although some officials were also buried at Saqqara in rock-cut tombs.[44] After the Amarna period, tombs of a different design appear at Saqqara.[45] Their chapels are free-standing and consist of an entrance into an open court, leading to three shrines for the funerary cult. Depending on the wealth of the owner, the layout could be expanded by adding another court or more rooms, and increasing the numbers of statues and stelae in the building. The basic plan of these chapels resembles a small temple with a pylon and open court leading to the

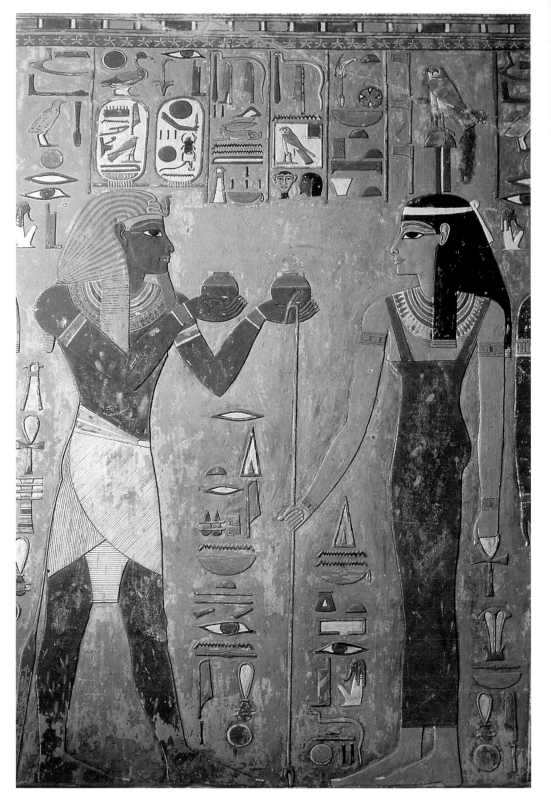

192 Scene cut in raised relief showing King Horemheb offering wine to Hathor as goddess of the west. The king is identified by the two cartouches placed above his head, while his action is spelled out in the vertical column of hieroglyphs in front of his figure: 'giving wine to the lady of the two lands', a title that here refers to Hathor. These hieroglyphs all face to the right in the same direction as the king's figure. The rest of the hieroglyphs in the scene face left and refer to Hathor. At the top of the scene the goddess says: 'I have come that I may be your protection.' In front of her figure the inscription runs: 'I have given to you the throne of Osiris for ever.' Behind her is the standard text: 'All life is behind her like Ra', which incorporates the *ankh*-sign that the goddess holds in her rear hand. Hathor wears on her head a tall falcon emblem used as a hieroglyph to write the word for 'west', showing that she is present in her aspect of the goddess of the necropolis, which lies on the west bank at Thebes, where the sun sets. In this form Hathor receives the dead and helps them make the difficult transition from this world to the next. The decoration in the tomb of Horemheb is of the highest quality. Obvious Amarna characteristics like the pronounced belly, crescent navel and prominent buttocks, which were present in the decoration of the tombs of King Tutankhamun and his successor King Ay, have disappeared, but the short Amarna lower leg that is less than a third of the hairline height is still retained. Painted plaster on limestone. Eighteenth Dynasty, post-Amarna period.

193 Painted scenes in the tomb chapel of the official Iniuia at Saqqara, showing on the two side walls Iniuia with his wife and children before a seated figure of the god Osiris accompanied by the goddesses Isis and Nephthys. Beneath each scene there runs a narrow frieze bounded by black lines within which lotus plants and fish are depicted on a blue background that represents water. The back wall is decorated with a double scene showing Iniuia standing with his arms raised in adoration before Osiris on the left and Sokar, the god of the necropolis in the Memphite region, on the right. It was once thought that flat painting was not used in the New Kingdom tombs at Saqqara, but excavations in the 1990s have proved this supposition wrong, even though very few painted scenes have survived in good condition. Painted plaster on mud brick. Eighteenth Dynasty, post-Amarna period.

ritual inner part of the building. It is possible that their inspiration came from royal funerary temples.

In the late Eighteenth Dynasty the main building material for these tomb chapels was mud brick with the addition of stone elements, such as doorways and stelae. The walls of important rooms, such as the main chapel, were lined with blocks of limestone into which relief scenes were cut. In less important areas, such as side chapels and statue rooms, which had vaulted ceilings, the mudbrick walls were simply plastered and decoration added in flat paint. Today little of this painted plaster has survived, and it is only in recent excavations that its use in New Kingdom chapels at Saqqara has been discovered (fig. 193).[46]

While still a private person Horemheb built a tomb for himself at Saqqara in the reign of Tutankhamun, and it is the finest and best-preserved of such tombs so far excavated (fig. 194).[47] The chapel underwent several changes in plan to enlarge it, no doubt as Horemheb's star rose. Some of the decoration was traditional, showing the deceased before

offerings, but many of the scenes reflect Horemheb's military career and include rows of subdued northern and southern foreigners. A group of foreign rulers grovel as they are presented by Horemheb to the king and queen at the window of appearance, while elsewhere prisoners are brought to the royal couple enthroned in a kiosk. In these scenes Horemheb clearly acts as the agent of the king, but in another scene foreign prisoners are presented to Horemheb himself, not the king. Since the subjection of foreigners was the ritual duty of the king, Horemheb comes close to usurping a royal prerogative and may be expressing his aspirations to royal power. Although Horemheb never used this tomb himself, a royal *uraeus* was added to his figures after he became king (fig. 195).

The non-royal figures in this and other Memphite tombs have some traits in common with Amarna figures, although they do not have the short lower leg. Male figures exhibit narrow shoulders, a high small of the back, slender limbs and no musculature. Such proportions produce a small

a b c

194 Plans of the three main building stages of the tomb of Horemheb at Saqqara. Eighteenth Dynasty.
(a) 1. Forecourt
 2. Colonnaded court
 3. Cult room flanked by chapels
(b) 1. Statue room and side rooms converted from the original forecourt
 2. Colonnaded court
 3. Cult room flanked by chapels
 4. Forecourt added in front of the original forecourt
(c) 1. Statue room and side rooms
 2. Colonnaded court
 3. Cult room flanked by chapels
 4. Colonnaded court with pylon gateway converted from the forecourt
 of stage (b)
 5. Forecourt added in front of the new pylon

195 Figure of the general Horemheb on a limestone panel from his tomb at Saqqara. Horemheb stands with his arms raised in adoration. The gesture is explained by the text, which opens with an invocation to a number of funerary deities, including Osiris and Anubis, that begins 'adoration to you'. After asking for the usual offerings of 'bread, beer, cattle, birds, cold water, wine and milk' on behalf of Horemheb, the text continues: 'Hail to you, foremost of the West, Osiris, who resides in the Thinite *nome*. I have come to you with my two arms (raised) in adoration of the beauty of your person that you may place me among your followers like the spirits who lead the underworld and live on *maat* every day. I am one of them. My abomination is evil, I have acted according to *maat* on earth without fail.' Horemheb wears sandals and the elaborate, pleated clothing of the late Eighteenth Dynasty, including an ankle-length bag tunic with two wide sashes tied round the waist to form a longer and shorter kilt. His complex, multi-layered braided wig falls below shoulder level. From his back is slung a long feathered fan which goes with his title 'fan-bearer on the king's right' and marks the bearer as being of particularly high status, because of the close association with the king's person. The *uraeus* on the figure's forehead is secondary, having been added after Horemheb ascended the throne as king. H. of panel 180 cm. Eighteenth Dynasty, post-Amarna period. London, British Museum.

upper torso and a long lower part of the body and give an overall impression of elegance. This is enhanced by the elaborately draped and tied costume that often adds a rather dandified effect (fig. 195). Representations of the king and deities remain more traditional in their proportions, with wider shoulders and a lower small of the back (fig. 188).

Conclusion

Amarna art has sometimes, most misleadingly, been classed as 'naturalistic'. It is doubtful whether any of the categories that have been devised for the artistic styles of other cultures should be applied to the art of ancient Egypt, but if one were to do so the term 'expressionistic', or even 'mannerist', would be more appropriate for Amarna art. Although we may never know the underlying reasons for the changes in the proportions of the human figure at this time, it seems more plausible to attribute them to Akhenaten's religious convictions than to see them as truthfully reflecting, as some scholars have done, some diseased condition suffered by the king. There is certainly no reason to suppose that art under Akhenaten became any more realistic than it had been traditionally.

After Akhenaten's death religious orthodoxy returned and with it a more traditional rendering of bodily proportions, especially in figures of deities and the king. Nevertheless, Amarna influence was not totally erased and non-royal figures in the private tombs at Saqqara retained the high small of the back and slender limbs of Amarna figures (although the short lower leg was abandoned), not only in the immediate post-Amarna period but throughout the rest of the New Kingdom, as we shall see in the next chapter.

Notes
1 E.g. Redford 1967, 88–169; 1984; Murnane 1977, 123–69, 231–3; Aldred 1988, 169–82; Johnson 1990.

2 Aldred 1973, 50, fig. 30; Redford 1984, figs 4.4–4.6.
3 Aldred 1973, 97 no.11; Smith and Redford 1976, 95–9.
4 But see Martin 1986.
5 Smith and Redford 1976; Redford 1988; Redford 1984, 57–136. For activities at Memphis see Löhr 1975.
6 Aldred 1976.
7 Murnane and Van Siclen 1993.
8 Robins 1996b.
9 Baines 1985a, 99–101.
10 Robins 1996b.
11 E.g. Davies 1903, pls 37–8, 41; 1905a, pls 22–3; 1905b, pls 2–3, 28–9.
12 Russman 1980.
13 Robins 1994a, 121–43.
14 Martin 1989b.
15 Martin 1989b, 50.
16 Martin 1989b, 27–48.
17 Martin 1974, 105–6.
18 Martin 1974, pls 6–9.
19 Smith and Redford 1976; Redford 1988.
20 Redford 1984, 57–136.
21 Gohary 1992.
22 Kemp 1989, 281–3.
23 But see Bianchi 1990; Cruz–Uribe 1992.
24 Kemp 1976, 92–9; Kemp 1989, 276–87; O'Connor 1995a, 284–90.
25 O'Connor 1995a, 289–90.
26 Kemp 1976; 1989, 288; O'Connor 1995a, 288.
27 Ikram 1989; Saleh and Sourouzian 1987, no.167; Aldred 1973, figs 45, 53.
28 E.g. Saleh and Sourouzian 1987, no.160.
29 Saleh and Sourouzian 1987, no.165.
30 Davies 1903; 1905a, b; 1906, 1908a, b.
31 But see Davies 1905b, pls 5, 7–8.
32 Davies 1905b, pls 22–4.
33 Davies 1908a, pls 9–10.
34 E.g. Murnane 1995, nos 63c–65, 66.10–66.16, 70.4–70.6, 71.4.
35 Aldred 1973, 205 no.141.
36 Fairman 1972; Ray 1975; Redford 1984, 192–3; Reeves 1990b, 24–5.
37 Epigraphic Survey 1994.
38 Carter 1923; 1927; 1933; Reeves 1990b.
39 Robins 1994a, 155–8.
40 Reeves 1990b; McLeod 1970; Tait 1982; McLeod 1982; Littauer and Crouwel 1985; Eaton Krauss and Graefe 1985; Jones 1990; Eaton-Krauss 1993.
41 Davies and Gardiner 1962.
42 Hornung 1971.
43 Robins 1994a, 157–9.
44 Zivie 1988; 1990.
45 Martin 1991.
46 Schneider 1993; Martin forthcoming.
47 Martin 1989a.

The glories of empire

THE NEW KINGDOM (III)

196 View looking east from the first room in the tomb of Queen Nefertari, principal wife of King Ramses II, in the Valley of the Queens (no.66). The entrance to the tomb lies to the right, so that the figures of the gods Anubis and Osiris in their shrines look out from the tomb, which represents the underworld, towards the entrance, in order to greet Nefertari as she passes through the door that marks the divide between the worlds of the living and the dead. The burial chamber lies to the left at the bottom of a descending stairway. In the rooms seen here the queen meets and offers to a variety of solar and underworld deities. To the left of the inner doorway is the scarab-headed deity Khepri who represents the rising sun, and to the right the falcon-headed sun god Ra-Harakhty, seated with Hathor as the goddess of the west. On the far wall of the end room is a figure of Osiris seated back to back with a figure of the god Atum, whose shoulder can just be seen here. Atum as the setting sun descends into the underworld and merges temporarily with Osiris before his regeneration and rebirth into the eastern sky at dawn. Painted relief-cut plaster. Nineteenth Dynasty.

Because Horemheb, like Ay and Tutankhamun before him, had no son, he appointed his vizier Paramesse as his heir. Paramesse, who came from a military family of the eastern Delta, already had an adult son and a grandson, so that the succession was ensured for at least two generations.[1] After ruling for less than two years under the name Ramses, he was duly succeeded by his son, Sety I, and then by Sety's son, Ramses II, who reigned for sixty-seven years. These kings continued the restoration of monuments damaged during the Amarna period and built widely in their own right throughout Egypt. Because of the length of his reign, Ramses II was able to undertake more building projects than any other king.

During the Amarna period and its aftermath the Egyptians had lost the northernmost part of their empire, including the city of Qadesh, to the rising power of the Hittite empire in Anatolia. Sety I recovered Qadesh, but it proved impossible to hold it. Ramses II tried to regain the city in a battle fought in his regnal year 5.[2] The outcome was indecisive, but Ramses claimed a great victory over the Hittites, which he depicted in a number of his temples. Although hostilities continued, neither side gained the advantage, and Ramses and the Hittite king signed a treaty in year 21. This was cemented in year 34 when Ramses married the Hittite king's daughter.[3]

Ramses was succeeded by his thirteenth son, Merenptah, who ruled for ten years and successfully defeated a Libyan invasion of the western Delta. But after his death the reign of his successor, Sety II, was interrupted by a usurper, named Amenmesse, while the next king, Siptah, came to the throne young and died after only six years. His successor, Tawosret, the widowed consort of Sety II, ruled for only two years. This period of unstable rule was ended

through a successful bid for the throne by a man called Sethnakhte, the first king of the Twentieth Dynasty. After a short reign, he was succeeded by his adult son, Ramses III, who ruled for more than thirty years. During his reign Egypt faced a great population movement that affected Anatolia and Syria–Palestine, in which the so-called Sea Peoples moved south through the eastern Mediterranean coastlands and tried to enter Egypt to settle.[4] Ramses stopped them in his year 8, in land and sea battles at the very borders of Egypt. In his years 5 and 11 he defeated further Libyan invasions of the western Delta, although Libyan immigration into Egypt continued.

Ramses III was assassinated in a plot to alter the succession. He was followed by eight more kings called Ramses over the next ninety years, during which royal power declined, building programmes contracted and control of Palestine was lost. There was tension between north and south, and the king may have travelled south less often and left the administration of the region to the high priests of Amun. During the reign of Ramses XI Nubia was lost to Egypt, a line of military high priests took over at Thebes and a man called Smendes gained control of Lower Egypt. Ramses XI continued nominally as king, but on his death Smendes became the next king, with his residence at the new Delta city of Tanis.

The king

The royal tomb

Despite the northern origins of the Nineteenth Dynasty, kings continued to be buried at Thebes. Because Ramses I's reign was so short, his tomb is small, with painted rather than relief-cut decoration. Nevertheless the style of the

197 Relief from a pillar in the tomb of King Sety I in the Valley of the Kings (no. 17) showing Sety I and the goddess Hathor, mistress of the western desert, holding hands. With her other hand, Hathor holds out her *menit*-necklace to the dead king, who raises his hand in the gesture of adoration to touch it. The necklace, sacred to the goddess, has connotations of rebirth which make it an appropriate item in this context. The goddess's dress is unusual in that it is decorated with a pattern based on the titles and names of the king. In contrast to the clearly distinguished skin colours of the king and Hathor in the tombs of Tutankhamun and Horemheb, Hathor's skin is here painted the same dark colour as Sety's. The short Amarna lower leg has been abandoned and the lower legs of the figures are fully a third, if not more, of the hairline height. The high-quality relief-cutting and painting is demonstrated by the layering and delicate treatment of the transparent, pleated linen. Painted plaster on limestone, H. 226.5 cm. Nineteenth Dynasty. Paris, Louvre.

paintings is clearly similar to that of the reliefs in the tomb of Horemheb, including the use of proportionally short lower legs. By contrast, figures in Sety I's tomb have traditionally proportioned lower legs, one-third of the hairline height (fig. 197).[5]

Sety's tomb began a new tradition in which the walls and ceilings were decorated from the entrance all the way to the burial chamber.[6] The expanded decoration focused on familiar themes: the king with deities and the journey of the sun through the underworld.[7] An underworld text, already used in the burial chamber of Thutmose III and today known as the *Litany of Ra*, decorated the first two corridors of the tomb and deals with the temporary merging of Ra and Osiris at night in the underworld, when the two deities formed a single being.[8] The sun crossed the sky during the day and at night sank into the underworld, to which the king's tomb was assimilated, in order to merge once more with Osiris, with whom the dead king was identified. The ceiling in the burial chamber was painted with images of constellations to represent the night sky, reinforcing the notion of the tomb as a microcosm.

The tomb decoration is mostly cut in high-quality painted raised relief (fig. 197). One room is not finished and shows the artists' work in progress.[9] The scenes were originally laid out on the walls and two pillars in red outline. They were then gone over in black, corrections being made where necessary and details filled in. At this point work stopped and the scenes were never cut into relief or painted (fig. 198). Of interest is the fact that nowhere were squared grids used. The large figures of the king and various deities that appear on the eight pillar faces are drawn freehand with great assurance. Their proportions conform to those current at this period and show that artists were not dependent on grids for achieving well-drawn human figures. Comparable unfinished work in the tomb of Horemheb shows that guide lines, but not grids, were used there,[10] and the lines make it easy to see that the figures there still have the short 'Amarna' leg.

Royal tombs continued to be built in the Valley of the Kings for the rest of the New Kingdom using similar architecture and decorative repertory.[11] Nevertheless, no tomb was ever an exact copy of another, and stylistic differences are recognisable between different artists and as one generation of artists replaced the next.[12] The tombs were constructed by a special group of roughly sixty men who lived in the government village of Deir el-Medina situated in the desert on the west bank at Thebes.[13] These workmen included stone cutters who hacked the tombs out of the rock, outline draughtsmen who drew the scenes and texts

198 Unfinished scene on a pillar in the tomb of King Sety I in the Valley of the Kings (no.17) showing the king and the goddess standing facing towards each other. The goddess holds an *ankh* sign to Sety's nose with her rear hand, while she embraces him with her forward arm. The figures and hieroglyphs have been sketched by a draughtsman, first in red and then in black, but they were never cut into relief. This allows us to appreciate the assured hand of the artist and the beauty of line, in the rendering both of the hieroglyphs and the figures. The latter exhibit the slightly aquiline nose and small mouth characteristic of the Nineteenth Dynasty profile. Red and black paint on plastered limestone. Nineteenth Dynasty.

on the walls, and sculptors who cut them into relief. They were organised into two teams under two chief workmen and the scribes of the tomb. The village was established in the Eighteenth Dynasty but we know most about it from the Nineteenth and Twentieth Dynasties. The Deir el-Medina workmen were responsible first and foremost for the king's tomb. In the Eighteenth Dynasty other members of the royal family did not have decorated tombs. However, this changed in the Nineteenth Dynasty, when decorated tombs were introduced for important royal women and children, situated to the south of the Valley of the Kings in what is now called the Valley of the Queens,[14] not far from Deir el-Medina. These tombs were also built by the royal workmen.

The most famous of the tombs was commissioned by Ramses II for his first principal wife, Nefertari (fig. 196).[15] As with a king's tomb, there is no tomb chapel, and the cult of the queen was probably conducted in the king's funerary temple, where the cult of his mother was also enacted. The tomb is decorated throughout in brightly painted relief of the highest quality which, because of the poor condition of the limestone in the Valley of the Queens, was cut not into the stone itself but into layers of plaster applied on top of the stone. The door at the entrance to the tomb has painted on its soffit (the underside of the lintel) an image of the sun on the desert horizon flanked by figures of Isis and Nephthys as kites. The whole is oriented so that the top of the sun is nearest the outside of the tomb. As Nefertari enters the tomb, she and the sun sink together into the horizon and pass into the underworld. Inside the tomb the decoration shows Nefertari welcomed to this realm by Osiris and Anubis. A stairway descends to the burial chamber, which represented the domain of Osiris and was decorated with underworld scenes illustrating the collection of funerary texts now known as the *Book of the Dead*. Here Nefertari's body, identified with that of Osiris, lay in its sarcophagus. Her spirit, however, was united with the sun god Ra, and, with the coming of day, left the underworld to rise again into the sky. As Nefertari travelled out of the tomb, she once more passed under the soffit of the entrance door, but this time in the opposite direction. Now she rises over the horizon with the sun, and united the two ascend triumphantly into the sky from the eastern horizon.

Logically, this last image should have faced towards the east and the rising sun, with the burial chamber to the west where the realm of the dead lay. In fact, the tomb is oriented from south to north. However, like many buildings whose actual and ritual orientations did not match, the tomb was given a symbolic orientation that was reinforced

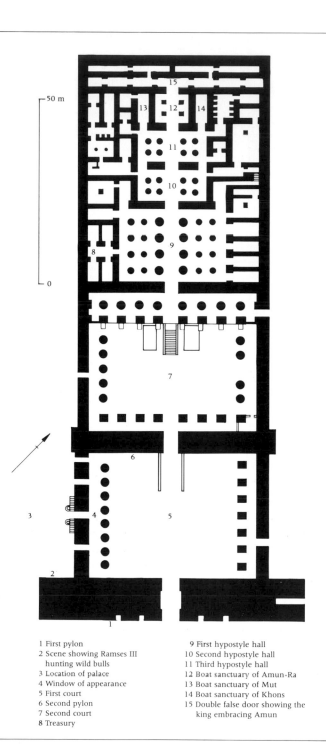

199 Plan of the funerary temple of Ramses III at Medinet Habu, Thebes. Twentieth Dynasty.

1 First pylon
2 Scene showing Ramses III hunting wild bulls
3 Location of palace
4 Window of appearance
5 First court
6 Second pylon
7 Second court
8 Treasury
9 First hypostyle hall
10 Second hypostyle hall
11 Third hypostyle hall
12 Boat sanctuary of Amun-Ra
13 Boat sanctuary of Mut
14 Boat sanctuary of Khons
15 Double false door showing the king embracing Amun

through the decoration. Symbolic east and west were established by the position of the entrance and burial chamber. Symbolic south was marked by images of the goddess Nekhbet in vulture form perched on the Upper Egyptian plant, and the symbolic north by the cobra of the goddess Wadjit on the papyrus plant of Lower Egypt.

A recent discovery and on-going excavation in the Valley of the Kings reveal that Ramses II built an enormous, partly decorated, communal tomb, long since robbed, to house the burials of the majority of his fifty or so sons. Its architecture is unique. The entrance opens into two consecutive chambers that lead into a large room with four rows of four rock-cut square pillars. From here a long corridor extends to join a second corridor running horizontally, so as to form a T shape. Forty-eight small rooms open off either side of the passageways. Two more corridors with similar rooms descend from the pillared room. These small rooms are undecorated, and may be funerary chapels rather than burial chambers, in which case the latter are still to be found.

Funerary temples

Thebes As in the Eighteenth Dynasty, funerary temples were situated at the desert's edge and were dedicated to a special form of Amun-Ra in which the god and the dead, deified king merged.[16] They followed the general temple model whereby the outer parts dealt with the subjugation of foreigners at the edge of the world and the restricted inner parts with the world of the gods and divine ritual. In the funerary temple of Hatshepsut an area symbolising a palace had been placed near the sanctuary, south of the temple axis.[17] Over time this palace grew larger and gravitated towards the front of the temple where there was more room. In the temple of Sety I it adjoined the south side of the first court, and this remained the pattern.[18] The palace may have been used for royal ceremonies in the king's lifetime,[19] but its function was primarily to provide the dead king with a setting in which he could exercise his role as ruler for all time.

The funerary temple of Ramses II, now known as the Ramesseum, and that of Ramses III are of the same basic type, and Ramses III plainly took that of his illustrious predecessor as a general model for his own. Of the two, Ramses III's temple at Medinet Habu is the better known (figs 199–200), and, even though its back part is not well preserved, the overall scheme of decoration is clear.[20] The front part of the temple comprises two open courts leading to the covered rear part, which has now mostly lost its roof. The outer face of the first pylon is decorated with images of

200 Reconstruction drawing of the funerary temple of King Ramses III and its enclosure at Medinet Habu, Thebes. The drawing shows the mudbrick enclosure walls, the fortified stone tower at the entrance and the mudbrick storerooms and offices that surrounded the temple proper. The storerooms housed all the goods that came into the temple from its vast estates, presented as ritual offerings and used to pay the temple personnel. Twentieth Dynasty.

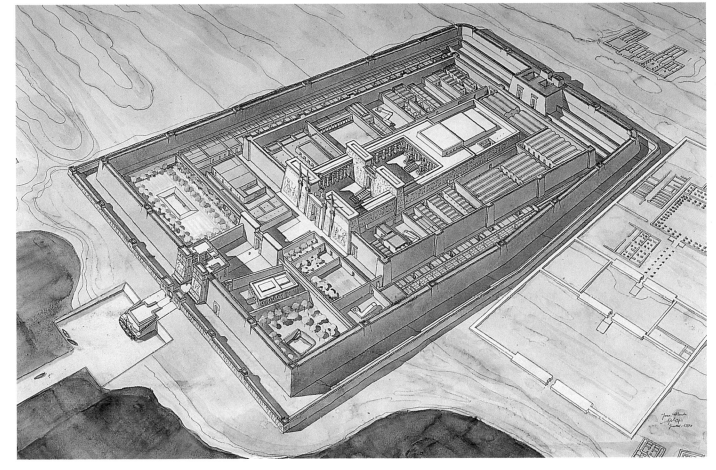

the smiting king, while on the back of the southern tower the king is shown hunting wild bulls in the marshes. The exterior walls of the temple are carved with scenes showing the king's campaigns against the Nubians, Libyans and Sea Peoples. Inside the first court this theme is continued with depictions of the Libyan campaign of year 11, a text recounting the battles of year 8 and a scene in which the king presents prisoners to Amun and Mut. On the south side an elaborate window of appearance links the court with the palace beyond. It is surrounded by images of the king smiting enemies and includes three-dimensional heads of foreigners attached to the wall below the level where the king would have stood, placing them under his feet. Opposite, on the north side of the court, a row of seven pillars have colossal engaged statues of the king facing south towards the palace. In the second court, transitional between the outer and inner temple areas, the decoration is dominated by depictions of the harvest festival of Min (fig. 201), the festival of the funerary deity Sokar and

the procession of the sacred boats of Amun-Ra, Mut and Khons, when the gods were brought out from their hidden sanctuaries and processed before the public. The transitional position of such decoration between the outer and inner parts of the temple reflects the intermediate status of festivals, in which the ritual performance was more open than the rites conducted in the innermost rooms.

The covered rear part of the temple leads through three hypostyle halls to the boat sanctuary of Amun-Ra, flanked on either side by boat sanctuaries for Mut and Khons. Here the boats of the Theban triad would rest when they came from the east bank to visit the temple. In this sacred, inner part the chaotic outer rim of the world and the public festivals of the ordered realm of Egypt give way to the world of the divine, where king and deities interact (fig. 3). Accordingly, the decoration changes to depict the king performing ritual actions for the deities inhabiting the temple, and the actions of the deities for the king, such as the giving

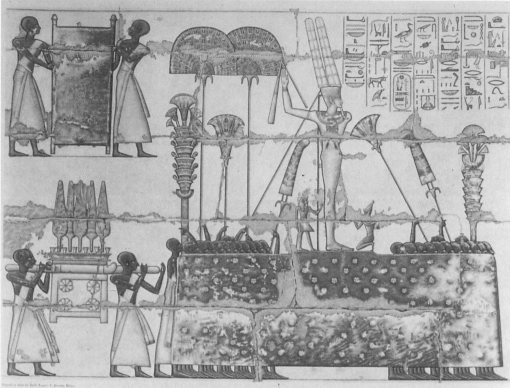

THE FIGURE OF MIN CARRIED IN PROCESSION

201 Scene showing the statue of Min carried in procession at the Min festival. Unlike other divine statues that were hidden from the public gaze within sacred boats, the statue of Min is uncovered and open to view. It is raised on poles carried on the shoulders of priests. The poles are draped with a large red cloth decorated with circular metal studs, each embossed with a star. Other priests carry a variety of brightly coloured fans and two standards in the shape of formal bouquets. A small bronze or gold image of the king kneels in front of the statue, while another stands behind with its forward hand raised in adoration. Behind the group carrying the statue, in the upper register, two priests carry a screen. In the lower register four more priests carry a chest containing lettuces, the plant sacred to Min because of the similarity between the milky sap of the plant and seminal fluid. From the funerary temple of Ramses III at Medinet Habu. Twentieth Dynasty.

of life. The centre of the king's cult lay at the back of the temple in a room immediately behind the boat shrine of Amun-Ra. Here a false door enabled the king to enter the temple from the world of the dead in order to take part in the rituals that were performed there.

Abydos The site of Abydos remained important as the main cult centre of Osiris in Upper Egypt, and, beginning with Ahmose of the Eighteenth Dynasty,[21] a number of New King-

dom kings built funerary monuments there. The funerary temple built by Sety I is unusual in its layout because, instead of one main sanctuary, it has seven placed side by side (fig. 202).[22] They are dedicated to the dead king himself, to the three national deities, Ptah, Ra-Horakhty and Amun-Ra, and to the triad of Abydos, Osiris, Isis and Horus. The sanctuary of Osiris opened into a complex of rooms at the rear of the temple that related to the special Osiris rituals performed at Abydos and perhaps also to the merging of the dead king with Osiris.

A second peculiarity of the temple is that, instead of it being the usual rectangular shape, a complex of rooms, containing an area dedicated to the Memphite gods Sokar and Nefertem, a pillared hall for the storage of portable sacred boats and various service and storage areas, was added at the south side of the temple at the rear, giving the building an inverted and reversed L-shaped plan. The decoration includes a number of lists of different kinds, including an extensive list of kings before which Sety, followed by his son Ramses, censes.

Sety died before the temple was completed, and the poorly preserved first and second courts were decorated in relief by Ramses II. The interior of the main temple was already finished in high-quality painted raised relief (fig. 203). The decoration in the Sokar–Nefertem complex was cut into relief but never painted. In other parts of the southern wing the decoration was not cut into relief, but painted only, presumably in order to finish it quickly.[23] In the reign of Ramses II artists began reworking it in relief but this project was never completed. In the painted areas surviving traces of horizontals and verticals show that squared grids were used here, unlike the unfinished room in Sety's tomb. One grid seems to have been drawn for each scene, appropriate to the size of the major figure in it. Other figures drawn at different scales do not appear to be grid-related, but were presumably added freehand with proportions achieved by eye. By contrast, some non-human elements within the scene seem to have been positioned in relation to the grid.

Sety's name presented a problem at Abydos, as it did also in his tomb. Sety means 'he of Seth', referring to the god who had murdered Osiris. The cult of Seth was prominent in the eastern Delta, where he was associated with the Semitic god Baal whose worship had been introduced into Egypt around the time of the Hyksos. This was the home territory of the Nineteenth Dynasty royal family, whose members seem to have been adherents of the god. The name Sety is usually written with an image of the god Seth (fig. 204a). If this writing of the name had been used in

Sety's temple, then images of Osiris's murderer would have occurred throughout the building. Instead, the name of the king replaced the figure of Seth with the *tit/setet*-hieroglyph, which was associated with Isis and often used as a powerful amulet of protection (fig. 204b). Since the king's tomb represented the realm of Osiris where the body of the king and god became one, the image of that god's murderer would also have been dangerous in this context. In the tomb, however, the image of Seth was replaced by that of Osiris, resurrected ruler of the underworld (fig. 204c).

As in all temples, the decorative scheme was carefully planned. In Sety's own sanctuary[24] the Iunmutef priest, who traditionally enacts the ritual for a dead king, is

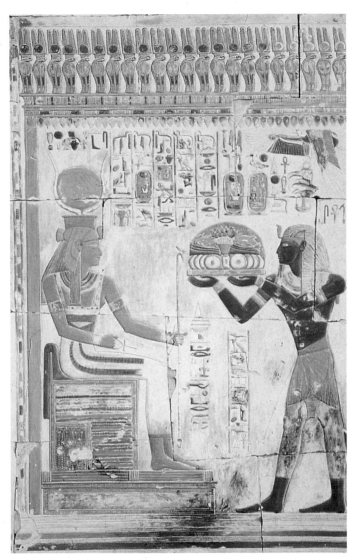

203 Facsimile painting of a scene from the chapel of Isis in the Osiris complex showing King Sety I offering a platter of food to a seated figure of the goddess raised on a dais. Isis says: 'I have given you power over the south and victory over the north', thus confirming the universal rule of Sety. The colours used in this scene and throughout the temple are limited to yellow, red, dark blue and turquoise, imitating gold and the semi-precious stones used by the Egyptians in their jewellery. Temples were made as beautiful as possible, in order to attract the deities to whom they were dedicated and persuade them to take up residence there. Temple of King Sety I at Abydos. Nineteenth Dynasty.

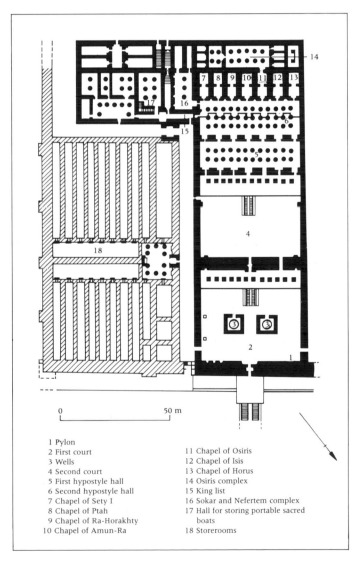

1 Pylon
2 First court
3 Wells
4 Second court
5 First hypostyle hall
6 Second hypostyle hall
7 Chapel of Sety I
8 Chapel of Ptah
9 Chapel of Ra-Horakhty
10 Chapel of Amun-Ra
11 Chapel of Osiris
12 Chapel of Isis
13 Chapel of Horus
14 Osiris complex
15 King list
16 Sokar and Nefertem complex
17 Hall for storing portable sacred boats
18 Storerooms

202 Plan of the temple of King Sety I at Abydos. Nineteenth Dynasty.

204 Drawing of three versions of King Sety I's name. (a) The normal writing, here taken from the temple of Amun at Karnak. The name is written with a squatting figure with the head of the Seth animal. (b) In the temple of King Sety I at Abydos, where the so-called Isis-knot is substituted for the Seth figure. (c) In the tomb of King Sety I, where a figure of the god Osiris is substituted for the figure of Seth. In (b) and (c), Sety's cartouche includes the epithet 'beloved of Ptah' that the king regularly used. However, in (a) the epithet 'beloved of Amun' has been substituted, no doubt acknowledging the supremacy of Amun within his temple at Karnak.

a b c

depicted burning incense and presenting offerings, and the dead king is shown in the company of various deities, being led, embraced and crowned by them, confirming his status and acceptance by the gods (fig. 205). In the other six sanctuaries the king is shown performing the ritual before depictions of the various deities and before their sacred boats (fig. 206).[25] As always in temples the images of the deities and their boats face out of their sanctuaries while that of the king faces inwards, corresponding to the entry of the priest performing the ritual into the sanctuary. This orientation was reversed in the room in the southern extension where other divine boats were stored. Here the king faces towards the entrance through which the boats would have been taken out for use in the main part of the temple and later returned.[26]

205 Scene showing King Sety I enthroned between the goddesses Nekhbet and Wadjit above a triple *sema tawy* motif tied by the gods Thoth and Horus. The texts repeat the visual message. Horus 'unites Upper and Lower Egypt under the throne of his son' and Thoth says: 'I have united Upper and Lower Egypt for you.' The king is confirmed for all time as the ruler of the two parts of Egypt united in his person. Chapel of King Sety I, temple of Sety I, Abydos. Limestone. Nineteenth Dynasty.

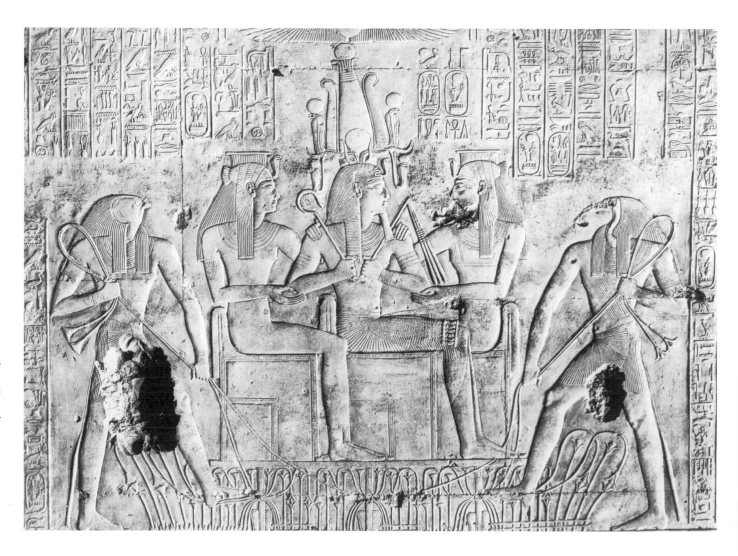

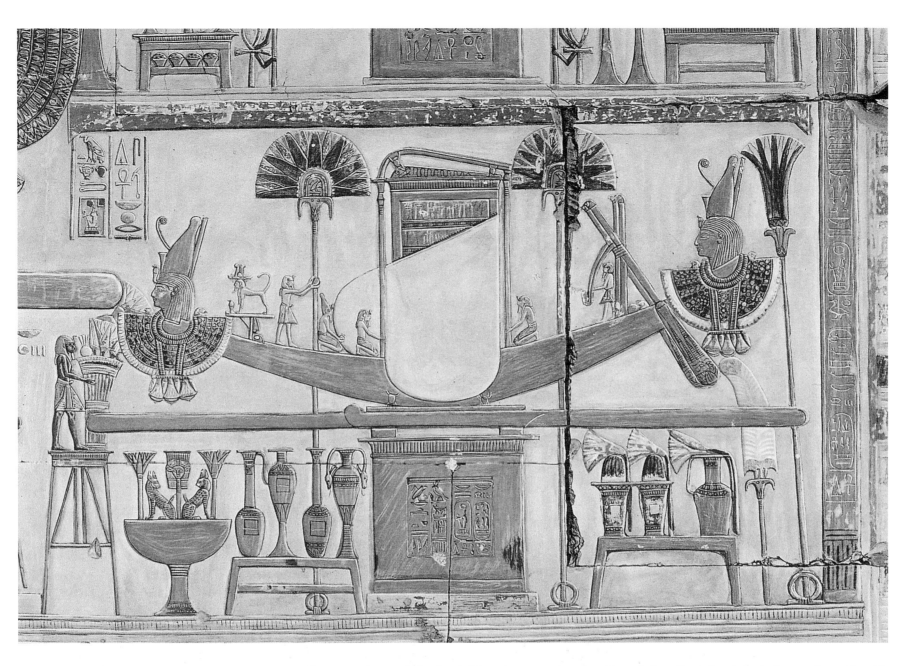

206 Detail from a facsimile painting of a scene in the chapel of the god Amun-Ra in which the king burns incense before the sacred boats of the divine triad Amun-Ra, Khons and Mut. The detail shows the sacred boat of the goddess Mut resting on a stand. The bow and stern are in the form of heads of the goddess wearing the double crown, the *uraeus*, two gold *shebyu*-necklaces made of gold rings, an elaborate broad collar and a separate pectoral in the form of three lotus flowers alternating with four buds. On the deck of the boat are a series of standing and kneeling statues of the king whose colour scheme suggests the flesh is silver and the clothing gold. The statue of Mut herself is hidden within the great gilded shrine that takes the place of a cabin on the boat. Two tall semi-circular fans stand one either side of the shrine, indicating the divine presence inside. Various ritual vessels of gold rest on stands placed around the pedestal supporting the sacred boat. One large bowl contains figures of lotuses, cats and a Hathor mask on a pole. These images are placed above the bowl on its rim in order to render them visible. The lotuses refer to the young sun god and rebirth. The Hathor mask and cats were associated with the goddess Hathor, but a close connection between Hathor and Mut meant that these symbols came to refer also to Mut. The top of the scene is marked by an elongated dark blue hieroglyph for 'sky'. Temple of King Sety I at Abydos. Nineteenth Dynasty.

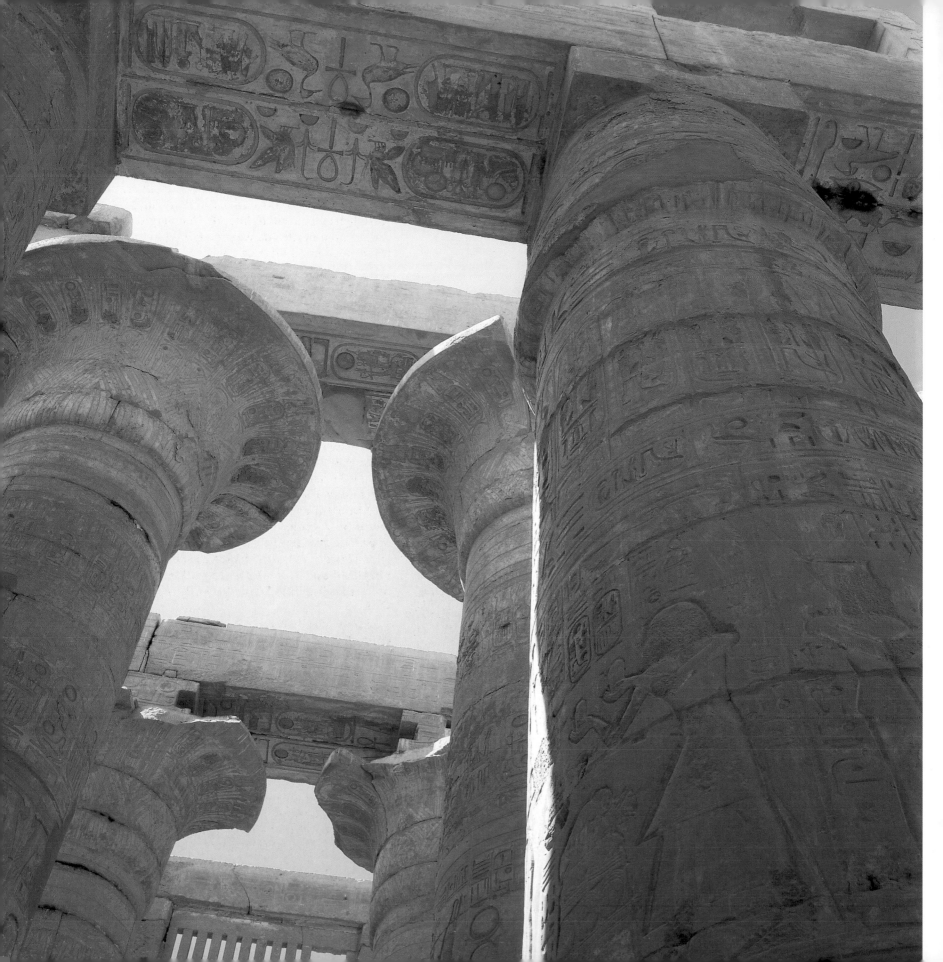

207 *left* The columns of the hypostyle hall in the temple of Amun at Karnak, showing the open papyrus umbel capitals of the two taller central rows and the closed papyrus bud capitals of the rest of the columns. The difference in height allowed for clerestory lighting, and one of the window grilles can be seen at the bottom of the picture. The undersurfaces of the architraves (soffits) are carved with the king's cartouches. Sandstone. Nineteenth Dynasty.

208 Scene on the west wall in the hypostyle hall of the temple of Karnak showing King Ramses II offering a tray of food to the deities Amun-Ra and Mut. The king bends forward slightly before the deities in a visual rendition of the notion of offering, a pose which is already encountered in the reign of Amenhotep III and becomes common in the Ramesside period. It contrasts with the upright posture of the divine couple, who stand passively to receive the king's gift. Even though the scene is on an interior wall, it is worked in sunk relief, the prevailing form of relief used in the reign of Ramses II, whether inside or outside. Sandstone. Nineteenth Dynasty.

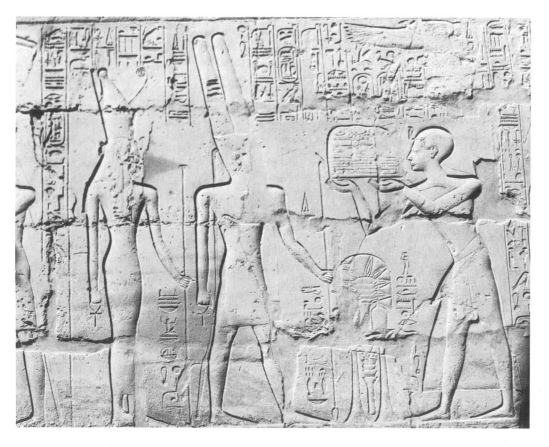

State temples

At Karnak Horemheb had built a pylon (the second) in front of the one constructed by Amenhotep III in order to form a new entrance to the temple. Sety I turned the space between this and the third pylon into a gigantic hypostyle hall with 134 columns (figs 147, 207).[27] The difference in height between the twelve columns that formed the two central rows and the smaller columns on either side meant that clerestory window grilles could be inserted to bring some light into the dim interior. The interior and exterior walls on the north side were decorated by Sety I, whereas the decoration on the south side is in the name of Ramses II (fig. 208).[28] As would be expected, the interior decoration relates to the king and deities, showing the acceptance of the king by the gods; festivals; processions of sacred boats, and daily temple ritual. On the exterior walls Sety and Ramses depicted versions of their foreign campaigns.[29]

Large-scale battle scenes, usually representing specific campaigns, were a common theme in temple decoration in the Nineteenth and Twentieth Dynasties, and we have already met them in Ramses III's funerary temple. Such scenes had their forerunners in the early Eighteenth Dynasty, but only fragments of these have survived.[30] In battle scenes, whatever the amount of subsidiary activity, the king is always the dominant figure. In a series of scenes, usually depicting a specific campaign, he is shown charging in his chariot into disorderly masses of the enemy or winning in hand-to-hand combat with an enemy leader, followed by a triumphant return to Egypt with long lines of prisoners whom he presents to a deity. The foreigners, who were depicted as a chaotic mass on the battlefield, are now lined up in registers in a visual representation of the order that has been imposed on them by the victorious king.

Sety's reliefs on the north wall are arranged around a door placed in the centre of the wall that forms a side entrance to the hypostyle hall (fig. 209). The wall provides a spatial analogue to the Egyptians' world: the door at the centre represents Egypt, and the east and west extremities represent the foreign lands at the edge of the world.[31] The scenes are laid out so that battles take place at the eastern and western ends of the wall. The action then moves towards the doorway as the victorious king returns to Egypt with rows of bound prisoners, culminating in their presentation to Amun-Ra back home. The significance of the battle scenes is recapitulated in two further scenes on either side of the doorway, in which the king smites a group of foreigners in front of Amun-Ra. The god holds out to the king a curved sword that as a hieroglyph means 'physical

209 Part of a battle scene on the exterior north wall of the hypostyle hall at Karnak showing King Sety I battling against the Shasu in Canaan during his first regnal year. The king is charging into a mass of the enemy in his chariot, drawn by a pair of rearing horses. The reins are knotted round his waist in order to free his hands so that he can draw his bow and shoot arrows into the foe. In reality the king would have had a charioteer to drive the horses, but to depict a second man in the chariot would have spoilt the dramatic effect and reduced the heroic image of the king. As it is, the large figure of the king bears down upon the chaotic mass of smaller enemies who are already hopelessly vanquished. The king is further marked out and protected by the sun disk and Nekhbet vulture that hover above him and by the tall fan held behind him by an animated *ankh*-sign. The visual image of carnage is complemented by the text, which says in part that the king 'prevailed over them like a lion, making them into heaps of corpses throughout their valleys'. Sandstone. Nineteenth Dynasty.

strength, power' and here symbolises the king's divinely given power to conquer his foreign enemies.

The battle scenes can be read in a number of ways. Like the motif of the smiting king, they work to preserve the inner purity of the temple by keeping out impure, malign influences. They ensure, on a cosmic level, the survival of the ordered world. They display to the viewer the might of the king and his central position in the world. In addition, their specificity gives them another dimension as an account of actual events and of the victories of a particular king. Only a small group of potential viewers would have had the knowledge to read the hieroglyphic captions, but the intention was probably also to present a divine audience with a record of the king's achievements for all time.

At the temple of Luxor Ramses II added a large colonnaded court fronted by a pylon to form a new entrance to the temple (fig. 152).[32] The axis of the court does not follow the axis of the rest of the temple but veers slightly to the

east, perhaps to accommodate a triple shrine dating from the time of Hatshepsut.[33] Rather than dismantle this building, Ramses incorporated it into his structure, reworking it in his own name. In front of the entrance pylon he erected two obelisks, two colossal seated statues either side of the entrance, and two colossal standing statues in front of each wing. The standing colossi on the east side were made of red granite, the colour of the rising sun, and the two on the west of black granite, the colour of Osiris.[34] Instead of the usual smiting motifs, the outer face of the pylon is decorated with a series of scenes representing Ramses' battle against the Hittites at Qadesh, in which the outcome is presented as a great victory (fig. 210).[35] The composition contains unique episodes specific to this particular campaign, such as the beating of captured Hittite spies. In addition to those at Luxor, versions were carved at Karnak, the Ramesseum, Abydos and Abu Simbel.

Inside the court at Luxor are more colossal statues of the king. In the southern part, striding statues, originally made for Amenhotep III, are placed between the columns.[36] Two further seated statues are situated either side of the entrance to the colonnade (fig. 211). Like many of Ramses' colossal statues, those at Luxor incorporate small two- or three-dimensionsal figures of consorts or royal children beside his lower legs. The four seated statues show the king wearing the double crown on the *nemes*-headdress with the *uraeus* on his forehead and the long royal false beard. His hands are placed palm down on his thighs. He wears nothing but the knee-length kilt, leaving his torso, lower legs and feet bare. The size and solemn frontal pose of the statues designate them as guardians of the entrances they flank and display the power and authority of the king. Elaborate *sema tawy* motifs, in which the two plants are tied by fecundity figures, are carved on either side of the thrones, while on the two sides of the pedestal are cut rows of northern and southern bound enemies with the names of their territories. The king thus guarantees the order of a united Egypt and the subjugation of all its chaotic enemies.

Two of the statues have names.[37] The one to the east of the pylon entrance is called 'Ruler of the Two Lands' and the one to the west of the colonnade entrance inside the court is called 'Ra of the Rulers' (fig. 211). On the front of the pedestal, two figures of the Iunmutef priest adore the king's cartouches, and the inscription refers to offerings for 'the living royal *ka* Ra of the Rulers' (fig. 212). Further, a number of votive stelae have survived showing that similar named colossi in Ramses II's Delta residence, Per-Ramses, were objects of veneration.[38] Thus such colossi represent a divine aspect of the king in the form of his living *ka*. They

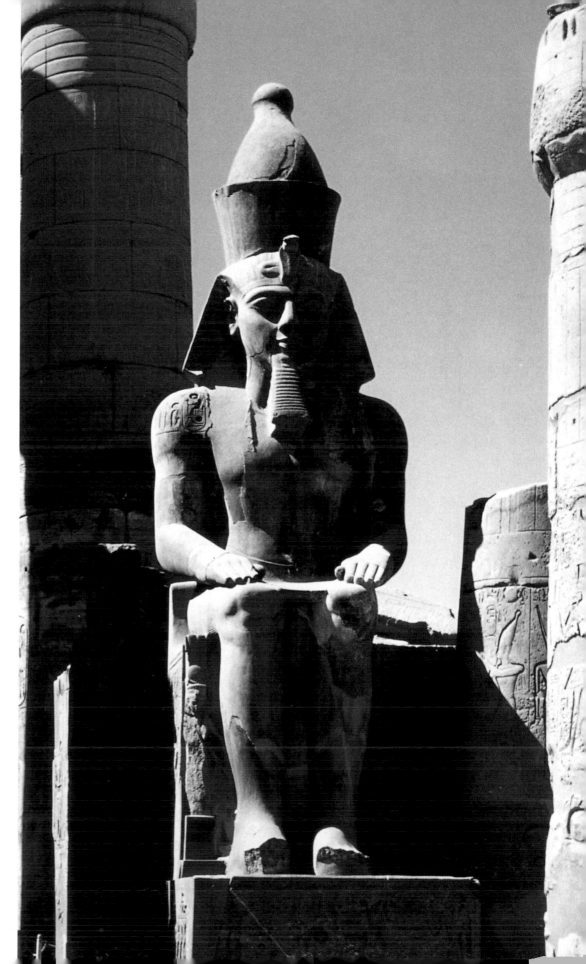

210 Scene from the Battle of Qadesh fought by King Ramses II against the Hittites, showing the king shooting arrows at his enemies while charging them in his chariot. This version of the battle was carved on the pylon of the temple of Luxor, where it replaced the more usual image of the king smiting his enemies. The significance of the battle depiction was similar to that of the smiting scenes. In addition to displaying the power of the king and his role as maintainer of order, the images acted as a barrier to separate the inner sacred space of the temple from the impure world outside and to repel any polluting influences that threatened the temple. Sandstone. Nineteenth Dynasty

211 One of a pair of colossal *ka*-statues of King Ramses II guarding the entrance to the colonnade in the temple of Luxor. It bears the name 'Ra of the Rulers' and forms an overwhelming image of kingship, displaying the double crown, the rearing *uraeus* on the *nemes*-headdress and the long, flaring royal beard. The sides of the throne bear the *sema tawy* motif and the sides of the pedestal are decorated with bound prisoners, above which the king sits. Nineteenth Dynasty.

212 Detail of the front of the pedestal of the *ka*-statue of King Ramses II called 'Ra of the Rulers' in the temple of Luxor (fig. 211). Two figures of the Iunmutef priest, wearing the characteristic leopard skin and plaited sidelock, make the ritual gesture of offering to the paired cartouches of Ramses II. The text reads: 'Take to yourself the offerings and provisions that go forth from the presence of your father Amun-Ra for the living royal *ka*, Ra of the Rulers.' Nineteenth Dynasty.

213 Façade of the great temple at Abu Simbel in Nubia. The temple is cut back into the sandstone cliff that borders the west bank of the Nile at this point, and the façade takes the place of the entrance pylon in a free-standing temple. Nineteenth Dynasty.

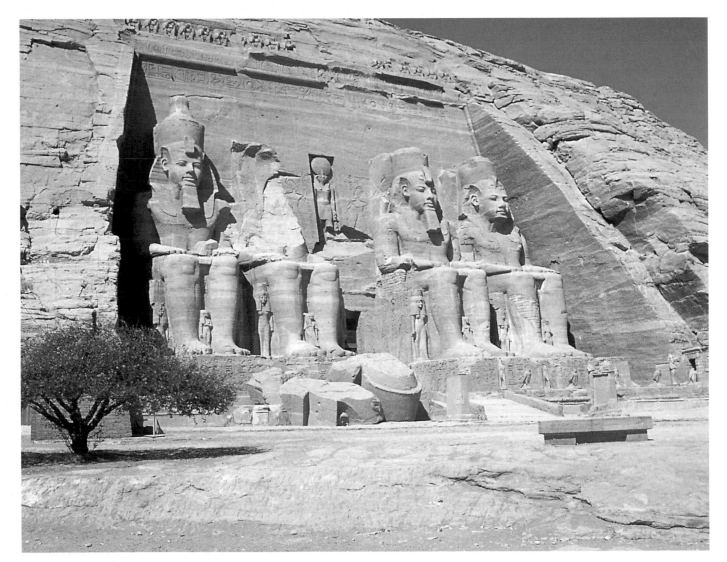

214 Scene in the small temple at Abu Simbel showing Queen Nefertari, the first principal wife of King Ramses II, being crowned by the goddesses Hathor and Isis. Nefertari wears the typical queen's crown of the period, which combines the two tall falcon feathers with the sun disk and horns of Hathor. She stands facing left between the two goddesses, who raise their forward arms so as to place their hands one either side of the crown. The scene, which is very unusual for a queen, is adapted from kingly iconography. The three female figures in the scene exhibit the typically elegant proportions of the Nineteenth and Twentieth Dynasties. They have slender arms, narrow shoulders and high, slender waists, below which the buttocks and front of the thighs swell out slightly before narrowing again into the long lower legs. Sandstone. Ninteenth Dynasty.

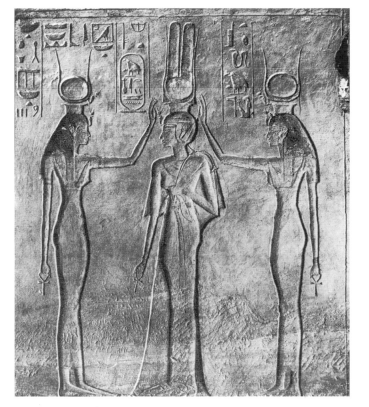

By his right leg is cut the hieroglyph that reads *user* and by his left an image of the goddess Maat. The figure in the niche, therefore, provides a cryptic writing of Ramses' throne name, Usermaatra.[41] The figures of Maat that the king offers also write his prenomen, since the goddess wears a sun disk, Ra, on her head in addition to the feather that reads *maat*, and carries the *user*-hieroglyph. Although the image of Ra-Horakhty stresses the solar aspect of the temple, the display of Ramses' name over the entrance indicates that the temple was dedicated to a divine form of the king.

Inside the temple the decoration in the outer hall is associated on the south side with Amun-Ra, and on the north side with Ra-Horakhty. In the inner hall and sanctuary a deified form of Ramses appears instead of Ra-Horakhty.[42] In some instances the name of the deified king, like other deities' names, is not written in a cartouche. The earthly form of the king, identified by his names in two cartouches, performs the ritual before his divine manifestation.[43] In the sanctuary the rock-cut cult statues represent Ra-Horakhty, the king, Amun-Ra and Ptah side by side.[44] The notion of the king's deification seems to have developed while the temple was being built and decorated, since figures of the divine form of the king were added to some scenes after they had already been cut.[45]

The neighbouring Small Temple was built for Ramses' first principal wife, Nefertari, and dedicated to the goddess Hathor whose image stood in the sanctuary.[46] The façade of the temple was fronted by six colossal standing statues about 10 m high. The outer and innermost ones on either side of the entrance represent the king, and the middle ones the queen. Inside Nefertari is given unusual prominence for a queen. She is shown alone offering to deities, and in one scene is crowned by Isis and Hathor (fig. 214), when normally such divine coronation scenes are reserved for the king. In the sanctuary on the south wall Nefertari censes and plays the sistrum before the two goddesses, Mut and Hathor. On the opposite wall the king censes and libates before deified images of himself and Nefertari. The unusual role given to the queen in the decoration almost certainly had a precedent in the temple of Sedeinga, now badly ruined, built by Amenhotep III a few kilometres to the north of Soleb, in which Queen Tiy was prominently featured.[47]

Non-royal monuments

Tombs and funerary equipment

At Thebes tomb chapels continued to be rock-cut, but the repertory of scenes decorating them changed.[48] Scenes of

had their own cults in which offerings were made to them, and because they stood at temple entrances, although within the enclosure, access to them was less restricted than to the inner parts of the building. Unlike the hidden temple deities, the king's statues could thus be addressed directly and could act as the conduit between humanity and the divine world.

Nubia had been conquered by Egypt at the beginning of the Eighteenth Dynasty, and successive kings had built towns and temples there, including the temple of Amenhotep III at Soleb.[39] Under Ramses II seven new temples were erected in Lower Nubia, of which the most famous are the Great and Small Temples at Abu Simbel.[40] Both were cut into the sandstone cliffs that at this point bordered the Nile on the west. Instead of the pylon of a free-standing temple, both temples are fronted by a rock-cut façade. That of the Great Temple is 30 m high and 35 m wide, with four colossal seated statues about 21 m high having smaller figures of royal family members by the lower legs (fig. 213). Above the entrance two relief-cut figures of the king offer an image of the goddess Maat, 'order', to a falcon-headed statue wearing a sun disk on his head, identified by the text as the sun god, Ra-Horakhty, who emerges from a niche.

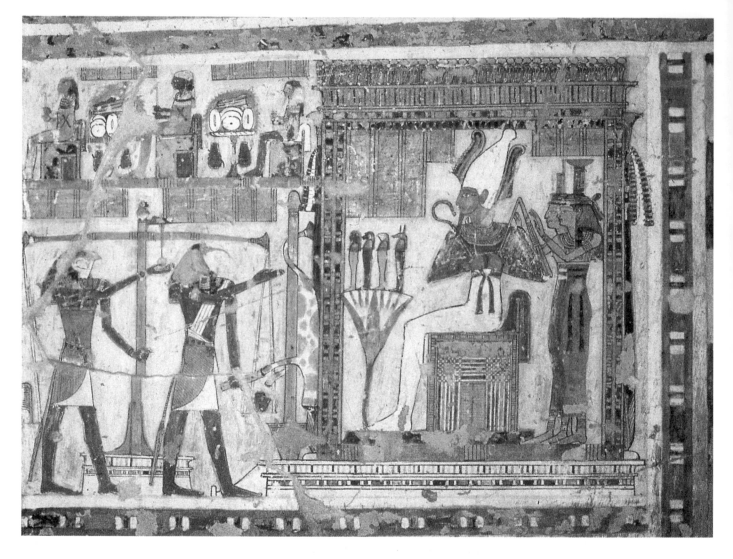

215 Scene in the Theban tomb chapel (no.178) belonging to Neferrenpet, also called Kenro, the scribe of the treasury of the estate of Amun-Ra, showing the heart of the deceased balancing on the scales against the feather of *maat*. The successful result is presented by the god Thoth to Osiris, who is seated in an elaborate shrine accompanied by the goddesses Isis and Nephthys. The predominant colours used in the tomb are yellow, red-brown, dark blue, turquoise and white, against a white ground. The scene illustrates the underworld subject matter typical of tomb decoration in the Nineteenth and Twentieth Dynasties that replaced the earlier 'everyday life' scenes of the Eighteenth Dynasty. Painted plaster. Nineteenth Dynasty.

everyday life, the deceased hunting in the desert and fishing and fowling in the marshes, foreigners presenting tribute and the enthroned king giving audience almost completely disappear.[49] Instead the decoration concentrates on the passage into the next world, drawing extensively on the *Book of the Dead*,[50] a body of funerary texts and accompanying illustrations (vignettes) that is first known from the Eighteenth Dynasty, although many of the texts derive from earlier sources. Their function was to provide the deceased with the knowledge necessary to reach the next world safely. Frequent scenes include the funeral procession and rites before the tomb, the dangerous journey into the underworld through the gates that guard it, the weighing of the heart and subsequent presentation to Osiris (fig. 215), and life in the next world. The deceased is also shown

216 Scene in the tomb chapel of the priest Panehsy at Thebes (no.16) showing the deceased in the next world, kneeling in front of a tree laden with fruit, out of whose trunk the tree goddess manifests herself in order to offer food and drink to Panehsy and his *ba*. In front of this scene is another in which Panehsy and his wife, a musician of Amun, sit before a table of offerings, with their *ba*s placed behind them. Painted plaster. Nineteenth Dynasty.

adoring various deities, such as Osiris, Anubis and Ra, while Hathor, in her cow form, emerges from the Theban cliffs in order to help the deceased make the perilous transformation from this life to the next. Nourishment is guaranteed to the deceased by scenes showing the tree goddess, identified variously with Hathor, Isis and Nut, pouring water and presenting food to the dead tomb owner (fig. 216).

Some scenes relating to this life occur, but they are mainly concerned with the duties of the tomb owner in relation to a temple – for example, he may be shown performing the cult before a divine image, engaged in the administration of the institution or concerned with overseeing the large herds of temple livestock. Rock-cut or freestanding statues of the owner and family members situated in the niche at the rear of the inner room still formed the focal point of the ritual in the chapel.

At Deir el-Medina the workmen built their own tombs near the village, and usually decorated the burial chamber in addition to or instead of the tomb chapel, something that

was rarely done elsewhere and that may have been due to the influence of the royal tomb on which they worked.[51] As in the chapels, the decoration came from the *Book of the Dead*, and was concerned with the passage into the realm of Osiris and with the daily solar cycle. In the burial chamber of Sennedjem, who lived in the reign of Ramses II, the solar cycle is depicted on the ceiling, which represents the sky, whereas the walls represent the realm of Osiris and the successful passage there of Sennedjem and his wife.[52] On the north wall immediately opposite the entrance a large figure of Osiris as ruler of the underworld dominates the burial chamber (fig. 217). Anubis leads Sennedjem towards Osiris and, although the weighing of the heart is not shown, Sennedjem must be understood as having successfully passed the judgment. On the east wall a vignette from the *Book of the Dead* shows Sennedjem and his wife in the next world where, in a well-watered land known as the Field of Rushes, they plough, sow and harvest grain and flax (fig. 218). Trees are laden with fruit,

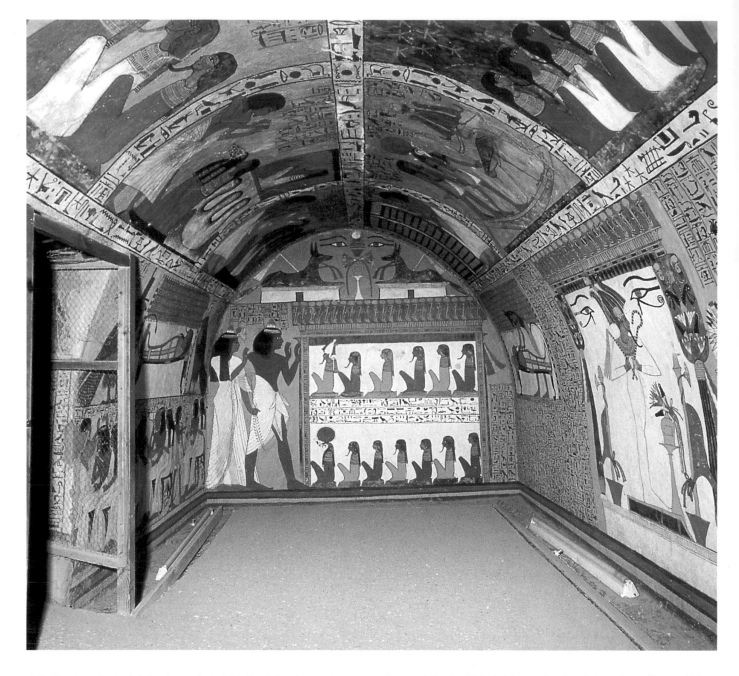

217 View into the burial chamber at Deir el-Medina belonging to the workman in the Place of Truth Sennedjem (Theban tomb 1), looking towards the west wall. Immediately opposite the entrance door, in the middle of the north wall, is a large image of Osiris, the ruler of the underworld, in a shrine. To the left the funerary god Anubis is shown attending to the mummy of Sennedjem as it lies on a lion embalming-bed. On the opposite wall the goddesses Isis and Nephthys, in the form of kites, stand at the foot and head of the mummy, identifying the dead Sennedjem with Osiris whom Isis brought back to life. At the top of the west wall two figures of the Anubis jackal face each other. Below, Sennedjem and his wife are shown 'giving praise to all the gods of the underworld', who sit within a shrine in two registers, the upper one headed by Osiris and the lower one by Ra. The colour scheme in the burial chamber shows an overall yellow background with the interior of the shrines painted white. This contrasts with the tomb of Nefertari (fig. 196), where the background was white and the interior of shrines yellow. Painted plaster. Nineteenth Dynasty.

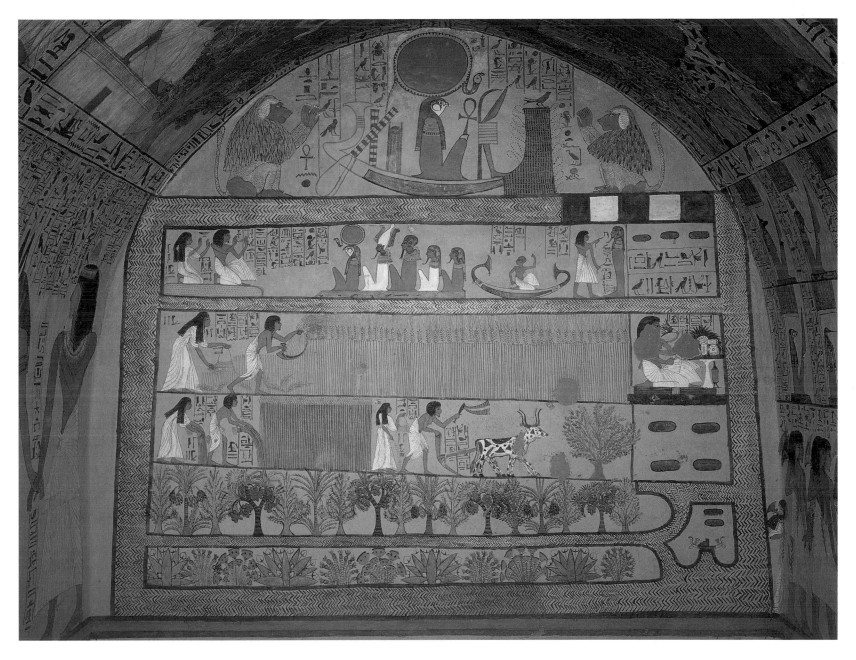

218 The east wall in the burial chamber of Sennedjem at Deir el-Medina (Theban tomb 1, see also fig. 217), showing Sennedjem and his wife, Iyneferti, in the next world. The series of scenes depicted here forms the vignette to chapter 110 of the *Book of the Dead*, whose purpose was to enable the dead to plough, reap, eat, drink, copulate and do everything they used to do on earth in the afterlife. The scenes are surrounded by channels of water within which grow abundant grain, flax, fruit trees and the brightly coloured poppies, cornflowers and mandrake fruits used to make bouquets and floral collars. The flax, which is pulled up by the roots, is harvested by both Sennedjem and Iynerferti, but only Sennedjem cuts the grain, while his wife collects the fallen ears in a basket. This division of labour reflects that found in agricultural scenes depicting the harvest in this life, where only men cut the grain but both sexes pull flax. At the very top of the wall the sun god is shown in his boat passing through the underworld. The direction of travel is established by the texts relating to the two squatting baboons: the one behind the boat adores the sun god as he sets and the one in front 'gives praise to Ra-Horakhty as he rises'. Painted plaster. Nineteenth Dynasty.

219 Scenes from the tomb chapel at Saqqara belonging to Raia, the overseer of singers of Ptah. In the top register Raia is depicted playing the harp before seated figures of the deities Ptah and Hathor, mistress of the southern sycomore, a Memphite form of the goddess, here depicted with a cow head. The scene shows Raia performing his earthly duties in the temple in the service of Ptah. The two registers below represent the funeral procession of Raia and the rites before the tomb. Above, a team of cattle, one obviously a cow, drag Raia's shrine-like sarcophagus containing his coffins and mummy 'to the west, the place of silence'. They are driven forwards by a man called Ptahrekh, while another man, Shedamun, turns towards the sarcophagus to burn incense and pour a libation. Behind, a group of female and male mourners follow. Right at the front, facing towards the cattle, is a small figure of a male calf with only three legs. Other versions of these scenes show that the mutilated calf really belongs to the rites before the tomb, when the foreleg is cut off, so that it can be offered to the deceased. Here, the calf is placed instead with the cows that drag the sarcophagus. In the lowest register the coffin stands upright, supported by a figure of the god Anubis. Raia's wife, Mutemwia, kneels mourning at the foot of the coffin, while behind her Shedamun, clad in a leopard skin, holds out an incense burner and libation vessel as part of the burial rites. He is followed by a male figure holding a papyrus scroll, from which he reads the spoken part of the ritual. A group of female and male mourners follow, many of them labelled as singers, who presumably worked under Raia in the temple. Limestone, H. 143.5 cm. Nineteenth Dynasty.

and plants of red poppies, blue cornflowers and yellow mandrake fruits flourish.

At Saqqara the later Eighteenth Dynasty practice of building free-standing tomb chapels continued.[53] As at Thebes, the decoration was concerned with the owner's service to the gods in this world, the funeral procession and rites before the tomb (fig. 219), offerings and ritual for the deceased, and the relationship of the deceased to the deities who could guarantee passage to the next world.[54] For many chapels the focal point in the offering room seems to have been a stela rather than a statue.[55]

Funerary stelae of the Nineteenth and Twentieth Dynasties varied in size, shape and complexity of composition. Many continue the Eighteenth Dynasty tradition of having an upper scene showing the deceased adoring funerary deities and a lower register with the deceased seated before a table of offerings together with family members, of whom a large number are often shown (fig. 220).[56] Some stelae, however, dispense with the lower register and retain only the image of the deceased adoring deities, paralleling the greater prominence of divine and underworld themes in non-royal tomb decoration.[57] Other funerary motifs, such as the rites before the tomb and the tree goddess, are sometimes included.[58]

Papyrus rolls containing selections from the *Book of the*

220 *left* Stela of the official Paser from his tomb chapel at Saqqara, where it stood at the far end of the open entrance court against the mudbrick wall to the north of the entrance to the chapel itself. It was once balanced by a second stela, now lost, on the south side. Originally an offering table or basin stood in front of each stela. In the top register of the surviving stela Paser, overseer of builders of the lord of the Two Lands, and his brother, the royal scribe and chief lector priest Tjuneroy, stand on the right facing left with their arms raised in adoration before the divine figures of Osiris, Isis and Hathor, mistress of the southern sycomore, here shown as a cow emerging from the cliff of the western desert to help the deceased make the transfer from this world to the next. Below this scene five lines of hieroglyphs write an offering formula that invokes Osiris, Wenennefer, Ptah-Sokar, Anubis and all the gods of the underworld for the benefit of the *ka* of Paser, including the request 'to enter and leave the necropolis without being turned back at the gates to the underworld'. At the bottom a second scene shows Paser and his wife Pipuy seated on the left facing right before a table of offerings, above which the text reads: 'everything that goes forth from on the altar of the ennead, the lords of Memphis for the *ka* of ... Paser and his wife, beloved of him, Pipuy.' To the right of the table the surface is divided into two sub-registers. Above, four figures kneel facing Paser and Pipuy: Pipuy's father, mother and mother's mother, and Paser's sister-in-law. Below, another five figures kneel, consisting of a sister of Paser, three sons and a daughter. Limestone, H. 176 cm. Nineteenth Dynasty. London, British Museum.

Dead were first produced in the Eighteenth Dynasty and continued to be made into the Ptolemaic period.[59] Copies were placed with the deceased in the burial chamber, and many fine examples come from the later New Kingdom.[60] The texts are written in columns of hieroglyphs that face right but, perhaps in part because of the peculiarity of the underworld, they are read from left to right, contrary to normal practice. They are written in black ink with headings and important passages in red. The accompanying vignettes are painted in a variety of colours. During this period the majority of manuscripts belong to men, although the wife of the owner may be included in some of the vignettes in a secondary position (fig. 2).

In the late Eighteenth Dynasty a new sort of anthropoid coffin came into use alongside the black-painted type. By the reign of Ramses II the new type had superseded the older. The ground was yellow with decoration in red, light blue and dark blue, all covered by a varnish that has darkened over time and changed the blues to greens. The new scheme imitated gold and coloured inlay, and exceptional coffins used gold rather than paint (fig. 221).[61] It became normal to show the forearms crossed on the chest underneath the elaborate collar through which the hands protrude. Women's hands were usually depicted open and men's clenched, holding amulets. Below the collar a kneeling figure of the goddess Nut spreads her wings in protection. On the lower part of the lid the spaces between the bands of text show the deceased and deities, burial rites, and various scenes taken from the decorative repertory of tomb chapels. On the case Thoth and the four sons of Horus are still depicted. Traditionally the coffin showed the deceased in an idealised form wearing the divine three-part wig and, if male, the long beard associated with male

221 Outer coffin of Henutmehyt, the mistress of the house and musician of Amun, showing the yellow ground typical of Ramesside coffins, decorated with hieroglyphs and figures added in red, light blue and dark blue. Unusually, the upper part of the coffin is covered with gold. A large necklace covers the chest and arms, the shape of the latter being modelled under the necklace, while the extended hands emerge non-realistically through the necklace. Below, a pectoral hangs between a pair of *wedjat*-eyes. Under the pectoral a figure of the sky goddess Nut kneels with outstretched wings whose tips sweep up to touch Henutmehyt's elbows. Over the legs the four sons of Horus are depicted between bands of inscription. The gold on the coffin not only displays Henutmehyt's wealth and status, but also associates her with divine beings in general and with the sun god in particular. In addition to her outer coffin Henutmehyt also had an inner coffin covered entirely in gold, and a funerary mask and open-work mummy board covering the wrapped mummy. Thebes. Painted and gilded wood, H. 187 cm. Nineteenth Dynasty. London, British Museum.

222 Kneeling temple statue of the royal scribe and treasurer Panehsy presenting a shrine containing frontal images of the deities Horus, Osiris and Isis. Panehsy wears elaborate pleated clothes and a complex wig that falls below shoulder level at the front in two lappets on either side of the neck. This type of wig began to appear towards the end of the Eighteenth Dynasty, before which it was unusual for male wigs to fall past the shoulders. H. 107 cm. Nineteenth Dynasty. London, British Museum.

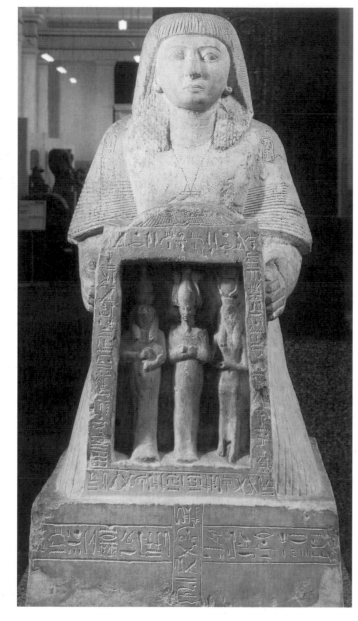

deities. However, for most of the Nineteenth and Twentieth Dynasties the three-part wig was replaced by male and female wig types worn in life, and for women earrings and a lotus flower on the forehead. For men the long divine beard was abandoned.

At the end of the Twentieth Dynasty the living wig types were once more replaced by the divine three-part wig for both men and women, and men were again given the divine beard.[62] On the sides of the coffin case the vignettes were composed in a horizontal strip, bounded at the top and bottom by a frieze or line of text. For most of the Nineteenth and Twentieth Dynasties the interiors of coffins were left plain, but by the very end of the period decoration was also being applied to the inside.

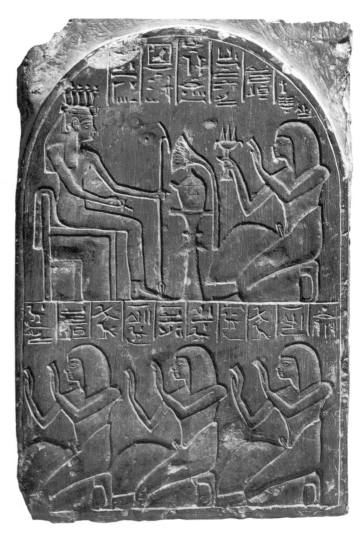

223 *right* Votive stela of the workman in the Place of Truth (Deir el-Medina) Nefersenut. At the top Nefersenut kneels before a seated figure of the goddess Hathor. In his forward hand he holds up a brazier of burning incense, while he raises his rear hand in the gesture of adoration. Below, three left-facing figures kneel with their hands raised in adoration. They are Nefersenut's son Paneb, his son Aapehty and the son of his daughter, who is another Paneb. The composition of the stela places the goddess in the primary position in the upper register, facing right. The dedicator of the stela, Nefersenut, occupies the same register in a subordinate position, while his male relatives are put in the less prestigious register below. Almost certainly from Deir el-Medina. Limestone, H. 42.5 cm. Nineteenth Dynasty. London, British Museum.

From left

224 Votive stela of the mistress of the house Iyi. This stela is very similar in its composition to the stela of Nefersenut (fig. 223). It is divided into two registers, with the dedicator Iyi kneeling on the right side of the upper register, facing towards a figure of the goddess Anukis on the left. Below, three female figures, all labelled as 'her daughter', kneel facing left. Unlike temple statues, women could freely dedicate votive stelae. They adapted scene types and texts common on stelae dedicated by men, rather than developing unique types of their own. Thebes. Limestone, H. 27 cm. Nineteenth to Twentieth Dynasty. London, British Museum.

225 Votive stela dedicated by the workman in the Place of Truth (Deir el-Medina) Irynefer and his wife, the mistress of the house Mehykhati. The stela is divided into two registers. In the upper one a large image of the goddess Taweret stands on the left, facing right towards a table of offerings. Below, Irynefer and Mehykhati kneel facing left towards the goddess. Irynefer occupies the more prestigious forward position, taking precedence over his wife, as was usual with married couples. Almost certainly from Deir el Medina. Limestone, H. 30.5 cm. Nineteenth Dynasty. London, British Museum.

226 Stela of the 'effective spirit of Ra' (*akh iqer en Ra*) Khamuy, who is shown seated, facing to the right, before a table of offerings. Stelae dedicated to 'effective spirits of Ra' commemorated powerful deceased family members. They were set up in houses, where they formed the focal point of an offering cult. Through rituals, living family members could maintain contact with the dead and invoke their help and protection for the occupants of the house. Deir el-Medina. Limestone, H. 19 cm. Nineteenth Dynasty. London, British Museum.

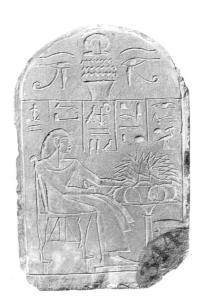

Votive monuments

During the Nineteenth and Twentieth Dynasties a large number of statues and stelae were dedicated in temples and shrines. As earlier, temple statues almost always represented men. An increasingly common type of statue, which may have had its origins in the late Twelfth Dynasty, shows the owner carrying one or two standards topped by small divine images, and probably refers to a cult role performed by the subject.[63] The motif, already known from earlier, of offering a cult object or divine image, often in a shrine, grew in popularity, and occurs with both kneeling and block statues (fig. 222). The statue becomes a permanent record of the subject's devotion to a particular deity or group of deities, as well as allowing him to participate for eternity in all the temple rituals and to receive offerings.

Votive stelae were widely dedicated in temples and shrines, and many are known from the village of Deir el-Medina (figs 223–5).[64] In contrast to temple statues, votive stelae seem to have been freely erected by women.[65] Donors, standing or kneeling, could be shown in the upper register adoring a deity or deities, sometimes with further family members in the register below, or they could be placed, often kneeling, in the register below the deity. In both cases the deities were normally located on the left side of the stela, facing right, with the adoring donor facing left towards them. The orientation of some stelae is reversed, perhaps because of the context in which they were set up,[66] although this can hardly ever be confirmed.

Many votive stelae are dedicated for couples. The design of these stelae gives the primary position to the husband and the secondary one to the wife.[67] No special compositional or textual forms were developed specifically for stelae dedicated by women. Female figures were simply substituted for male ones and feminine grammatical forms replaced masculine forms in the inscriptions (compare figs 223 and 224).

Household cult

The houses at Deir el-Medina had altars in their front rooms for the performance of household cult, which seems to have centred on the protection and continuity of the family.[68] Wall niches in the house held stelae dedicated to deceased family members in transfigured form as an 'effective spirit of Ra'.[69] The stelae normally show the deceased seated facing right before a table of offerings with an identifying caption (fig. 226). Most of the subjects are men, but a few women occur. Since the dead had the power to interfere in the affairs of the living for good or ill, these deceased family members could be entreated through the performance of ritual and the presentation of offerings to protect the family and ensure the fertility of the women. Other niches held small three-dimensional busts, which also seem to have represented deceased family members.[70] Made of painted limestone or sandstone, they were shown wearing a divine, chest-length three-part wig and a large, brightly

227 Painted ancestor bust. Like stelae commemorating effective spirits of Ra (fig. 226), ancestor busts were set up in houses and were objects of cult. However, instead of representing named individuals, they probably stood for the mass of family ancestors who were no longer remembered by name. H. 24 cm. Nineteenth to Twentieth Dynasty. London, British Museum.

228 *far right* Fertility figurine showing a nude woman wearing a heavy, enveloping wig, lying on a bed with a child by her legs. Similar images have been found in New Kingdom houses at Amarna, Memphis and Deir el-Medina. They were associated with the household cult and were meant to promote fertility and successful childbirth. Limestone, L. 23.5 cm. Nineteenth to Twentieth Dynasty. London, British Museum.

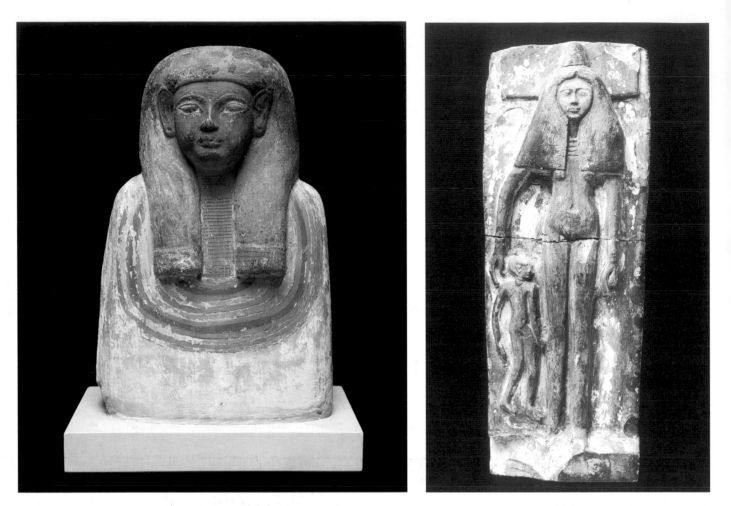

painted collar (fig. 227). They are rarely inscribed and even their gender is unclear. They may have represented family ancestors in general, while the stelae represented specific individuals who were still remembered by the living. That the busts were recipients of ritual is shown by two stelae depicting a woman adoring or offering to a bust.[71]

The emphasis on protection and fertility is taken up by other images found in houses. Fertility figurines, mostly of baked clay or limestone, were found in large numbers at Deir el-Medina and also at other New Kingdom settlement sites.[72] They depict nude women with elaborate wigs, often lying on a bed with a child beside them (fig. 228). Like their Middle Kingdom counterparts, they were concerned in a domestic context with the successful conception, bearing and rearing of children to ensure the continuity of the family.[73] Altars were often decorated with images of the household deity, Bes, depicted with the body of a short-limbed (achondroplastic) dwarf and leonine face, who was connected with sexual matters and with the protection of women in childbirth and young children.[74] The bottom of a more elaborate scene was found in one house.[75] It is distinctive enough for the subject matter to be reconstructed by comparison with a series of images drawn by the villagers on flakes of limestone (*ostraka*).[76] Since the Theban cliffs were made of limestone, these flakes were a readily available, free material which the villagers used for writing and sketching. A number of sketches show scenes in which an almost nude woman sits on a stool in a special 'birth arbour' suckling a child, often with one or more attendants presenting a mirror and an eye make-up tube and applicator (fig. 229),[77] and this is certainly also the subject of the wall painting. Other *ostraka* show a fully dressed woman seated with her child on a bed with legs in the form of Bes.[78] By depicting a successful conclusion to the dangerous process of childbirth, these images could help bring about the desired outcome.

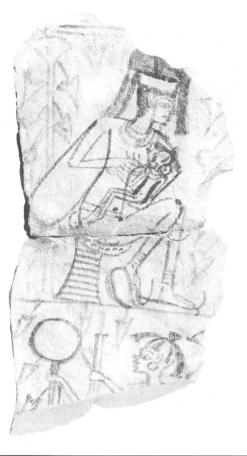

229 Fragmentary limestone *ostrakon* showing an almost nude woman seated on a stool and suckling a child in a columned pavilion decorated with convolvulus. In the register below, a Nubian servant, recognisable by hairstyle and facial features, brings a mirror and a tube containing eye paint and an applicator. Other *ostraka* show similar scenes, and may relate to wall decoration in houses. Probably from Deir el-Medina. H. 16.5 cm. Nineteenth to Twentieth Dynasty. London, British Museum.

230 *below* Large limestone *ostrakon* showing a king's son and a vizier before King Ramses IX, who stands at a window of appearance. The text and scene have much in common with two similar scenes of King Ramses III, one in his funerary temple at Medinet Habu and one in his temple in the precinct of Mut at Karnak, although in these scenes the king's figure is shown much larger than those of his subordinates. The texts and scene on the *ostrakon* have been very carefully drawn, first in red and then corrected in black. From Thebes. H. 48.5 cm. Twentieth Dynasty. London, British Museum.

Ostraka *and artistic practices*

The artists of Deir el-Medina produced thousands of sketches on *ostraka* with a wide variety of subject matter and functions.[79] Some relate to tomb and temple decoration and may represent an initial draft of a scene, or an apprentice's practice copy of a finished scene (fig. 230). Other pieces showing deities were made as votive offerings (fig. 231). Yet other *ostraka* are covered with a variety of unconnected practice images – heads, hands, hieroglyphs and so on. Some apparently comprise working sketches of objects that the artists were commissioned to make. A large number contain images of animals. One group represents a topsy-turvy world in which not only do animals perform human tasks but predators such as cats and foxes are shown herding geese and waiting on mice, their natural prey.[80] These are not subjects found in temple and tomb art, but they also occur on painted papyri (fig. 232)[81] and perhaps illustrate oral stories with animal characters.[82]

These *ostraka* allow us to see the work of individual artists rather than the team efforts that produced the royal tombs. We get a glimpse of how artists were trained through copying and practice.[83] The vast majority of sketches are drawn freehand without a grid, in contrast to Eighteenth Dynasty artists' sketches with grids. Perhaps it is significant that, although grids were used in Eighteenth

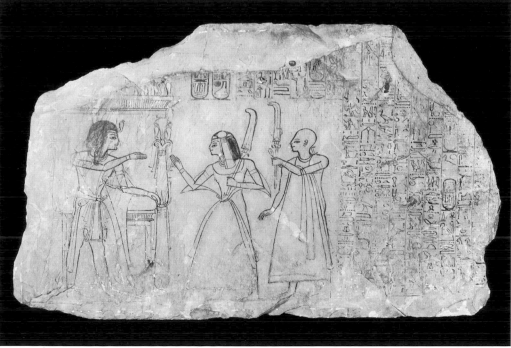

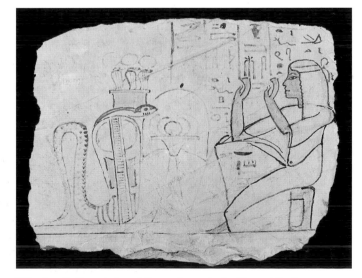

231 *above* Votive *ostrakon* of the workman in the Place of Truth (Deir el-Medina) Khnummose, who is shown kneeling in adoration before the cobra goddess Meresger, who protected the Theban necropolis and so was a particularly popular deity at Deir el-Medina. From Deir el-Medina, Thebes. Limestone, H. 16.5 cm. Nineteenth Dynasty. London, British Museum.

232 Painted papyrus showing various animals engaged in human activities. At the left an antelope and lion sit opposite one another on stools playing the board game *senet*. To the right a flute-playing fox herds a small group of goat-like animals, and another fox and a cat drive a flock of birds. Finally, only partly preserved, a lion standing upright at the end of a bed has intercourse with a hoofed animal that lies on its back. Although the precise significance of these depictions and others like them are lost on the modern viewer, part of their appeal lies in the inappropriate mingling of predator and prey. Further, the artist has drawn the figures with great verve, expressed in the vigour of his outlines and the oversized eyes of the predators, so that one is impressed by the sheer exuberance of these animals. H. 15.5 cm. Twentieth Dynasty. London, British Museum.

Dynasty kings' tombs, they were not employed in the unfinished room in Sety I's tomb, nor in Nineteenth and Twentieth Dynasty private Theban tombs. It is possible that Deir el-Medina artists of the later New Kingdom were not trained to draw on grids. This would distinguish them from the artists who decorated the temple of Sety I at Abydos, where we know grids were used.

The human figure

The proportions of human figures continue those of the post-Amarna Eighteenth Dynasty.[84] Private male figures have narrow shoulders, a very high small of the back, a raised navel and thin, unmuscled arms, so that the upper part of the body appears small compared with the overall height (figs 217–20). Royal and divine male figures are more conservative and the small of the back remains lower and the shoulders broader than in private figures (figs 197–8, 208). When male and female figures are depicted together, differences between the two are almost always maintained so that female figures have narrower shoulders and a higher small of the back than the male. There is a tendency in all figures to lengthen the lower leg, so that it is more than a third of the hairline height.

Male costume becomes increasingly elaborate as more and more material is incorporated (figs 197, 216, 219). Female dress continues to be treated in many, though not all, cases as transparent in order to show the body underneath, thus stressing the role of women in ensuring the continuation of the family in this world and the rebirth of the dead into the next (figs 219–20).[85]

Conclusion

The return to a more traditional style and repertory of subject matter after the extraordinary innovations of the Amarna period has led some commentators to stigmatise Ramesside art as stagnant, simply repeating long-estab-

lished formulae with little new vitality. In fact the art of Sety I's reign reached a high point in sheer aesthetic quality that ranks it alongside the art of Senwosret I's reign. The lapidary grace and sheer perfection of the figures decorating the walls of Sety's temple at Abydos still have the power to overwhelm and move the modern viewer, and if most of the subject matter remains traditional, that is because it conforms to what was appropriate inside the sacred space of a temple. Innovation, however, was not avoided, as is demonstrated by changes in tomb decoration. For the first time royal tombs were decorated for their whole length, and new underworld books were introduced to fill the space and continued to be added into the Twentieth Dynasty. In non-royal tomb chapels the repertory of 'everyday life' scenes, some going back to the Old Kingdom, was mostly abandoned, and instead the fate of the deceased in the next world was emphasised. We shall see in the next chapters that this ability to innovate and adapt older traditions to new circumstances continued throughout the Third Intermediate Period and beyond.

Notes

 1 Kitchen 1982, 16–18.
 2 Murnane 1990; Kitchen 1982, 53–64.
 3 Kitchen 1982, 75–88.
 4 Sandars 1978; Murnane 1980, 12–15.
 5 Robins 1994a, 159.
 6 Hornung 1991, 11.
 7 Hornung 1991, 15–26.
 8 Hornung 1990a, 121.
 9 Hornung 1991, pls 78–95.
10 Hornung 1971, pls 26–59.
11 E.g. Guilmont 1907; Piankoff and Rambova 1954; Hornung 1990a, b. See also Wilkinson 1994b.
12 Keller 1981; 1991, 60–7.
13 Bierbrier 1982a; Valbelle 1985; Keller 1991; McDowell forthcoming.
14 Porter and Moss 1964, 749–69.
15 Goedicke and Thausing 1971; McDonald 1996.
16 Stadelmann 1978; 1979; 1986.
17 Stadelmann 1973, 229–30.
18 Stadelmann 1973, 222.
19 But see Stadelmann 1979, 312 n. 68.

20 Epigraphic Survey 1930; 1932; 1934; 1940; 1957; 1963; 1964; 1970; Murnane 1980.
21 Harvey 1994.
22 Calverley 1933; 1935; 1938; 1958.
23 Baines 1989b.
24 Calverley 1935, pls 29–37.
25 Calverley 1933; 1935, pls 1–28.
26 Baines 1989b.
27 Barguet 1980, 344.
28 Nelson 1981.
29 Epigraphic Survey 1986.
30 Harvey 1994.
31 Epigraphic Survey 1986, 1.
32 Porter and Moss 1972, 302–9.
33 Porter and Moss 1972, 309–10, pl. 30.
34 Porter and Moss 1972, 304 (9)–(12), plan 30.
35 Porter and Moss 1972, 304 (13)–(14).
36 For Middle Kingdom monuments re-used by Ramses II see Sourouzian 1984.
37 Habachi 1969, 18–20.
38 Habachi 1969, 26–39.
39 Adams 1977, 217–45.
40 Habachi 1969, 1.
41 Habachi 1969, 9–10, fig. 8, pl. 5a.
42 Habachi 1969, 4–6.
43 E.g. Habachi 1969, 6 fig. 5.
44 Habachi 1969, pl. 5b.
45 Habachi 1969, 8–10, pls 3–4.
46 Desroches Noblecourt and Kuentz 1968.
47 Kozloff and Bryan 1992, 110.
48 Strudwick 1994.
49 E.g. Davies 1927b; 1948; Seele 1959; Seyfried 1990; Assmann 1991; Hofmann 1995; Seyfried 1995.
50 Saleh 1984.
51 E.g. Bruyère 1926–9; Valbelle 1975; Zivie 1979; Wild 1979.
52 Shedid 1994a.
53 Martin 1991, 40, fig. 10; Martin 1985.
54 Martin 1987.
55 Martin 1991, 118, 122, 126, 132–3.
56 E.g. James 1970, pls 29, 45.1, 47; Bierbrier and Parkinson 1993, pls 101.1, 103.1; Robins 1995, no. 2.
57 Robins 1995, no.18; Bierbrier 1982b, pl. 45.
58 E.g. James 1970, pl. 32; Bierbrier 1982b, pl. 62; Bierbrier and Parkinson 1993, pls 63, 73; Robins 1993, fig. 73.
59 A few examples are known from the Roman period: Quirke 1993, 24.
60 Quirke 1993, 15–19.
61 Niwiński 1984, 438–41; Taylor 1989, 35.
62 Taylor 1989, 39.
63 Chadefaud 1982.
64 E.g. Tosi and Roccati 1972; Bierbrier 1982b, pls 64–6.1, 70–3, 81, 86–7.1, 88–9; Bierbrier and Parkinson 1993, pls 31–41, 46, 50–3.
65 Robins 1995, 18–22, nos 8–9 (illustrations for nos 8 and 10 reversed).
66 Fischer 1977a, 20–6.
67 Robins 1994b.
68 Valbelle 1985, 118, 261–2; Friedman 1994.
69 Demarée 1983.
70 Friedman 1985.
71 Friedman 1994, 109 fig. 11; Bierbrier and Parkinson 1993, pls 54.1, 55.1.
72 Bruyère 1939, 3, pl. 43; Peet and Woolley 1923, pls 12.4, 23.5; Giddy and Jeffreys 1993.
73 Pinch 1983.
74 Bruyère 1939, 255 fig. 131, 257 fig. 133, 259 fig. 136.
75 Bruyère 1939, 59, pl. 10 bottom.
76 Brunner-Traut 1955. For wall paintings in the earlier workmen's village at Amarna see Kemp 1979.
77 E.g. Vandier d'Abbadie 1937, pl. 52 upper; Vandier d'Abbadie 1959, pl. 120 upper.
78 E.g. Vandier d'Abbadie 1937, pls 52–4; Vandier d'Abbadie 1959, pl. 120 lower; Petersen 1973, pls 69–71. See also Pinch 1983.
79 Vandier d'Abbadie 1937; 1959; Brunner-Traut 1956; 1979; Petersen 1973.
80 E.g. Vandier d'Abbadie 1937, pls 37–48; Fazzini et al. 1989, no. 62.
81 Omlin 1973.
82 Brunner-Traut 1968.
83 Keller 1991, 51.
84 Robins 1994a, 254–5.
85 Robins 1996a.

Fragmentation and new directions

THE THIRD INTERMEDIATE PERIOD

233 Gold funerary mask of King Psusennes I, found on the mummy of the king in his tomb at Tanis. The king is shown wearing the *nemes*-headdress, a large *uraeus*, the plaited divine beard and a broad beaded collar ending in a row of pendant lotus flowers. The idealised, youthful features are modelled with great skill in the thin sheet metal, into which the eyes and eyebrows are inlaid with black and white glass and the beard straps on either side of the face with lapis lazuli. The mask links the dead king to the gods, whose flesh was of gold, and to the sun god in particular, since gold shines like the sun. H. 48 cm. Twenty-first Dynasty. Cairo, Egyptian Museum.

The Twentieth Dynasty ended with a power split between north and south. Theoretically Egypt was ruled by the kings of the Twenty-first Dynasty from the new residential city of Tanis in the eastern Delta. In practice the high priests of Amun at Thebes controlled most of Upper Egypt, even though they acknowledged the kings of the Twenty-first Dynasty. In fact, the royal family and the high priests were related and often intermarried. The last king of the dynasty, Psusennes II, may also have been high priest at Thebes, thus temporarily reuniting the two areas.

At his death Psusennes was succeeded by a Libyan chief called Shoshenq, who became the first king of the Twenty-second Dynasty. After their various defeats groups of Libyan prisoners had been settled in northern Egypt by Ramses III. They had developed into a professional military class that together with further Libyan immigrants became powerful enough to marry into the royal family. Shoshenq's son Osorkon II was married to Psusennes II's daughter. Shoshenq and his son exercised control over Thebes by placing family members in top positions in the priesthood of Amun, and both appointed sons as high priests. However, later in the dynasty during the reign of Takelot II, civil war broke out because of opposition in Thebes to the appointment of the king's eldest son as high priest. The declining authority of the king was further weakened in the subsequent reign of Shoshenq III when Pedubaste I, possibly Shoshenq's brother, founded a rival Twenty-third Dynasty. Although the Twenty-second Dynasty continued to be widely acknowledged in the Delta, Thebes favoured the kings of the Twenty-third. The ensuing political instability allowed numerous local magnates to push their own claims to independent authority, and Egypt divided into a series of rival regions in Middle Egypt and the Delta, including a chiefdom in the western Delta centred on Sais that later would provide the Twenty-fourth and Twenty-sixth Dynasties of kings. Meanwhile, south of the Egyptian border, the former colony of Kush, now an independent kingdom, was gathering strength, and its rulers began to expand their power northwards, forcing Thebes to acknowledge their overlordship by the mid eighth century. Eventually these kings, as the Twenty-fifth Dynasty, conquered and briefly reunited all of Egypt, bringing the Third Intermediate Period to an end.

During the divided rule of the Third Intermediate Period royal resources diminished, and great architectural undertakings on a comparable scale to those of the New Kingdom were rare. Nevertheless, kings continued to sponsor building projects, especially in the Delta and Middle Egypt, even if much of their material was re-used from earlier monuments. Alongside the political turmoil the period was one of religious and artistic innovation, and work of a high standard continued to be produced.

The king

The royal tomb

The royal necropolis in the Valley of the Kings was abandoned, and kings of the Twenty-first and Twenty-second Dynasties were buried at Tanis in small, underground burial chambers built mostly of limestone blocks, many of which were re-used from earlier monuments.[1] There may once have been funerary chapels above. In contrast to previous practice, the tombs were located within the Amun temple enclosure in the city, placing the dead king under the protection of the deity. In addition they could be easily guarded. During the later Twentieth Dynasty the royal

234 Anklet of King Psusennes I, found in his tomb at Tanis. Although kings and other men are not shown wearing anklets in art, this piece of jewellery is one of a pair that was found on the mummy of the king. It is made of gold and inlaid with dark blue lapis lazuli and red carnelian, two of the most popular stones used in jewellery. Maximum diameter 6.1 cm. Twenty-first Dynasty. Cairo, Egyptian Museum.

235 Block from the north side of the outer (east) face of the monumental *sed*-festival entrance of King Osorkon III in the temple of Bastet at Bubastis, showing the king, followed by Queen Karoma, making an offering. The king wears the double crown as he does in most of the scenes on the two outer (east) faces of the gate. The queen's figure exhibits the large breast, buttocks and thighs that become fashionable during the Third Intermediate Period, replacing the more slender ideal of the later New Kingdom (fig. 214). Red granite, 178 cm. Twenty-second Dynasty. London, British Museum.

tombs at Thebes had been systematically robbed, leaving a mess that was cleared up at the beginning of the Twenty-first Dynasty and no doubt making rulers very security-conscious about their own burials.[2]

Although the tombs took a very different form from those in the Valley of the Kings, they were decorated with wall reliefs that continued New Kingdom traditions.[3] The scenes relate to the solar cycle, the realm of Osiris, and the union of Osiris and Ra, and are drawn from the *Amduat*, other underworld books and the *Book of the Dead*. While many are traditional for royal tombs, others are taken over from private burials. Their purpose was to help ensure the safe transition of the ruler to the afterlife.

Many of the burials were placed in outer, anthropoid, stone sarcophagi. These were almost all either re-used, or re-cut from older building blocks.[4] The body of Psusennes I was enclosed in an outer pink granite sarcophagus, an inner black granite sarcophagus and a solid silver coffin decorated with a feather pattern, continuing the decorative tradition found on the coffins of Tutankhamun that ultimately went back to the *rishi*-coffins of the Seventeenth Dynasty.[5] The body wore a gold mask (fig. 233), gold finger- and toe-stalls, numerous pieces of jewellery, and amulets to protect the deceased during the dangerous transition to the

afterlife.[6] The king's anklets were decorated with a winged scarab pushing the disk of the sun before it, all above the hieroglyph *aa* (fig. 234). The whole group writes the king's throne name Aakheperra, but it also visually refers to the daily journey of the sun across the sky. The image is thus appropriate to a funerary context, with its reference to the solar cycle guaranteeing the king's continued existence.[7]

State temples

Tanis and Bubastis Although the site of Tanis is covered with blocks, columns, obelisks and statues with the names of earlier rulers, especially Ramses II, there are no buildings that can be dated before the Twenty-first Dynasty.[8] The site

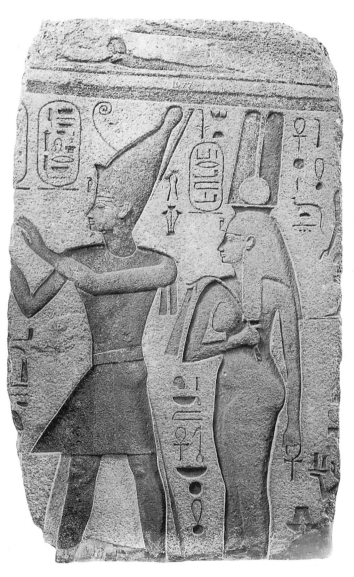

236 *right* Colossal grey granite head of a king, wearing a *nemes*-headdress, with eyes that were once inlaid. The head belongs to one of a pair of seated statues inscribed for King Osorkon III. It can, however, be identified stylistically as originally representing King Amenemhat III of the Twelfth Dynasty. The re-use of earlier material by later kings was a well-known phenomenon in ancient Egypt. Bubastis. H. 79 cm. Twelfth/Twenty-second Dynasty. London, British Museum.

237 Block from the north inner (west) face of the monumental *sed*-festival entrance of King Osorkon III in the temple of Bastet at Bubastis, showing the king, wearing the *sed*-festival robe and the red crown, seated in the *sed*-festival kiosk. Red granite, H. 106.6 cm. Twenty-second Dynasty. London, British Museum.

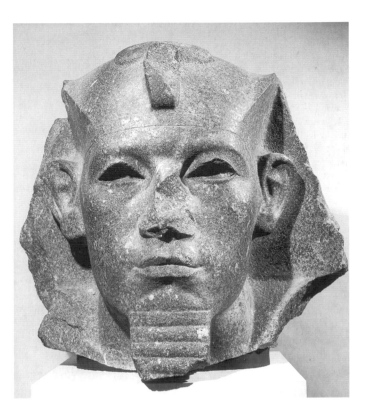

lies in the north-eastern Delta on the east bank of a branch of the Nile, not far downstream from the Ramesside residence of Per-Ramses.[9] Perhaps because of a change in the course of the river, Per-Ramses was abandoned at the end of the New Kingdom and Tanis founded. Both building material and ready-made monuments to adorn the city were brought from older sites, especially from the nearby Ramesside residence. Tanis was built from the start as the residence city of the Twenty-first Dynasty, and this naturally included the erection of temples to the city's deities. However, the traditional cult of Baal/Seth, long established in the eastern Delta, was abandoned, and Amun-Ra, who already had temples at Per-Ramses, was adopted as the main deity of Tanis together with the other members of the Theban triad, his consort Mut and the young god Khons.[10] A great temple was built to Amun-Ra and smaller ones for the other two members of the triad, with work being contributed by kings of both the Twenty-first and Twenty-second Dynasties.

Unlike Tanis, Bubastis, the home city of the Twenty-second Dynasty, went back to very early times.[11] The main temple was dedicated to Bastet, originally a lioness goddess. In the Third Intermediate Period, however, she underwent a change into a cat goddess, represented either totally as a domestic cat or as a woman with a cat's head.[12] She was now seen as the complement to dangerous lioness goddesses such as Sakhmet, who had to be propitiated to prevent them doing harm.

The kings of the Twenty-second Dynasty undertook a number of projects in the main temple and elsewhere. As at Tanis, older sites were exploited for material that could be re-used, and blocks and statues from the Old and Middle Kingdoms were incorporated in the new buildings. A pair of black granite statues originally made as images of Amenemhat III were transformed into statues of Osorkon III by the addition of an inscription naming that king (fig. 236). The same king built an entrance in the temple of Bastet showing the performance of the age-old *sed*-festival celebrating the renewal of kingship.[13] Such an extensive representation of the festival does not seem to have been depicted since the reign of Amenhotep III. Like the latter king, Osorkon emphasised the role of the queen and royal daughters in the rituals. The gateway is oriented from east to west. On the two short east faces the king wears the double crown, combining the red and white crowns (fig. 235). On the south side and the southern west face the king wears the white crown of Upper Egypt, and on the north side and the northern west face the red crown of Lower Egypt (fig. 237). This division fits not only the

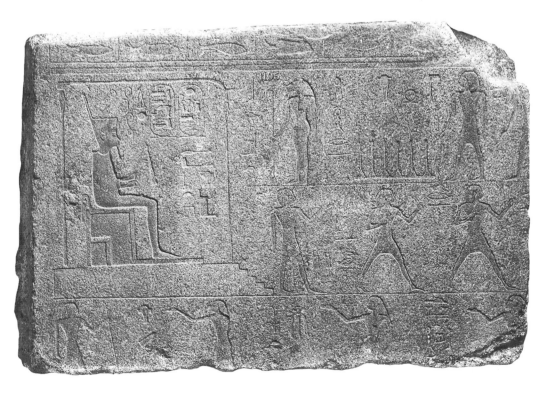

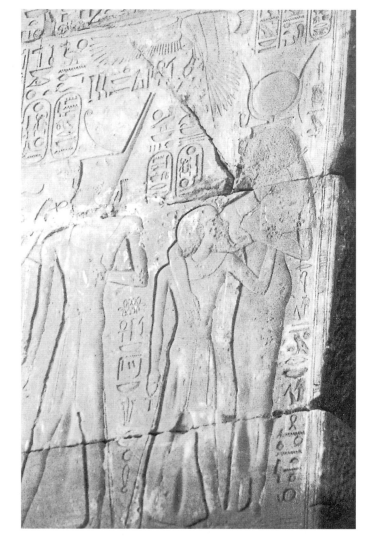

238 Relief from the gateway of King Shoshenq I at Karnak, showing King Osorkon II suckled by the goddess Hathor. Both figures stand, but the figure of the king is drawn on a smaller scale, so that his mouth is on a level with the goddess's nipple. Hathor embraces the king with her forward arm and offers her breast with her rear hand as the king grasps her forearm with his hand. In his rear hand he holds an *ankh*, perhaps to symbolise the life that is transferred to him along with the divine essence of the goddess's milk. As she suckles the king, Hathor says: 'My son of my body, my beloved, Osorkon, I have raised you as a great ruler of Egypt, as the lord of the circuit of the sun disk.' Twenty-second Dynasty.

general notion of ritual orientation found in architecture but also the emphasis placed on dual kingship in the *sed*-festival rites, when many of the rituals were carried out twice, once for each part of the country.

Karnak Late in his reign Shoshenq I decided to create a new, impressive entrance to the temple of Karnak by constructing in front of the second pylon built by Horemheb a vast court with a colonnade on each side that incorporated the entrance to a small temple of Ramses III that stood to the south-east of the pylon (fig. 147). It is possible that this enclosure replaced in stone an earlier one built of mud brick. On the south side of the court between Ramses' temple and the pylon Shoshenq built a gateway into the court.[14] On the outside wall, true to tradition, the decora-

tion consists of a large-scale scene showing the king smiting enemies in front of Amun-Ra.[15] In addition to depicting Shoshenq performing one of the fundamental duties of kingship, the scene also commemorates the king's successful campaign into Palestine, when he plundered the temple in Jerusalem.[16]

Scenes on the interior of the entrance show Shoshenq with his son, the high priest of Amun, Iuput.[17] They are mainly concerned with the legitimation of the king. In one group the Theban triad bestows its approval on the king, who receives the symbols for *sed*-festivals from Amun-Ra, is embraced by Khons and is suckled by Mut.[18] In another scene it is Hathor who suckles the king and transfers her divine essence to him. Shoshenq died before the decoration of the gateway could be completed, while it was never even begun in the rest of the court. His son and successor, Osorkon II, added similar scenes relating to legitimacy on the gate, in which he was shown receiving *sed*-festival symbols from Amun-Ra, being suckled by Hathor (fig. 238), and crowned by Amun-Ra and Mut.[19] Several generations later further decoration was added in the reigns of Takelot II and Shoshenq III.[20]

The area north-east of the New Kingdom enclosure wall of the Amun temple did not contain cult buildings until the Twenty-second Dynasty, when it was identified as a burial place of Osiris and given over to his cult.[21] During the reign of Osorkon III a chapel dedicated to Isis was built there by a well-known priest and official, Hory, who belonged to a prominent Theban family (fig. 147).[22] Osorkon appears in the decoration, which combines Osirian and solar references, and also included scenes, now only fragmentary, relating to a divine birth, probably of Horus. As a nude child, Horus is shown being purified by two deities with water symbolised by a stream of *ankh*-signs and *was*-signs, and receiving from Isis the symbol for 'years' and a *menit*-counterpoise signifying 'regeneration'. These are all scenes taken from traditional kingship iconography, and the young god and the king are merged in them.

Within the precincts of the chapel a number of older monuments were set up in addition to contemporary ones.[23] These included private statues, statues of Thutmose III and Amenhotep II, and a stela of Sety I. In addition to piously preserving monuments that had been dedicated at Karnak, they provided ready-made furnishings for the chapel, rather as older material had been used at Tanis and Bubastis, although on a much smaller scale.

Another chapel, dedicated to Osiris Ruler of Eternity, was built nearby during the co-regency of Osorkon IV and Takelot III of the Twenty-third Dynasty.[24] The two kings are

239 An open-work faience necklace spacer showing on one side (*left*) the goddess Isis seated with the young god Horus on her lap in the midst of a papyrus thicket. The image refers to the myth of Horus's upbringing in the Delta marsh of Khemmis in order to keep him hidden from the god Seth, the murderer of his father. Such images became popular in the Third Intermediate Period, perhaps because the king, who was a manifestation of Horus, now had his permanent residence in the Delta. The northern connection is further emphasised by the red crown worn by Horus. In addition to its royal connotations, the motif related to successful childbirth, to the safeguarding of young children and to the rebirth of the deceased into the afterlife.

The other side (*right*) shows a young god squatting on a lotus flower protected by two winged cobras. The image refers to the birth of the sun god from a lotus flower at the time of creation and by extension to his daily rebirth. L. 2.4 cm. Third Intermediate Period. London, British Museum.

shown in a double scene, in which Osorkon kneels before Amun and Thoth, and Takelot before Atum and Shu, who write the names of the kings on the leaves of the *ished*-tree to ensure long and prosperous reigns for them. This scene type goes back to the New Kingdom and was associated with coronation and with renewal at the *sed*-festival. Elsewhere Osorkon adores Osiris, Isis and Nephthys and is embraced by Horus in the presence of the deities of Karnak. Osiris represents Osorkon's royal predecessors who have all merged with the god at their deaths. Horus, as the successor of Osiris, represents legitimate kingship, so that, by embracing him, the god shows his acceptance of Osorkon.[25]

In addition to the two kings another important figure appears, the god's wife of Amun Shepenwepet I, daughter of Osorkon IV. During the Third Intermediate Period the office of god's wife, which had had little prominence since the Eighteenth Dynasty, once again became important at Thebes.[26] Now the god's wife was a king's daughter, who did not marry but adopted her officially appointed successor. Her symbolic role in the cult of Amun-Ra, referred to in scenes where she shakes sistra before the deity, was, as earlier, to stimulate the god to re-enact creation so as to ensure the continued existence of the ordered world. In addition, the god's wife appears in Theban temple decoration in scenes taken over from kingly iconography, something that had not occurred before. In the chapel of Osiris Ruler of Eternity Shepenwepet is crowned by Amun-Ra and suckled by goddesses,[27] motifs traditionally relating to the legitimation of kingship and the transference of divine essence, indicating that the god's wife also had an important part to play in the Osiris cult at Karnak.

Osiris, Isis and Horus

By the Third Intermediate Period an important development throughout the country was the increasing promi-

nence of Osiris, who became a god of the living as well as the dead. His sister-consort Isis became a model wife and mother, in addition to protecting the dead and guaranteeing them regeneration. Horpakhered, 'Horus the child', hardly known before the end of the New Kingdom, absorbed earlier forms of the child Horus and other child gods, and became a protector against harmful animals, a god of fertility and a manifestation of the reborn sun.[28] At the same time the concept of divine triads grew in importance, and Horpakhered became the model for adding a third deity to cults that had no child god. The connection between Horus and the king meant that imagery relating to Horus could also be read as referring to the king, as in the Isis chapel at Karnak, and Twenty-second and Twenty-third Dynasty kings often used the epithets 'son of Isis' or 'Horus son of Isis' in their titularies.[29]

One reason for the new prominence given to Isis and Horus may have been the removal of the royal residence to the Delta, for it was in the Delta, in the papyrus swamps of Khemmis, that Isis raised the young Horus and kept him safe from all danger.[30] An iconographic innovation of the Third Intermediate Period was the motif of Horus as a falcon perched in a papyrus thicket.[31] Other images that became common showed Isis offering her breast to Horpakhered seated on her lap, sometimes surrounded by a papyrus thicket,[32] and the young god squatting on a lotus representing the newborn sun.[33] Although these motifs occur on monumental material, they were far more widespread on smaller objects, appearing, for example, on blue faience chalices in the form of a lotus that is itself a symbol of creation and rebirth.[34] Other motifs show the king smiting or victorious in his chariot, and groups of deities with bound captives. The chalices, on which the king and the young god are identified, relate to creation myths and the New Year festival, and are concerned with the renewal of divine and royal power.

The same motifs decorate various items of jewellery, such as openwork faience necklace spacers that have a different scene on each side. In one example Isis is shown in the midst of a papyrus thicket with Horpakhered, who is wearing the crown of Lower Egypt, seated on her lap as she proffers her breast (fig. 239). On the other side the young god squats on a lotus flower protected by two winged cobras. Both images relate to birth, rebirth and renewal. The young god on a lotus is also found on a pair of bracelets belonging to Prince Nimlot, who may have been the son of Shoshenq I (fig. 240).

Amulets showing a goddess holding a child god on her lap and offering her left breast with her right hand became

240 Pair of hinged bracelets belonging to Nimlot, son of King Shoshenq I, each decorated with a figure of a child god squatting on a lotus flower, carrying the kingly *heqa*-sceptre and wearing a *uraeus*. Infancy is indicated by the forefinger placed in the mouth and the child's sidelock. On his head the deity wears a moon disk and crescent rather than the sun disk. The figure is flanked and protected by two large *uraei*, forming a balanced composition of the type favoured by the Egyptians. The design is reversed on the two bracelets, so that the god faces right on one and left on the other. Possibly from Sais. Gold with lapis lazuli and decayed coloured glass inlays, H. 4.2 cm. Twenty-second Dynasty. London, British Museum.

common in the Third Intermediate Period (fig. 16).[35] Amulets were worn for protection by the living and the dead, and many that were used in life were then placed with the mummy after death. An image of a goddess and child god would not only promote the well-being of women and children and protect them from the dangers of this world, but would also guarantee the deceased protection during the perilous transition to the next. Other amulets that became popular at the same time show Horpakhered alone, nude with a child's plaited sidelock and wearing the *uraeus* on his forehead.[36] As Horpakhered was successfully guarded from every danger that threatened him, so also the wearer hoped to be protected.

Non-royal monuments

Burials

In the Twenty-first Dynasty fundamental changes occurred in burial customs at Thebes. Decorated tomb chapels disappeared and burials were made in rock-cut caches without paintings or reliefs.[37] The scenes once found on the chapel walls now appeared on coffins and on the increasing number of funerary papyri placed with burials. Although it is not clear why tomb chapels were abandoned, it may have been thought that unmarked rock-cut chambers were less likely to be robbed. However, the tomb chapel decoration had performed the important function of guaranteeing rebirth and providing a safe passage to the next world, and could not just be abandoned. Instead it migrated to coffins and funerary papyri. Funerary beliefs, continuing New Kingdom ideas, emphasised the merging of the forms of the sun god and Osiris as aspects of the creator or great god. The deceased achieved life after death through identifica-

tion with the great god and the unending cycle of transformations that followed one upon another during the journey across the day and night skies.[38] In the course of these changes the repertory of scenes on coffins and papyri became much wider than in earlier tombs.

Those who could afford it would be buried in an outer and inner coffin.[39] The quality varied widely.[40] Poorer ones are often unnamed, although there are sometimes blank spaces that were meant to be filled in with the name of the owner. Such items were bought ready-made from cheap workshops, whereas those belonging to high-ranking members of the elite would be custom-built.

Coffin exteriors continued later New Kingdom traditions with scenes in red, light blue and dark blue (the blue now turned green by varnish) on a yellow ground.[41] On the lid, below the traditional large collar and crossed hands, a figure of the sky goddess Nut spread her wings in protection, under which strips of text divided the surface into compartments showing the deceased with deities, and a variety of religious emblems. On the case of the outer coffin older motifs, such as the four sons of Horus, continued to be used. On the inner coffin (fig. 241), however, a new repertory of scenes developed, referring to the journey into the underworld and the daily cycle of the sun,

241 Inner coffin of an unnamed person, showing the exterior decoration painted in red, dark blue and light blue on a yellow ground. Crossed mummy braces are painted in red on the chest. These represent actual red leather straps that were draped over the shoulders of mummies either on top or just below the outer layer of bandages. Their function is unknown, but they are frequently found on mummies dating to the Twenty-first and Twenty-second Dynasties, and can also be seen on depictions of mummiform deities (fig. 242). Thebes. Wood, H. 183 cm. Twenty-first Dynasty. London, British Museum.

242 *far right* The interior of the outer coffin of Nesmut, musician of Amun. The floor of the coffin is divided into a series of registers showing different scenes and motifs painted in a variety of colours on a yellow ground. Each register divides into two balanced parts that face each other either side of a central motif. In one, two divine, mummiform figures sit back to back either side of a central column of hieroglyphs. On the right Nesmut pours a libation before the god, but on the left it is the *wab*-priest of Amun, Amenmose, who performs the ritual. The two parts are united by the sky hieroglyph and the winged sun disk at the top of the register. Other registers show two falcons, one wearing the white crown and one the red, each facing a central cartouche containing the name of the god Osiris; the vulture and cobra facing a cartouche of the deified King Amenhotep I (fig. 243); and two figures of the Anubis jackal, each with a *wedjat*-eye above their back, facing towards one another. The scenes are richly coloured and detailed, as in the patterning of the god's seats and the rendering of plumage, and very little of the background is left unfilled. Thebes. Painted wood, H. 213.5 cm. Early Twenty-second Dynasty. London, British Museum.

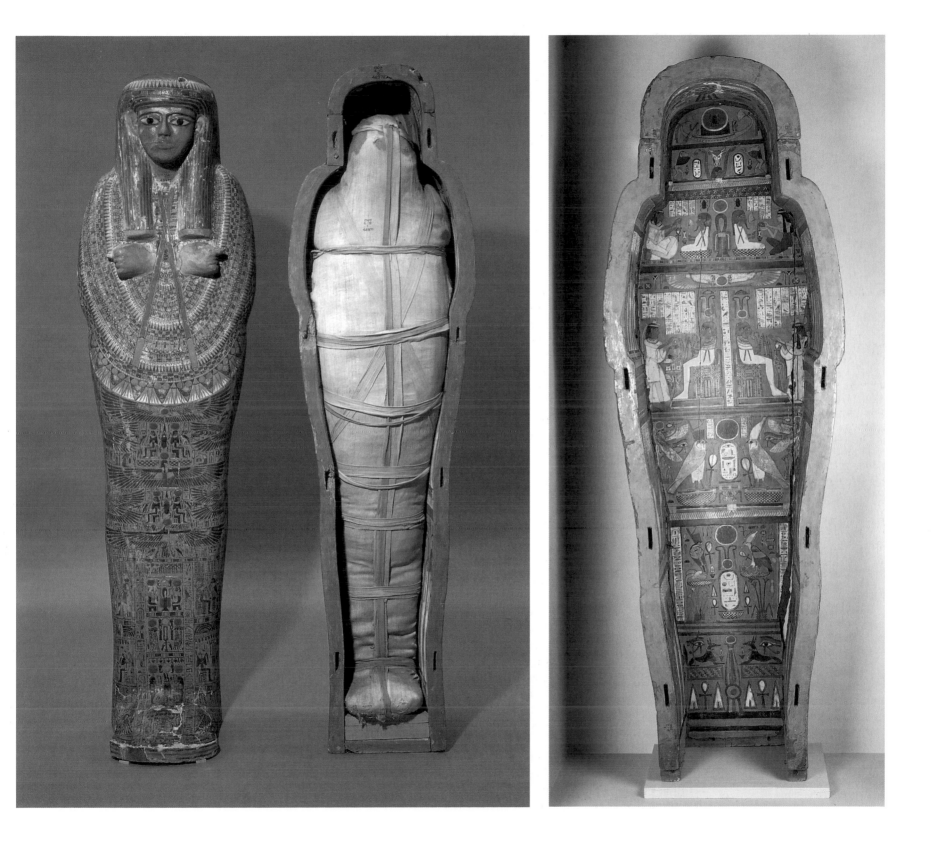

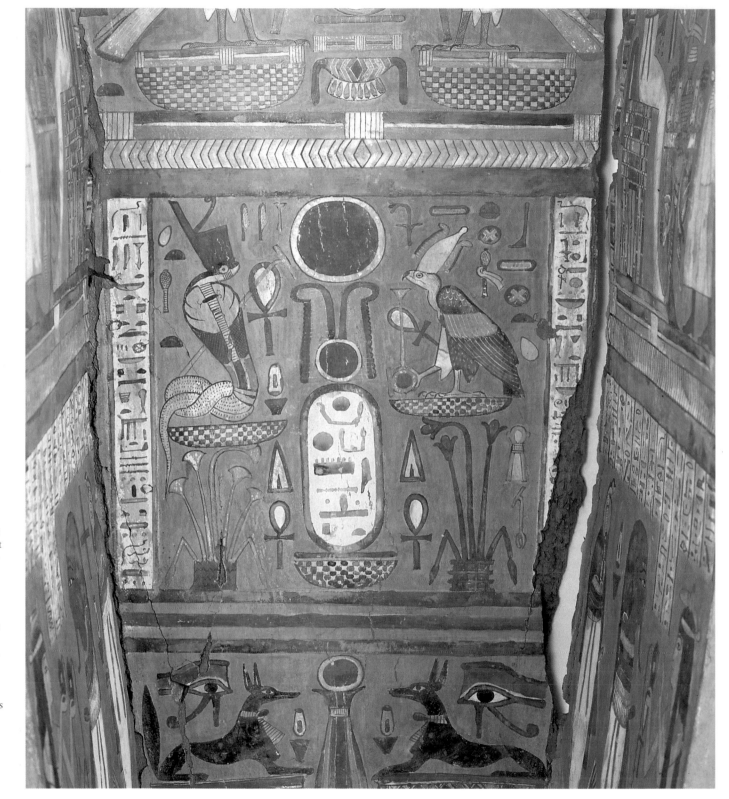

243 Detail from the coffin of Nesmut, the musician of Amun (fig. 242), showing a symmetrical motif centred on the cartouche of the deified King Amenhotep I. On the right side the goddess Nekhbet is shown as a vulture wearing the white crown of Upper Egypt, perched on a patterned basket that rests on the plant of Upper Egypt. This image is balanced on the left by the goddess Wadjit as a cobra wearing the red crown on the papyrus plant of Lower Egypt. The composition reflects the notions of duality, balance and, above all, order that were so important to the ancient Egyptians for the maintenance of the universe and the survival of both the living and the dead. Thebes. Painted wood. Early Twenty-second Dynasty. London, British Museum.

including the Hathor cow emerging from the western mountain, the tree goddess, the weighing of the heart, the journey of the sun boat and the triumph over Apophis, and the separation of the sky goddess Nut and the earth god Geb during creation.

The interiors of coffins were now also decorated with multicoloured motifs on a yellow or red ground (fig. 242).[42] There is considerable variation in the decoration. In some the floor is occupied by a large image of the goddess of the west, or of the *djed*-pillar that by the New Kingdom had come to represent Osiris, or of the deified king Amenhotep I or, less often, Thutmose III.[43] These were surrounded by smaller divine figures that extended on to the side walls. In others the floor and sides were divided into registers, with some showing the deceased offering and libating before solar and underworld deities, whereas others depicted protective deities in emblematic form: paired Horus falcons with the crowns of Upper and Lower Egypt; winged *uraei* representing Nekhbet and Wadjit; the same goddesses paired as vulture and cobra on the Upper Egyptian lily and Lower Egyptian papyrus respectively (fig. 243); paired Anubis jackals; *wedjat*-eyes; and *ankh*-hieroglyphs.

By the reign of Osorkon II these coffins were superseded by a new type, in which polychrome decoration was painted on a light ground and the crossed hands were no longer shown (fig. 244).[44] The deceased had one to three coffins and a cartonnage case in which the mummy was wrapped. The decoration was simplified to consist of more general motifs of rebirth and protection comprising divine emblems and winged deities, rather than specific excerpts from funerary compositions. Solar symbolism became even more important, and Ra-Horakhty appears more frequently than Osiris. In addition, the divine boat of the Memphite funerary deity Sokar is a common motif. Despite the numerous depictions of deities, the deceased is only infrequently shown with them. Texts become shorter, consisting mainly of offering formulae and labels identifying figures. The sky goddess Nut disappears from the lid exterior and is instead placed, full-face, on the floor of the coffin with her arms outspread to embrace the deceased, who, like the self-generating sun, would be reborn from her.

Temple sites increasingly came to be used as cemeteries for non-royal burials. At Thebes the precincts of the funerary temple of Ramses II were used as a cemetery for several hundred Twenty-second Dynasty burials.[45] Once again the burials were associated with small tomb chapels. These were brick-built, but several had inscribed stone blocks and some painted decoration. Associated with these and other burials elsewhere were brightly painted wooden funerary

stelae.[46] Unlike earlier funerary stelae set up in memorial or tomb chapels that mostly had men as their primary owners and included other family members, these stelae were placed with the body and normally represented the deceased only, whether male or female.

The traditional scene of the deceased seated before offerings has disappeared, leaving only a single scene showing the more recent motif of the deceased adoring a deity, sometimes Osiris, but, in accordance with the increasingly solar emphasis of funerary beliefs, more frequently Ra-Horakhty (fig. 245). The deity sits or stands on the left, facing right, and the deceased opposite, facing left. The texts identifying the deity and the deceased, often with a brief offering formula, mostly appear together towards the top of the scene; there are no texts below. At the top the curved border of the stela may be decorated with a sky sign, below which there may be a winged sun disk or a sun disk flanked by two *uraei*, *wedjat*-eyes and circular *shen*-signs. Some examples revert to a combination of symbols common in the Eighteenth Dynasty, consisting of a *shen*-sign above the sign for water flanked by two *wedjat*-eyes. In the Eighteenth Dynasty the

winged sun disk was placed over divine and royal figures only, but by the later New Kingdom this distinction had broken down and the sun disk could occur over non-royal figures. The use of the *shen*-sign, water and *wedjat*-eyes on Third Intermediate Period stelae was a choice, not a necessity, and represents a conscious archaism. The solar aspect of these stelae is emphasised even more strongly in examples where the sun boat is shown at the top,[47] or the arched body of the sky goddess from which the sun is reborn frames the scene.[48] Although the basic formula for these single-scene stelae is constantly repeated, the way the individual elements are put together, the complexity of composition, the style and quality of workmanship all vary, so that no two stelae are the same.

Just as funerary stelae now belonged to women as well as men, so *Books of the Dead* and other funerary papyri were also made for women, in contrast to the almost exclusively male or shared ownership found during the Nineteenth and Twentieth Dynasties. At Thebes, where all extant funerary papyri of the period come from, it was customary during the Twenty-first Dynasty and the early part of the Twenty-second to have two funerary papyri.[49] One was normally a *Book of the Dead* (fig. 246), which was placed within a wooden figure of Osiris, a custom going back to the Nineteenth Dynasty. The other, usually placed between the legs of the mummy, might be a short version of the *Litany of Ra* containing coloured vignettes showing the different solar and Osirian forms of the great god with whom the deceased was to be identified. It was later superseded by depictions of the ninth to twelfth hours of the night in the underworld, perhaps inspired by the decoration in the burial chamber of Amenhotep II, which had recently been re-used as a burial place for some of the New Kingdom royal mummies that had been rescued from their own plundered tombs (fig. 247). At the end of the Twenty-first Dynasty and the beginning of the Twenty-second a wide range of new funerary compositions was created by mixing elements of the *Amduat*, the *Litany of Ra* and the *Book of the Dead* with new illustrations, to form what are called vignette papyri because they consist mainly of illustrations with few texts.[50]

For most of the Twenty-first Dynasty the iconographic repertory of funerary papyri and coffins tended to complement each other rather than to repeat the same scenes. Over time, however, they tended to coalesce, so that by the late Twenty-first Dynasty similar motifs are found on coffins and papyri.[51] Then, at roughly the same time as yellow coffins gave way to white coffins with their simplified decoration, funerary papyri disappeared, as did the

245 Funerary stela of Deniuenkhons, the mistress of the house and musician of Amun, before the deity Ra-Horakhty-Atum. The god stands on the left, facing right, in the primary compositional position, before a table piled high with offerings of bread, birds, fruit and lotus flowers. Below are two cos lettuces and a jar of drink. Deniuenkhons stands on the right side of the stela facing the god, with her arms raised in adoration. The top of the stela is equated with the sky, symbolised by a blue 'sky'-hieroglyph that runs around the curve. Below, the sun is represented by a winged sun disk that arches over the whole scene, binding the two halves together. Between the winged sun disk and the columns of hieroglyphs that identify the figures, the sun is again represented, this time as the scarab beetle that pushes the sun disk out of the underworld over the eastern horizon. Here it is flanked by two jackals representing the funerary deity Anubis and signifying the underworld from which the sun rises each day. The thick arms and heavy buttocks and thighs of Deniuenkhons' figure exemplify a new ideal for the female figure that comes into fashion during the Third Intermediate Period and contrasts with the slender image that was usual in the Nineteenth and Twentieth Dynasties (figs 214–15). Probably from Thebes. Painted sycomore fig wood, H. 33 cm. Third Intermediate Period. London, British Museum.

246 Vignette from the *Book of the Dead* belonging to Djedkhonsiusankh, musician of Amun, showing her burning incense before the solar deity Ra-Horakhty-Atum. The god, who sits on the left facing right, is represented as a mummiform figure with a falcon head. He wears a sun disk adorned with a *uraeus* and carries the crook and flail. Djedkhonsiusankh stands on the right facing left, raising a pot of burning incense before the god. Her figure is drawn in the voluptuous style of the period, with a full breast above a roll of fat. The figures have been outlined in black, with red and blue paint added on the sun disk and *uraeus*, the figure and seat of the god, the large lotus flower draped over the offering stand, and on the burning incense. Djedkhonsiusankh's hair has been painted black, but otherwise her figure is left in outline only. Paint on papyrus, H. 25.5 cm. Third Intermediate Period. London, British Museum.

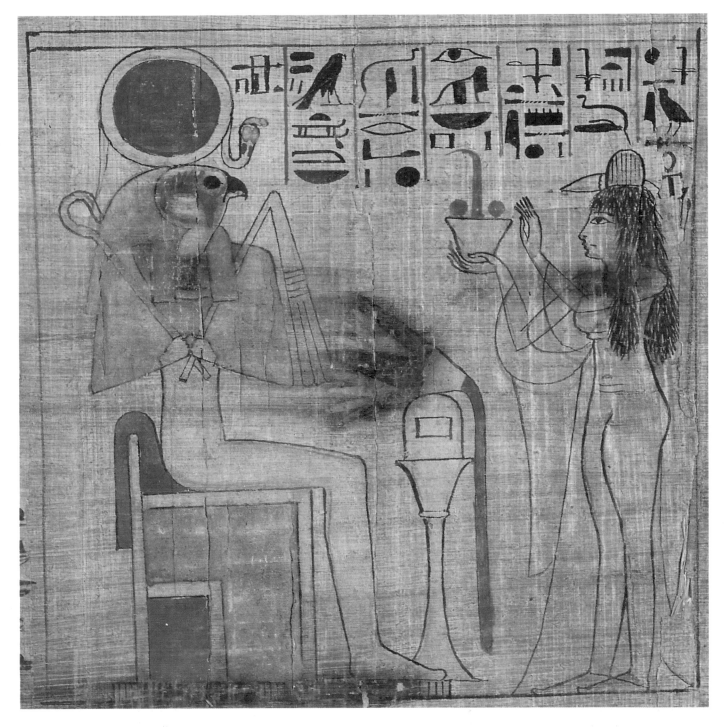

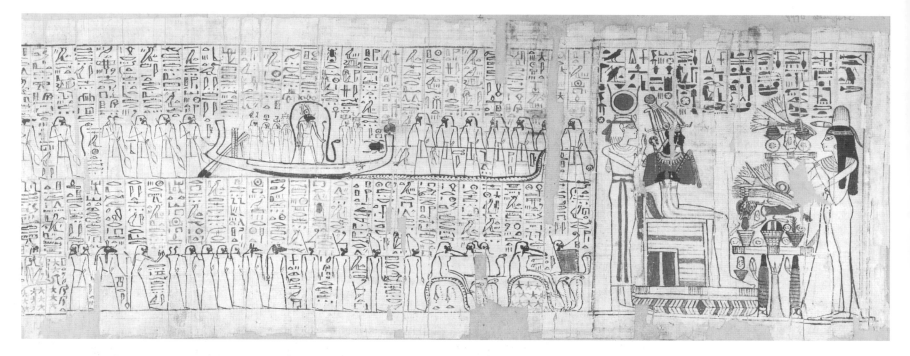

247 Funerary papyrus of the musician of Amun-Ra king of the gods Tentshedmut, who offers food and lotuses to the deities Osiris and Isis. This vignette is followed by two registers showing the eleventh and twelfth hours in the underworld. In the twelfth hour, depicted in the upper register, the ram-headed nocturnal form of the sun god is shown travelling on the solar boat. The boat and all its occupants pass through the body of a snake, entering at its tail and coming out rejuvenated at its mouth. The sun is then reborn once more on the eastern horizon. Thebes, Third Intermediate Period. Painted papyrus, H. 24.5 cm. Third Intermediate Period. London, British Museum.

Osiris figures in which they were often placed. Although extracts from the *Book of the Dead* and other underworld books still occur on the walls of a few royal tombs, their disappearance from coffins and the discontinuation of funerary papyri suggests a shift in funerary beliefs, perhaps under influence from the north, where funerary papyri do not seem to have been used.

Temple monuments

There are few non-royal statues that date to the Twenty-first Dynasty, and those of the Twenty-second and Twenty-third Dynasties were almost all dedicated in temples rather than associated with burials.[52] Nevertheless, even though they were set up in the owner's lifetime, such statues could also serve a funerary function in that they perpetuated the owner's name and were provided with offerings long after the owner was dead. Like temple statues in earlier periods, they mostly represented men, and statues of women were rare. However, an extremely fine female statue represents Shepensopdet, the daughter of a high priest of Amun, granddaughter of Osorkon III, and wife of the high official Hory who built the chapel of Isis at Karnak (fig. 248).[53] Shepensopdet's statue was found in a large cache of statues in the main temple of Amun, but the text makes it clear that Hory originally set it up for his wife in the Isis chapel that he had built.[54]

Although statue poses were traditional, and the block statue was particularly popular, an innovative element was the tendency to decorate the surface of the statues with figures of deities cut in shallow sunk relief. Shepensopdet's statue is decorated on the front of her dress with standing figures of Osiris, Isis and Nephthys. Sometimes the groups are fairly complex, showing, for example, Isis and Nephthys adoring the boat of Ptah-Sokar-Osiris, or Horus and Thoth adoring the special form of the *djed*-pillar associated with Osiris.[55] An interesting statue from Karnak belonged to the high priest of Amun Shoshenq, who later became the short-lived Shoshenq II (fig. 249). The style, wig and costume show that the statue was originally made in the late Eighteenth or early Nineteenth Dynasty. By the Twenty-second Dynasty it had suffered damage to its right sleeve and left hand. Shoshenq had these areas repaired and his name inscribed on the statue. In addition, a figure of Amun in sunk relief was carved on the chest and a figure of Osiris on the front of the kilt to bring it into line with contemporary statues.

The quality of metal-working reached a new peak during this period, and royal and elite statues were also cast in bronze and elaborately inlaid with gold and silver (fig. 250).[56] Relatively few examples have survived, probably because such objects were later melted down for their metal content. Nevertheless it is interesting that, in contrast to stone statues, a number of bronze ones represent women.

248 Statue of Shepensopdet, granddaughter of King Osorkon III. The finely worked statue shows Shepensopdet seated with her right hand flat on her thigh and her left hand holding a lotus flower. On the front of her ankle-length dress, where it covers her lower legs, is cut a standing figure of the god Osiris, flanked on either side by figures of the goddesses Isis and Nephthys. Higher up, on her lap, is a figure of the god Herishef of Herakleopolis as a ram. An image of the goddess Bastet of Bubastis, the city from which the Twenty-second Dynasty came, is cut on her right shoulder. The texts on the seat and pedestal identify Shepensopdet and record that the statue was commissioned by her husband, Hory, who had it set up in the Isis chapel built by him for Osorkon III at Karnak. The statue was later moved, since it was found amongst a large cache of statues in the main temple of Amun. Grey granite, H. 83.5 cm. Twenty-second Dynasty. Cairo, Egyptian Museum.

249 *far right* Statue, dating originally to the late Eighteenth or early Nineteenth Dynasty, repaired and reinscribed by the high priest of Amun Shoshenq, later King Shoshenq II. Shoshenq also had figures of the gods Amun and Osiris cut on the chest and kilt respectively, as was the fashion on contemporary statues. Shoshenq is unlikely to have been unable to commission an original statue, and this re-use of an older monument may derive from the respect for the past that was a characteristic of the Third Intermediate Period. Temple of Amun, Karnak. Green breccia, H. 48 cm. Eighteenth to Nineteenth Dynasty/Twenty-second Dynasty. Cairo, Egyptian Museum.

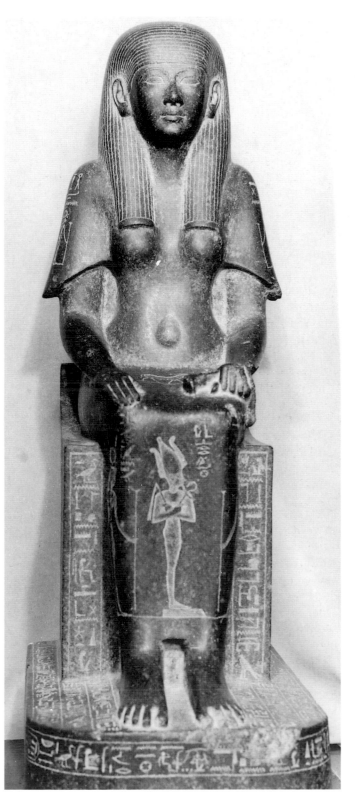

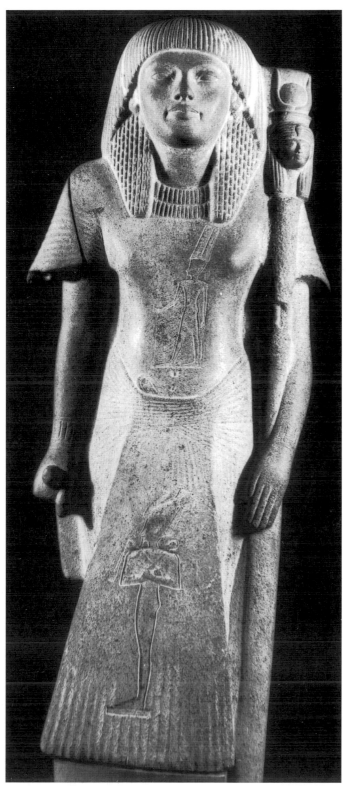

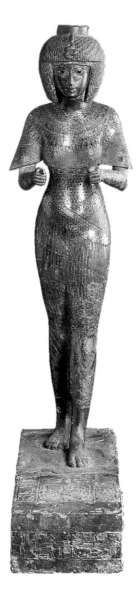

Abydos Abydos remained important as a site sacred to Osiris with many people visiting and leaving offerings at the supposed tomb of the god. A stela from the reign of Osorkon II set up by Pashedbastet, the fourth priest of Amun at Thebes, illustrates a pious attitude towards the past that we have already seen in the slightly later chapel of Isis built by Hory at Karnak. The priest Pashedbastet tells how, on a visit to Abydos, he was strolling out in the desert and found an old funerary stela.[57] He cleared the sand away, marked the monument off with boundary stones, endowed it with fields and established daily offerings to be made there for Osiris. He then set up his own stela, in order to leave a record of what he had done.

Earlier, in the Twenty-first Dynasty, Psusennes, a son of a high priest of Amun at Thebes, Menkheperra, and himself a priest of Min, Horus and Isis at Coptos, set up a large stela 91.4 cm high (fig. 251).[58] It shows Psusennes offering to Osiris, Horus and Isis with five lines containing an offering formula below. The object that Psusennes offers is a crudely drawn Isis-knot amulet, which is not only unexpected but also at odds with the high quality of the rest of the relief. In fact the amulet is drawn over an earlier, partially erased figure of the goddess Maat, who symbolised the correct order of the universe. Scenes in which kings offer images of Maat are part of the repertory of New Kingdom royal iconography, affirming that the king rules in accordance with Maat, and were not meant for non-royal usage. At some point Psusennes' appropriation of the motif must have been noticed and steps taken to change his offering to something more suitable to his status.

The human figure

For much of the Third Intermediate Period private male figures follow New Kingdom traditions, with slender limbs, narrow shoulders, a fairly high small of the back, no musculature and full, elaborately pleated garments. Royal and divine figures were normally more conservative, as in the later New Kingdom. Some representations of private women continue the slender figure found in later New Kingdom art (fig. 247), but others show a new rendering of the female body, which must represent a new ideal of how women should look. A high, slender waist contrasts with heavy buttocks and broad thighs, the breast is often large, even drooping, and rolls of fat are occasionally shown beneath it (fig. 246).[59] Although there are some changes in the way the dress is draped round the figure, the material is still usually treated as transparent, rendering visible the body with its reference to potential fertility and rebirth.

250 Bronze statue of the god's wife Karomama, inlaid with gold, silver and electrum. Karomama wears an ornate collar inlaid in great detail and a feathered dress in the form of wings that wrap around her carefully modelled body. The gesture of the hands shows that she was once shaking a pair of sistra (sacred rattles) that are now lost, as is her headdress. The bare bronze was once covered with gold leaf. Almost certainly from Thebes, perhaps Karnak. H. 59 cm. Twenty-second Dynasty. Paris, Louvre.

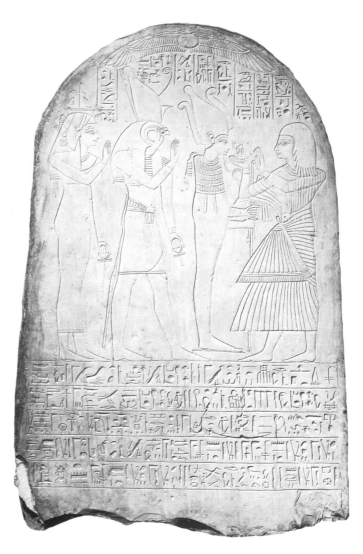

251 Stela of the priest Psusennes, son of the high priest of Amun Menkheperra, from Abydos. Psusennes appropriately offers to Osiris, Horus and Isis, the divine triad of Abydos. The scene is delicately executed in a style that still owes much to the later New Kingdom. Psusennes has narrow shoulders and a high small of the back, resulting in a small upper torso in comparison with the long lower part of the body. His lavish, pleated costume, consisting of a long bag tunic tied round the waist with a wide sash that dips down in front, continues Ramesside fashions. Although the dress of the deities is traditional, Horus's figure also has narrow shoulders, a high small of the back and long legs. This stela falls towards the end of the development of the New Kingdom artistic style, which was gradually replaced during the Third Intermediate Period by styles based on older monuments leading eventually to the archaising trends of the Twenty-fifth Dynasty. H. 91.4 cm. Twenty-first Dynasty. London, British Museum.

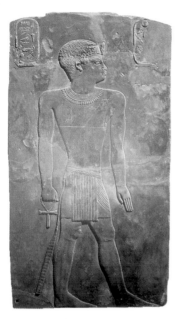

252 Plaque of King Iuput II, made of Egyptian faience. Little is known about this king except that he was one of the many rulers found in the Delta in the late Third Intermediate Period and that he submitted to the Nubian King Piye when the latter campaigned in Lower Egypt. Iuput's figure is depicted in the archaising style that was introduced at this time and displays pronounced musculature, broad shoulders and a low small of the back (compare fig. 251). His costume ultimately goes back to the First Dynasty (see fig. 25). H. 29.3 cm. Late Third Intermediate Period. New York, Brooklyn Museum of Art.

At the end of the period a plaque with a representation of Iuput II, a minor Delta king, shows a male figure with proportions that had not been seen since the beginning of the Eighteenth Dynasty and that ultimately go back to the Old Kingdom (fig. 252).[60] Not only are the shoulders broad and the limbs thick, but the small of the back and the lower border of the buttocks are low. We shall see in the next chapter that such archaising proportions become the norm in the Twenty-fifth and Twenty-sixth Dynasties.

Conclusion

The Third Intermediate Period, in spite of being a time of political disruption, shows no falling off in artistic standards. At Thebes there was a change in burial practices resulting in an abandonment of the decorated tomb chapel, so that the visual expression of funerary beliefs that was once a feature of its walls was transferred to the coffins that enclosed the deceased and accompanying items such as funerary papyri and painted wooden stelae. The latter represent a new, distinctive type of stela, executed with great vigour in bright colours. Without doubt, however, some of the most remarkable artistic products of this time were the brightly painted coffins, whose interior and exterior designs, illustrating aspects of the underworld and divine protection, form at their best unsurpassed examples of the painter's art in ancient Egypt.

Notes

1 Montet *et al.* 1947; Montet 1951; 1960; Hope 1988, 26–38; Yoyotte *et al.* 1988, 19–27.
2 Reeves 1990a, 271–8; Stadelmann 1971.
3 Montet *et al.* 1947; Montet 1951, pls 11–16; 1960, pls 29–42; Fazzini 1988, 24–5, pls 35–8.
4 Yoyotte *et al.* 1988, 32–3 no. 5.
5 Taylor 1989, 41.
6 Hope 1988, 74–98 nos 23–46.
7 For the king's funerary equipment see Montet 1951.
8 Baines and Malek 1980, 177.
9 Montet 1942; Yoyotte *et al.* 1988, 10–18.
10 Hope 1988, 18.
11 Habachi 1957; 1975.
12 Otto 1975, 629; Malek 1993, 95–6.
13 Naville 1892; Fazzini 1988, 17–19, pls 11–15.
14 Epigraphic Survey 1954.
15 Epigraphic Survey 1954, pls 2–9.
16 Kitchen 1986, 293–302.
17 Epigraphic Survey 1954, pls 10–11.
18 Myśliwiec 1988, pl. 16.
19 Epigraphic Survey 1954, pls 13–15.
20 Epigraphic Survey 1954, pls 16–22.
21 Fazzini 1988, 13; Redford 1986b, 1–2.
22 Redford 1986b.
23 Redford 1986b, 2–3.
24 Porter and Moss 1972, 205–6 (9)–(22).
25 Fazzini 1988, 21, pl. 17.
26 Gitton and Leclant 1977, 797–801.
27 Porter and Moss 1972, 205 (11) I, II, 206 (15) 1; Fazzini 1988, pl. 18 no.2; Myśliwiec 1988, pl. 27a.
28 Meeks 1977.
29 Fazzini 1988, 11; Redford 1986a, 329.
30 Redford 1983, 81–3; 1986a, 329.
31 Fazzini 1988, 9.
32 Fazzini, 1988, 11.
33 Schlögl 1977; Baines 1985b; Fazzini 1988, 8–9.
34 Tait 1963.
35 Andrews 1994, 48–9.
36 Andrews 1994, 16.
37 Niwiński 1988, 15, 17–18, pl. 1A; Niwiński 1989, 34–7.
38 Niwiński 1989, 38–42.
39 Niwiński 1988, 8; Taylor 1989, 42.
40 Raven 1991.
41 Niwiński 1988, 7; Taylor 1989, 42.
42 Niwiński 1988, 7; Taylor 1989, 43.
43 Myśliwiec 1988, frontispiece, pls 2–4a.
44 Niwiński 1984, 446–9; Taylor 1989, 47–52.
45 Quibell 1898, 9–14.
46 Quibell 1898, 11, pls 20–1; Bierbrier 1987, pls 2.2–18.2.
47 E.g. Curto *et al.* 1990, 154 no.102.
48 Aldred *et al.* 1980, 116 fig. 102.
49 Niwiński 1989, 43; Quirke 1993, 18.
50 Niwiński 1989, 43–5; Quirke 1993, 18–19.
51 Niwiński 1989, 219–28.
52 Fazzini 1988, 21–2.
53 Hope 1988, 52–3 no. 4; Russmann 1989, 157–9 no. 73.
54 Redford 1986b, 10.
55 E.g. Fazzini 1988, 22, pl. 22; Priese 1991, 169 no.100.
56 E.g. Settgast and Wildung 1989, nos 58–9; Priese 1991, no.139; Aldred 1980, no.169; Ziegler 1990b, 71; Quirke and Spencer 1992, 73 fig. 53.
57 Jacquet-Gordon 1967.
58 MacIver and Mace 1902, 94 pls 31, 34 no. 8; Kitchen 1986, 270–1.
59 E.g. Peck and Ross 1978, nos 17–20, 22; Bierbrier 1987, pls 2.3, 10.1, 16.1, 18.2.
60 Fazzini *et al.* 1989, no. 69.

Looking to the past

THE LATE PERIOD (I)

253 Funerary stela of Ankhefenkhons, priest of Amun. Underneath an arching winged sun disk a double scene shows Ankhefenkhons adoring Ra-Horakhty on the right and Atum on the left, the two deities representing the rising and setting sun and thus the complete solar cycle. The rest of the stela is taken up by six lines of text in which Ra-Horakhty and Atum promise bread, beer, cattle, birds, incense, wine, milk, all good and pure things and all sweet things on which the god lives, all offerings and provisions for the *ka* of Ankhefenkhons. The figures on the stela are narrow across the shoulders and waist, giving the impression of slender, elongated bodies. These attenuated proportions are frequently found on Twenty-sixth Dynasty funerary stelae from Thebes (fig. 269) and elsewhere, and can recur into the Ptolemaic period. They form a considerable contrast with the robust style of figure that was also in fashion at this time (fig. 270). Probably from Thebes. Painted sycomore fig wood, H. 47.3 cm. Twenty-sixth Dynasty. London, British Museum.

About two centuries after Egyptian control of Nubia was lost at the end of the New Kingdom, this region emerged as an independent kingdom, known by the ancient name of Kush. By around 770 BC, the ruler Kashta extended his influence into Egypt as far as Thebes. His daughter, Amenirdis, was adopted by Shepenwepet I, the incumbent god's wife, as her heir. During the reign of Kashta's successor, Piye, the local rulers of Sais in the western Delta were gaining power and beginning to expand into the Nile valley. Piye responded by campaigning north to Memphis and compelling the local rulers to acknowledge his suzerainty. He then returned to Kush, leaving the situation in Egypt basically unchanged.

The next Kushite king, Shabaka, was again confronted by a resurgent Sais, whose ruler had now adopted the titles of king. Moving north, Shabaka killed the new king in battle, conquered the rest of Egypt, and established Memphis as his Egyptian capital, dividing his time between there and his homeland. The Twenty-fifth or Kushite Dynasty is considered to have begun with Shabaka, who was succeeded by his nephew, Shebitku, followed by his own son, Taharqa. The god's wife Amenirdis I adopted Shebitku's sister, Shepenwepet II, who later adopted Taharqa's daughter Amenirdis II.

In the Near East the Neo-Assyrian empire was at its height. In 671 BC King Esarhaddon invaded Egypt, captured Memphis and imposed the payment of tribute. Taharqa fled south, but retook Memphis two years later. Meanwhile Esarhaddon's successor Assurbanipal invaded, making an alliance with Necho of Sais and his son Psamtik. Taharqa was succeeded by his nephew Tantamani, who reconquered Egypt and killed Necho. Assurbanipal returned, forcing Tantamani to flee to Kush, and sacking Thebes.

However, the Assyrian empire was by this time in trouble and Assurbanipal needed his troops elsewhere. Psamtik of Sais was left to hold Egypt for the Assyrians, but as the empire's difficulties mounted he stopped sending tribute. Using Greek and Carian mercenaries, he gradually eliminated other local rulers and gained control of Thebes, installing his daughter Nitokris as heir of the incumbent god's wife.

The Twenty-sixth or Saite Dynasty was a period of internal growth and some expansion abroad, and Egypt was once more recognised as a major state in the Near East. Peaceful relations existed with Kush until 591 BC, when Psamtik II invaded that land, although he did not occupy it. The fourth king of the dynasty, Apries, was overthrown by an army revolt led by General Amasis, who seized the throne. During the latter's reign the power of Persia was growing rapidly in the Near East, and in 525 BC the Persian king Cambyses defeated Psamtik III, the last king of the Twenty-sixth Dynasty, and added Egypt to his empire.

Characteristics of Twenty-fifth and Twenty-sixth Dynasty art

One of the most salient features of the art of this period is archaism.[1] Artists turned away from the developments of the later New Kingdom and Third Intermediate Period and returned to older models. This trend, which seems to have occurred first in the Delta towards the end of the Third Intermediate Period,[2] was adopted by the Kushite rulers, and spread throughout Egypt on both royal and private monuments. Statues and private relief in Theban tombs drew on Old, Middle and New Kingdom models.[3] The

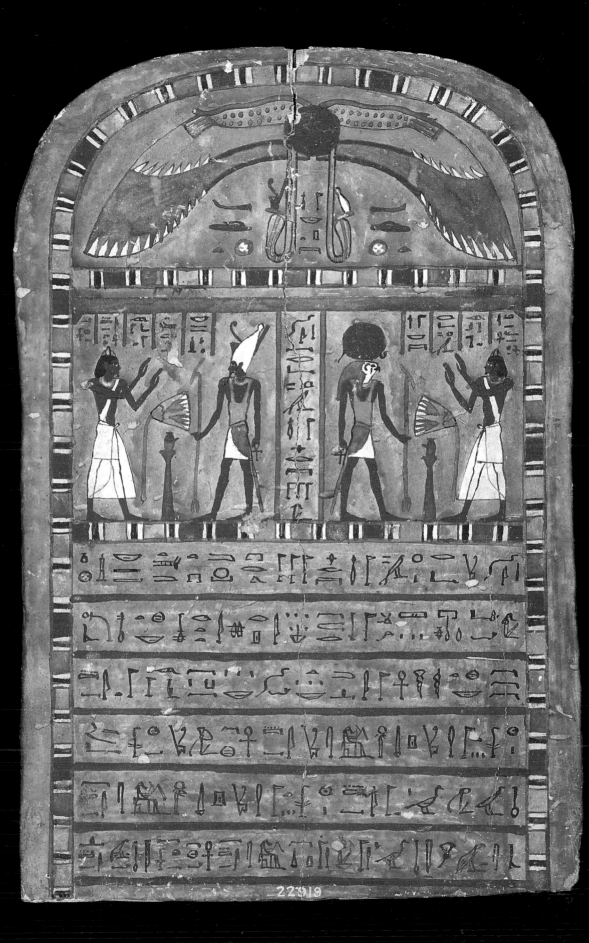

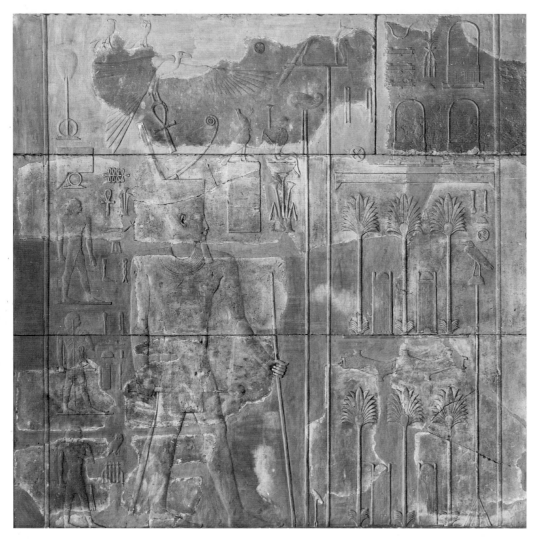

since the hairline at 21.6 squares no longer lay on a grid line. In the new system the length of the forearm from elbow-bone to finger-tips was six squares, instead of the five squares of the old system. In life, in a man of average stature, this distance measured approximately one small cubit (45 cm) or six palms, so that in the new grid system one square represented one palm. We do not know whether or not the new system was developed in order to achieve this correspondence with units of measurement.

The exact modes of transmission from the older models to the later versions have engendered much debate.[6] By this period Egyptian civilisation was over two millennia old and the Egyptians lived surrounded by their past. Artists had easy access to older monuments all around, from which they could copy directly, or collect examples to form pattern books that could be drawn upon when designing a monument. In addition older archival sources, perhaps kept in temples, may have been brought into play. A number of earlier monuments have scenes covered with copyists' grids, which can be recognised because they run over paint and carved relief and are therefore not part of the original sketch. Many consist of a random number of squares that do not relate to any grid system. However, two of the Third Dynasty panels under the Step Pyramid of Djoser preserve copyists' grids that conform to the later grid system.[7] A gateway in the palace of Apries at Memphis contains scenes that are closely related to the Djoser panels (fig. 254).[8] The excavator thought them to be Twelfth Dynasty, because of their high quality.[9] Later, they were ascribed to the Third Dynasty after the discovery of Djoser's panels in the Step Pyramid complex.[10] They are now dated to the Twenty-sixth Dynasty,[11] but it is tempting to think that the design of Apries' gateway was influenced by a close study of Djoser's panels.

Consciousness of the past was part of ancient Egyptian culture, and we have already seen, for instance, how Neb-hepetra Montuhotep of the Eleventh Dynasty looked to Old Kingdom Memphite art as a model. During the Third Intermediate Period there was a strong interest in older works of art, not least because of the embellishment of such cities as Tanis and Bubastis with monuments re-used from earlier periods. This interest might have led artists working in the royal centres of the Delta to use these older works as models and thus introduce archaising features into their work, as in the plaque of Iuput II (fig. 252). It was this archaising style that was adopted by the Kushites for their monuments, and they may have seen it as a way to associate themselves with the great periods of the past and give themselves legitimacy. Archaism must have served the

254 Relief from a gateway of the palace of King Apries at Memphis. The content and style of the scenes on the gateway are closely related to the Third Dynasty panels of King Djoser found beneath the Step Pyramid complex. They are not, however, copies and demonstrate the way in which Twenty-sixth Dynasty artists drew inspiration from works of the past to produce contemporary monuments. Limestone. Twenty-sixth Dynasty. Copenhagen, Ny Carlsberg Glyptotek.

return to 'classic' Old Kingdom proportions seen in the figure of Iuput II at the end of the Third Intermediate Period became the norm (fig. 252), and male figures show broad shoulders, a low small of the back and thick limbs with musculature.[4]

Artists did not, however, aim at exact imitation but at revival and reinterpretation, and inspiration from the past was mixed with innovation. One of the greatest changes was a reform of the grid system during the Twenty-fifth Dynasty.[5] The squares of the earlier system in use since the Twelfth Dynasty were reduced in size, so that five old squares corresponded to six squares in the new system. Thus standing figures, which had once consisted of eighteen squares between their soles and hairlines, now comprised twenty-one between their soles and upper eyelids,

255 Double scene in the tomb chapel of the god's wife Amenirdis I showing the Iunmutef offering to the deceased. Two figures of Amenirdis sit back to back, each facing a table of offerings before which the Iunmutef, wearing a leopard skin and braided sidelock attached to a wig, makes the ritual gesture of offering. Amenirdis wears the tall double feathers and vulture headdress, with a *uraeus* replacing the vulture head, and carries the whisk, all of which were originally items of insignia pertaining to the mother and the principal wife of the king. The balanced composition is worked in high quality, crisply cut sunk relief. Medinet Habu, Thebes. Twenty-fifth Dynasty.

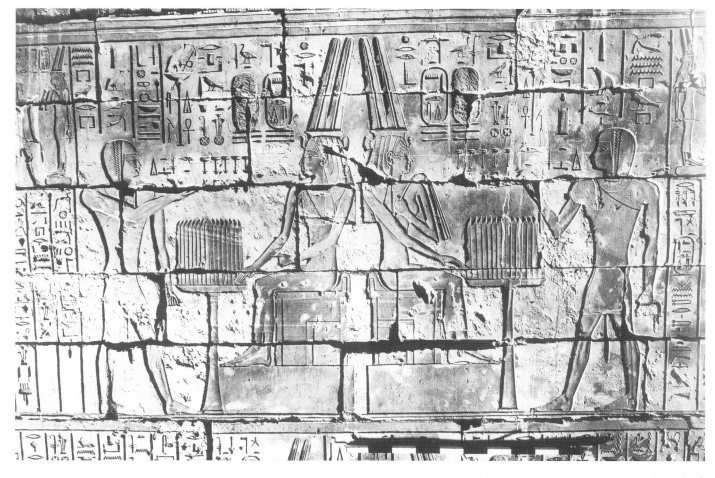

agenda of the Saite rulers too, perhaps marking them as the inheritors of Egypt's great tradition after the recent humiliation of Assyrian conquest. In any case, it is important to remember that these archaising trends were not the result of a decline in artistic imagination and creativity, and that the best artists did not merely copy but drew their inspiration from a range of older models in order to fashion something new.

The king and the god's wife of Amun

The Nubian kings of the Twenty-fifth Dynasty were buried not in Egypt but in their homeland, near their capital of Napata.[12] They had adopted Egyptian funerary practices, and their tombs consisted of a vaulted rock-cut burial chamber, decorated with Egyptian underworld texts and scenes, together with a superstructure consisting of a pyramid and a relief-decorated offering chapel attached to the east face.

The burials of the kings of the Twenty-sixth Dynasty have never been found, but they were undoubtedly located in their home city of Sais, little of which now remains. According to Herodotus, 'the inhabitants of Sais buried all kings who were native to the province inside the temple precinct',[13] continuing the practice that had developed in the Third Intermediate Period.

At Thebes the god's wives of Amun, whose role in the cult of Amun often paralleled that of the king, were buried in the precinct of the temple of Ramses III at Medinet Habu, opposite a small temple of Amun constructed by Hatshepsut and Thutmose III and extended in the Twenty-fifth and Twenty-sixth Dynasties.[14] The decoration of their tomb chapels included scenes derived from temple contexts showing the deceased god's wife, or her successor who buried her, performing rituals for various deities. In addition the age-old scene showing the deceased seated before a table of offerings with priests performing the funerary ritual, which had fallen out of use in the Third Intermediate

Period, was reintroduced to decorate the chapels' cult rooms (fig. 255).[15]

The god's wives, who had taken over their insignia from the iconography of king's wives and mothers, are shown in their chapels in the archaising costume of a mid Eighteenth Dynasty queen. They wear the sheath dress, tripartite wig, vulture headdress and double feathers, but without the usual addition of cow horns and sun disk, which did not come into use until after the mid Eighteenth Dynasty. It seems probable that the images were modelled on figures of Meritra-Hatshepsut, queen of Thutmose III, that appear in the nearby Eighteenth Dynasty temple.

Why, then, were the burials of these pre-eminent priestesses in the cult of Amun of Karnak situated at Medinet Habu? The answer lies in the Egyptian views about the nature of the site and its connection with Amun. We have already seen that the ordered universe was created within the boundless, timeless realm of chaos, and that creation took place on a mound that rose up out of the primordial waters, Nun. The creative potential of Nun, and thus of the creator god, was represented by eight primordial deities. At Thebes the creator was Amun and the mound of creation, containing the primordial deities, was located at Medinet Habu, marked by the small Eighteenth Dynasty temple.[16] From the end of the New Kingdom the statue of Amun was taken across the river to Medinet Habu every ten days to renew the god's creative powers. The mound also contained a tomb of Osiris, and Amun was identified with Osiris as the night sun that was reborn each day as Ra. The connection between Amun and Osiris is already evident in the Third Intermediate Period Osiris and Isis chapels built at Karnak. Further, numerous stone and bronze statues of Osiris were found at Medinet Habu, many inscribed with the names of one or more god's wives and their officials.[17] The link between Amun and Medinet Habu, and the potential for regeneration residing in the mound, made the site an ideal burial place for the god's wives of Amun, where they would participate in the regular renewal of their god and so achieve rebirth for themselves.

State temples

Kings built widely but in many cases within older temple complexes rather than undertaking major new constructions. It is possible that larger building projects were carried out at Sais and elsewhere in the Delta, but little now survives. In other parts of Egypt many structures of the Twenty-fifth and Twenty-sixth Dynasties were later dismantled and their blocks re-used in subsequent buildings (fig. 258).

Much of the surviving evidence for royal building comes from Thebes, where the Twenty-fifth Dynasty carried out a programme to extend and embellish the entrances to temples.[18] A new form of colonnade became popular, consisting of two or four rows of columns leading up to the entrance.[19] The columns were in the traditional form of a papyrus stem topped by an open papyrus umbel capital, but they were linked at their lower parts by intercolumnar screen walls, decorated with traditional ritual scenes. These included depictions of the 'royal visit' that had been part of the repertory of temple decoration since the Eighteenth Dynasty.[20] Such scenes reflect rituals performed when the king entered the temple and made the transition from the impure, outside world to the divine world inside. The combination of columns and screen walls remained in use throughout the Late and Graeco-Roman periods, frequently occurring in small kiosk buildings and to form the façade of hypostyle halls. At Karnak Taharqa built four new colonnades. Three were at the entrances to temples to the east, south and north of the Amun temple.[21] The fourth stood on the west of the Amun temple itself, at the main entrance, in the middle of the great entrance court begun by Shoshenq I (figs 147, 256).[22]

Taharqa also erected a building next to the sacred lake as the setting for a ritual performed when the statue of Amun returned from Medinet Habu (fig. 147).[23] The building was designed to celebrate the union of Amun with the creative powers of Nun and the primordial deities, and with the nocturnal and diurnal manifestations of the sun. The temple consists of a superstructure built over a series of underground rooms. Of the decoration on the superstructure only that on the exterior north wall has survived to any extent; it shows the popular sequence of the royal visit, with the king leaving the palace and being purified by Thoth and Horus before making offerings to various deities (fig. 257). The subterranean part of the temple represents the underworld into which Amun must descend as the setting sun before triumphantly rising again as Ra at dawn the next day. The decoration of the stairway and the complex of rooms through which the statue of Amun was taken depicts the journey of the god into the underworld, the mysteries that happen there and the return to this world. As in other temple buildings, the architecture and its decoration aim to provide a setting that complements the rituals to be performed there, in this case forming a microcosm through which the statue of the deity moves in the same way as the deity himself moves through the cosmos.

The importance of the site of Medinet Habu on the west bank at this period is demonstrated through the building

256 King Taharqa's colonnade in the first court of the temple of Amun at Karnak, from the top of the first pylon. Only one complete column remains standing. Sandstone. Twenty-fifth Dynasty.

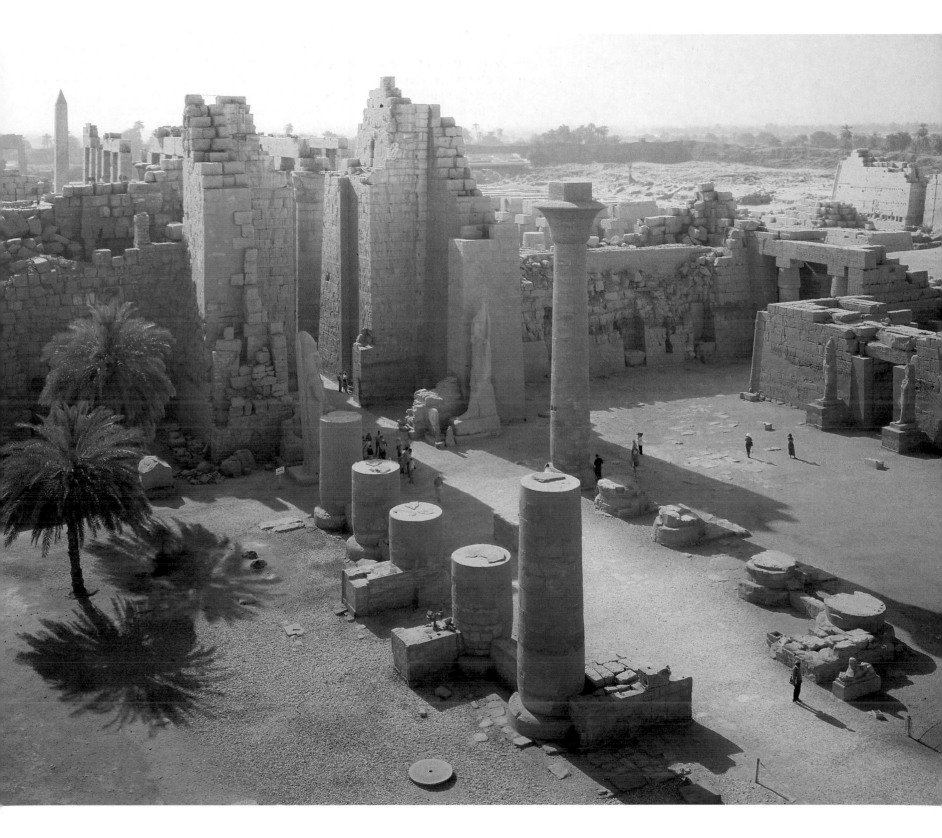

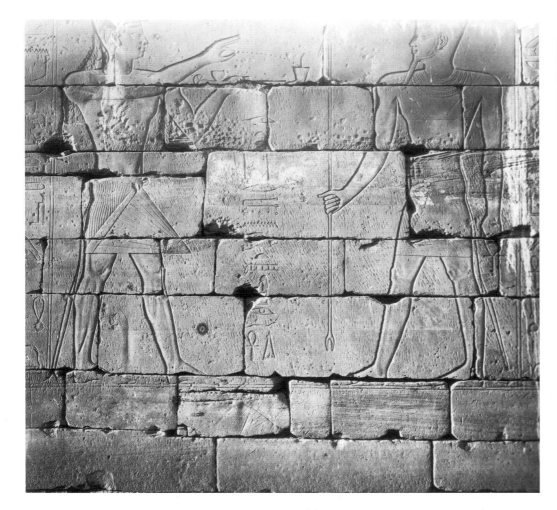

258 Block re-used in the pavement of the open court in the Ptolemaic temple of Horus at Edfu. The relief shows a falcon-headed deity, undoubtedly Horus, followed by a goddess, offering three lilies representing Upper Egypt to a seated figure of a king who holds the crook and flail. The king's name has been erased, but the distinctive version of the cap crown that he wears dates the piece to the Twenty-fifth Dynasty. Originally the figure wore the double *uraeus* that distinguished Twenty-fifth Dynasty kings, but one cobra has been removed, probably during the reign of Psamtik II, who systematically mutilated the images of the Nubian rulers. Twenty-fifth Dynasty.

257 Sunk relief showing King Taharqa censing before the god Atum. The figures exhibit the broad shoulders, low small of the back, stocky limbs and musculature that are characteristic of the Twenty-fifth Dynasty and ultimately derive from the style of the late Fifth and early Sixth Dynasties. However, the streamers that fall from the back of the king's crown were an innovation of the Eighteenth Dynasty. Exterior north wall of Taharqa's building by the sacred lake at Karnak. Twenty-fifth Dynasty.

activities undertaken by the Twenty-fifth and Twenty-sixth Dynasties to enlarge the small Eighteenth Dynasty temple.[24] Shabaka fronted the temple by a long narrow room with a pylon at the east end to form a new entrance. Later still, probably during the Twenty-sixth Dynasty, a colonnade was added to the front of the pylon with two rows of four columns linked by screen walls and, like most such structures, closed at the front with an elaborate broken lintel gateway. The screen walls on both sides were decorated with relief scenes showing the king performing foundation ceremonies and other rituals, while the two wings of the gateway display representations of the king smiting his enemies. In the Thirtieth Dynasty Nectanebo I re-cut all the cartouches with his own name.

The worship of Amun had been taken to Napata in the New Kingdom, and the god had become the Kushite state deity. Thus the Twenty-fifth Dynasty paid particular attention to Amun's cult centre in Egypt. Nevertheless, the importance of Osiris at Karnak did not diminish, and Osiris chapels, where Amun played an important role in the decoration, continued to be built throughout the Twenty-fifth and Twenty-sixth Dynasties (fig. 147).[25] These buildings were often dedicated jointly by the king and the god's wife,[26] and the decoration was divided between the two (fig. 259). At least one building was dedicated in the name of the god's wife alone and the king's figure does not appear at all.[27] Many of the scene types show the god's wife in roles traditionally belonging to the king: adoring and offering to deities; offering Maat, the correct order of the cosmos (fig. 260); performing foundation rituals; being embraced, crowned, suckled and offered life by deities; and enacting *sed*-festival rituals. In addition the god's wife adopts a 'throne' name, usually incorporating the name of the goddess Mut,[28] so that she has two cartouches like a king, although her titularies and insignia were modelled on those of queens. Sometimes she wears the archaising sheath dress, and sometimes the contemporary form of the loose, wrap-around dress. The close relationship between Amun-Ra and the god's wife is demonstrated by a small faience statue, now broken and missing the heads, showing Amenirdis I seated on the lap of Amun, who holds her in his arms.[29]

Royal iconography

Although the kings of the Twenty-fifth Dynasty were foreigners, their depictions show them in the main as traditional Egyptian rulers, with just a few elements that set

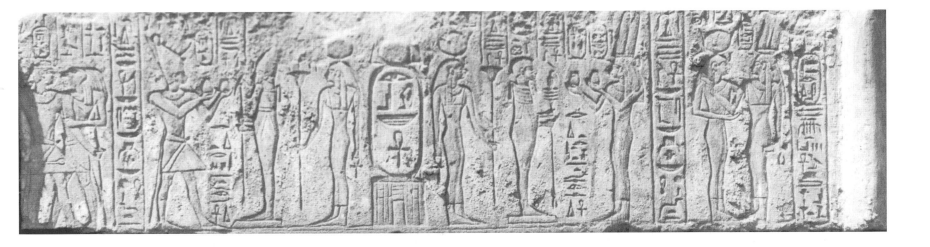

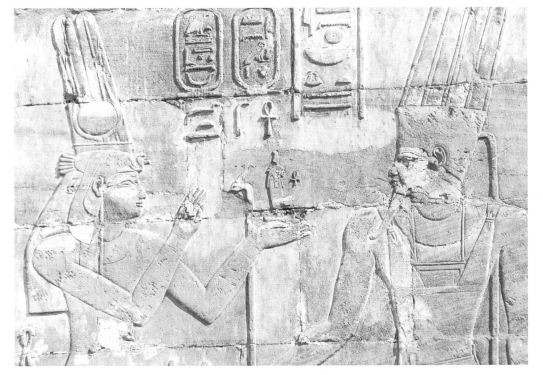

259 *above* Lintel from the chapel of Osiris Lord of Life (*Nebankh*) in the precinct of the temple of Amun at Karnak. The lintel is divided in two by a large cartouche containing the name of the god Osiris in the centre. The left side belongs to the king and the right to the god's wife. On the left Taharqa is embraced by Horus and offers wine to Osiris and a goddess. On the right Hathor embraces the deceased god's wife Amenirdis II, and her adopted successor the god's wife Shepenwepet II offers milk to Ptah and Hathor. The actions of the king are exactly balanced by those of the god's wives, who interact with the various deities in ways that were once limited to the king. Hathor says to Amenirdis: 'I have given you all life and dominion, all health and all joy like Ra for ever', a type of speech which is usually addressed to the king. Sandstone. Twenty-fifth Dynasty.

260 Relief showing the god's wife Shepenwepet I offering an image of the goddess Maat to Amun-Ra. Maat represented the correct order of the universe, established by the creator god when the ordered world was created. The king ruled in accordance with Maat and is shown in temple rituals offering Maat to the gods, confirming his role as the maintainer of cosmic order. In this scene the god's wife takes over the kingly role of offering Maat. The figures are rendered in a heavy style typical of the Twenty-fifth Dynasty. Amun-Ra has broad, muscled shoulders and Shepenwepet has thick arms that contrast with the slender limbs of Ramesside and some early Third Intermediate Period female figures (figs 214–15, 247). Both figures have pronounced wings to their noses, full lips set close beneath the nose, chubby cheeks and thick necks. Chapel of Osiris Ruler of Eternity (*Heqadjet*) in the precinct of the temple of Amun at Karnak. Sandstone. Twenty-fifth Dynasty.

them apart from other kings. The close-fitting cap crown, known from the late Middle Kingdom (fig. 119),[30] is worn with a wide headband, probably made of gold, decorated around the top with a row of *uraei*.[31] Two *uraei*, often crowned with the red and white crowns, were attached at the front of the band. Their tails run back over the head to meet the band at the rear, where two streamers fall down the back (fig. 258).[32] The two *uraei* were also worn with other Egyptian crowns.[33] No native Egyptian king ever wore two *uraei* on his brow, although queens often did so, when the reference was to the goddesses Nekhbet and Wadjit, and thus to Upper and Lower Egypt.[34] The two *uraei* of the Twenty-fifth Dynasty kings are usually also understood to refer to Upper and Lower Egypt.[35] Even when they no longer ruled Egypt, Kushite kings continued to wear the double *uraeus*. One stela shows a later Kushite king wearing the double *uraeus*, one with the white crown and the other with the red, and the text of Amun says: 'I have established Nekhbet and Wadjit on your brow.'[36] Here, even though the king no longer rules over Egypt, the implication is that the *uraei* represent Upper and Lower Egypt.

Another non-traditional feature was the use of ram's-head amulets, the ram being the sacred animal of Amun-Ra, which was especially associated with the deity's worship in Kush. On statues the king may be shown with one such amulet suspended round his neck (fig. 261), most often with two more attached one to each end of the cord, the ends being pulled forward over the shoulders to lie against the chest. Similar amulets might also be suspended from the ears,[37] although adult Egyptian males, including kings, are only very exceptionally shown wearing earrings. Ram's-head amulets are less often depicted on Egyptian monuments than on Nubian ones, suggesting that the Kushites saw a difference between their own and Egyptian traditions. When Psamtik II attacked the images of Kushite kings in Egypt, he not only had their names removed and often replaced with his own, but also had one of the *uraei* erased (fig. 258)[38] and, on statues, the ram's-head amulets hanging round the neck.[39]

Figures of the Kushite kings and god's wives are often shown with a distinctive rendering of the features in two and three dimensions (figs 255, 258, 260–1), recalling those seen in the figure of Iuput II (fig. 252). The head tends to be round with full cheeks, sometimes verging on the chubby. The nose is short with a pronounced wing to the nostril, and there is little space between the bottom of the nose and the upper lip. The lips are usually prominent and the chin short. The neck is thick and often short, and rises vertically from the shoulders.[40] Some of these features are found also on depictions of private figures in the Twenty-fifth Dynasty (figs 266, 268, 270).

The elite

In the later Twenty-fifth to Twenty-sixth Dynasties high officials were buried in a variety of tomb types in the traditional necropoleis at Giza, Saqqara and Thebes.[41] At Thebes many in the service of the god's wife revived the custom of constructing rock-cut burial complexes with tomb chapels. However, they did not copy the form of Middle or New Kingdom tombs, but created a new type of complex on a much larger scale than before.[42] Instead of being cut into a rising cliff they were constructed on the level ground of the desert bay at Deir el-Bahri. Monumental free-standing brick structures, of which little now survives, stood over a series of cult rooms and burial chambers cut into the rock below. The whole was surrounded by a brick enclosure wall.

Different complexes vary in size and plan, but certain elements tend to reappear.[43] A passage descended from the north and made a right-angled turn to the west to lead eventually into an open, sunk, pillared court in which offering tables were set up. Beyond this court were underground cult rooms, side rooms for subsidiary family burials and an offering room for the owner. A series of passages, rooms and descending stairs led to the shaft at the bottom of which lay the burial chamber, often decorated, where the tomb owner was interred. As in earlier periods, owners were almost exclusively male, but at least two tombs belonged to women, both of whom were in the service of the god's wife.[44]

The combination of passages, rooms and stairs is reminiscent of New Kingdom royal tombs, but much of the decoration derives from that of private tomb chapels, which had fallen out of use in the later New Kingdom and Third Intermediate Period. As in the chapels of the god's wives, the owner is once more shown seated in front of a table of offerings. Offering lists, processions of offering-bearers and butchers slaughtering oxen (fig. 262), all former staples of funerary decoration, were also revived. Scenes of 'daily life', not used for over half a millennium, were reintro-

261 Bronze statuette of a Twenty-fifth Dynasty king. The kneeling figure was originally attached to a base by the tenon beneath its knees and was perhaps once part of a larger group representing the king offering to a deity. The king wears the cap crown with the wide band to which two *uraei* are attached at the front, and a ram's head amulet is suspended from a cord around his neck. Temple T, Kawa, Nubia. H. 9.3 cm. London, British Museum.

duced to show the tomb owner overseeing agricultural labours, swamp activities and workshop production, and fishing and fowling in the marshes (fig. 263). Alongside this material funerary texts occur, including excerpts and vignettes from the *Book of the Dead*. The different models were always adapted to meet contemporary needs and styles. Motifs from Eighteenth Dynasty painted Theban tomb chapels were translated into relief,[45] and slender Eighteenth Dynasty male figures were transformed into broad-shouldered muscled forms.[46]

Around the beginning of the seventh century a new type of wooden coffin replaced the inner cartonnage mummy case of the Twenty-second and Twenty-third Dynasties (fig. 264).[47] It represented the deceased standing on a rectangular pedestal, with a raised back pillar on the underside of the case. This new form can derive only from the traditional base and back pillar of a statue, and, since a coffin, like a statue, is an image of the deceased, the transfer of formal features from one to the other presumably stresses this similarity. In addition to the formal changes, a new style of decoration began to develop, reviving subject matter that had gone out of use in the Twenty-second Dynasty, including vignettes and long extracts from the *Book of the Dead*. The chest area of the lid was once again protected by an image of Nut with outspread wings. Beneath, a scene sometimes showed the weighing of the heart, below which the lid was divided into three vertical sections. A small vignette from the *Book of the Dead* was placed at the top of the central panel containing vertical text columns. Either side, at right angles, images of deities alternated with texts containing their recitations. An alternative scheme was adopted for the coffin lids of lower-status owners. Beneath the weighing of the heart the surface was divided into horizontal bands, containing fur-

ther images but only brief inscriptions. Whatever the lid type, the back of the case was painted on the raised back pillar with columns of text or a large *djed*-pillar, the backbone of Osiris, while horizontal lines of text covered the sides of the case. The inside was decorated with a large figure of Nut or Hathor, or more excerpts from the *Book of the Dead*. The identity of the deceased with Osiris was sometimes emphasised by painting the face of the coffin green. The inner coffin was placed inside one or two more anthropoid coffins that remained traditional in form with a flat back and no pedestal. The decoration of both the inner and outer coffins was painted in bright colours on a white or yellow ground, on plastered linen that covered the wood of the coffin.

A further change at the end of the Third Intermediate Period was the introduction of a new type of rectangular outer coffin, with four posts rising from the corners and a vaulted lid (fig. 265).[48] Wooden images of falcons and jackals, now often lost, were attached to the posts and lid. The outside of the case was decorated with figures of deities in shrines separated by texts, sometimes with the archaising scene of the deceased seated before a table of offerings on one of the short ends (fig. 266). The vaulted lid, representing the sky, was decorated with images of the diurnal and nocturnal solar boats. The form of the coffin is based on that of similarly shaped shrines that contained divine images, such as those depicted on the case of the coffin, for the coffin contained the divine, mummified form of the deceased.

Large stone mummiform outer sarcophagi, which had not been used in private burials since the New Kingdom, came back into fashion, continuing in use into the second century BC.[49] They were made of various materials, such as basalt, limestone or granite, all of which were also

263 Fragment of relief from a fishing scene in the tomb of Montuemhat at Thebes (no.34, see also fig. 262). The fragment preserves two fish pierced by spears in a pool of water surrounded by a thicket of papyrus. This detail belongs to the well-known type of fishing scene in which the tomb owner spears fish from a papyrus skiff and which was normally balanced by a second scene in which the tomb owner hunted birds with a throw-stick (fig. 11). These paired scenes first appeared in the Old Kingdom and remained popular until the late Eighteenth Dynasty. However, they went out of use when the repertory of tomb chapel decoration began to change in the post-Amarna period and early Nineteenth Dynasty. Then, after a gap of about seven hundred years, the scenes were revived by the artists working on Montuemhat's tomb as they turned to older monuments to collect suitable material for its decoration. Limestone, H. 26.4 cm. Late Twenty-fifth to early Twenty-sixth Dynasty. Cleveland Art Museum.

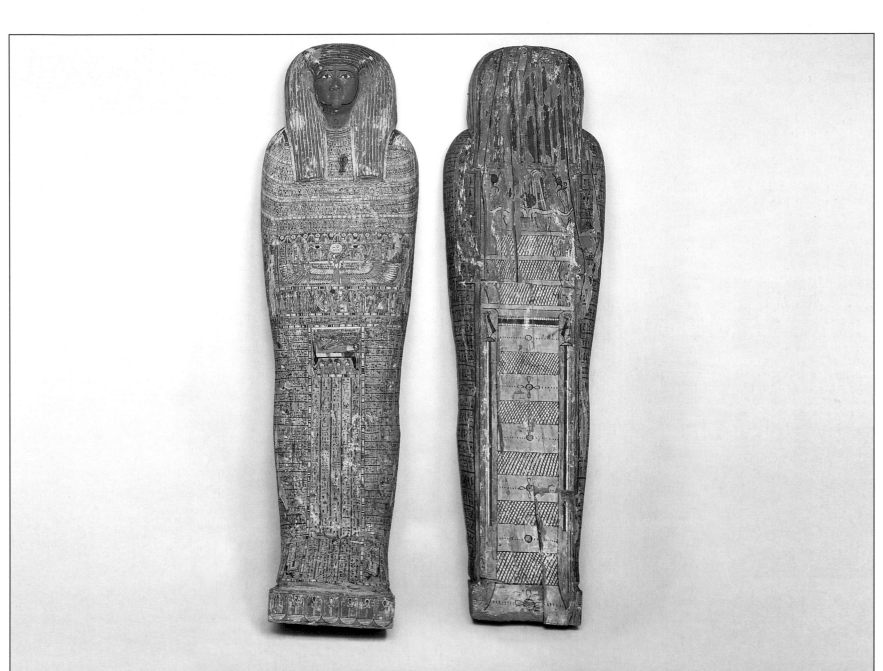

264 Inner coffin of Irthoreru, representing the new type of wooden inner coffin that stands on a rectangular pedestal and replaced the cartonnage mummy case around the beginning of the seventh century BC. The lid is painted with an elaborate floral collar with falcon-head terminals. Below, a kneeling figure of the goddess Nut spreads her wings in a gesture of protection, and, underneath, a horizontal register the width of the lid depicts the weighing of the heart and the presentation of the deceased to Osiris and other deities. The rest of the lid is divided vertically into three sections. In the centre, above five vertical columns of texts, the mummy of the deceased is depicted lying on a lion embalming-bed with his *ba* hovering over him. Under the bed are four canopic jars to hold the viscera of the deceased. The lid of each one is in the form of one of the four sons of Horus whose task it is to protect the viscera. Either side of the central section, images of deities and texts containing their recitations run at right angles. The front of the pedestal is decorated with an emblematic frieze that repeats the group of an *ankh* flanked by two *was*-sceptres standing on a *neb*-basket, meaning 'all life and dominion'. The bottom of the coffin is decorated with a large *djed*-pillar, a symbol of Osiris that came to be regarded as representing the god's backbone. Akhmim. Painted wood, H. 165 cm. Twenty-sixth Dynasty. London, British Museum.

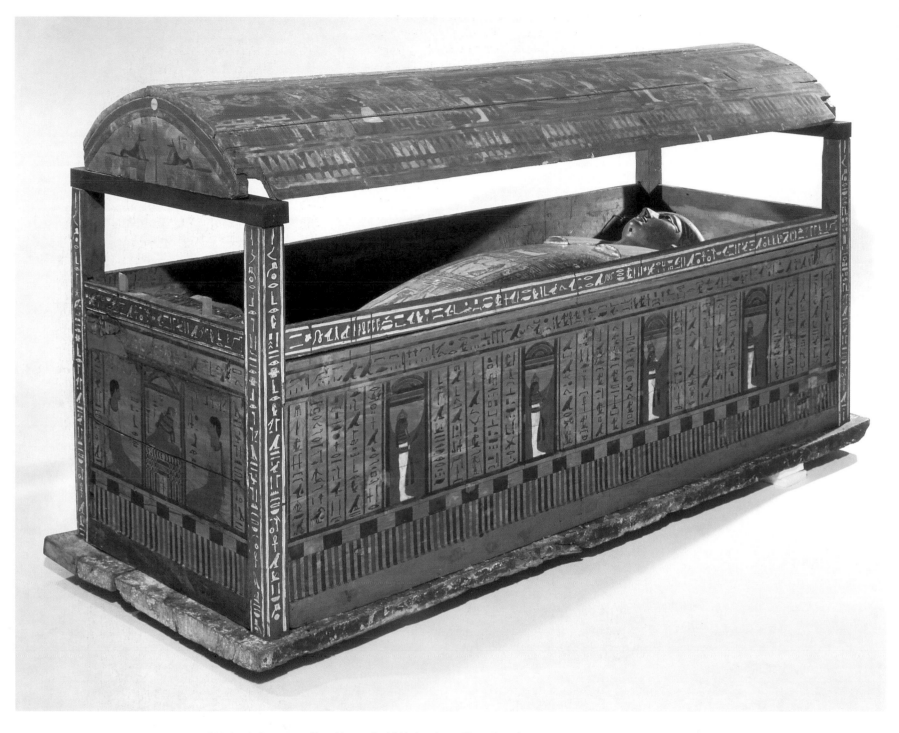

265 Rectangular outer coffin with a vaulted lid belonging to Hor, priest of Montu and son of Ankhhori and Karem. This type of coffin was introduced at the end of the Third Intermediate Period. Deir el-Bahri, Thebes. Painted wood, L. 215 cm. Twenty-fifth to Twenty-sixth Dynasty.

employed in making statues, and the sarcophagi demonstrate the same high quality of stone-working that was achieved in statuary. In the sarcophagus of Sasobek, vizier of Psamtik I, the form of the mummified body is subtly modelled on the lid, and the deceased wears a divine beard and three-part wig (fig. 267). The hands, holding amulets such as the *djed*-pillar and Isis knot, are visible on the chest. Below them a kneeling image of the sky goddess spreads out her wings over columns of text that run down the centre of the lid.

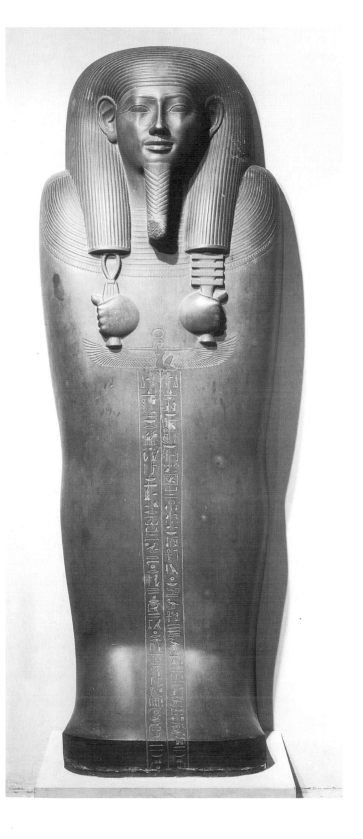

266 End of the rectangular outer coffin of Hor (see fig. 265), showing Hor seated before a table of offerings while the Iunmutef performs the offering ritual. Above the table is written 'a thousand loaves of bread, a thousand jars of beer, a thousand head of cattle and birds'. The features of the two figures both show a pronounced wing to the nostril and full lips set close beneath the nose. Deir el-Bahri, Thebes. Painted wood, L. 215 cm. Twenty-fifth to Twenty-sixth Dynasty.

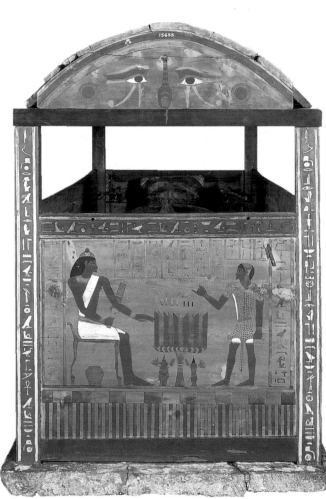

267 Black basalt sarcophagus lid of Sasobek, the northern vizier in the reign of Psamtik I. The design achieves a harmonious balance between the decorated and undecorated areas, highlighting the smooth, polished surface of the bare stone. H. 223 cm. Twenty-sixth Dynasty. London, British Museum.

268 Funerary stela of the mistress of the house Hetepamun, daughter of the priest of Montu, Lord of Thebes, Mapu, showing the deceased at the right adoring an unidentified rearing snake with a beard, and the gods Ra-Horakhty and Osiris. The arch of the stela is decorated by a curving sky hieroglyph with a winged sun disk below. The sides of the scenes are framed by the standard of the west on the left and the standard of the east on the right. Below, two lines of hieroglyphs contain an offering formula invoking Ra-Horakhty, 'that he may give offerings of bread, beer, cattle, birds and incense'. Probably Thebes. Painted sycomore fig and tamarisk wood, H. 31.5 cm. Twenty-fifth Dynasty. London, British Museum.

269 Funerary stela of Djedhor, musician (?) of the house of Amun, showing the deceased adoring the underworld deities, Osiris, Isis and the four sons of Horus. A winged sun disk spreads across the top of the stela, with a single line of hieroglyphs containing an offering formula below. At the bottom of the stela three lines of hieroglyphs contain a second version of the offering formula. Probably from Thebes. Painted sycomore fig wood, H. 31.5 cm. Twenty-sixth Dynasty. London, British Museum.

Only a few papyri with the *Book of the Dead* are known from the Twenty-sixth Dynasty;[50] these revive a custom that had fallen out of use during the later Third Intermediate Period and Twenty-fifth Dynasty. However, the text and vignettes had undergone several revisions from earlier versions. The corpus of spells was standardised at 165 in a set order. Most were traditional, but some are not known from earlier.

At Thebes the Third Intermediate Period tradition of painted wooden stelae continued, but at other sites painted stone stelae seem to have been more common.[51] Around the beginning of the Twenty-fifth Dynasty at Thebes the typical Third Intermediate Period stela that consisted of a single scene only without independent text gradually gave way to stelae that included several lines of text beneath the scene, frequently containing a version of the traditional offering formula on behalf of the deceased (fig. 268).[52] Although the scene continues to show the deceased most frequently adoring Ra-Horakhty, a second deity, for instance Osiris, may also be included.

By the Twenty-sixth Dynasty the deceased is frequently shown before a whole row of deities, often comprising Osiris, Isis and the four sons of Horus (fig. 269). This sequence is sometimes headed by a figure of Ra-Horakhty, who may replace Osiris. A different scene type, purely solar in theme, was divided in two, with the deceased in one half adoring Ra-Horakhty and in the other Atum (fig. 253). The two deities, representing the rising and setting sun respectively, together encompass the solar cycle and the promise of rebirth that it offered the deceased. At Abydos the single-scene stela seems to have stayed in use much longer.[53] It is found throughout the Twenty-fifth Dynasty, only finally disappearing during the Twenty-sixth (fig. 270).

Although the archaising motif of the deceased seated before a table of offerings, which had been a major part of funerary stelae into the New Kingdom, was revived in Theban tomb chapels, it only rarely occurs on funerary stelae of this period.[54] The scenes on stelae continue to develop from the forms established in the Third Intermediate Period rather than returning to earlier models and subject matter.

By contrast, statues of the Twenty-fifth and Twenty-sixth Dynasties draw widely on earlier periods for their models. They do not reverse the Third Intermediate Period trend by which most statues were made for a temple rather than a tomb, although some Theban tombs revived the practice of including rock-cut statues.[55] Three schist statues were placed in the burial chamber of an official called Psamtik at Saqqara,[56] but only one represents the deceased,

showing him protected by the Hathor cow, an image originally developed for the king.[57] Transferred to the tomb owner, it shows Hathor protecting and aiding him during the dangerous process of rebirth. The other statues represent Osiris and Isis.[58]

Because most statues were placed in temples, very few depict women,[59] although some pair statues are known from the Twenty-sixth Dynasty.[60] Statue poses at this period are traditional, with standing, kneeling and block statues being the most common; seated figures are less frequent. The scribe statue was revived in the reign of Psamtik I.[61] Statues in the style of works from the Old, Middle and New Kingdoms can be found (figs 271–2), but elements may also be mixed. In one of the many statues of Montuemhat, the fourth prophet of Amun at Thebes at the end of the Twenty-fifth and beginning of the Twenty-sixth Dynasties,

the youthful, taut, muscled body is reminiscent of the Old Kingdom, but the figure wears a New Kingdom wig type, while the harsh rendering of the features is neither Old nor New Kingdom in style, and perhaps owes something to Middle Kingdom models (fig. 273).[62] Other statues with unyouthful, harsh and individual-seeming features are found alongside idealising images in the Twenty-fifth Dynasty and the beginning of the Twenty-sixth.[63] During the Twenty-sixth Dynasty there is a preference for calm, even bland, idealising features with rounded contours and a dreamy smile. One of the hallmarks of Twenty-sixth Dynasty statuary is the virtuoso treatment of stones such as schist, granite, basalt and diorite. The smooth, polished, rounded forms give the end product a plasticity and softness that belies the hard nature of the material (fig. 7).

A growing trend at this time was the presentation of votive statues of deities in temples, often with texts asking for some benefit for the donor from the deity. We have already seen that numerous stone and bronze statues of Osiris were dedicated at Medinet Habu. A grey schist statue from the Theban area depicts a standing, winged figure of Isis protecting a smaller figure of Osiris standing in front of the goddess (fig. 274).[64] The inscription states that it was dedicated by the chief steward of the god's wife, Shoshenq, who served Ankhnesneferibra. He petitions Isis for a long life and a good burial. These were traditional benefits often requested on earlier funerary monuments, and it is clear that votive statues were dedicated not just for the owner's lifetime but in perpetuity, so that they could also have a funerary function.

Another official of Ankhnesneferibra dedicated a bronze figure of Amun-Ra-Kamutef, the potent form of the creator god (fig. 275).[65] The image stands on a small base that in turn rests on a larger one. Gold-inlaid scenes on the sides depict various aspects of the god. The solar aspect is shown by a squatting image of the young sun god, and the raising of the sun boat into the eastern sky. A series of fecundity figures represents the god as bringer of fertility, and the god as ruler of the universe is shown by the nine bows depicted under his feet and the *sema tawy* motif with Horus and Thoth binding the plants. In phraseology once reserved to address kings, the god says to the donor, 'I have given to you all life and dominion'. Like Shoshenq, the donor also asks for a good burial.

Not all dedications spell out the favours the donor hopes to obtain. There can be no doubt, however, that the presentation of a votive image was a way for the donor to interact with the deity to obtain some benefit. The custom of presenting votive offerings was an old one, but the prolifera-

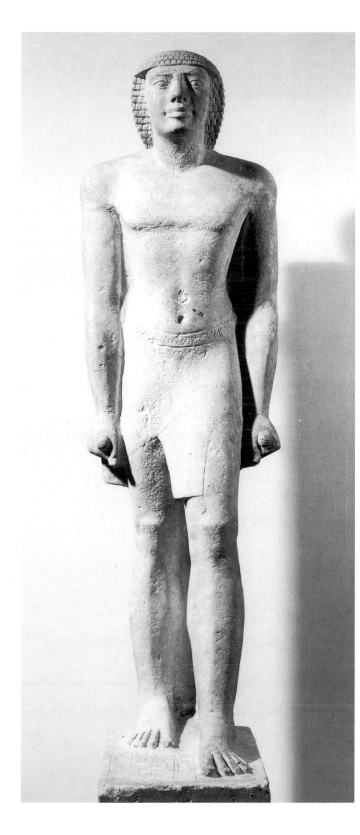

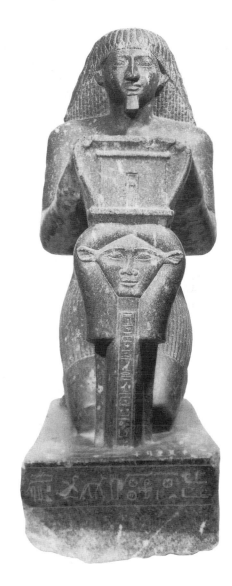

271 *left* This standing statue of the official Tjayasetimu makes a reference to Old Kingdom funerary statues in its pose, style and wig type (fig. 66), illustrating the archaising trend of the Twenty-fifth and Twenty-sixth Dynasties, when artists looked back to earlier periods for their models. Limestone, H. 126 cm. Twenty-fifth to Twenty-sixth Dynasty. London, British Museum. (See also fig. 9.)

272 Kneeling statue of Nespeqashuty, the southern vizier of King Psamtik I, presenting a large Hathor emblem. The statue was probably set up at Karnak and resembles a type of temple statue that first became popular in the Eighteenth Dynasty. The shoulder-length double wig that sweeps back from the face was common in the Eighteenth Dynasty but far less so in the later New Kingdom, when the lower layer of the wig lengthened to form two lappets that fell forward over the shoulders one either side of the neck (fig. 222). Black granite, H. 72 cm. Twenty-sixth Dynasty. London, British Museum.

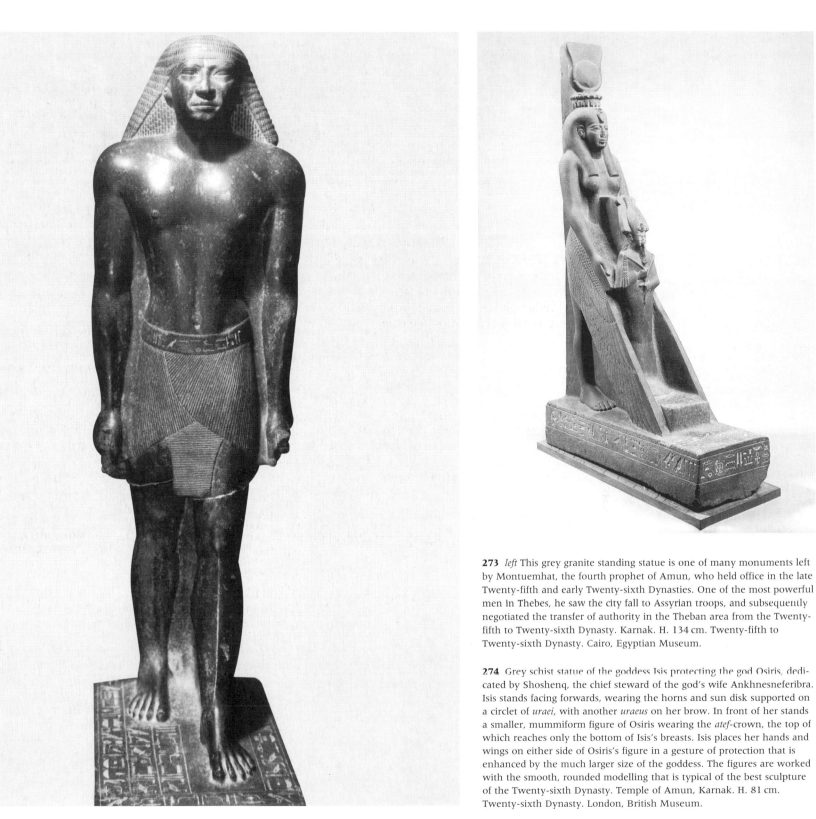

273 *left* This grey granite standing statue is one of many monuments left by Montuemhat, the fourth prophet of Amun, who held office in the late Twenty-fifth and early Twenty-sixth Dynasties. One of the most powerful men in Thebes, he saw the city fall to Assyrian troops, and subsequently negotiated the transfer of authority in the Theban area from the Twenty-fifth to Twenty-sixth Dynasty. Karnak. H. 134 cm. Twenty-fifth to Twenty-sixth Dynasty. Cairo, Egyptian Museum.

274 Grey schist statue of the goddess Isis protecting the god Osiris, dedicated by Shoshenq, the chief steward of the god's wife Ankhnesneferibra. Isis stands facing forwards, wearing the horns and sun disk supported on a circlet of *uraei*, with another *uraeus* on her brow. In front of her stands a smaller, mummiform figure of Osiris wearing the *atef*-crown, the top of which reaches only the bottom of Isis's breasts. Isis places her hands and wings on either side of Osiris's figure in a gesture of protection that is enhanced by the much larger size of the goddess. The figures are worked with the smooth, rounded modelling that is typical of the best sculpture of the Twenty-sixth Dynasty. Temple of Amun, Karnak. H. 81 cm. Twenty-sixth Dynasty. London, British Museum.

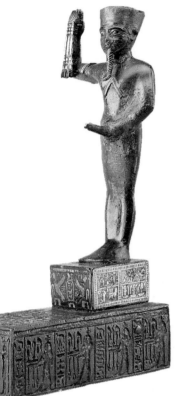

275 Statuette of Amun-Ra-Kamutef dedicated by Tjahorpakhepesh, an official of the god's wife Ankhnesneferibra. Thebes. Bronze with gold inlay, H. 22.3 cm. Twenty-sixth Dynasty. London, British Museum.

tion of small bronze statuettes of deities for this purpose was a fast growing phenomenon that continued in popularity into the Ptolemaic period.

Conclusion

The Twenty-fifth and Twenty-sixth Dynasties undoubtedly formed yet another high-spot in the long history of Egyptian creativity. The period wholeheartedly embraced the archaising trend begun at the end of the Third Intermediate Period. The stylistic developments of the New Kingdom were discarded and older models once more looked to for inspiration. However, these models were never copied exactly but were adapted to meet current religious and funerary needs and to conform to contemporary stylistic trends. The standards of artistic production for the king and the elite were extraordinarily high, as is most visibly demonstrated today by the incredible quality achieved in the hard stone statues that are so characteristic of the period.

Notes

1 Manuelian 1994.
2 Redford 1986a, 328–30; Leahy 1992, 238–9.
3 Bothmer 1960, Russmann 1989, 164; Manuelian 1983; 1985.
4 Robins 1994a, 256–7.
5 Robins 1985; 1994a, 160–81.
6 Manuelian 1983; 1994, 1–59.
7 Firth and Quibell 1935, pls 15–16; Robins 1994a, 169–70.
8 Porter and Moss 1981, 830.
9 Petrie 1909, 5–6.
10 Mogensen 1930, 95 (no. A703), pl. 102.
11 Porter and Moss 1981, 830.
12 Dunham 1950, tomb nos 15–18; Dunham 1955, tomb no.1; Török 1995, 208–9.
13 Book II, 169.
14 Hölscher 1954, 17–30; Leclant 1965, 154–60; Porter and Moss 1972, 476–80.
15 Fazzini 1988, 24, pl. 40; Leclant 1965, pls 83–5; Myśliwiec 1988, pl. 39.
16 Fazzini 1988, 22; Parker et al. 1979.
17 Porter and Moss 1972, 480–1.
18 E.g. Myśliwiec 1988, pls 28–30a.
19 Leclant 1965, 200–16.

20 Fazzini 1988, 15.
21 Leclant 1965, 56–8, 84–6, pls 31, 50–3.
22 Leclant 1965, 8–13, pl. 1; Lauffray 1979, 99–107.
23 Parker et al. 1979.
24 Hölscher 1939, 26–8, 33–6, 52–5.
25 Leclant 1965, 23–36, 41–54, 99–105, 110–13, pls 8–11, 17–28, 62–3, 68–70; Fazzini 1988, 20–1, pls 18–21; Myśliwiec 1988, pl. 65.
26 For the god's wife see Leclant 1965, 353–86; Gitton and Leclant 1977; Fazzini 1988; Graefe 1981.
27 Leclant 1965, 91–3, pls 56–60.
28 Gitton and Leclant 1977, 800.
29 Leclant 1965, 105–6, pl. 66.
30 Davies 1982.
31 Leahy 1992, 232–3.
32 Myśliwiec 1988, pls 30b–e, 32, 34–5.
33 E.g. Myśliwiec 1988, pl. 31c–d.
34 Robins 1993, 24; Troy 1986, 123–4.
35 Russmann 1974, 40.
36 Welsby 1996, fig. 7.
37 E.g. Myśliwiec 1988, pls 30b, 34.
38 E.g. Myśliwiec 1988, pl. 35b.
39 Leahy 1992, 238.
40 For the differences between individual kings see Myśliwiec 1988, 30–45.
41 Eigner 1984; el Sadeek 1984; Leahy 1988.
42 Eigner 1984; e.g. Assmann 1973; 1977; Bietak and Reiser–Haslauer 1978, 182; Kuhlmann and Schenkel 1983; Russmann 1994; 1995a.
43 Eigner 1984; Manuelian 1988.
44 Assmann 1977 (Mutirdis); Theban tomb 390, Porter and Moss 1960, 440–1 (Ireteru).
45 E.g. Fazzini et al. 1989, no.71.
46 Manuelian 1985.
47 Taylor 1989, 53–61, figs 43–50.
48 Taylor 1989, 56, fig. 42; Niwiński 1984, 449, 452.
49 Buhl 1959.
50 Quirke 1993, 20–1; Mosher 1992, 143, 170.
51 Munro 1973.
52 Munro 1973, 175–6.
53 Munro 1973, 176.
54 E.g. Bierbrier 1987, pl. 20.
55 E.g. Russmann 1994, 14 fig. 11.
56 Porter and Moss 1981, 670.
57 Cairo Museum CG 784, Saleh and Sourouzian 1987, no. 251.
58 Cairo Museum CG 38358 and 38884, Saleh and Sourouzian 1987, nos 252, 250.
59 Bothmer 1960, xxxvii.
60 E.g. Seipel 1992, no.154.
61 Bothmer 1960, xxxv–xxxvii.
62 Leclant 1961, 3–20. For other statues see ibid., 20–107, pls 3–33.
63 Russmann 1989, nos 77, 79, 81.
64 Graefe 1981, 219–21 (P20).
65 Graefe 1981, 224–7 (P24).

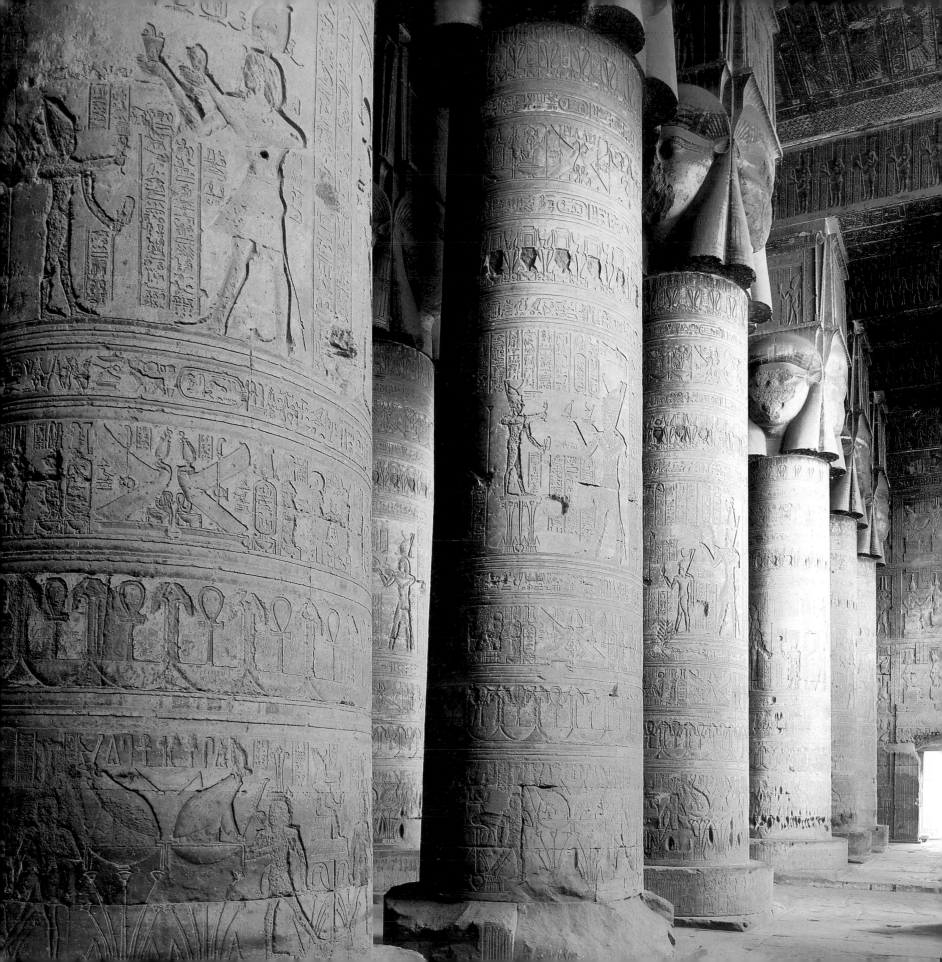

The final flowering

THE LATE PERIOD (II) AND THE PTOLEMAIC PERIOD

In 525 BC the Persian king Cambyses conquered Egypt and added it to his growing empire, so bringing the Twenty-sixth Dynasty to an end. Five Persian kings formed the ensuing Twenty-seventh Dynasty. Although within Egypt some of these rulers appear on monuments as traditional kings, there were frequent revolts against their authority, and the Persians were expelled from Egypt in 404 BC. For sixty years Egypt was again ruled by native kings, but the country's ability to maintain its independence was impaired by a succession of usurpations and short reigns. The Twenty-eighth Dynasty comprised only one king, who was overthrown after five years by the founder of the Twenty-ninth Dynasty, which lasted only twenty years. The last king of the dynasty, after less than a year on the throne, was deposed by Nectanebo I, who founded the Thirtieth Dynasty and ruled for nearly twenty years. His successor was swiftly replaced by Nectanebo II, who also ruled for almost twenty years, so that the Thirtieth Dynasty was a time of relative stability and prosperity.

In 343 BC the Persians reconquered Egypt. Their rule was so unpopular that when Alexander the Great entered the country with his armies in 332 BC, the Egyptians welcomed him as a deliverer. However, Alexander did not stay long, but left to pursue his conquests elsewhere until his death at Babylon in 323 BC. For nearly two decades Egypt acknowledged the Macedonian rulers Philip Arrhidaeus and Alexander IV. Authority in Egypt was held by Alexander's general, Ptolemy son of Lagus, who had rushed Alexander's body from Babylon to Memphis, where he buried it and claimed Egypt as his satrapy. Finally, in 304 BC, Ptolemy declared himself king.

His descendants ruled Egypt for more than two and a half centuries. They were shown on Egyptian monuments as traditional Egyptian kings, and they supported an extensive programme of temple building in fulfilment of that role. Nevertheless, the cultural and political interests of the Ptolemies were focused outside Egypt, and were dominated by their rivalries with the other Hellenistic kings amongst whom Alexander's empire had been divided. Although Egypt formed the Ptolemies' economic base, Egyptian culture and tradition in themselves were less important to the new dynasty. Alexandria, a newly founded Greek city, became the capital and Greek the official language, although Egyptian language and law continued to be used in governing the Egyptian population.

In 31 BC the last Ptolemaic ruler, Cleopatra VII, was defeated at the Battle of Actium and, in the following year, she committed suicide. Egypt fell to Octavian, the victor of Actium, who as Augustus became the first Roman emperor.

The king

The royal tomb

The burials of the kings of the Twenty-eighth to Thirtieth Dynasties are lost. Pieces from the funerary equipment of Nectanebo I and II are known (fig. 277),[1] but their tombs were destroyed in antiquity. Like all royal tombs from the Twenty-first Dynasty onwards, they were probably situated within a temple precinct. Those of the Thirtieth Dynasty kings may have been located in their home city of Sebennytos in the Delta, although it is possible that the tomb of Nectanebo II was situated within the precinct of the temple of Isis that he founded at nearby Behbeit el-Hagar. However, since he fled to Nubia after the Persian conquest in 343 BC, he was not buried in Egypt. The Ptolemies were interred at Alexandria around the tomb of Alexander,

276 Columns with Hathor head capitals in the first hypostyle hall of the temple of Hathor at Dendera. The hypostyle hall was built during the Ptolemaic period, but was not decorated until the Roman period, with the name of Nero appearing on the walls and that of Claudius on the columns. Nevertheless, the columns display the three fields into which temple decoration was divided. At the bottom are three registers of emblematic groups. A horizontal band of text divides them from the main area showing ritual interactions between the king and deities. This is separated by another band of text from further registers of emblematic figures at the top. Sandstone. Ptolemaic to Roman Period.

277 Sarcophagus of King Nectanebo II decorated with extracts from the *Amduat* under-world texts. The sarcophagus was never used by Nectanebo, as he fled to Nubia when the Persians invaded in 343 BC. It was found in Alexandria, where it had been employed as a ritual bath in a mosque, hence the holes in the side for draining the water. Green breccia, H. 118.5 cm. Thirtieth Dynasty. London, British Museum.

278 *right* Detail of a limestone door jamb from the Serapeum (the burial place of the Apis bulls) at Saqqara showing King Nectanebo II being embraced by the goddess Isis. The king wears the white crown and the goddess the horns and sun disk on a vulture headdress. The details of the vulture's plumage and the beaded collars of the two figures are meticulously incised into the stone. The individual curls of Isis's wig are drilled at the lower end to give them added volume. The two faces exhibit features that are frequently repeated in Thirtieth Dynasty and early Ptolemaic art: full cheeks, small half-smiling mouth, prominent, round chin and fleshy throat. Thirtieth Dynasty. Paris, Louvre.

279 *above* Detail of an intercolumnar screen wall showing King Nectanebo I offering a loaf of bread. The king wears the cap crown and kneels, bending forwards as he holds out the bread. The figure is cut with simple elegance in high-quality sunk relief. The interior surface is smooth, with little detailing but with subtle, rounded modelling, especially apparent in the face and stomach region. The tips of each finger are rendered separately, a trait that would last into the early Ptolemaic period. Although the expression is bland, the face is rendered distinctive by its large beak of a nose over a small mouth and jutting chin. Alexandria. Black basalt, H. 122 cm. Thirtieth Dynasty. London, British Museum.

whose body had been moved there from its original site in Memphis.[2] All these tombs are now lost, but presumably the burials were Hellenistic rather than Egyptian in style.

State temples

The kings of the Thirtieth Dynasty and their Ptolemaic successors presided over the last and greatest period of temple construction in ancient Egypt. The Thirtieth Dynasty programme ranged from sites in the Delta to the island of Philae at the southern border of Egypt (figs 278–9); most of what was built is now lost.[3] The Ptolemies followed in their footsteps, and the best-preserved Egyptian temples, at Dendera,[4] Edfu[5] and Philae (figs 280–1 and 304),[6] survive from this period. Following Egyptian tradition, additions and alterations were frequently made to existing temples, but at many sites new and bigger structures replaced older buildings, whose dismantled materials were re-used in the new temples (fig. 258).

280 The temples of Philae at Aswan, dating from the Thirtieth Dynasty to the Roman period. The original island on which the temples stood was submerged after the construction of the High Dam in the 1960s. The buildings were moved to a higher neighbouring island that was 'landscaped' to resemble the original one in shape. At Aswan the Nile runs through an area of granite, and the hard, rocky outcrops in the river, around and over which the water swirls and cascades, form the last of a series of cataracts that obstruct the river's course from south to north.

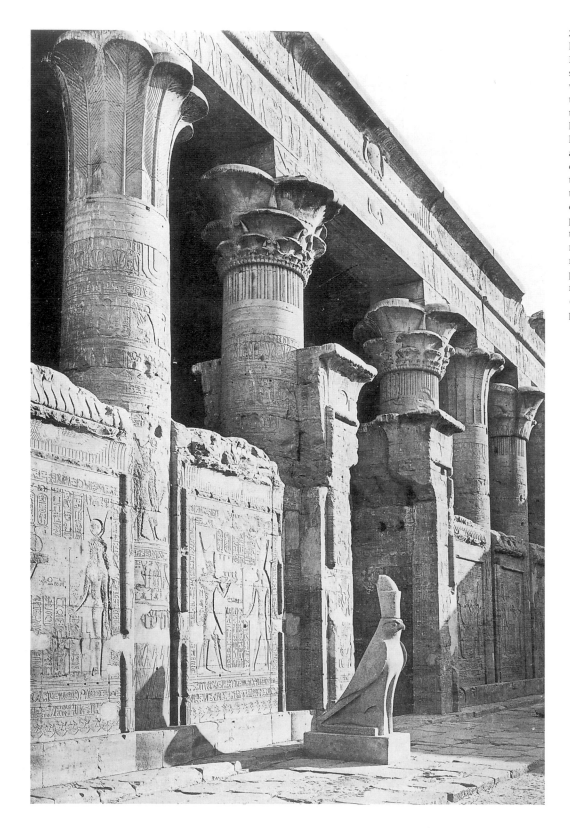

281 Façade of the first hypostyle hall in the temple of Horus at Edfu, showing the intercolumnar screen walls. These are decorated with scenes of the king offering to the deities of the temple. In the two nearest scenes the deities face left away from the entrance to the hypostyle hall, since they are always shown coming from the direction of the sanctuary, while the king is shown going towards the interior. On the opposite side of the doorway, in order to preserve their ritual orientation, the positions of the figures are reversed, so that the deities face right and the king left. The blocks paving the open court were re-used from earlier buildings (fig. 258). Sandstone. Ptolemaic period.

282 Plan of the temple of Horus at Edfu. Ptolemaic period. Like most ancient Egyptian temples, the plan is symmetrical around the long axis on which the sanctuary lies. Although it appears to offer open access from the entrance through the pylon straight through to the sanctuary, it must be remembered that there were doorways at the points of transition from one part of the temple to the next, and that these would have been closed by wooden or metal doors which no longer exist, thus denying entry to all except those specifically authorised to pass through.

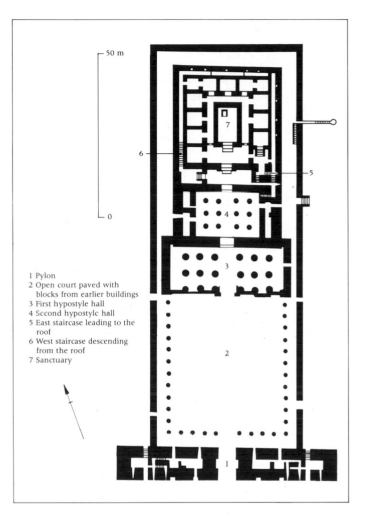

1 Pylon
2 Open court paved with blocks from earlier buildings
3 First hypostyle hall
4 Second hypostylc hall
5 East staircase leading to the roof
6 West staircase descending from the roof
7 Sanctuary

Although these temples were built and endowed with resources provided by foreign rulers, they were deeply traditional in form and remained almost entirely uninfluenced by Hellenistic theological ideas or artistic concepts. Their architecture descends directly from the great New Kingdom temples through the developments of the Late Period. The basic temple plan retains the entrance pylon, open court, hypostyle hall and darkly mysterious sanctuary on the central axis (fig. 282). The characteristic intercolumnar screen walls that form the façade of Ptolemaic hypostyle halls descend from the intercolumnar screen walls of the entrance porticos of the Twenty-fifth and Twenty-sixth Dynasties (fig. 281).

Temples continued to be regarded as models of the cosmos at the time of creation,[7] houses for the deity and ritual spaces where the king, or priests as his designated substitutes, interacted with deities.[8] It is unclear how far the non-Egyptian-speaking Ptolemies participated in temple ritual, but it is doubtful if they ever travelled to the great temples of Upper Egypt, even for the most important festivals.[9] The decoration continued the established tradition of showing the king performing the ritual and receiving legitimation from the deities (fig. 283), although the royal cartouches were sometimes left blank in periods of disorder, illustrating how the role of the king, rather than his identity, was what mattered for the temple.

Egypt under the Ptolemies is often considered a time of stagnating or dying tradition. Yet, for the elite Egyptians who shaped religious and philosophical thinking, the period was one of vital new developments. Traditional mythological and ritual texts were reworked and placed on temple walls where they had not been inscribed before. The hieroglyphic script was further developed, as new values were given to traditional signs, a large number of new signs were created, and visual puns and multiple readings were used to enrich the meaning of texts. Nevertheless, most literate Egyptians learned only the demotic script, and knowledge of hieroglyphs was restricted to a small, priestly group.

The decoration of Ptolemaic temples followed and developed earlier rules and practices.[10] Walls and columns were divided into three fields – the base area, the main area in the middle and the frieze at the top – and a different type of decoration was appropriate to each (fig. 276). The base area could contain symbolic marsh representations, fecundity figures and *nome* personifications bringing offerings into the temple, and groups of emblems representing deities. It was strongly marked off from the main area, often by a horizontal band of text. At the top of the wall the frieze comprised repeated emblematic groups or long rows of deities adored by a figure of the king. The small scale of these friezes set high above the ground meant that they were not clearly visible to human viewers. In between these two border areas lay the main field of decoration, which carried up to four, occasionally five, registers containing square or rectangular scenes. The number of scenes in a register depended on the width of the area being decorated, but within that area each register normally had the same number of scenes, aligned exactly above one another. These scenes showed the ritual acts performed by the king before deities, and the acts performed by deities for the king (figs 276, 283). The figures were on a larger scale than in the base or frieze areas, emphasising the primary position of these scenes in the hierarchy of decoration.

Although these scenes are firmly traditional in their subject matter, the inscriptions contained within them

283 Two scenes showing King Ptolemy VIII led by the goddesses Nekhbet and Wadjit to the god Sobek-Ra and receiving *sed*-festival symbols from the god Horus, above a lower register of fecundity figures. The two scenes demonstrate the typical layout of Ptolemaic temple scenes. Each scene is framed on either side by a single column of vertical text referring to the figure behind which it is placed, so that the scenes are separated from each other by two text columns. Within the scenes, inscriptions are ordered in vertical columns and horizontal rows contained within strongly delineated straight lines, and rectilinear spaces are left around the crowns of the various figures. The style of the figures shows the high relief and smooth, rounded modelling that is a continuation of the style developed in the Thirtieth Dynasty. As in all temple decoration, the scenes are given no background setting, and the interaction of the king and deities takes place outside the time and space of the mundane world. The fecundity figures, placed at the base of the temple wall, form the lowest field of decoration and have less status in the hierarchy of decoration than the scenes above. Temple of Kom Ombo. Ptolemaic Period.

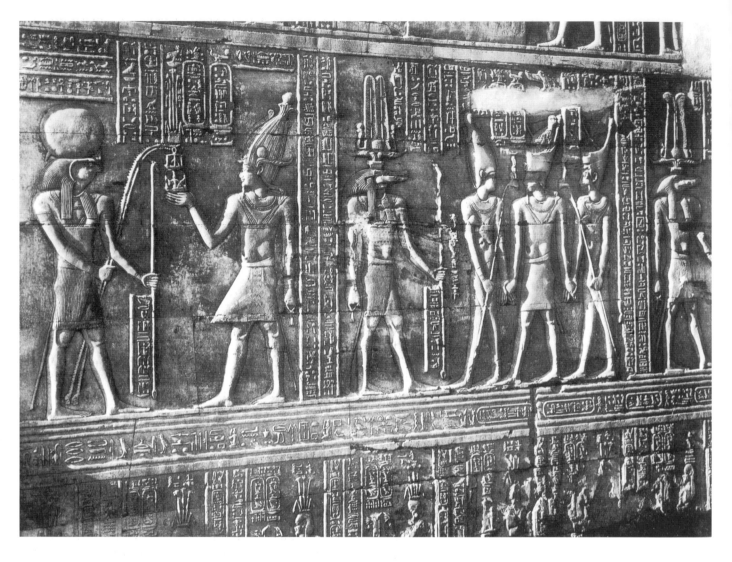

become longer than in earlier periods. The hieroglyphs are mostly ordered in vertical columns interspersed with some horizontal lines of text, so that at the tops of scenes the inscriptions leave clear, rectilinear spaces around the heads or crowns of figures (figs 281, 283), a layout that can already be found in the preceding Late Period. During the Ptolemaic period a scheme developed by which temple scenes were framed and separated from those on either side by vertical columns of inscriptions, one behind the figure of the king and the other behind the deity (fig. 283).[11] The layout and content of these framing inscriptions evolved by the reign of Ptolemy VIII into a scheme whereby the inscriptions of both deity and king, in addition to being linked to the content of the scene they framed, could also be read vertically down the wall across all the registers, each

column forming a complete composition. In this way, the columns running behind the royal figures give an elaborate version of the titulary of the king, whose universal presence in the scenes provides the unifying element in the scheme of decoration.

Analysis of the main scenes in the temples at Philae has shown that there were rules governing not only the use of royal and divine attributes but also types of offerings, who could receive them and where on the wall they could occur.[12] Lettuces, long associated with Min, were presented only to that god, and the scribal palette only to Thoth, the scribe of the gods. In most cases where the king offers a figure of Maat, the recipient is Amun, and where he performs acts of libation and censing it is before Osiris. The *wensheb* (an object associated with time), *menit*-counter-

poise and mirror are offered only to female deities, and myrrh, the *wedjat*-eye and the ritual of spearing enemies to male deities. Scenes depicting the king's purification, crowning and performance of foundation ceremonies are confined to the lowest register on the walls. Other scenes where the king censes or offers burnt foods, meats, eye paint or an endowment of fields never appear above the two lowest registers, whereas scenes relating to the sky are always higher than these registers. The offerings found in scenes on door lintels are limited in type and do not include those that are restricted to the lower registers of the walls. Thus the decoration of temple walls was laid out according to sets of interlocking rules that nevertheless allowed for considerable variation.

A number of monuments preserve squared grids, showing that these continued in use. They followed the later system in which standing figures comprised twenty-one squares to the upper eyelid or the root of the nose and seated figures seventeen, and controlled not only the proportions of figures but also the layout of complete scenes and registers.[13] In the reign of Ptolemy I a small chapel dedicated to Thoth was erected at Tuna el-Gebel, the necropolis settlement of the city of Hermopolis in Middle Egypt.[14] The walls were decorated with a series of scenes in a single register, each showing the king offering to a deity. Extensive grid traces show that a single grid ran the length of the walls and governed the layout of all the scenes. Each scene was separated from the next by an incised vertical line that runs midway between two grid verticals (fig. 284). At the top of every scene columns of hieroglyphs identify the king and the deity. The lower limit of these columns is formed by horizontal 24 above the baseline. The king's cartouches are two squares wide, with the vertical edges of the cartouche lying on vertical grid lines. Other columns of hieroglyphs are two squares wide, bounded by grid verticals and separated from each other by a full grid square down the middle of which an incised column marker runs. Within the scene there is usually a column of hieroglyphs in front of the deity's forward leg. This is bounded on one side by the deity's sceptre, which runs down a grid vertical, and on the other by a column marker, which coincides with a second vertical three squares away. Gods hold their *was*-sceptres exactly seven squares in front of their axial vertical, whereas goddesses hold their papyrus sceptres only six squares in front. The difference here lies in the fact that goddesses stand with their feet together and do not stride like male deities. The top of the papyrus sceptre lies on horizontal 21, whereas the top of the *was*-sceptre lies on horizontal 22 with the top of the shaft on horizontal 21. The

bottom of both sceptres lies on horizontal 1. The king and deities are shown wearing a variety of crowns of different heights in these scenes, but when they wear the double or red crown the top rises to horizontal 27 of the grid.

Forty-eight scenes on a gateway built in the reign of Ptolemy III in front of the temple of Khons at Karnak are more complex in their compositions, since they contain more figures, longer inscriptions and framing texts.[15] Although no grids survive, hypothetical grids can be calculated for each scene by dividing the distance on standing figures between the soles of the feet and the root of the nose by twenty-one. If this is done for all forty-eight scenes and the results analysed, certain consistent relationships between the compositions and the grid become apparent (fig. 285). Some, like the *was*-sceptre and papyrus sceptre, are similar to what is found in Ptolemy I's chapel, whereas others are different. For instance, the lower limit of the columns at the tops of the scenes is horizontal 23 rather than 24, the difference perhaps being due to the longer inscriptions. Although hieroglyph columns are still two squares wide, the column markers coincide with the verticals that form the edges of the columns instead of lying half a square to either side. This change would have had the advantage of allowing the inclusion of more text. Nevertheless in some scenes there was not quite sufficient room for all the text to be included if the columns were to be the full two squares wide. In these cases the widths of the columns were slightly narrower so as to enable, for instance, eight columns to fit into a width of fifteen, as against sixteen, squares, six columns to fit into ten squares rather than twelve, or two columns into three and not four squares (fig. 286). This manipulation of text was necessary because the width of each scene, which was determined by the width of the jambs and inner surfaces of the gate, could not be altered.

Relief of the Ptolemaic period developed an easily recognisable style, evolving from trends of the Thirtieth Dynasty that had themselves developed out of Twenty-sixth Dynasty work. There was thus no break between what had gone before and what was produced under the Ptolemies. The decoration of monuments followed the traditional principles of two-dimensional art, with its use of registers, baselines and composite human figures, without any attempt to render depth through perspectival devices such as foreshortening, as in the Hellenistic tradition. Figures further developed the rounded modelling of body and limbs already seen in the Thirtieth Dynasty (fig. 278), producing a rather heavy, fleshy effect, as can be seen, for instance, in the way female breasts swell out and overlap the upper arm (fig. 283).[16]

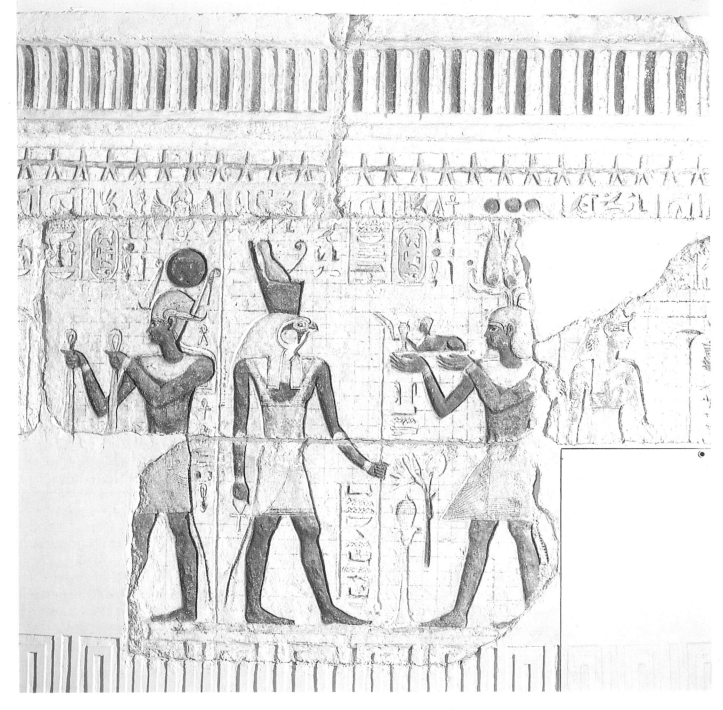

284 Painted limestone relief from the chapel of King Ptolemy I at Tuna el-Gebel, showing the king offering to Horus son of Isis. Most of the squared grid on which the scene was laid out can still be seen. The figures comprise twenty-one squares to the top of their eyes; horizontal 24 marks the bottom of the text columns, and the top of Horus's double crown reaches to horizontal 27. One side of Horus's *was*-sceptre runs down a vertical line and forms a column marker for the hieroglyphs placed in front of the god's legs. The second column marker runs down another vertical three squares away. H. of scene 96 cm. Hildesheim, Pelizaeus-Museum.

285 Facsimile drawing of a scene from the gateway of King Ptolemy III at Karnak showing the king offering a *menit*-necklace to the deities Rattawy and Horpakhered (Horus the Child). A hypothetical squared grid has been added to the drawing, calculated by dividing the height of the figures between the soles of the feet and the root of the nose by twenty-one, the number of squares on which standing figures were drawn at this period. The resulting grid yields axial verticals for the three figures that run exactly through the middle of the paired horns worn by all three. The sceptres of the deities and the column markers all lie on vertical lines. The columns of hieroglyphs are all two squares wide, Rattawy's sceptre is six squares in front of her axial vertical and Horpakhered's is seven squares in front of his. The difference of a square is because the god stands with one foot forward, whereas the goddess stands with her feet almost together. Ptolemaic period.

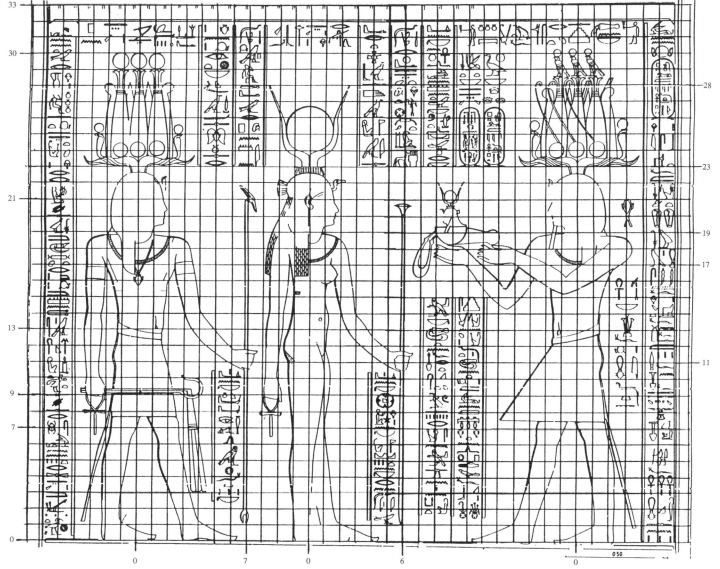

The temple year consisted both of a daily liturgy and of a cycle of festivals that re-enacted the mythology of the temple and its deities in ritual performances that moved through the temple's sacred space and other buildings within the temple precinct, and between different temples. One such festival celebrated the divine birth of the temple's principal deity, if male, or the birth of a young god to the principal deity, if female. It took place in a building adjacent to the main temple called a 'birth house', that was decorated with a series of scenes depicting the birth of the young god.[17] Although scenes relating to the divine birth of Horus were part of the decoration of the Twenty-second Dynasty Isis chapel at Karnak, the earliest surviving birth house was built by Nectanebo I at Dendera,[18] and the tradition lasted into the Roman period. The scenes, however, were an adaptation and reinterpretation of the cycle of scenes showing the divine birth of the king found in New Kingdom temples.[19] Yet, even though it was now the birth of the young god and not the king that was celebrated, the rituals also served to renew the king, since the king was identified with the god, and the young god's iconography was kingly.

At Edfu, the principal cult centre of Horus, the festivals celebrated the god's birth, accession to the kingship, his triumph over Seth,[20] and the renewal of royal power. A living falcon was chosen as the incarnation of Horus on earth, and the rituals centred on this bird together with the cult statue

286 Facsimile drawing of a scene from the gateway of
King Ptolemy III at Karnak showing the king burning
incense before the goddess Hathor. A hypothetical
squared grid has been added to the drawing, as in fig.
285. The grid yields axial verticals for the two figures that
pass through the middle of their paired horns, just as in
fig. 285. Similarly, Hathor's sceptre runs down a vertical,
six squares in front of her axial vertical. However, owing
to space restrictions, although some of the column
markers lie on verticals, others do not. At the top of the
scene the space available for the five columns of
inscription together with the king's cartouches is limited
by the forward horns on the crowns of the two figures to
twelve and a half squares. The king's cartouches normally
occupy three and a half squares, including a column
marker on one side but not on the other. Thus, if the
columns had been given the normal width of two
squares, the inscription together with the royal cartouches
would have occupied thirteen and a half squares.
Therefore, the width of the whole text had to be reduced
by one square, causing the draughtsman to narrow the
columns. Similar steps had to be taken with the
inscription between the two figures, since the space is
limited by Hathor's thumb and the king's kilt, so that four
columns of text had to be inserted into a width of only
seven squares. Ptolemaic period.

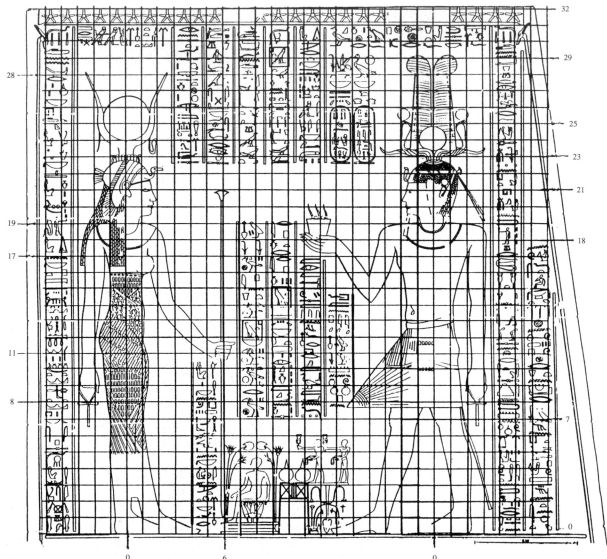

of Horus. Although the Ptolemaic kings did not participate,
the performance of the cult maintained the cosmic role of
kingship through the re-enactment of its mythology, thus
guaranteeing the continued existence of the ordered uni-
verse.[21]

The cult statues of a temple remained the focal point of
the ritual. At set times these images were carried in portable
shrines to the roof of the temple and exposed to the life-
giving rays of the sun in order to re-energise them, a ritual
that may well have gone back to the New Kingdom. The
performance of the rite was incorporated into the architec-
ture of some Ptolemaic temples, which included two stair-
ways leading to the roof: a winding one on the east side and
a straight one on the west. The statues were taken from the
sanctuary, processed up the east staircase and placed in an
open kiosk that stood on the roof. After the completion of
the ritual they were taken down the west staircase and
returned to the darkness of the sanctuary. Processions of
priests carrying the portable shrines containing the statues
decorate the walls of the staircase (fig. 287).[22]

Among such cult statues were images of the king and
his predecessors. Part of the decree preserved on the
famous Rosetta Stone is concerned with establishing the
cult of the ruling king, Ptolemy V. It gives us a glimpse not
only of the royal cult but of temple cult in general. 'It was
resolved ... to set up in the most prominent place of every
temple an image of the EVER-LIVING King PTOLEMY, THE
BELOVED OF PTAH, THE GOD EPIPHANES EUCHARIS-

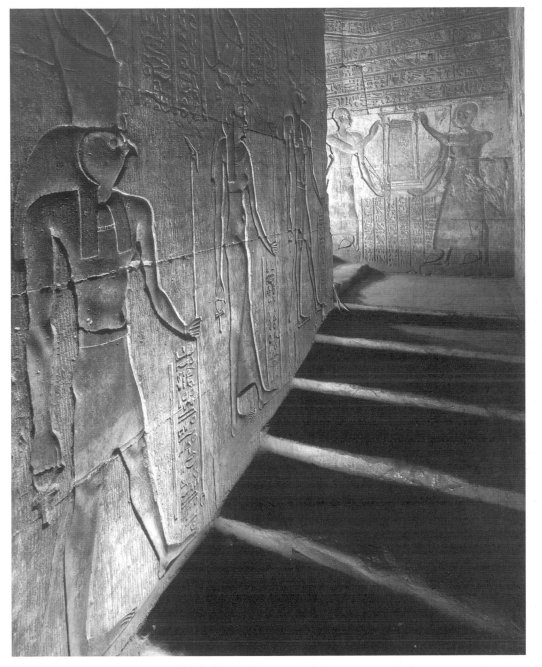

TOS beside which shall stand the principal god of the temple, handing him the weapon of victory, all of which shall be manufactured (in the Egyptian) fashion; and that the priests shall pay homage to the images three times a day, and put upon them the sacred garments, and perform the other usual honours such as are given to the other gods in the Egyptian festivals; and to establish for King PTOLEMY ... a statue and golden shrine in each of the temples, and to set it up in the inner chamber with the other shrines; and in the great festivals in which the shrines are carried in procession the shrine of the GOD EPIPHANES EUCHARISTOS shall be carried in procession with them.'[23]

The elite

Temples remained the primary places for the setting-up of statues by the elite, enabling their owners to remain for ever in the presence of the temple's deities, to participate in their rituals and to receive a share of their offerings.[24] The statues also preserved the owners' names and images after death, so that they were remembered in this world and continued to exist in the next. However, the owners identified themselves mainly by priestly titles relating to the temple and its deities, rather than by secular offices held outside the temple. Traditional standing, kneeling and block statues were still made; seated ones were abandoned, but later revived during the Roman period.[25] Ptolemaic block statues tend to be taller in relation to their width and depth than earlier examples, giving them an elongated appearance (fig. 288). Statues of women occur once more after a long hiatus, although they remain less common than those of men.[26] They maintain the idealised, youthful appearance of traditional female images (fig. 289). Statues of men can be divided into

287 Part of the east staircase leading to the roof in the temple of Horus at Edfu. The relief decoration shows, on the left, a procession of deities ascending the stairs, and, ahead, two priests carrying a portable shrine containing a cult statue. The decoration refers to the ritual of carrying the cult statues of the temple up on to the roof in order to expose them to the life-giving rays of the sun. After the ritual they were brought back down by another staircase on the west side of the temple. Sandstone. Ptolemaic period.

288 Block statue of Wahibra, priest of Amun at Karnak. On the front of the statue a scene shows Wahibra adoring a figure of the god Osiris. Like all statues of the period, this one would have been set up in a temple, where it would have received offerings and served as a funerary statue for Wahibra after he was dead. The image has a bland, idealising face with full cheeks and a half smile that is typical of the period but contrasts with other, contemporary statues with non-idealising features (fig. 292). Karnak. Black basalt, H. 34 cm. Ptolemaic period. The Harer Family Trust.

241

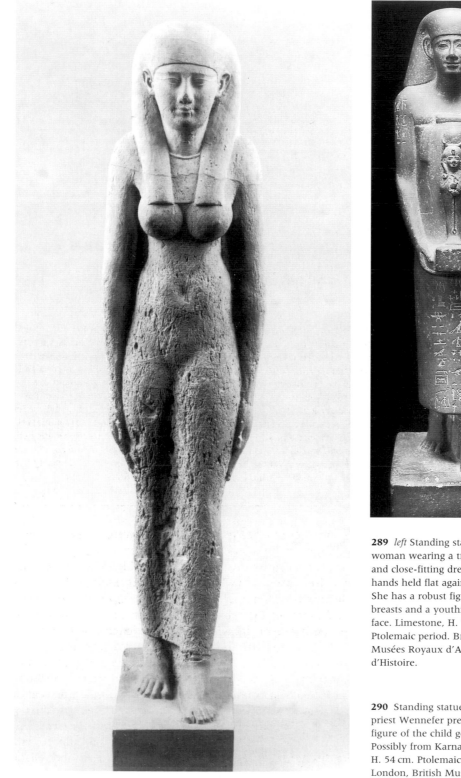

289 *left* Standing statue of a woman wearing a tripartite wig and close-fitting dress, with her hands held flat against her thighs. She has a robust figure with full breasts and a youthful, idealised face. Limestone, H. 78.3 cm. Ptolemaic period. Brussels, Musées Royaux d'Art et d'Histoire.

290 Standing statue of the *wab*-priest Wennefer presenting a figure of the child god Khons. Possibly from Karnak. Basalt, H. 54 cm. Ptolemaic period. London, British Museum.

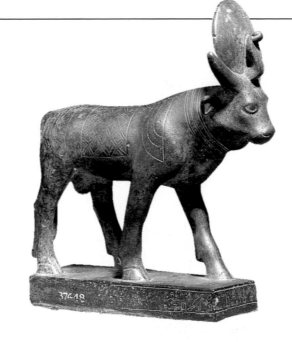

291 Bronze statuette of the Apis bull, the earthly manifestation of the god Ptah of Memphis. There was only ever one Apis bull at a time, set apart from other animals by its special set of markings. On the death of one Apis, these markings enabled the bull calf that embodied the next Apis to be identified in a search that encompassed the whole country. Most surviving bronzes representing the Apis bull display very similar stylised versions of these markings. A triangular blaze is shown on the forehead and a winged sun disk, scarab or vulture on the withers and hindquarters, with the wings spreading over the flanks of the animal. In addition, there is a collar round the neck and a patterned blanket spread over the back. Although not obvious from the bronzes, we know from other representations that the bull was black and white in colour, and presumably it was the interplay between the patches of these two colours that formed the desired markings. The bronzes also usually show the bull with a sun disk and uraeus between its horns to signify the divine aspect of the animal. The Apis was kept in its own sanctuary near the temple of Ptah at Memphis and, from the New Kingdom until the Ptolemaic Period, the bulls were buried in special catacombs at Saqqara. Although the cult of the Apis bull goes back to early times, it achieved great popularity in the Late and Ptolemaic Periods, judging by the enormous number of votive bronzes that represent the animal. Probably from Lower Egypt. H. 18 cm. London, British Museum.

those that are idealising (fig. 290) and those that have often been regarded as 'realistic', since they show lines and wrinkles on the face (fig. 292). It has been suggested by some scholars that the latter were Hellenistic rather than Egyptian in concept, even though male images with non-idealising features had a long tradition in ancient Egyptian art (figs 129, 273). Such images are not, however, individual portraits, a notion that was not of importance to the ancient Egyptians,[27] but should instead be regarded as relating to the traditional mature image given to male officials but not to women. That the statues of the Ptolemaic period remain within the Egyptian tradition is shown by their poses and by the universal use of the back pillar, a standard Egyptian feature, but not a Hellenistic one.

The Late Period custom of presenting small votive statues, often of bronze, at temples and shrines continued. Many were images of the deities of the temple, but others took the form of sacred animals (fig. 291). Throughout the first millennium there was an increasing emphasis on the animals associated with various deities. Some, like the Apis or Mnevis bulls, had only one representative at a time, who was unique in his generation. In other cases, the association extended to whole species, such as falcons, sacred to Horus, ibises to Thoth and cats to Bastet. Some of these votive images are of extremely high quality, whereas others were mass-produced for visitors who came to the temple and wanted to make a dedication.

Horus stelae, which first appeared in the late New Kingdom and Third Intermediate Period, became increasingly common from the fourth century into the Ptolemaic period.[28] They consisted of an image of the Horus child standing on crocodiles, with other dangerous animals held

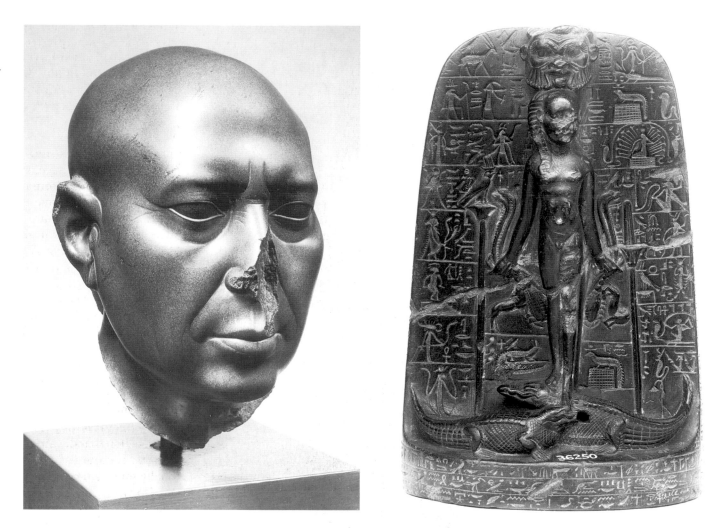

292 Green schist head from the statue of a man, showing non-idealising features with vertical lines above the bridge of the nose, lines at the corners of the eyes and between the nose and the mouth. Statues such as this one were once thought to be realistic images in the tradition of Hellenistic rather than Egyptian art. However, the use of a back pillar links them firmly to Egyptian traditions, and they should be compared with earlier non-idealising male images that were meant to represent the mature official. H. 21.5 cm. Ptolemaic period. Berlin, Ägyptisches Museum.

in his grasp, together with protective images and texts (fig. 293). Their function was to ward off attacks from harmful creatures, and to cure snake bites and scorpion stings. They derived their potency from the myth of Horus's childhood in the marshes of Khemmis, when he was saved from a scorpion and given power over all dangerous animals. Some stelae were set up in temple precincts where sufferers could have access to them. They were activated by pouring water or some other liquid over the object to absorb the power of the image and texts, which could then be transferred to those who needed healing through drinking the liquid or having it poured over them. Similar stelae have been found in houses, and also in burials, where they presumably helped protect the deceased from some of the dangers of the underworld.

Magical statues inscribed with spells and sometimes incorporating a Horus stela (fig. 294) also became popular

293 Horus stela (*cippus*) depicting the young god Horus the Child (Horpakhered), shown nude with a sidelock, trampling on two crocodiles and grasping snakes, scorpions and lions in his hands, so as to display his power over them and their inability to hurt him. Above his head is a mask of the protective god Bes, while other protective and beneficial images are arranged around his central figure. Stelae like this one were intended both to prevent attacks by harmful creatures and to cure the victims of snake bites and scorpion stings. H. 21 cm. Thirtieth Dynasty to Ptolemaic period. London, British Museum.

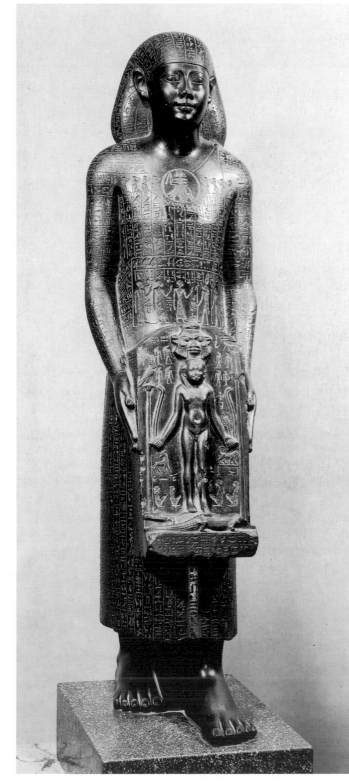

294 Black basalt statue of a man holding a Horus stela. The statue is inscribed all over with texts that promise healing in return for offerings or prayers on behalf of the owner. The smooth plastic working of the hard basalt and the bland idealised features are typical of many sculptures of the fourth century BC. H. 67.7 cm. Thirtieth Dynasty to early Ptolemaic period. Paris, Louvre.

in the fourth century BC as a means of healing.[29] The donor, whom the statue represented, was named as in a typical temple statue, but the inscriptions offered healing in return for prayers or offerings. Thus the owner not only gained merit for helping people but also hoped to attract attention and offerings long after his death.

Burials

In the fourth century some burials of the upper elite continued to include a chapel as part of the funerary structure. A number of reliefs from decorated doorways, most frequently the lintels, have survived from Lower Egyptian tombs.[30] Three themes are prominent: the deceased male owner seated before a procession of offering-bearers (figs 295–6), a theme ultimately going back to the Old Kingdom; a group of musicians, usually a seated male harpist and several women, playing in front of a seated figure of the deceased; and activities in the marshes.

The format of these limestone lintels is similar, with the deceased usually seated at the left end, facing the activity that is spread in a single register across the rest of the stone. The Thirtieth Dynasty looked back to the Twenty-sixth Dynasty in both art and writing, probably as a deliberate reaction to the foreign rule of the Persians, and these reliefs draw on the tradition of tomb chapel decoration established in Lower Egypt during the Twenty-sixth Dynasty.[31] Figures are modelled roundly and smoothly, without musculature, with the contours of the body subtly shaped. The chin is usually small and round and the throat fleshy, features that are also typical of the reliefs of Nectanebo II and the early Ptolemies (fig. 278). Both male and female genital regions are often revealed on secondary figures. Many figures show the reversed leg posture, by which the forward leg is the near instead of the far leg, a phenomenon that had become common in the Twenty-sixth Dynasty. Stylistic differences arise from variations in the spacing of the figures against the background. In some of the reliefs the figures are well separated from one another, each surrounded by its own space (fig. 295). In others they crowd together and any intervening space is filled with offerings, so that the background is reduced to a minimum (fig. 296).

Funerary stelae remained part of the burial equipment throughout this period. At Thebes brightly painted wooden stelae were still in vogue.[32] Well-preserved examples show that the stelae stood on two small supports, and often had a small, wooden figure of the deceased as a *ba* or spirit in the form of a human-headed bird placed on the top (fig. 297).[33] They were thus free-standing rather than set into a niche or wall. The surface of the stela was divided most frequently

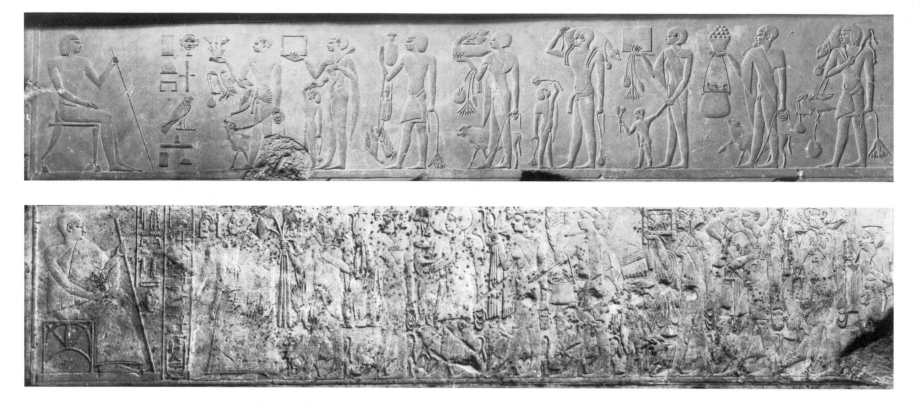

295 *top* Lintel of Horhotep from his tomb chapel at Buto, showing Horhotep seated on the left facing a line of offering-bearers. Horhotep is represented by a simply dressed, archaising figure wearing a round wig and knee-length kilt that looks back ultimately to Old Kingdom models. The offering-bearers are spread out over the surface, with each individual separated from the next by an area of background. The figures are modelled in a smooth, rounded relief. Limestone, H. 29.6 cm. Thirtieth Dynasty. Cairo, Egyptian Museum.

296 Limestone lintel from the tomb chapel of Tjanefer, showing Tjanefer seated on the left facing a line of offering-bearers, in the same basic scene type as in fig. 295. The style, however, is quite different. Tjanefer is wearing the voluminous, enveloping garments of contemporary fashion in contrast to the archaising figure of Horhotep, and the offering-bearers, one on top of the other, crowd out the background surface. The figures are roundly modelled and display the concave noses, small mouths, round chins and fleshy throats of the period. Heliopolis. H. 30.5 cm. Cairo, Egyptian Museum.

into three or four fields. The top one (the lunette) contained a winged sun disk, usually arching over two figures of the Anubis jackal and two cobras representing Nekhbet and Wadjit, and the bottom one horizontal lines of text, often an offering formula. In between, the male or female owner adores a row of funerary deities. Frequently another register is added immediately below the lunette, in which the deceased adores the sun boat whose perpetual cycle guarantees survival after death. Because the stelae were free-standing, some were also decorated on the back with an image of the sun at the top, with its rays spreading below between two standards representing the east and the west, another reference to the daily course of the sun.[34]

At other sites stone stelae predominate.[35] The most common formula was to show a winged sun disk at the top, below which the deceased adores a row of standing deities above a text arranged in horizontal lines. A stela from Saqqara belonging to a woman called Taimhotep, who was the wife of the high priest of Ptah at Memphis, dates to year 10 of Cleopatra VII. It is worked in high-quality sunk relief and shows Taimhotep on the right, facing left, before the funerary deities Osiris, Apis, Isis, Nephthys and Anubis (fig. 298). Traces of an incised grid remain on the background where it was not completely smoothed away. The figures

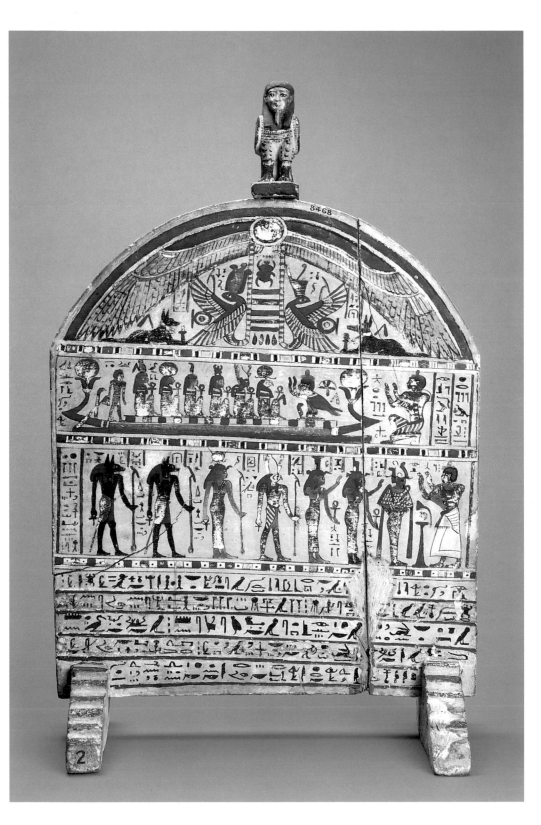

exhibit a great deal of detail and modelling for their small size, and an extraordinary feature of the female figures is the depiction of both breasts. One breast lies in profile on the front line of the body, and the other, also in profile, is placed on the expanse of the chest. The same phenomenon is found on the stela of Taimhotep's husband,[36] but is not known from elsewhere. Below the scene an inscription arranged in twenty-one lines contains an offering formula and biographical text.[37]

Although the stela of Taimhotep belongs to the end of the Ptolemaic period, it is entirely Egyptian in form and subject matter. Some monuments, however, show a mixture of Egyptian and Hellenistic styles that usually, to our eyes at least, appears rather unsuccessful. The most famous is the family tomb belonging to the high priest of Thoth Petosiris. Situated at Tuna el-Gebel, the cemetery of Hermopolis in Middle Egypt, it probably dates to the reign of Philip Arrhidaeus. Most of the Hellenising scenes are confined to the outer room of the chapel and for their subject matter revive the tradition of 'daily life' scenes (fig. 299). In the inner, more sacred, room, only the lowest and least important registers containing offering-bringers are not Egyptian in style. The style of the rest of the decoration, which is concerned with the rites before the tomb, the afterlife and the deceased with various deities, is firmly traditional. Thus, although the two different styles are used within one monument, they are hierarchically ranked, with the more important decoration being executed in a purely Egyptian style.

Images of Isis and Nephthys, the goddesses who mourned the murdered Osiris and brought him back to life, had long been common on funerary equipment, for they promised that the deceased, identified with Osiris, would also achieve new life. Free-standing statues of the goddesses had begun to be placed in burials in the Second Intermediate Period, and finely crafted wooden standing statues date to the New Kingdom and Third Intermediate

297 Free-standing funerary stela of Neswy mounted on two stepped supports with an image of the deceased as a *ba*-bird perched at the top. On the surface of the stela a winged sun disk arches over a scarab beetle placed immediately below the disk to represent the rising sun. Two winged *uraei* identified as the goddesses Nekhbet and Wadjit hang from the disk, and on either side two jackals represent the god Anubis. In the register below, Neswy kneels on the right facing the sun boat, in which six solar deities sit. Neswy's *ba* stands at the front of the boat facing the deities, with arms raised in adoration. In the next register Neswy stands adoring a row of underworld deities: Osiris, Isis, Nephthys, Horus son of Isis, Hathor, Anubis and Wepwawet. Thebes. Painted sycomore fig wood, H. 53.5 cm. Ptolemaic period. London, British Museum.

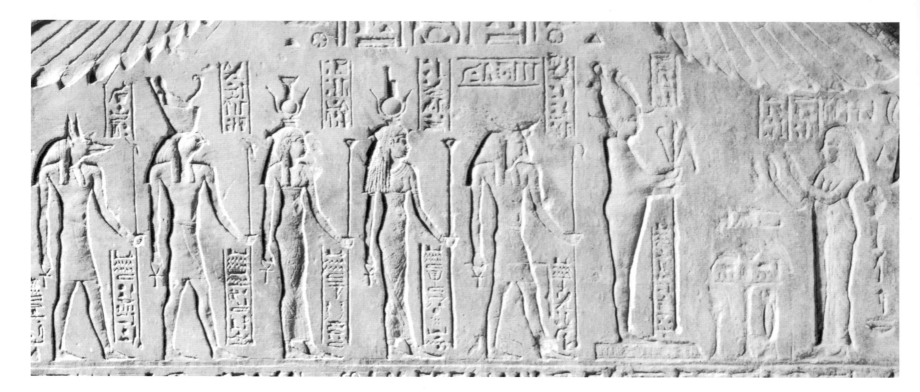

298 Detail from a limestone funerary stela from Saqqara dated to year 10 of Cleopatra VII, belonging to Taimhotep, wife of Psherenptah, the high priest of Ptah at Memphis. Ptolemaic period. London, British Museum.

299 Detail from a scene showing labourers picking grapes for wine-making, in the outer room of the tomb chapel of Petosiris, the high priest of Thoth, at Tuna el-Gebel. The subject belongs to the ancient Egyptian tradition of so-called everyday life scenes, but the style is heavily influenced by Hellenistic art, as can be seen here in the faces, clothing and, above all, the treatment of the nude figure. Tuna el-Gebel. Macedonian period.

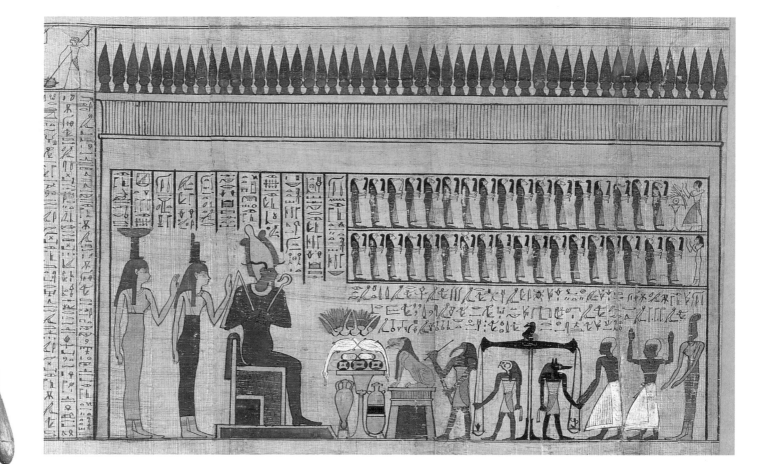

300 *left* Painted and plastered wooden figure of the goddess Nephthys inscribed for the priest Irthorereru. The goddess is identified by the hieroglyphic form of her name worn on her head. She is shown kneeling with her breasts bared and her hands, palms turned back, in front of her face in the attitude of mourning. The image would have been paired with a similar one of the goddess Isis and placed in Irthorereru's burial chamber near the coffin. The presence of the two mourning goddesses helped identify the deceased with the god Osiris, in whose resurrection he hoped to share. H. 59 cm. Ptolemaic period. London, British Museum.

301 Part of the *Book of the Dead* belonging to the scribe of the oracle Hor, showing the weighing of the deceased's heart before the deities Osiris, Isis and Nephthys. At the top, two registers show Hor above and his wife below adoring thirty-five mummiform figures, each holding a feather representing *maat*. These are the assessors of the dead, who normally number forty-two. The goddess Maat appears below as a female figure with a feather in place of her head. In front of her Hor raises his arms in triumph. A second figure of Hor is led by the god Anubis to the balance, on the other side of which Thoth, scribe of the gods, stands with brush and palette to record the result and announce it to Osiris. The creature squatting on the shrine in front is the monster who waits to devour the hearts that fail the test. The faces of Isis and Nephthys exhibit the concave nose, round chin and fleshy throat of the Thirtieth Dynasty and early Ptolemaic period. While their figures and that of Maat are on the whole slender, all three exhibit the full breasts, here overlapping the upper arm, that are characteristic of Ptolemaic female figures. Akhmim. Paint on papyrus, H. 42.8 cm. Ptolemaic period. London, British Museum.

302 Wrapped mummy with cartonnage trappings consisting of five pieces covering the head, chest, abdomen, legs and feet. The decoration uses traditional funerary motifs relating to the solar cycle and to the underworld: the winged scarab pushing the sun disk; the sky goddess with the sun disk on her head; the four sons of Horus; the goddesses Isis and Nephthys mourning the deceased, who lies on a lion embalming-bed; mummiform figures representing denizens of the underworld; and the paired jackals of Anubis. The elaborate floral collar with falcon-head terminals incorporates the image of the lotus flower. At its centre hangs a pectoral in the form of a shrine enclosing the image of the sun disk on the horizon, invoking the perpetual rhythm of the rising and setting sun, whose unending journey the deceased hopes to join. Paint on layers of plastered linen (cartonnage), H. 170 cm. Ptolemaic period. Atlanta, Michael C. Carlos Museum, Emory University.

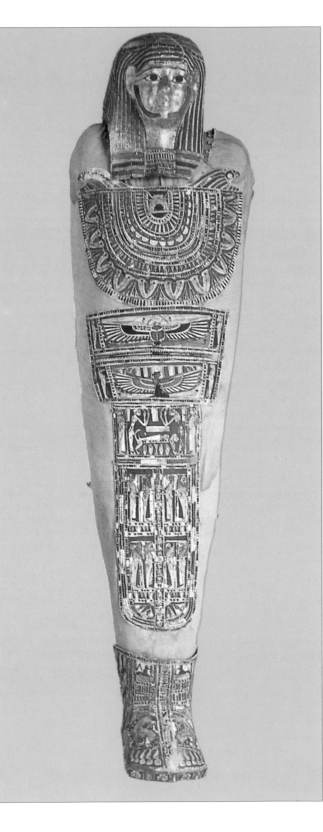

Period.[38] In the Late and Ptolemaic periods brightly painted wooden figures of these goddesses kneel rather than stand, with one or both hands raised with the palm turned towards the face in the gesture of mourning (fig. 300).[39] Their role as mourners is also marked by their bare breasts. The goddesses are identified in the traditional manner by wearing the hieroglyphs that form their names on their heads.

The number of surviving *Books of the Dead* increases from the middle of the fourth century on.[40] Although most are from Thebes, others come from Memphis. They all share a common tradition going back to the revised version of the Twenty-sixth Dynasty, but local features had evolved in the layout of the documents and in some of the vignettes and the sequences of spells. Further revisions took place in the early third century. Uncoloured vignettes were usual during the fourth and third centuries, but later colour was reintroduced (fig. 301). As well as being written on papyrus, *Books of the Dead* were inscribed on linen shrouds and mummy bandages.[41] By the late Ptolemaic period comprehension of the *Book of the Dead* began to break down. Texts are often so badly written that they are unintelligible, and it would seem that the scribes no longer understood what they were copying.

Large stone anthropoid sarcophagi continued to be used by the wealthy into the late Ptolemaic period.[42] In addition, one or two wooden coffins might enclose the mummy.[43] The more costly were made from imported wood, while cheaper ones used less prestigious local timber. The inner cartonnage sheath that had been introduced in the Third Intermediate Period gave way to a new arrangement, probably dating back to the Twenty-sixth Dynasty but becoming common from the early Ptolemaic period on.[44] The mummified body, wrapped in a linen shroud, was decorated with four to six separate pieces of cartonnage covering the head, chest, lower ribcage, stomach, legs and feet.[45] The head piece, resembling the traditional funerary mask, was placed over the head, and the foot piece over the feet. The other pieces were flat. They were stitched to the shroud and covered the front of the body only. Examples are known where the place for the name of the deceased is left blank or filled in with dots, showing that they were acquired ready-made rather than being commissioned for a particular individual.[46] The sets of individual pieces would have been easier and cheaper for workshops to turn out than the full cartonnage sheath, and this may have been one reason for the change.

The decoration of the cartonnage pieces draws on traditional funerary motifs (fig. 302). The mask is usually given

a version of the divine three-part wig to mark the transformation of the deceased into a divine being. The face is often gilded to show the same transformation, since gold was the flesh of deities and also associated with the sun god, the guarantor of life after death. Across the top of the head a winged scarab beetle is shown pushing the sun disk in its perpetual cycle. The piece covering the chest consists of the elaborate collar with falcon-head terminals that had been a part of coffin decoration for well over a millennium. The motifs found on the coverings of the lower ribcage, stomach and legs are more variable. They include a winged scarab, the kneeling figure of the sky goddess with her wings outstretched in protection, the mummy of the deceased lying on a lion bed, mourned by Isis and Nephthys, the four sons of Horus and mummiform figures with different heads that represent denizens of the underworld and perhaps ultimately derive from forms of the sun god in the *Litany of Ra*. The foot covering may be painted with images of the two feet of the deceased, or with more funerary motifs, including recumbent figures of Anubis as on the foot of a coffin. Instead of a realistic image of feet, the toes may be represented by five *uraei* with sun disks on their heads to signify the nails. On the underside of the foot covering, beneath the feet of the mummy, is normally painted a pair of sandal soles. Many examples are decorated with simple chequer designs, but others display images of bound prisoners. These latter perhaps relate to similarly decorated sandals worn in life by the king, who thus literally trampled his enemies, representing chaos, under his feet as he walked.[47] When transferred to the dead the bound prisoners stand for the enemies of the sun god and the chaotic forces of death that the deceased must overcome in order to pass into the afterlife.[48]

Conclusion

Although ancient Egypt, during the final stages of its history, fell again under foreign rule and the Ptolemies were ethnically non-Egyptian, for the most part architecture, the images employed in its decoration and the ways of treating them remained essentially Egyptian. Many of the features that characterise Ptolemaic art have their origins in the Late Period, including the high, smoothly rounded and heavily modelled relief style, sometimes attributed to Greek influence. However, despite the influence of Hellenistic art on some monuments, such as the tomb chapel of Petosiris, it would be incorrect to ascribe the major artistic developments of the Ptolemaic period to outside factors. Monuments of traditional Egyptian type resisted external influences even into the Roman period, although works of art made for the non-Egyptian population naturally employed Hellenistic styles. It was not until the adoption of Christianity as the official religion of Egypt that traditional artistic styles gave way to those of the outside world.

Notes

1 De Meulenaere 1982a, 451; 1982b, 452.
2 Fraser 1972, 15–16.
3 Myśliwiec 1988, pls 79–84, 87–92.
4 Cauville 1990.
5 Cauville 1984.
6 Junker 1958; Junker and Winter 1965; Vassilika 1989.
7 Baines 1976; Finnestad 1985.
8 Goyon 1988.
9 Baines 1995a, 41–2, 43–4.
10 Baines 1976.
11 Winter 1968.
12 Vassilika 1989, 83–123, 204–7.
13 Robins 1994a, 161–81, 187–91, 197, 200, 204–7, 208, 209–11, 257–8.
14 Derchain 1961.
15 Clère 1961.
16 For stylistic developments in the treatment of the human figure at Philae see Vassilika 1989, 125–54, 207–9.
17 Daumas 1977.
18 But see Fazzini and Peck 1981, 122–6.
19 Brunner 1964.
20 Fairman 1974.
21 Goyon 1988.
22 Goyon 1988.
23 Andrews 1981, 27.
24 Baines 1995a, 40.
25 Bothmer 1960, xxxv–xxxvi.
26 Bothmer 1960, xxxvii.
27 Spanel 1988; Bianchi 1988, 55–9.
28 Kákosy 1980; Hodjash and Berlev, 1982, 244–74.
29 Russmann 1989, no.89.
30 Leahy 1988. For examples of jambs see Vassilika 1995, 118–19 no. 55; Fazzini *et al.* 1989, no.78.
31 Leahy 1988.
32 Munro 1973; Bierbrier 1987.
33 E.g. Bierbrier 1987, pls 70, 74, 82, 92.2.
34 E.g. Bierbrier 1987, pls 72, 76, 90.2, 91.3.
35 Munro 1973.
36 Munro 1973, pl. 63.
37 Lichtheim 1980, 59–65.
38 Fischer 1976, 42–3; Seipel 1989, no.124.
39 Seipel 1989, nos 121–3; Bietak and Reiser-Haslauer 1982, 185 fig. 81, 193–5 no.561, fig. 86 (for confirmation of the Ptolemaic date of this burial, see Bierbrier 1987, 38).
40 Mosher 1992; Quirke 1993.
41 De Caluwe 1991.
42 Buhl 1959.
43 Saleh and Sourouzian 1987, no.260.
44 Niwiński 1984, 458.
45 Scott 1986, 160–1; D'Auria *et al.* 1988, 193–5.
46 Peet 1914, 92.
47 Reeves 1990b, 155.
48 Simpson 1973; Corcoran 1995a, 53–5; Corcoran 1995b, 3321–2, fig. 3.

Epilogue

In the foreword to this book I stated that one of my major aims was to explore the reasons why art was so important to the ancient Egyptians. We have seen that its significance related mainly to the king and the elite. It both embodied the notion of kingship, central to state ideology, and underpinned the privileged position of the elite through whom the king governed. The king and the elite were both the patrons and the audience in a self-sustaining system that reinforced and justified the established social order. Most of the population had no part in the system, but they cannot have been unaware of the great monuments that were part of the landscape, even though these were mostly shut away within high enclosure walls. Although excluded from entry, the non-elite must have received an unmistakable message concerning the power of the state.

In addition to its socio-political role, art also incorporated and reinforced the social structure of the elite group. In most periods the higher an official was in the bureaucracy, and so closer to the king who was the primary controller of resources, the more likely he was to have access to the royal workshops and the services of the best artists to make his monuments. Thus aesthetic quality embodied and displayed status to all knowledgeable viewers. Only men, however, gained their status from bureaucratic office. Women could not hold office and benefit from its privileges, so that their status accrued mainly from that of their parents or their husbands. The male monopoly of office is reflected in the art through the far greater number of monuments owned by men than women, and through the gender hierarchy that privileged husbands over wives by generally giving them the primary position in both two- and three-dimensional compositions. Nevertheless, the frequent inclusion of wives, mothers and other female relatives on the monuments of men suggests they had a salient role within society. The nature of their contribution is indicated by the idealised female image used to depict women of all ages. As well as embodying an aesthetic concept of feminine beauty, the youthful image that frequently reveals the form of the body stresses the role of women as potential child-bearers, on whom the continuity of the family and society depended.

The ancient Egyptian world encompassed far more than just human society, and art helped the living express their relationship to both deities and the dead, who were thus included among the intended audience. Temples and tombs were microcosms that reflected the ordered universe which it was the king's duty to maintain. The architecture and decoration of both exhibited and enhanced their functions. Temples formed places where deities, manifest in their cult statues, and humanity, represented by the king or by priests as his representatives, met and interacted through ritual performances, the aim of which was to persuade the deities to maintain the existence and order of the created world. In a broader context, temple complexes provided settings for the great festivals and their processions, in which a wider audience could participate. Tomb chapels were meeting places with the dead, and they provided a setting for the enactment of the funerary cult, during which the dead could manifest themselves in their statues and other images in the chapel. The decoration of the chapel and much of the funerary equipment was designed to ensure that the deceased was fully equipped for the next life and had a safe passage there. Visits to the necropolis by the living, including those made during the annual Festival of the Wadi at Thebes, also had

303 Part of the *Book of the Dead* of the high official Hunefer, showing Osiris enthroned, with Isis and Nephthys standing behind him and the four sons of Horus on a lotus blossom. Possibly from Memphis, Nineteenth Dynasty. London, British Museum.

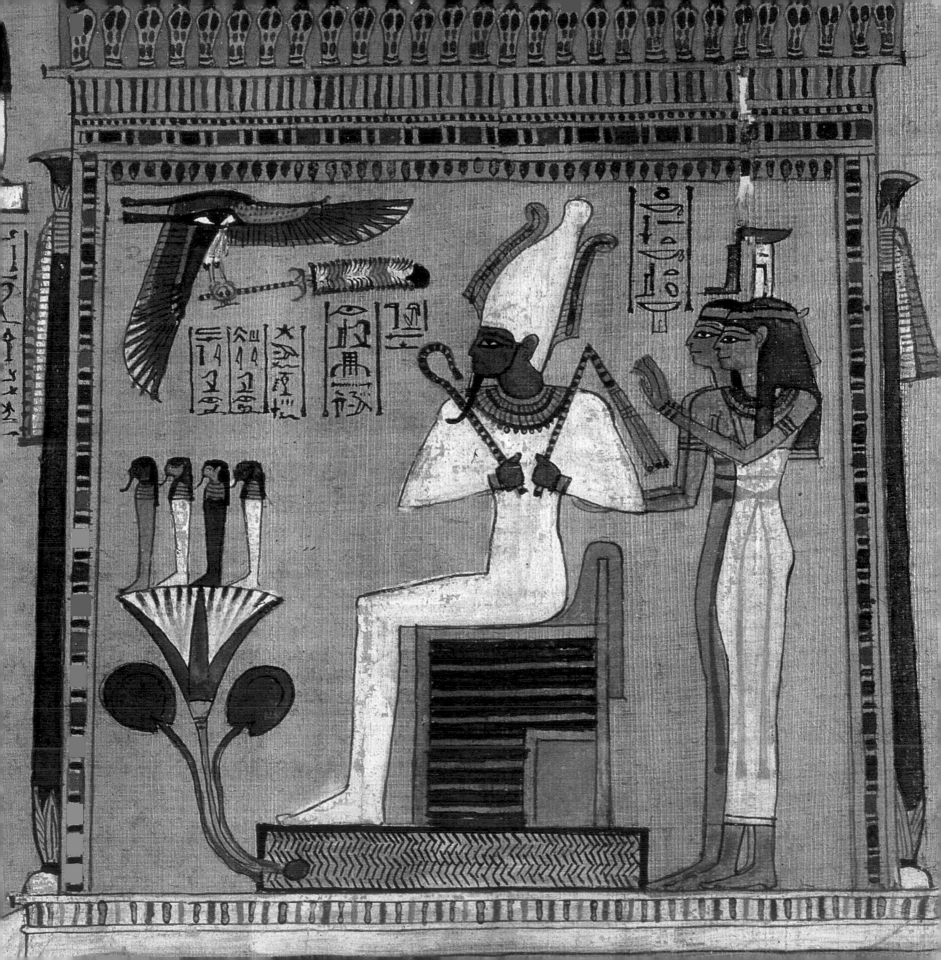

304 View of the second pylon of the Temple of Isis at Philae, from the birth house. The column capitals, with their complex and lush foliage, are typical of the Graeco-Roman Period.

the social function of enhancing the coherence of families and the community as a whole.

The multiple functions of art defined the range of subject matter represented, and artists had to work within the requirements of their patrons. Nevertheless, art was not static. It was subject to constant change, as can be charted, for instance, in the variations found in relief style, the proportions of the human body, and the modelling of the body in two and three dimensions. While some changes, especially those associated with a return to older models, as during the reign of Nebhepetra Montuhotep, may have had ideological motives, others probably occurred as a result of the natural creativity of good artists or of suggestions on the part of the patron. As social structure and religious and funerary beliefs altered over the millennia, these changes were reflected in the introduction of new compositions and artistic genres, often with old and new occurring side by side. For instance, Eighteenth Dynasty tomb chapels contained many scene types already known in the Old Kingdom, but they also included figures of the king in kiosk scenes and images of funerary deities that had been excluded from chapels of the earlier period. By the Nineteenth Dynasty most of the scenes known from the Eighteenth were replaced by underworld scenes and texts drawn from the *Book of the Dead*, perhaps because of increasing emphasis on the deceased's passage into the afterlife or because of changes in the type of subject matter it was permissible to display in non-royal tombs. At the end of the New Kingdom decorated tomb chapels disappeared altogether, but their decorative repertory was transferred to coffins, so that the deceased could continue to benefit from it.

Although the basic function of the coffin had from early times been to protect the body of the deceased, it was also conceptualised in a number of other ways, for instance as a dwelling place for the deceased, as the womb of the sky goddess Nut from which the deceased was reborn, as a protection against the dangers inherent in passing through death to the afterlife, and as an image of the deceased as a divine being. Both the form and decoration of coffins underwent many mutations over time, as funerary beliefs developed and shifted emphasis. Other changes occurred in the scenes on funerary stelae. From the Early Dynastic Period through the Old and Middle Kingdoms the primary image showed the deceased seated before offerings. In the Eighteenth Dynasty this was joined by scenes of the deceased adoring underworld deities, especially Osiris, who had the power to provide a safe passage into the afterlife. Gradually the earlier image dropped out of use, leaving only that of the deceased adoring. However, in the Third Intermediate Period the deity adored was frequently Ra-Horakhty, referring to the solar aspect of the afterlife, guaranteed by the constant cycle of the sun. Finally, Late Period and Ptolemaic funerary stelae usually included both solar and underworld deities.

The art of ancient Egypt was thus no more unchanging than the institutions and beliefs that it served. Nevertheless, because its significance derived from its ability to express and legitimise the world view shared by the king and the elite, only if this world view continued to exist would ancient Egyptian art remain meaningful. Neither the rule of the foreign Ptolemies, with the introduction of a competing ideology, nor the Roman conquest in 30 BC, after which the ruler ceased even to reside in Egypt, destroyed the indigenous world view, which persisted among the elite priesthoods of the temples. It may be, however, that unending foreign subjugation finally sapped the vitality of traditional Egyptian culture, for when Christianity emerged as a dominant force in the Roman empire, the conversion of Egypt was relatively rapid. With the adoption of Christianity there came a whole new world view that rendered the traditional one not only meaningless but also abhorrent. Old funerary beliefs and customs were replaced by new, and the ancient rituals of the temples, once central to maintaining the ordered world of the cosmos, were silenced, to be replaced by liturgies that praised and petitioned a new deity. The purposes for which the monuments of pharaonic Egypt had been built were no longer relevant, and gradually over the centuries the sands of the deserts covered the ancient temples and tombs.

Abbreviations and Bibliography

ASAE Annales du Service des Antiquités de l'Égypte

BES Bulletin of the Egyptological Seminar

BSFE Bulletin de la Société Française d'Égyptologie

DE Discussions in Egyptology

GM Göttinger Miszellen

JARCE Journal of the American Research Center in Egypt

JEA Journal of Egyptian Archaeology

JNES Journal of Near Eastern Studies

JSSEA Journal of the Society for the Study of Egyptian Antiquities

LÄ Lexikon der Ägyptologie

MDAIK Mitteilungen der Deutschen Archäologischen Instituts, Kairo

NARCE Newsletter of the American Research Center in Egypt

RdÉ Revue d'Égyptologie

SAK Studien zur altägyptischen Kultur

ZÄS Zeitschrift für ägyptische Sprache und Altertumskunde

Adams, W. Y. 1977, *Nubia, Corridor to Africa*, London.

Aldred, C. 1970, 'Some Royal Portraits of the Middle Kingdom in Ancient Egypt', *Metropolitan Museum Journal* 3, 27–50.

Aldred, C. 1973, *Akhenaten and Nefertiti*, London.

Aldred, C. 1976, 'The Horizon of the Aten', *JEA* 62, 184.

Aldred, C. 1980, *Egyptian Art in the Days of the Pharaohs 3100–320 BC*, London.

Aldred, C. 1988, *Akhenaten, King of Egypt*, London and New York.

Aldred, C. *et al.* 1980, *L'Égypte du crépuscule*, Paris.

Allen, J. 1988, *Genesis in Egypt: the Philosophy of Ancient Egypt Creation Accounts*, New Haven.

Altenmüller, H. 1984, 'Pyramidentexte', *LÄ* 5, 14–23.

Altenmüller, H. 1986, 'Ein Zaubermesser des Mittleren Reiches', *SAK* 13, 1–27.

Andrews, C. 1981, *The Rosetta Stone*, London.

Andrews, C. 1994, *Amulets of Ancient Egypt*, London.

Arnold, D. 1974a, *Der Tempel des Königs Mentuhotep von Deir el-Bahari*, I, *Architektur und Deutung*, Mainz.

Arnold, D. 1974b, *Der Tempel des Königs Mentuhotep von Deir el-Bahari*, II, *Die Wandreliefs des Sanktuares*, Mainz.

Arnold, D. 1976, *Gräber des alten und mittleren Reiches in el-Tarif*, Mainz.

Arnold, D. 1979, *The Temple of Mentuhotep at Deir el-Bahari*, New York.

Arnold, D. 1982, 'Pyramiden, MR und später', *LÄ* 4, 1263–72.

Arnold, D. 1988, *The Pyramid of Senwosret I*, New York.

Arnold, D. and Hornung, E. 1980, 'Königsgrab', *LÄ* 3, 496–514.

Arnold, Dor. 1991, 'Amenemhat I and the Early Twelfth Dynasty at Thebes', *Metropolitan Museum Journal* 26, 5–48.

Assmann, J. 1973, *Das Grab des Basa (Nr. 389) in der Thebanischen Nekropole, Grabung im Assasif 1963–70*, II, Mainz.

Assmann, J. 1977, *Das Grab des Mutirdis, Grabung im Assasif 1963–70*, VI, Mainz.

Assmann, J. 1991, *Das Grab des Amenemope TT 41*, Mainz.

Aufrère, S., Golvin, J.-Cl. and Goyon, J.-Cl. 1991, *L'Égypte restituée: Sites et temples de Haute Égypte*, Paris.

Ayrton, E., Currelly, C. and Weigall, A. 1904, *Abydos*, III, London.

Baines, J. 1976, 'Temple Symbolism', *Royal Anthropological Institute News* 15, 10–15.

Baines, J. 1985a, *Fecundity Figures: Egyptian Personification and the Iconology of a Genre*, Warminster.

Baines, J. 1985b, review of H. Schlögl, *Der Sonnengott auf der Blüte, JEA* 71 rev. supp., 46–7.

Baines, J. 1989a, 'Communication and Display: the Integration of Early Egyptian Art and Writing', *Antiquity* 63, 471–82.

Baines, J. 1989b, 'Techniques of Decoration in the Hall of Barques of the Temple of Sethos I at Abydos', *JEA* 75, 13–30.

Baines, J. 1990, 'Trône et dieu: aspects du symbolisme royal et divin des temps archaïques', *BSFE* 118, 5–37.

Baines, J. 1994, 'On the Status and Purposes of Ancient Egyptian Art', *Cambridge Archaeological Journal* 4, 67–94.

Baines, J. 1995a, 'Kingship, Definition of Culture, and Legitimation', in: D. O'Connor and D. Silverman (eds), *Ancient Egyptian Kingship*, Leiden, 3–47.

Baines, J. 1995b, 'Origins of Egyptian Kingship', in: D. O'Connor and D. Silverman (eds), *Ancient Egyptian Kingship*, Leiden, 95–156.

Baines, J. and Eyre, C.J. 1983, 'Four Notes on Literacy', *GM* 61, 65–96.

Baines, J. and Malek, J. 1980, *Atlas of Ancient Egypt*, Oxford.

Barguet, P. 1962, *Le temple d'Amon-Rê à Karnak*, Cairo.

Barguet, P. 1980, 'Karnak' *LÄ* 3, 341–52.

Beckerath, J. von. 1975, 'Amenemhet III', *LÄ*, 1, 190–1.

Beckerath, J. von. 1982, 'Mentuhotep III', *LÄ* 4, 68–9.

Behrens, P. 1982, 'Nacktheit', *LÄ* 4, 292–4.

Bell, L. 1985, 'Luxor Temple and the Cult of the Royal *Ka*', *JNES* 44, 251–94.

Bianchi, R.S. 1988, *Cleopatra's Egypt: Age of the Ptolemies*, Brooklyn.

Bianchi, R.S. 1990, 'New Light on the Aton', *GM* 114, 35–42.

Bianchi, R.S. 1995, 'Ancient Egyptian Reliefs, Statuary, and Monumental Paintings', in: J. Sasson (ed.), *Civilizations of the Ancient Near East*, IV, New York, 2533–54.

Bianchi, R.S. 1996, *Splendors of Ancient Egypt from the Egyptian Museum Cairo*, London.

Bierbrier, M. 1982a, *The Tomb-Builders of the Pharaohs*, London.

Bierbrier, M. 1982b, *Hieroglyphic Texts from Egyptian Stelae etc. Part 10*, London.

Bierbrier, M. 1987, *Hieroglyphic Texts from Egyptian Stelae etc. Part 11*, London.

Bierbrier, M.L. and Parkinson, R. 1993, *Hieroglyphic Texts from Egyptian Stelae etc. Part 12*, London.

Bietak, M. 1979, *Avaris and Piramesse: Archaeological Exploration in the Eastern Nile Delta*, London.

Bietak, M. 1996, *Avaris the Capital of the Hyksos: Recent Excavations at Tell el-Dabca*, London.

Bietak, M. and Reiser-Haslauer, E. 1978, *Das Grab des Anch-Hor, Obersthofmeister des Gottesgemahlin Nitokris*, I, Vienna.

Bietak, M. and Reiser-Haslauer, E. 1982, *Das Grab des Anch-Hor, Obersthofmeister des Gottesgemahlin Nitokris*, II, Vienna.

Bissing, F. von. 1905, *Das Re-Heiligtum des Königs Ne-woser-re (Rathures)*, I, Leipzig.

Bissing, F. von. 1923, *Das Re-Heiligtum des Königs Ne-woser-re (Rathures)*, II, Leipzig.

Bissing, F. von. 1928, *Das Re-Heiligtum des Königs Ne-woser-re (Rathures)*, III, Leipzig.

Bisson de la Roque, F. 1930, *Rapport sur les fouilles de Médamoud (1929)*, Cairo.

Bisson de la Roque, F. 1937, *Tôd (1934 à 1936)*, Cairo.

Blackman, A.M. 1914, *The Rock Tombs of Meir*, I, London.

Blackman, A.M. 1915a, *The Rock Tombs of Meir*, II, London.

Blackman, A.M. 1915b, *The Rock Tombs of Meir*, III, London.

Blackman, A.M. 1924, *The Rock Tombs of Meir*, IV, London.

Blackman, A.M. 1931, 'The Stela of Thethi, Brit. Mus. no. 614' *JEA* 17, 55–61.

Blackman, A.M. 1953a, *The Rock Tombs of Meir*, V, London.

Blackman, A.M. 1953b, *The Rock Tombs of Meir*, VI, London.

Borchardt, L. 1907, *Das Grabdenkmal des Königs Ne-user-re*, Leipzig.

Borchardt, L. 1910, *Das Grabdenkmal des Königs Sahu-re*, I, Leipzig.

Borchardt, L. 1911, *Statuen und Statuetten von Königen und Privatleuten im Museum von Kairo, Nr. 1–1294*, Berlin.

Borchardt, L. 1913, *Das Grabdenkmal des Königs Sahu-re*, II, Leipzig.

Bothmer, B.V. 1960, *Egyptian Sculpture of the Late Period 700 BC to AD 100*, Brooklyn.

Bourriau, J. 1988, *Pharaohs and Mortals: Egyptian Art in the Middle Kingdom*, Cambridge.

Bourriau, J. 1991, 'Patterns of Change in Burial Customs during the Middle Kingdom', in: S. Quirke (ed.), *Middle Kingdom Studies*, New Malden, Surrey, 3–20.

Breasted, J.H. Jr. 1948, *Egyptian Servant Statues*, Washington D.C.

Brovarski, E. 1984, 'Serdab' *LÄ* 5, 874–9.

Brunner, H. 1964, *Die Geburt des Gottkönigs*, Wiesbaden.

Brunner-Traut, E. 1955, 'Die Wochenlaube', *Mitteilungen des Instituts für Orientforschung* 3, 11–30.

Brunner-Traut, E. 1956, *Die altägyptischen Scherbenbilder (bildostraka) der Deutschen Museen und Sammlungen*, Wiesbaden.

Brunner-Traut, E. 1968, *Altägyptische Tiergeschichte und Fabel: Gestalt und Strahlkraft*, Darmstadt.

Brunner-Traut, E. 1977, 'Farben', *LÄ* 2, 117–28.

Brunner-Traut, E. 1979, *Egyptian Artists' Sketches: Figured Ostraka from the Gayer-Anderson Collection in the Fitzwilliam Museum, Cambridge*, Istanbul.

Brunton, G. 1920, *Lahun*, I, *The Treasure*, London.

Bruyère, B. 1926, *Rapports sur les fouilles de Deir el Médineh (1924–1925)*, Cairo.

Bruyère, B. 1927, *Rapports sur les fouilles de Deir el Médineh (1926)*, Cairo.

Bruyère, B. 1928, *Rapports sur les fouilles de Deir el Médineh (1927)*, Cairo.

Bruyère, B. 1929, *Rapports sur les fouilles de Deir el Médineh (1928)*, Cairo.

Bruyère, B. 1939, *Rapports sur les fouilles de Deir el Médineh (1934–1935)*, Part 3, Cairo.

Bryan, B. 1991, *The Reign of Thutmose IV*, Baltimore and London.

Bucher, P. 1932, *Les textes des tombes de Thoutmosis III et d'Amenophis II*, Cairo.

Buhl, M.-L. 1959, *The Late Egyptian Anthropoid Stone Sarcophagi*, Copenhagen.

Caluwe, A. de. 1991, *Un Livre de Morts sur bandelettes de momie*, Brussels.

Calverley, A.M. 1933, *The Temple of King Sethos I at Abydos*, I, London and Chicago.

Calverley, A.M. 1935, *The Temple of King Sethos I at Abydos*, II, London and Chicago.

Calverley, A.M. 1938, *The Temple of King Sethos I at Abydos*, III, London and Chicago.

Calverley, A.M. 1958, *The Temple of King Sethos I at Abydos*, IV, London and Chicago.

Carter, H. 1923, *The Tomb of Tut-ankh-amen*, I, London.

Carter, H. 1927, *The Tomb of Tut-ankh-amen*, II, London.

Carter, H. 1933, *The Tomb of Tut-ankh-amen*, III, London.

Carter, H., Newberry, P.E. and Maspero, G. 1904, *The Tomb of Thoutmôsis IV*, London.

Case, H.C. and Payne, J.C. 1962, 'Tomb 100: the Decorated Tomb at Hierakonpolis', *JEA* 48, 5–18.

Cauville, S. 1984, *Edfou*, Cairo.

Cauville, S. 1990, *Le temple de Dendera*, Cairo.

Cenival, J.L. de. 1963, *Egypt*, Lausanne.

Chadefaud, C. 1982, *Les statues porte-enseignes de l'Égypte ancienne (1550–1085 avant J.C.): signification et insertion dans le culte du Ka royal*, Paris.

Chevrier, H. 1934, 'Rapport sur les travaux de Karnak (1933–1934)', *ASAE* 34, 159–76.

Clère, P. 1961, *La porte d'Évergète à Karnak*, Cairo.

Corcoran, L.H. 1995a, *Portrait Mummies from Roman Egypt (I–IVth Centuries AD): with a Catalog of Portrait Mummies in Egyptian Museums*, Chicago.

Corcoran, L.H. 1995b, 'Evidence for the Survival of Pharaonic Religion in Roman Egypt: the Portrait Mummy', in: W. Haase and H. Temporini, *Aufstieg und Niedergang der Römischen Welt*, Part II: Principat, vol. 18.5, 3316–32.

Cruz-Uribe, E. 1992, 'Another Look at an Aton Statue', *GM* 126, 29–32.

Curto, S. *et al.* 1990, *Il senso dell'arte nell'antico Egitto*, Milan.

Daressy, G. 1903, 'Le palais d'Aménophis III et le Birket Habu', *ASAE* 4, 165–70.

Daumas, F. 1977, 'Geburtshaus', *LÄ* 2, 462–75.

D'Auria, S., Lacovara, P. and Roehrig, C. 1988, *Mummies and Magic: the Funerary Arts of Ancient Egypt*, Boston.

Davies, N. de G. 1901a, *The Mastaba of Ptahhotep and Akhethotep at Saqqareh*, Part II, London.

Davies, N. de G. 1901b, *The Rock Tombs of Sheikh Saïd*, London.

Davies, N. de G. 1902a, *The Rock Tombs of Deir el Gebrawi*, I, London.

Davies, N. de G. 1902b, *The Rock Tombs of Deir el Gebrawi*, II, London.

Davies, N. de G. 1903, *The Rock Tombs of El Amarna*, I, London.

Davies, N. de G. 1905a, *The Rock Tombs of El Amarna*, II, London.

Davies, N. de G. 1905b, *The Rock Tombs of El Amarna*, III, London.

Davies, N. de G. 1906, *The Rock Tombs of El Amarna*, IV, London.

Davies, N. de G. 1908a, *The Rock Tombs of El Amarna*, V, London.

Davies, N. de G. 1908b, *The Rock Tombs of El Amarna*, VI, London.

Davies, N. de G. 1913, *Five Theban Tombs*, London.

Davies, N. de G. 1922, *The Tomb of Puyemrê at Thebes*, I, New York.

Davies, N. de G. 1923, *The Tomb of Puyemrê at Thebes*, II, New York.

Davies, N. de G. 1925, *The Tomb of Two Sculptors at Thebes*, New York.

Davies, N. de G. 1927a, *The Tomb of Nakht at Thebes*, New York.

Davies, N. de G. 1927b, *Two Ramesside Tombs at Thebes*, New York.

Davies, N. de G. 1930, *The Tomb of Ken-amun at Thebes*, I–II, New York.

Davies, N. de G. 1933a, *The Tomb of Nefer-hotep at Thebes*, New York.

Davies, N. de G. 1933b, *The Tombs of Menkheperrasonb, Amenmose and Another*, London.

Davies, N. de G. 1941, *The Tomb of the Vizier Ramose*, London.

Davies, N. de G. 1943, *The Tomb of Rekh-Mi-Re at Thebes*, New York.

Davies, N. de G. 1948, *Seven Private Tombs at Kurnah*, London.

Davies, N. 1963, *Scenes from some Theban Tombs*, Oxford.

Davies, N. and Gardiner, A.H. 1915, *The Tomb of Amenemhet (No.82)*, London.

Davies, N. and Gardiner, A.H. 1962, *Tutankhamun's Painted Box*, Oxford.

Davies, W.V. 1981, *A Royal Statue Reattributed*, London.

Davies, W.V. 1982, 'The Origin of the Blue Crown', *JEA* 68, 69–76.

Davies, W.V. 1987, *Egyptian Hieroglyphs*, London.

Davies, W.V. (ed.) forthcoming, *Colour and Painting in Ancient Egypt*, London.

Demarée, R. 1983, *The 3h ikr n Rc-Stelae: on Ancestor Worship in Ancient Egypt*, Leiden.

Derchain, Ph. 1961, *Zwei Kapellen des Ptolemäus I Soter in Hildesheim*, Hildesheim.

Desroches Noblecourt, C. 1981, *Un siècle de fouilles françaises en Égypte 1880–1980*, Paris.

Desroches Noblecourt, C. and Kuentz, Ch. 1968, *Le petit temple d'Abou Simbel*, I–II, Cairo.

Dolinska, M. 1994, 'Some Remarks about the Function of the Thutmosis III Temple at Deir el-Bahari', in: R. Gundlach and M. Rochholz, *Ägyptische Tempel – Struktur, Funktion und Programm*, Hildesheim, 33–45.

Drenkhahn, R. 1995, 'Artisans and Artists in Pharaonic Egypt', in: J.M. Sasson (ed.), *Civilizations of the Ancient Near East*, I, New York, 331–43.

Dreyer, G. 1993, 'A Hundred Years at Abydos', *Egyptian Archaeology* 3, 10–12.

Dreyer, G. *et al.* 1993, 'Umm el-Qaab: Nachuntersuchungen im frühzeitlichen Königsfriedhof. 5./6. Vorbericht', *MDAIK* 49, 23–62.

Duell, P. 1938, *The Mastaba of Mereruka*, I–II, Chicago.

Dunham, D. 1937, *Naga-ed-Dêr Stelae of the First Intermediate Period*, Oxford.

Dunham, D. 1950, *El Kurru*, Cambridge, Mass.

Dunham, D. 1955, *Nuri*, Cambridge, Mass.

Dunham, D. and Simpson, W.K. 1974, *The Mastaba of Queen Mersyankh III: Giza 7530–7540*, Boston.

Dziobek, E. 1990, *Das Grab des Sobekhotep. Theben Nr 63*, Mainz.

Dziobek, E. 1992, *Das Grab des Ineni, Theben Nr 81*, Mainz.

Eaton-Krauss, M. 1984, *The Representation of Statuary in Private Tombs of the Old Kingdom*, Wiesbaden.

Eaton-Krauss, M. 1993, *The Sarcophagus in the Tomb of Tutankhamun*, Oxford.

Eaton-Krauss, M. 1995, 'Pseudo-Groups', *Kunst des Alten Reiches Symposium in Deutschen Archäologischen Institut Kairo am 29. und 30. Oktober 1991*, Mainz, 57–74.

Eaton-Krauss, M. and Graefe, E. 1985, *The Small Golden Shrine from the Tomb of Tutankhamun*, Oxford.

Edel, E. and Wenig, S. 1974, *Die Jahreszeitenreliefs aus dem Sonnenheiligtum des Königs Ne-user-re*, Berlin.

Edwards, I.E.S. 1965, 'Lord Dufferin's Excavations at Deir-El-Bahri and the Clandeboye Collection', *JEA* 51, 16–28.

Edwards, I.E.S. 1993, *The Pyramids of Egypt*, rev. ed., London and New York.

Eigner, D. 1984, *Die monumentalen Grabbaute der Spätzeit in der Thebanischen Nekropole*, Vienna.

Emery, W.B. 1938, *The Tomb of Hemaka*, Cairo.

Emery, W.B. 1949, *Great Tombs of the First Dynasty*, I, Cairo.

Emery, W.B. 1954, *Great Tombs of the First Dynasty*, II, London.

Emery, W.B. 1958, *Great Tombs of the First Dynasty*, III, London.

Epigraphic Survey, 1930, *Medinet Habu*, I, Chicago.

Epigraphic Survey, 1932, *Medinet Habu*, II, Chicago.

Epigraphic Survey, 1934, *Medinet Habu*, III, Chicago.

Epigraphic Survey, 1940, *Medinet Habu*, IV, Chicago.

Epigraphic Survey, 1954, *The Bubastite Portal*, Chicago.

Epigraphic Survey, 1957, *Medinet Habu*, V, Chicago.

Epigraphic Survey, 1963, *Medinet Habu*, VI, Chicago.

Epigraphic Survey, 1964, *Medinet Habu*, VII, Chicago.

Epigraphic Survey, 1970, *Medinet Habu*, VIII, Chicago.

Epigraphic Survey, 1980, *The Tomb of Kheruef, Theban Tomb 192*, Chicago.

Epigraphic Survey, 1986, *The Battle Reliefs of King Sety I*, Chicago.

Epigraphic Survey, 1994, *The Festival Procession of Opet in the Colonnade Hall*, Chicago.

Épron, L. and Daumas, F. 1939, *Le Tombeau de Ti*, I, Cairo.

Evers, H.G. 1929, *Staat aus den Stein: Denkmäler, Geschichte und Bedeutung der Ägyptischen Plastik während des Mittleren Reichs*, I–II, Munich.

Fairman, H.W. 1972, 'Tutankhamun and the End of the 18th Dynasty', *Antiquity* 46, 15–18.

Fairman, H.W. 1974, *The Triumph of Horus, an Ancient Egyptian Sacred Drama*, Berkeley and Los Angeles.

Fakhry, A. 1959, *The Monuments of Sneferu at Dahshur*, I, *The Bent Pyramid*, Cairo.

Fakhry, A. 1961a, *The Monuments of Sneferu at Dahshur*, II, *The Valley Temple*, part 1, *The Temple Reliefs*, Cairo.

Fakhry, A. 1961b, *The Monuments of Sneferu at Dahshur* II, *The Valley Temple*, part 2, *The Finds*, Cairo.

Faulkner, R.O. 1969, *The Ancient Egyptian Pyramid Texts*, Oxford.

Fay, B. 1996, *The Louvre Sphinx and Royal Sculpture from the Reign of Amenemhat II*, Mainz.

Fazzini, R. 1988, *Egypt Dynasty XXII–XXV*, Leiden.

Fazzini, R. and Peck, W. 1981, 'The Precinct of Mut during Dynasty XXV and Early Dynasty XXVI, a Growing Picture', *JSSEA* 11, 115–26.

Fazzini, R., Bianchi, R., Romano, J. and Spanel, D. 1989, *Ancient Egyptian Art in the Brooklyn Museum*, New York and London.

Finnestad, R.G. 1985, *Image of the World and Symbol of the Creator: on the Cosmological and Iconological Values of the Temple of Edfu*, Wiesbaden.

Firth, C.M. and Quibell, J.E. 1935, *The Step Pyramid*, I–II, Cairo.

Fischer, H.G. 1958, Review of L. Habachi, *Tell Basta* in: *American Journal of Archaeology* 62, 330–3.

Fischer, H.G. 1959, 'An Example of Memphite Influence in a Theban Stela of the Eleventh Dynasty', *Artibus Asiae*, 22, 240–52.

Fischer, H.G. 1968, *Dendera in the Third Millennium BC down to the Theban Domination of Upper Egypt*, Locust Valley, New York.

Fischer, H.G. 1973, 'Redundant Determinatives in the Old Kingdom', *Metropolitan Museum Journal* 8, 7–25.

Fischer, H.G. 1976, *Varia*, Egyptian Studies, I, New York.

Fischer, H.G. 1977a, *The Orientation of Hieroglyphs* Part I, *Reversals*, New York.

Fischer, H.G. 1977b, 'Gaufürst', *LÄ* 2, 408–17.

Fischer, H.G. 1986, *L'écriture et l'art de l'Égypte ancienne: quatre leçons sur la paléographie et l'épigraphie pharaonique*, Paris.

Fischer, H.G. 1989. *Egyptian Women of the Old Kingdom and of the Heracleopolitan Period*, New York.

Franke, D. 1991, 'The Career of Khnumhotep III of Beni Hasan and the so-called "Decline of the Nomarchs"', in: S. Quirke (ed.), *Middle Kingdom Studies*, New Malden, Surrey, 51–67.

Frankfort, H. 1939, *Cylinder Seals: a Documentary Essay on the Art and Religion of the Ancient Near East*, London.

Fraser, P.M. 1972, *Ptolemaic Alexandria*, I, Oxford.

Freed, R. 1981, 'A Private Stela from Naga ed-Der and Relief Style of the Reign of Amenemhat I', in: W.K. Simpson and W.M. Davis (eds), *Studies in Ancient Egypt, the Aegean, and the Sudan*, Boston, 68–76.

Freed, R. 1984, 'The Development of Middle Kingdom Egyptian Relief Sculptural Schools of Late Dynasty XI with an Appendix on the Trends of Early Dynasty XII (2040–1878 BC)', unpublished doctoral dissertation, Institute of Fine Arts, University of New York, Ann Arbor, Michigan.

Friedman, F. 1985, 'On the Meaning of Some Anthropoid Busts from Deir el-Medîna', *JEA* 71, 82–97.

Friedman, F. 1994, 'Aspects of Domestic Life and Religion' in: L.H. Lesko (ed.), *Pharaoh's Workers: the Villagers of Deir el Medina*, Ithaca and London, 95–117.

Friedman, F. 1995, 'The Underground Relief Panels of King Djoser at the Step Pyramid Complex', *JARCE* 32, 1–42.

Giddy, L. and Jeffreys, D. 1993, 'The People of Memphis', *Egyptian Archaeology* 3, 18–20.

Gitton, M. 1976, 'Le rôle des femmes dans le clergé d'Amon à la 18e dynastie', *BSFE* 75, 31–46.

Gitton, M. and Leclant, J. 1977, 'Gottesgemahlin', *LÄ* 2, 792–812.

Goedicke, H. 1971, *Re-used Blocks from the Pyramid of Amenemhet at Lisht*, New York.

Goedicke, H. and Thausing, G. 1971, *Nofretari: eine Dokumentation der Wandgemälde ihres Grabes*, Graz.

Goelet, O. 1993, 'Nudity in Ancient Egypt', *Sources, Notes in the History of Art* 12 no. 2, 20–31.

Gohary, J. 1992, *Akhenaten's Sed-Festival at Karnak*, London and New York.

Gorelick, L., Gwinnett, A.J. and Romano, J.F. 1991–2, 'The Broken and Repaired Statuette of Pepi I: an Ancient or Modern Repair?', *BES* 11, 33–46.

Goyon, J.-C. 1988, 'Ptolemaic Egypt: Priests and the Traditional Religion', in: R.S. Bianchi, *Cleopatra's Egypt: Age of the Ptolemies*, Brooklyn, 29–39.

Graefe, E. 1981, *Untersuchungen zur Verwaltung und Geschichte der Institution der Gottesgemahlin des Amun vom Beginn des Neuen Reiches bis zur Spätzeit*, I–II, Wiesbaden.

Graefe, E. 1985, 'Talfest', *LÄ* 6, 187–9.

Griffiths, J.G. 1960, *The Conflict of Horus and Seth from Egyptian and Classical Sources: a Study in Ancient Mythology*, Liverpool.

Griffiths, J.G. 1980, *The Origins of Osiris and his Cult*, Leiden.

Guilmont, F. 1907, *Le Tombeau de Ramsès IX*, Cairo.

Habachi, L. 1957, *Tell Basta*, Cairo.

Habachi, L. 1963, 'King Nebhepetre Menuthotep: His Monuments, Place in History, Deification, and Unusual Representations in the Form of Gods', *MDAIK* 19, 16–52.

Habachi, L. 1969, *Features of the Deification of Ramesses II*, Glückstadt.

Habachi, L. 1975, 'Bubastis', *LÄ* 1, 873–4.

Habachi, L. 1985, *The Sanctuary of Heqaib*, I–II, Mainz.

Haeny, G. 1981, *Untersuchungen im Totentempel Amenophis' III*, Wiesbaden.

Harpur, Y. 1986, 'The Identity and Positions of Relief Fragments in Museums and Private Collections: the Reliefs of *R'-htp* and *Nfrt* from Meydum', *JEA* 72, 23–40.

Harvey, S. 1994, 'Monuments of Ahmose at Abydos', *Egyptian Archaeology* 4, 3–5.

Hassan, S. 1960, *The Great Pyramid of Khufu and its Mortuary Chapel*, Cairo.

Hawass, Z. 1995, 'Programs of the Royal Funerary Complexes of the Fourth Dynasty', in: D. O'Connor and D. Silverman (eds), *Ancient Egyptian Kingship*, Leiden, 221–62.

Hawass, Z. and Verner, M. 1996, 'Newly Discovered Blocks from the Causeway of Sahure', *MDAIK* 52.

Hayes, W.C. 1953, *The Scepter of Egypt*, I, New York.

Hayes, W.C. 1959, *The Scepter of Egypt*, II, New York.

Helck, W. 1982, 'Palermostein', *LÄ* 4, 652–4.

Helck, W. 1991, 'Überlegungen zum Ausgang der 5. Dynastie', *MDAIK* 47, 163–7.

Hodjash, S. and Berlev, O. 1982, *The Egyptian Reliefs and Stelae in the Pushkin Museum of Fine Arts, Moscow*, Leningrad.

Hofmann, E. 1995, *Das Grab des Neferrenpet gen. Kenro (TT 178)*, Mainz.

Hölscher, U. 1939, *The Excavation of Medinet Habu*, II, *The Temples of the Eighteenth Dynasty*, Chicago.

Hölscher, U. 1954, *The Excavation of Medinet Habu*, V, *Post-Ramessid Remains*, Chicago.

Hope, C.A. 1988, *Gold of the Pharaohs*, Sydney.

Hornung, E. 1971, *Das Grab des Haremhab im Tal der Könige*, Bern.

Hornung, E. 1990a, *The Valley of the Kings, Horizon of Eternity*, New York.

Hornung, E. 1990b, *Zwei ramessidische Königsgräber: Ramses IV. und Ramses VII.*, Mainz.

Hornung, E. 1991, *The Tomb of Pharaoh Seti I/Das Grab Sethos' I*, Zurich and Munich.

Hornung, E. 1992, *Idea into Image*, New York.

Hornung, E. and Staehelin, E. 1974, *Studien zum Sedfest*, Geneva.

Ikram, S. 1989, 'Domestic Shrines and the Cult of the Royal Family at el-Amarna', *JEA* 75, 89–101.

Jacquet-Gordon, H. 1962, *Les noms des domaines funéraires sous l'ancien empire égyptien*, Cairo.

Jacquet-Gordon, H. 1967, 'The Illusory Year 36 of Osorkon I', *JEA* 53, 63–8.

James, T.G.H. 1953, *The Mastaba of Khentika called Ikhekhi*, London.

James, T.G.H. 1970, *Hieroglyphic Texts from Egyptian Stelae etc.* Part 9, London.

Jaroš-Deckert, B. 1984, *Das Grab des Jnj-jt.f: die Wandmalereien der XI. Dynastie*, Mainz.

Jéquier, G. 1924, *Les temples ptolémaïques et romains*, Paris.

Jéquier, G. 1929, *Tombeaux de particuliers contemporains de Pepi II*, Cairo.

Jéquier, G. 1936, *Le monument funéraire de Pepi II*, I, Cairo.

Jéquier, G. 1938, *Le monument funéraire de Pepi II*, II, Cairo.

Jéquier, G. 1940, *Le monument funéraire de Pepi II*, III, Cairo.

Johnson, W.R. 1990, 'Images of Amenhotep III in Thebes: Styles and Intentions', in: L.M. Berman (ed.), *The Art of Amenhotep III: Art Historical Analysis*, Cleveland, 26–46.

Jones, D. 1990, *Model Boats from the Tomb of Tutankhamun*, Oxford.

Junker, H. 1940, *Giza*, IV, Vienna and Leipzig.

Junker, H. 1958, *Der Grosse Pylon des Tempels der Isis in Philä*, Vienna.

Junker, H. and Winter, E. 1965, *Das Geburtshaus des Temples der Isis in Philä*, Vienna.

Kaiser, W. 1969, 'Zu den königlichen Talbezirken der 1. und 2. Dynastie in Abydos und zur Baugeschichte des Djoser-Grabmals', *MDAIK* 25, 1–22.

Kaiser, W. 1971, 'Die kleine Hebseddarstellung in Sonnenheiligtum des Neuserre', in: *Festschrift Ricke: Aufsätze zum 70. Geburtstag von Herbert Ricke*, Wiesbaden, 87–105, folding plates 4–5.

Kaiser, W. 1981, 'Zu den Königsgräbern der 1. Dynastie in Umm el-Qaab', *MDAIK* 37, 247–54.

Kaiser, W. and Dreyer, G. 1982, 'Umm el-Qaab: Nachuntersuchungen im frühzeitlichen Königsfriedhof. 2. Vorbericht', *MDAIK* 38, 211–69.

Kákosy, L. 1980, 'Horusstela', *LÄ* 3, 60–2.

Kanawati, N. 1993, *The Tombs of el-Hagarsa*, I–II, Sydney.

Kanawati, N. and McFarlane, A. 1993, *Deshasha: the Tombs of Inti, Shedu and Others*, Sydney.

Kaplony, P. 1980, 'Ka-Haus' *LÄ* 3, 284–7.

Kaplony, P. 1963 *Die Inschriften der Ägyptischen Frühzeit*, I–III, Wiesbaden.

Keller, C. 1981, 'The Draughtsmen of Deir el-Medina: a Preliminary Report', *NARCE* 115, 7–14.

Keller, C. 1991, 'Royal Painters: Deir el-Medina in Dynasty XIX', in: E. Bleiberg and R. Freed (eds), *Fragments of a Shattered Visage: the Proceedings of the International Symposium on Ramesses the Great*, Memphis, 50–67.

Kemp, B.J. 1966, 'Abydos and the Royal Tombs of the First Dynasty', *JEA* 52, 13–22.

Kemp, B.J. 1967, 'The Egyptian First Dynasty Royal Cemetery' *Antiquity* 41, 22–32.

Kemp, B.J. 1975, 'Abydos', *LÄ* 1, 28–42.

Kemp, B.J. 1976, 'The Window of Appearance at El-Amarna, and the Basic Structure of this City', *JEA* 62, 81–99.

Kemp, B.J. 1979, 'Wall Paintings from the Workmen's Village at El-Amarna', *JEA* 65, 47–53.

Kemp, B. 1989, *Ancient Egypt: Anatomy of a Civilization*, London and New York.

el-Khouli, A. 1991, *Meidum*, Sydney.

el-Khouli, A. and Kanawati, N. 1989, *Quseir el-Amarna: the Tombs of Pepy-ankh and Shewen-wekh*, Sydney.

el-Khouli, A. and Kanawati, N. 1990, *The Old Kingdom Tombs of el-Hammamiya*, Sydney.

Kitchen, K.A. 1982, *Pharaoh Triumphant: The Life and Times of Ramesses II*, Warminster.

Kitchen, K.A. 1986, *The Third Intermediate Period in Egypt (1100–650 BC)*, 2nd ed., Warminster.

Kozloff, A. and Bryan, B. 1992, *Egypt's Dazzling Sun: Amenhotep III and his World*, Cleveland.

Kuhlmann, K. 1977, *Der Thron im alten Ägypten*, Glückstadt.

Kuhlmann, K. and Schenkel, W. 1983, *Das Grab des Ibi, Obergutsverwalters der Gottesgemahlin des Amun (Thebanisches Grab Nr 36)*, Mainz.

Labrousse, A., Lauer, J.-Ph. and Leclant, J. 1977, *Le temple haut du complexe funéraire du roi Ounas*, Cairo.

Lacau, P. 1909, *Stèles du Nouvel Empire*, Cairo.

Lacau, P. and Chevrier, H. 1956, *Une chapelle de Sésostris Ier à Karnak*, I, Cairo.

Lacau, P. and Chevrier, H. 1969, *Une chapelle de Sésostris Ier à Karnak*, II, Cairo.

Lacau, P. and Chevrier, H. 1977, *Une chapelle d'Hatshepsout à Karnak*, I, Cairo.

Lacau, P. and Chevrier, H. 1979, *Une chapelle d'Hatshepsout à Karnak*, II, Cairo.

Lacovara, P. 1994, 'In the Realm of the Sun King. Malkata, Palace-City of Amenhotep III' *Amarna Letters* 3, 6–21.

Lapp, G. 1983, 'Sarg: Särge des AR und MR', *LÄ* 5, 430–4.

Lapp, G. 1993, *Typologie der Särge und Sargkammern von der 6. bis 13. Dynastie*, Heidelberg.

Lauer, J.-Ph. 1936, *La pyramide à degrés: l'architecture*, I–II, Cairo.

Lauer, J.-Ph. 1939, *La pyramide à degrés: compléments*, III, Cairo.

Lauer, J.-Ph. 1962, *Histoire monumentale des pyramides d'Égypte*, I, *Les pyramides à degrés (IIIe Dynastie)*, Cairo.

Lauer, J.-Ph. and Leclant, J. 1969, 'Découverte de statues de prisonniers au temple de la pyramide de Pépi I', *RdÉ* 21, 55–62.

Lauer, J.-Ph. and Leclant, J. 1972, *Le temple haut du complexe funéraire du roi Téti*, Cairo.

Lauer, J.-Ph. and Leclant, J. 1979, *Recherches dans la pyramide au temple haut du pharaon Pépi Ier à Saqqarah*, Leiden.

Lauffray, J. 1979, *Karnak d'Égypte, Domaine du divin*, Paris.

Leahy, A. 1992, 'Royal Iconography and Dynastic Change, 750–525 BC: the Blue and Cap Crowns' *JEA* 78, 223–40.

Leahy, L. 1988, 'Private Tomb Reliefs of the Late Period from Lower Egypt', thesis submitted for the degree of Doctor of Philosophy at the University of Oxford.

Leclant, J. 1961, *Montuemhat, Quatrième Prophète d'Amon Prince de la Ville*, Cairo.

Leclant, J. 1965, *Recherches sur les monuments thébains de la XXVe dynastie dite éthiopienne*, Cairo.

Le Fur, D. 1994, *La conservation des peintures murales des temples de Karnak*, Paris.

Lepsius, R. 1884, *Die Längenmasse der Alten*, Berlin.

Lichtheim, M. 1973, *Ancient Egyptian Literature*, I, Berkeley, Los Angeles and London.

Lichtheim, M. 1980, *Ancient Egyptian Literature*, III, Berkeley, Los Angeles and London.

Lichtheim, M. 1988, *Ancient Egyptian Autobiographies chiefly of the Middle Kingdom: a Study and an Anthology*, Freiburg.

Littauer, M. and Crouwel, J. 1985, *Chariots and Related Equipment from the Tomb of Tutankhamun*, Oxford.

Lloyd, S. and Müller, H.W. 1980, *Ancient Architecture*, Milan.

Löhr, B. 1975, 'Ahanjati in Memphis', *SAK* 2, 139–87.

Lucas, A. 1962, *Ancient Egyptian Materials and Industries*, 4th ed., rev. and ed. by J.R. Harris, London.

McDonald, J. 1996, *House of Eternity: the Tomb of Nefertari*, Los Angeles.

McDowell, A. forthcoming, *Village Life in Ancient Egypt: Laundry Lists and Love Songs*, Oxford.

MacIver, D.R. and Mace, A.C. 1902, *El Amrah and Abydos*, London.

Mackay, E. 1917, 'Proportion Squares on Tomb Walls in the Theban Necropolis', *JEA* 4, 74–85.

McLeod, W. 1970, *Composite Bows from the Tomb of Tutankhamun*, Oxford.

McLeod, W. 1982, *Self-Bows and Other Archery Tackle from the Tomb of Tutankhamun*, Oxford.

Malaise, M. 1984, 'Les représentations de divinités sur les stèles du Moyen Empire', in: *Orientalia J. Duchesne-Guillemin emerito oblata*, Leiden, 393–420.

Malek, J. 1986, *In the Shadow of the Pyramids*, London.

Malek, J. 1993, *The Cat in Ancient Egypt*, London.

Manuelian, P.D. 1983, 'Prolegomena zur Untersuchungen saitischer "Kopien"', *SAK* 10, 221–45.

Manuelian, P.D. 1985, 'Two fragments of relief and a new model for the tomb of Montuemhat at Thebes', *JEA* 71, 98–121.

Manuelian, P.D. 1988, review of D. Eigner, *Die monumentalen Grabbaute der Spätzeit in der thebanischen Nekropole*, *JNES* 47, 297–304.

Manuelian, P.D. 1994, *Living in the Past: Studies in Archaism of the Egyptian Twenty-Sixth Dynasty*, London.

Mariette, A. 1872, *Monuments divers recueillis en Égypte et en Nubie*, Paris.

Mariette, A. 1889, *Les mastabas de l'ancien empire*, Paris.

Martin, G.T. 1974, *The Royal Tomb at el-Amarna*, I, London.

Martin, G.T. 1985, *The Tomb Chapels of Paser and Ra'ia at Saqqâra*, London.

Martin, G.T. 1986, 'Shabtis of Private Persons in the Amarna Period', *MDAIK* 42, 109–29.

Martin, G.T. 1987, *Corpus of Reliefs of the New Kingdom from the Memphite Necropolis and Lower Egypt*, London.

Martin, G.T. 1989a, *The Memphite Tomb of Horemheb, Commander-in-Chief of Tutankhamun*, I, *The Reliefs, Inscriptions, and Commentary*, London.

Martin, G.T. 1989b, *The Royal Tomb at el-Amarna*, II, *The Reliefs, Inscriptions and Architecture*, London.

Martin, G.T. 1991, *The Hidden Tombs of Memphis*, London and New York.

Martin, G.T. forthcoming, in: W.V. Davies (ed.), *Colour and Painting in Ancient Egypt*, London.

Martin, K. 1984, 'Sedfest', *LÄ* 5, 782–90.

Massart, A. 1957, 'The Egyptian Geneva Papyrus MAH 15274', *MDAIK* 15, 172–85.

Meeks, D. 1977, 'Harpokrates', *LÄ* 2, 1003–11.

Mekhitarian, A. 1954, *Egyptian Painting*, Geneva.

Meulenaere, H. de. 1982a, 'Nektanebos I', *LÄ* 4, 450–1.

Meulenaere, H. de. 1982b, 'Nektanebos II', *LÄ* 4, 451–3.

Michalowski, K. 1970, *Karnak*, New York, Washington D.C. and London.

Mogensen, M. 1930, *La Glyptothèque Ny Carlsberg: la collection égyptienne*, Copenhagen.

Mond, R. and Myers, O. 1940, *Temples of Armant: a Preliminary Survey*, London.

Montet, P. 1942, *Tanis: Douze années de fouilles dans une capitale oubliée du Delta Égyptien*, Paris.

Montet, P. *et al.* 1947, *Les constructions et le tombeau d'Osorkon II à Tanis*, Paris.

Montet, P. 1951, *Les constructions et le tombeau de Psousennès à Tanis*, Paris.

Montet, P. 1960, *Les constructions et le tombeau de Chéchanq III à Tanis*, Paris.

Morgan, J. de. 1895, *Fouilles à Dahchour 1894*, I, Vienna.

Morgan, J. de. 1903, *Fouilles à Dahchour en 1894–1895*, II, Vienna.

Mosher, M. Jr. 1992, 'Theban and Memphite Book of the Dead Traditions in the Late Period', *JARCE* 29, 143–72.

Moussa, A. and Altenmüller, H. 1977, *Das Grab des Nianchchnum und Chnumhotep*, Mainz.

Müller, H.W. 1940, *Die Felsengräber der Fürsten von Elephantine*, Glückstadt, Hamburg and New York.

Munro, P. 1973, *Die spätägyptischen Totenstelen*, Glückstadt.

Murnane, W.J. 1977, *Ancient Egyptian Coregencies*, Chicago.

Murnane, W.J. 1980, *United with Eternity: a Concise Guide to the Monuments of Medinet Habu*, Chicago and Cairo.

Murnane, W.J. 1990, *The Road to Kadesh: a Historical Interpretation of the Battle Reliefs of King Sety I at Karnak*, Chicago.

Murnane, W.J. 1995, *Texts from the Amarna Period in Egypt*, Atlanta.

Murnane, W.J. and Van Siclen, C. 1993, *The Boundary Stelae of Akhenaten*, London and New York.

Murray, M. 1905, *Saqqara Mastabas*, I, London.

Myśliwiec, C. 1988, *Royal Portraiture of the Dynasties XXI–XXX*, Mainz.

Naville, E. 1892, *The Festival Hall of Osorkon II in the Great Temple of Bubastis (1887–1889)*, London.

Naville, E. 1894, *The Temple of Deir el Bahari*, I, London.

Naville, E. 1896, *The Temple of Deir el Bahari*, II, London.

Naville, E. 1898, *The Temple of Deir el Bahari*, III, London.

Naville, E. 1901, *The Temple of Deir el Bahari*, IV, London.

Naville, E. 1906, *The Temple of Deir el Bahari*, V, London.

Naville, E. 1907, *The XIth Dynasty Temple at Deir el-Bahari*, I, London.

Naville, E. 1908, *The Temple of Deir el Bahari*, VI, London.

Naville, E. 1910, *The XIth Dynasty Temple at Deir el-Bahari*, II, London.

Naville, E. 1913, *The XIth Dynasty Temple at Deir el-Bahari*, III, London.

Nelson, H. 1981, *The Great Hypostyle Hall at Karnak*, I, Part 1, *The Wall Reliefs*, ed. W.J. Murnane, Chicago.

Newberry, P.E. 1893a, *Beni Hasan*, I, London.

Newberry, P.E. 1893b, *Beni Hasan*, II, London.

Newberry, P.E. 1893c, *El Bersheh*, I, London.

Newberry, P.E. 1894, *El Bersheh*, II, London.

Nicholson, P.T. 1993, *Egyptian Faience and Glass*, Aylesbury.

Nims, C. 1966, 'The date of the dishonoring of Hatshepsut', *ZÄS* 93, 97–100.

Niwiński, A. 1984, 'Sarg. NR-SpZt', *LÄ* 5, 434–68.

Niwiński, A. 1988, *21st Dynasty Coffins from Thebes: Chronological and Typological Studies*, Mainz.

Niwiński, A. 1989, *Studies on the Illustrated Theban Funerary Papyri of the 11th and 10th Centuries BC*, Freiburg and Göttingen.

O'Connor, D. 1980, 'Malkata', *LÄ* 3, 1173–7.

O'Connor, D. 1985, 'The "Cenotaphs" of the Middle Kingdom at Abydos', in: P. Posener Kriéger (ed.), *Mélanges Gamal Eddin Mokhtar*, II, Cairo, 161–77.

O'Connor, D. 1989a, 'City and Palace in New Kingdom Egypt', *Cahiers du Recherches de l'Institut de Papyrologie et d'Égyptologie de Lille* 11, 73–87.

O'Connor, D. 1989b, 'New Funerary Enclosures (*Talbezirke*) of the Early Dynastic Period at Abydos', *JARCE* 26, 51–86.

O'Connor, D. 1991a, 'Mirror of the Cosmos: The Palace of Merenptah', in: E. Bleiberg and R. Freed (eds), *Fragments of a Shattered Visage: the Proceedings of the International Symposium on Ramesses the Great*, Memphis, 167–98.

O'Connor, D. 1991b, 'Boat Graves and Pyramid Origins: New Discoveries at Abydos, Egypt', *Expedition* 33 no.3, 5–17.

O'Connor, D. 1992, 'The Multiple Levels of Meaning in the Ka-chapel of Nebhepetre Mentuhotep (Dyn. XI) at Dendereh', paper delivered at the 1992 annual meeting of the American Research Centre in Egypt.

O'Connor, D. 1995a, 'Beloved of Maat, the Horizon of Ra: the Royal Palace in New Kingdom Egypt', in: D. O'Connor and D. Silverman (eds), *Ancient Egyptian Kingship*, Leiden, 263–300.

O'Connor, D. 1995b, 'The Earliest Royal Boat Graves', *Egyptian Archaeology* 6, 3–7.

Omlin, J. A. 1973, *Der Papyrus 55001 und seine satirisch-erotischen Zeichnungen und Inschriften*, Turin.

Otto, E. 1975, 'Bastet', *LÄ* 1, 628–30.

Parker, R. A., Leclant, J. and Goyon, J.-C. 1979, *The Edifice of Taharqa by the Sacred Lake of Karnak*, Providence and London.

Parkinson, R. 1991, *Voices from Ancient Egypt: an Anthology of Middle Kingdom Writings*, London.

Parkinson, R. and Quirke, S. 1995, *Papyrus*, London.

Payne, J.C. 1993, *Catalogue of the Predynastic Egyptian Collection in the Ashmolean Museum*, Oxford and New York.

Peck, W. H. and Ross, J. G. 1978, *Drawings from Ancient Egypt*, London.

Peet, T. E. 1914, *The Cemeteries of Abydos: Part II, 1911–1912*, London.

Peet, T. E. and Woolley, C. L. 1923, *The City of Akhenaten*, I, London.

Petersen, B. E. J. 1973, *Zeichnungen aus einer Totenstadt*, Stockholm.

Petrie, W. M. F. 1892, *Medum*, London.

Petrie, W. M. F. 1896, *Koptos*, London.

Petrie, W. M. F. 1898, *Deshasheh*, London.

Petrie, W. M. F. 1900a, *Dendereh 1898*, London.

Petrie, W. M. F. 1900b, *The Royal Tombs of the First Dynasty 1900*, Part I, London.

Petrie, W. M. F. 1901, *The Royal Tombs of the Earliest Dynasties 1901*, Part II, London.

Petrie, W. M. F. 1902, *Abydos*, I, London.

Petrie, W. M. F. 1903, *Abydos*, II, London.

Petrie, W. M. F. 1909, *The Palace of Apries*, London.

Petrie, W. M. F. and Brunton, G. 1924, *Sedment*, I, London.

Piankoff, A. 1964, *The Litany of Re*, New York.

Piankoff, A. and Jacquet-Gordon, H. 1974, *The Wandering of the Soul*, Princeton.

Piankoff, A. and Rambova, N. 1954, *The Tomb of Ramesses VI*, New York.

Pinch, G. 1983, 'Childbirth and Female Figurines at Deir el-Medina and el-Amarna', *Orientalia* 52, 405–14.

Polz, D. 1995, 'Excavations in Dra Abu el-Naga', *Egyptian Archaeology* 7, 6–8.

Polz, F. 1995, 'Die Bildnisse Sesostris' III und Amenemhats III: Bemerkungen zur königlichen Rundplastik der späten 12. Dynastie', *MDAIK* 51, 227–54.

Porter, B. and Moss, R. 1934, *Topographical Bibliography of Ancient Egyptian Hieroglyphic Texts, Reliefs, and Paintings*, IV, *Lower and Middle Egypt*, Oxford.

Porter, B. and Moss, R. 1960, *Topographical Bibliography of Ancient Egyptian Hieroglyphic Texts, Reliefs, and Paintings*, 2nd ed., I, *The Theban Necropolis*, Part I, *Private Tombs*, Oxford.

Porter, B. and Moss, R. 1964, *Topographical Bibliography of Ancient Egyptian Hieroglyphic Texts, Reliefs, and Paintings*, 2nd ed., I, *The Theban Necropolis*, Part 2, *Royal Tombs and Smaller Cemeteries*, Oxford.

Porter, B. and Moss, R. 1972, *Topographical Bibliography of Ancient Egyptian Hieroglyphic Texts, Reliefs, and Paintings*, 2nd ed., II, *Theban Temples*, Oxford.

Porter, B. and Moss, R. 1974, *Topographical Bibliography of Ancient Egyptian Hieroglyphic Texts, Reliefs, and Paintings*, 2nd ed. J. Malek, III, *Memphis*, Part I, *Abu Rawash to Abusir*, Oxford.

Porter, B. and Moss, R. 1981, *Topographical Bibliography of Ancient Egyptian Hieroglyphic Texts, Reliefs, and Paintings*, 2nd ed. J. Malek, III, *Memphis*, Part 2, *Saqqara to Dahshur*, Oxford.

Posener-Kriéger, P. 1976, *Les archives du temple funéraire de Néferirkarê-Kakaï*, I–II, Cairo.

Priese, K.-H. 1991, *Ägyptisches Museum*, Mainz.

Quibell, J. E. 1898, *The Ramesseum*, London.

Quibell, J. E. 1900, *Hierakonpolis*, Part I, London.

Quibell, J. E. 1913, *The Tomb of Hesy*, Cairo.

Quibell, J. E. and Green, F. W. 1902, *Hierakonpolis*, Part II, London.

Quirke, S. 1990a, *The Administration of Egypt in the Late Middle Kingdom: the Hieratic Documents*, New Malden, Surrey.

Quirke, S. 1990b, *Who Were the Pharaohs?*, London.

Quirke, S. 1993, *Owners of Funerary Papyri in the British Museum*, London.

Quirke, S. and Spencer, A. J. 1992, *The British Museum Book of Ancient Egypt*, London.

Rachewiltz, B. de. 1960, *The Rock Tomb of Irw-k3-Pth*, Leiden.

Radwan, A. 1969, *Die Darstellungen des regierenden Königs und seiner Familienangehörigen in den Privatgräbern der 18. Dynastie*, Berlin.

Raven, M. 1991, *The Tomb of Iurudef, a Memphite Official in the Reign of Ramesses II*, Leiden and London.

Ray, J.D. 1975, 'The Parentage of Tutankhamun', *Antiquity* 49, 45–7.

Redford, D.B. 1967, *History and Chronology of the Eighteenth Dynasty of Egypt: Seven Studies*, Toronto.

Redford, D.B. 1983, 'Notes on the History of Ancient Buto', *BES* 5, 67–101.

Redford, D.B. 1984, *Akhenaten, the Heretic King*, Princeton.

Redford, D.B. 1986a, *Pharaonic King-lists, Annals and Day-books*, Mississauga.

Redford, D. 1986b, 'New Light on Temple J at Karnak', *Orientalia* 55, 1–15.

Redford, D.B. 1988, *The Akhenaten Temple Project*, II, Toronto.

Reeves, C.N. 1990a, *Valley of the Kings: the Decline of a Royal Necropolis*, London and New York.

Reeves, C.N. 1990b, *The Complete Tutankhamun. The King. The Tomb. The Royal Treasure*, London.

Reeves, N. and Taylor, J.H. 1992, *Howard Carter Before Tutankhamun*, London.

Reisner, G.A. 1936, *The Development of the Egyptian Tomb*, Cambridge, Mass.

Ricke, H. *et al.* 1965, *Das Sonnentempel des Königs Userkaf*, I, *Der Bau*, Wiesbaden.

Ricke, H. *et al.* 1969, *Das Sonnentempel des Königs Userkaf*, II, *Der Funde*, Wiesbaden.

Robins, G. 1985, 'Standing Figures in the Late Grid System of the 26th Dynasty', *SAK* 12, 101–16.

Robins, G. 1986, *Egyptian Painting and Relief*, Aylesbury.

Robins, G. 1990a, 'The Reign of Nebhepetre Montuhotep II and the Pre-unification Theban Style', in: G. Robins (ed.), *Beyond the Pyramids: Egyptian Regional Art from the Museo Egizio, Turin*, Atlanta, 39–45.

Robins, G. 1990b, *Beyond the Pyramids: Egyptian Regional Art from the Museo Egizio, Turin*, Atlanta.

Robins, G. 1990c, 'Problems in Interpreting Egyptian Art', *DE* 17, 45–58.

Robins, G. 1993, *Women in Ancient Egypt*, London.

Robins, G. 1994a, *Proportion and Style in Ancient Egyptian Art*, Austin, Texas.

Robins, G. 1994b, 'Some Principles of Compositional Dominance and Gender Hierarchy in Egyptian Art', *JARCE* 31, 33–40.

Robins, G. 1995, assisted by Sheramy D. Bundrick, *Reflections of Women in the New Kingdom: Ancient Egyptian Art from The British Museum*, San Antonio, Texas.

Robins, G. 1996a, 'Dress, Undress, and the Representation of Fertility and Potency in New Kingdom Egyptian Art', in: N. Kampen (ed.), *Sexuality in Ancient Art*, Cambridge and New York.

Robins, G. 1996b, 'The Representation of Sexual Characteristics in Amarna Art', *JSSEA* 23, 29–41.

Romano, J. forthcoming, 'Sixth Dynasty Royal Sculpture', in: *Critères de datation iconographiques et stylistiques de l'Ancien Empire*, Cairo.

Roth, A. M. 1993, 'Social Change in the Fourth Dynasty: the Spatial Organization of Pyramids, Tombs, and Cemeteries', *JARCE* 30, 33–55.

Russmann, E. R. 1974, *The Representation of the King in the XXVth Dynasty*, Brussels and Brooklyn.

Russmann, E. R. 1980, 'The Anatomy of an Artistic Convention: Representation of the Near Foot in Two Dimensions through the New Kingdom', *BES* 2, 57–81.

Russmann, E. R. 1989, *Egyptian Sculpture: Cairo and Luxor*, Austin.

Russmann, E. R. 1994, 'Relief Decoration in the Tomb of Mentuemhat (TT 34)', *JARCE* 31, 1–19.

Russmann, E. R. 1995a, 'The Motif of Bound Papyrus Plants and the Decorative Program in Mentuemhat's First Court (Further Remarks on the Decoration of the Tomb of Mentuemhat, 1)', *JARCE* 32, 117–26.

Russmann, E. R. 1995b, 'A Second Style in Egyptian Art of the Old Kingdom', *MDAIK* 51, 269–79.

el Sadeek, W. 1984, *Twenty-sixth Dynasty Necropolis at Gizeh: an Analysis of the Tomb of Thery and its Place in the Development of Saite Funerary Art and Architecture*, Vienna.

Saleh, M. 1977, *Three Old Kingdom Tombs at Thebes*, Mainz.

Saleh, M. 1984, *Das Totenbuch in den thebanischen Beamtengräbern des Neuen Reiches, Texte und Vignetten*, Mainz.

Saleh, M. and Sourouzian, H. 1987, *The Egyptian Museum Cairo*, Mainz.

Sandars, N. 1978, *The Sea Peoples: Warriors of the Ancient Mediterranean, 1250–1150 BC*, London.

Säve-Söderbergh, T. 1957, *Four Eighteenth Dynasty Tombs*, Oxford.

Schäfer, H. 1908, *Urkunden der älteren Äthiopenkönige*, Leipzig.

Schäfer, H. 1986, *Principles of Egyptian Art*, ed. E. Brunner-Traut, trans. and ed. J. Baines, Oxford.

Scheel, B. 1989, *Egyptian Metalworking and Tools*, Aylesbury.

Schlögl, H. 1977, *Der Sonnengott auf der Blüte: eine ägyptische Kosmogonie des Neuen Reiches*, Geneva.

Schneider, H. 1993, 'The Rediscovery of Iniuia', *Egyptian Archaeology* 3, 3–5.

Schulz, R. 1992, *Die Entwicklung und Bedeutung des Kuboiden Statuentypus: eine Untersuchung zu den sogenannten 'Würfelhockern'*, I–II, Hildesheim.

Scott, G. 1986, *Ancient Egyptian Art at Yale*, New Haven.

Seele, K. C. 1959, *The Tomb of Tjanefer at Thebes*, Chicago.

Seipel, W. 1989, *Ägypten: Götter, Gräber und die Kunst 4000 Jahre Jenseitsglaube*, I, Linz.

Seipel, W. 1992, *Gott. Mensch. Pharao: Viertausend Jahre Menschenbild in der Skulptur des Alten Ägypten*, Vienna.

Sethe, K. 1914, 'Hitherto Unnoticed Evidence regarding Copper Works of Art of the Oldest Period of Egyptian History', *JEA* 1, 233–6.

Settgast, J. and Wildung, D. 1989, *Ägyptisches Museum Berlin*, 4th ed., Berlin.

Seyfried, K.-J. 1990, *Das Grab des Amonmose (TT 373)*, Mainz.

Seyfried, K.-J. 1995, *Das Grab des Djehutiemhab (TT 194)*, Mainz.

Shedid, A. G. 1994a, *Das Grab des Sennedjem: ein Künstlergrab der 19. Dynastie in Deir el Medineh*, Mainz.

Shedid, A. G. 1994b, *Die Felsgräber von Beni Hassan in Mittelägypten*, Mainz.

Simpson, W. K. 1973, 'Ptolemaic-Roman Cartonnage Footcases with Prisoners Bound and Tied', *ZÄS* 100, 50–4.

Simpson, W. K. 1974, *The Terrace of the Great God at Abydos: the Offering Chapels of Dynasties 12 and 13*, New Haven and Philadelphia.

Simpson, W. K. 1976, *The Mastabas of Qar and Idu, G7101 and 7102*, Boston.

Simpson. W. K. 1980, *Mastabas of the Western Cemetery: Part I*, Boston.

Simpson, W. K. 1982, 'Egyptian Sculpture and Two-Dimensional Representation as Propaganda', *JEA* 68, 266–71.

Simpson, W. K. 1984, 'Sesostris III', *LÄ* 5, 903–6.

Smith, H. S. 1992, 'The Making of Egypt: a Review of the Influence of Susa and Sumer on Upper Egypt and Lower Nubia in the 4th Millennium BC', in: R. Friedman and B. Adams (eds), *The Followers of Horus: Studies Dedicated to Michael Allen Hoffman*, Oxford, 235–46.

Smith, R. and Redford, D. B. 1976, *The Akhenaten Temple Project*, I, *Initial Discoveries*, Warminster.

Smith, W. S. 1946, *A History of Egyptian Sculpture and Painting in the Old Kingdom*, London.

Smith, W. S. 1981, *The Art and Architecture of Ancient Egypt*, 2nd ed., Harmondsworth.

Sourouzian, H. 1984, 'Rischi-Sarg', *LÄ* 5, 267–9.

Sourouzian, H. 1988, 'Standing Royal Colossi of the Middle Kingdom reused by Ramesses II', *MDAIK* 44, 229–54.

Spanel, D. 1988, *Through Ancient Eyes: Egyptian Portraiture*, Birmingham, Ala.

Spencer, A. J. 1978, 'Two Enigmatic Hieroglyphs and their Relation to the Sed-Festival', *JEA* 64, 52–5.

Spencer, A. J. 1980, *Early Dynastic Objects*, Catalogue of Egyptian Antiquities in the British Museum, V, London.

Stadelmann, R. 1971, 'Das Grab im Tempelhof: der Typus des Königsgrabes in der Spätzeit', *MDAIK* 27, 111–23.

Stadelmann, R. 1973, 'Tempelpalast und Erscheinungsfenster in der thebanischen Totentempeln', *MDAIK* 29, 221–42.

Stadelmann, R. 1978, 'Tempel und Tempelnamen in Theben-Ost und -West', *MDAIK* 34, 171–80.

Stadelmann, R. 1979, 'Totentempeln und Millionenjahrhaus in Theben-Ost und-West', *MDAIK* 35, 303–21.

Stadelmann, R. 1984, 'Sonnenheiligtum', *LÄ* 5, 1094–9.

Stadelmann, R. 1986, 'Totentempeln III', *LÄ* 6, 706–11.

Steckeweh, H. 1936, *Die Fürstengräber von Qaw*, Leipzig.

Steindorff, G. 1913, *Das Grab des Ti*, Leipzig.

Steindorff, G. 1946, 'The Magical Knives of Ancient Egypt,' *Journal of the Walters Art Gallery* 9, 41–51, 106–7.

Stewart, H. M. 1967, 'Stelophorous Statuettes in the British Museum', *JEA* 53, 34–8.

Strauss-Seeber, C. 1994, 'Bildprogramm und Funktion der Weissen Kapelle in Karnak', in: R. Gundlach and M. Rochholz, *Ägyptische Tempel – Struktur, Funktion und Programm*, Hildesheim, 287–318.

Strudwick, N. 1994, 'Change and Continuity at Thebes: the Private Tomb after Akhenaten', in: C. Eyre, A. Leahy and L. M. Leahy, *The Unbroken Reed: Studies in the Culture and Heritage of Ancient Egypt in Honour of A. F. Shore*, London, 321–36.

Tait, G. A. D. 1963, 'The Egyptian Relief Chalice', *JEA* 49, 93–138.

Tait, W. J. 1982, *Game-boxes and Accessories from the Tomb of Tutankhamun*, Oxford.

Taylor, J. 1989, *Egyptian Coffins*, Aylesbury.

Taylor, J. 1995, 'Tracking down the Past', *British Museum Magazine* 21, 8–11.

Tefnin, R. 1979, *La statuaire d'Hatshepsout: portrait royal et politique sous la 18e Dynastie*, Brussels.

Terrace, E.L.B. and Fischer, H.G. 1970, *Treasures of the Cairo Museum*, Boston.

Thomas, N. 1995, *The American Discovery of Egypt*, Los Angeles.

Tooley, A. 1995, *Egyptian Models and Scenes*, Aylesbury.

Török, L. 1995, 'The Emergence of the Kingdom of Kush and her Myth of the State in the First Millennium BC', *Cahiers de Recherches de l'Institut de Papyrologie et d'Égyptologie de Lille* 17, 203–28.

Tosi, M. and Roccati, A. 1972, *Stele e altri epigrafi di Deir el Medina (n. 50001–50262)*, Turin.

Troy, L. 1986, *Patterns of Queenship in Ancient Egyptian Myth and History*, Uppsala.

Tylor, J.J. and Griffith, F.Ll. 1894, *The Tomb of Paheri at El-Kab*, London.

Tytus, R. de P. 1903, *A Preliminary Report on the Re-excavation of the Palace of Amenhetep III*, New York.

Valbelle, D. 1975, *La tombe de Hay à Deir el-Médineh (N° 267)*, Cairo.

Valbelle, D. 1985, *Les ouvriers de la tombe: Deir el-Medineh à l'époque Ramesside*, Cairo.

Vandersleyen, C. 1971, *Les guerres d'Amosis*, Brussels.

Vandier, J. 1958, *Manuel d'Archéologie Égyptienne*, III, *Les Grandes Époques, La Statuaire*, Paris.

Vandier d'Abbadie, J. 1937, *Catalogue des ostraca figurés de Deir el Médineh (Nos 2001–2733)*, Cairo.

Vandier d'Abbadie, J. 1959, *Catalogue des ostraca figurés de Deir el Médineh (Nos 2734 à 3053)*, Cairo.

Van Siclen, C.C. 1995, 'The Valley Temples at Deir el Bahari', paper delivered at the 1995 meeting of ARCE.

Vassilika, E. 1989, *Ptolemaic Philae*, Leuven.

Vassilika, E. 1995, *Egyptian Art*, Cambridge.

Velde, H. te. 1977, *Seth, God of Confusion: a Study of his Role in Egyptian Mythology and Religion*, Leiden.

Verner, M. 1977, *The Mastaba of Ptahshepses*, Prague.

Verner, M. 1994, *Forgotten Pharaohs, Lost Pyramids: Abusir*, Prague.

Waddell, W.G. 1940, *Manetho*, Cambridge, Mass. and London.

Waseda University 1993, *Studies in the Palace of Malqata: Investigations at the Palace of Malqata, 1985–1988*, Tokyo.

Watson, P. 1987, *Egyptian Pyramids and Mastaba Tombs*, Aylesbury.

Weatherhead, F. 1992, 'Painted Pavements in the Great Palace at Amarna', *JEA* 78, 179–94.

Welsby, D. 1996, *The Kingdom of Kush: the Napatan and Meroitic Empires*, London.

Wenig, S. 1966, *Die Jahreszeitenreliefs aus dem Sonnenheiligtum des Königs Ne-user-re*, Berlin.

Wente, E. 1990, *Letters from Ancient Egypt*, Atlanta.

Werbrouck, M. 1949, *Le temple d'Hatshepsout à Deir el Bahari*, Brussels.

Wild, H. 1953, *Le Tombeau de Ti*, II, Cairo.

Wild, H. 1966, *Le Tombeau de Ti*, III, Cairo.

Wild, H. 1979, *La tombe de Néferhotep (1) et Nebnefer à Deir el Médîna (N° 6)*, Cairo.

Wildung, D. 1977, *Imhotep und Amenhotep*, Munich and Berlin.

Wildung, D. 1984, *L'âge d'or de l'Égypte: le Moyen Empire*, Fribourg.

Wilkinson, R.H. 1994a, *Symbol and Magic in Egyptian Art*, London and New York.

Wilkinson, R.H. 1994b, 'Symbolic Location and Alignment in New Kingdom Royal Tombs and their Decoration', *JARCE* 31, 79–90.

Willems, H. 1988, *Chests of Life: a Study of the Typology and Conceptual Development of Middle Kingdom Standard Class Coffins*, Leiden.

Winlock, H.E. 1934, *The Treasure of El-Lahun*, New York.

Winlock, H.E. 1942, *Excavations at Deir el Bahari*, New York.

Winlock, H.E. 1955, *Models of Daily Life in Ancient Egypt*, Cambridge, Mass.

Winter, E. 1968, *Untersuchungen zu den ägyptischen Tempelreliefs der Griechisch-Römischen Zeit*, Vienna.

Wood, W. 1978, 'A Reconstruction of the Reliefs of Hesy-Re', *JARCE* 15, 9–24.

Yoyotte, J. *et al.* 1988, *Gold of the Pharaohs*, Edinburgh.

Ziegler, C. 1990a, *Catalogue des stèles, peintures et reliefs égyptiens de l'Ancien Empire et de la Première Période Intermédiaire, vers 2686–2040 avant J.C.*, Paris.

Ziegler, C. 1990b, *The Louvre, Egyptian Antiquities*, London.

Zivie, A.-P. 1979, *Le tombe de Pached à Deir el-Medineh (no. 3)*, Cairo.

Zivie, A.-P. 1988, 'Aper-El et ses voisins: considérations sur les tombes rupestres de la XVIIIe dynastie à Saqqarah', in: A.-P. Zivie (ed.), *Memphis et ses nécropoles au nouvel empire*, Paris, 103–12.

Zivie, A.-P. 1990, *Découverte à Saqqarah: le vizir oublié*, Paris.

Further Reading

Although, for reasons of space, I have been unable to treat in any depth the so-called minor arts, such as amulets, jewellery, pottery, textiles and decorated cosmetic objects, I have included books relating to these items in the reading list.

Aldred, C., *Jewels of the Pharaohs*, London, 1971.

Aldred, C., *Akhenaten and Nefertiti*, London, 1973.

Aldred, C., *Egyptian Art in the Days of the Pharaohs 3100 320 BC*, London, 1980.

Aldred, C., *Akhenaten, King of Egypt*, London and New York, 1988.

Andrews, C. (ed.), *The Ancient Egyptian Book of the Dead*, trans. R.O. Faulkner, London, 1985.

Andrews, C., *Ancient Egyptian Jewellery*, London, 1990, 2nd ed. 1996.

Andrews, C., *Amulets of Ancient Egypt*, London, 1994.

Arnold, Dor., *The Royal Woman of Amarna: Images of Beauty from Ancient Egypt*, New York, 1996.

Baines, J., 'On the Status and Purposes of Ancient Egyptian Art', *Cambridge Archaeological Journal* 4 (1994), 67–94.

Baines, J., 'Palaces and Temples of Ancient Egypt', in: J. Sasson (ed.), *Civilizations of the Ancient Near East*, I, New York, 1995, 303-17.

Bianchi, R.S., *Cleopatra's Egypt: Age of the Ptolemies*, Brooklyn, 1988.

Bianchi, R.S., 'Ancient Egyptian Reliefs, Statuary, and Monumental Paintings', in: J. Sasson (ed.), *Civilizations of the Ancient Near East*, IV, New York, 1995, 2533–54.

Bianchi, R.S., *Splendors of Ancient Egypt from the Egyptian Museum Cairo*, London, 1996.

Bothmer, B.V., *Egyptian Sculpture of the Late Period 700 BC to AD 100*, Brooklyn, 1960.

Bourriau, J., *Umm el-Ga'ab: Pottery from the Nile Valley Before the Arab Conquest*, Cambridge, 1981.

Bourriau, J., *Pharaohs and Mortals: Egyptian Art in the Middle Kingdom*, Cambridge, 1988.

Bourriau, J., 'Patterns of Change in Burial Customs during the Middle Kingdom', in: S. Quirke (ed.), *Middle Kingdom Studies,* New Malden, Surrey, 1991, 3–20.

Breasted, J.H., Jr, *Egyptian Servant Statues*, Washington D.C., 1948.

Brovarski, E., Doll, S. and Freed, R. (eds), *Egypt's Golden Age: The Art of Living in the New Kingdom, 1558–1085 BC*, Boston, 1982.

Brunner-Traut, E., *Egyptian Artists' Sketches: Figured Ostraka from the Gayer-Anderson Collection in the Fitzwilliam Museum, Cambridge*, Istanbul, 1979.

Corcoran, L.H., *Portrait Mummies from Roman Egypt (I–IVth Centuries AD): with a Catalog of Portrait Mummies in Egyptian Museums*, Chicago, 1995.

D'Auria, S., Lacovara, P. and Roehrig, C., *Mummies and Magic: The Funerary Arts of Ancient Egypt*, Boston, 1988.

Davies, W.V. (ed.), *Colour and Painting in Ancient Egypt*, London, forthcoming.

Drenkhahn, R., 'Artisans and Artists in Pharaonic Egypt' in: J.M. Sasson (ed.), *Civilizations of the Ancient Near East*, I, New York, 1995, 331-43.

Fay, B., *The Louvre Sphinx and Royal Sculpture from the Reign of Amenemhat II*, Mainz, 1996.

Fazzini, R., *Egypt Dynasty XXII–XXV*, Leiden, 1988.

Fazzini, R., Bianchi, R., Romano, J. and Spanel, D., *Ancient Egyptian Art in the Brooklyn Museum*, New York and London, 1989.

Gaballa, G.A., *Narrative in Egyptian Art*, Mainz, 1976.

Groenewegen-Frankfort, H.A., *Arrest and Movement: an Essay on Space and Time in the Representational Art of the Ancient Near East*, Chicago, 1951.

Habachi, L., *The Sanctuary of Heqaib*, I–II, Mainz, 1985.

Hall, R., *Egyptian Textiles*, Aylesbury, 1986.

Hayes, W.C., *The Scepter of Egypt*, I–II, New York, 1953, 1959, rev. ed. 1990.

Hope, C., *Egyptian Pottery*, Aylesbury, 1987.

Hope, C., *Gold of the Pharaohs*, Sydney, 1988.

Hornung, E., *The Valley of the Kings, Horizon of Eternity*, New York, 1990.

Hornung, E., *The Tomb of Pharaoh Seti I/Das Grab Sethos' I*, Zurich and Munich, 1991.

Hornung, E., *Idea into Image*, New York, 1992.

Kemp, B.J., *Ancient Egypt: Anatomy of a Civilization*, London and New York, 1989.

Kozloff, A. and Bryan, B., *Egypt's Dazzling Sun: Amenhotep III and his World*, Cleveland, 1992.

McDonald, J., *House of Eternity: The Tomb of Nefertari*, Los Angeles, 1996.

McDowell, A., *Village Life in Ancient Egypt: Laundry Lists and Love Songs*, Oxford, forthcoming.

Martin, G.T., *The Memphite Tomb of Horemheb, Commander-in-Chief of Tutankhamun*, I, *The Reliefs, Inscriptions, and Commentary*, London, 1989.

Martin, G.T., *The Royal Tomb at el-Amarna*, II, *The Reliefs, Inscriptions and Architecture*, London, 1989.

Martin, G.T., *The Hidden Tombs of Memphis*, London and New York, 1991.

Mekhitarian, A., *Egyptian Painting*, Geneva, 1954.

Murnane, W.J., *United with Eternity: a Concise Guide to*

the Monuments of Medinet Habu, Chicago and Cairo, 1980.

Nicholson, P.T., *Egyptian Faience and Glass*, Aylesbury, 1993.

Niwiński, A., *Twenty-first Dynasty Coffins from Thebes: Chronological and Typological Studies*, Mainz, 1988.

Niwiński, A., *Studies on the Illustrated Theban Funerary Papyri of the 11th and 10th Centuries bc*, Freiburg and Göttingen, 1989.

Peck, W.H. and Ross, J.G., *Drawings from Ancient Egypt*, London, 1978.

Piankoff, A. and Rambova, N., *The Tomb of Ramesses VI*, New York, 1954.

Piankoff, A. and Rambova, N., *Mythological Papyri*, New York, 1957.

Quirke, S. and Spencer, A.J., *The British Museum Book of Ancient Egypt*, London, 1992.

Redford, D.B., *Akhenaten, the Heretic King*, Princeton, 1984.

Reeves, C.N., *The Complete Tutankhamun. The King. The Tomb. The Royal Treasure*, London, 1990.

Riefstahl, E., *Ancient Egyptian Glass and Glazes in the Brooklyn Museum*, Brooklyn, 1968.

Robins, G., *Egyptian Painting and Relief*, Aylesbury, 1986.

Robins, G., *Proportion and Style in Ancient Egyptian Art*, Austin, Texas, 1994.

Robins, G., assisted by Sheramy D. Bundrick, *Reflections of Women in the New Kingdom: Ancient Egyptian Art from The British Museum*, San Antonio, Texas, 1995.

Robins, G., 'Dress, Undress, and the Representation of Fertility and Potency in New Kingdom Egyptian Art', in: N. Kampen (ed.), *Sexuality in Ancient Art*, Cambridge and New York, 1996, 27-40.

Romano, J.F. 'Jewelry and Personal Arts in Ancient Egypt', in: J. Sasson (ed.), *Civilizations of the Ancient Near East*, III, New York, 1995, 1605-21.

Russmann, E.R., *Egyptian Sculpture. Cairo and Luxor*, Austin, 1989.

Schäfer, H., *Principles of Egyptian Art*, ed. E. Brunner-Traut, trans. and ed. J. Baines, Oxford, 1986.

Smith, W.S., *A History of Egyptian Sculpture and Painting in the Old Kingdom*, London, 1946.

Smith, W.S., *The Art and Architecture of Ancient Egypt*, 2nd ed., Harmondsworth, 1981.

Spanel, D., *Through Ancient Eyes: Egyptian Portraiture*, Birmingham, Ala., 1988.

Taylor, J., *Egyptian Coffins*, Aylesbury, 1989.

Tooley, A., *Egyptian Models and Scenes*, Aylesbury, 1995.

Vassilika, E., *Egyptian Art*, Cambridge, 1995.

Verner, M., *Forgotten Pharaohs, Lost Pyramids: Abusir*, Prague, 1994.

Wilkinson, A., *Ancient Egyptian Jewellery*, London, 1971.

Wilkinson, R.H., *Reading Egyptian Art*, London and New York, 1992.

Wilkinson, R.H., *Symbol and Magic in Egyptian Art*, London and New York, 1994.

Winlock, H.E., *Models of Daily Life in Ancient Egypt*, Cambridge, Mass., 1955.

Illustration Acknowledgements

EA = British Museum, Department of Egyptian Antiquities accession number

Half-title: EA 30841; frontispiece: EA 22941; map on page 11 by Claire Thorne; **1** Graham Harrison; **2** EA 10470; **3** Epigraphic Survey 1957, pl. 322. Reproduced courtesy of the Oriental Institute, University of Chicago; **4** EA 12337 (Libyan), EA 12361 (Syrian), EA 12288 (Nubian); **5** Graham Harrison; **6** Ägyptisches Museum, Berlin, 16100; **7** EA 111; **8** Gay Robins; **9** EA 1682; **10** EA 29594; **11** EA 37977; **12** Gay Robins; **13** EA 718. T.G.H. James, *Hieroglyphic Texts*, Part 1 (2nd edn, 1961), pl. 29, no. 2; **14** EA 1242; **15** EA 46629; **16** EA 66632; **17** Wild 1966, pl. 173; **18** Gay Robins; **19** Egypt Exploration Society; **20** Dunham and Simpson 1974, fig. 8 (detail). Reproduced by permission of the Museum of Fine Arts, Boston; **21** Davies 1943, pl. 60; **22** Davies 1905, pl. 18. Reproduced by permission of the Egypt Exploration Society; **23** Drawing by Christine Barratt after F.W. Green; **24** EA 35502; **25** Egyptian Museum, Cairo, JE 14716; **26** Louvre, Paris, E 11007. Service Photographique de la RMN; **27** Ashmolean Museum, Oxford, E 3632. Drawing by Richard Parkinson after Marion Cox; **28** Ashmolean Museum, Oxford, E 3631. Drawing by Helen Whitehouse; **29** EA 32650; **30** EA 35597; **31** Petrie 1901, pl. 23, nos 200 and 197. Reproduced by permission of the Egypt Exploration Society; **32** Ashmolean Museum, Oxford, E 517; **33** EA 37996; **34** Quibell 1900, pl. 40 (lower); **35** Smith 1981, fig. 32; **36** Graham Harrison; **37** Paul T. Nicholson; **38** Drawing by Claire Thorne after Lloyd and Müller 1980, 83; **39** Drawing by Richard Parkinson; **40** Egyptian Museum, Cairo, JE 49158; **41** J.-C. Golvin; **42** Drawing by Claire Thorne after Fakhry 1961a, fig. 1; **43** Fakhry 1961a, pl. 15b; **44** Fakhry 1961a, frontispiece; **45** Egyptian Museum, Cairo, CG 14; **46** Egyptian Museum, Cairo, CG 1427. Hirmer

Fotoarchiv; **47** Murray, 1905, pl. 1; **48** EA 171; **49** El-Khouli 1991, pl. 38. Drawing by Lyla Pinch Brock, reproduced by permission of the Australian Centre for Egyptology; **50** EA 60914; **51** Egyptian Museum, Cairo, CG 3 and 4. Photo: Jürgen Liepe; **52** Egyptian Museum, Cairo, JE 39133. Werner Forman Archive; **53** Drawing by Claire Thorne after Edwards 1993, fig. 38; **54** Drawing by Claire Thorne after Edwards 1993, fig. 42; **55** Ägyptisches Museum, Berlin, 21782. Bildarchiv Preussischer Kulturbesitz (photo: Jürgen Liepe); **56** Drawing by Claire Thorne after Porter and Moss 1974, plan xxxvi; **57** Von Bissing 1905, pl.1; **58** Ägyptisches Museum, Berlin, 20038. Bildarchiv Preussischer Kulturbesitz (photo: Jürgen Liepe); **59** Egyptian Museum, Cairo, JE 33034; **60** Brooklyn Museum of Art, 39.120; **61** Drawing from Fischer 1977a, fig. 30; **62** Brooklyn Museum of Art, 39.119; **63** EA 718. Drawing from T.G.H. James, *Hieroglyphic Texts*, Part 1 (2nd edn, 1961), pl. 28; **64** Graham Harrison; **65** Jéquier 1929, pl. 9; **66** EA 1239; **67** EA 55722; **68** Kunsthistorisches Museum, Vienna, ÄS 7507; **69** EA 1181; **70** Egyptian Museum, Cairo, CG 22. Photo: Jürgen Liepe; **71** Simpson 1980, fig. 31. Reproduced by permission of the Museum of Fine Arts, Boston; **72** Pelizaeus-Museum, Hildesheim, inv. no. 18; **73** EA 55730; **74** Simpson 1976, fig. 34. Reproduced by permission of the Museum of Fine Arts, Boston; **75** EA 1170; **76** Davies 1901, pl. 17. Reproduced by permission of the Egypt Exploration Society; **77** Graham Harrison; **78** EA 1450 (1907-10-15-497); **79** EA 1783; **80** EA 1260; **81** EA 37895; **82** The Metropolitan Museum of Art, New York, Purchase, 1914 (14.2.7); **83** The Metropolitan Museum of Art, New York, Rogers Fund, 1913 (13.182.3); **84** EA 614a; **85** EA 614; **86** EA 1450 (1907-10-15-460); **87** Egyptian Museum, Cairo, JE 46048. Photo: Geoffrey Martin; **88** *Mitteilungen des Deutschen Archäologischen Instituts, Abteilung Kairo,*

1963, 24 fig. 7 (detail); **89** EA 30841; **90** The Metropolitan Museum of Art, New York, Harris Brisbane Dick Fund, 1957 (57.95); **91** Drawing by Claire Thorne after Arnold 1974a, pl. 27; **92** Arnold, 1974a, frontispiece (upper); **93** The Metropolitan Museum of Art, New York, Museum Excavations, 1921-2, Rogers Fund, 1922 (26.3.29); **94** EA 720; **95** EA 732; **96** EA 1397; **97** Egyptian Museum, Cairo, JE 66329; **98** Louvre, Paris, E 15113. Photo © Maurice et Pierre Chuzeville/Musée du Louvre; **99** The Metropolitan Museum of Art, New York, Museum Excavations and Rogers Fund, 1908 (08.200.1); **100** Drawing by Claire Thorne after Arnold 1988, pl. 75; **101** The Metropolitan Museum of Art, New York, Rogers Fund, 1909 (09.180.13AB); **102** Arnold 1988, fig. 20; **103** Petrie Museum, University College London, 14786; **104** Drawing by H. Parkinson; **105–6** Gay Robins; **107** Egyptian Museum, Cairo, JE 48851; **108** EA 1152; **109** The Metropolitan Museum of Art, New York, Museum Excavations, 1913-14 (15.3.1164); **110** EA 829; **111** EA 579; **112** EA 30841; **113** The Metropolitan Museum of Art, New York, Museum Excavations, 1919-20, Rogers Fund and Edward S. Harkness Gift, 1920 (20.3.7); **114** EA 569-570; **115** EA 462; **116–17** EA 579; **118** EA 12270; **119** EA 969; **120** EA 686; **121** Fitzwilliam Museum, Cambridge, E.2-1946; **122** Henri Stierlin; **123** EA 18175; **124** The Metropolitan Museum of Art, New York, Purchase, Edward S. Harkness Gift, 1926 (26.7.1275); **125** EA 52863; **126** EA 52951; **127** EA 12270; **128** EA 24385; **129** EA 1785; **130** EA 428; **131** EA 101; **132** EA 1163; **133** EA 871; **134** Gay Robins; **135** EA 7; **136** Erik Hornung; **137** Gay Robins; **138** Paul T. Nicholson; **139** Drawing by Claire Thorne after de Cenival 1963, 84; **140–1** Gay Robins; **142** The Metropolitan Museum of Art, New York, Museum Excavations, 1926-8; Rogers Fund, 1931 (31.3.163); **143** The Metropolitan Museum of Art, New York,

Rogers Fund and Edward S. Harkness Gift, 1929 (29.3.1); **144** The Metropolitan Museum of Art, New York, Rogers Fund and Edward S. Harkness Gift, 1929 (29.3.3); **145** Gay Robins; **146** Paul T. Nicholson; **147** Drawing by Claire Thorne after Porter and Moss 1972, plan 6; **148–50** Gay Robins; **151** J.-C. Golvin; **152** Drawing by Claire Thorne after Kemp 1989, fig. 72; **153** Museum of Fine Arts, Boston. Gift of Mrs Horace L. Mayer (1970.636); **154** The Metropolitan Museum of Art, New York, The Theodore M. Davis Collection, Bequest of Theodore M. Davis, 1915 (30.8.45); **155** The Metropolitan Museum of Art, New York, Rogers Fund, 1933 (33.8.8); **156** Dziobek 1992, pl. 33; **157** EA 920; **158** Gay Robins; **159** EA 37984; **160** EA 37987; **161** EA 43465; **162** Gay Robins; **163** EA 2320; **164** EA 902; **165** Ashmolean Museum, Oxford, 1893/173; **166** EA 51101; **167** EA 480; **168** EA 174; **169** The Metropolitan Museum of Art, New York, Gift of the Earl of Carnarvon, 1914 (14.10.2ab); **170** EA 29770; **171** EA 29580; **172** Egyptian Museum, Cairo, RT 10.11.26.4. Photo Jürgen Liepe; **173** Davies 1906, pl. 31. Reproduced by permission of the Egypt Exploration Society; **174** Ashmolean Museum, Oxford, 1893.1-41 (75); **175** Davies 1905b, pl. 28. Reproduced by permission of the Egypt Exploration Society; **176** Martin, 1989b, pl. 68. Reproduced by permission of the Egypt Exploration Society; **177** Egyptian Museum, Cairo, JE 55938; **178** Smith and Redford 1988; **179** Davies 1903, pl. 33. Reproduced by permission of the Egypt Exploration Society; **180** Davies 1903, pls 10-10a. Reproduced by permission of the Egypt Exploration Society; **181** Davies 1908b, pl. 4. Reproduced by permission of the Egypt Exploration Society; **182** Ägyptisches Museum, Berlin, 14145. Bildarchiv Preussischer Kulturbesitz (photo: Margarete Büsing); **183** Brooklyn Museum of Art, 29.34; **184** Davies 1908a, pl. 20. Reproduced by permission of the Egypt Exploration Society; **185** Davies 1905b, pl. 22. Reproduced by permission of the Egypt Exploration Society; **186** Davies 1905a, pl. 23. Reproduced by permission of the Egypt Exploration Society; **187–8** Gay Robins; **189** Egyptian Museum, Cairo, JE 61467. Photo Jürgen Liepe; **190** The Metropolitan Museum of Art, New York. Photography by the Egyptian Expedition; **191** K. El Mallakh and Arnold C. Brackman, *The Gold of Tutankhamun*, New York, 1978, pl. 5; **192** Frank Teichmann; **193** Hans Schneider; **194** Martin 1991, 37, fig. 9; **195** EA 550; **196** J. Paul Getty Trust 1992. Photo: Guillermo Aldana; **197** Louvre, Paris, B 7. Photo RMN - Chuzeville; **198** Metropolitan Museum of Art, New York. Photography by the Egyptian Expedition; **199** Drawing by Claire Thorne after Smith 1981, fig. 356; **200** J.-C. Golvin; **201** Courtesy of the Oriental Institute of the University of Chicago; **202** Drawing by Claire Thorne after Lloyd and Müller 1980, 163; **203** Courtesy of the Oriental Institute of the University of Chicago; **204** Drawings by Claire Thorne after (a) Epigraphic Survey 1986, pl. 28; (b) Calverley 1935, pl. 45; (c) Hornung 1991, pl. 93 (left); **205** Calverley 1935, pl. 37. Reproduced by permission of the Egypt Exploration Society; **206** Calverley 1935, pl. 11. Reproduced by permission of the Egypt Exploration Society ; **207** Graham Harrison; **208–12** Gay Robins; **213** Paul T. Nicholson; **214** Desroches Noblecourt and Kuentz 1968, pl. 98; **215–16** J.E. Livet; **217** Dr A. Shedid; **218** Graham Harrison; **219** Martin 1985, pl. 22. Reproduced by permission of the Egypt Exploration Society; **220** EA 165; **221** EA 48001; **222** EA 1377; **223** EA 316; **224** EA 370; **225** EA 284; **226** EA 344; **227** EA 61083; **228** EA 2371; **229** EA 8506; **230** EA 5620; **231** EA 8510; **232** EA 10016; **233** Egyptian Museum, Cairo, JE 85913. Werner Forman Archive; **234** Egyptian Museum, Cairo, JE 85781; **235** EA 1077; **236** EA 1063 ; **237** EA 1105; **238** Gay Robins; **239** EA 26233; **240** EA 14594-5; **241** EA 48791-2; **242–3** EA 36211; **244** EA 6659; **245** EA 27332; **246** EA 10044; **247** EA 9970; **248** Egyptian Museum, Cairo, CG 42228; **249** Egyptian Museum, Cairo, JE 36988; **250** Louvre, Paris, N 500. Photo: RMN - H. Lewandowski; **251** EA 642; **252** Brooklyn Museum of Art, 59.17; **253** EA 22919; **254** Ny Carlsberg Glyptotek, Copenhagen, Æ.I.N.1046; **255** Courtesy of the Oriental Institute of the University of Chicago; **256** Graham Harrison; **257** Courtesy of the Oriental Institute of the University of Chicago; **258–60** Gay Robins; **261** EA 63595; **262** The St Louis Art Museum (Ancient and Islamic Art), 1:1958; **263** The Cleveland Museum of Art, Gift of the Hanna Fund, 1949.499; **264** EA 20745; **265–6** EA 15655; **267** EA 17; **268** EA 8453; **269** EA 8475; **270** EA 1317; **271** EA 1682; **272** EA 1132; **273** Egyptian Museum, Cairo, CG 42236; **274** EA 1162; **275** EA 60042; **276** Graham Harrison; **277** EA 10; **278** Louvre, Paris, N 402. Service Photographique de la RMN; **279** EA 22; **280** Graham Harrison; **281** Jéquier 1924, pl. 25; **282** Drawing by Claire Thorne after Aufrère, Golvin and Goyon 1991, 251; **283** Jéquier 1924, pl. 50, no.1; **284** Pelizaeus-Museum, Hildesheim, inv. no. 1883; **285** After Clère 1961, pl. 24; **286** After Clère 1961, pl. 68; **287** Cauville 1984, pl. 20; **288** The Harer Family Trust, no. 27; **289** Musées Royaux d'Art et d'Histoire, Brussels, E 3073; **290** EA 55254; **291** EA 37448; **292** Ägyptisches Museum, Berlin, 12500. Bildarchiv Preussischer Kulturbesitz; **293** EA 36250; **294** Louvre, Paris, E 10777. Service Photographique de la RMN; **295** Egyptian Museum, Cairo, JE 46591; **296** Egyptian Museum, Cairo, JE 29211; **297** EA 8468; **298** EA 147; **299** Graham Harrison; **300** EA 60859; **301** EA 10479; **302** Michael C. Carlos Museum, Emory University, Atlanta, 1921.6; **303** EA 9901/3; **304** Graham Harrison.

Index